SUCH FREEDOM, IF ONLY MUSICAL

SUCH FREEDOM, IF ONLY MUSICAL

Unofficial Soviet Music during the Thaw

PETER J. SCHMELZ

OXFORD
UNIVERSITY PRESS

2009

OXFORD
UNIVERSITY PRESS

Oxford University Press, Inc., publishes works that further
Oxford University's objective of excellence
in research, scholarship, and education.

Oxford New York
Auckland Cape Town Dar es Salaam Hong Kong Karachi
Kuala Lumpur Madrid Melbourne Mexico City Nairobi
New Delhi Shanghai Taipei Toronto

With offices in
Argentina Austria Brazil Chile Czech Republic France Greece
Guatemala Hungary Italy Japan Poland Portugal Singapore
South Korea Switzerland Thailand Turkey Ukraine Vietnam

Published by Oxford University Press, Inc.
198 Madison Avenue, New York, New York 10016

www.oup.com

Oxford is a registered trademark of Oxford University Press

Library of Congress Cataloging-in-Publication Data
Schmelz, Peter John.
Such freedom, if only musical : unofficial Soviet music during the Thaw / Peter J. Schmelz.
p. cm.
Includes bibliographical references and index.
ISBN 978-0-19-534193-5
1. Music—Political aspects—Soviet Union. 2. Music—Soviet Union—History and
criticism. I. Title.
ML3917.R8S36 2009
780.947'0904—dc22 2008020553

9 8 7 6 5 4 3 2 1
Printed in the United States of America
on acid-free paper

For Julian

ACKNOWLEDGMENTS

This book would have been impossible without the assistance and support of numerous individuals. First and foremost, profuse thanks are due those who took time from their busy schedules to converse with me about the past (and present): Eduard Artem'yev, the late Gennadiy Aygi, Alexander Baltin, Valentin Berlinsky, Boris Berman, Lidiya Davïdova, Grigoriy Frid, Vladimir Frumkin, Tatyana Grindenko, Leonid Hrabovsky, Francisco Infante, Karen Khachaturyan, Stanislav Kreychi, Anatoliy Kuznetsov, Roman Ledenyov, Aleksey Lyubimov, Lev Markiz, Vladimir Martïnov, Mikhaíl Marutayev, Alexander Medvedev, Aleksey Nikolayev, Mark Pekarsky, Inna Yefimovna Prus, Svetlana Savenko, Rodion Shchedrin, Valentin Silvestrov, Sergey Slonimsky, Irina Nikitishna Tambiyeva, Boris Tishchenko, the late Andrey Volkonsky, and Viktor Yekimovsky.

I am also indebted to the following people for providing crucial materials and for helping establish contacts with many of the above individuals both in Russia and in the United States: Virko Baley; the family of Nikolai Karetnikov and especially his son Anton Karetnikov; Valentina Kholopova; Sevil' Sabitovna Krïlatova (sister of Alemdar Karamanov); Anatoliy Kuznetsov; Anna Nisnevich; Karma Mikhaílovna Slezkina; and the late Valeriya Tsenova.

I am also grateful to the staffs at the various institutions and archives I consulted while in Moscow, including Marina Petrovna Savel'eva, at the *Notnaya biblioteka* at the Moscow House of Composers, and Yelena Gafner and the staff at the Russian State Archive of Literature and Art (RGALI). Irina Lutsenko and Anastassia Maxwell helped transcribe several taped interviews.

This project benefited greatly from the aid and advice of many librarians, especially John Bewley, Nancy Nuzzo, and Brad Short, as well as the indefatigable interlibrary loan staff at the University at Buffalo (SUNY) and at Washington University in St. Louis.

Several individuals deserve thanks for answering specific questions or helping me obtain materials during the course of my research: Victoria Adamenko; Marjorie Agosin; the British Film Institute and the School of Slavonic and East European Studies (SSEES) at University College London; Philip Bullock; David Code; Stephen Collier; J. Martin Daughtry; Melissa Dinverno; Bruce Durazzi;

Eike Fess at the Archive of the Arnold Schönberg Center in Vienna; Elizabeth Horan; Alexander Ivashkin; Charles Lyons; David Pinkerton; Ewa Radziwon at the Warsaw Autumn Festival; the Paul Sacher Foundation; Dr. Erika Schaller at the Archivio Luigi Nono; Astrid Schirmer at Institut de Recherche et Coordination Acoustique/Musique (IRCAM); John Turci-Escobar; and Benjamin Walton.

Specific translation questions were ably answered by Beate Kutschke, Michael Long, Mikhail Palatnik, Reynold Tharp, and the late John Thow.

Funding to research and complete the book was made possible by two organizations. Research that led to the completion of this book was supported in part by the Title VIII Research Scholar Program, which is funded by the U.S. Department of State, Program for Research and Training on Eastern Europe and the Independent States of the Former Soviet Union, and administered by the American Councils for International Education (ACTR/ACCELS). The opinions expressed herein are the author's own and do not necessarily express the views of either the U.S. Department of State or the American Councils. Completion of the book was made possible by a 2004 summer stipend awarded by the National Endowment for the Humanities. Any views, findings, conclusions, or recommendations expressed in this publication do not necessarily reflect those of the National Endowment for the Humanities.

The examples and illustrations for the book were funded in part through the kind assistance of the Manfred Bukofzer Publication Endowment Fund of the American Musicological Society. Generous research support from Edward S. Macias, executive vice chancellor and dean of the Faculty of Arts and Sciences at Washington University in St. Louis, also proved essential for subsidizing the examples. I would also like to acknowledge Pat Orf's invaluable help during the permissions process.

Portions of the text have appeared in print under different form. Sections of chapters 1 and 3 previously appeared as "Andrey Volkonsky and the Beginnings of Unofficial Music in the Soviet Union" in the *Journal of the American Musicological Society*. Parts of the critique of Alexei Yurchak's work advanced in my introduction also appear in different, much expanded form in my "From Scriabin to Pink Floyd: The ANS Synthesizer and the Politics of Soviet Music between Thaw and Stagnation" (portions of chapter 5 also appear here); and in my "What Was 'Shostakovich,' and What Came Next?"

I had numerous opportunities to present material in this book publicly. I am especially grateful to the following for inviting me to participate in their colloquia and conferences: Karen Ahlquist and the Department of Music at The George Washington University; William Quillen and Anna Nisnevich at the University of California at Berkeley ("Glinka and His Legacies," April 2005); and Eleonor Gilburd and Denis Kozlov at Berkeley ("The Thaw: Soviet Society and Culture during the 1950s and 1960s," May 2005). An early version of the

epilogue was originally read at the March 2005 Répertoire International de Littérature Musical (RILM) conference, "Music's Intellectual History: Founders, Followers & Fads," organized by Zdravko Blažeković. I am also indebted to the participants and listeners at these events for their valuable feedback.

The majority of this book was completed in Ithaca, New York, during a blissful summer of research and writing. My friends there helped keep me grounded, in particular Javier Fernandez and Hilary Merlin, Will and Ginia Harris, Emma Kuby and Brian Bockelman, Gregg Lightfoot, Brent Morris, Mike Schmidley, and Emma Willoughby.

Other friends, teachers, and colleagues I would like to thank for their support, advice, and encouragement over the past decade include Katherine Bergeron, Malcolm Hamrick Brown, David Code, Stephen Collier, Elena Dubinets, Melina Esse, Danielle Fosler-Lussier, Matthew Gelbart, Roy Guenther, Jacob Hosler and Dunja Popovic, Beth Levy, Michael Long, Keeril Makan, Scott Miller, Klára Móricz, Simon Morrison, Martin Riker, David Schneider, Reynold Tharp, Benjamin Walton, Holly Watkins, Richard Wexler, and Laura Youens. I am also grateful for the exceptionally warm welcomes from my many new friends and colleagues in the Department of Music and the College of Arts and Sciences at Washington University in St. Louis; their many words of encouragement and support both individually and collectively helped me make a seamless transition to my new job. Special thanks are due my senior colleagues Dolores Pesce, chair of the Department of Music, Hugh Macdonald, Craig Monson, and Robert Snarrenberg for their help and advice.

Don Giller and Martin Kennedy have my deep gratitude for successfully tackling my difficult music examples. Kim Schultz graciously agreed to take the author's photo for the jacket.

I am extremely grateful to my editor Suzanne Ryan for her encouragement, positive support, and good cheer throughout the publishing process. I would also like to thank my production editor Heather Hartman, as well as Norman Hirschy and Lora Dunn, for kindly and patiently responding to my countless e-mails. The anonymous readers for Oxford University Press and Mary Hunter provided many perceptive comments and saved me from several errors of fact and interpretation. I am thankful to them for their time and interest. Others who read and commented on portions of the manuscript throughout its many incarnations include Katherine Bergeron, Bruce Alan Brown, Louise Goldberg, Laurel Fay, and Yuri Slezkine. I am also thankful for the support and assistance of Laurel Fay, whose experience both personally and professionally with the composers from the Thaw generation is unequalled. In the end, however, this book would not have been written without the assistance and example of two scholars, one Russian, the other American.

The late Yuriy Nikolayevich Kholopov initiated most of my Moscow contacts and helped arrange many of the interviews. His introductions made my

work on this book possible on the most fundamental level. Almost as crucial were my weekly meetings with him in late 2000 and early 2001. These sessions provided me the necessary background information and broader context as I digested the information I gleaned from my interviews and other Russian sources.

The main inspiration and guide for this work was Richard Taruskin, who started the whole process in Berkeley by saying, almost offhandedly, "So you'll go to Moscow and do your interviews...," giving little hint of how much effort this would require, but also how rewarding it would be in the end. I am forever grateful for his advice, his insatiable pursuit of knowledge, his moral sense, discerning critical eye, and mighty editorial hand. (I am especially thankful for his taking the time to read the introduction during a busy trip to Moscow.) If any errors persist in my work, they do so despite his—and all of my other helpers'—best efforts.

Finally, I need to express my immeasurable debt to my family: Robert and Sandy Schmelz, Wook and Kum Lim, Mark and Lori Schmelz, Judy and Jake Kerber, Grandma Jeanette and late Grandpa Ralph, and Grandma Dorothy and late Grandpa Jack. My late mother Nancy Schmelz still serves me as an example of good humor, enthusiasm, and boundless energy. The upheavals and distractions of this book most directly affected my wife Julian and my daughter Elia, who arrived just in time for the final submission of the manuscript and who started walking during the production stage. Julian has been patient and centered throughout our many separations and moves. It is to her that I lovingly and appreciatively dedicate this book.

CONTENTS

NOTE ON TRANSLITERATION

In this book I use the transliteration system developed by Gerald Abraham for the *New Grove Dictionary of Music and Musicians* (1980), as amended by Richard Taruskin in his *Musorgsky: Eight Essays and an Epilogue* (1993) and also described by him at the beginning of his *Stravinsky and the Russian Traditions: A Biography of the Works through Mavra* (1996). Briefly, the most obvious departures from the Library of Congress system are the use of "ï" for the Russian "ы"; the use of "ya" and "yu" for "я" and "ю," respectively; and the use of "y" for the Russian "й." This last change allows for a more accurate representation of certain adjectival endings, especially in the genitive plural form "ий," which is rendered as "iy" and not "ii." Further alterations and exceptions are discussed in greater detail by Taruskin in the two sources cited earlier.

This system is followed strictly in both the text and the footnotes, although with a few exceptions. Familiar figures are referred to by the more common forms of their names in the main text and in the body of the footnotes (e.g., Schnittke, Silvestrov, and Scriabin, with the sole exception of Chaikovsky, whose name follows the Russian orthography). Names ending in "-sky" retain the "-y" ending in the text, but are transliterated strictly ("-skiy") in the references given in the notes and in the bibliography. Additionally, I have consistently used Leonid Hrabovsky's spelling of his name (Hrabovsky, based on its Ukrainian form) and not its Russian representation (Grabovskiy). Finally, faced with two competing user-friendly alternatives, I also have opted throughout for the more common transliteration of the Chuvash poet Gennadiy Aygi's last name, rather than the more accurately pronounced (at least by English speakers) "Aigi."

There have been many translations of Russian sources on unofficial music in the past decade, but because of the inadequacies of many of these translations, all of my quotations and references are to the original Russian unless otherwise indicated in the notes. Also, unless otherwise credited, all translations are my own.

ABBREVIATIONS

BAS Shnitke, Al'fred [Alfred Schnittke], and Aleksandr Ivashkin. *Besedï s Al'fredom Shnitke*. Moscow: RIK "Kul'tura," 1994.

f. fond (collection)

GNAS Shnitke, Al'fred [Alfred Schnittke], and Dmitriy Shul'gin. *Godï neizvestnosti Al'freda Shnitke: Besedï s kompozitorom*. Moscow: Delovaya liga, 1993.

l. list (page)

NVV Pekarskiy, Mark. *Nazad k Volkonskomu vperyod*. Moscow: Kompozitor, 2005.

op. opis' (inventory) (this is a Russian archival term and is not to be confused with "Op." meaning "opus number")

PED Denisov, Edison, and Dmitriy Shul'gin. *Priznaniye Edisona Denisova: Po materialam besed*. Moscow: Kompozitor, 1998.

RGALI Russian State Archive of Literature and Art (Rossiyskiy gosudarstvennïy arkhiv literaturï i iskusstv)

SG Kholopova, Valentina, and Enzo Restan'o [Restagno]. *Sofiya Gubaidulina*. Moscow: Kompozitor, 1996.

SR Shnitke, Al'fred [Alfred Schnittke]. *A Schnittke Reader*. Edited by Alexander Ivashkin. Translated by John Goodliffe. Bloomington: Indiana University Press, 2002.

yed. khr. yedinitsa khraneniya (storage unit)

SUCH FREEDOM, IF ONLY MUSICAL

1

Introduction

Having bumped into memory, time learns its impotence.

—Joseph Brodsky (1940–96), "Brise Marine"

My generation [in Romania], spurred on by the surfacing of books in the libraries of old men, was not a true adversary of the regime. We wanted to escape, not to fight.

—Andrei Codrescu (b. 1946), *The Disappearance of the Outside*

When you do something to react against a rigid system, the product loses its authenticity. Rather one has to act as though the system doesn't exist at all. That's the only way music continues to be viable in the longer term.

—Alfred Schnittke to Anders Beyer (1990)

The death of Joseph Stalin on 5 March 1953 launched the Soviet Union, willingly or unwillingly, into a new era. Stalin tightly coiled all aspects of Soviet life around his personality, and his demise forced Soviet citizens from all levels of society to untangle his legacy and to reconsider their future course. The general process of political, social, and cultural reawakening that followed, presided over by his successor, Nikita Khrushchev, was dubbed the "Thaw" or *Ottepel'* after Ilya Ehrenburg's eponymous 1954 novel.[1] Some have seen the Thaw as a precursor of the perestroika of the 1980s, with Khrushchev

1. Ehrenburg, *The Thaw*. For a good general overview of the sociocultural trends from the period, see Vail' and Genis, *60-ye: Mir sovetskogo cheloveka*. For an exploration of the label "Thaw" as a metaphor, see Bittner, *The Many Lives of Khrushchev's Thaw*, 1–13.

laying the groundwork for Mikhaíl Gorbachev's later "rebuilding" of the Soviet Union. Katerina Clark calls the Gorbachev years the "ultimate thaw."[2] Or, as William Taubman succinctly declares, "[Khrushchev] began the process that destroyed the Soviet regime."[3] Like the more recent, more familiar period of perestroika, during the decade that Khrushchev was at the helm nearly every aspect of Soviet society relaxed. All of the arts from literature to music reflected the newfound openness, although each understandably did so in different ways.

With Alexander Solzhenitsyn and Yevgeny Yevtushenko at the forefront, literary authors in particular became renowned for expanding the boundaries of the permissible by addressing previously taboo topics such as the Gulag system or the broader disaffections within Soviet society. Masha Gessen writes that during the Thaw Soviet citizens "rediscovered the Word,"[4] while Nancy Condee emphasizes the "literocentric culture of the Thaw period." According to Condee, "literature constituted the primary cultural field within which the party leadership most publicly engaged the liberal intelligentsia."[5]

While the story of literature and the visual arts during the Thaw has been told many times, the music of the Thaw, and specifically the "unofficial" compositions of the 1950s and 1960s, remains, as one recent writer has put it, "an unstudied continent."[6] Condee acknowledges painting and cinema (and to some extent jazz) as "secondary cultural fields" trailing behind literature, but she ignores art music entirely.[7] Yet far from a tertiary cultural field (or worse), unofficial art music engaged with the most pertinent transformations in Soviet aesthetics and society during the 1950s and 1960s. Literature may have attracted the most attention both from the party leadership and from the liberal urban intelligentsia, but the world of Soviet unofficial music created

2. Clark, *The Soviet Novel: History as Ritual,* 267.

3. Taubman, *Khrushchev: The Man and His Era,* xx. Another interpretation advanced by Natan Eydel'man puts the 1960s as the "Second Perestroika, if the NEP [period of the 1920s] is considered the first." Eydel'man, "Vremya, sulivsheye stol'ko nadezhd," I:7 (see also G. Manevich, "Khudozhnik i vremya, ili Moskovskiy 'podpol'ye 60-kh," I:13). The Russian music historian Levon Hakobian treats the entire post-Stalin era as a single "Bronze Age" divided into four smaller periods. Akopyan [Hakobian], *Music of the Soviet Age, 1917–1987,* 220.

4. Gessen, *Dead Again: The Russian Intelligentsia after Communism,* 10.

5. Condee, "Cultural Codes of the Thaw," 161.

6. Selitskiy, *Nikolai Karetnikov: Vïbor sud'bï, issledovaniye,* 74. For a general discussion of the arts during the Thaw, see Johnson McMillan, *Khrushchev and the Arts;* and Eggeling, *Politika i kul'tura pri Khrushchove i Brezhneve, 1953–1970gg* (although he does not address music at all). On literature, see Clark, *The Soviet Novel: History as Ritual;* and Blake and Hayward, eds., *Half-way to the Moon: New Writing from Russia.* On the unofficial visual arts, see Talochkin and Alpatova, eds., *"Drugoye iskusstvo";* as well as White, ed., *Forbidden Art;* Rosenfeld and Dodge, eds., *Nonconformist Art;* and Golomshtok, "Unofficial Art in the Soviet Union." For a more popular treatment, see McPhee, *The Ransom of Russian Art.*

7. Condee, "Cultural Codes of the Thaw," 162.

equally compelling alternatives to the dominant narratives of the Thaw. It, too, helped create the "third space of inner freedom, private life, moral ambiguity, neutrality, indifference, or sincere feelings" that Condee calls "an essential feature of Thaw culture." Nor was unofficial art music always hidden during the Thaw, as indicated by Khrushchev's numerous public pronouncements on music, and especially dodecaphony (i.e., twelve-tone music or serialism).[8] When Khrushchev declared in a much-cited speech from the "Meeting of Party and Government Leaders with Writers and Artists" on 8 March 1963 that "we flatly reject this cacophony in music," he was inveighing against not jazz as Condee claims but, rather, "dodecaphony," or as Khrushchev defined it "the music of noises"—which "in all probability...stands for the same thing as cacophony."[9]

The young Soviets responsible for this music are not as familiar to European and American audiences today as more prominent Soviet composers like Dmitriy Shostakovich or Sergey Prokofiev. Many histories of Soviet or Russian music pass over or ignore the next generation of composers, as Francis Maes does in his otherwise thorough survey of Russian music, claiming that "it is probably too early" for a discussion of the compositions of these younger composers.[10] Yet, as Maes himself acknowledges, since the dissolution of the Soviet Union many of these composers have been well represented on concert programs and recordings throughout Europe and America, foremost among them Alfred Schnittke, Sofia Gubaidulina, Edison Denisov, Arvo Pärt, and, increasingly, Valentin Silvestrov. As Schnittke and Denisov have already passed away and the others are advanced in years, the time is long overdue for a detailed description and appraisal of their lives and times.

Consistently referred to during the Thaw as "young composers" ("molodïye kompozitori") in the Soviet press, they produced music reflecting the tumultuous period under Khrushchev in all its contradictions.[11] These composers

8. When discussing the postwar Soviet approach to dodecaphony and serialism, I will generally use "serialism" to denote the overarching phenomenon of which twelve-tone music and "total serialism" are subsets, unless the writer is specifically using the terms "dodecaphony" or "twelve-tone" (or "twelve-tonish"; see chapter 4). This helps to avoid any confusion that might arise from emphasizing twelve-tone composition as the dominant trend.

9. See Condee, "Cultural Codes of the Thaw," 173–74; and Khrushchev, "Lofty Ideas and Artistic Skill Give Soviet Literature and Art Its Great Strength; Speech at a Meeting of Party and Government Leaders with Writers and Artists, March 8, 1963," 183. The excerpts in this speech pertaining to music are also reprinted as "Declaration Made by Nikita Khrushchev on 8 March 1963 Stating His Views on Music in Soviet Society," 953–54.

10. Maes, *A History of Russian Music*, 374. Exceptions are Hakobian's *Music of the Soviet Age* and Lemaire's two general surveys, *Le destin russe et la musique* and *La musique du XXe siècle en Russie et dans les anciennes Républiques soviétiques,* although neither author provides a detailed discussion of the Thaw's music.

11. A note on "young composers": In Russian the phrase "young composer" is as generic as its literal English translation, but in Soviet usage during the Thaw it acquired more particular shades of meaning.

wrote music that drew heavily on the examples of the Western avant-garde as they used the opportunities afforded them by the new freedoms of the Thaw to peruse both new and older scores that had been off-limits under Stalin. Initially, these composers were spurred by the novelty of the techniques they were seeing in the new scores from the West. The young Soviets felt embarrassed by the belatedness foisted on them by decades of stale socialist realist doctrine; they felt that they needed to "catch up" with Western composers, mastering musical techniques already familiar in the West but still new to them, hampered by the cloistered education of the Soviet conservatories. Unfortunately, Soviet arts officials capitalized on this anxiety, frequently mocking the "young composers" for their epigonism. Dmitriy Kabalevsky chastised "young composer" Alemdar Karamanov for just this in 1959: "I cannot understand what A. Karamanov is searching for. If he is searching for new sharp sounds (and so it often seems), let him be deluded no longer: the contemporary Western 'avant-gardists' have gone much further forward in comparison with his 'discoveries.' Would it not be more fruitful to turn his attempts toward new, greater, vital themes?"[12] Despite, or perhaps because of, such taunting, the music still sounded fresh to Soviet listeners, and throughout the 1960s it drew avid audiences eager to keep pace with the latest in compositional trends. Thanks to a small but dedicated group of performers, during the 1960s this music became the focus of an unofficial concert subculture.

CONFRONTATION OR ESCAPE?

Not all of the literature produced during the Thaw was concerned so directly with social commentary à la Solzhenitsyn. Most authors continued to churn out rather anodyne fare. A few others, such as Andrey Sinyavsky, who wrote under the pseudonym Abram Tertz, pursued entirely different directions; Sinyavsky experimented with both form and content in search of a "phantasmagoric art" that emphasized the "absurd" and the "fantastic."[13]

In contrast to the Soviet literature of the Thaw, a greater range of interests is apparent in the visual arts produced from the late 1940s through the 1960s, and these interests better match the preoccupations of unofficial music at the time. Much of the visual arts was staunchly orthodox. For example, *Power to*

The very specific use to which I am putting "young composers" has its genesis in the negative criticism of the time. I am using it to refer to a specific group of composers, those composers who would only later, in the mid-1960s, become unofficial, after the power relations within Soviet musical life had solidified, and the unofficial musical subculture had developed into its most widespread form. See also Schmelz, "Andrey Volkonsky and the Beginnings of Unofficial Music in the Soviet Union," 140 n. 2.

12. Kabalevskiy, "Kompozitor—prezhde vsego grazhdanin," 19.
13. Tertz, *The Trial Begins and On Socialist Realism,* 218–19.

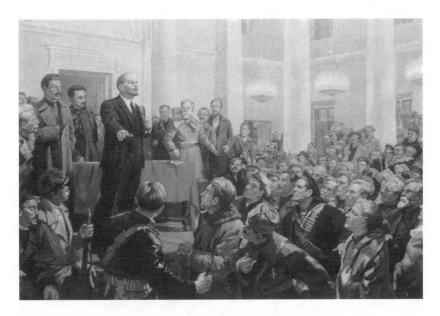

Figure 1.1. Nikolai Kritsky and Group, *Power to the People* (1957).
Credit: Courtesy of Yuri Traisman's collection. Nikolai Kritsky and Group, "Power to the People," 1957, oil on linen, 55 × 90 inches.

the People from 1957 is a typically grandiose socialist realist canvas in the strict representational style, completed by a collective of painters led by Nikolai Kritsky. It depicts Lenin, flanked by Stalin, rallying the revolutionary forces (see fig. 1.1). Everything here—form and content alike—proceeds according to plan.

In the mid-1950s, such socialist realist art began to be challenged by artists such as Oscar Rabin (b. 1928), once proclaimed by his friend and associate Alexander Glezer as the "absolute leader of the nonconformist" artists in Moscow and Leningrad.[14] *Ferris Wheel in the Evening*, a painting by Rabin dating from 1977, has a dingy, muted color scheme, and its focus on shapes and textures—to say nothing of its subjects, including sex, drinking, religion, toilets, the KGB, and Rabin himself (the bespectacled figure near the center of the wheel)—acted as the exact antitheses of everything represented by the painting produced by Kritsky and his colleagues (see fig. 1.2).

Rabin's approach, both in this somewhat later painting and in his earlier canvases, was shared by many artists during the Thaw, particularly by the group of painters, including Vyacheslav Kalinin (b. 1939) and Vasiliy Shulzhenko (b. 1949), who became known as the "Baraknaya Shkola," after the Russian

14. Glezer, ed., *Iskusstvo pod bul'dozerom (sinyaya kniga)*, 39.

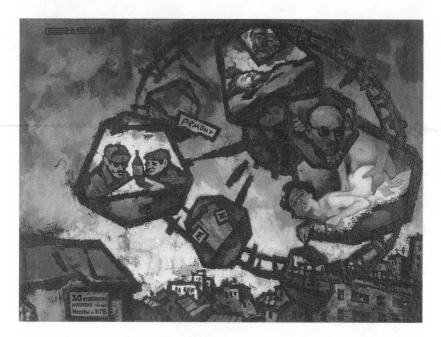

Figure 1.2. Oscar Rabin, *Ferris Wheel in the Evening* (1977).
Credit: Oscar Rabin. *Ferris Wheel in the Evening*, 1977. Oil on canvas, 81 × 111 cm. The Jane
Voorhees Zimmerli Art Museum, Rutgers, The State University of New Jersey. The Norton and
Nancy Dodge Collection of Nonconformist Art from the Soviet Union. Photograph by Jack
Abraham. 06638.

word for "barracks" or "hut."[15] Like Solzhenitsyn and other authors of the time,
Rabin and his fellow realist painters revealed the unseemly side of Soviet soci-
ety. They reveled in forbidden, perverse, and banal images that had been pur-
posely ignored by the optimistic art demanded under Stalin, especially during
the repressive *Zhdanovshchina,* the crackdown on the art, literature, and music
of his final years (named after cultural official Andrey Zhdanov).

These two stylistic currents—socialist realism and an expanded, almost
naturalistic realism—were not the only possibilities in postwar Soviet art.
Francisco Infante's *Space-Movement-Infinity (Project for a Kinetic Object)*
from 1963 represents a countervailing tendency unlike anything in contem-
porary Soviet literature (see fig. 1.3). Indebted stylistically to early-twentieth-
century Russian "Futurists" or "Constructivists" such as Malevich, Tatlin, or

15. See Bowlt, "The Soviet Nonconformists and the Legacy of the Russian Avant-Garde," 54 and 80
n. 9. For more on Rabin's painting, see Kennedy, "Realism, Surrealism, and Photorealism: The Reinven-
tion of Soviet Art of the 1970s and 1980s," 276. For more on debates over realism in Soviet painting at
the end of the 1950s, see Reid, "Toward a New (Socialist) Realism," 228–29 and 231–34.

Figure 1.3. Francisco Infante, "Space–Movement–Infinity (Project for a Kinetic Object)" (1963). Credit: Francisco Infante. *Space–Movement–Infinity (Project for a Kinetic Object)*, 1963. Ink and tempera, 70.3 × 91 cm. The Jane Voorhees Zimmerli Art Museum, Rutgers, The State University of New Jersey. The Norton and Nancy Dodge Collection of Nonconformist Art from the Soviet Union. Photograph by Jack Abraham. 05336.

Rodchenko, Infante (b. 1943) depicts abstract geometric shapes.[16] His art lacks the social impetus behind Rabin's painting, or at least displays no overt social content. In an autobiographical sketch from 1997, Infante noted that he turned to repetitive abstract, geometric shapes, "endless squares, circles, triangles," because they helped "ease the weight of the pressing world." For Infante, this "weight" did not stem from a sense of social oppression; its source was more metaphysical. It came, he said, from the "overwhelming" sensations of the "infinity... of the world surrounding me" (hence the title of fig. 1.3).[17] Infante's

16. For more on the parallels (and differences) between the Russian "avant-garde" of the 1910s and 1920s and the postwar Soviet "avant-garde" in the visual arts, see Bowlt, "The Soviet Nonconformists and the Legacy of the Russian Avant-Garde," 49–80; as well as Groys, *The Total Art of Stalinism*.

17. After 1975 Infante extended this idea of infinity and the "secret of the world" to his idea of "Artefakts" ("Artefakti"), works for which he is better known today: "Special installations existing only to be photographed, in which an artificial object—a symbol of the technical aspect of the world—and nature—a symbol of the infinite beginning—correspond with one another conceptually." Infante, "Kak ya stal khudozhnikom," 8.

spiritual explanation may be read in a more literal sense as well. As a result of the ideological requirements of socialist realism, by denying an explicit content in his abstract geometric canvases and sculptures Infante was, in fact, actually engaging in an indirect political act—an act of escape, of denial, of negation—even as his works attempted to control and circumscribe the terrifying infinity that he sensed around him.[18] The artist's denial of content was offset by the active displaying of his work in small home exhibits, or in exhibits arranged unofficially in scientific institutes or in clubs in the main Soviet cultural centers. When placed before attentive viewers seeking experiences new and different from those dictated by officialdom, art without an explicit content like Infante's took on other, potentially more oppositional, connotations.

The same shifts we have witnessed in the Soviet visual arts applied to the art music composed in the 1950s and 1960s by younger Soviet composers. Over the course of the Thaw unofficial Soviet music tacked between the aesthetic positions of the Rabin and Infante works in figures 1.2 and 1.3, positions that we may call mimetic and abstract, borrowing and expanding on the musicologist Karol Berger's terms.[19] In Berger's A Theory of Art, these two modes are allied with his two "ideal types" of art music and popular music: abstract music is to art music as mimetic music is to popular music. Abstract music leads listeners to contemplate the musical work as a whole taken out of time. It encourages a way of listening that "favors the artistic mode of experience in which one wants to go beyond isolated moments and to take in the form of the whole in active anticipatory and recollecting contemplation."[20] The attention of the listener is preoccupied by form; there is no explicit content beyond the parameters of the musical "object," and especially harmony or the "abstract logic of tonal relations."[21]

Mimetic music, by contrast, is representational; it is connected in some way with language, which "whether explicitly present or implied, [is considered] the essential component of music, on a par with harmony, and not as something added to music."[22] Thus, any song is mimetic, as is opera or other texted vocal music. But mimetic music does not need to have an explicit, sung text, for any piece of instrumental music inspired by a story or program—from Berlioz's Symphonie fantastique to the third movement of Mahler's First Symphony—is mimetic to varying degrees.

18. Many theorists of social meaning in modern art, among them Adorno, have noted that abstract art "protests," as Alfred Andersch declared, "by withdrawing itself, against content that has sunk to the level of ideology." Cited in Dahlhaus, "Progress and the Avant-Garde," 17. See also Adorno, "The Aging of the New Music," 192.

19. Berger, A Theory of Art, 150, see also 146–51.

20. Ibid., 133.

21. Ibid., 133–34.

22. Ibid., 139.

Berger proposes a "paradigm shift" in musical thinking "between 1780 and 1820" when abstraction increasingly began to share ground with the mimesis that had been the dominant mode for the previous two centuries (beginning in the late sixteenth century).[23] By the end of the nineteenth century, both approaches found vocal advocates, as demonstrated by the conflict between, on the one hand, Wagner and the mimetic followers of the New German School, and, on the other, the disciples of Hanslick and Brahms, the purveyors of abstract "absolute music." But as Berger argues, after a century and a half—from 1800 until just after World War I—in which abstract music and mimetic music "productively interacted," "by the 1950s, the productive interaction there had been between the two ideas during the nineteenth century was deeply disturbed and at times completely ceased."[24] Berger summarizes, "In the twentieth century, [the idea of mimetic music] became so completely disreputable in art music circles that in recent decades it required something of an effort of historical imagination and sympathy to understand how it could ever have been taken seriously."[25] Thanks to the dictates of socialist realism, only in the Soviet Union and its satellites was mimetic art music actively produced and encouraged.[26]

In postwar Europe and America, by contrast, abstract music came to be prized. Worthwhile music was understood, in Berger's words, "as simply itself, the pure sounding form, not pointing to any transcendent meaning."[27] The most efficient means of achieving these ends was thought to be through atonality or serial techniques. Because of the grudges of the cold war, and the pronouncements emanating from the Soviet Union that inveighed against "formalism" (read: "abstraction") in the arts, the opposition between abstraction and mimesis became a "musical cold war between abstraction and mimesis" that "reached its most rigorous form at Darmstadt in the early 1950s," as Berger concludes.[28] As we shall see, the same opposition also reached an apex within the Soviet Union of the 1960s among the musical works of the unofficial Soviet composers, who reinterpreted and reinvigorated the battle of form and content.

At first, the aesthetic interests of the unofficial composers recalled those of Infante and his colleagues in the Movement group ("Dvizheniye," founded by

23. Ibid., 131–32 and 133–35.

24. Ibid., 139.

25. Ibid.

26. There has been a spate of recent work on socialist realism in the Eastern Bloc, including Berg, von Massow, and Noeske, eds., *Zwischen Macht und Freiheit: Neue Musik in der DDR;* and Bek, Chew, and Macek, eds., *Socialist Realism and Music.* See also Silverberg, "The East German *Sonderweg* to Modern Music, 1956–1971," esp. 186–266; and, on Romania, Sandu-Dediu, "Dodecaphonic Composition in 1950s and 1960s Europe," esp. 180–88.

27. Berger, *A Theory of Art,* 139.

28. Ibid., 146 and 150.

Lev Nusberg in 1962), as well as those of other abstract artists such as Lidiya Masterkova (b. 1929) and her husband Vladimir Nemukhin (b. 1925), both members of the Lianozovo school. The early performances of works from this initial, abstract phase of unofficial music also served a similar social function. The serial techniques they used fostered an abstract style, even when texts, often obscure or abstract themselves, were involved (for a Western precedent, think of Boulez's *Le Marteau sans maître*).[29] To various degrees, these works were escapist. They opposed the dictates of socialist realism by withdrawing from its social demands. Their compositions also suggested newness and freedom to their listeners, and allowed them to escape the sounds of officially sanctioned Soviet reality while remaining in the very midst of that reality.

The second phase of unofficial music is more difficult to characterize, but begins to approach the aesthetic stance of Rabin's *Ferris Wheel in the Evening*. In the second half of the 1960s, many of the unofficial composers reacted against the perceived confines of their earlier abstract compositions and turned to more mimetic, representational styles. They moved from serial techniques to aleatory devices and a range of familiar tonal gestures and harmonies, including direct quotations of familiar compositions from the past. Moreover, they often juxtaposed the divergent styles aligned with these various techniques to narrate very detailed plots. The examples given here of paintings by Infante and Rabin thus roughly map out the aesthetic and stylistic range of this generation of composers as they moved from abstraction to mimesis, thence to dynamic combinations and blendings of the two.

The aesthetic shift from abstraction to mimesis in unofficial Soviet music during the Thaw is no more than a general observation; it has been informed, however, by the specifics of contemporary Soviet criticism and the comments of the unofficial composers themselves. As Berger acknowledges, there is a wide spectrum of possibilities between the two poles of representation: "Abstraction," he writes, "is clearly a matter of degree."[30] Texted works such as Volkonsky's *Suite of Mirrors* and *Concerto itinérant* could be very abstract for Soviet listeners, and especially Soviet critics. And nontexted, serial works occasionally were received as mimetic, particularly when serialism was employed in a more familiar (more tonal or metric) manner, as in the last movement of Schnittke's *Music for Piano and Chamber Orchestra*, Pärt's First Symphony, or sections of Gubaidulina's *Night in Memphis*.[31] Liminal cases, as usual, prove most instructive. They demonstrate the gradually expanding

29. For Berger, music that is tonal and "metric" (p. 31) is inherently more representational than atonality or serialism. Even in music lacking a text or explicit program, tonality can suggest an "imaginary world." Ibid., 34 (on Schoenberg and twelve-tone music, see 30–31).

30. Ibid., 20.

31. Ibid., 30–34.

expressive capabilities allowed by a wider stylistic and technical palette, mediated through the continuing tensions between the willfully opaque and the willingly transparent.

BECOMING *VNYE*

As the young Soviets grappled with the often conflicting demands of personal taste, official doctrine, and the new styles suggested by their still-novel techniques, their music also played a significant, although ambiguous and even paradoxical, role within Soviet society. Understanding the changing and complicated nature of this social role requires a substantial modification of typical Western views of these composers and their music. In fact, this music has been consistently misunderstood in the West from the very beginning. On the rare occasions when compositions by the young Soviets appeared on the programs of the Warsaw Autumn Festival or were heard at concerts in New York or Paris—as was the case with Denisov's works in the mid-1960s, thanks to conductors like Leonard Bernstein and Bruno Maderna—critics often responded with a surprise bordering on condescension, usually calling attention to its inherent "Russianness," as Boulez did of Denisov's music.[32] Or, as one French critic wrote after a performance of Denisov's *Sun of the Incas,* it was "the sensation of the concert; just imagine—a Soviet musician writing serial music" (to which the Russian musicologist Svetlana Savenko sarcastically responds, "In other words, 'peasants are also capable of love!'").[33] The sheer novelty and exoticism of "avant-garde" Soviet music usually precluded any other, more substantive response.

A more persistent tendency among Western writers has been to cast the unofficial composers as "dissidents." As Joseph Horowitz writes, describing the 2003 "Masterpieces of the Russian Underground" festival presented by the Chamber Music Society of Lincoln Center, "the underground composers shared with Shostakovich an urgent dissident vision bypassing the certainties of Socialist Realism."[34] Although active participants in a socially meaningful concert subculture, the unofficial composers were in no ways dissidents, or at least no more so than any other creative artists within the Soviet system. The romanticizing assumption is fueled by Western cold war myths of artistic

32. Kholopov and Tsenova, *Edison Denisov,* 184–85. Boris Schwarz was also guilty of essentializing: "One perceives a 'Russian' flavor in the vocal lines of Denisov and Volkonsky; it is not all that 'international.'" Schwarz, *Music and Musical Life in Soviet Russia, Enlarged Edition, 1917–1981,* 454.

33. Savenko, "Interpretatsiya idey avangarda v poslevoyennoy sovetskoy muzïke," 34 (she repeats this in Savenko, "Poslevoyennïy muzïkal'nïy avangard," 417). This review, from the Parisian *Carrefour,* was originally cited in Kholopov and Tsenova, *Edison Denisov,* 22.

34. Horowitz, "Where Composers Still Held Sway, from Underground."

production in the Soviet Union that do a disservice to all artists active at the time by singling out certain ones as more heroic than the rest. As the percussionist Mark Pekarsky told me: "Everyone was a dissident. Every decent person was a dissident in his soul. Not everyone cried out against Soviet power. Protest could be different, but no one among us [musicians] went out and took part in demonstrations. Such a passive confrontation, [only] musical. [To actively demonstrate] you needed to be brave, and it meant that you would get less far in your career."[35] Or as the pianist Aleksey Lyubimov admitted: "In general I wasn't acquainted with any dissidents. I received *samizdat* of course; I read both Solzhenitsyn and Pasternak that way...but there wasn't any personal contact. There simply wasn't enough time; there wasn't even the thought of meeting with those people. And besides that there was also a bit of fear of course."[36] And the composer Rodion Shchedrin bluntly declared: "I am certain that there were no kinds of dissidents [in music]. That's nonsense. A dissident for me is one who took part in demonstrations or who was put in jail. In the first place, they all received apartments from the Union of Composers. If you are a dissident then don't take those apartments. Denisov received an apartment, as did Schnittke and Gubaidulina. They didn't buy those apartments—they received them from the Union of Composers."[37] Both Lyubimov's and Shchedrin's comments point to a telling difference between music and the other arts during the Thaw. A few musicians took more direct stances against the government, as was the case with Rostropovich's open letter to *Pravda, Izvestiya, Literaturnaya gazeta,* and *Sovetskaya kul'tura* of 30 October 1970 regarding the controversy surrounding Solzhenitsyn's receipt of the Nobel Prize for Literature, but such acts of overt opposition were rare.[38] In music there were no Solzhenitsyns, Joseph Brodskys, or Andrey Sinyavskys, writers who were prominently punished by the government during the 1960s and early 1970s. Generally the unofficial music of the Thaw played a less direct, albeit no less significant, role in contemporary cultural life.

The unofficial composers and the unofficial concert subculture that developed around their music in the mid-1960s are better understood as musical analogues to the black or, better, gray markets that were so integral to the Soviet economy. Like the gray market, or "shadow economy," unofficial music took advantage of

35. Pekarskiy, interview.
36. Lyubimov, interview.
37. Shchedrin, interview. See also Shchedrin and Vlasova, "Iskusstvo—eto tsarstvo intuitsii," 5.
38. The letter was not published by these newspapers. The text is reprinted in Grum-Grzhimailo, *Rostropovich i yego sovremenniki,* 116–18; an English translation appears in Wilson, *Rostropovich,* 354–57. Gubaidulina reportedly had contact with "the dissidents" (and encounters with the KGB) because of her second husband Kolya (Nikolai) Bokov's *samizdat* activities, but as Kurtz notes "as a composer she had little to contribute to political action programs." See Kurtz, *Sofia Gubaidulina,* 68, as well as 62–63, 88, and 107–9.

the gaps in the official musical structures. This music was criticized throughout the 1960s because it did not fulfill official socialist realist requirements, yet it was not, strictly speaking, illegal to perform it (although there were some rare exceptions). Even so, performances of unofficial music still necessitated the exploitation of loopholes in the official regulations governing the proper use of official spaces. After all, because everything was ultimately at least nominally owned and controlled by the state, there were by definition no "nonofficial" venues.

In his recent book, *Everything Was Forever, until It Was No More: The Last Soviet Generation* (2006), the anthropologist Alexei Yurchak describes marginal Soviet organizations and "milieus" similar to those of unofficial music (e.g., loose literary clubs or archeological circles), by using the Russian word "vnye." *Vnye* literally translates as "outside," but in Yurchak's usage it denotes "contexts that were in a peculiar relationship to the authoritative discursive regime—they were 'suspended' simultaneously inside and outside of it, occupying the border zones between here and elsewhere."[39] He elaborates on *vnye* as follows: "The meaning of this term . . . is closer to a condition of being simultaneously inside and outside of some context." As he continues, "being *vnye* was not an exception to the dominant style of living in late socialism but, on the contrary, a central and widespread principle of living in that system. It created a major *deterritorialization* of late Soviet culture, which was not a form of opposition to the system. It was enabled by the Soviet state itself, without being determined by or even visible to it."[40] The idea of *vnye* is also similar to that of "internal emigration," for "unlike emigration, *internal emigration* captures precisely the state of being inside and outside at the same time, the inherent ambivalence of this oscillating position."[41] By concentrating on this quality of "suspension," Yurchak's work provides a much-needed revision to those binary views of the Soviet state that emphasize, in his words, oppositions such as "oppression and resistance, repression and freedom, the state and the people, official economy and second economy, official culture and counterculture, . . . and so on."[42] As Yurchak demonstrates, these terms are all indebted to

39. Yurchak, *Everything Was Forever, until It Was No More*, 127.

40. Ibid., 127–28. "Deterritorialize" is a loose borrowing from Gilles Deleuze and Félix Guattari, who use it as one half of an oscillating pair: "deterritorialize" and "reterritorialize," taken by Yurchak from their book *A Thousand Plateaus: Capitalism and Schizophrenia*, esp. 10–11. Yurchak's use of the term varies throughout his book, but it often suggests "hollowing out" or "enervating" or doing something otherwise negative to one part of the opposition he creates, borrowing from Bakhtin, between authoritative discourse and individual "authors," e.g., individuals. Nonetheless, he is at pains to emphasize that "it would be wrong to equate this process simply with progressive stagnation or decay" (p. 295).

41. Yurchak, ibid., 132.

42. Ibid., 5. Yurchak is not alone in avoiding such clear-cut oppositions. In a critique of an earlier Yurchak article, Savitskiy discusses the "Symbiosis-rivalry" ("simbioz-sopernichestvo") between "official" and "unofficial" in the Soviet literary world. Savitskiy, *Andegraund: Istoriya i mifi Leningradskoy neofitsial'noy literaturï*, 65–66. See also Komaromi, "The Unofficial Field of Late Soviet Culture."

a peculiar mixture of cold war antipathies, perestroika retrospectivism, and post-Soviet nostalgia.

The primary strength of Yurchak's provocative theoretical and ethnographic exploration of what he calls the "Last Soviet Generation" during late socialism, is that it allows him to focus on those aspects of Soviet cultural existence that have been most troublesome to Western commentators and especially those discussing music. Yurchak writes, "What tends to get lost in the binary accounts is the crucial and seemingly paradoxical fact that, for great numbers of Soviet citizens, many of the fundamental values, ideals, and realities of socialist life (such as equality, community, selflessness, altruism, friendship, ethical relations, safety, education, work, creativity, and concern for the future) were of genuine importance, despite the fact that many of their everyday practices routinely transgressed, reinterpreted, or refused certain norms and rules represented in the official ideology of the socialist state."[43] These are the same binarisms that continue to entrap Shostakovich in Western interpretations, frustratingly stuck between "Soviet Russia's most loyal musical son" and "dissident."[44] They are also the same preconceptions possessed by those like Horowitz who persist in portraying the young, unofficial composers of the 1960s as dissidents, or as a recent festival at the Juilliard School would have it, as the "Soviet Avant-Garde" who were actively "Breaking the Chains."[45] Yurchak instead calls attention to the small, everyday deeds of Soviet citizens that may not automatically fit our definitions of resistance, but nonetheless gradually weakened the Soviet state from within.

Despite its many important revisions, one of the central problems with Yurchak's survey is its insufficient consideration of history, and it is to the issue of chronology and the development of this "suspended" *vnye* culture that my examination of unofficial music in the 1960s seeks to provide a necessary corrective and a necessary extension. Although Yurchak decries the widespread practice in "academic and journalistic writing today" of casting as resistant any

43. Yurchak, *Everything Was Forever, until It Was No More*, 8. Yurchak follows in the footsteps of the recent " 'third generation' of Soviet scholars," including Stephen Kotkin, Yuri Slezkine, and others who also push against, refine, or abandon the older totalitarian and revisionist models of Soviet life. For a useful discussion of the shifting trends in Soviet historical studies by a member of the "second generation," see Fitzpatrick, "Introduction," 1–14 (the quoted phrase is on p. 7).

44. See Taruskin, "The Opera and the Dictator," 40; as well as Taruskin, "The 2000 Cramb Lecture." Volkov's *Shostakovich and Stalin* (esp. pp. 36 and 65) is the most recent in a long string of works that insist that Shostakovich was not "an idealistic fellow traveler who later became disillusioned" but, rather, a "democratic non-Communist" (read: "dissident") from the outset. A welcome departure is Alex Ross's more sensitive treatment of Shostakovich in his *The Rest Is Noise*, esp. 218.

45. See annotations by Joel Sachs to the program for "Focus!: Breaking the Chains: The Soviet Avant-Garde, 1966–1991" (21–28 January 2005): "This festival is for those brave outsiders who defied the censors and the career-makers to follow their own visions" (p. 4). My thanks to Laurel Fay for providing me a copy of the program from the festival.

actions not in strict compliance with state directives, I argue that during the late 1950s and early 1960s, during the initial stages of de-Stalinization, something more critical and more oppositional, however qualified, was possible than became the case later on during the period Yurchak is primarily discussing. This was the case especially with students during the late 1950s and early 1960s, many of whom were moved by Khrushchev's 1956 "Secret Speech" and the Hungarian uprising of the same year to contest actively the assumptions of both Stalin's "Cult of Personality" and the foundations of Soviet communism. As the historian Alexander Pïzhikov has demonstrated, these students mounted their challenges through official and, with increasing frequency, "'illegal' ['nelegal'nïye'] political groups and clubs," as well as through letters of protest to officials, the compiling of alternative political platforms and proclamations, and self-published newspapers in schools and universities.[46] In short, in this early stage of the Thaw, the balanced, apolitical *vnye* culture Yurchak describes did not yet exist. It had only just come into existence by the mid-1970s, having begun to solidify after the Soviet invasion of Czechoslovakia in 1968.[47] The *vnye* milieus, in turn, disappeared with perestroika, when numerous "informal" groups (or "neformali") flourished, particularly among Soviet youth.[48] Before the mid-1970s, however, a wider range of more politicized *vnye* spaces existed, some of which occasionally even tipped Yurchak's balanced formulation by straying beyond—or more appropriately "outside"—official oversight.

Yurchak's examination of *vnye* and his critique of resistance is drawn from his study of individuals "born between the 1950s and early 1970s," individuals who came of age between the late 1960s and the early 1980s, rather than on figures born in the 1920s or 1930s, the figures who reached young adulthood during the Thaw.[49] These two generations had decidedly different experiences of Soviet socialism. Initially, the members of the generation born in the 1930s who attended the conservatories of the 1950s, the so-called *shestidesyatniki* (or "men of the sixties"), were much more idealistic than the cohort Yurchak

46. Pïzhikov, *Khrushchovskaya "ottepel'*," 280, and in general 278–89. Reid similarly documents heated discussions that erupted among students in Leningrad following the landmark December 1956 Picasso exhibition. See Reid, "Toward a New (Socialist) Realism," 222. See also Taubman, *Khrushchev: The Man and His Era*, 285–87; and Zubkova, *Russia after the War*, esp. 185–90 and chapter 19.

47. For more on the development and significance of *vnye* milieus in music, see Schmelz, "From Scriabin to Pink Floyd: The ANS Synthesizer and the Politics of Soviet Music between Thaw and Stagnation." A critique of Yurchak's account of the 1970s as "static" and "repetitive" appears in Schmelz, "What Was 'Shostakovich,' and What Came Next?" 302–3 and 332–33.

48. See Pilkington, "'The Future Is Ours': Youth Culture in Russia, 1953 to the Present," 375; and Pilkington, *Russia's Youth and Its Culture: A Nation's Constructors and Constructed*, 118–61 and 320–21 n. 1.

49. Yurchak, *Everything Was Forever, until It Was No More*, 31; and Schmelz, "What Was 'Shostakovich,' and What Came Next?" 303–4.

is describing. They have even been called by some the "last idealists."[50] Or as Natan Eydel'man notes in his overview of the 1960s: "At that time there was a burning vision and a certain lifting of spirits, which today strikes one as funny."[51] The same idealism holds for unofficial music audiences in the 1960s and helps explain their positive responses at unofficial concerts.

Historians have recently renewed debates regarding the possibilities for resistance over the course of Soviet and Russian history.[52] One response, offered by Lynne Viola, among others, has been to consider a spectrum of resistant acts (or "categories of resistance") ranging from active to passive while carefully accounting for both context and motivation.[53] Another suggestion has been to hone our understanding of resistance through an examination of the "problem of generation—understood both as age cohorts and as subjectively constructed groups," in other words, the shifting possibilities for resistance offered to or expressed by different groups in different places at different times within Soviet history.[54] Like Yurchak, I am highly critical of the idea of "resistance," yet I do not want to discard it entirely and in the process ignore the testimony of those participants in unofficial concerts—and especially listeners and performers—who claimed them to be a liberating activity, connoting resistance, opposition, or protest of some sort, however passive, limited, or contingent. Similarly, I do not want to downplay the difficulties of life in the Soviet Union by unduly stressing the "normal" aspects of existence. I want to construct a more complex middle ground, considering a spectrum of possibilities for resistance by investigating eyewitness claims and using them to enrich our understanding of the historical and generational development of Yurchak's concept of *vnye*.

One of the central concerns of the present study, therefore, will be to explore the meanings and operations of the musical venues and organizations that stood *vnye* official power structures during the Thaw, as well as the nature of their changing "suspension" during the period. Specifically, this book

50. Anninskiy, "Shestidesyatniki, semidesyatniki, vos'midesyatniki…: K dialektike pokolenii v russkoy kul'ture," 12, cited in Condee, "Cultural Codes of the Thaw," 164.

51. Eydel'man, "Vremya, sulivsheye stol'ko nadezhd," 7. See also Gubaidulina and Tsïbul'skaya, "Oni nenavideli menya do togo, kak slïshali moyu muzïku…," 40.

52. For a good overview, see David-Fox, Holquist, and Poe, eds., *The Resistance Debate in Russian and Soviet History*, esp. the introduction, "Resistance Pro and Contra," 5–11, and David-Fox's "Whither Resistance?" 230–37.

53. Viola, "Popular Resistance in the Stalinist 1930s: Soliloquy of a Devil's Advocate," 70–75 and 101; see also David-Fox, "Whither Resistance?" 233–34; and Barker, "The Culture Factory," 21–22. Although his binary opposition of "public" and "hidden" transcripts does not work in the Soviet Union (as Yurchak, and others, have correctly noted—Viola is an exception, see her pp. 98–99), the political scientist James Scott's idea of a continuum of resistant acts might also be a potential model. See Scott, *Domination and the Arts of Resistance: Hidden Transcripts*, 26 and 198.

54. David-Fox, Holquist, and Poe, "Resistance Pro and Contra," 10.

investigates the shifting connotations of abstract and mimetic unofficial Soviet music during the late 1950s and over the course of the 1960s, when the freedom suggested or inspired by certain unofficial venues, pieces, performers, or composers helped audiences imagine alternative possibilities to those suggested by Soviet authorities, principally through the ubiquitous stylistic tropes of socialist realism.

Initially, the composers' actions were more constrained. Unofficial composers, particularly during the abstract serial phase, did not actively resist or oppose. Instead they withdrew—they withdrew from the dominant demands of socialist realism, as well as from the social concerns behind many of the artistic products of their more openly critical contemporaries in literature and the visual arts. As Andrei Codrescu wrote of his own generation in Romania, unofficial composers "wanted to escape, not to fight." They felt, like Schnittke, that only by ignoring the system could art retain its "authenticity." The sense of withdrawal persisted in some composers' works well into the 1970s.

Paradoxically, this withdrawal facilitated by the abstract styles cultivated by serialism's "strict" controls—the title of Volkonsky's first serial composition, *Musica Stricta,* is not entirely innocent nor bereft of deeper significance—suggested freedom to Soviet auditors. Listeners could actively imagine alternatives, or at least momentarily escape, seduced by the new sound worlds they were hearing. In this way, unofficial music, and especially its abstract phase, operated as the "third space" that Condee claims Khrushchev cultivated, an "inner freedom" that was "implicitly a different truth from party truth."[55]

This disjuncture between construction and reception points to broader interpretations of serialism and aleatory techniques—and of abstraction and mimesis—and primarily those interpretations made from the perspective of the cold war and its musical politics. For example, Anne Shreffler has recently considered the musical and political implications of "freedom" and "control" in postwar music, and specifically serialism, in the West, focusing on the CIA-sponsored Congress for Cultural Freedom and Stravinsky's *Threni.*[56] In the West, as in the USSR, serialism represented freedom from the forced meanings of socialist realism—it was an audible demonstration of "freedom of expression"—but it failed to attract European and American audiences in the same way that it did Soviet listeners.[57] In the West, serial composers really were, to

55. Condee, "Cultural Codes of the Thaw," 168. Here Condee is referring to Ehrenburg's writing on Stendhal and the controversy it engendered over the idea of "inner freedom."

56. Shreffler, "Ideologies of Serialism: Stravinsky's *Threni* and the Congress for Cultural Freedom," 222.

57. There is a burgeoning literature on the significance of postwar serialism (and new music in general) against the backdrop of the cold war. See, e.g., Brody, " 'Music for the Masses': Milton Babbitt's Cold War Music Theory," 161–92; Beal, *New Music, New Allies: American Experimental Music in West Germany from the Zero Hour to Reunification;* Carroll, *Music and Ideology in Cold War Europe;* DeLapp,

paraphrase Boris Groys's interpretation of the unofficial visual arts in the post-war USSR, "intolerant of the people and the...kitsch in which the people live."[58] The music of the young Soviets, by contrast, consistently drew a broader spectrum of interested listeners than their European or American counterparts at Darmstadt or Princeton (if they can be said to be counterparts at all, given their drastically different circumstances, materially, socially, and politically). When many of the unofficial composers gradually rejected abstract serialism in favor of aleatory techniques and polystylism at the end of the Thaw, in the process creating more accessible, more mimetic compositions, they were still enthusiastically applauded by audiences. Significantly, they were also applauded by those Soviet critics who had previously condemned the abstractionism of their early 1960s works, but who now heard the more familiar mimetic dramaturgy as a capitulation to socialist realist requirements. The unofficial composers' engagement with both sides of the abstract/mimetic cold war divide posited by Berger thereby complicates our understanding of all of these terms—and especially "freedom" and "control" and their political and musical implications.[59] Examining the Soviet negotiation of the abstraction/mimesis continuum during the Thaw also helps us understand how and why European and American composers made similar transitions during the postwar decades.

One final problem then is terminological, for there is no good label that accurately describes the social sphere of composers, listeners, performers, and music that I am discussing. Fully aware of the binaries suggested by "unofficial," I have cautiously chosen to use this term throughout. With its emphasis on the power structures—and, therefore, the inherent tensions—of Soviet life, it proves less problematic than terms such as "dissident," "outsider," "nonofficial," "nonconformist," "underground," or even "avant-garde," all previously favored by writers occupied with the music, art, or literature of the time.[60] There are

"Copland in the Fifties: Music and Ideology in the McCarthy Era," esp. chapter 2; Fosler-Lussier, *Music Divided: Bartók's Legacy in Cold War Culture;* Shreffler, "Ideologies of Serialism: Stravinsky's *Threni* and the Congress for Cultural Freedom"; and Beckles Willson, *Ligeti, Kurtág, and Hungarian Music during the Cold War*. See also Taruskin, "A Myth of the Twentieth Century: *The Rite of Spring,* the Tradition of the New, and 'The Music Itself'"; and Taruskin, "Nationalism," 17:702–3.

58. Groys, *The Total Art of Stalinism,* 78. The classic example of this intolerance is Babbitt's editorially titled "Who Cares If You Listen?" (it was originally called "The Composer as Specialist"). See also Brody, "'Music for the Masses': Milton Babbitt's Cold War Music Theory," 178 and passim.

59. Berger, *A Theory of Art,* 150; see also 146–51.

60. Examples include: Baigell and Baigell, eds., *Soviet Dissident Artists;* Tsenova, ed., *Underground Music from the Former U.S.S.R.;* Sachs, "Notes on the Soviet Avant-Garde"; Savenko, "Poslevoyennïy muzïkal'nïy avangard," 407–32 (on the term "avant-garde" see 413); Rosenfeld and Dodge, eds., *Nonconformist Art: The Soviet Experience, 1956–1986;* and Savitskiy, *Andegraund: Istoriya i mifï Leningradskoy neofitsial'noy literatury*. Savitskiy surveys the various terms for "underground" literature in his pp. 39–51, and there he traces the evolution of the term "unofficial" ("neofitsial'nïy") (pp. 42–44), and specifically its importation from the West. He locates its first appearance in the title of Sjeklocha and Mead, *Unofficial Art in the Soviet Union*.

also pragmatic concerns: "unofficial" is more wieldy than *vnye* or "suspended" would be (*"vnye* music" rings awkward to both Russian and English speakers, and, while poetic, "politically suspended music" raises similar difficulties). Let "unofficial" then continually remind readers of the suspended position of this music and its composers, performers, and listeners, all primarily using official means of production and dissemination, but continually counteracting, contradicting, and redefining them from within.

The development of the unofficial musical world spanned the long decade from Khrushchev's time in power to that of Brezhnev, running from the beginning of the Thaw in the mid-1950s into the middle of the 1970s, the time widely, and perhaps misleadingly, known since the late 1980s as the era of "stagnation" ("zastoy").[61] During this period, the generation of Soviet composers educated in the conservatories of the 1950s came into their own. First a relatively unified group, they progressed along similar technical and stylistic paths until they began to diverge in the mid-1960s. By 1974 their earlier unity had fully splintered, a musical fragmentation mirroring the fragmentation of contemporaneous Soviet society. Many historians put the end of the Thaw at the time Khrushchev was removed from power in October 1964 (if not slightly earlier, with the ill-fated Manezh exhibition of late 1962, or slightly later, with the Soviet invasion of Czechoslovakia in August 1968), but the musical Thaw extends past this boundary. Its freedoms were felt by musicians in the unofficial concert subculture well into the 1970s, when new social forces, new musical styles, and a new generation of younger composers had come to prominence.[62] Shostakovich's death in 1975 marked the musical Thaw's definitive, if belated, end.

Unfortunately, despite the significant role played by unofficial music, because official Soviet publications tended to censor these composers with silence, the history of these composers, their music, and their audiences remained largely undocumented at the time. (An important exception was Václav Kučera's [b. 1929] little-known book, *New Trends in Soviet Music*, published in Prague in 1967 and based upon his long familiarity with the "young composers" from the USSR's main musical centers, initiated during his study from 1951–56 with

61. As Yurchak correctly cautions, citing work by the Russian historian K. Rogov, this term was retrospective. Rogov notes that the idea of "stagnation" was one aspect of the "myth of the 1970s" that "began to be formed at the end of the 1980s." The idea of "stagnation" arose as a binary opposite to the then-blossoming idea of perestroika (as well as the "Thaw" of the 1960s). See Yurchak, *Everything Was Forever, until It Was No More*, 7; and Rogov, "O proyekte 'Rossiya/Russia'—1970-ye godï," 7.

62. See Condee, "Cultural Codes of the Thaw," 161–62; and Rogov, ed., *Semidesyatïye kak predmet istorii Russkoy kul'turï*, esp. 7–28. See also Schmelz, "From Scriabin to Pink Floyd"; and Schmelz, "What Was 'Shostakovich,' and What Came Next?"

Vissarion Shebalin at the Moscow Conservatory.)[63] Historians such as Boris Schwarz who have relied only on the official reportage of the period have thus presented only one side of the story.[64] Denisov was already lamenting this fact in 1965: "A person expressing a judgment about Soviet music only on the basis of what he sees on the posters of the Moscow Philharmonic and on what he reads, for example, in *Sovetskaya muzïka,* obviously runs into not only an incomplete, but also a distorted picture of our musical life."[65]

In an attempt to correct the distortions that Denisov decried, I have turned to oral history, an approach increasingly common in recent historical scholarship on the Soviet period.[66] I have augmented official reportage with extensive interviews that I carried out with many of the leading participants and eyewitnesses of the Thaw, including composers, performers, and listeners, supplemented and verified by archival documents when available. I have attempted as much as possible to present their impressions and recollections in their own words, often at some length, while also preserving the tone of the dialogues (and sometime disputes) that characterized our discussions.

Despite the optimism of Joseph Brodsky's poetic contention that memory can prove time impotent, memory is not necessarily victorious. Often oral history creates more problems than it resolves. It is frequently skewed by the biases of both questioner and questioned. Some aspects of the past can never be recaptured; sometimes the most that can be achieved is to shed some light, however weak, on the figures in the shadows. Keeping this in mind, all quotations here from living participants must be read for what they are, reminiscences made some three to four decades after the fact.

The book thus has its roots in two periods: the 1960s of my informants' memories, and the Russia at the end of the twentieth century when I conducted my interviews. These two periods intertwine and feed one another, as all of the memories within the book are colored by the deep nostalgia many Russians had at the dawn of the new millennium for the remembered and

63. Kučera, *Nové proudy v sovětské hudbě: Eseje a stránky z deníku.* The American musicologist Stanley Krebs's dissertation (subsequently published) was also an important early record of unofficial music. Krebs, *Soviet Composers and the Development of Soviet Music,* esp. 452–64 (diss.) and 336–41 (book).

64. Schwarz, *Music and Musical Life in Soviet Russia.* See also Fay, review of *Music and Musical Life in Soviet Russia,* 359.

65. Denisov, "Za ob'yektivnost' i spravedlivost' v otsenke sovremennoy muzïki," 28.

66. Many writers on the Soviet period have turned to oral history, from Lourie, *Russia Speaks: An Oral History from the Revolution to the Present;* to most recently on the grandest scale, Figes, *The Whisperers: Private Life in Stalin's Russia.* This approach is also being fruitfully adopted in musicological investigations of music of the recent past, as in Beal's aforementioned research on music in postwar Darmstadt, and Laura Silverberg's work on music in the German Democratic Republic from 1956 to 1971. See Beal, *New Music, New Allies;* and Silverberg, "The East German *Sonderweg* to Modern Music, 1956–1971."

misremembered securities of the Soviet Union and specifically for the 1960s, the period of burgeoning freedoms under Khrushchev when they were eager students. Their nostalgia helps reveal the contingencies of the freedoms in both the Russian 1990s and the Soviet 1960s: tantalizing, incomplete, and perhaps ultimately elusive.

The chapters in this book trace the origins, development, and meanings of unofficial music and unofficial concertgoing in some of the main cultural centers of the Soviet Union—specifically Moscow, Leningrad, Kiev, and Tallinn—from the beginnings of Khrushchev's Thaw to the middle of Brezhnev's Stagnation. My main research was conducted in Moscow, and my primary focus is the Russian and Soviet capital. I have tried to offset this acknowledged Moscow-centrism through interviews with representatives from all four cities. There is, in any case, an argument that can be made for concentrating on Moscow: it was one of the most, if not the most, liberal Soviet city, thanks to the large and constantly changing presence there of foreign diplomats, journalists, and visitors. As a result, Moscow's unofficial musicians had many easily accessible ways to receive and send new music. Of course, as shall become a mantra throughout this book, there were always exceptions.

Many composers may be counted among the ranks of those who played important roles during the period; in the interests of space I have chosen to focus on the most prominent among them, singling out Volkonsky, Denisov, Schnittke, Gubaidulina, Pärt, and Silvestrov for attention. Other composers will be introduced as necessary, among them Nikolai Karetnikov, Alemdar Karamanov, and Leonid Hrabovsky, but the dominant trends of the musical Thaw are evident in the works of the main six.[67] Instead of discussing every composer or piece of music from the period, I have opted to engage only with the seminal compositions from the Soviet 1960s, those compositions that received the most press and drew the largest audiences, and that best represent the period, with all its vicissitudes. As a result, I have chosen to omit some composers widely known today, such as Galina Ustvolskaya, who were rarely mentioned either by my informants, or by critics, officials, or other composers.

The second and fifth chapters provide general historical portraits of the beginning and the middle of the musical Thaw, respectively. The remaining chapters are loosely arranged chronologically. The second chapter describes life in the Soviet conservatories in the immediate wake of Stalin's death when

67. Although he neglects Volkonsky, Gerard McBurney noted that when he was in Moscow in the 1980s, "musicians talked not of the big *three* composers (Schnittke, Denisov, Gubaidulina) but of *five*, including Arvo Pärt and Silvestrov." McBurney, review of recordings of Denisov, Gubaidulina, Karetnikov, and Silvestrov, 54.

the unofficial composers were young conservatory students. It surveys the varied foreign and domestic musical sources then beginning to come to their attention that proved most crucial to their developing aesthetic sensibilities and their attempts to "catch up" musically with the West. It also examines the nascent unofficial subculture already taking root in the Soviet conservatories thanks to these new sources. The chapter concludes with the 1957 visit of Glenn Gould, the 1962 visit of Igor Stravinsky, and the multiple visits of Luigi Nono over the course of the 1960s, discussing the overall impact that these foreign emissaries had on unofficial Soviet music.

The third chapter focuses on the first and initially most prominent of the "young composers," Andrey Volkonsky, considering the creation, reception, and interpretation of three of his early abstract serial compositions, *Musica Stricta, Suite of Mirrors,* and *Laments of Shchaza,* heard at the first unofficial concerts of the Thaw. This chapter also begins to address the meanings of serialism and abstraction in the late-Soviet context, detailing the specifically Soviet approaches to composing with and teasing meaning from serial techniques. Chapter 4 concentrates on Edison Denisov and his 1964 composition *Sun of the Incas* and the transition it marked for the "young composers." Denisov's work signaled a shift in official attitudes toward them all; thanks to its successful export he—and by extension they—came to greater prominence on the world stage. The premiere of this composition marked Denisov's ascendancy among the "young composers" as he drew the spotlight that had once shined solely on Volkonsky. In part a result of Denisov's outspokenness, as well as the changing political landscape of the Soviet Union (namely Khrushchev's ouster and Brezhnev's assumption of power), during the period after the performance of *Sun of the Incas* the "young composers" gradually became unofficial. Officialdom began to perceive their creations as more than youthful indiscretions and began to react accordingly. At this time, many of the composers also began turning to more mimetic modes of musical composition.

Chapter 5 presents a mid-decade overview of unofficial musical life at its height. It details performers, clubs, and institutions just after the first performances of Denisov's *Sun of the Incas* and Volkonsky's *Laments of Shchaza.* It examines the central musical players and venues in the central Soviet musical cities, including Grigoriy Frid's Moscow Youth Musical Club and Volkonsky's early music ensemble Madrigal. This chapter also discusses the vagaries of Soviet musical life: the constantly fluctuating nature of "bans," and the methods and strategies that performers used to circumvent official regulations, both written and unwritten, in order to play unofficial music.

Chapter 6 details the changing musical landscape of the late 1960s, when an increasing number of unofficial composers, foremost among them Pärt, Schnittke, Silvestrov, and Gubaidulina began using more familiar mimetic approaches to musical dramaturgy, approaches not unlike those required by

socialist realism. These mimetic styles were enabled by their increasing adoption of both tonal quotations and aleatory devices. Together the familiarity of tonality and the freedom that aleatory techniques allowed them to insert in their compositions facilitated the construction of their musical dramas.

The topic of chapter 7 is the musical aftermath of the repressive year of 1968—the year of Prague Spring's "socialism with a human face" and the subsequent Soviet invasion of Czechoslovakia. In the years following 1968 Denisov again had difficulties with the musical authorities, and Volkonsky and his confreres penned an attempted response, the improvisational *Rejoinder*. This composition raises further questions of being *vnye* and of resisting, this time from the perspective of the Thaw's end.

The conclusion of the musical Thaw is the central subject of chapter 8. Two events in particular signaled the Thaw's end: Volkonsky's emigration in 1973, and the premiere of Schnittke's polystylistic First Symphony in 1974. In its multiplicity Schnittke's composition managed to encompass most of the dominant trends of the musical Thaw, both abstract and mimetic, even as it signaled the moment when the young Soviets arguably caught up with the West. This chapter describes the construction and reception of Schnittke's composition and reconsiders its role in the changing musical landscape of mid-1970s Soviet music, a moment of new styles and a new, younger musical generation as interested in progressive rock as in serialism. At this time, mimesis and abstraction began to interact more productively in Soviet music—to return to Berger's formulation. The *vnye* nature of the unofficial composers and unofficial concert life also began to shift. Soviet life outwardly became more rigid, *pace* Yurchak, but it also became easier to hear new, challenging music in larger venues, even as it began to convey different, less resistant meanings to Soviet listeners.

2

The Dam Bursts: The First
and Second Conservatories

Yes, in my case "youth" has been dragged out to an absurd degree. And it's not only me;
all the writers of my generation were officially considered "young writers" up till they
were forty-five.

—Vasiliy Aksyonov to John Glad (1982/3)

The unofficial world of music began in fits and starts during the 1950s, much
like the Thaw itself. Music only gradually broke from the constraints that had
been binding it since the "historic" February 1948 Resolution of the Central
Committee of the All-Union Communist Party (Bolsheviks) that attacked
Shostakovich, Prokofiev, Khachaturyan, Shebalin, Myaskovsky, and other
Soviet composers for their "formalist" indiscretions.[1] Although this was a slug-
gish process, the reforms began almost immediately after Stalin's death. Aram
Khachaturyan launched one of the opening salvoes in the attack on the old
strictures in a November 1953 *Sovetskaya muzïka* article titled "On Creative
Courage and Inspiration." In this article, similar to early post-Stalin essays
on Soviet literature by the writer Ilya Ehrenberg (the author of the *Thaw*),
Khachaturyan argued for an openness in the use of the term "socialist real-
ism," and touched on questions of tradition and innovation in music that
would pervade discussions for the next twenty years.[2] The ongoing debate over
Shostakovich's Symphony No. 10 that filled the pages of *Sovetskaya muzïka* in

1. See "Soviet Music Policy, 1948" and "Discussion at a General Assembly of Soviet Composers,
Moscow, 17–26 February 1948"; and Werth, *Musical Uproar in Moscow.*
2. See Khachaturyan, "O tvorcheskoy smelosti i vdokhnovenii"; and Schwarz, *Music and Musical
Life in Soviet Russia,* 273–75. On Ilya Ehrenberg, see Rubenstein, *Tangled Loyalties,* 279.

1953 and 1954 was another crack in the facade, as was Shostakovich's receipt of the title People's Artist of the USSR in 1954.[3] The increasing number of public positive responses to Shostakovich's work began repairing the damage of the 1948 resolution. Prokofiev, too, began his slow ascent to "classic" status.[4] The real watershed moment for music at least was the 1958 Declaration of the Central Committee that finally "amended and canceled" the 1948 resolution and "restored the dignity and integrity of Soviet composers attacked in that resolution."[5] But as the historian Stephen Bittner has shown in his detailed institutional analysis of Moscow's Gnesin Institute during the Thaw, often these debates and declarations left only confusion. Khrushchev's "Secret Speech" at the 1956 XX Party Congress denouncing the crimes of Stalin suggested curricular reform without specifying the nature of that reform, ultimately raising more questions than it answered for both administrators and students at the institute.[6]

As a result of such confusion and a general resistance to change within the system, the restrictive atmosphere provoked by the 1948 resolution persisted well into the next decade. Despite the liberalizing trend of the 1950s, it was still an extremely conservative time in which to learn the craft of composition, and it was against the often ambiguous—still repressive, yet progressively loosening—background of these years that the majority of the "young composers" were schooled. The education they acquired, both through official and unofficial channels, directly colored the types of music that they began to write when they came into their own as composers in the 1960s following their graduation from the Soviet conservatory system. During the 1950s, the composers under discussion really were literally "young composers." Most were conservatory students, either undergraduate or graduate students, and it was then that they first began probing avant-garde techniques. This education continued upon their graduation, when they hurriedly tried to make up for lost time and tried to fill in the gaps left by their official schooling.

The term "young composers" had ramifications far beyond its literal meaning. "Young" was symptomatic both of a certain attitude on the part of the

3. Schwarz, *Music and Musical Life in Soviet Russia*, 278–83; and Fay, *Shostakovich: A Life*, 189–92.

4. See Schmelz, "After Prokofiev."

5. "Declaration of the Central Committee of the Communist Party of the Soviet Union Amending and Canceling the Resolution of 10 February 1948 and Restoring the Dignity and Integrity of Soviet Composers Attacked in That Resolution." See also Schwarz, *Music and Musical Life in Soviet Russia*, 311–12.

6. See Bittner, *The Many Lives of Khrushchev's Thaw*, 40–74 (also Bittner, "Exploring Reform: De-Stalinization in Moscow's Arbat District, 1953–1968," 273–338). Bittner focuses on archival materials relating to the institute administration's internal discussions regarding curricular reform and student misconduct. His "top-down" account supplements my more "bottom-up" perspective, focused as I am on the students' perspectives on reform. See also Pizhikov, *Khrushchovskaya "ottepel'*," 278–79. For a useful reminder of the traditional view of the "open talk" of the Thaw as a construct of the "talkative intelligentsia" of the urban centers as opposed to the "stoicism and silence" of the majority, see Figes, *The Whisperers*, 599.

older authorities toward these composers and the general mood of their work and of the work of their colleagues in art and literature, indeed of the cultural zeitgeist in general. As the former Khrushchev speechwriter Fedor Burlatsky recalled, "It was young people who personified the Thaw."[7] Boris Kats, biographer of Boris Tishchenko, one of the youngest of the "young composers," has his own explanation for the phenomenon that author Vasiliy Aksyonov (b. 1932) describes in the epigraph to this chapter, the fact that these artists' "youth" extended well into their mid-forties. Kats writes, "In the ordinary consciousness for some time the words 'modern' and 'youth' became almost synonymous: to be modern, it seemed, also meant to be young."[8] Just as the new, younger characters of many well-known books at the end of the 1950s and beginning of the 1960s like Aksyonov's own *Ticket to the Stars* (*Zvyozdnïy bilet,* 1961) began to attract notice, so did the new, younger artists, writers, and composers who were beginning to experiment with new creative strategies, and especially with more abstract means of expression. Their youthful energy and the public's attraction to the new and experimental in their works also began to draw the often jealous attention of the moribund elder generation.

This chapter is about the musical formation of the young Soviet composers and their particular "youth culture," the nascent form of the unofficial music culture of the 1960s.[9] Through a variety of sources, both foreign and domestic, both legal and illicit, the curious "young composers" became aware of the musical techniques prohibited from Soviet musical life for the previous decades, most significantly the many varieties of serialism. At the same time, foreign musicians began to visit in increasing numbers, bringing firsthand contact with figures as diverse as Glenn Gould, Igor Stravinsky, and Luigi Nono, who further widened the young Soviets' awareness of both the theories and practices of European musical modernism. Driven by curiosity and what Arvo Pärt called a "hunger" for the new, the "young composers" already were forced to negotiate between the conflicting demands of their official conservatory training and the aesthetics of the Western works and artists they were newly encountering.

THE FIRST CONSERVATORY

Most of the composers who comprise the musical *shestidesyatniki* were students during the 1950s (table 2.1). Alfred Schnittke underscored the importance of his years at the Moscow Conservatory: "For us the five years at the

7. Burlatsky, *Khrushchev and the First Russian Spring,* 13.

8. Kats, *O muzïke Borisa Tishchenko: Opït kriticheskogo issledovaniya,* 8.

9. On Soviet youth culture from 1950 to 1980, see Pilkington, *Russia's Youth and Its Culture: A Nation's Constructors and Constructed,* esp. chapter 2 (44–71).

Table 2.1. Composers and their dates of conservatory attendance (listed chronologically by city)

	Undergraduate	Graduate ("Aspirantura")
Moscow		
Nikolai Karetnikov (1930–94)	1948–53	—
Andrey Volkonsky (1933–2008)	1950–54[a]	—
Rodion Shchedrin (b. 1932)	1950–55 (piano and composition)	1955–59 (composition)
Edison Denisov (1929–96)	1951–56	1956–59
Alfred Schnittke (1934–98)	1953–58	1958–61
Alemdar Karamanov (1934–2007)	1953–58	1958–63
Sofia Gubaidulina (b. 1931)	1954–59	1960–63
Leningrad		
Sergey Slonimsky (b. 1932)	1950–55 (piano and composition)	1955–58 (composition and theory)[b]
Boris Tishchenko (b. 1939)	1957–62 (piano and composition)[c]	1962–65 (composition)
Kiev		
Leonid Hrabovsky (b. 1935)	1954–59	1959–62[d]
Vitaly Hodzyats'ky (b. 1936)	1956–61	—
Valentin Silvestrov (b. 1937)	1958–63/64[e]	—
Tallinn		
Arvo Pärt (b. 1935)	1957–63	—

[a] Volkonsky was expelled from the Moscow Conservatory in late summer/early autumn 1954.
[b] Different sources give different dates for the completion of Slonimsky's various areas of specialization. See Danko, "Slonimsky, Sergey Mikhaylovich"; Kholopova, "Impul'sï novatorstva i kul'turnïy sintez v tvorchestve Sergeya Slonimskogo," 42; and Rïtsareva, *Kompozitor Sergey Slonimskiy*, 37.
[c] Tishchenko was expelled during his first year at the Leningrad Conservatory, and he was not allowed to return as a composition student until two years later (1959).
[d] These are the dates supplied in Savenko, "Konstantï stilya Leonida Grabovskogo," 91 n. But they must be qualified: Hrabovsky took his final graduate exams in October 1962, but did not pass all of the sections. He requested to be readmitted in early 1963 and only later completed the degree (it is unclear exactly when; see RGALI, f. 2077, op. 1, yed. khr. 2174, 1. 3).
[e] According to Baley, Silvestrov graduated from the Kiev Conservatory in 1964 (Baley, "Sil'vestrov, Valentyn Vasil'yovych"). According to Savenko, he graduated in 1963 (Savenko, "Rukotvornïy kosmos Valentina Sil'vestrova," 72).

conservatory...were five years granted by fate, when one was independent (if one was not expelled). Because, while one studied one did not have to strive for that life-line at the Union of Composers, one was free. But later that freedom ended. Forever."[10] The situation in the conservatory was perhaps not as idyllic as Schnittke's account might suggest. During the 1950s, the decade in which he, Denisov, Gubaidulina, and Volkonsky, among others, attended the Moscow Conservatory, the situation was often quite bleak. The composer Nikolai Karetnikov presents a humorous account of a typical lecture. As amusing as it may be to Western sensibilities, it was no doubt frightfully close to the actual situation:

> As he entered the auditorium, the lecturer placed the score of Mahler's Fourth Symphony on the stand, opened it to the first page and spoke: "Here comrades we have the Austrian composer Mahler. He was born in 1860 and died in 1911. He was the main conductor of opera in Prague, Hamburg, and Vienna. In Vienna he was also the main conductor of the Philharmonic. He wrote ten symphonies and five symphonic vocal cycles. This composer was reactionary, bourgeois and static." The lecturer closed the score and placed it to the side. "Now we turn to Richard Strauss."[11]

Karetnikov ends this anecdote with the line "thus, in 1951 we 'did' ['proshli'] Mahler." He also describes the denunciation of a student by a classmate in 1952 for carrying two Stravinsky scores in the Moscow Conservatory corridors; this denunciation precipitated a search of the conservatory dormitory for the offending scores.[12] But this hermetic world did not end with Stalin's death, for when Schnittke was beginning his studies at the Moscow Conservatory in 1953 the frigid atmosphere of Stalin's regime still lingered and continued to do so throughout the 1950s. Like Karetnikov, Gubaidulina remembered that "sometimes the authorities of the Moscow Conservatory organized raids of the student dormitories, searching for scores by Stravinsky and other contemporary Western composers."[13]

The works of Stravinsky and even the important pre-1948 works of Prokofiev and Shostakovich were unavailable at this time to students without

10. Talochkin and Alpatova, eds., *"Drugoye iskusstvo,"* I:305.

11. Karetnikov, *Gotovnost' k bïtiyu,* 20–21.

12. Ibid., 24; and Karetnikov and Golubeva, "Osvobozhdeniye ot dvoyemïsliya," 16.

13. Gubaidulina and Lukomsky, "'Hearing the Subconscious': Interview with Sofia Gubaidulina," 27. This contradicts Gubaidulina's statement to Kurtz that "When I arrived in Moscow in 1954 they had lifted the prohibitions and stopped searching the dorms at the conservatory. It had also become possible again to listen to Stravinsky and Hindemith in the archives." Kurtz, *Sofia Gubaidulina,* 38.

special approval.[14] The conservatory libraries and the Lenin Library in Moscow during the 1950s and the 1960s did have these and other "banned" scores, but they were only accessible if one went through the proper official channels, or if one was in good favor with the proper individuals.[15] For example, as a graduate student at the Leningrad Conservatory, Sergey Slonimsky was allowed access to scores that were prohibited to undergraduates.[16] The composer Aleksey Nikolayev told me that he and several of his classmates could listen to Schoenberg, Webern, and Berg in the Moscow Conservatory sound library only because the technician there trusted them.[17] Tishchenko also remembered the head of the Leningrad Conservatory sound recording room ("kabinet zvukozapisi"), Alexander Gomarteli, letting him and his colleagues (still high-school students) "all but secretly sneak in" to hear the "still semiforbidden ['poluzapretnïye'] Eighth Symphony by Shostakovich, Scriabin's *Prometheus,* Stravinsky's *Petrushka* and *Symphony of Psalms,* and Mahler's Ninth and Tenth Symphonies."[18] The lexicographer Nicolas Slonimsky writes that the musicians he met in Kiev in November 1962 "told me that in order to consult a German music dictionary in the library here a special permit and some sort of certificate of political reliability from the board of directors are required. Why, asked I. Well, one might look up articles about Schoenberg or Webern."[19]

As was to be expected, the conservatories were roughly divided in two, separated like Soviet society into an official world and an unofficial world "suspended" within that world, or as Schnittke later dubbed them "the external, official way and the internal, student way."[20] Gubaidulina herself subdivided the students into three groups: "The first—the academic-conservative, the second—very radical, represented by Volkonsky, and the third—lying somewhere between the first and the second groups with Rodion Shchedrin as its main figure." According to Gubaidulina, "Volkonsky's trend elicited the most sympathy," among musicians as well as artists and poets.[21]

14. GNAS: 13. Karamanov also mentioned this; see Kholopov, "Autsaider sovetskoy muzïki: Alemdar Karamanov," 120. See also Kholopov's recollection of the period in Kholopov and Tsenova, *Edison Denisov,* 11 (esp. n. 8).

15. Yekimovskiy, interview; and Martïnov, interview. A similar situation existed in the main libraries in Leningrad and Moscow where "students and people with contacts" had access to otherwise inaccessible literature by foreign authors and by Soviet authors from the 1920s, like Nikolai Gumilyov (1886–1921), Acmeist poet and Anna Akhmatova's first husband. Yurchak, *Everything Was Forever, until It Was No More,* 144–45.

16. Slonimskiy, interview. See also Slonimskiy, *Burleski, elegii, difirambï v prezrennoy proze,* 121. Mazo corroborates this. See Mazo, "The Present and the Unpredictable Past," 377.

17. Nikolayev, interview.

18. Tishchenko, "Moya konservatoriya," 1:236. See also Gakkel', "Iz pyatidesyatïkh godov," 2:103.

19. Slonimsky, *Perfect Pitch,* 263.

20. GNAS: 14–15.

21. SG: 21.

Certain figures were able to bridge the divide Schnittke and Gubaidulina described, foremost among them the few sympathetic professors who played an invaluable role in unofficially providing the more curious students at the conservatories with access to "dangerous" Western works. One of the foremost of these was Vissarion Shebalin (1902–63), a composer who had lost his position in the aftermath of the 1948 resolution on music, but returned to teach in the fall of 1951. One of his students was Karetnikov, who tells of an incident that illustrates both the paranoia of the Moscow Conservatory in the early 1950s and the role played by liberal instructors like Shebalin. In Karetnikov's account, in the spring of 1952 one of Shebalin's composition students, Mikhaíl Marutayev, wrote a scherzo that drew controversy from the conservatory authorities because it included the repeated interval of a minor seventh.[22] A month after the initial scandal had passed, an official commission from the Union of Composers was set up at the conservatory to investigate Shebalin. One by one they summoned his students for questioning, among them Karetnikov. The inquiry began:

—So…you study with Shebalin?
—Yes.
—And how does Shebalin run the class?
—He takes and corrects our compositions, presenting and analyzing the works
of various composers.
—And you don't happen to remember which composers?
—Glinka, Chaikovsky, Borodin, Musorgsky.…And feeling that the list was
overly pure and seemingly premeditated I added, accenting the name a
little—and recently we were shown Debussy…
—And what did you think of him?
—Nothing really.…Nothing in particular.…That is.…There are some useful
devices.…[23]

In the end, despite the interrogation of Shebalin's students, the incident ended with no expulsions. Marutayev received an "academic leave," instead.[24] Shebalin remained in his position, because, in the end, no one was willing to

22. For some reason, Karetnikov does not name the author of the scherzo. Marutayev freely admits to it, and among conservatory graduates of a certain age the author was widely known. This was not Marutayev's sole clash with authorities; he later was held to task for his equally innocuous First String Quartet. Marutayev, interview. His scherzo was also criticized in a 1952 article in *Sovetskaya muzïka*. See Barsova, Golovinskiy, and Roytershteyn, "Kompozitorskaya molodyozh' Moskovskoy konservatorii," 27. The *Scherzo* was published in 1962. See Marutayev, *Skertso* (the score gives 1950 as the date of composition).

23. Karetnikov, *Gotovnost' k bïtiyu*, 22.

24. Marutayev, interview.

inform on him. Karetnikov attributes the students' support to the fact that "We all really liked Shebalin, because after all he showed us Mahler and Stravinsky."[25] Schnittke remembered that he went even further than that and showed his students scores by Schoenberg, Webern, Berg, and Hindemith: "Actually his class was a secret seminar in the study of the newest music."[26] According to Gubaidulina, Shebalin even played Boulez's *Le Marteau sans maître* for his students in 1956.[27]

Along with the dangers of nonconformity that existed in the years before Stalin's death and extended into the mid-1950s, Karetnikov's anecdote illustrates the degree of solidarity that existed among the students and the more liberal professors. Gubaidulina also singled out Shebalin for praise. She had been unhappy with her studies under Yuriy Shaporin (1887–1966) during her first year at the Moscow Conservatory and came to view Shebalin as a more talented pedagogue, although she studied formally under Nikolai Peyko (1916–95) during her undergraduate years (1954–59), and with the then-ailing Shebalin only for her graduate work (he died shortly before she completed her degree).[28] Denisov concurred with her estimation of Shebalin: "It mattered little that not all of his advice turned out to be correct, but rather that it was always exceptionally well-intentioned, with a completely serious attitude toward his pupils. There was no kind of patronizing or derision. Besides, he frequently played in class the type of music that ordinarily couldn't be heard anywhere else. For example, even Prokofiev and Shostakovich, whose music was practically banned at the time."[29] This gives some idea of the distance these students, raised on a diet of Chaikovsky and Rachmaninoff, would have to travel in the next decade.[30] Beginning at a time when even the elder statesmen of Soviet music—Shostakovich, Prokofiev, Myaskovsky, Khachaturyan—were off limits thanks to the 1948 resolution on music, they would have still larger deficits to fulfill when it came to the music of the contemporary Western avant-garde.

Among his instructors at the Leningrad Conservatory in the 1950s, Slonimsky singled out his composition professor Orest Yevlakhov (1912–73),

25. Karetnikov, *Gotovnost' k bïtiyu,* 23 (see also 14–16).

26. Talochkin and Alpatova, eds., *"Drugoye iskusstvo,"* I:303.

27. See SG: 18. At this time Shebalin did not have a copy of the score to *Le Marteau,* only a recording; in March 1959 Shostakovich gave it to him as a birthday present. See Fay, *Shostakovich: A Life,* 215.

28. SG: 17–18. See also Kurtz, *Sofia Gubaidulina,* 37–40, 46–47, and 51. Gubaidulina also remembered attending Friday evening gatherings at Shebalin's home, accompanied by her then-professor Nikolai Peyko. Ibid., 43–44.

29. PED: 42. See also Kholopov and Tsenova, *Edison Denisov,* 11–12; Denisov and Nikolayev, "Tonchaishiy muzïkant, zamechatel'nïy pedagog (o V. Ya. Shebaline)," 56–58; and Denisov, "Shebalin-uchitel'."

30. Volkonskiy, interview, 21 October 1999.

a Shostakovich student, for teaching his students the word "freshness" ("svezhest'") as a critical criterion.[31] Slonimsky later underscored this idea—"fresh music"—as a "password" among "progressive musicians" during the Thaw.[32] (Other Thaw "passwords" included "youth," "modern" ["sovremennaya"], and even, as we shall see, "Krenek.") Slonimsky also recalled his professor of score reading, Izraíl' Finkel'shteyn, who gave him scores by Mahler and Strauss, Anatoliy Dmitriyev (1908–78), who "was always drawn to new, contemporary music" and who "read the first lectures at the Leningrad Union of Composers on Berg's *Wozzeck* and Stravinsky's *The Rake's Progress*"; as well as the "modernist" Mikhaíl Druskin (b. 1905–?), reportedly the "most 'left' of the musicologists" at the conservatory ("left" was used frequently by my informants to indicate aesthetic open-mindedness or avant-garde or unofficial tendencies; it does not mean "leftist" in a political sense).[33]

The Tallinn and Kiev conservatories also had relatively progressive instructors who encouraged the experiments of their students, if not without occasional reservations. Pärt fondly recalled his open-minded professor of composition at the Tallinn Conservatory, Heino Eller (1887–1970), a Glazunov pupil, whose students also included Eduard Tubin and Jaan Rääts.[34] In Kiev, the composer Boris Lyatoshinsky (1895–1968) was the indispensable mentor. Lyatoshinsky, a student of Reinhold Glière, taught at the Kiev Conservatory from 1920 until the 1960s (he also taught at the Moscow Conservatory beginning in 1935, though he was mainly associated with the institution in Kiev). Although he was not, and could not be, as lenient as Shebalin, he still went beyond the activities of his more pedantic colleagues. In his orchestration classes he would supplement the traditional fare of Rachmaninoff, Beethoven sonatas, Chaikovsky, and Rimsky-Korsakov by bringing in scores from his personal library that included the still-dangerous works of Wagner and Scriabin, including *Tristan und Isolde* and the *Poem of Ecstasy* (this in the late 1950s!).[35] On at least one occasion Lyatoshinsky also officially defended one of his pupils, Leonid Hrabovsky. He wrote a note on Hrabovsky's behalf attached to a letter the "young composer" sent to the Secretariat of the Union of Composers of the USSR following his 11 February 1963 dismissal from his post at the Kiev Conservatory for, in Lyatoshinsky's words, "his dodecaphonic experiments" (the official pretense for the action was Hrabovsky's refusal of a

31. Slonimskiy, "Iz vospominaniy," 1:205 (this whole essay is an appreciation of Yevlakhov). For more of Slonimsky's memories of Yevlakhov see also Slonimskiy, *Burleski, elegii, difirambï*, 91–92, 97, and 112–13.

32. Slonimskiy, "Zapretit' zapretï!" 91; Schmelz, "After Prokofiev," 503.

33. Slonimskiy, *Burleski, elegii, difirambï*, 117–19. For more on the Leningrad Conservatory in the 1950s, see Gakkel', "Iz pyatidesyatïkh godov."

34. Hillier, *Arvo Pärt*, 28; and Bradshaw, "Arvo Paart," 25.

35. Hrabovsky, e-mail to author, 13 January 2000.

new teaching position at a musical preparatory school ["uchilishche"]—effectively a demotion). Lyatoshinsky's letter fell on deaf ears and Hrabovsky did not return to the conservatory again until 1966.[36]

Although publicly supportive of his students, in private Lyatoshinsky did not always look positively on their experiments. Valentin Silvestrov remembers the "question that ... Lyatoshinsky gave me regarding one of my radical works from the beginning of the 1960s: 'Do you like this?' " Silvestrov answered in the affirmative, "but the question of the wise old man, the same question my opponent might raise—only aggressively!—that question became ingrained in my soul."[37] Lyatoshinsky, although liberal, was approaching composition from a more conservative perspective, and such conservative opinions voiced by respected "wise old men" like Lyatoshinsky and Shebalin exerted a strong influence on the young students, certainly a stronger influence than the generally reactionary opinions of official publications like *Sovetskaya muzïka*.[38] These professors might have been more receptive in their tastes than the official orthodoxy, but they did not accept everything equally. The doubts sown by their professors carried over into the 1960s with these composers, and must be counted among the several factors that provoked their later stylistic shifts, especially their shifts to more mimetic styles.

In addition to contact with tolerant professors, students most frequently gained familiarity with "blacklisted" works through official organizations at the conservatories or through more informal meetings among themselves. These organizations and groups laid the foundation for the unofficial concerts that would blossom in the mid-1960s. One of the student groups at the Moscow Conservatory, called the NSO ("Nauchnoye studencheskoye obshchestvo" or Scholarly—or Scientific—Student Society), was particularly adventurous. Started in 1950, the NSO was led by Denisov from the mid-1950s until 1957 when Valentina Nikolayevna Kholopova took over (now a professor at the Moscow Conservatory, she was its organizer until

36. Letter dated 15 February 1963. RGALI, f. 2077, op. 1, yed. khr. 2174, l. 25 (see also Schmelz, "Listening, Memory, and the Thaw," 9–10). For Hrabovsky's published memories of his teacher see Hrabovsky, "O moyom uchitele," 47–51. Hrabovsky told me that his dismissal (and Igor Blazhkov's removal from his conducting post in Kiev) resulted from an aborted performance of his *Symphonic Frescoes* (*Simfonicheskiye freski*, 1961) planned by Blazhkov in March 1963. In a letter dated 13 November 1962, Nicolas Slonimsky writes of a "young dodecaphonic beatnik who was expelled from the [Kiev] conservatory for the sin of Schoenbergianism," but must have been describing one of Hrabovsky's colleagues. Slonimsky, *Perfect Pitch*, 262.

37. Sil'vestrov and Frumkis, "Sokhranyat' dostoinstvo ...," 12. Another reminiscence of Lyatoshinsky by Silvestrov (in addition to those of Hodzyats'ky, Volodymyr Huba [b. 1938], and other former pupils) appears in "Otmechaya 100-letiye so dnya rozhdeniya B. N. Lyatoshinskogo: Svidetel'stvuyut ucheniki," 23–28.

38. Yekimovsky's interaction with his professor, Aram Khachaturyan, at the Gnesin Institute in the mid-1960s revealed a similar intergenerational tension. See Yekimovskiy, *Avtomonografiya*, 26.

the beginning of the 1960s).[39] Schnittke acknowledged the important role that this organization played for the students of the conservatory, mentioning auditions of Shostakovich's symphonies, Stravinsky's *Rite of Spring* and *Petrushka,* an evening of French chansons, and a 1956 session featuring Boulez's *Le Marteau sans maître* (possibly the event where Shebalin played his recording that Gubaidulina recalled).[40] Kholopova singled out the NSO as the most important meeting place for the young students, a place where they could hear foreign compositions as well as their own works. "We received all of our education there," she said, citing performances of Denisov, Volkonsky, Bartók, Shostakovich, Myaskovsky, Boulez, and Prokofiev.[41] Significantly, an official report from December 1954 noted that "right now the majority of [NSO] meetings take place without any participation by professors or instructors, which undoubtedly has an extremely negative impact on their quality."[42] It was exactly this aspect of the NSO that made it so influential for the student composers: early in its history the group's meetings lacked official oversight. They were literally "outside" official control. Although the December 1954 report presumably changed the situation, the sense that the NSO was somehow set apart persisted. Roman Ledenyov, reminiscing about the NSO, told a later interviewer that "everything was not as terrible ['strashno'] as they now say it was."[43]

Alemdar Karamanov provided a more general sense of the atmosphere at the NSO sessions, as well as at other student gatherings, both formal and informal: "We fought until exhausted and quarreled very seriously.... 'Global' problems of every type were discussed, but there was nothing more important than art for us—it was literally as if the ultimate fate of the world depended on the fate of art and music."[44] As young students, they still held idealistic views of the power of music, fueled no doubt by the pervasive idealism of the Thaw. They had not yet become jaded by the ambiguous and often contradictory demands of socialist realism and the still intransigent Soviet system.

39. Kholopova, *Kompozitor Al'fred Shnitke,* 35 and 37. When the NSO was first being formed, the original title was to be NOS, but as that is the Russian for "nose," the initials were rearranged. Kholopov, interview, 25 October 2000. The NSO was divided into several subgroups by specialization within the conservatory, e.g., NSO for the theory-composition department, NSO for the piano department, etc. This is based upon official plans and reports for the NSO that Kholopov kept in his personal archive, and that he kindly let me examine. See also Keldïsh, *100 let Moskovskoy konservatorii: Kratkiy istoricheskiy ocherk,* 185.

40. GNAS: 14.

41. Kholopova, interview. See also Kholopova, *Kompozitor Al'fred Shnitke,* 35–37.

42. "Otchotnïy doklad o rabote nauchnogo studencheskogo obshchestva Moskovskoy Ordena Lenina Gosudarstvennoy Konservatorii im. P. I. Chaikovskogo," dated in pencil December 1954 (in Yuriy Kholopov's handwriting); the comment cited here is on pp. 4–5. I am grateful to Professor Kholopov for providing me with a copy of this document from his personal archive.

43. Ledenyov, "Mne vsegda khotelos' idti ot emotsiy," 21.

44. Karamanov, "Muzïka—provodnik zvuchashchego mira," 32.

The Leningrad Conservatory had its own equivalent of the NSO called SNO (the same names as the Moscow organization, but in a different order), although it was not quite as adventurous as the Moscow group.[45] As an undergraduate Tishchenko was the leader of this group, and his description of its meetings echoes the energy encountered at the Moscow Conservatory: "There were discussions, arguments, and even fights." Tishchenko also recalled that the meetings were devoted to poetry as well as music, and, in fact, it was at a meeting of this type, a "musical-poetic gathering" arranged by his friend, composer Vladislav Uspensky, that Tishchenko befriended the young Joseph Brodsky in either 1959 or 1960.[46]

Because of the often radical fare of the Moscow Conservatory NSO meetings (usually prudently unlisted in the official NSO plans and reports), there were frequently conflicts between conservatory officials and the student leadership over repertoire. Denisov recalled an incident when he and Nikolai Kopchevsky (a pianist who was a student of Heinrich Neuhaus) performed Shostakovich's Symphony No. 9 in a four-hand arrangement at an NSO meeting in 1954.[47] According to Denisov, the matter was so controversial that it resulted in a rebuke from Alexander Sveshnikov (1890–1980), the rector of the conservatory and also a well-known choral director.[48] Schnittke added to his account of the story (which culminated in a phone call from Boris Yarustovsky [1911–78] of the Central Committee Section on Culture) that following this incident, similar "scandals" followed with works by Stravinsky, Bartók, Schoenberg, and Hindemith.[49] To illustrate the hair-trigger on which the conservatory leadership's sensibilities continued to operate, Denisov even had a vocal piece, *Two Romances on Poems of Robert Burns,* removed from a student concert (possibly sponsored by the NSO) during his time at the conservatory because it began with the line: "Of all the winds that exist, to me the Western is dearer." This supposed reference to the decadent West made the piece off-limits, even though the line continued: "because it carries to you news of my

45. Tishchenko, interview. An NSO also existed at the Gnesin Institute, although from Bittner's evidence it seems unlikely that it had the same effect as the ones at the conservatories in Moscow and Leningrad. See Bittner, *The Many Lives of Khrushchev's Thaw,* 49 (also Bittner, "Exploring Reform: De-Stalinization in Moscow's Arbat District, 1953–1968," 287).

46. Tishchenko, interview.

47. According to the NSO documents in Kholopov's archive, this meeting took place not in 1952 as Denisov told Shul'gin, but at the first of two separate Shostakovich meetings held in "November and December" 1954, the second of which was devoted to the Eighth Symphony. The document ("Plan of Work for the NSO of the Theory-Composition Department"—"Plan raboti NSO teoretiko-kompozitorskogo fakul'teta") is without a date, although Kholopov annotated it as the "1954/55 school year," which corresponds with Denisov's statement to Armengaud that the event took place during his "fourth year" at the conservatory. See PED: 39; and Denisov and Armengaud, *Entretiens avec Denisov,* 52. See also GNAS: 14; and Schmelz, "After Prokofiev," 496–97.

48. PED: 39; and Denisov and Armengaud, *Entretiens avec Denisov,* 52.

49. GNAS: 14.

beloved."[50] Yet by April 1958 a character reference in Denisov's personal file at the Moscow Union of Composers positively cited his leadership of the NSO, "where he worked with great interest and accomplished many useful things."

Although not direct instructors of the unofficial composers, Shostakovich and Prokofiev also exerted a huge influence, as shown by the central role that their symphonies played in the conflicts between conservatory officials and the "young composers" at the NSO sessions. Sofia Gubaidulina put their importance above all others: "For us the names Prokofiev and Shostakovich were our main means of support."[51] To be sure, Shostakovich was a more immediate presence than Prokofiev (who after all had died in 1953—on the same day as Stalin), but his importance for the younger composers stemmed to a large degree from his official standing, namely his chairing of the Russian Union of Composers from its founding in 1960 until 1968 (when his student Georgiy Sviridov took over). Shostakovich's leadership position and the official power that he wielded is all too often either ignored or downplayed in English-language accounts of his life. Yet Shostakovich possessed enough official political power that he was frequently able to use his authority to benefit younger composers. For example, when Silvestrov and Vitaly Hodzyats'ky were expelled from the Ukrainian Union of Composers, one of the first people they turned to for assistance was Shostakovich.[52] Even the jazz saxophonist Aleksey Kozlov cited Shostakovich as a benefactor in his recent autobiography.[53] Shostakovich was instrumental in gaining Denisov admittance to the Moscow Conservatory and also helped Schnittke secure a recording of his conservatory diploma piece *Nagasaki* in 1959.[54] Slonimsky resented Shostakovich for only assisting and protecting his own students, and specifically for not defending him more actively on several occasions.[55] In short, Shostakovich is a figure with whom almost every member of this generation (unofficial or not) had contact, and they all equally felt his loss upon his death in 1975 (even Slonimsky).[56]

50. PED: 59–60. The poem was Burns's "Of a' the Airts." The text given is a retranslation from the Russian; the original reads: "Of a' the airts the wind can blaw / I dearly like the West, / For there the bonie Lassie lives, / The Lassie I lo'e best." See Burns, *The Canongate Burns*, 332.

51. SG: 15–16. For a general introduction to Shostakovich and music after 1953, see McBurney, "Soviet Music after the Death of Stalin: The Legacy of Shostakovich," 120–37. For a consideration of Prokofiev's reception by the younger generation during the Thaw see Schmelz, "After Prokofiev."

52. Sil'vestrov, interview. See also chapter 7.

53. Kozlov, *Kazyol na sakse: I tak vsyu zhizn'*, 194–96.

54. Kholopov and Tsenova, *Edison Denisov*, 9–10; and Ivashkin, *Alfred Schnittke*, 68–69. I discuss *Nagasaki* in my paper "Schnittke and the Bomb," presented at the 2007 Annual Meeting of the American Musicological Society in Québec City.

55. Slonimskiy, interview; Slonimskiy, *Burleski, elegii, difirambï*, 130–31; and Denisov and Slonimskiy in Wilson, *Shostakovich: A Life Remembered*, 343–44 (Denisov) and 429–30 (Slonimskiy; a different version of this material originally appeared in Slonimskiy, *Burleski, elegii, difirambï*, 138–39 and 133–34).

56. Slonimskiy, *Burleski, elegii, difirambï*, 135.

The peril was that older figures like Shostakovich and Prokofiev were often too influential. Many of the pieces written by the younger composers in their conservatory years were imitations of these composers' styles. Denisov felt this especially strongly, so much so that although he carried out an active correspondence with Shostakovich in the 1950s and wrote a Piano Trio dedicated to him in 1954 and a piece titled *D-S-C-H* (after Shostakovich's musical monogram) in 1969, he responded later in his life with some very critical words about Shostakovich as both individual and composer, denying his influence entirely.[57] At this time, Denisov also turned with special vehemence against Prokofiev.[58] Schnittke, too, felt the influence of Shostakovich, but did not exhibit the same defensiveness as Denisov, later admitting his reliance on a similar type of musical dramaturgy (he also wrote an approving essay about Prokofiev in 1990).[59] Volkonsky initially viewed Shostakovich and his music with suspicion because of all his "public work" ("obshchestvennaya deyatel'nost'"), but after a performance of the Viola Sonata by Richter and Bashmet in Florence, he reevaluated the music.[60] The "young composers" could not avoid these powerful musical personalities, and though they benefited both from their example and at least Shostakovich's frequent interventions, they came to resent their overwhelming personal styles. The reactions of "sons against fathers" must then be counted among the multitude of factors that drove the unofficial composers to their technical and stylistic experimentation in the 1960s, reminiscent of the original *shestidesyatniki* that Turgenev had described in his famous novel a century before. Bittner discusses the anxiety that both academic administrators and government officials felt throughout the 1950s and early 1960s about just such a generational conflict, alternately denying or attempting to forestall it. Such fears of "sons against fathers" pervaded official reactions against contemporary youth culture throughout the Thaw.[61]

THE SECOND CONSERVATORY

No matter how permissive individual instructors may have been, the musical institutions of the Soviet Union themselves were as conservative as official institutions must be in a society with totalitarian aspirations. Students may have been encouraged to experiment on their own, but they were unable to

57. See Schmelz, "What Was 'Shostakovich,' and What Came Next?" 305–10.

58. See Schmelz, "After Prokofiev."

59. GNAS: 27–28; Schmelz, "What Was 'Shostakovich,' and What Came Next?" 316 and 319–28; Shnitke, "Krugi vliyaniya"; Shnitke, "On Prokofiev (1990)," 65; and Schmelz, "After Prokofiev."

60. NVV: 111–12.

61. See Bittner, *The Many Lives of Khrushchev's Thaw*, 43–46 (also Bittner, "Exploring Reform: De-Stalinization in Moscow's Arbat District, 1953–1968," 273–79).

submit their experimental works for official examinations or to fulfill institutional requirements. The penalties for nonconformity were often quite high, as demonstrated by the dangerous "sevenths" in Marutayev's scherzo or the scandal over Denisov's performance of Shostakovich at the NSO meeting. As we shall see in chapter 3, Volkonsky's case represented an extreme, as he was actually expelled for his extravagances.

Musical taste did slowly broaden. As early as 1956, the journalist Grigoriy Shneyerson commented in *Sovetskaya muzïka* on the gradual acceptance of musical "impressionists."[62] After the May 1958 declaration that revoked the 1948 resolution, a broader range of works by Soviet composers became available. This restoration of the musical past was the true beginning of the Thaw in music, as it also allowed more pieces by a wider range of domestic and foreign composers to be heard, even if the Darmstadt and Second Viennese circles were still largely off-limits, at least officially. Rodion Shchedrin described the situation in a speech he delivered at the plenary congress of the Union of Composers in 1963: "In the last years great changes have taken place in our musical life. After the Party Resolution of 1958 ... such figures as Hindemith, Bartók, Stravinsky, Britten, Honegger, Poulenc, Milhaud, Orff, and others not only entered the horizon of our composers but became the object of creative absorption. All this contributed to the enrichment of the musical language of our young composers." In his next sentence, of course, he was quick to caution his colleagues not to be in too much of a hurry to follow these composers' leads.[63] However these cautionary words were really unnecessary, for these were not the figures in whom his colleagues were primarily interested. Their eyes and ears were eager for names still absent from Shchedrin's list (nor indeed did Shchedrin remain immune to their attraction).

The study begun by the "young composers" in their conservatory years continued into the 1960s, after most of them had officially graduated and, like Denisov, Schnittke, and Hrabovsky, had even been hired to teach at their alma maters.[64] The intense musical debates and interaction among these former students spilled into the following decade. Denisov aptly described the 1960s as his "second conservatory," the time that he studied on his own what had been kept from the conservatory curriculum.[65]

By this point, all of the "young composers" realized that they had been denied important aspects of their musical education. Schnittke actually vented his anger publicly in the October 1961 *Sovetskaya muzïka* in a letter to the

62. Shneyerson, "O nekotorïkh yavleniyakh zarubezhnoy muzïki," 120–25.

63. Shchedrin, "Tvorit' dlya naroda vo imya kommunizma," 18, cited in Schwarz, *Music and Musical Life in Soviet Russia*, 421.

64. Kholopov and Tsenova, *Edison Denisov*, 36–40; and Ivashkin, *Alfred Schnittke*, 86–87.

65. PED: 22.

editor titled "Develop the Study of Harmony" that he began by declaring the insufficiency of his conservatory training.[66] Schnittke complained that most of the composers of the twentieth century possessed more rigorous, advanced theoretical skills than those imparted to students at the conservatory. Orff, Hindemith, Messiaen, and Bartók were all composers that he regarded as worth looking into further and for which task the basic I-V-IV harmonic training taught at the conservatory proved poor equipment. Schnittke ended with a battle cry that helps to explain the constantly changing work of the unofficial composers until the late 1960s: "Music will not wait—it is moving forward in seven league boots and brings forth new artistic discoveries every year. It is up to you comrade theorists!"[67] It was this simultaneous game of catching up to and overtaking the West (similar to Khrushchev's own policy pronouncements)—encapsulated by a near constant emphasis on being "modern" (as opposed to an official emphasis on being properly "contemporary")—that drove the study and practice of the unofficial composers in the 1960s. Denisov and Schnittke were not alone; many of the unofficial composers acknowledged their own informal study of Western avant-garde scores by Boulez, Xenakis, Ligeti, Pousseur, Stockhausen, Bartók, Webern, Berg, and Schoenberg.[68] The works of the leading European modernists, the scores of Schoenberg and other composers of serial music, continued to be officially condemned and their access restricted into the 1960s, but, like outlawed literature, they were available through a variety of other channels, from official Soviet sources to visiting foreign musicians and composers.

Most of the sources for advanced (and even not so advanced) Western music were foreign, nonetheless some information about Western "bourgeois" modernists was also incidentally available in official domestic publications. Sometimes the government's propaganda efforts backfired. The primary example of this is Shneyerson's *On Music Living and Dead*, which ranted against the "dead" music of the Western avant-garde. Here is a typical section on Schoenberg:

> Schoenberg's role in the history of music was extremely negative. He succeeded in confusing and destroying much in musical art, but he did not succeed in creating anything....Dodecaphony as a system was already fully compromised in the early 1930's. The aura of "great innovator" surrounding Schoenberg's name has long since paled and withered. Obviously, life did not confirm the truth of his teaching....Schoenberg contributed much to the decadent schools of composition disguised as "Avant-Garde." Such manifestations as

66. Shnitke, "Razvivat' nauku o garmonii," 44–45. For more on the debates within Soviet music about "contemporaneity" and "modernity" sparked by this essay, see Schmelz, "After Prokofiev," 509.

67. Shnitke, "Razvivat' nauku o garmonii," 45.

68. See Ivashkin, *Alfred Schnittke*, 62 and 85; and Kholopov and Tsenova, *Edison Denisov*, 14.

dodecaphony, abstract painting, and existentialist philosophy are natural and unavoidable results of bourgeois decadence and its reactionary ideology.[69]

This book, it should be noted, did not represent Shneyerson's own views. Shneyerson was a music journalist by trade who often simply translated fundamental statements from Western sources without verifying their accuracy or hearing the music under discussion before couching them in the requisite official Soviet aesthetic terminology.[70] This hardly mattered, for the copious examples in the book were more important then Shneyerson's hackneyed prose (these examples were much more numerous in the 1964 edition, reflecting the general loosening of restraints). Richard Taruskin writes, "This little book with a press run of under 6,000 went from hand to hand until virtually the whole Soviet musical elite had copied out and all but memorized the morsels of forbidden fruit that it contained."[71] Or, as Tishchenko put it, "in that book [Shneyerson] provided all the recipes for avant-garde music." Nearly all of the composers I interviewed confirmed its importance, including Viktor Yekimovsky, Eduard Artem'yev, Vladimir Martïnov, and Tishchenko.[72]

Sovetskaya muzïka proved to be another, albeit infrequent and inaccurate, source for information on the ways and means of avant-garde compositional techniques, foremost among them those of serial composition. One of the earliest examples came in the November 1958 issue, which contained an important although little-mentioned article by the conservative East German composer and musicologist Johannes Paul Thilman (1906–73) called "On the Dodecaphonic Method of Composition."[73] This article, like Shneyerson's *On Music Living and Dead*, was intended to point out the weaknesses of Schoenberg's system. Unfortunately, its professed "scientific" methodical tone only ended up playing into the hands of the "enemy." In its very thoroughness, Thilman's clinical analysis of the "disease" (as the Soviet editor dubbed the method) ended up resembling a primer on composing twelve-tone music, and contained helpful hints about how to write it, including several samples of twelve-tone rows and a brief précis of the main rules for constructing them, including: "1. Every note may be repeated only after the remaining 11 are heard"; and "2. The same intervals should not be frequently repeated in the row, because it will lead to monotony."[74]

69. Shneyerson, *O muzïke, zhivoy i myortvoy,* 276–78 (1964 ed.) (this quotation is slightly altered from the 1960 edition, pp. 176–77); quoted in Schwarz, "Arnold Schoenberg in Soviet Russia," 92.

70. PED: 65.

71. Taruskin, review of Peter D. Roberts, *Modernism in Russian Piano Music: Skriabin, Prokofiev, and Their Russian Contemporaries,* 865. The actual print run of the 1960 edition was 3,545; the 1964 edition's was 5,780.

72. Artem'yev, interview; and Yekimovskiy, Martïnov, and Tishchenko, interviews.

73. Til'man, "O dodekafonnom metode kompozitsii," 119–26.

74. Ibid., 124.

More significantly for later Soviet serial practice, Thilman even went so far as to include several "manipulations" that could be applied to the fundamental row, including "rotation" ("vrashcheniye")—"Every row may be divided into groups of three, four, five, six... notes; every one of the groups may be viewed as a type of goal and every one may be 'rotated,' that is 'rotated around itself,'" "Interpolation" ("vklyucheniye")—"Other notes may be inserted into any interval [in the row], so long as the rule forbidding repetition [of intervals] is not violated," and "substitution" ("zamena")—"The succession of notes in the row may be changed with the aid of 'substitutions,' which occur necessarily in polyphonic compositions when several lines are simultaneously realized, resulting in the repetition or simultaneous sounding of the same pitch."[75] These rules diverge markedly from Schoenberg's own twelve-tone principles, and show the possible influence of serial theorists like Ernst Krenek.[76] Interestingly, they seem to be the only rules from Thilman's article that some of the young Soviets obeyed in their later serial experiments.

Thilman's overall evaluation of twelve-tone music is itself notable. He waxes more philosophical than most Soviet commentators, quoting Adorno and Huxley among others on the isolation, fear, and inherent negativity at the root of all modern aesthetics (and specifically twelve-tone music), yet Thilman does not view Schoenberg's system as inherently evil. For Thilman the problem lies not with the method but in its realization. At the close of the article he writes of the "sharp divide between the large demands made on the intellect by the observance of such a strictly organized method of composition, and the marks of unbridled barbarity in the piece that results from the application of the method." Furthermore, the system with its "exceptionally strict rules... might be, perhaps, helpful for school exercises, if it did not have such a dogmatic character."[77] Such concessions about the twelve-tone system were notably different from the Soviet cultural line that categorically opposed it. They do reveal a great deal, however, about the possible intellectual and emotional motivations for writing serial music in the Soviet Union. As both the unofficial composers and their audiences

75. Ibid., 125.

76. Krenek applied rotations in his *Lamentations of Jeremiah* (Lamentatio Jeremiae Prophetae: Secundum Breviarium Sacrosanctae Ecclesiae Romanae), Op. 93 (1941–42), first published in a facsimile edition in the United States in 1942 (the first printed edition appeared only in 1957 in Germany). Krenek described the work's rotations in the introduction to the 1957 edition of the score (it is not in the original American publication) as well as in his "Extents and Limits of Serial Techniques," esp. 74–78. (Krenek did not discuss serial rotations in his 1940 textbook, *Studies in Counterpoint*.) Jelinek's explanation of rotation in his 1958 text is more similar to Thilman's, as is Eimert's in his 1964 *Grundlagen der musikalischen Reihentechnik*. See Jelinek, *Anleitung zur Zwölftonkomposition*, esp. II:175–78 ("die Rotation") and chapter 20, "Die Interpolation" (pp. 179–88); and Eimert, *Grundlagen der musikalischen Reihentechnik*, 136–37.

77. Til'man, "O dodekafonnom metode kompozitsii," 126.

soon discovered, serial music could be both mentally engaging and viscerally expressive. And despite its "dogmatic character," the system proved pedagogically useful for these composers, as Thilman unwittingly predicted. Their first works were essentially substitutions for school exercises they were never assigned.

The Austrian composer Marcel Rubin's detailed article on "Webern and His Followers" in the April 1959 *Sovetskaya muzïka* went beyond Thilman's introduction to the twelve-tone system by tutoring his readers in the theory and practice of total serialism and aleatory music. Rubin (1905–95) took Webern to task for the ills of serialism, both past and present. Schoenberg and Berg were treated with leniency because of their strong, continued connections to the tonal tradition. In contrast, once Webern started down the serial "path," Rubin declared, "he followed [it] without looking back, [and] his music no longer expressed any kinds of feelings or ideas, but became only a product of calculation; or, more precisely, his music already ceased being music."[78] Such boilerplate criticism was unexceptional, aside from the target shifting now from Schoenberg to Webern. More important, as part of Rubin's indictment, after cautioning "student theoreticians" about the ills of placing theory before practice, he provided rows for Berg's Violin Concerto, Webern's Op. 21 Symphony (including its opening and final measures), and Boulez's *Structures Ia*.[79] As Rubin traced the "road leading from dodecaphonic music to serialism and from serialism to aleatory music" he discussed musical pointillism, *Klangfarbenmelodie*, electronic music, and chance composition, as well as several details of the "Procrustian" twelve-tone system, including the by now familiar four basic forms of the series.[80] Significantly, Rubin also introduced his readers to the contemporary descendents of Webern and their serialization of parameters beyond pitch (duration, dynamics, attack, timbre, etc.), among them Olivier Messiaen (*Mode de valeurs et d'intensités*), Boulez (*Structures Ia*), Stockhausen (*Zeitmasze*), and Krenek (*Sestina* and his article "Extents and Limits of Serial Techniques"). He concluded with digs at the "chaos" produced by Stockhausen's *Klavierstück XI* and John Cage's chance methods. Possibly guided by Rubin's brief survey—one of the few introductions to the topic available in the USSR—a number of the young Soviets later began applying total serial procedures before turning, like Rubin's narrative, to aleatory devices. (Shneyerson also surveyed this ground in his *On Music Living and Dead*, including a discussion of Boulez's *Structures Ia* in both editions and a

78. Rubin, "Vebern i yego posledovateli," 177. This was the second article by Rubin to appear in *Sovetskaya muzïka*. The first was Rubin, "Yest' li budushcheye u atonal'noy muzïke?" 142–46; the third, Rubin, "O muzïkal'nom i nemuzïkal'nom," 182–84.

79. Rubin, "Vebern i yego posledovateli," 179.

80. Ibid., 184.

reproduction of a page from Cage's *Concert for Piano and Orchestra: Solo for Piano* in the 1964 edition.[81])

In addition to these official domestic sources, the largest amount of information on Western modernist composers came from the influx of foreign scores and recordings—some of it legal, some not, most of it borderline—that began in the late 1950s. In the 1950s, Volkonsky's foreign relatives were a source, and in the 1960s Denisov also made valuable foreign connections. Often scores were sent to Soviet composers by leading Western composers such as Stockhausen, Nono, Ligeti, and Pousseur, but many were hand-delivered by Soviet musicians, who traveled abroad more frequently in the 1960s.[82] The theorist Yuriy Kholopov ordered scores by Webern (Variations, Op. 27), Stravinsky (*Canticum Sacrum*), and Schoenberg (*Suite*, Op. 25) from West Berlin, and bought Hindemith scores (including the piano score to *Mathis der Maler*) from the Leipzig office of Schott when he was stationed in Zossen, East Germany, in the Russian army (as a military band arranger) from 1955 to 1958. According to Kholopov, "They nearly arrested me when they found out about it."[83] By contrast, when Schnittke resided with his family in Vienna for two years (1946–48) immediately after World War II (his father worked as a translator for the short-lived Soviet run paper *Österreichische Zeitung*), his attention was focused more on Beethoven, Bruckner, Mozart, and Schubert, than on modern music.[84]

By the 1960s the floodgates had opened. The pianist Aleksey Lyubimov returned with all of Webern's scores when he went abroad for an international competition in the early 1960s.[85] Sergey Slonimsky received scores and recordings from his uncle, Nicolas Slonimsky, during his U.S. State Department Office of Cultural Exchange-sponsored Soviet visit in 1962 (Slonimsky

81. Shneyerson, *O muzïke zhivoy i myortvoy*, 333 and 343 (1964 ed.). He discussed these same works in the later Shneyerson, "Serializm i aleatorika—'tozhdestvo protivopolozhnostey,'" 106–17. Mazel' provided but a capsule definition of "total serialism" in his 1965 "O putyakh razvitiya yazïka sovremennoy muzïki: Dodekafoniya i pozdneyshiye avangardistskiye techeniya," 10. Denisov spoke generally, disparagingly, and somewhat hypocritically of it in his 1969 "Dodekafoniya i problemï sovremennoy kompozitorskoy tekhnii," 503–5. Jelinek only briefly discussed rhythmic and dynamic rows in his *Einleitung zur zwölftonkomposition*, II:225–30. Neither Eimert or Krenek discuss it in their respective twelve-tone composition manuals. See Eimert, *Lehrbuch der Zwölftontechnik;* and Krenek, *Studies in Counterpoint Based on the Twelve-Tone Technique*. Eimert, however, does consider it in his 1964 *Grundlagen der musikalischen Reihentechnik*, but this is hardly a practical introduction to the subject. Other more relevant serial sources were Ligeti's article on Boulez's *Structures Ia* and Stockhausen's *Texte, i*. See Savenko, "Poslevoyennïy muzïkal'nïy avangard," 414 and 416.

82. Ivashkin, *Alfred Schnittke*, 85. Nono also sent scores to Volkonsky (see later in this chapter). See Pekarskiy, "Pravdivaya istoriya," 61. On Schnittke's correspondence with Pousseur, see Kholopova, *Kompozitor Al'fred Shnitke*, 92.

83. Kholopov, interviews, 1 and 8 November 2000.

84. BAS: 29–30.

85. Lyubimov, interview; and Davïdova, interview, 14 September 1999.

had been instructed "to distribute these [American] materials to the proper institutions in the USSR").[86] The younger Slonimsky also purchased scores by Webern and Stravinsky, including *Canticum sacrum*, when he attended the Warsaw Autumn Festival in 1962.[87] In Leningrad, there was an individual named Vladimir Smirnov, who was "married to a French woman. She brought him everything. He was a passionate *philophonist*, collector of LPs—a real collector."[88] As Tishchenko recalled, Smirnov lent records such as Boulez's *Le Marteau sans maître* to composers in Leningrad to be copied onto reel-to-reel cassettes, which had only recently become available.[89] The pianist Mariya Yudina (1899–1970), a leading Soviet performer of new music (both European and domestic), also had contact with several prominent European composers, including Stockhausen, Nono, Stravinsky, and Pierre Souvtchinsky, who sent her scores by the European avant-garde.[90] The conductor Igor Blazhkov (b. 1936) had a source in Honolulu, Hawaii who sent him books and recordings on reel-to-reel tape or LP. This Honolulu connection allowed the Kiev composers to acquire Robert Craft's 1957 Webern recordings, as well as recordings of pieces by Schoenberg and Berg.[91] Blazhkov also maintained contacts with Stravinsky, Boulez, Krenek, Messiaen, and Lutosławski, aided in this by his correspondence and friendship with Yudina.[92]

Foreign students were another source of scores and recordings. According to his biographers, Denisov was first shown music from the Second Viennese School by his roommate in the conservatory dormitory, the French pianist Gerard Frémy.[93] The pianist Boris Berman also recalled that at the very end of the 1960s and early 1970s, American students at the Moscow Conservatory would bring him scores and recordings: "I remember Richard [Taruskin] brought LPs [as did another American history student]. He, being

86. Slonimskiy, interview. For more details on this visit, see Slonimskiy, *Burleski, elegii, difirambï*, 136–38; and Nicolas Slonimsky, *Perfect Pitch*, 213–18 and 260–63.

87. Slonimskiy, interview.

88. Tishchenko, interview.

89. Ibid. For more on reel-to-reel recorders in the Soviet 1960s, see Yurchak, *Everything Was Forever, until It Was No More*, 185–87.

90. See Bretanitskaya, ed., *Pyotr Suvchinskiy i yego vremya*, 326 (the entire correspondence between Yudina and Souvtchinsky is reproduced on pp. 321–83). Correspondence between Yudina and Souvtchinsky (as well as Stockhausen, Stuckenschmidt, and Adorno, among others), also appears in Yudina, *Mariya Yudina: Luchi bozhestvennoy lyubvi*, 466–75.

91. Hrabovsky, e-mail to author, 13 December 1999.

92. Ibid. For Yudina's letters to Blazhkov see Yudina, *Mariya Yudina: Luchi bozhestvennoy lyubvi*, 475–80. She also mentions Blazhkov in her letters to Pierre Souvtchinsky. See Bretanitskaya, *Pyotr Suvchinskiy i yego vremya*, 321–83, esp. 354 and 379.

93. Kholopov and Tsenova, *Edison Denisov*, 21 (Russian), 14 (1995 English ed.); and Bradshaw, "The Music of Edison Denisov," 3. Frémy was in Moscow from 1956 to 1959, studying with Heinrich Neuhaus, and maintains a career as a performer of contemporary piano music. See liner notes to Frémy, *John Cage: Sonatas and Interludes for Prepared Piano*.

an American, had access to the U.S. Embassy, and they had some records of American music to distribute and of course they didn't have an opportunity to distribute [them]. He basically was lifting all this stuff and bringing it to me. I got some good recordings of Foss, Carter, [and] Ives this way."[94] The young Soviets were the unintended beneficiaries of American cold war propaganda, although they were more concerned with the novelty of the musical techniques and styles they were hearing than with the intended ideological message behind these gifts.

Another important source of new techniques came from closer to home, namely the music of the Polish avant-gardists and the Warsaw Autumn Festival. Pieces by Lutosławski, Penderecki, and Górecki were more readily purchased in both Russia and Ukraine than were works by Western composers. Put simply, the Polish composers were permissible because they were communists. But the availability of their music applied more to scores than to recordings; Polish scores could be purchased at state stores while Western scores could not, but as a rule recordings were somewhat harder to obtain.[95] Apparently, the Poles took an active part in disseminating their music to the East, for Hrabovsky remembered that "starting in 1964, Polish authorities regularly sent me the scores and recordings of the Warsaw Autumn music, and I subscribed to the journal *Ruch muzychny*."[96] Karamanov recalled familiarizing himself with the music of the Polish school: "I sat over the scores in the library and at home for almost entire days, not tearing myself away. With the help of friends I tried to reproduce something at the piano, and played that something dozens of times in a row, so that the man on duty at the dormitory threatened to call the police."[97] The Polish composers became so influential that they gave rise to a new verb in the conservatory, as many students behaved like Karamanov and "Pendereckied" ("penderechit'"), or aped Penderecki's style.[98]

The Warsaw Autumn Festival itself, founded as a biennial event in 1956 and then held as an annual event from 1958 onwards, was to be an important

94. Berman, interview, 23 March 2001.

95. Yekimovskiy and Artem'yev, interviews. In Cynthia Bylander's dissertation she cites the difficulties that foreigners had in obtaining recordings of Polish music, but most of these difficulties faced Western Europeans. She does mention one Anosov, the musical director of the State Symphony in Moscow who claimed to have problems in getting Polish scores in Moscow, but this statement is from 1956. Judging from informants, by the end of the 1960s this was no longer an issue. See Bylander, "The Warsaw Autumn International Festival of Contemporary Music 1956–1961," 186 and 215. Adrian Thomas echoes these concerns and notes that "dissemination of these scores and recordings was very limited outside Poland," but again, according to my informants this is not entirely correct. Thomas, *Polish Music since Szymanowski*, 160.

96. Hrabovsky, e-mail to author, 10 March 2000.

97. Karamanov, "Muzïka—provodnik zvuchashchego mira," 32.

98. Ibid. This is the interviewer's word: "It seems to me that that was called 'to Penderecki'" ("Kazhetsya, eto nazïvalos' 'penderechit''").

sounding board for the leading unofficial composers, particularly Denisov and Schnittke. The rather anodyne "reasons for establishing the festival," as Cynthia Bylander explains, were to "acquaint Polish citizens with the music of the twentieth century and to help in the dissemination of Polish music internationally."[99] Little could the organizers have suspected that they were also acquainting certain curious Soviet citizens with the music of the twentieth century. Gubaidulina recounts the importance of the festival for her generation, describing how Soviets who attended would return to Moscow with "not only their impressions, but also records, tape recordings, scores, and books. We shared all of those riches with one another. And in these sessions of collectively hearing contemporary Western music what were perhaps our most important musical contacts arose. Sympathy and interest in the work of one another and even friendship grew."[100]

Soviet composers were frequently prevented from traveling to the festival, as Denisov was on numerous occasions, but, as Gubaidulina remembered, when allowed to attend they were able to expand their own horizons and act as messengers for their compatriots back home. The materials they brought with them contradicted official Soviet propaganda, and led to many aesthetic (and not only aesthetic) epiphanies. When asked by one interviewer "What definitively convinced you to leave the path of compromise" with Soviet officials, Schnittke acknowledged the "large number of recordings" that Denisov brought back from the Warsaw Autumn Festival in September of 1962 (he and Slonimsky were the first "young composers" to attend).[101] In Schnittke's words, these recordings "opened the eyes of many composers, including myself, to everything that was concealed by the curtain of official falsehood. It turned out that all the horrific stories about the 'monstrous hooligans' practicing there appeared to be deliberate lies, to put it mildly. From that moment we all became especially interested in everything being written over there."[102] Denisov's influence also extended in the other direction, for he was certainly a crucial figure in bringing Soviet unofficial music to Western audiences. Of all the unofficial Soviet composers represented at the Warsaw Autumn Festival from 1956 to 1974, Denisov had the largest number of performances, featured no less than six times (Schnittke, Pärt, Hrabovsky, Gubaidulina, and Sergey Slonimsky also received at least one performance during this

99. Bylander, "The Warsaw Autumn International Festival of Contemporary Music," 498. See also Thomas, *Polish Music since Szymanowski*, 83–91.

100. SG: 25.

101. This date is taken from Denisov's personal file at the Moscow Union of Composers. He had already attended the Prague Spring Festival in May 1961. See also Slonimskiy, *Burleski, elegii, i difirambï*, 23–25; and Slonimskiy, interview. Slonimsky again attended in 1969 for a performance of his *Concerto Buffo* (*Kontsert buff*); see his review of the festival: Slonimskiy, "Varshavskaya osen'-69," 125–27.

102. GNAS: 18.

period).[103] Yet the first time that Denisov attended the festival was not by offi-
cial invitation but as a tourist member of the Union of Composers, an honor
that required him to pay for the trip out of his own pocket.[104] More frequently
than not, he was prevented from attending the foreign festivals (and not only
in Poland) where his works were actually to be performed. The next time
Denisov would attend the Warsaw Autumn Festival would be six years later,
in 1968, although he was also permitted to visit the following year as well.[105]
(The same situation applied to Schnittke, who was first allowed to travel to a
foreign festival only in 1967 when they performed his *Dialogue* for cello and
seven performers in Warsaw.[106])

Domestic exchanges between students in the Soviet musical centers also
facilitated the acquisition and study of new scores and new recordings. Par-
ticularly strong ties existed between composers in Kiev and Moscow, and on
several occasions, items from Volkonsky's library were lent to composers in
Kiev. When Hrabovsky's Four Ukrainian Songs were performed in Moscow in
March 1962 (it had won an All-Union Competition) he picked up scores from
Volkonsky that had been requested by Blazhkov. On this visit Hrabovsky also
met Denisov and visited Volkonsky's home, where he heard his first Schoenberg
recording: *Herzgewächse* sung by Bethany Beardslee.[107] (Slonimsky recalled
meeting Hrabovsky on this visit, but Hrabovsky only remembered their meet-
ing in Leningrad the following year. Regardless, both composers spoke fondly
of one another.[108])

There were also frequent exchanges between Moscow and Leningrad.
Slonimsky had studied in Moscow at the Central Musical School from 1945
to 1950 and there met Karetnikov and Ledenyov.[109] Personal as well as offi-
cial business brought him and Tishchenko to Moscow with some regularity.[110]
As a result, Slonimsky received copies of scores by Webern, Stockhausen, and
Boulez, among others, from Denisov and Schnittke in the late 1950s and early
1960s.

103. Schnittke had four performances, and Pärt, Hrabovsky, and Gubaidulina each had one. Sergey
Slonimsky had two, and even Shchedrin, the "official modernist," had only four appearances at the festi-
val (with five pieces performed). Kaczynski and Zborski, *Warszawska Jesien/Warsaw Autumn*. Schwarz
is mistaken when he writes that Volkonsky received a performance there (a mistake picked up unquali-
fied by Lemaire in his history). Schwarz, *Music and Musical Life in Soviet Russia*, 323; and Lemaire, *La
musique du XXe siècle en Russie et dans les anciennes Républiques soviétiques*, 152. This mistake was
confirmed by the current management of the festival. Radziwon, e-mail to author, 19 April 2006.

104. PED: 60; see also Denisov and Pantiyelev, "Ne lyublyu formal'noye iskusstvo," 13.

105. From Denisov's personal file at the Moscow Union of Composers.

106. GNAS: 24.

107. Hrabovsky, e-mails to author, 4 and 5 January 2000.

108. Slonimskiy interview; Hrabovsky, e-mails to author, 4 and 5 January 2000.

109. Slonimskiy, interview; and Slonimskiy, *Burleski, elegii, difirambï*, 74.

110. Slonimskiy, interview; Slonimskiy, *Burleski, elegii, difirambï*, 98, 119, 129–30, 133, and 137
(among others); and Tishchenko, interview.

The connections between Leningrad and Kiev or Kiev and Tallinn were initially not as strong. It was only later, beginning with a 1963 visit to Leningrad, that Hrabovsky became more involved with the musicians in that city.[111] With Blazhkov's own move to Leningrad in the same year (1963) the ties between the two cities naturally strengthened. Tishchenko remembered that Blazhkov brought a "gigantic library" with him from Kiev, and that this library became a source for many Leningrad composers.[112] (Slonimsky also read a lecture on contemporary music at the Kiev Conservatory in 1965, when he met Silvestrov for the first time and renewed his acquaintance with Hrabovsky.[113]) The Kiev composers also met with Arvo Pärt on at least one occasion. As Hrabovsky fondly recalled, "Pärt visited Kiev in January of 1965 when his Symphony No. 1 was performed by Neeme Järvi with the State Symphony Orchestra of Ukraine. All we Kievers were present and celebrated the event afterwards at the Dnipro restaurant where both Estonians ordered a Tatar dish made from uncooked ground meat, and considerable doses of vodka!"[114]

Frequently the self-education that these composers embarked upon both during and after graduation was conducted in listening sessions with other composers, in Moscow most notably at Volkonsky's apartment. The soprano Lidiya Davïdova described these sessions:

> At the time Volkonsky was the single source, because all the composers—Sofia Gubaidulina, Alfred Schnittke, and Denisov...lived in the same building as he did...at the Union of Composers apartment building on Studencheskaya Street [44/28].... There Denisov and he met very frequently. Everyone came to see Volkonsky. He was the type of person whom everyone visited. They all met with him simply to talk. They listened to music for hours on end. At that time, talking to Volkonsky meant listening to music—for one, two, three hours, just listening to music.[115]

A similar circle existed in Leningrad in the mid-1960s where Slonimsky and his classmates I. Beletsky, V. Veselov, V. Tsïtovich, M. Elik, Ivanova, and L. Mikheyeva listened to works by Mahler, Stravinsky, Hindemith, Honegger, Schoenberg, Webern, and Berg, including *Pierrot Lunaire, Wozzeck,* the *Rite of Spring,* and *Svadebka (Les Noces)* among other pieces.[116] As Slonimsky put

111. Hrabovsky, e-mails to author, 4 and 5 January 2000.
112. Tishchenko, interview.
113. Slonimskiy, interview.
114. Hrabovsky, e-mail to author, 10 March 2000.
115. Davïdova, interview, 14 September 1999. See also NVV: 40–41.
116. Rïtsareva, *Kompozitor Sergey Slonimskiy,* 42; Slonimskiy, *Burleski, elegii, difirambï,* 121; and Slonimskiy, "Zapretit' zapretï!" 96.

it in his memoirs: "It was an entire Academy."[117] He also mentioned studying Webern with the philosopher Yakob Druskin, who "worshiped German music" and was the brother of the musicologist Mikhaíl Druskin: "Under his direction we studied all of the serial rows [in Webern]."[118]

Most of the "young composers" also analyzed scores, but often they turned to Western compositional texts, particularly as they attempted to grapple with serial composition. Both Schnittke and Pärt studied serial techniques by using the textbooks of Ernst Krenek and Herbert Eimert.[119] Thanks to Blazhkov's Hawaii connection, in 1961 the Kiev circle had also acquired a copy of Krenek's *Studies in Counterpoint Based on the Twelve-Tone Technique* as well as Hanns Jelinek's *Anleitung zur Zwölftonkomposition*.[120] Hrabovsky wrote a translation of the latter in pencil in an accountant's ledger, but because the music examples were only in the original copy of the Jelinek, Hrabovsky, Silvestrov, and Huba would meet to examine the music together at one another's apartments (this was another probable although unstated reason Hrabovsky was fired from his position at the Kiev Conservatory in February 1963).[121]

In Leningrad Tishchenko first learned of serial techniques not from Krenek's book but from one of George Perle's books (most likely *Serial Composition and Atonality,* first edition, 1962; second, 1968) in addition to Gilbert Chase's *America's Music: From the Pilgrims to the Present* (first edition, 1955; revised second edition, 1966), which included a section on Schoenberg, "who was considered an American composer. There were examples and dodecaphony was also explained."[122] Both of these volumes, along with scores by Schoenberg and Webern, were available at the Leningrad Conservatory's library (seeming to belie Hrabovsky's claim that scores by those composers were easier to obtain in Kiev).[123] Tishchenko also mentioned a book by the Czech writer Ctirad Kohoutek that was titled *Modern Compositional Theories of Western European Music* (*Novodobé skladebné teorie západoevropské hudby*), was published in Prague in 1962, and appeared in the Soviet Union in the late 1960s.[124] By the

117. Slonimskiy, *Burleski, elegii, difirambï,* 121.

118. Slonimskiy, interview.

119. See Eimert, *Lehrbuch der Zwölftontechnik* (it is unlikely that they used his later book *Grundlagen der musikalischen Reihentechnik*). The composers might have had access to Krenek's book in either its English or German forms: Krenek, *Studies in Counterpoint Based on the Twelve-Tone Technique;* in German as *Zwölfton-Kontrapunkt-Studien.*

120. Jelinek, *Anleitung zur Zwölftonkomposition, nebst allerlei Paralipomena.*

121. Hrabovsky, e-mail to author, 13 December 1999; and letter dated 15 February 1963, RGALI, f. 2077, op. 1, yed. khr. 2174, l. 25.

122. Tishchenko, interview.

123. Ibid. Hrabovsky told me, "It is curious that the score of *Pierrot* was available at the Kiev Conservatory Library, whereas in the Moscow and Leningrad conservatories the librarians were strictly ordered not to allow students to borrow such formalist works!" Hrabovsky, e-mail to author, 4 January 2000.

124. Tishchenko, interview. Kohoutek also wrote three other books on music, but all date from after 1969.

early 1960s Denisov had access to several of René Leibowitz's books including *Introduction à la musique de douze sons* (1949).[125] Gubaidulina studied serialism from "a Polish translation of a work by René Leibowitz" as well as Eimert's *Lehrbuch der Zwölftontechnik,* and Jelinek's twelve-tone book.[126] In addition to these texts, Kholopova recalled several other books and articles that influenced the "young composers" in Moscow at the time, including Erno Lendvai's writings on Bartók, Stockhausen's *Texte, i: Zur elektronischen und instrumentalen Musik* (1963), Schaeffer's *A la recherche d'une musique concrète* (1952) and *Traité des objets musicaux, essai interdisciplines...* (1966), and Ligeti's "Pierre Boulez: Decision and Automatism in Structure Ia" ("Pierre Boulez: Entscheidung und Automatik in der Structure Ia") (1958) and "Metamorphoses of Musical Form" ("Wandlungen der musikalischen Form") (1960), in addition to the overall influence of the new music periodical *Die Reihe* (where both of the latter articles appeared).[127]

One figure in particular is often treated as a living textbook for the young Soviets, a walking purveyor of Second Viennese teachings: Filipp Herschkowitz. Or, as the composer Viktor Suslin (b. 1942) has rather hyperbolically declared, Herschkowitz was "an apostle sent by Webern to teach the barbarians."[128] The Rumanian-born Filipp Herschkowitz (Gershkovich in Russian[129]) (1906–89) was a student of Berg's and Webern's who returned to the Soviet Union in 1946 where he wrote numerous papers on music of all periods and met informally to discuss composition and analyze pieces with various "students."[130] In the 1950s Herschkowitz was extremely poor and frequently visited the homes of younger students, such as Schnittke, Denisov, Pekarsky, and especially Volkonsky, in search of companionship and conversation about music.[131] None of his papers was published in the USSR in his lifetime, save two that appeared in Estonia, and only one of his compositions was published: his Capriccio for two pianos in 1957.[132] It must be emphasized that none of the young Soviets actually

125. Denisov, "Dodekafoniya i problemï sovremennoy kompozitorskoy tekhniki," 487.

126. Kurtz, *Sofia Gubaidulina,* 65.

127. Kholopova, *Kompozitor Al'fred Shnitke,* 70–71; and Savenko, "Poslevoyennïy muzïkal'nïy avangard," 414.

128. Suslin, "Herschkowitz Encountered," 40.

129. According to Dmitriy Smirnov, he always signed his scores "F. Herschkowitz." Smirnov, *A Geometer of Sound Crystals: A Book on Herschkowitz,* vii.

130. For an introduction to Herschkowitz, see Kholopov, "V poiskakh utrachennoy sushchnosti muzïki: Filipp Gershkovich," 24–40.

131. Ivashkin, *Alfred Schnittke,* 87; Volkonskiy, interview, 21 October 1999; Pekarskiy, interview. Aygi also reported that he made trips to Kiev where he stayed with Blazhkov, whom he respected a great deal, and also with Silvestrov. Hrabovsky also apparently met Herschkowitz, or at least knew of him, but did not indicate where or when any meetings had occurred. Aygi, interview; and Hrabovsky, e-mail to author, 5 January 2000. See also NVV: 114–15.

132. Ivashkin, *Alfred Schnittke,* 88. One of these papers was Gershkovich [Herschkowitz], "Tonal'nïye istoki Shonbergovoy Dodekafonii." See also Gershkovich [Herschkowitz], *Kaprichchio dlya dvukh*

studied serial music with him, for at the informal gatherings Herschkowitz presided over, like those taught by Schoenberg and Webern, only works from the nineteenth century, and especially the sonatas of Beethoven, were examined.[133] (The exceptions to this were the lectures on "the musical views of Anton Webern" that composer Dmitriy Smirnov [b. 1948] reports Herschkowitz delivered at the Leningrad Union of Composers in 1966 and at the Yerevan and Kiev conservatories between 1967 and 1969.[134]) Furthermore, as a result of his poverty, Herschkowitz was ill-equipped to teach anything other than Beethoven, as he himself had very few scores and no recordings. As a composer, Herschkowitz was less of an influence, because his music was almost never performed. The poet Gennadiy Aygi remembered a single evening at Grigoriy Frid's Moscow Youth Musical Club (see chapter 5) that included Herschkowitz's music. Volkonsky's response is suggestive, for after hearing one of Herschkowitz's Celan songs he commented to Aygi: "Perhaps it is supergenius, but I don't understand any of it."[135]

In his reminiscences of his private lessons with Herschkowitz, Smirnov provided a valuable glimpse into the older composer's pedagogical methods and his life in the 1960s and early 1970s. In these recollections Herschkowitz comes across as conservative and pedantic, not at all the proselytizer of the avant-garde suggested by many descriptions.[136] Herschkowitz was more important for his presence than for his direct dissemination of serial techniques. He alone had been abroad and had met the Viennese masters. Schnittke summarized his importance for the younger composers: "Herschkowitz influenced everyone like a dispensary with a distinctive soul. Talking with him and being exposed to caustic attacks from his side, I repeatedly received a strike of the switch, making me not stay overly long with one or another technical device."[137] The reverence that the younger composers felt for Herschkowitz

fortep'iano. His only other Soviet musical publication was his edition of Prokofiev's first three piano concertos, which appeared as vol. 5 of the collected works in 1957.

133. See Smirnov, "Geometr zvukovïkh kristallov." See also Smirnov, "A Visitor from an Unknown Planet: Music in the Eyes of Filipp Herschkowitz," 34–38. Both of these essays were incorporated into Smirnov's book-length treatment of Herschkowitz: Smirnov, *A Geometer of Sound Crystals*. See especially the list of Herschkowitz pupils that Smirnov includes on p. 4, n. 1. In his interview with me, Volkonsky also emphasized the fact that Herschkowitz taught only Beethoven; Volkonskiy, interview, 21 October 1999. See also Gubaidulina and Lukomsky, "My Desire Is Always to Rebel, to Swim against the Stream!" 15.

134. Smirnov, *A Geometer of Sound Crystals*, 4.

135. Aygi, interview. Between 1960 and the early 1970s Herschkowitz made several settings of Celan's texts; it is unclear which one Aygi was referring to. See Linder, "Herschkowitz, Philip"; and Smirnov, *A Geometer of Sound Crystals*, 241–42. For Smirnov's discussion of Herschkowitz's compositions, see ibid., 207–27.

136. See Smirnov, "Geometr zvukovïkh kristallov"; as well as Smirnov, *A Geometer of Sound Crystals*, 15–60.

137. GNAS: 19.

is evident in Schnittke's 1988 obituary for the composer, which he began: "It is hard to find anyone who so strongly influenced several generations of composers.... Herschkowitz merely had to tell his pupils what Webern had once told him about Beethoven's sonatas, and from his lips this was explanation enough of the history, prehistory, and future history of the most important of musical forms."[138]

Andrey Volkonsky was one of those most heavily influenced by Herschkowitz, and their interaction shows the extent to which Herschkowitz served as an unofficial ambassador for Vienna in Moscow. Volkonsky first met Herschkowitz while still a student, sometime in either 1953 or 1954. He recalled that: "I became acquainted with Herschkowitz, and he told me that he studied with Berg and Webern... Everything that I wrote then was neoclassical—a little Hindemith, a little Bartók, a little Stravinsky. I played a piece for him [*Serenade for an Insect*] and he told me that it was very good bad music ['ochen' khoroshaya plokhaya muzïka']. At first I didn't understand what he meant, but then I understood, and he was right, of course."[139] The two men, Volkonsky and Herschkowitz, met frequently and became close friends: "I was never his student, but I showed him what I wrote. He always spoke openly about what he thought. I often didn't agree with him.... We frequently quarreled, but although I was never his follower, he gave me a lot."[140] Aygi also reported that at the time Volkonsky was more direct about his opinion of Herschkowitz: "Without him I would not have become a composer. He was my teacher."[141] As we shall see in the next chapter, many other composers made similar statements about Volkonsky himself.

FOREIGN GUESTS

The greater frequency with which foreign musicians and composers were allowed to visit the Soviet Union in the late 1950s and early 1960s also led to valuable contacts. In a situation analogous to the more numerous exhibitions of Western art and more frequent cultural exchanges that took place in the late 1950s, such as the 1957 Sixth World Festival of Youth and Students, musicians such as Leonard Bernstein, Glenn Gould, Boulez, Stravinsky, Nadia Boulanger, Nicolas Slonimsky, and Otto Luening and Vladimir Ussachevsky all made

138. Shnitke, "In Memory of Filip Moiseevich Gershkovich," 70. See also the reminiscences published in *Tempo* in 1990: "Herschkowitz Encountered: Memoirs by Victor Suslin, Gerard McBurney and David Drew."

139. Volkonskiy, interview, 21 October 1999. This was one of Herschkowitz's favorite expressions. See Kholopova, *Kompozitor Al'fred Shnitke*, 70; as well as NVV: 115.

140. Volkonskiy, interview, 21 October 1999. See also NVV: 114–15 and 120–21.

141. Aygi, interview.

journeys behind the Iron Curtain over the course of the late 1950s and early 1960s (Bernstein toured with the New York Philharmonic in 1959; Stravinsky came during his eightieth birthday year in 1962; in June 1966 Boulanger sat on the jury for the Chaikovsky Competition in Moscow and also made a visit to the Leningrad Conservatory; Nicolas Slonimsky toured Russia, Ukraine, and several other Soviet republics on his U.S. Office of Cultural Exchange tour of Eastern Europe in 1962; Luening and Ussachevsky came to Kiev in 1962; and Boulez came with the BBC Symphony Orchestra in 1967).[142] These musicians are all credited with expanding the musical horizons of Soviet musicians and audiences. Orchestras such as the New York Philharmonic and the Boston Symphony astounded Soviet ears with their high level of technical skill.[143] For the "young composers" three specific figures made the biggest impression and warrant expanded treatment. We will consider them in chronological order: Gould, Stravinsky, and Nono.

Moses in the Desert

When Glenn Gould came to the Soviet Union, the Canadian was only twenty-four and was the first pianist from North America to play behind the Iron Curtain.[144] The tour is usually mentioned because of his impromptu lecture-recitals in Moscow and Leningrad where he performed compositions that would never have been allowed at his "official" concerts. Unfortunately, under the influence of reports by Denisov, Schnittke, and Gubaidulina that highlight the importance of this event, many Western authors have made incorrect

142. On Western art exhibitions and the Festival of Youth and Students, see Bowlt, "'Discrete Displacement': Abstract and Kinetic Art in the Dodge Collection," 295–96; and Reid, "Toward a New (Socialist) Realism." On Boulanger, see Tishchenko, interview; and Tishchenko, "Moya konservatoriya," 1:237 (although the Chaikovsky competition was held in Moscow, Tishchenko met her in Leningrad). For more details on Boulanger's visit to Moscow (no mention is made of a Leningrad visit), see Rosenstiel, *Nadia Boulanger: A Life in Music*, 380–81. On Luening and Ussachevsky see Hrabovsky, e-mail to author, 13 December 1999. On Boulez see SG: 30 (the date of the visit is incorrectly given as 1964 here). The BBC tour lasted from 6 to 15 January 1967 and included both Moscow (8 and 10 January) and Leningrad (13 and 14 January) performances. The programs included: Schoenberg, Five Pieces, Op. 16; Bartók, Second Piano Concerto; Webern, Variations, Op. 30, and Six Pieces, Op. 6; Boulez, *Eclat* (the Soviet premiere); Debussy, *La Mer* and *Images*; Stravinsky, *Le Chant du Rossignol*; and Berg, *Drei Bruchstücke aus Wozzeck*, and *Altenberg Lieder* (Heather Harper, soprano). I am grateful to Astrid Schirmer of IRCAM and to the Paul Sacher Foundation for their assistance in determining the specifics of the BBC tour.

143. There is a recording of the New York Philharmonic's performances in Moscow and Leningrad, including Beethoven's Egmont Overture, Brahms's Symphony No. 1, and Ravel's *La Valse* (see Bernstein, *Leonard Bernstein in Russia*).

144. Friedrich, *Glenn Gould: A Life and Variations*, 62; and Bazzana, *Wondrous Strange: The Life and Art of Glenn Gould*, 163.

generalizations about the concerts, and specifically about the nature of Gould's lecture-performances in Moscow and Leningrad.

Gould played first in Moscow, arriving in the Soviet capital on 7 May 1957. In his official concerts, his repertoire was fairly tame: Bach, Beethoven, and Berg's Op. 1 Sonata. On 12 May, though, Gould appeared in a more informal (although still official) recital called "Music in the West" at the Moscow Conservatory where he featured twentieth-century music: Berg's Sonata, Webern's Variations, Op. 27, and movements I and IV from Krenek's Piano Sonata, No. 3, Op. 92, No. 4. In a letter to the photographer Yousuf Karsh, he recalled his Soviet performances, seemingly describing the Moscow recital but really conflating his memories of this and a similar recital from the later Leningrad portion of the trip: "When I first announced what I was going to do, i.e. that I was going to play the sort of music that has not been officially recognized in the USSR since the artistic crises in the mid thirties, there was a rather alarming and temporarily uncontrollable murmuring from the audience....I am quite sure that many of the students were uncertain whether it was better for them to remain or walk out." Gould further remembered the reactions he provoked: "As I continued playing music of Schoenberg…Webern and Krenek, there were repeated suggestions from the student body, mostly in the form of discreet whispers from the committee on the stage but occasionally the odd fortissimo suggestion from the audience, that they would prefer to spend their time with Bach and Beethoven."[145] Gould described the effect as akin to traveling in outer space: "It was a sensation equivalent to that of perhaps being the first musician to land on Mars or Venus."[146] (See appendix B for the full text of Gould's Moscow Conservatory remarks.)

Gould remembered that his listeners were worried during his performance, and expressed a wish to have him switch to something more conservative. But throughout the recording of Gould's Moscow concert, and specifically his performances of Berg's Sonata and Webern's Variations—the first two pieces he discussed and performed—there is very little noise from the audience (this could be solely a matter of microphone placement). A gasp erupts when Gould announces he is going to play Webern's Variations without having "practiced it for two years," and a minor rustle ensues when Krenek's name is first mentioned, but this is more likely a result of the fact that Krenek was an unknown name to the Soviets. Or as Roman Viklyuk remembered, after Gould mentioned Krenek, "In the hall the young communists started to ask each other 'What did he say?' 'What did he say?' And in the audience people started to say, 'Krenek,' 'Krenek.' This was the password for an entirely new comprehension

145. Friedrich, ibid., 63–64; and Bazzana, ibid., 168–69.

146. Friedrich, ibid., 64. Bazzana notes what he calls the recurrent "visitor-from-another-planet" image that both the Soviets and Gould used to describe one another. Gould later reported that being in the Soviet Union "was like being on the other side of the moon." Bazzana, ibid., 167.

of life."[147] Another possible explanation is that in its Russian pronunciation, "Kshenek," sounds similar to Schoenberg (the k getting swallowed in the sh). Schoenberg would have been more expected than Krenek because Gould's historical narrative seemed to be leading inexorably from Berg and Webern to the father of twelve-tone music.

Instead of ending with Schoenberg, Gould concluded the lineage set up by his previous remarks and performed examples by going back to Bach— excerpts from the *Art of Fugue* and *Goldberg Variations*. His purpose was to point out the source of the very recent music he had been championing, and of the still-unmentioned twelve-tone techniques, in the works of the revered master. This hoary genealogy would hardly be worth repeating, were it not for the fact that similar narratives would play such a prominent role in later Soviet theoretical explanations of the twelve-tone system and serialism.

The content of Gould's "lecture" was of less interest than the sheer fact that he was saying such things in public; in any case in his cursory remarks Gould only briefly touched upon twelve-tone composition, and even then, never explicitly named it as such. These are the extent of his comments on Schoenberg:

> Within a year Alban Berg and his teacher Arnold Schoenberg were writing music absolutely without relation to any one tonality. The earliest works of Schoenberg and Berg without tonality were also to a certain extent without form. They were much too fluid without any real control over the material. Within a decade, within ten years, Schoenberg had begun to formulate, to work on a principle, whereby all the melodic units could be combined into what he called a "supertheme." To combine all the thematic ideas of the music into one complex of themes which would be used again and again in every conceivable position and variation of itself.[148]

Insight might have been offered into new techniques and musical devices, but Gould can hardly be said in any meaningful sense to have "described the twelve-tone technique of Arnold Schoenberg and his followers," as McBurney put it.[149] Gubaidulina, who was in attendance at the concert, could not have cared less about Gould's remarks: "It wasn't so important to understand what he was saying. His manner of playing, his touch and phrasing spoke more strongly than the most highflown rhetoric."[150] For Denisov, the Moscow

147. Roman Viklyuk, interview in *Glenn Gould: The Russian Journey*.

148. Transcribed from the recording of the lecture-recital, *Glenn Gould in Russia, 1957*. See also *Glenn Gould: The Russian Journey*.

149. McBurney, "Soviet Music after the Death of Stalin," 131.

150. SG: 19. According to pianist Vladimir Tropp, now head of the piano faculty at the Russian Academy of Music, after his visit a group of students published Gould's Moscow Conservatory

performance was "a genuine revelation."[151] And although Karetnikov told Anna Golubeva that he had not attended Gould's concerts in Moscow, he said to McBurney in a 1990 interview that "when he played Webern, it was a revelation because not one of us could have imagined that such music existed in the world."[152]

In Leningrad, Gould also performed before students, and according to Tischenko:

> Glenn Gould was an explosion. After a man hears Glenn Gould, he becomes a different person. He also completely remade me. I remember his concert which I attended. It was in the Small Hall of the Petersburg Conservatory. He played Bach's sixth partita, a partita by Sweelinck, Webern's Op. 27 variations and a movement from the third sonata of Krenek. Besides that he spoke a great deal—there was a translator, our English teacher E. A. Konstantinovskaya. Thus everything that he said, everything reached us.... You see the living Gould—and it's as if you had met Moses in the desert.[153]

Tischenko said that this was the first time he had heard Webern's music. Musicologist Vladimir Frumkin was also at Gould's recital at the Small Hall of the Leningrad Conservatory, and remembered the scandal it caused: "I was one of the students who took care of him (I was a graduate student).... And I helped him.... He asked for hot water for his hands, and it was so weird. And then he played some Bach, and then suddenly without any permission from the *Nachal'niki* [bosses] of the conservatory, he said 'And now I want to play for you the real heirs of the baroque geniuses like Bach.' And he started to play Schoenberg and Webern." Frumkin continued, noting the perplexed response of the professoriate to Gould's remarks: "And after he played several pieces, a professor of Marxist *Estetika* [Aesthetics], [Nikolai?] Parsadanov, he was also chairman of the Communist Party Committee of the conservatory, he came on the stage and said, 'Probably it was kind of an exaggeration, kind of a strange parallel, between those contemporary dissonant decadent composers and Bach.'... And so it was a real scandal, and it's maybe a good indication for you of the atmosphere, the fear [at that time]."[154] In his memoirs Sergey Slonimsky described a more overt reaction to Gould's Leningrad Conservatory recital

"lecture," suggesting that the remarks circulated in *samizdat* among at least some students in Moscow at the time. Interview in *Glenn Gould: The Russian Journey*.

151. Denisov and Armengaud, *Entretiens avec Denisov*, 66.

152. Karetnikov and Golubeva, "Osvobozhdeniye ot dvoyemïsliya," 16; and McBurney, "Soviet Music after the Death of Stalin," 131.

153. Tischenko, interview.

154. Frumkin, interview, 23 December 1999.

in an account that closely matches Gould's recollection to Karsh of his Soviet performances:

> Gould's visit agitated everyone. At the conservatory he played the variations of
> Webern, a composer still not known to anyone. Voices rang out: "It would be
> better to play Bach! Rachmaninov!" Hearing the names of those composers,
> Gould understood everything, he leapt up and declared: "I am playing
> the best music of the twentieth century. It is not only new, but it is deeply
> connected with the very old classics; the roots of this music are very solid."
> [Yekaterina] S. Gvozdeva translated that tirade, adding for herself: "Students,
> behave yourselves!" But not only the students—the professors sitting on the
> stage (among them was [piano professor Samariy] Savshinsky [1891–1968]),
> admired Gould's Bach and were perplexed in hearing Webern's pauses and
> rhythmically varying intervals.[155]

Gould's repertoire was slightly different in Leningrad, and may or may not have included Schoenberg; by all accounts he seems to have met with more resistance there.[156] In any case, Tishchenko's reverential tone reveals how viscerally emotional Gould's impact was on some of his Soviet listeners. What were the niceties of musical technique, after all, when in the presence of the "living Gould"? Gould also embodied the general awakening encouraged and represented by the Thaw. Or as Vladislav Chernushenko, now rector at the St. Petersburg Conservatory, declared, after Gould's visit, "We understood and realized that the musical world was comprised of more than what we had known and used. And to this day I feel and I see how this was happening, and how it was entering our soul and our musical consciousness."[157]

The Return of the Native

Almost as significant as Gould's visit was Stravinsky's. A living legend, most of whose music was still off-limits, returned home and attempted to tutor young, and not only young, Soviets on the intricacies of serialism.[158] Robert Craft's account of Stravinsky's October 1962 trip preserves nicely the political overtones

155. Slonimskiy, *Burleski, elegii, difirambï v prezrennoy proze,* 121.

156. Leonid Gakkel', a professor at the St. Petersburg Conservatory, wistfully recalled that the students "started to express their confusion and demanded that he play Bach, and so he did, but it was clear that he was a little disappointed for very obvious reasons. He wanted to elevate us a little, and instead we pulled him down." *Glenn Gould: The Russian Journey.*

157. *Glenn Gould: The Russian Journey.*

158. After the visit, more of Stravinsky's music became available in the USSR. Paul Moor notes that subsequently *Melodiya* released recordings of the *Capriccio, Symphony in Three Movements,* Piano

that continually dogged the visit (coinciding as it almost did with the Cuban missile crisis). Craft's diary entries from the tour, published as the cover story in *Encounter* in June 1963 and also as part of his and Stravinsky's *Dialogues and a Diary* the same year, were also one of the earliest and most widely read reports on serial music behind the Iron Curtain (if not one of the most condescending). Craft reports that in the Leningrad House of Composers, under a portrait of Glazunov, Stravinsky embarked on "what must have been the Union's first two-hour monologue on the 'twelve-tone system.'"[159] As Craft continued, the Leningrad audience was "incomparably better informed than any gathering has been so far, and the young men reveal themselves almost as *frondeurs* in comparison with their Moscow colleagues."[160] Two days later, again at the Leningrad House of Composers, Stravinsky listened to tapes of new works by Sviridov, Vadim Salmanov, Galina Ustvolskaya, and Edvard Mirzoyan. Craft evaluated them as follows: "After these samplers, no doubt carefully chosen to please good old radical us, how can I.S. continue to proselytize for a school whose musical logic is at least a light-year away [that is serialism], and whose emotional world is on the other side of the galactic field?"[161] Stravinsky is the returning prodigal son, but a prodigal son bearing gifts: a rare glimpse into the musical technology of the other side, or so Craft prides himself on thinking. For Soviet composers, and especially those of the younger generation, cut off so long from the musical developments of the West, the glimpse was both breathtaking and bewildering, as Gould's performances had been five years earlier.

Some of the "young composers" did meet with Stravinsky in Leningrad and were most likely at the meeting and concert that Craft described. Both Tishchenko and Slonimsky vividly remember meeting Stravinsky in Leningrad. Tishchenko declared: "It was a subject of absolutely cosmic scale for Russian musicians. I remember each of the words that he spoke. I remember how the cult of Stravinsky simply grew before my eyes.... Everyone became aware of and caught sight of Stravinsky. Of course, before that they knew of Stravinsky, but to be so close to him, shake his hand—for us young musicians it was

Concerto, Octet, Septet, and *Le Chant du rossignol*. Moor, "Notes from Our Correspondents: Moscow," 22–23. Several of these works had been heard in concerts during the visit. The repertoire at these performances included *Petrushka, Rite of Spring, Fireworks, Capriccio* for piano and orchestra, *Ode, Symphony in Three Movements, Orpheus,* and the *Firebird Suite.* Recordings of Stravinsky's performances during the visit have been released on CD: *Stravinsky in Moscow 1962;* they originally appeared on LP in 1962 as Melodiya D 010933-6 (see Bennett, *Melodiya: A Soviet Russian L. P. Discography,* 587–89). For an official response to the visit see Nest'yev, "Vechera Igorya Stravinskogo," 92–95.

159. Stravinsky and Craft, *Dialogues and a Diary,* 251; and Craft, *Stravinsky: Chronicle of a Friendship,* 198–99. See also Craft, "Stravinsky's Return: A Russian Diary," 43 (a slightly different version of this).

160. Ibid.

161. Stravinsky and Craft, *Dialogues and a Diary,* 254; Craft, *Stravinsky: Chronicle of a Friendship,* 201.

an extraordinary event."[162] There is a photograph of the young, eager Slonimsky peering over Stravinsky's shoulder as he inspects a display at Yudina's exhibit of Stravinsky memorabilia at the Leningrad House of Composers featuring, surprisingly, a copy of the program for the 1961 Leningrad premiere of Volkonsky's *Musica Stricta* (Stravinsky's Sonata for two pianos had also been on the program).[163] Yet in 2000 Slonimsky was more reserved about his memories of Stravinsky: "Yes, I met [with Stravinsky], but I did not show him my scores. It seemed to me that it was unnecessary to impose; it seemed to me that he absolutely didn't want to [see them]. It was funny. He behaved disdainfully toward Ustvolskaya and Salmanov. He was not gentle. But when I asked about his compositions, he spoke with interest."[164] Stravinsky went on to offer several other "lectures" on dodecaphony to his Soviet hosts, and ended a later one with the prophetic statement: "You, too, Tikhon Nikolayevich [Khrennikov], will be trying it soon." Craft thought to himself, "My own feeling is that to the custodians of this outward-growing society, Webern's music can only seem like the nervous ticks of a moribund culture. I feel no need for it here, in any case, or correspondence between it and what I have seen of Soviet life."[165] This is a thoughtful appraisal. And although Stravinsky's prophecy with respect to Khrennikov would come true in 1971, the cultural authorities were only too willing to concur with Craft's assessment.[166] They were not alone: despite Stravinsky's influence, soon many of the younger composers also began to sense the disjuncture that Craft had recognized between serialism and Soviet life.

Stravinsky's visit had other more immediate results, most notably an increased official tolerance of him and his music. The most visible demonstration of this is the new, separate, expanded chapter devoted to Stravinsky (with a detailed treatment of his late works) in the 1964 revised edition of Shneyerson's *On Music Living and Dead* (in the first edition he had shared a chapter with Hindemith).[167] Total acceptance, however, came only after his death.

162. Tishchenko, interview.

163. See Rïtsareva, *Kompozitor Sergey Slonimskiy*, photo insert.

164. Slonimskiy, interview.

165. Stravinsky and Craft, *Dialogues and a Diary*, 257–58.

166. Khrennikov would use twelve-tone rows in his 1971 Second Piano Concerto. See Schmelz, "Shostakovich's 'Twelve-Tone' Compositions and the Politics and Practice of Soviet Serialism," 346–47. See also Il'ichev's 26 December 1962 remarks recalling Stravinsky's negative comments about the works he heard by the Leningrad composers. See Afiani, ed., *Ideologicheskiye komissii TsK KPSS. 1958–1964: Dokumentï*, 375; and Il'ichev, "Silï tvorcheskoy molodyozhi—Na sluzhbu velikim idealam," 1–3. The adoption of serialism in Stravinsky's own late works reflected his own uncertainty and insecurity regarding his stylistic development and his own identity as a Russian composer. This makes his espousal of "seriation" to the Soviet composers doubly ironic as he attempts to encourage others to mimic his own "conversion." See in particular Taruskin, *Stravinsky and the Russian Traditions*, 2–4.

167. Shneyerson, *O muzïke zhivoy i myortvoy*, compare 138–58 (1960) with 211–46 (1964).

Friend or Foe?

A more direct and repeated foreign influence over the course of the 1960s was Luigi Nono, one of the most frequently mentioned foreign musical visitors of the Thaw. Nono played a distinct yet paradoxical role in the history of Soviet unofficial music because of his mingling of allegiances to communism (albeit Italian communism, quite different from the Soviet variety) and to avant-garde music.[168]

Many of the unofficial composers count Luigi Nono as an influence; it seems that he had contacts with nearly all of them, including Pärt, Denisov, Schnittke, Karetnikov, and Tishchenko.[169] Pärt dedicated his *Perpetuum Mobile* (1963) to Nono as did Denisov his 1964 *Italian Songs;* both Denisov and Schnittke considered him a friend.[170] Nono made more than one visit to the Soviet Union in the 1960s, and nearly every source cites a different date for his first visit; according to the Nono archive in Venice it occurred in 1962.[171] Schnittke described his appeal for the "young composers": "[Nono] influenced me and several of my colleagues—not only through his music but also by his character: impulsive, emotional, charming."[172] According to Kholopova, Nono was shocked that Schnittke had not studied any of Webern's scores, and thereafter made every effort to send him and his colleagues scores by composers ranging from the Second Viennese triumvirate to Stockhausen.[173] Regarding his dedication of *Perpetuum Mobile* to Nono, Pärt stated: "Yes, that was a spontaneous reaction to a visit he made to Estonia. It was the first meeting that we had ever had with a major contemporary composer from the West. That was an important experience for us."[174] Tishchenko told me that when Nono visited Leningrad for the first time, either in 1962 or 1963, "I showed him my music, and with his critical, truly sharp remarks, very specific, he gave me a great

168. A later interview with Luigi Nono in *Sovetskaya muzïka* touches briefly on some of his impressions from his contacts with Soviet musicians in the 1960s and 1970s. See Nono, "Naiti svoyu zvezdu," 109–14.

169. Karetnikov, "Vizit znatnogo modernista." This was translated into English as Karetnikov, "Two Novellas, No. 2: The Visit of a Distinguished Modernist," 46–47.

170. See Kholopov and Tsenova, *Edison Denisov,* 22.

171. Schaller, e-mail to author, 31 July 2002.

172. Polin, "Interviews with Soviet Composers," 10. In GNAS: 18, Schnittke puts Nono's visit at the end of 1953. This is a typographical error; he must have meant 1963. Kholopova gives the date as 1963. See Kholopova, *Kompozitor Al'fred Shnitke,* 67–68.

173. Kholopova, *Kompozitor Al'fred Shnitke,* 67–68. See also GNAS: 36–37; and Ivashkin, *Alfred Schnittke,* 85–86.

174. McCarthy, "An Interview with Arvo Pärt," 130. There is a photo of Nono and Pärt (with composer Jaan Rääts), dated 1963, in the "Pictorial Record of Estonian Music" at the end of Olt, *Estonian Music,* n.p.

deal."[175] Nono also reportedly sent Tishchenko a packet of scores from Universal Edition as a gift at the beginning of the 1960s, including "a great number of scores by Webern and Schoenberg."[176] Nono's influence, like that of the legendary Gould concert, continued to be felt well into the 1990s, although at least Volkonsky later grew disillusioned with the composer for his communist—and ostensibly Soviet—allegiances.[177]

The influence that Nono exerted on the "young composers" took several dimensions. One was concerned exclusively with Nono's music. When Denisov mentioned *Il canto sospeso* in a later article on serial techniques, he pointed only to the peculiarities of the row Nono used in the work and completely ignored its antifascist political content (its texts were by World War II resistance members).[178] Denisov's concern was a function of both the analytic nature of the article and his own primarily formalistic aesthetic leanings. It was also a reaction to the Soviet press's evaluation of this very piece. Yuriy Keldïsh (1907–95), in a November 1958 article on *Il canto sospeso*, had applauded Nono for the political content of the work, but criticized its "unnatural," "unexpected," and "disorderly" musical setting ("neyestestvennost'," "neozhidanniy," and "besporyadochniy").[179] For Keldïsh, following the ruling socialist realist doctrine, content was the primary interest. In ignoring content and focusing exclusively on technique in his own article, Denisov was directly contravening Soviet aesthetic criteria. This focus on musical details and techniques was symptomatic of the young Soviets' reception of Nono and Western influences in general.

More important was the broader role that Nono played in the musical development of the Soviet composers. As Pärt noted, Nono was one of the first of the avant-garde Westerners of the younger generation (Nono was born in 1924) to come into contact with them, and it was this rather than the political or even the technical aspects of his own music that counted. The general

175. Tishchenko, interview. Tishchenko recalled the date as 1963, but Sergey Slonimsky remembered meeting Nono in 1962 when the latter visited Leningrad. It is possible that he came in both years. Slonimskiy, interview. See also Tishchenko, "Moya konservatoriya," 1:237.

176. Tishchenko, interview.

177. After Nono refused to meet with Volkonsky at the Venice Biennale in 1977, Volkonsky wrote an open letter criticizing him to *La Stampa*, published on 11 December 1977. A Russian translation, with Nono's open response can be found in NVV: 209–12. See also *Muzïkal'naya akademiya* 1 (1996), which included a special section devoted to more positive reminiscences of Nono and his music, called "Do You Hear Us, Luigi?" ("Slïshish' li tï nas, Luidzhi?"), although some, e.g., Pekarsky, pointed to the problems raised by Nono's visits to the USSR. See Pekarskiy, "Pravdivaya istoriya," 60–65.

178. Denisov, "Dodekafoniya i problemï sovremennoy kompozitorskoy tekhniki," 491–92. In his later interviews with Armengaud, Denisov provided an even more general—and essentializing— description of his attraction to Nono: "For me the true face of Luigi Nono is tender and lyrical and not a mask of destruction. His works lie in the Italian tradition, along with the strong side and the frailty of Italian music in the tradition of the madrigal and especially in the tradition of Monteverdi and sometimes also of opera." Denisov and Armengaud, *Entretiens avec Denisov*, 78.

179. Keldïsh, "Pesnya, kotoraya ne prozvuchala," 128.

avant-garde trend that Nono embodied was more significant than the specifics of his music: his personal style and techniques had a minimal effect on the unofficial Soviet composers. Nono was more valuable because he was a source for information about contemporary Western music and because, unlike Gould or Stravinsky, he acted as a pipeline to the outside world, which became especially important for Denisov over the course of the decade (the Archivio Luigi Nono in Venice contains approximately twenty letters and postcards from Denisov to Nono).[180]

A stronger line of influence between Nono and the Soviets might have been expected. As a communist composing with serial techniques he might naturally have proved a powerful model for the young Soviets both ideologically and musically. The reason why he did not has its roots in a persistent mutual mis-understanding between Nono and the Soviet musical establishment. Keldïsh's article on *Il canto sospeso* reveals the perplexity with which the Soviets heard his music: "How is it possible to explain such a glaring contradiction between the idea of a composition and its concrete artistic embodiment?"[181] The baffle-ment was reciprocated by Nono. According to Rostropovich, Nono chided Khrennikov for not following Narkompros (People's Commissariat of Enlight-enment) leader Anatoliy Lunacharsky's early plea to Prokofiev ("You are a revo-lutionary in music, we are revolutionaries in life. We ought to work together."): "You claim to be a revolutionary force; you think you're at the forefront of every domain. Then, why do you oblige your composers to write conservative music?"[182] This connection between revolutionary politics and revolutionary music had been long abandoned in the Soviet Union, falling to the wayside with the formation of the creative unions in the early 1930s. As the Soviet lead-ership had unwaveringly linked communist and revolutionary politics solely with accessible music, "avant-garde" music, regardless of the intentions of its author, would always be "bourgeois" and "anti-Soviet." One of the corollaries of this was that the music composed by the young Soviets completely, and perhaps necessarily, lacked the polemical political component of Nono's work. Technique, in a sense, had become their politics.[183] Only in the West, and par-ticularly with Nono, was a connection between communism and avant-garde music, especially serialism, possible. In the small circles of unofficial compos-ers, performers and audiences in the 1960s Soviet Union, serial music at first represented not resistance, but rather an attempt at experimentation beyond

180. Bradshaw, "The Music of Edison Denisov," 3; Schaller, e-mail to author, 31 July 2002. See also Kholopova, *Kompozitor Al'fred Shnitke*, 68.

181. Keldïsh, "Pesnya, kotoraya ne prozvuchala," 129; see also Bogdanova, *Muzïka i vlast'*, 238–40.

182. Prokofiev, *Soviet Diary 1927 and Other Writings*, 262; Samuel, *Mstislav Rostropovich and Galina Vishnevskaya: Russia, Music, and Liberty*, 107–8.

183. For a useful consideration of the role of technique ("tekhnika") in the Soviet Union and the West during this period, see Cherednichenko, *Muzïkal'nïy zapas*, 15–25 and 32–37.

the confines of the official. At first its impetus was even more basic, fueled as it was simply by the curiosity of young, eager students.

Over the course of the 1950s and early 1960s foreign contacts, glimpses (and often only partial glimpses) of the forbidden fruit of the Western avant-garde, and a liberating sense of emancipation from the past all played a role in the artistic development of the young Soviets. The studies begun at the very start of the Thaw, helped by sympathetic teachers, friends from abroad, and visits by important foreigners, as well as the incremental relaxation of government arts policy, all helped the "young composers" to find their voices as they entered the 1960s. But the energetic group discussions and youthful debates of the new influences lasted until well after they had left the conservatory, fueling the near constant experimentation that colored their music throughout the new decade.

During their studies, both official and unofficial, these composers perpetually bemoaned the time lag that they felt separated them from their Western counterparts. Karetnikov lamented: "I was able to hear Wagner only at age 16 and I should have heard him at 11 or 12. Mahler should probably have followed at 15, and not at 23, and the Second Viennese School at perhaps 18 and not at 27. Eight to nine years was stolen from the lives of my generation, the most important [years] for the development of a person, and these losses will never be made good by anyone."[184] Schnittke decried comparisons between his *Pianissimo* and works by Ligeti such as *Atmosphères* and *Lontano*. Schnittke pleaded, "I finished *Pianissimo* in 1968, and at that time I had not even heard either *Atmosphères* or *Lontano*, which were written in 1967 and only came to us in 1969."[185] Schnittke rankled at the unflattering comparisons between the young Soviets and their Western brethren that this time lag created: "Because we were cut off from the Western avant-garde market, a situation was created in which everything that arose among us seemed to be borrowed from there."[186] Pärt was also defensive about his influences:

It's very possible that I was influenced by Cage, but it didn't come from his music, but from things that were, perhaps, completely unknown to me. I may have heard a word, or seen a face or a picture, or something by someone connected with Cage. When people are hungry they are sensitive to every hint of food. It's the same with ideas, particularly at that time in the Soviet Union. The hunger for information was so great that at times it was enough to hear just one or two chords and a whole new world was opened up.[187]

184. Selitskiy, *Nikolai Karetnikov: Vïbor sud'bï*, 64.
185. GNAS: 26. Schnittke was mistaken: *Atmosphères* was written in 1961.
186. Ibid. See also Kholopova, *Kompozitor Al'fred Shnitke*, 92.
187. McCarthy, "An Interview with Arvo Pärt," 130–33.

Pärt suggests that the "young composers," starved for information, simply devoured everything they heard.

The time lag also affected performers. For example, Western, and most often American, critics railed against Soviet pianists for their provincialism, as in Harold Schonberg's review of Sviatoslav Richter's first American tour in 1960: "Until recently however, the Russians were isolated. They learned to make music a certain way; and that way had many elements that had been discarded by the West for many years. The Russian style is not normally noted for its subtlety."[188] This reflected in no small part the cold war animosity that had long ago spilled over into the cultural arena, as much for performance as for the visual arts.

As a last, tongue-in-cheek example of this time lag in performance consider then-young percussionist Mark Pekarsky, parodying Soviet propaganda slogans as he bemoaned his situation right before he met Edison Denisov in 1964. Pekarsky complained that by that time Soviet musicians had:

[a]lready [missed] 30 years...of the most interesting experience with percussion of John Cage. Already the genius Christoph Caskel played *Zyklus* No. 9 for solo percussion by Stockhausen. Elliott Carter had already written his Eight Pieces for four timpani, and the great Sylvio Gualda was preparing at that time to play the work of genius, *Psappha,* by the genius Xenakis [*Psappha* was not premiered by Gualda until 1975]. Already...already...And there I stood behind my tiny little drum and worried over the difficult parts of Rimsky's *Sheherazade* or tried to play "The Flight of the Bumblebee" on the xylophone faster than everyone...further than everyone...higher than everyone.[189]

The unfortunate consequence of this time lag, for composers at least, was that their models and influences often seemed all too obvious, especially to critics in the West. This led to one of the central paradoxes of the unofficial composers. Even if they came honestly to their innovations, they were automatically cast as derivative by Western journalists. Faced with a triumphant avant-garde in the West and a stifling artistic bureaucracy at home, they were stuck hopelessly in the middle.

188. Schonberg, "An Evaluation of Richter."
189. Pekarskiy, "Kryostnïy otets," 189.

3

Andrey Volkonsky and the Beginnings of Unofficial Music

In the middle of the 1950s, Andrey Volkonsky was one of the prime sources for new music in the Soviet Union. He was one of the most outspoken members of his generation, and the first to employ serial techniques. His compositions were also the first to receive important performances. Volkonsky's story, therefore, proves indispensable for understanding the composition and reception of unofficial Soviet music in its early, abstract phase. The premieres of Volkonsky's three most influential serial works, *Musica Stricta,* *Suite of Mirrors,* and *Laments of Shchaza,* set the stage for the unofficial musical subculture that would flourish by the mid-1960s. These works became touchstones for all of the other compositions written and performed by the young Soviets in the 1960s. Many years later, fellow "young composer" Edison Denisov singled out for praise both *Musica Stricta* and *Suite of Mirrors:* "Precisely these compositions were the ones that exerted a very great influence on us. On all of us."[1] What follows, then, is an investigation of Volkonsky's controversial career and the compositional background and performance history of his three epoch-defining opuses. It will trace Volkonsky's development from difficult conservatory student to notorious "young composer" to charismatic performer of early music, charting his fluctuating reception by Soviet officials while also considering the nature of his own opposition to officialdom. Volkonsky later stated: "Striving to change the political system was uninteresting to me ['neinteresno']. I don't consider myself to be a dissident. I was in opposition ['protivnik'], yes, but those are different things."[2] This ambivalence begins to hint at the complicated role Volkonsky played in Soviet musical life: oppositional, but not

1. PED: 28.
2. NVV: 142.

directly so, only musically. The response of his listeners, by contrast, suggested something different.

THE PRODIGAL SON

We start with biography, for Volkonsky's lineage was always the first factor mentioned by writers, Western and Russian alike. His background begins to explain the various reactions, both positive and negative, he received from the Soviet authorities, his fellow composers, and his audiences. Volkonsky came from a family with a long and distinguished history familiar to all Russians; it was, after all, incorporated as the surname of one of the central families, the Bolkonskys (with a son named Andrey), in Tolstoy's *War and Peace* (Tolstoy's mother's maiden name was Volkonsky).[3] Andrey Mikhaílovich Volkonsky was born in Geneva in 1933 and was raised there and in Paris, but his parents—idealistic, patriotic, and homesick—returned to the USSR in the fall of 1947, a return that proved dangerous for the family and difficult for Volkonsky himself, accustomed since birth to the openness of the West.[4] Volkonsky did not want to return to Russia, and as his close friend, the unofficial poet Gennadiy Aygi, told me, together Volkonsky and his friend, Nikita, "ran away while everyone else had already left for the train station. They ran away, and because of them they even had to postpone their departure for a day while they searched for them all over Paris....[Volkonsky] didn't want to leave at all. He was very European in his understanding, in his customs."[5] The trauma inflicted by the move is evident from Volkonsky's remarks in a 1974 article: "All of my activities in Russia had the goal of maintaining my personality against the horrible pressures of the state, of defending my individuality, my Western culture, and the musical education that I had received in my first life."[6]

3. See Wilson, *Tolstoy,* 22. Sergey Rachmaninoff was also a distant relative of Volkonsky, as his daughter had married a Volkonsky. There is an entire book devoted to the family's genealogy. See Kholopov, "Initsiator: O zhizni i muzïke Andreya Volkonskogo," I:5 n. See also NVV: 31–33 and 60. Oksana Drozdova similarly begins her recent brief survey of Volkonsky's life, works, and aesthetic beliefs with an emphasis on his familial bonds. See Drozdova, "Andrey Volkonskiy—Chelovek, kompozitor, ispol-nitel'," 290–98.

4. Volkonsky's father "believ[ed] that the wartime alliance of the great powers would continue into peace." Volkonsky also noted that his father's "Russian patriotism got the better of him." Kamm, "Composer Tells of Artistic Battle in Soviet," 14. According to Aygi, Volkonsky's father, Mikhaíl Petrovich Volkonsky (1891–1961), was an officer before the revolution (in 1912 he graduated from the Imperial Alexander Lyceum in St. Petersburg), but also a singer. See Aygi, interview with Adamenko, "Sud'ba Andreya Volkonskogo," 10. See also Kholopov, "Initsiator: O zhizni i muzïke Andreya Volkonskogo," 6; NVV: 61; as well as Aygi, interview, and Baltin, interview.

5. Aygi, interview. See also NVV: 69–73.

6. Volkonskiy, "Sprechen, ohne gehört zu werden," 21. Volkonsky wrote that he had lived "three lives": his childhood in Geneva and in Paris, his years in the Soviet Union, and his life in Europe after his emigration in 1973.

Volkonsky's musical pedigree was established early on, for while a child in Geneva he had studied piano with Dinu Lipatti for about six months, although he did not take well to his distinguished instructor and would "even hide from Lipatti whenever he came to our home."[7] He was also widely rumored to have studied composition with Nadia Boulanger in Paris, but he told me that this last connection was false, that he had never had lessons with her.[8] Instead, the Boulanger myth became one of many that swirled around his outspoken personality.[9]

Like his purported study with Boulanger, much of Volkonsky's life before his return to the USSR remains veiled, but the connections he maintained with Western Europeans proved invaluable for his information-starved Soviet colleagues.[10] Consider Aygi on Volkonsky's wider influence:

Andrey Volkonsky, a composer and musician, whom I believe a genius, among all who were a part of the "underground culture," was a very refined individual with the highest European culture. What was most important for us was that he alone had a connection with the West. After the war, his family returned to the Soviet Union from France, and Andrey, ignoring the danger, continued to maintain his connections with his foreign friends. All works of Western literature reached him: Ionesco, Beckett, Kafka, and through him we became acquainted with the *"Encyclopedia of Abstract Art."*[11] ... He was the first to bring into our lives the music... of the Middle Ages and the Renaissance.

7. Pekarskiy, "Pokloneniye piligrima Pekarskogo gore Sent-Viktuar," 38. In his 1974 German article, Volkonsky also recalled hearing Furtwängler, Gieseking, Schnabel, and Bruno Walter as a child. Volkonskiy, "Sprechen, ohne gehört zu werden." See also NVV: 59 and 68–69.

8. Volkonskiy, interview, 21 October 1999. Volkonsky himself played a large role in the creation of this myth. The entire story follows: When Volkonsky's family moved from Geneva to Paris in 1946, Lipatti wrote Boulanger a letter of recommendation on his behalf so that he could take lessons with her. For unknown reasons, Volkonsky never studied with Boulanger, but when he arrived in Moscow and was applying to the Moscow Conservatory he listed Boulanger, because as he told Drozdova in a 1994 interview: Lipatti and Boulanger made for a good impression. The legend was further solidified when Boulanger's eightieth birthday celebration was held in Monte Carlo in 1967, and Volkonsky received an invitation as a former pupil (he did not attend). Subsequently, when an elderly Boulanger met Aram Khachaturyan in Budapest, and Khachaturyan remarked that her former pupil was currently studying in Moscow, Boulanger replied that she remembered Andrey very well (no doubt spurred on by either politeness, a memory lapse, or the guest list at her birthday bash). All of this is drawn from Drozdova's dissertation, "Andrey Volkonskiy," 21–23. See also NVV: 28–29. Frans C. Lemaire perpetuates the myth in his *New Grove Dictionary of Music and Musicians* article on Volkonsky, which also reproduces a number of other inaccuracies regarding Volkonsky's compositions *Laments of Shchaza* and *Rejoinder* (Lemaire, "Volkonsky, Andrey Mikhaylovich," 26:883–84).

9. McBurney makes the uncorroborated claim that Volkonsky studied with Messiaen. McBurney, "The Music of Roman Ledenev," 25.

10. This was true only after 1953. Volkonsky stated that even he had difficulties in obtaining materials before Stalin's death. See Volkonskiy, "Sprechen, ohne gehört zu werden."

11. Aygi meant Michel Seuphor's *Dictionary of Abstract Painting* (*Dictionnaire de la peinture abstraite*) (1957), translated into English as *Dictionary of Abstract Painting* (1957). Aygi, interview.

Through him we became familiar with the newest music of Schoenberg and Webern.... In that sense he was a teacher of artists, poets, and musicians alike. He himself never suspected that, thanks to his marvelous, impulsive, brilliant nature, his artistry, he was our Teacher.[12]

Lidiya Davïdova recalled Volkonsky in similar terms: "Volkonsky was a major figure who played a very great role in the life of Russia, because, thanks to him, Russia heard the music of the Renaissance and the early Baroque for the first time. He also had scores that his relatives sent him from abroad and also records sent by his relatives. You could say the same about modern music, because at his apartment I heard for the first time Schoenberg—*Pierrot Lunaire*—and the Webern cantatas."[13] Boris Tishchenko also had nothing but praise for his colleague, whom he first met in Leningrad in 1963: "Precisely he, precisely in the 1960s, discovered the regularity of the music that he composed. He was the first swallow of the avant-garde. And those who came after him... they already followed in his tracks. I consider A. Volkonsky the discoverer."[14] It seems that no one who met Volkonsky or heard a performance of his ever forgot the experience. Although seemingly hyperbolic, these quotations are representative; nearly every one of my informants was as glowing in their fond memories of Volkonsky.[15] As violist Fyodor Druzhinin (b. 1932) has written, "Many, myself included, felt something akin to love for him."[16]

Edison Denisov was one of those closest to Volkonsky during his conservatory years and after, a fact that explains his early veiled defense of Volkonsky in the pages of *Sovetskaya muzïka* in a 1956 article titled "Yet Again on the Education of the Young."[17] And like the others, in later reminiscences Denisov was unstinting in his praise of his friend and colleague: "But the most important thing was that Andrey was the first who played for us many generally unknown compositions. And they were by no means necessarily from the twentieth century. No. There was a great deal of good music from, let's say,

12. Talochkin and Alpatova, eds., *"Drugoye iskusstvo,"* I:59.

13. Davïdova, interview, 14 September 1999. Volkonsky corroborated that his relatives were a source for his scores and records. He also mentioned that visiting foreign musicians such as Lukas Foss provided materials. Volkonskiy, interview, 21 October 1999.

14. Tishchenko, interview.

15. Composers Leonid Hrabovsky and Alexander Baltin (b. 1931) both praised Volkonsky, and even Rodion Shchedrin recognized his talent. Hrabovsky, e-mail to author, 5 January 2000; Baltin, interview; and Shchedrin, interview. See also NVV: 239–40; Talochkin and Alpatova, eds., *"Drugoye iskusstvo,"* I:305–6; and Krebs, *Soviet Composers and the Development of Soviet Music,* 459 (diss.) and 340 (book).

16. Druzhinin, *Vospominaniya,* 146. The most recent example of Volkonsky adulation is Pekarskiy's *Back to Volkonsky Forward* (*Nazad k Volkonskomu vperyod*), an unabashedly subjective book-length paean to the composer, and a typically idiosyncratic mélange of memoir, oral history, biography, and hagiography.

17. Denisov, "Yeshcho o vospitanii molodyozhi," 28.

before Bach. In my opinion, he revealed that amazing period to us practically by himself." Denisov also mentioned Volkonsky's collections of both recordings and scores, as well as books: "At that time he had two huge libraries, one of literature and one of music. Huge. And I remember, for example, that he was the first from whom I heard the name Gesualdo. He gave me whole volumes of the latter's compositions.... It was one of those discoveries that were extremely helpful in turning away from all of the academic routines that they taught us."[18] As Aygi, Davïdova, Tishchenko, and Denisov more than suggest, Volkonsky played a central role in the early careers of the unofficial Moscow and Leningrad composers—and not only in those two cities, for he also had important connections with composers in Kiev. His central role in Soviet musical life was driven by his Westernness and the connections, knowledge, and image it entailed, in addition to his oft-noted charisma. Druzhinin vividly described the force of his personality: "In conversations with ordinary people he was also hypnotic, compelling his listeners to gaze adoringly at him, nodding their heads in agreement, saying yes to him, although only a minute before this interaction they had been convinced of just the opposite."[19]

Volkonsky's influence also extended beyond the world of music. Later in the 1950s Volkonsky became notable among artists and poets for the exhibitions he held at his home, including group and individual exhibits by unofficial visual artists.[20] Through Volkonsky, the unofficial worlds of music and art met one another. These were some of the rare occasions when such a meeting took place during the Thaw (they will be discussed further in chapter 5).

Shortly after Volkonsky's family returned to the Soviet Union, his parents were sent by the authorities (by Stalin himself, claim Pekarsky and the composer Alexander Baltin) to Tambov, a small village southeast of Moscow and the site of a former Volkonsky estate.[21] Volkonsky remained behind in Moscow with his aunt and enrolled in classes at the Moscow Musical School attached to the Moscow Conservatory (called "Merzlyakovka" because of its location on Merzlyakovsky Lane ["Merzlyakovskiy pereulok"]), where he remained for almost a year. He then rejoined his family and quickly finished his secondary education at the Tambov Musical School, at which time he was accepted at the Moscow Conservatory, beginning his studies there in 1950.[22] Predictably, Volkonsky found the classes at the conservatory uninteresting and deadening. Many of his professors, including Yuriy

18. PED: 28.

19. Druzhinin, *Vospominaniya*, 147. See also NVV: 251–52.

20. See Talochkin and Alpatova, eds., *"Drugoye iskusstvo,"* I:57, as well as Golomshtok and Glezer, *Soviet Art in Exile,* 107.

21. NVV: 75; and Baltin, interview.

22. NVV: 76, 78, 80–81, 83–84.

Fortunatov (1911–98), realized that he already knew more than the others, students and teachers alike, and allowed him to miss their classes (although he regularly attended the sixteenth-century counterpoint course taught by Semyon Bogatïryov [1890–1960]).[23] At the conservatory he studied composition with the conservative Yuriy Shaporin, a pairing that in retrospect does seem "absurd," to borrow Yuriy Kholopov's adjective.[24] Yet Volkonsky retains admiration for his former teacher, at least as an individual. In my interview with him, Volkonsky repeatedly emphasized that "Shaporin was a kind man ['dobrïy chelovek']." When Volkonsky started at the conservatory, the aftermath of the 1948 resolution on music was still being felt, particularly as it had forced prominent instructors like Shostakovich and Shebalin out of their teaching posts. This left entering composers with little choice, or with few good choices. "Few [of the professors] who remained were pleasant people," Volkonsky told me. Shaporin was one of the few who remained, and Volkonsky selected him "because I decided that he wouldn't especially bother me. He was kind. He was afraid then, like everyone was afraid, but he was kind.... He left me alone, and sometimes even gave me money, [saying] 'Poor student, go get something to eat.'"[25]

The admiration Volkonsky expressed for his teacher was reciprocated by Shaporin, who described his pupil in the following terms to the English journalist Alexander Werth: "Volkonsky... was an exceptionally brilliant and original composer" whose music was "polyphonic, lapidary, classical and rather chromatic."[26] Several of my informants noted that Shaporin's admiration for Volkonsky was so great that on at least one occasion the elder composer called the younger to ask his opinion about voicing the final chord in one of his romances.[27]

As Werth also informed his Western readers, Volkonsky "had lately been expelled from the [Moscow] Conservatory," an action taken at the beginning of the 1954–55 academic year.[28] The reasons for the expulsion were

23. Bogatïryov called Volkonsky his "most punctual student" (Pekarskiy, "Pokloneniye piligrima Pekarskogo gore Sent-Viktuar," 38). See also NVV: 85. Volkonsky also regularly attended mathematics classes at Moscow State University, and even contemplated pursuing mathematics instead of music after the 1948 resolution on music, and, according to Aygi, after his expulsion from the conservatory. NVV: 30–31; Druzhinin, Vospominaniya, 146; Aygi and Adamenko, "Sud'ba Andreya Volkonskogo," 10; and Aygi, interview.

24. Kholopov, interview, September 1999.

25. Volkonskiy, interview, 21 October 1999. See also NVV: 86.

26. Werth, Russia under Khrushchev, 266.

27. Ledenyov, interview; and Baltin, interview. Drozdova also mentions this. See Drozdova, "Andrey Volkonskiy" (diss.), 31.

28. Werth, Russia under Khrushchev, 266 (he does not mention the specific date). See also Kholopov, "Initsiator," 6; Drozdova, "Andrey Volkonskiy" (diss.), 31; and Schwarz, Music and Musical Life in Soviet Russia, 364. Lemaire claims that the expulsion occurred in 1953, "a week after" the premiere of his Concerto for Orchestra, which actually occurred in June of 1954. That Volkonsky was expelled in June (or July) of 1954 does not jibe with Schnittke's explanation, which suggests that it occurred in

complex, but centered upon Volkonsky's intractability and the conservatory's unwillingness to assume responsibility for him any longer. According to the Russian musicologist Oksana Drozdova, the official reason for his expulsion was that Volkonsky did not read Soviet magazines or newspapers and that he participated poorly in conservatory life.[29] Frans Lemaire has written that Volkonsky "was expelled from the conservatory, having been denounced by another student for possessing scores by Schoenberg and Stravinsky," a rumor widely circulated at the time.[30] The circumstances of the expulsion were typically underhanded. Alfred Schnittke summarized the situation: "He was expelled in such a simple manner. His [first] wife [Khel'vi] gave birth to a son [Pyotr/Peeter, b. 1954] in Tallinn, and he traveled there and lingered for a while, and was late for the beginning of the school year, and they expelled him from the conservatory. Later they invited him to return, but he said that in general he didn't need to. And thus after that he led a marvelous existence, without any kind of connection to the conservatory at all."[31] Schnittke's account is more or less accurate; no doubt Volkonsky's possession of modernist scores was known to the authorities, together with his other activities and general outspokenness. They all served as the base roots of the expulsion for which his tardiness was the pretense.[32] It must be added, however, that according to Drozdova, Volkonsky's departure from the conservatory was a gradual process: he was given an "academic leave" ("akademicheskiy otpusk") in 1952, returned in 1953, and was

the autumn of that year. Lemaire, "Volkonsky, Andrey Mikhaylovich," 26:883. Lemaire's source is undoubtedly Krebs, who incorrectly wrote that "within a week of the performance of the Concerto [in June of 1954] ... [Volkonsky] was expelled from the conservatory." Krebs, *Soviet Composers and the Development of Soviet Music* (book), 340.

29. Drozdova, "Andrey Volkonskiy" (diss.), 31. Her material is drawn from a 1994 interview she conducted with Volkonsky.

30. Lemaire, "Volkonsky, Andrey Mikhaylovich," 26:883. Pekarsky's book blames Shchedrin for the denunciation. NVV: 83–84. Volkonsky told me that "there was no official reason" for the dismissal: it was only "ideological." Volkonskiy, interview, 21 October 1999. He provided a similar explanation to Kurtz. See Kurtz, *Sofia Gubaidulina*, 37. Schwarz writes that the expulsion was for "insubordination." Schwarz, *Music and Musical Life in Soviet Russia*, 364. Baltin noted that Volkonsky had been informed on earlier by another student for possessing a Bartók score, but this did not lead immediately to his dismissal. Baltin, interview. (Baltin's story also appears in NVV: 83.) This might have been the incident Karetnikov related in his memoirs about the denunciation of a fellow student for carrying Stravinsky scores (see chapter 2).

31. Schnittke, quoted in Talochkin and Alpatova, eds., "*Drugoye iskusstvo,*" I:305. Volkonsky corroborated this story. Volkonskiy, interview, 21 October 1999.

32. Shchedrin had a much more pragmatic (and jaded) explanation for Volkonsky's expulsion. He claims that the suggestion that Volkonsky was expelled as a result of his music is a "myth." According to Shchedrin, Volkonsky was expelled just like any other student who never attended classes; there were no other underlying reasons. Of course, Shchedrin's own personal biases may be the cause for this reading of events. Shchedrin, interview. See also the epilogue.

then expelled in 1954.[33] Such "academic leaves" and expulsions were hardly unusual. Recall Marutayev's "academic leave" after the scandals surrounding his orchestral scherzo in spring 1952. The slightly younger Tishchenko, later a pupil of Dmitriy Shostakovich, was expelled from the Leningrad Conservatory during the 1957–58 academic year only to be reaccepted in 1959 and given a stipend in 1960.[34]

Once the conservatory had washed its hands of Volkonsky, he should have drifted into obscurity. This would have been the case, had his talent and outspokenness not already begun to attract wider attention outside the conservatory walls. As with most facets of life in the Soviet Union, Volkonsky's situation was not so simple. Despite his expulsion, he became a member of Muzfond on 2 July 1955 and the Union of Composers in either 1955 or 1956, receiving an apartment from them in the process ("Muzfond" or "Muzïkal'nïy fond SSSR" was the purse strings of the Union of Composers).[35] These official connections, together with his membership in the Union of Cinematographers, allowed Volkonsky to eke out a living by composing film music, like many composers of his generation.[36]

Therefore, what might have been the end of Volkonsky's career was actually its beginning. Rather than ignoring and silencing him, the Union of Composers continued to respond to Volkonsky's activities, and a surprisingly full portrait of his musical progress and his popular and critical reception over the remainder of the 1950s and 1960s can be gleaned from the pages of *Sovetskaya muzïka* and other official publications. In fact, the chronicle of Volkonsky's compositional development began well before his expulsion with reviews of his student works, including a Piano Trio (1950), a cantata *The Visage of Peace* (*Obraz mira/Le visage de la paix*) to word of Paul Éluard (1952), and a Concerto for Orchestra (1953).[37] (Volkonsky himself had even contributed to the debates concerning Shostakovich's Symphony No. 10 with his 1954 *Sovetskaya*

33. Drozdova, "Andrey Volkonskiy" (diss.), 33; Baltin, interview. Baltin told me that both he and Volkonsky received the year leave thanks to a psychologist who was trying to save them from a Commission from the Section on Culture of the Central Committee ("Komissiya iz otdel kul'turï TsK") that was trying to determine which conservatory students were "trustworthy" ("blagonadyozhnïye"). In the original German edition of his Gubaidulina biography, Kurtz wrote that "Volkonsky broke off his studies just after a year leave of absence 'for medical reasons'" ("Brach Andrej Wolkonskij gerade nach einem Jahr Urlaub 'aus medizinischen Gründen' sein Studium ab"). The English translation incorrectly reads: "Andrei Volkonsky quit 'for medical reasons.'" Kurtz, *Sofia Gubaidulina*, 66 (German), 37 (English).

34. Tishchenko, interview.

35. Kholopov gives the date of his membership in the Union of Composers as 1955 (and does not mention Muzfond), while Drozdova says that he joined the Union of Composers "a year after" ("cherez god") he joined Muzfond (Drozdova, "Andrey Volkonskiy" [diss.], 40; Kholopov, "Initsiator," 7). Pekarsky underscores the importance of the apartment to Volkonsky. NVV: 126–27. For the history of Muzfond and its responsibilities, see Tomoff, *Creative Union*, 47–57 and elsewhere.

36. Davïdova, interview, 14 September 1999; Volkonskiy, interview, 21 October 1999; and NVV: 118 and 146–48.

37. NVV: 95–96.

muzïka article "An Optimistic Tragedy."[38]) Volkonsky's early public reception perfectly encapsulates the vagaries of both Soviet musical life and Soviet criticism. When he initially proved problematic Volkonsky was not categorically silenced. Instead, as coverage of Volkonsky's career in the 1950s press reveals, Soviet critics alternately praised and condemned the "young composer," their uncertainty about how best to convert the talented and yet contemptuous Volkonsky everywhere apparent.[39]

The official ambivalence toward Volkonsky is best reflected in remarks made by Mattias Sokol'sky in a May 1956 article. Here Sokol'sky noted Volkonsky's expulsion and added: "Perhaps it would not be worth mentioning this were it not for two serious circumstances. Andrey Volkonsky is well known not only as a violator of institutional discipline (for which, undoubtedly, the punishment is deserved), but also as a first-rate talent, one of [our] gifted young composers."[40] Volkonsky was too important—and too talented—to expel and then ignore. Possibly under pressure from the Union of Composers, the conservatory leadership had thought it best to avoid further controversy by expelling Volkonsky and leaving his fate to the union and the more public forum of *Sovetskaya muzïka*.[41] The predictable if unintentional by-product of this decision was that the aura around Volkonsky's name only increased, even resulting in a few unexpectedly positive articles.

One of the approving reviews Volkonsky received came in the June 1956 issue of *Sovetskaya muzïka*: an article by musicologist Marina Sabinina titled simply "The Piano Quintet of Andrey Volkonsky." As she refutes earlier criticisms of the piece by Vasiliy Kukharsky published in the previous number of *Sovetskaya muzïka,* Sabinina's review gives a valuable glimpse of one of Volkonsky's earliest compositions. It also suggests the general tenor of the official discussions surrounding his creative development. Sabinina began by acknowledging the contradictory opinions held about the then-twenty-three-year-old composer, between "those who see in him one of the most gifted and promising of our young composers, and those who see him as a lost sheep from the Formalist herd." She then turned to Kukharsky's criticisms of the quintet: its "pseudo-innovations" ("lzhenovatorstvo") and its lack of real melodies or brilliant ideas. Like many of his other critics, Sabinina emphasized Volkonsky's youth in her defense, but turned the tables by attributing Volkonsky's failings to the harshness of his critics. She touched on the subject of his expulsion, like

38. Volkonskiy, "Optimisticheskaya tragediya."

39. A fuller account of Volkonsky's reception in the 1950s can be found in Schmelz, "Andrey Volkonsky and the Beginnings of Unofficial Music in the Soviet Union," 153–57.

40. Sokol'skiy, "Tormozï sovetskoy muzïki," 58.

41. That the Union of Composers had initiated the expulsion because the conservatory was unable to deal with Volkonsky itself was suspected at the time, at least by Volkonsky. See NVV: 105.

earlier critics (including Kukharsky) faulting the conservatory administrators for "not finding the correct individual response in the education of a 'difficult' student.... "[42] It was now two years since Volkonsky's expulsion, and Sabinina questioned whether Volkonsky had been able to find the correct path on his own. Her answer is "not yet": "He is now in the period of 'becoming,' and of forming. But he is searching stubbornly, persistently."[43] His Piano Quintet indicated to her that he had moved forward toward a more "realistic" (i.e., not "formalist") position. How wrong she would soon prove to be.

Sabinina's examples shed light on Volkonsky's early style, and, more important, his style just before he turned to serialism. She found the main theme of the first movement to be "epically severe" and to have something in common "with the melodies of the old folk *Bïlïnï*'s," or traditional Russian heroic poems. This is no surprise, for, we are told, the ideas for the quintet came to Volkonsky while he was working on his opera *Ivan the Terrible* (an opera that apparently was never finished). Other examples in Sabinina's review led her to point out rather more orthodox sources than those that would inform Volkonsky's later pieces: old religious versicles ("stikhi") and Rachmaninoff (in the second theme of the first movement), Prokofiev (particularly in the second movement, "Burlesque"), and Bach.

Most of the moments that Sabinina focused on are diatonic, with prominent seconds and sevenths to be sure, but nothing out of place in a tonal context, or at least not aberrant enough to arouse her suspicions. Her overall evaluation of the piece was positive: "In any event, the quintet of Andrey Volkonsky is a gratifying landmark, indicating the first serious creative success of a young, talented artist."[44] In at least one corner, public approval had come at last to the now-independent Volkonsky. Not only public approval came; Mariya Yudina was struck by both his Piano Quintet and Viola Sonata, and often performed them in concert in the late 1950s and early 1960s.

As we shall see, Yudina also participated in prominent performances of Volkonsky's later, more "avant-garde" compositions. The Piano Quintet for the most part lies in a different stylistic world from these later creations, yet some hints of his mature style may be detected in the third movement, "Passacaglia." Its chromaticism (including, initially, a near-twelve-tone row as the passacaglia theme), counterpoint, and baroque forms were magnified in one of his next works, the Viola Sonata. These impulses, in addition to the quintet's double-fugue finale, also formed the framework for his first serial composition, *Musica Stricta*.[45]

42. Sabinina, "Fortepiannïy kvintet Andreya Volkonskogo," 20.

43. Ibid., 21.

44. Ibid., 24.

45. For examples from the Piano Quintet, see Schmelz, "Andrey Volkonsky and the Beginnings of Unofficial Soviet Music," 158–59.

The string of articles touching on Volkonsky's unfolding career was the most attention yet given to a composer of his generation other than the far tamer and more respectable Rodion Shchedrin, who popped up frequently in articles on young composers in *Sovetskaya muzïka* beginning in 1956.[46] That Volkonsky was considered important enough to warrant repeated mention in *Sovetskaya muzïka* showed his preeminence among musicians of his generation. This status would gradually begin to shift after the premiere of *Musica Stricta*. It and Volkonsky's successive compositions inspired increasingly heated responses and shrill rhetoric from officialdom, until the moment in the mid-1960s when they realized that Volkonsky was unredeemable, lost for good to the forces of "formalism." By that time a small, devoted group of Soviet listeners had already been captivated by Volkonsky's new sounds, and the social world of unofficial music was flourishing.

MUSICA STRICTA: LITERAL TWELVE-TONENESS

Sabinina's examination of Volkonsky's Piano Quintet demonstrated the range of influences at work in one of his early pieces, influences that ran from Bach to Prokofiev. It also revealed Volkonsky's preoccupation with counterpoint and with classical and baroque forms. At the time he wrote the quintet, Webern and Schoenberg obviously had yet to exert a strong pull on him. Volkonsky's Viola Sonata (1955–56[47]), composed for violist and founder of the Moscow Chamber Orchestra Rudolf Barshai, betrayed influences similar to those seen in the Piano Quintet, except that the level of dissonance had been increased; Bartók, Stravinsky, and Shostakovich now shared the stage with Bach and Prokofiev.[48] The third movement, "Toccata," confirms the

46. The Sabinina article would not be the last to discuss Volkonsky or his music. Kabalevsky and Viktor Trambitsky criticized Volkonsky's recent string quartets (No. 1, 1955, and No. 2, 1958) in a series of articles (Kabalevskiy, "Tvorchestvo molodïkh kompozitorov Moskvï"; Kabalevskiy, "Tvorchestvo molodïkh," 3–15; and Trambitskiy, "Znacheniye zamïsla," 21–26) while Yuriy Korev took on the Viola Sonata (also 1956—see later; Korev, "Vecher al'tovïkh sonat," 137–38). See also Drozdova, "Andrey Volkonskiy" (diss.), 38–40. A brief, insulting (because it was highly approving) appraisal by L. Zhirov of Volkonsky's music for a children's film titled "The New Adventures of Puss in Boots" ("Novïye pokhozhdeniya kota v sapogakh," 1958), directed by Alexander Rou, also appeared in the February 1959 issue of *Sovetskaya muzika* (Zhirov, "Udacha molodogo kompozitora," 125) (apparently this was one of his first film scores).

47. The date on the manuscript copy of the score in the possession of the Moscow Conservatory Library is 1956. Kholopov gives the date for the sonata as 1955, Drozdova as 1956. See Kholopov, "Initsiator"; and Drozdova, "Andrey Volkonskiy" (diss.). In his *New Grove Dictionary of Music and Musicians* article on Volkonsky, Lemaire is probably closer to the truth, dating it as 1955–56. See Lemaire, "Volkonsky, Andrey Mikhaylovich."

48. Druzhinin reports that he and Yudina were to perform the sonata in the Small Hall of the Moscow Conservatory on 6 June 1959, but because she was not yet ready to perform the work Volkonsky was called

Example 3.1. Volkonsky, Viola Sonata, movement III, Toccata, measures 1–7.

upon to substitute at the last minute. Barshai and Volkonsky had performed it one time, also in the Small Hall, "no more than a month" before this performance, and according to Yudina, Volkonsky preferred Druzhinin's rendition (Druzhinin, *Vospominaniya*, 148, 173; Kuznetsov, interview, 19 October 2000). Pekarsky incorrectly writes that Yudina performed the sonata at this concert (NVV: 98). A concert with the same repertoire (Schubert, Honegger, Volkonsky, and Hindemith) occurred on 10 February 1961 in the Small Hall of the Leningrad Philharmonic. No doubt on this occasion Yudina herself was the accompanist.

neoclassical predilection to which Volkonsky readily admitted, as well as the rhythmic influence of Stravinsky, Prokofiev, and Bartók (ex. 3.1).

The fourth movement is a virtual imitation of Shostakovich, with its somber repeated minor seconds in the bass, and its expansive melodic line (similar in style to the viola's solo at the beginning of the piece) (ex. 3.2). In both the fourth movement and the opening of the first movement (ex. 3.3), the harmonic borrowings from Shostakovich and Bartók are also explicit in the symmetrically structured, chromatic harmonies, the rhythmic style, and the texture. The similarity between the outer movements also has deeper roots: the entire viola part in the final movement (beginning in m. 16) is a retrograde of the opening viola cadenza in movement I (specifically mm. 1–65), with added piano accompaniment (compare mm. 1–6 of ex. 3.3 with the ending

Example 3.2. Volkonsky, Viola Sonata, movement IV, measures 1–7.

Example 3.3. Volkonsky, Viola Sonata, movement I, measures 1–26.

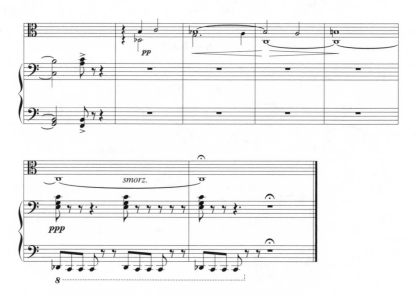

Example 3.4. Volkonsky, Viola Sonata, movement IV, final seven measures.

of movement IV, ex. 3.4, starting with m. 2 of the latter example).[49] Volkonsky was thinking about retrogrades even before he began trying his hand at composing with twelve tones.

Neither the Viola Sonata nor the earlier Piano Quintet provided any indication that Volkonsky would soon become the enfant terrible of the Soviet musical scene. The real turning point came later in the very year that the sonata was completed, when Volkonsky began work on his solo piano piece, *Musica Stricta* (1956–57).[50] This piece is usually acknowledged as the first Soviet twelve-tone composition and is no doubt deserving of the designation.[51] Closer examination will reveal the specifics of Volkonsky's unique approach to atonal and serial composition, demonstrating the wide range of influences at work on the first of the unofficial composers in the mid-1950s, especially in their initial abstract phase.[52] In *Musica Stricta* Volkonsky revealed his own personal brand of serial composition and in so doing deviated considerably from Schoenberg's twelve-tone method. For example, although twelve-tone rows occur in every movement, no single unifying twelve-tone row occurs throughout the composition. Furthermore, several of the movements include a number of different rows. Each movement is its own test case, and as the work unfolds, the listener gets the sense of Volkonsky probing the possibilities of the method.

49. NVV: 120.

50. There is some consensus on the date for this work: Drozdova, Lemaire, and Kholopov all place it in 1956 (Drozdova, "Andrey Volkonskiy" [diss.]; Lemaire, "Volkonsky, Andrey Mikhaylovich"; and Kholopov, "Initsiator"). However, the Beliaeff score is dated 1957, and the ending in the score is followed by "Moscau 1957." See Volkonskiy, *Musica Stricta*.

51. Earlier Russian "futurist" composers such as Nikolai Roslavets (1880/81–1944), Leo Ornstein (1893–2002), Nikolai Obukhov (1892–1954), and Yefim Golïshev (1897–1970) employed proto-serial structuring, although none of them produced actual twelve-tone, or even strictly serial, music. All of these composers might be better grouped under the label "twelve-tonish," reflecting not a rigorous or thoroughgoing serialism, but rather various degrees and manners of exploiting the total chromatic. See Kholopov, "Tekhniki kompozitsii Nikolaya Roslavtsa i Nikolaya Obukhova v ikh otnoshenii k razvitiyu dvenadtsatitonovoy muzïki," 87. For an emphasis of their serial aspects, see Gojowy, "Nikolai Andreevič Roslavec, ein früher Zwölftonkomponist," 22–38; or Gojowy, *Neue sowjetische Musik der 20er Jahre*. For a further explanation of the Russian distinctions between atonal, "twelve-tonish," twelve-tone, and serial music, see chapter 4. More compelling as a possible distant harbinger of one strand of the young Soviets' "serial" techniques (again, interpreted loosely) is Golïshev, who, in works like his String Trio (ca. 1925), his only published composition, used a type of "twelve-tone" composition very similar to that in the third movement of Volkonsky's *Musica Stricta* (see later), although it is unlikely (but not impossible) that Volkonsky knew the work. See Roberts, *Modernism in Russian Piano Music*, I:110–21, and especially 117–18 on Golïshev's "cyclical use of the twelve pitches," and example 13–14b (II:224–25).

52. A general overview of the composition is sketched out in Kholopov, "Initsiator," 10. Oksana Drozdova also analyzes the piece in her dissertation on the composer, but approaches the composition from a different perspective informed by her Russian theoretical training. She unfortunately misses out on some key details (e.g., the number of rows in the second movement), and avoids any broader historical or cultural interpretations. See Drozdova, "Andrey Volkonskiy" (diss.), 245–48.

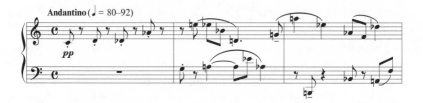

Example 3.5. *Musica Stricta*, movement I, measures 1–3.

The first movement of *Musica Stricta*, in fact, is not twelve-tone at all. Instead it uses a fundamental unifying motive ("Grundgestalt") similar to those used by Schoenberg in his Op. 11 and Op. 19 piano pieces. This four-note motive consists of three half-steps and a perfect fifth (also inverted as a fourth) that may appear in any order. It can be seen clearly in the opening three measures (ex. 3.5). Several twelve-tone rows do appear from measures 19 to 24, but they only serve to break up the straightforward presentation of the central motive (ex. 3.6). These twelve-tone rows are not related to one another; at least in this initial movement, Volkonsky appears not to be wedded to dodecaphony as a unifying principle. Instead, the twelve-tone rows act as a contrast to the atonal material of the rest of the movement.[53]

In the fugal second movement, however, Volkonsky moves closer to traditional twelve-tone writing. And yet, here again, he uses no fewer than four distinct rows, none of which is a repetition of those heard in the first movement (despite some motivic similarities). He pits the basic permutations of the initial row, the "subject" of the fugue, against three other rows (labeled A, B, and C in ex. 3.7), while linking the subject and these "countersubjects" with statements of successive fourths or fifths (perfect, diminished, or augmented, derived from positions 4–6 in row A, 4–5 and 7–8 in row B, and 2–5 and 9–10 in row C) (see mm. 3–4 and m. 6 in ex. 3.7).[54] Volkonsky intuitively and literally followed his own idea of what a twelve-tone fugue should sound like.

The third movement acts as an interlude between the more strictly constructed second and fourth movements. It plays on the opposition between two twelve-tone collections presented in alternation, but only rarely stated

53. For more on these twelve-tone rows and their relationship to the later practice of Soviet serialism, see Schmelz, "Shostakovich's 'Twelve-Tone' Compositions."

54. Although most likely independently conceived, Volkonsky's fourths and fifths here bear some resemblance to Schoenberg's serially derived "melodic chains of fifths and tritones" in the sixth movement, the Gigue, from his *Klavierstücke*, Op. 25. See Ashby, "Schoenberg, Boulez, and Twelve-Tone Composition as 'Ideal Type,'" 609–10.

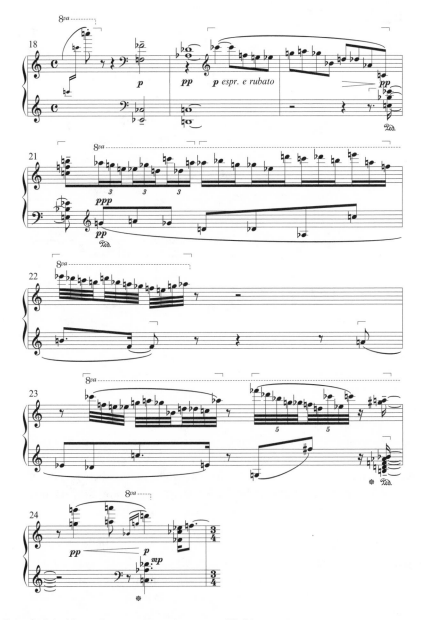

Example 3.6. *Musica Stricta*, movement I, measures 18–24.

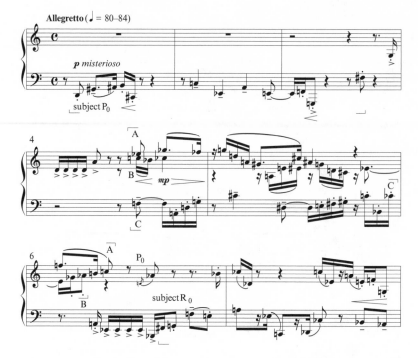

Example 3.7. *Musica Stricta*, movement II, measures 1–7.

linearly. Significant is the palindromic structuring (a continuation of that seen in the Viola Sonata's outer movements): the work's first two measures (the first presentations of each twelve-tone "row") are followed by their respective retrograde forms in measures 3 and 4 (m. 1 in 3, m. 2 in 4), and the final measure is a retrograde of the opening measure (exx. 3.8a and 3.8b).

The final movement of *Musica Stricta* returns to the stricter fugal texture of the second movement, this time as a double fugue. The most significant aspect of this movement is the increasing reliance on octave doubling and diatonically referable chords. The piece is twelve-tone throughout and refers to two rows: one the fugal subject (in the left hand in mm. 1–4), the other the countersubject (the mainly chromatic descending figure beginning in the right hand of m. 1) (ex. 3.9a). However, the octave doublings and triadic statements that do not refer to either row (beginning especially in mm. 19–20 and 22–23, and the final 20 measures; exx. 3.9b and 3.9c) begin to disrupt what had been orderly statements of the row. The increase in octaves and obsessively repeated toccata-like patterns over the course of the movement suggests that in the

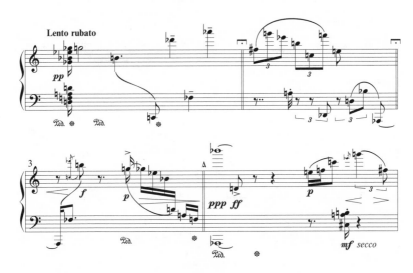

Example 3.8a. *Musica Stricta,* movement III, measures 1–4.

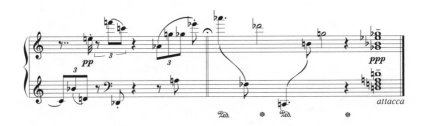

Example 3.8b. *Musica Stricta,* movement III, measures 23–24.

course of composition Volkonsky got caught up in the dramatic momentum of the piece and instinctively reached for the vocabulary of Prokofiev's (or Bartók's) piano pieces from the 1910s and 1920s.[55]

55. Such an interpretation is bolstered by the fact that Volkonsky's early studies consisted of "sight reading and improvising" at the piano. See NVV: 92. Ledenyov also remembered Volkonsky's affection for Prokofiev while a student. See Ledenyov, "Mne vsegda khotelos' idti ot emotsiy," 20. For more on the connections between Prokofiev and Volkonsky in this movement, see Schmelz, "After Prokofiev."

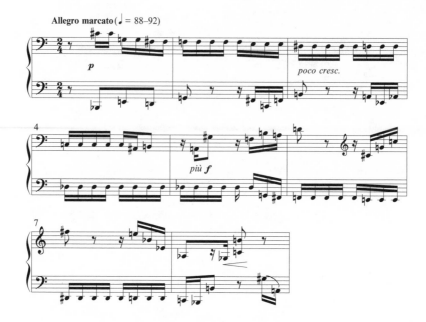

Example 3.9a. *Musica Stricta*, movement IV, measures 1–8.

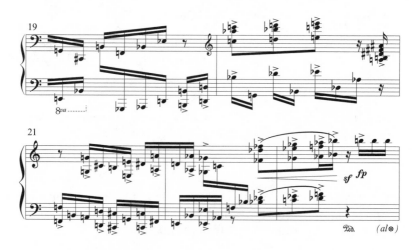

Example 3.9b. *Musica Stricta*, movement IV, measures 19–23.

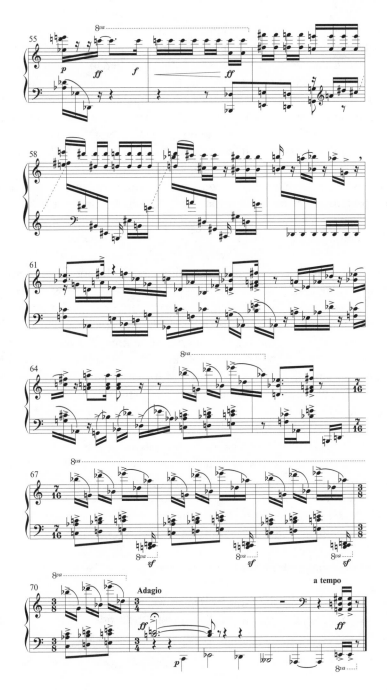

Example 3.9c. *Musica Stricta* movement IV, measures 55–end.

The second and fourth movements of *Musica Stricta* demonstrate how strongly Volkonsky still felt the pull of traditional forms, just as Schoenberg and Webern had been strongly influenced by earlier forms when working with twelve-tone techniques for the first time. Tradition offered him a crutch, a comfortable means for dealing with a technique he was not fully familiar with. And tradition influenced him not just formally, but stylistically as well. When I spoke to him in 1999, he acknowledged this by stating that there were "remnants of neoclassicism in the second movement, and a little Bartók in the finale."[56] He has also singled out Hindemith as an influence.[57]

In his 1974 German article Volkonsky mentioned more specific, and more contemporary, models for the work: "The first serial composition that I composed myself had a little from all of these influences [Schoenberg, Berg, Webern, Stockhausen, Nono, and Boulez], because the pieces by Schoenberg and the pieces by Stockhausen were all completely new to me."[58] As he said to me: "Somehow I learned about everything suddenly, not only the Second Viennese School, but also what was happening then in the West. It was as if everything arrived at the same time."[59] Yet it is unlikely that he was following any of these composers (and particularly the younger three) literally when composing *Musica Stricta*, for Volkonsky also admitted to me his unfamiliarity with twelve-tone techniques while at work on the piece, and exhibited some of the defensiveness characteristic of his generation's attitudes toward their first "avant-garde" experiments. Referring to the period before he started composing *Musica Stricta*, he told me:

> I decided that I didn't understand [twelve-tone] techniques very well. I understood [them] in principle. But there [in *Music Stricta*] I did everything incorrectly. And it's good that I did it incorrectly. Because there are octaves, for example, which Schoenberg forbade, and there are also triads, which he also forbade. But I simply didn't know that; I thought that I had written a twelve-tone composition. And it's true that [those techniques] exist in places [in the piece]. But I named it *Musica Stricta* because of the strict techniques, although I used them entirely according to my own manner.[60]

At the time, Volkonsky thought he had written an orthodox twelve-tone composition. That his approach differed from the models he was ostensibly

56. Volkonskiy, interview, 21 October 1999. In 1974 Volkonsky wrote, "It was okay that I wrote Neoclassical music for so many years because I didn't know anything else" (Volkonskiy, "Sprechen, ohne gehört zu werden").

57. NVV: 119.

58. Volkonskiy, "Sprechen, ohne gehört zu werden."

59. Volkonskiy, interview, 21 October 1999.

60. Ibid. He expresses a similar sentiment in NVV: 119–20.

following shows us something about the uneasy position he and the members of his generation occupied during the 1950s and 1960s. They desperately wanted to emulate the West, and were condemned for doing so at home. It was only when they gained fuller access to twelve-tone scores from the West in the 1960s and 1970s that they realized they had been doing it "incorrectly."

For its first audiences, by contrast, the sound of the piece was captivating enough: that it was based on an intuitive, sui generis application of the technique made little difference. As the theorist Yuriy Kholopov noted, coining a word useful for our understanding of Soviet serialism: "It is not necessary for the listener to distinguish the number of tones in the series, for they hear the twelve-toneness ['dvenadtsatitonovost']."[61] However, Soviet listeners had few chances to hear the composition. Volkonsky first performed *Musica Stricta* in late 1957 or early 1958 before a small audience at a jubilee in honor of the seventy-fifth birthday of the artist Artur Fonvizin (1882/3–1973) at the Moscow House of Artists ("Moskovskiy dom khudozhnikov"). Yudina, the work's dedicatee—and, as we have seen, already a Volkonsky partisan—heard the work at this event and, in Volkonsky's words, "then and there decided to play it."[62] Yet the first truly public performance had to wait nearly four years, until 6 May 1961, when Yudina played it at the Gnesin Institute in Moscow, where she had been teaching until the end of the 1959–60 school year.[63] The work was part of her repertoire for the 1960–61 season, and as she wrote in a late-1960/early-1961 letter to Volkonsky, she had initially intended to perform it

61. Kholopov, "Initsiator," 10.

62. NVV: 219. Fonvizin was born on 31 December 1882 (Old Style)/11 January 1883 (New Style), and the exhibit probably ran from December to January. The date was 1957 according to Lerner, ed., *Artur Fonvizin*, 57–58. Another source on Fonvizin puts the seventy-fifth anniversary exhibit in 1958. See Zagyanskaya, *Artur Vladimirovich Fonvizin*, 36–37 and the final "Chronicle of the Life and Work of A. V. Fonvizin."

63. In a letter to Pierre Souvtchinsky dated 3 March 1961, Yudina wrote that "on the 26th of this month...I will yet again play the 'premiere' of Volkonsky's *Musica Stricta* ('Fantasia Ricercare'), dedicated to me—a remarkable work from 1957" (Bretanitskaya, ed., *Pyotr Suvchinskiy i yego vremya*, 346). Yudina moved the performance from 26 March to April, and then again to the beginning of May, when it finally occurred. Kuznetsov, interview, 15 September 2004. Regarding Yudina's dismissal from the Gnesin Institute, see Yudina, *Mariya Yudina: Luchi bozhestvennoy lyubvi*, 709. In a letter to Volkonsky started on 22–23 December 1960 and finished after 3 January 1961, Yudina refers to her dismissal: "For as you know they expelled me from the so-called institute for playing new music, most likely Pasternak and other thoughts...." The last phrase refers to Yudina's penchant for reciting "off-limits" poetry before her concerts. This letter is in the archive of Anatoliy Kuznetsov, who kindly provided me with a facsimile. It was also published in a shortened version in *Moskovskaya pravda*, 3 September 1989, and in *Muzïkal'naya zhizn'*, no. 8 (1999): 8. Finally, "*Drugoye iskusstvo*" provides a date for a performance of *Suite of Mirrors* and *Musica Stricta* of 29 January 1961. But as Kurtz notes, this date is "unreliable"; for one, it includes a piece, Denisov's Violin Sonata, not composed until 1963 (see later). Talochkin and Alpatova, eds., "*Drugoye Iskusstvo*," I:29 (Second Ed. 68–70); Kurtz, *Sofia Gubaidulina*, 298–99.

on a trip to Paris in late 1960 that was canceled at the last minute.[64] (If anything must be considered the "beginning of postwar Soviet New Music," it is the 1961 Gnesin Institute public premiere of *Musica Stricta* and not the 1962 premiere of *Suite of Mirrors* insisted upon by Kurtz and Köchel, both following Aygi.[65])

It seems fitting that Yudina, a figure already known for her nonconformity, should have given the premiere of Volkonsky's peculiar piece.[66] In the 1960s she went through a period when she would play only "modern" pieces, deciding, as Karetnikov tells it, that Beethoven and Brahms were "boring and obsolete." She suffered for this attraction to "new music": first she was fired from her job at the Gnesin Institute and later was prevented by the Union of Composers from concertizing or making recordings until "the desire to play 'old' music returned to her."[67] Yet Yudina's interest in new music was predicated on the fact that for her much of it was not new at all; she had heard and performed most of it in the 1920s (after all, she had performed alongside Shostakovich in the Soviet premiere of Stravinsky's *Les noces* in 1926). Yudina thus served as a crucial bridge across the chasm of the Stalinist 1930s and 1940s, the "forgotten years" that haunted all of the "young composers" save Volkonsky (at least in part). It was natural that the two would be drawn to one another.

The first half of the concert at the Gnesin Institute began with the first prelude and fugue from Bach's *Well-Tempered Clavier*, followed by Hindemith's Sonata for two pianos (1942) and Bartók's Sonata for two pianos and percussion (1937).[68] The only piece after the intermission was *Musica Stricta*, which Yudina played twice. Yudina's premiere of *Musica Stricta* contributed

64. Yudina to Volkonsky, Moscow, 22–23 December 1960/3 January 1961.

65. Kurtz, *Sofia Gubaidulina*, 82; Jürgen Köchel in Danuser, Gerlach, and Köchel, eds., *Sowjetische Musik im Licht der Perestroika,* 439 (Köchel provides an incorrect date for this concert, see later); and Aygi and Adamenko, "Sud'ba Andreya Volkonskogo," 10 (cited in NVV: 37).

66. Davïdova claimed that Yudina and Volkonsky were the only two musical figures in the 1960s that she would call "dissidents." Davïdova, interview, 14 September 1999. For a more sanitary Soviet-era appreciation of Yudina, see Kuznetsov, ed., *Mariya Veniaminovna Yudina: Stat'i, vospominaniya, materialï.* Volkonsky's name does not appear in the repertoire list at the end of the book.

67. Karetnikov, "M. V. Yudina," in *Gotovnost' k bïtiyu,* 66–67. After returning from a 24 February to 1 March 1963 tour of the Russian "Far East," Yudina was denounced in a letter ostensibly written by a group of listeners who had heard her in Khabarovsk (reportedly the director—I. I. Tesnek—and the teachers at the Khabarovsk Music School [Khabarovskoye muzïkal'noye uchilishche]). They were upset by her performance and advocacy of "formalist" compositions by Stravinsky, Volkonsky, and Hindemith. As a result, the concert organizations of the Soviet Union, including Roskontsert and Goskontsert, were ordered to stop programming Yudina, and she was prevented from teaching. Yudina was able to return to concertizing only in the fall of 1966. Yudina, *Mariya Yudina: Luchi bozhestvennoy lyubvi,* 712 and 291–92; see also Yudina, "A. M. Volkonskiy," 252.

68. There is no central archive of concert programs in Russia today, aside from an uncatalogued and incomplete collection at the Moscow Conservatory, and some programs in the holdings of the Soviet Union of Composers and the Moscow Philharmonic at RGALI. The concert programs for works by the "young composers" that I have been able to obtain were drawn exclusively from private collections.

greatly to its reception as an oppositional work. She approached the performance of the piece aggressively, for as Volkonsky put it, "she loved that kind of provocation." According to Volkonsky, Yudina turned to the audience before playing and said: "I am going to play a new composition, but I will play it two times because you may not understand it. I will repeat it and don't applaud after the first time, applaud only after the second."[69] Aleksey Lyubimov remembers her comments somewhat differently. "Yudina's concerts were generally very significant occurrences," he recalled: "[*Musica Stricta*] pleased the public.... They already knew Volkonsky and talked about the fact that it would be something unusual.... And after the applause [following the performance, Yudina] said, 'Let's listen to that ingenious music again.'"[70] Anatoliy Kuznetsov recollected that the stagehands then appeared to remove the microphone and dimmed the lights on stage; Yudina played the second time in "complete darkness," while the audience remained illuminated.[71] (Yudina later noted that "*beforehand* they asked me not to repeat it as an encore, and it was necessary to 'submit' ['prishlos' 'pokorit'sya']...in order not to complicate the life of Andrey Volkonsky"; Yudina clearly reneged on her initial promise.[72])

The audience apparently took Yudina's instructions in stride. At the time there was, according to Volkonsky, "a tremendous curiosity about new things that it is difficult to conceive of today."[73] Not everyone, however, enjoyed the new music. One audience member was Roman Ledenyov, himself a "young composer" who would soon develop a strong taste for Webern's music. Ledenyov remembers being unimpressed by *Musica Stricta,* calling it a "dry piece" ("sukhaya veshch'"). He suggested to me in conversation that other audience

Unfortunately, the program for the Moscow premiere of *Musica Stricta* was not to be found among them. The information regarding the pieces at this performance was compiled by Yudina scholar Anatoliy Mikhaĭlovich Kuznetsov, who kindly supplied it to me (Kuznetsov, interview, 19 October 2000). See also Slushatel' [a listener], "Na kontserte M. Yudinoy."

69. Volkonskiy, interview, 21 October 1999. See also NVV: 220.

70. Lyubimov, interview. Kuznetsov also remembered the announcement as following Yudina's first rendition of *Musica Stricta*. Kuznetsov, interview, 30 January 2001. Yudina's repetition might have been inspired by the example of Schoenberg's Society for Private Musical Performances (Verein für musikalische Privataufführungen), but there were Soviet precedents as well, among them the 9 January 1927 Moscow premiere of Shostakovich's Piano Sonata No. 1. The Sonata had not been well received at its premiere in Leningrad, so at his Moscow performance Shostakovich repeated it "for the sake of a better mastering of the music" by the audience. See "Shostakovich: Letters to His Mother, 1923–1927," 21 and 22 n. 1.

71. Kuznetsov, interview, 30 January 2001. There is a photograph of Volkonsky and Yudina on stage after the premiere, together with a photograph of the performers after the Bartók Sonata for two pianos and percussion on the same program. See photo insert between pp. 200–1 in Yudina, *Vï spasyotes' cherez muzïku.*

72. Yudina, "A. M. Volkonskiy," 251.

73. Volkonskiy, interview, 21 October 1999.

members might have felt the same way, although, judging from other eyewitness reports, the detractors were clearly in the minority.[74]

By all accounts, when the piece was performed in Leningrad five days later audiences were as curious and enthusiastic as those in Moscow had been.[75] An advertisement for one of the Leningrad concerts proudly proclaims: "All pieces performed for the first time [in Leningrad]," which was undoubtedly true (fig. 3.1). The piece was heard in two Leningrad venues— first on Thursday 11 May at the Concert Hall at the Finland Station, while on Friday 12 May the program was repeated slightly altered at the Leningrad House of Composers. At the first Leningrad concert the program was *Musica Stricta*, Stravinsky's Sonata for two pianos (1944), and Lutosławski's Variations on a theme of Paganini for two pianos (1942) on the first half, followed after the intermission by Bartók's Sonata for two pianos and percussion (see fig. 3.1). A program from the second concert with Yudina's annotations indicates that the Hindemith Sonata from the Moscow concerts now replaced the Lutosławski Variations, while *Musica Stricta* was disguised, now identified only as "Fantasia" (its partial subtitle—the full subtitle was "Fantasia-Ricercare" ["Fantaziya-Richerkata"]). Bartók's sonata again ended the concert (fig. 3.2).

In an essay from 1966, Yudina recalled that the hall at the House of Composers was "jam-packed" and that "after the Bartók, after all the curtain calls and bows…," her friend, Leningrad composer Mikhaíl Matveyev (b. 1912), came up to her and declared, "We all were overwhelmed."[76] Yudina maintained Volkonsky's composition in her repertoire, and her approach to performing it became still more aggressive, until eventually she began to get the attention of the authorities. On 19 November 1961 at a concert in the Small Hall of the Leningrad Philharmonic, Yudina played Webern's Variations, Op. 27, and Volkonsky's *Musica Stricta* (both twice) and read poetry by Pasternak and Nikolai Zabolotsky from the stage. As a result of this concert and the "scandal" it provoked, Yudina was prohibited from taking

74. Ledenyov, interview. Ledenyov spoke more approvingly of Volkonsky's early works to McBurney, declaring of one unnamed composition (possibly *Musica Stricta*): "I can still remember that music in all its details." See McBurney, "The Music of Roman Ledenev," 25.

75. The ethnomusicologist Margarita Mazo recalls attending the second Leningrad performance, and echoes the excitement of many who witnessed these early Volkonsky concerts. E-mail to author, October 2003. For her perceptive observations on the late Soviet music scene see Mazo, "The Present and the Unpredictable Past."

76. Yudina, "Ob istorii vozniknoveniya russkogo teksta (perevoda) 'Zhizni Marii' Rainera Marii Ril'ke," 173–74. In this essay, Yudina also remembered the concert as "one of my most successful concerts with my young partners; we were many, we were happy, we rehearsed literally day and night" (p. 173). A photograph of Yudina and the other performers following the performance of the Bartók Sonata for two pianos is reproduced in ibid., in the photo insert after p. 704 (the top of the seventh page of the insert).

Figure 3.1. Advertisement for the Leningrad premiere of *Musica Stricta* (Thursday, 11 May 1961).

Пятница
12
МАЯ
1961г.

Вечер из цикла:

„НАШИ ГОСТИ"

Профессор Мария Вениаминовна
ЮДИНА

Марина ДРОЗДОВА

Руслан НИКУЛИН

Виктор ДЕРЕВЯНКО

Валентин СНЕГИРЕВ

ВЕЧЕР
СОВРЕМЕННОЙ МУЗЫКИ

В программе:

I отделение

Андрей Волконский — Фантазия — *Musica stricta"* Juter Rata
Исполняется в первый раз

Игорь Стравинский — Соната для
двух роялей соч. 1944 г.
Исполняется в первый раз

Пауль Хиндемит — Соната

Витольд Лютославский — Вариации
на тему Паганини для двух роялей
Исполняется в первый раз

для 2-х ср-но (1942)

II отделение

Бела Барток — Соната для двух
роялей и ударных инструментов
Исполняется в первый раз

Figure 3.2. Program for the second Leningrad performance of *Musica Stricta* (Friday, 12 May 1961, at the Leningrad House of Composers), with Yudina's annotations and emendations.

part in concerts organized by the Leningrad Philharmonic (the concert bureau).[77]

The official response to *Musica Stricta* was predictable, if not immediate. A negative review appeared in *Sovetskaya muzïka* in July 1961, two months after the Gnesin Institute concert. It was typically signed anonymously by "a listener" ("Slushatel'"), and it provides a tantalizing, if slanted, glimpse of the Moscow audience's reaction. The "listener" reported: "Yudina performed [*Musica Stricta*] twice, and then with enthusiasm and persistence encouraged the audience to call out the composer. The public, doing justice to the power

77. Kuznetsov, interviews, 19 October 2000 and 30 January 2001; Yudina, *Mariya Yudina: Luchi bozhestvennoy lyubvi,* 486 n. 6, 176 n. 33, and 292; and Yudina, "A. M. Volkonskiy," 251–52. In this last source, Yudina claimed that after this performance "my concertizing was halted ['moya kontsertnaya deyatel'nost' bïla prekrashchena']," but again this "halting" only applied to her activities in Leningrad, as evidenced by her February 1962 Lvov performance of *Musica Stricta*.

and authority of the pianist, awarded the creator with applause. But the work of A. Volkonsky left a fundamental feeling of deep incomprehension, dissatisfaction, and, more than anything, fear for his creative future ['sud'ba'].["][78] These comments are highly biased, eliding the audience's apparent enthusiasm in the second sentence with the official response in the third. Readers would assume that the "public" had been left with a "fundamental feeling of deep incomprehension," when instead the "listener" and his handlers were presenting a veiled threat to Volkonsky. This threat itself represented a crucial shift in the official stance toward the "young composer," for it was the first time this tone was taken with either his compositions or his "future."

Significantly, the "listener" later undercut this account, and suggested that following the concert any sense of incomprehension and dissatisfaction (if it had really existed in the first place) gave way instead to excitement: "In the lobby were heard conversations alleging that it was 'so new!' "[79] If this is an accurate reading of events, it implies that *Musica Stricta*'s novelties outweighed any difficulties they might have presented the audience.

The review went on to praise Yudina's playing, as well as Bartók's composition, while lambasting Hindemith ("technically refined but chilly") and unleashing a two-column attack against Volkonsky.[80] The concluding comments indicated the attitude of the Union of Composers toward Volkonsky at the time: their unwillingness to let him vanish into obscurity. Quite the contrary, for as the "listener" wrote: "For some reason the Moscow Union of Composers has given little attention to the works of such gifted composers as Volkonsky. One must find the true path to his heart, to make the young composer believe in the benevolence of public criticism, and believe that our harsh judgments are dictated only by the sincere wish to see Volkonsky at the forefront of the young creators of Soviet music."[81] They still believed that the "gifted composer" Volkonsky could be saved with "benevolent," if "harsh," public criticism. In light of Volkonsky's later career, these pronouncements seem hopelessly naive indeed. Volkonsky was apparently the authorities' favorite scapegoat among the "young composers." Instead of silence he received constant mention in the Soviet press, and although his stream of unsatisfactory works had repeatedly tested the limits of official tolerance, nothing was done to prevent his new compositions from receiving performances. (Another mention of *Musica Stricta* appeared later in 1961 when Sergey Aksyuk criticized

78. Slushatel' [a listener], "Na kontserte M. Yudinoy," 89.

79. Ibid.

80. Ibid. Other eyewitnesses with whom I spoke claimed that Yudina actually had a great deal of difficulty in playing the piece. Baltin remembered Volkonsky himself commenting on the numerous wrong notes in her performance. Baltin, interview. She also took liberties with his dynamic markings (NVV: 167–68).

81. Slushatel' [a listener], "Na kontserte M. Yudinoy," 89–90.

Volkonsky in an article from the 4 November 1961 issue of *Sovetskaya kul'tura* titled "Forward March, Music!"[82] And Yudina also drew critical press in an article testily titled "This Is Not Music" after her performance of *Musica Stricta* on 22 February 1962 at the Large Hall of the Lvov Conservatory.[83]) Volkonsky proved emblematic of both the inefficiency of the Soviet system as well as its need for visible targets to help articulate official policy. Like Shostakovich in 1936, Volkonsky enabled officials to frame and form socialist realism during the immediate post-Stalin decade.

SUITE OF MIRRORS: EXOTIC TWELVE-TONENESS

From 1956 to 1960 Volkonsky was the only "young composer" experimenting with serial techniques. The other composers remained attached to the conservatories, and their music betrayed stronger allegiances to socialist realism than to the Western avant-garde (e.g., Schnittke's *Songs of War and Peace* [*Pesni voynï i mira*] or Pärt's *Our Garden*, Op. 3 [*Nash sad*, or in Estonian *Meie Aed*] both 1959).[84] But Volkonsky continued to explore the abstract stylistic and formal world he had begun working with in *Musica Stricta* in his next compositions, including the brief, thoroughly serial *Serenade for an Insect* (1958–59[85]), as well as in the unpublished *Music for Twelve Instruments* (1957).[86] *Serenade for an Insect* intricately unfolded and exhausted all forty-eight possible row forms (prime, retrograde, inversion, and retrograde inversion, and their transpositions) over the course of its thirty-seven measures.[87] As might be expected,

82. Aksyuk, "Razvorachivaisya v marshe, muzïka!" See also Schwarz, *Music and Musical Life in Soviet Russia*, 344–45.

83. Durnev, "Eto ne muzïka," cited in NVV: 189–90.

84. In the same speech in which he condemned Volkonsky, Aksyuk praised these two compositions. Aksyuk, "Razvorachivaisya v marshe, muzïka!" A recording of Pärt's composition is available: Pärt, *Pro and Contra*.

85. Drozdova, Lemaire, and Kholopov all agree on 1958 for the work, but the Belaieff score is dated 1959 (Drozdova, "Andrey Volkonskiy" [diss.]; Lemaire, "Volkonsky, Andrey Mikhaylovich"; Kholopov, "Initsiator"; and Volkonsky, *Sérenade pour un insecte*).

86. All sources agree on the date for this composition (Drozdova, "Andrey Volkonskiy" [diss.]; Lemaire, "Volkonsky, Andrey Mikhaylovich"; Kholopov, "Initsiator"). Krebs mentioned that Volkonsky intended to write an opera in the late 1950s or early 1960s (the period is unclear, but seems to be shortly after the Viola Sonata) that was to have included three orchestras: "a small chamber group, a jazz band, and an orchestra of Russian folk instruments." (See Krebs, *Soviet Composers and the Development of Soviet Music*, 460 [diss.] and 340 [book].) It is possible that this work eventually became his unpublished, nonoperatic *Les Mailles du temps* (*Uzelki vremeni*) for three groups of instruments (1968–69; Drozdova, Kholopov, and Lemaire are in agreement here). See also NVV: 126.

87. Volkonskiy, interview, 30 July 2004. Volkonsky told Czech composer Václav Kučera that he named his composition after awakening from a nap to find a dragonfly perched on the score (Kučera, *Nové proudy v sovětské hudbě*, 21). Volkonsky tells the story himself in NVV: 120–21. For a brief notated example see Schmelz, "Andrey Volkonsky and the Beginnings of Unofficial Music in the Soviet Union," 180.

Volkonsky resorted to frequently convoluted row presentations to achieve this *recherché* goal. The work's serial framework, with its fragmented and overlapping row statements, is obscured in performance (aided by its programmatic title). Despite its detailed construction, the pointillistic, motivically driven *Serenade* is accessible and engaging, its style similar to Schoenberg's *Five Pieces for Orchestra*, Op. 16. This resemblance is not accidental, for as Volkonsky told a *New York Times* correspondent in 1973 "my overnight, radical transformation as a composer came when I first heard [Schoenberg's] 'Five Pieces for Orchestra.'"[88] In fact, on 30 June 1962 Volkonsky wrote a letter requesting scores to Schoenberg's widow, Gertrud, in which he proclaimed: "For me and my friends, Schoenberg is God the Father for our Time, and he is in the line of great German music (Bach, Beethoven, Wagner, Mahler). I must tell you that I am somewhat afraid in writing to you because for me Schoenberg is truly a God since he was able to create the universe and all that it includes."[89] Inspired perhaps by his infatuation with Schoenberg's music, Volkonsky's next composition after *Serenade for an Insect* reportedly went even further in its serial structures.

According to Václav Kučera, Volkonsky explored "total serialism" ("multi-serialisma") in his *Music for Twelve Instruments,* but decided that it was not for him: "I had to undergo this 'trial by fire.' For me it was a significant milestone. To go further in terms of rational musical construction would scarcely be possible without the help of a counting machine. It would also be useless. Beyond the limits of total serialism there is already almost no room for creating."[90] Without the evidence of the score, which remains unpublished, the degree to which Volkonsky serialized multiple parameters, if at all, in this composition remains unclear. When asked recently whether *Music for Twelve Instruments* involved multiple serial elements, Volkonsky said yes, but admitted that he did not remember the score very well. He said that he thought the rhythm

88. Kamm, "Composer Tells of Artistic Battle in Soviet," 14. In this article, the date Volkonsky claimed he first heard this composition, 1965, must be incorrect—1955 would make more sense in terms of his stylistic evolution (this is not the only dating error in the piece). Volkonsky also admitted to me that this was the Schoenberg composition that he most admired (although he claimed to like only the first movement; Volkonskiy, interview, 21 October 1999).

89. 30 June 1962 letter from Andrey Volkonsky to Gertrud Schönberg. Arnold Schoenberg Center, Gertrud Schoenberg Collection (Satellite Collection S4). "Pour moi comme pour mes amis, Schönberg est Dieu le Père pour notre Temps et il est de la lignée de la grande musique allemande (Bach, Beethoven, Wagner, Mahler). Il faut vous dire que j'avais un peu peur de vous écrire, car pour moi Schönberg est veritablement un Dieu, parce qu'il a su créer l'univers, avec tout ce qu'il comporte." I am indebted to Reynold Tharp for his translation assistance. I also am grateful to the Schoenberg Center and to Eike Fess at the archive for providing me a copy of this letter. Volkonsky told the *New York Times* correspondent in 1973 that Gertrud Schoenberg had sent him Schoenberg's monogrammed wallet, but the Schoenberg Center has no record of this.

90. Kučera, *Nové proudy v sovětské hudbě,* 21.

was not serialized, although the notes were, and, of course, the "number of instruments was significant."[91] Volkonsky later reworked the material in *Music for Twelve Instruments* (including changing the instrumentation) and used it "symbolically" in his "anti-serial" composition *Immobile* for piano and orchestra (1977–78).[92] He was referring to the section from rehearsal 10 to 11 in *Immobile*, the moment when the second instrumental group (consisting of twelve instruments, naturally) enters for twelve measures. In this brief section each instrument unfolds one of the twelve transpositions of the prime form of the row (with some alterations and repetitions), but neither the dynamics nor the rhythm appears to be serialized. Although Volkonsky claimed that much of the original remained in this section of *Immobile*, the relationship between the two compositions remains to be fully explored.[93] Whether or not *Music for Twelve Instruments* was an exercise in total serialism, it and *Serenade for an Insect* reveal Volkonsky's enduring interest in serial methods; despite his "trial by fire," Volkonsky continued to actively draw upon serial techniques in his succeeding compositions.

Like *Musica Stricta*, his next major work demonstrated his personal interpretation of the techniques and presented an even better example of what Pärt later called "dancing on one leg." As Pärt told an interviewer in 1986:

> Yes, [my music from the 1960s] was influenced by such things as twelve-tone, serial and aleatoric music; all that came to us from the West. Perhaps someone had also done it in Russia but we didn't know about it. For example, when I was studying we had two books of exercises by Eimert and Krenek and that was all, apart from a few odd examples or illegal cassettes. But one doesn't need to know that much—if someone says that there's a country where the people dance on only one leg and you've never seen it, then you can try it yourself if you want: you might do it better than the people who did it in the first place![94]

Volkonsky's subsequent attempt at "dancing on one leg" was a set of songs for soprano and instrumental ensemble called *Suite of Mirrors* (1960), based

91. Volkonskiy, interview, 30 July 2004. The composition could not be obtained from Volkonsky, as he was unsure of its location, a situation exacerbated by his poor health.

92. Ibid. Kholopov and Lemaire both agree on these dates, while Drozdova and the Salabert score both indicate 1978 (Drozdova, "Andrey Volkonskiy" (diss.); Lemaire, "Volkonsky, Andrey Mikhaylovich"; Kholopov, "Initsiator"; Volkonsky, *Immobile*). For more on this composition see NVV: 206.

93. Volkonskiy, interview, 30 July 2004.

94. McCarthy, "An Interview with Arvo Pärt," 130–33. Pärt does not mention Volkonsky here, but it is likely that by the mid-1960s he would have known of him, if not his early compositions like *Musica Stricta*. This account of how Pärt became familiar with twelve-tone techniques is also recounted in Bradshaw, "Arvo Paart," 25–28.

on a "suite" of poems with the same title by Federico García Lorca.[95] Volkonsky's setting of the poems presents a unique "mirrored" reading of Lorca's enigmatic, repetitive, "musical" texts, through a rigorous reinterpretation of serial techniques developed from his early usage in *Musica Stricta*. Nonetheless, like the earlier piano composition, several movements in the suite are not exclusively serial. As a whole, it was an even better example of the rapidity with which the young Soviet composers adapted the basic techniques of serialism (or what they took to be the basic techniques) to fit their own changing aesthetic goals. Denisov was one of those most struck by Volkonsky's newest work. In a controversial 1966 Italian article (we will return to this more fully in chapter 4) he described *Suite of Mirrors* as a "magnificent" piece and "one of the best creations of Soviet music." Furthermore, he provocatively asserted that "the influence it exercised on the young generation in the USSR is comparable only to the one made by the Fifth Symphony of Shostakovich, which also represents one of the decisive moments in the evolution of Soviet music."[96]

For the Soviets, Lorca was an officially acceptable poet, because he was a "heroic Spanish poet-democrat, killed by fascists."[97] However, Volkonsky's piece, and particularly the evocative, abstract, and unclear texts that he selected for setting, directly opposed the clarity and accessibility demanded by the aesthetics of socialist realism. It is no wonder that it would become one of the most important compositions of the decade, having a great impact on the other unofficial composers and spawning several prominent imitations by creators from Denisov to Gubaidulina. Volkonsky's setting portrayed another side to the revolutionary Lorca, one where heroic zeal gave way to exotic abstraction.

Suite of Mirrors as written by Lorca consisted of fourteen poems, of which Volkonsky selected nine.[98] When asked why he picked Lorca and those particular texts, Volkonsky was unhelpful, saying that he picked the cycle simply because "I liked it."[99] The texts he did choose are opaque and impressionistic. Several of the texts employ religious imagery, explicitly mentioning Christ

95. The suites were written by Lorca when he was still young (1920–23), and most were not published in his lifetime. He had taken the idea of the suite from music, inspired by contemporary composers such as Debussy as well as by Renaissance or Baroque composers, and especially by Spanish Renaissance musicians like Mudarra, Narváez, and Cabezón. For more on the suites see the introduction to García Lorca, *Collected Poems*, xxx.

96. Denisov, "Le tecniche nuove non sono una moda," 12. This translation is from the Italian (with thanks to the late John Thow for his assistance): "La *Suite degli specchi* è una delle migliori creazioni della musica sovietica, e l'influenza da essa esercitata sulla giovane generazione nell'URSS si può paragonare soltanto a quella che ebbe la 'Quinta Sinfonia' di Sciostakovic, che rappresenta anch'essa uno dei momenti decisivi nell'evoluzione della musica sovietica."

97. Keldïsh, "Pesnya, kotoraya ne prozvuchala," 129.

98. According to Aygi, Volkonsky wanted to set the poems in their original Spanish, but had only a *samizdat* edition of Lorca's poems in Russian translated from the Spanish by the poet Vladimir Burich (1932–94). Aygi, interview.

99. Volkonskiy, interview, 21 October 1999.

(No. 1, "Credo/Simvol/Simbolo"; see ex. 3.10), God (No. 4, "Rays/Luchi/Rayos";
see ex. 3.12), and Adam and Eve, as in No. 8, "Initium/Nachalo/Initium":

Adam i Yeva.	Adam & Eve.
Zmey-iskusitel' razbil	The serpent cracked
na sotni melkikh oskolkov	the mirror
zerkalo,	in a thousand pieces,
kamnem	& the apple
yabloko bïlo.	was his rock.[100]

Although these three poems refer to religious figures, and several others
evoke a general mysticism, the overwhelming abundance of images in the
cycle (most of which are not religious) and the uncertain, fleeting manner in
which these specific religious images are presented, mitigated any subversive-
ness "Christ" or "God" might have presented for the atheistic Soviet authori-
ties, a fact borne out, as we shall see, by the early reception of the work.[101]
Instead, the intent of most of the poems was highly ambiguous, as in No. 2,
"The Giant Mirror/Velikoye zerkalo/El gran espejo":

Mï zhivyom	We live beneath
pod zerkalom velikim.	a giant mirror.
Chelovek goluboy!	Man is blue!
Osanna!	Hosanna!

Most of the texts to *Suite of Mirrors* are of the latter sort, any potential subver-
siveness lying in the sheer impenetrability of their abstract images.[102]
 The literary scholar Nigel Dennis has provocatively interpreted "Initium"
in terms of Lorca's wider output: "Man's fall from grace, in other words, is
conveyed by means of the destruction of the instrument [the mirror] that
enabled him to see himself in his entirety, as an inviolate whole. Man's essential
condition—and one might say the essential condition of Lorca's poetry too—is
initially determined not only by his expulsion from the Garden of Eden but

100. This translation and all of the others from the *Suite of Mirrors* are by Jerome Rothenberg and
are taken from García Lorca, *Collected Poems*, 168–79.
 101. When officials came to observe the rehearsals before the premiere, the cautious performers
decided to only vocalize the words "God" and "Christ." Yet when the words were sung at the premiere,
none of the subsequent criticism singled them out. NVV: 124.
 102. Lorca's suites have resisted easy characterization by literary scholars. Generally, the suites have
been noted for their "wistful tonality" as well as their "gentle irony and mock sentimentality" (Maurer,
introduction to *Collected Poems*, xxxi). Some have also remarked upon the "randomly kaleidoscopic"
manner of some of the poems (like "He" ['Él'] from *The Forest of Mirrors* [*La selva de los relojes*]), as well
as the "pretentiousness" of others, especially the briefest moments of *Suite of Mirrors* (like "The Giant
Mirror" or "Rays"; Walters, *Canciones and the Early Poetry of Lorca*, 110–11).

also by his fragmentation. His subsequent destiny, in figurative terms at least, is to search among the splinters of that shattered mirror for his own lost innocence and identity."[103] This reading compellingly matches Volkonsky's position in Soviet society at the time, and especially his relationship to the lost "Eden" of his European childhood, for the *Suite of Mirrors* obviously resulted from his own "search among the splinters" of musical modernism as he struggled to find his own compositional "identity." Volkonsky's selection of the texts suggested an interest in provocative pictures and exotic subjects that would allow him to try new techniques as well as experiment with new instrumental colorings, including vocal colorings. He took full advantage of the repetitions, pauses, and non sequiturs of Lorca's texts by creating numerous symmetrical constructions that were derived from his earlier serial practice as seen in *Musica Stricta*, yet taken a step further. Symmetries, reflections, and refractions pervade the *Suite of Mirrors,* reflecting musically its elusive texts.[104]

The first song, "Credo," contains many of the ideas of symmetry that can be found throughout the later movements. As we have seen, the first image in the text is a religious one: "Christ, a mirror in each hand." The first pitches of "Credo" present a sonority, E♭-G♭, that will become a reference throughout the cycle, often as part of an E♭-minor triad (as in the second movement, "Giant Mirror" ["Velikoye zerkalo"], which uses an E♭-minor scale for its melodic pitch material, although the accompaniment often strays from this). Measures 3–4 of "Credo" also unfold a palindromic ordering of the pitches in the prime form of the basic series of the piece (P_0), a foreshadowing of what is to come (ex. 3.10). The symmetries and tonal references in the first measures of "Credo" are almost as important to the construction of the piece as the underlying serial and quasi-serial techniques.

The pitches in the opening measures (including the E♭-G♭) lay out the basic eight-note series to the work (P_0, E♭-G♭-F-D-A♭-C♭-B♭-G), the inversion (I_0, E♭-C-D♭-F♭-B♭-G-A♭-C♭) of which is presented linearly in measure 5. What is most important to note is that this series (in its first appearance) is constructed of transpositions of the same four-note motive (rising minor third, descending half-step, descending minor third: E♭-G♭-F-D; exx. 3.10 and 3.11). Volkonsky claimed to have picked primarily consonant intervals, and especially thirds, as the basis for this series because he "wanted to compose music accessible to the public, while still maintaining my newly acquired technique."[105] Despite these attempts to create a sense of "pseudotonality," the other aspects of the *Suite,* and especially the symmetrical orderings, diminished any traditional accessibility.

103. Dennis, "Lorca in the Looking-Glass," 43–44. Many thanks to Lorca scholar Melissa Dinverno for her helpful assistance in directing me to these sources.

104. For an evocative (if inaccurate) overview of Volkonsky's piece see also Cherednichenko, *Muzïkal'nïy zapas,* 56–57.

105. NVV: 121 and 207.

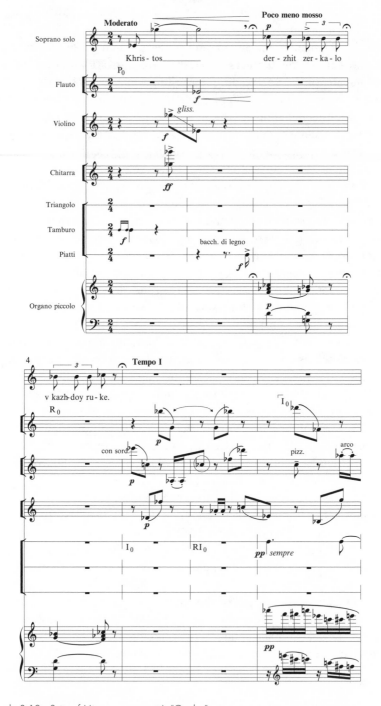

Example 3.10. *Suite of Mirrors*, movement I, "Credo."

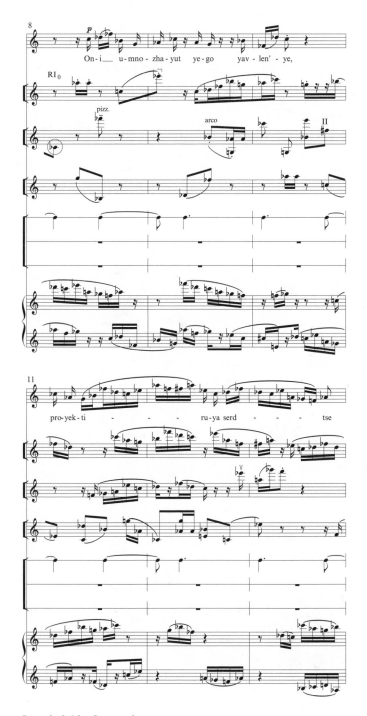

Example 3.10. *Continued*

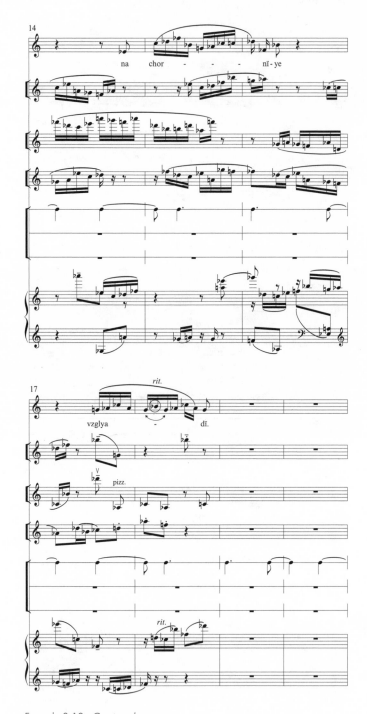

Example 3.10. *Continued*

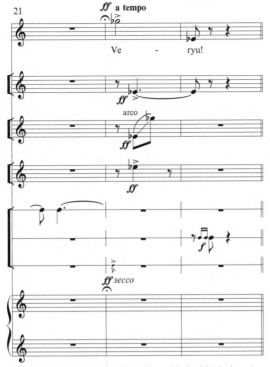

Christ, a mirror in each hand. / He multiplies his shadow. /
He projects his heart through his black visions. / I believe!

Example 3.10. *Continued*

Example 3.11. The basic series of *Suite of Mirrors*.

When something resembling a twelve-tone row does appear (as in mm. 11–12 in the soprano) it is comprised of eleven different pitches (the A♭ is repeated) and results from the retrograde form of I_0 running into a statement of I_5 (ex. 3.10). (Also notice that this statement of I_5 subsequently reverses course at the very end of m. 12, when the I_5 turns upon itself to become a statement of RI_5.) Thus, most of the piece is governed by a basic eight-note series constructed from two consecutive statements of the main four-note motive starting a perfect fourth apart and separated by a tritone (ex. 3.11).[106] This eight-note series governs enough of the musical material in this movement and the movements that follow to be called the basic series of the composition, but it is important to emphasize that it does not determine every single pitch within the composition, as the first movement aptly demonstrates. At an even more fundamental level, much of the material derives from individual statements of the four-note motive itself (as in the organ's left hand in mm. 9–10: E♭-C-C♯-E), or from the enjambment of several transpositions/permutations of either the motive or its retrograde, or fragments of both (as in the organ's left hand from mm. 7–12).

Of even greater moment are the palindromic presentations of the eight-note series, characterized by mirrored writing of the kind we observed in the third and fourth measures and the soprano in measures 12–13 of example 3.10. For example, measures 5–6 are symmetrical around the C♭ heard in the violin on the first eighth note of measure 6. This is also true with measures 7–8 (flute, violin, guitar) and measures 8–10 (voice), both around C♭ (on the first eighth note of m. 8—flute, violin, guitar—and the second sixteenth note of m. 9 in the voice), as well as the flute in measures 11–16 around the F♭ in measure 13. The vocal line in measures 17–18 is a palindrome around the central B♭, and its highest pitches—C♭, B♭, C♭—are also the central pitches of the palindromic vocal phrase in measures 3–4. Furthermore, the already identified mirroring in the voice in measure 12 on the F♭ (almost the exact middle of the movement) acts as the center for a large-scale palindrome that lasts from the B♭ in measure 8 until the B♭ in measure 18 (imitated by the flute in mm. 11–16). As this brief summary suggests, nearly every phrase displays this type of mirrored writing. The ending of the movement is also a retrograde of the opening, ending with the E♭, a move already prefigured by the extended reversal that takes place in the soprano in measure 12. "I believe" are the last words of the song, and if this is a statement of faith, it is a faith in intricate motivic permutations, palindromes, and exotic colorings.

106. As example 3.11 indicates, the last tetrachord of I_5 is identical to the first tetrachord of I_0, yet as the soprano melody in mm. 11–13 of example 3.10 shows (RI_0, I_5, RI_5), Volkonsky never elides the two forms. He does, however, use this identity to create a mirroring between the last four sixteenth notes of m. 11 and the last four of m. 12, a small-scale reversal that overlaps with the larger palindrome of mm. 12–14.

The brief fourth movement of *Suite of Mirrors,* "Rays/Luchi/Rayos," is the best encapsulation of Volkonsky's serial thinking in this composition. It both begins with the Eb/Gb referential sonority and is built on the basic series to the piece—P_0 in the violin and guitar, I_9 in the voice and flute. Furthermore, the entire movement is another palindrome, turning upon itself at the end of measure 8, not unlike Webern's Symphony, Op. 21, or Berg's *Chamber Concerto* (ex. 3.12). The final spoken line of the poem, "God is the pivot," implies this concern, a hint to listeners of what has just happened.

Like all the movements in this suite, however, the unusual timbres of "Rays" distinguish it from Volkonsky's extant earlier works, save *Serenade for an Insect.* The most notable example of these colorings in the suite is No. 6, "Shinto/Sintoizm/Sinto," which uses wood blocks, guitar, and organ to evoke an exotic Spanish/Asian fusion, the "small golden bells" and "dragon pagoda" of the text filtered through a young Soviet's stereotypes of Spanish music. Although this movement, like the castanets in the second movement, "Malagueña," of Shostakovich's later Fourteenth Symphony (1969, also a setting of a Lorca text), might strike listeners today as too obvious, it beguiled Soviet ears. Volkonsky's attraction to novel sonorities and unusual colorations would be further developed in his other compositions from the 1960s, chief among them his next vocal work, *Laments of Shchaza.*

Volkonsky's serial language in the first and fourth movements of *Suite of Mirrors* and in this composition as a whole is thus heavily indebted to the type of motivic writing initially observed in the first movement of *Musica Stricta.* It is a flexible yet controlled means of composing that has its roots in Schoenberg's atonal pieces as well as several of Webern's twelve-tone rows (for example, the rows to Webern's Op. 24 Concerto, the Op. 28 Quartet, and the Op. 30 Variations for Orchestra, all of which are based on transpositions and inversions of a basic three- or four-note motive). What is unusual is that Volkonsky had apparently foregone the complicated twelve-tone fugal structures of the later movements of *Musica Stricta*—to say nothing of the exhaustive serialism in *Serenade for an Insect* or the "total serialism" of *Music for Twelve Instruments*—in favor of this more motivic and "mirrored" type of writing.[107] For Soviet arts officials and Soviet audiences, by contrast, the resulting pointillistic sounds and their unusual instrumentation were still "avant-garde," abstract, and off-limits, and hence either repulsively "formalist" or attractively alien.

The first performance of *Suite of Mirrors* took place on a program that also included *Musica Stricta* and Azerbaijani composer Murad Kazhlayev's String

107. "Eyes" ("Glaza/Los ojos"), the seventh movement of the suite, is the single exception, as its opening resembles a fugal exposition. Here the opening flute melody (based on a new eight-note series derived from P_0) is immediately imitated (at a fourth) in the organ and violin (mm. 2–4), and repeated completely an octave higher in the soprano (mm. 5–8). Similar imitative textures permeate the remainder of the movement, but the quasi-fugal structure is abandoned.

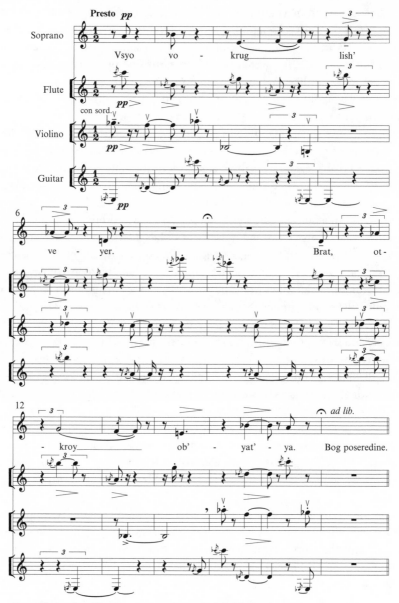

Everything's a fan. / Brother, open up your arms. / God is the pivot.

Example 3.12. *Suite of Mirrors*, movement IV, "Rays."

Quartet (1960) at the Small Hall of the Moscow Conservatory on 9 or 10 February 1962, a banner year for musical and artistic freedom in the Soviet Union.[108] Aygi, Davïdova, and Lev Markiz, the violinist in the premiere, all remember that the first half of the program featured *Musica Stricta* and Kazhlayev's quartet, followed by *Suite of Mirrors* as the sole work in the second half.[109] Volkonsky recalls both of his works being performed after the intermission.[110]

Davïdova sang the premiere of the work. As she recollected, "There was a rumor going around that Volkonsky needed a singer. I called him and reminded him of our earlier acquaintance [the two had met in the late 1940s when Volkonsky's family had first returned to Russia], and said that I could come and sing for him. I sang Bach (an excerpt from the 51st Cantata). Then he gave me his composition *Suite of Mirrors,* saying 'Now, look at this. Would you be able to sing it?'" Davïdova successfully sight-read the piece, and agreed to sing in the premiere at the conservatory.[111] She was a logical choice for the part, and she would go on to become the preeminent singer of new music in the Soviet Union for at least the next decade. Denisov later described her voice: "She was by education a pianist and perhaps her voice was not really so large, but her internal musicality and her understanding of everything that she performed always astonished." Furthermore, Denisov concurred with Volkonsky's comment that "she worked like a 'machine.'" Denisov elaborated upon this: "You

108. There is disagreement over the date of the premiere, yet all available evidence points to it as occurring in February 1962. Kuznetsov lists 9 February 1962 (Yudina, *Mariya Yudina: Luchi bozhestvennoy lyubvi,* 479 n. 12). Professor Malcolm H. Brown, then an exchange student at the Moscow Conservatory, remembers seeing a poster for the concert in the hall of the Moscow Conservatory in 1962 (he was in Moscow from January through June of that year; Brown, conversation). Furthermore, a February 1963 *Sovetskaya muzïka* article criticizing the concert in question referred to it as happening "last year," and an article by Vano Muradeli that appeared in *Pravda* on 17 December 1962 discussed *Suite of Mirrors* as if it were a work still fresh in listeners' minds. (See unsigned article, "Glavnoye prizvaniye sovetskogo iskusstva," 6–9; and Muradeli, "Za narodnost' muzïki," 3.) Kučera agrees with Kuznetsov that the concert occurred in February (if a day later, on the 10th), but he gives the year as 1961. (Kučera, *Nové proudy v sovětské hudbě,* 22.) This is obviously a typographical error, as it would put the premiere of *Suite of Mirrors*—and a performance of *Musica Stricta*—before the acknowledged first performance of *Musica Stricta* itself. The discrepancy over the day—9 vs. 10 February—unfortunately persists. Pekarsky's date for the concert is 29 January 1961, but he seems to be confusing the premiere with the later 9 January 1967 Leningrad performance (this is not the only such factual or typographical error in his book). Elsewhere he quotes Aygi giving the date of the premiere as 1962 (NVV: 122–23 and 37). Pekarsky's date also coincides with that in the unreliable *"Drugoye iskusstvo,"* its possible source (*"Drugoye iskusstvo,"* I:29). The performers given there are the same as those Volkonsky and Davïdova recall participating in the 1962 premiere (see later), but the program is different: the two Volkonsky compositions are on the first half, with Gubaidulina's *Intermezzo* for eight trumpets, sixteen harps, and percussion (1961) and Denisov's Sonata for violin and piano (1963) on the second.

109. Markiz, interview; Aygi, interview; and Davïdova, interview, 14 September 1999.

110. NVV: 124. Volkonsky described the same arrangement in 1973 to a *New York Times* correspondent (although the date here, 1961, is incorrect). Kamm, "Composer Tells of Artistic Battle in Soviet."

111. Davïdova, interview, 14 September 1999. Volkonsky's somewhat different version of this encounter and his general appraisal of her singing can be found, along with Davïdova's recollection of her first meeting with Volkonsky, in NVV: 79–80, 123, and 220–21.

could give her anything you wanted and she never made a mistake. And if she memorized something, then even if all the instruments around her made mistakes, she would still sing exactly perfectly. Moreover, she was a musician without perfect pitch, and nevertheless, she could sing even without a preparatory pitch for the first note."[112] The qualities that Denisov described were captured for posterity on several recordings from the period that survive in the archives of the recording studio at the Moscow House of Composers. On these recordings, particularly on a late-1969/early-1970 recording of Denisov's song cycle *Laments,* these characteristics of Davïdova's voice can be heard: her precise pitch placement, and her even, penetrating tone. Denisov is right that hers is not a "big" voice, but such a sound would be wrong for the music she was primarily singing, or at least those new works, like Denisov's and Volkonsky's vocal compositions, where steel-like precision was more crucial.[113] As Yudina's performance style had for *Musica Stricta,* Davïdova's voice played a large role in the successful premieres of difficult vocal works like *Suite of Mirrors.*

The other participants in the Moscow premiere of *Suite of Mirrors* included, in addition to Davïdova, Volkonsky on organ, Lev Markiz on violin, Naum Zaidel' on flute, Valentin Snegiryov on percussion, and a guitarist with the last name of Kaloshin.[114] Yudina again played *Musica Stricta.* Davïdova described the tension surrounding the days immediately before the concert: "Then came the performance. We were afraid they would ban it at the last minute.... We were afraid that the leaders of the Philharmonic [the Moscow concert bureau] would attend one of the rehearsals and attempt to take the scores and replace them with simpler music. Thankfully nobody came."[115] Volkonsky said that the artistic director of the Philharmonic, M. A. Grinberg, actually did visit one of the rehearsals, but that nothing came of it, although before this visit Volkonsky had been asked to remove Yudina from the program because of her "scandalous reputation." Grinberg did take action the day of the concert, but not in as drastic a manner as Davïdova and the others feared: a recording of the concert was being made for Soviet radio, thus he demanded the removal of the microphones during the intermission.[116] The only other distraction at the concert came from

112. PED: 156.
113. Ibid. A CD recording exists of the later 1967 Leningrad performance of *Suite of Mirrors* with Davïdova singing under the direction of Blazhkov (Volkonskiy, *Mirror Suite*). The recording of Denisov's *Laments* mentioned earlier has also been released on CD (*Edison Denisov: Les Pleurs*).
114. Davïdova recalled that "for a long time they couldn't find a guitarist," and Volkonsky remembered Kaloshin as an "entirely unknown person" who taught at "some music school" in Moscow, but who "had no kind of relationship to contemporary music at all" and "had never seen that type of music before." Neither Davïdova nor Volkonsky remembered his first name and it is not provided in *"Drugoye iskusstvo"* (Davïdova, interview, 14 September 1999; Volkonskiy, interviews, 23 and 27 September 2004; and Talochkin and Alpatova, eds., *"Drugoye iskusstvo,"* I:79). See also NVV: 123–24.
115. Davïdova, interview, 14 September 1999.
116. NVV: 124.

the audience. Volkonsky remembered a large number of listeners arriving late and noisily waiting outside the hall, intending to enter only for the second half of the concert (the "Volkonsky" half as he recalled). According to both Daviḍova and Volkonsky, the concert was a huge success, an "unbelievable success, of course!" as Daviḍova put it to me. It was such a success, in fact, that the audience asked to hear either one or both Volkonsky pieces again (accounts vary), a request the shocked musicians willingly fulfilled.[117]

The performance was less successful with the Soviet authorities, although the official response took longer to appear, this time amidst the critical attacks on Volkonsky that had begun in earnest following the disastrous late-1962 Manezh exhibition at which Khrushchev had openly, and memorably, confronted a group of abstract painters from the studio of Eli Belyutin. The first prominent, general attacks on Volkonsky came in speeches delivered by Khachaturyan and Central Committee Secretary Leonid Il'ichev on 24 and 26 December 1962, respectively. (Khrushchev's visit to the gallery had occurred on 1 December.) Khachaturyan bluntly declared that the "future of this all-round gifted musician alarms us." The later, published version of Il'ichev's remarks was equally hostile: "Neither can one pass over the position of the composer Andrey Volkonsky—a gifted man, who for some reason feels comfortable in fashionable clothes borrowed from someone else. What good does he find in locking himself into a narrow little world of refined composition, capable of arousing interest perhaps only in musical snobs?"[118] An inkling of the official stance toward Volkonsky's song cycle came in one of the first articles to respond to the Manezh affair and to address its impact on music, composer Vano Muradeli's "For Nationality in Music" in *Pravda* on 17 December 1962, in which he proudly noted that with the "exception of *Suite of Mirrors* by composer A. Volkonsky we [composers] have yet to encounter musical works of the [abstract] trend on our concert stages."[119] (Recall that Muradeli's opera *The Great Friendship* had been the nominal instigation of the 1948 resolution on music.)

117. Volkonskiy, "Sprechen, ohne gehört zu werden"; Kamm, "Composer Tells of Artistic Battle in Soviet" (according to this source both Volkonsky pieces "had to be repeated"); and NVV: 122, 124, and 37. See also Anatoliy Agamirov in Talochkin and Alpatova, eds., *"Drugoye iskusstvo,"* I:306. Kuznetsov notes a Leningrad performance "at the same time" conducted by Blazhkov, but might be thinking of the later 1967 *Suite of Mirrors* performance in that city. Yudina, *Mariya Yudina: Luchi bozhestvennoy lyubvi,* 479 n. 12.

118. Khachaturyan's comment is taken from the shorthand report ("stenogramma") of these sessions: Afiani, ed., *Ideologicheskiye komissii TsK KPSS. 1958–1964: Dokumentï,* 317. Il'ichev's original remarks about Volkonsky appear on p. 375 of this book, although the cited comments do not appear in the shorthand report, and are taken from the substantially revised version published as Il'ichev, "Silï tvorcheskoy molodyozhi—na sluzhbu velikim idealam." For more on the musical repercussions of the Manezh affair see Schwarz, *Music and Musical Life in Soviet Russia,* 363–65, 416–21. For comprehensive coverage of the event and its wider ramifications see McMillan, *Khrushchev and the Arts.* The story from Khrushchev's perspective is told in Taubman, *Khrushchev,* 588–96.

119. Muradeli, "Za narodnost' muzïki."

A lengthier appraisal of *Suite of Mirrors* appeared almost two months later in a February 1963 *Sovetskaya muzïka* article titled "The Principal Vocation of Soviet Art." After a page of generic commentary on the high ideals of Soviet composition, Volkonsky's name appears, denounced by the unnamed author in the typically purple prose of Soviet musical criticism. Yet the reviewer, as many negative reviewers do, actually touches on several important points, foremost among them the abstraction of *Suite of Mirrors* and the official Soviet reading of these particular Lorca texts: "And how can the means of dodecaphony, pointillism, and aleatory devices realize in music the image of the people's victorious battle? After all, those 'systems' are the *blood relations of abstractionism*. Last year Volkonsky's *Suite of Mirrors,* a pointillistic piece for soprano and a truly eccentric chamber orchestra, was performed in the Small Hall of the conservatory. The text was compiled from poems by Lorca, prepared so that the ardent muse of the wonderful revolutionary poet of Spain appeared before Soviet listeners in mystical attire embroidered in unclear erotic patterns" [emphasis added].[120] Apparently the texts were not overtly religious and hence openly rebellious to official ears; but they were "mystical," "unclear," "erotic," and hence of dubious worth. Again, what upset Soviet officials almost more than the texts was the inherent abstraction of the musical devices that Volkonsky used to set them, an a priori suspicion only confirmed by the "pointillistic" and "truly eccentric" sound of the work. After all, as Muradeli's comments illustrated, "abstraction" was one of the buzzwords in the critical attacks that followed the Manezh exhibition.[121] The review continued by describing and denouncing what was undoubtedly an important segment of the audience: the "clamorous, fashionable girls and boys, enthusiastically demanding encores." It concluded by casting aspersions on those very youths, who were, of course, only following the fad of the moment: "If they are also legitimate judges of 'contemporary' art, then it is already indisputable: such art is not our contemporary."[122] It was younger audiences like these who made up a crucial segment of unofficial concert-goers. Many of them were students who actively discussed the new modes of artistic expression, defended abstractionism, questioned socialist realism, and asked as one did, "Why is it impermissible to depict the tragic, offensive aspects of our life ['Pochemu nel'zya izobrazhat' grustnïye, otritsatel'nïye yavleniya nashey zhizni']?"[123] Needless to say, although Volkonsky's works implicitly engaged many of these issues, his compositions pointedly avoided the last question.

120. Unsigned article, "Glavnoye prizvaniye sovetskogo iskusstva," 7.
121. Muradeli, "Za narodnost' muzïki."
122. Unsigned article, "Glavnoye prizvaniye sovetskogo iskusstva," 7.
123. Pïzhikov, *Khrushchovskaya "ottepel',"* 287–88.

LAMENTS OF SHCHAZA: EXOTIC ROTATIONS

As a conclusion to our discussion of Volkonsky's early compositional career, let us briefly turn to his *Laments of Shchaza* (*Zhalobï Shchazï*), an important composition with a difficult reception history. Completed by 1962, *Laments of Shchaza* is another texted yet abstract work, this time based upon traditional lamentations from Dagestan.[124] Volkonsky made numerous trips to Dagestan—an autonomous region within the Russian Federation, bordering on the Caspian Sea—where he became infatuated with the indigenous culture and purchased large numbers of crafts and books, among them a book or books containing Shchaza's laments.[125] Under ordinary circumstances, because they celebrated an ethnic population of the USSR such "national" texts should have been perfectly acceptable as the basis for a Soviet song cycle. At least this would have been the case had the composer been someone other than Volkonsky.

Laments of Shchaza was Volkonsky's most elaborate and most determined composition thus far, and was clearly beholden to Boulez's *Le Marteau sans maître*, a composition that, as we saw in chapter 2, circulated during the late 1950s in Soviet musical circles in both recording and score. Boulez's influence is most audible in Volkonsky's instrumentation, with the notable addition of his own instrument, the harpsichord, and the more "oriental" English horn in place of Boulez's alto flute.[126] And although it is unlikely that Volkonsky had unlocked Boulez's own complex rotation system (the Russian who would do that, Lev Koblyakov, came much later[127]) or that found in Krenek's *Lamentations of Jeremiah* (1941–42) and Stravinsky's later serial works (e.g., *Movements for piano and orchestra*, 1958–59), he applied his own technique of serial rotations in *Laments of Shchaza*.[128]

124. There are widely divergent dates for this composition; it was most likely completed in 1962. Drozdova gives the date as 1962, Lemaire as 1961, Kholopov as 1960. The Universal Edition score is dated 1962, and Schwarz and Kučera write that it was composed in 1962. Drozdova, "Andrey Volkonskiy" (diss.); Lemaire, "Volkonsky, Andrey Mikhaylovich"; Kholopov, "Initsiator"; Volkonskiy, *Les plaintes de Chtchaza*; Schwarz, *Music and Musical Life in Soviet Russia*, 443; Kučera, *Nové proudy v sovětské hudbě*, 22.

125. On Volkonsky's trips to Dagestan and the Caucasus in general, see NVV: 134–38.

126. For the significance of the English horn in conjuring the Orient in Russian music, see Taruskin, "'Entoiling the Falconet,'" 152–85, esp. 168 and 172.

127. Koblyakov, "P. Boulez, 'Le Marteau sans maître,' Analysis of Pitch Structure," 24–39.

128. Volkonsky's rotations in this score are similar to those applied by Alfred Schnittke in his *Music for Chamber Orchestra*. They are unlike those later used by Nikolai Karetnikov in his Fourth Symphony and, as we shall see, by Denisov in his Music for Eleven Winds and Timpani. As *Laments of Shchaza* was not premiered until 1965, and the contacts between Volkonsky, Karetnikov, and Schnittke were not tight, it is unlikely that Volkonsky's composition influenced the others. Denisov's score predates Volkonsky's (1961) and so might have influenced *Laments of Shchaza*, but the rotations in the two pieces are very different. Most likely all four composers independently developed their respective rotation techniques. Krenek's rotations in his *Lamentations of Jeremiah*, and

The texts of the work draw from the writings of Shchaza of Kurkla ("Shchaza iz Kurkli" or "Shchaza Kurklinskaya"), a "famous lamenter and poetess" of Dagestan.[129] According to Volkonsky, Shchaza was to have been stoned to death because she had been raped by the son of a local nobleman, or barin ("barchuk"), but she escaped, unable to ever return home. As a result she spent the rest of her life composing "laments" about her "bitter fate": "They were a cry of despair from an oppressed and unfortunate woman."[130] These laments are a traditional part of Dagestani (and Russian) folklore, originally recited as part of the burial ritual to exert a magical influence on the course of the departed into the afterlife, but eventually becoming an expression of individual grief at the loss of a close family member.[131] In his setting Volkonsky used three poems by Shchaza and added his own prefatory movement based on meaningless vowel/consonant combinations not found in Shchaza's poetry that would also be interpolated into the original text of the fourth movement.

The specific texts that Volkonsky selected are more literal and less opaque than the Lorca texts in *Suite of Mirrors*. They begin with gossiping villagers in movement two, and in movement three move to the heights of a mountaintop and then a meadow as the narrator escapes from the village to "wander in order to get new strength" ("Vpolne ya gulyat' poshla/chtob nabrat'sya novïkh sil"). In nature the narrator finds only sorrow, as "the grass, all in tears, stands around" ("trava vsya v slezakh stoit vo krug"). The final text of movement four is the culmination of this journey from the quotidian to the profound, as the narrator complains of the "thoughts in the heart day and night" from which it is "impossible to escape," the "grief that is always with me" ("Dumï v serdtse den' i noch'...Dumam vïrvat'sya nevmoch'...A pechal' vsegda pri mne"). The protagonist has been trying to avoid her sorrow, and the final admonition is both a resigned demand for and acknowledgment of grief: "Eyes! Why do you not shed tears?...Cry!" ("OCHI! Chto vï slyoz ne l'yote?...plach'te!").

The outer movements of the cycle provide the best introduction to the style and techniques of the composition. The pensive first movement of *Laments of*

especially his "diatonic" series of rotations, might have been a distant influence on Volkonsky and Schnittke, but they are more similar to the techniques employed by Denisov or Karetnikov. See the preface to Krenek, *Lamentatio Jeremiae Prophetae* (1957); and Krenek, "Extents and Limits of Serial Techniques," 74–75. Theorists have also identified rotations in Nono's compositions, but it does not appear that his approach had a specific impact on Soviet serial practice. See Guerrero, "Serial Intervention in Nono's *Il canto sospeso*," 22. My thanks to Bruce Durazzi for this reference.

129. The correct Dagestani pronunciation of this name is Shchá-za (with the accent on the first a), however Volkonsky, with his French-tinged Russian, pronounced it Shcha-zá (with the accent on the second a). Kholopov, interview, 25 October 2000. For more on Shchaza see Abukov, Vagidov, and Khaibullayev, eds., *Antologiya Dagestanskoy poezii*; and Gamzatov and Dalgat, eds., *Traditsionnïy fol'klor narodov Dagestana*, 181 (quotation), 193, and 466.

130. NVV: 124.

131. Gamzatov and Dalgat, eds., *Traditsionnïy fol'klor narodov Dagestana*, 168–70.

Shchaza follows, with some exceptions, an especially rigid plan, involving per-
mutations of each of the four instruments' initial series.[132] Perhaps imitating
Thilman's example (see chapter 2), but no doubt following his own intuition,
Volkonsky devised a method of circulating the pitches of these initial series
to allow for both motivic consistency and harmonic and motivic variety. The
process governing the piece sounds more complicated than it actually is: in
each part, the initial pitch (B♭ in the voice, E in the English horn, G♭ in the
violin, and A♭ in the viola) is held constant as the first note of each of the
derived series (ex. 3.13a). Each derived series begins with the initial pitch, then
includes every other note after that pitch (when applied to the initial voice
series, the result is: B♭-C♭-F-G♯). When the next-to-last note of the original
series is reached, the two neighboring pitches are kept together (G♯-A), then
the second pitch of the original series is returned to. From this point, every
other pitch in the original series (i.e., the pitches overlooked in the first pass
through the series—C-D♭-E) is selected (ex. 3.13b shows the rotations in the
voice part). The derived series that results can be found in the voice starting
at rehearsal 3 (ex. 3.13a). The same procedure is followed in nearly every part,
with some exceptions.

Since the identity of the series is lost in this process of rotation, motives
play a significant role in the composition, especially the opening English
horn motive, a rising chromatic tetrachord with the second and third pitches
reversed (E-F♯-F-G).[133] This motive is echoed at the tritone in the soprano
in her first entrance at rehearsal 2 (B♭-C-C♭-D♭), and then expanded in the
same phrase to become the motive F-E-G♯-A (ex. 3.13a). This same motive,
and particularly its half-steps, lie at the root of the material in the active sec-
ond movement, and, in fact, the entire second movement can be traced back
to this original motive and its permutations.

The later movements of *Laments of Shchaza,* and especially the spare,
increasingly resigned (and relatively free) third movement, show a continued
preoccupation with colors, motivic and intervallic unity, and quasi-serial per-
mutations similar to the rotations in movement I. (The instrumental and vocal
colors in the third movement also bear resemblance to several moments in
Suite of Mirrors, most noticeably its seventh movement, "Eyes.") Rotations are

132. Lemaire writes that "in *Les plaintes de Shchaza* a series of eight notes undergoes eight inver-
sions," but it is unclear what he means by this. Lemaire, "Volkonsky, Andrey Mikhaylovich." Drozdova
makes several acute observations, especially about the fourth movement of *Laments of Shchaza,* but she
insists on pushing the entire work into a serial framework, ignoring or otherwise trying to rationalize
repetitions or other departures from this system that result from the unacknowledged rotation pattern.
Drozdova, "Andrey Volkonskiy" (diss.), 262–71 and 319–20.

133. This is why it is understandable that Richard Swift wrote that the pitches in the composition
"are derived from three tetrachords and their permutations" in his review of the 1970 Universal Edition
publication of the score. Swift, review, 321.

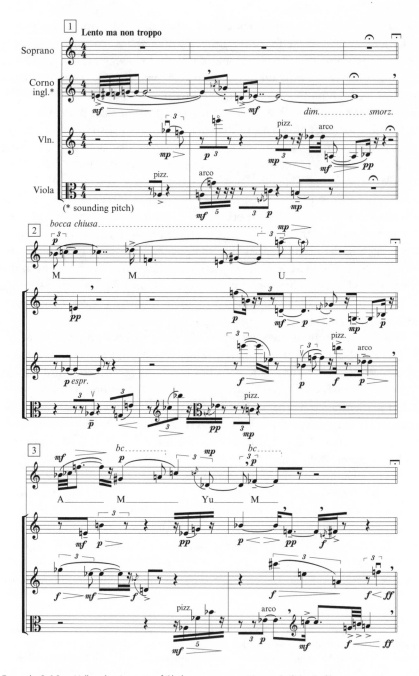

Example 3.13a. Volkonsky, *Laments of Shchaza,* movement I, pp. 1–2 (rr. 1–3).

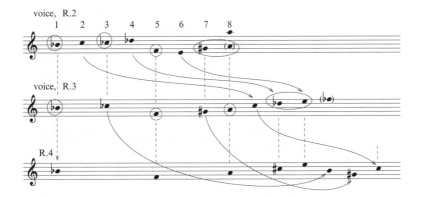

Example 3.13b. Volkonsky, *Laments of Shchaza,* movement I, explanation of the rotations.

especially important to movement IV of *Laments of Shchaza,* and initially fol-
low strictly the pattern established in the first movement and continued in the
third movement. Yet by the end of the fourth movement the rotations have
grown considerably freer, or are absent entirely, subsumed by the large-scale
repetition that closes the work.

The fourth movement acts as the capstone of the entire cycle and is struc-
tured according to a reprise of material both from within the movement and,
more notably, from earlier in the composition. Motives and intervals already
emphasized throughout the cycle recur here, including the opening vowels
and the English horn motive from movement one (the movement begins with
an expanded version of this motive in the violin: B-Bb-D-Eb, although it is
played so quickly as to be nearly inaudible as such). On the local level, entire
blocks are repeated throughout the movement, as at rehearsal 3, which is
repeated exactly (all the voices) at rehearsal 12, rehearsal 16, and rehearsal 24;
or rehearsal 6, which recurs at rehearsal 27 with the soprano an octave higher
and the same text—"serdtse" or "heart" (exx. 3.14a and 3.14b); or the extended
opening block, which has analogs at rehearsal 14, rehearsal 26, rehearsal 30,
and rehearsal 36.

The most significant large-scale recurrence of material occurs near the
ending of the fourth movement, rehearsal 36, signaled by the return of the
first movement's English horn motive in its original form and with its origi-
nal instrumentation. At this moment, the agitated tone of the movement—the
score is marked *Très nerveux (aussi vite que possible),* reflecting the inescapable
thoughts of grief in the text—begins to relax, a process mirroring the transi-
tion from movements two to three, from agitation to resignation. The promi-
nent return of the opening English horn motive is followed by a restatement
of the ambiguous vowels and consonants (and the accompanying music) from

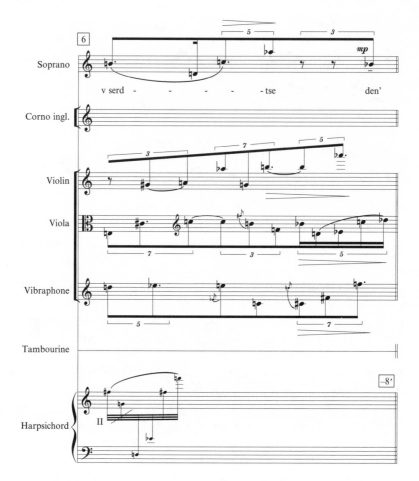

Example 3.14a. Volkonsky, *Laments of Shchaza,* movement IV, rehearsal 6.

movement one, which are now interpolated (rotated into) the fourth movement material. The first return of the vowel/consonant music occurs at rehearsal 38, analogous to measure 4 in movement I. Rather than completely repeating this material, Volkonsky intersperses it with new text, as at rehearsal 39, where the

Example 3.14b (opposite). Volkonsky, *Laments of Shchaza,* movement IV, rehearsal 27.

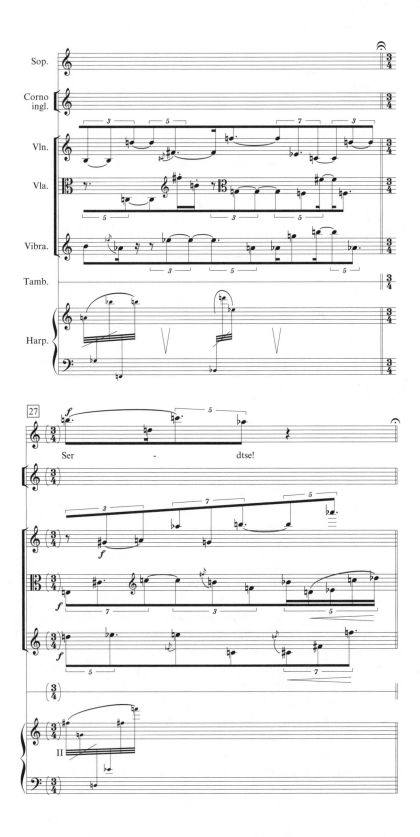

Ser - dtse!

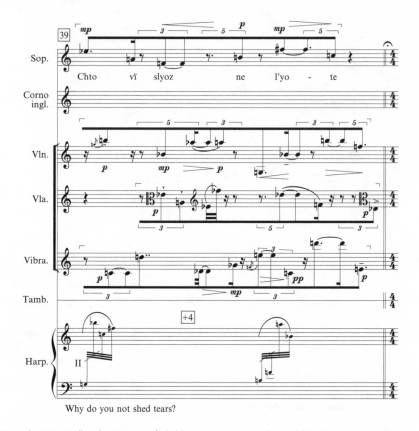

Why do you not shed tears?

Example 3.15. Volkonsky, *Laments of Shchaza,* movement IV, rehearsal 39–40.

line "Why do you not shed tears" appears before the "M" enters at rehearsal 40, a return of the "M"—soprano, English horn, and partial viola rhythm—from measure 5 (2 after r. 2) of the first movement (with the last sixteenth note of m. 4 included as a grace note) (ex. 3.15 and 3.13a). At the same time, the "nervous" material, the "volley" of notes, from the opening of movement four persists, simultaneously undergirding and opposing the returning vowels. This process continues, and at first fragments of the earlier material and then entire segments appear without the addition of new text, as at rehearsal 56 and 57 where two lines from the first movement recur (analogous to mm. 15–17 and mm. 18–19, respectively) (exx. 3.16a and 3.16b).

This technique serves two functions. It rounds out the form of the work, adding cohesion to originally disparate texts, and as the returning material

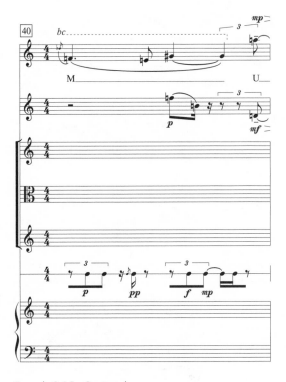

Example 3.15. *Continued*

collides with and eventually subsumes the frantic gestures of movement four, it also adds to the ongoing narrative of the piece. In particular, when heard after movements two and three and in the context of movement four we now understand that the vowels and consonants represent weeping—lamentation. What was enigmatic in the first movement is now clarified. The recurring blocks in the final movement also reflect in the large the rotations that permeate the details of the entire composition's serial construction. This repetition of material gives some coherence to the fourth movement's fragmented bursts of "twelve-toneness," a result of Volkonsky's by now trademark pauses, similar to those first heard in the third movement of *Musica Stricta* (or in Boulez's *Le Marteau sans maître;* the vowels themselves are clearly borrowed from the final movement of *Le Marteau,* "'Bel edifice et les presentiments,' double").[134] Nonetheless, although *Laments of Shchaza* contains mimetic moments, especially in its first and final movements, it still tilts toward abstraction overall.

134. For Volkonsky's reflections on these pauses see NVV: 121 and 126.

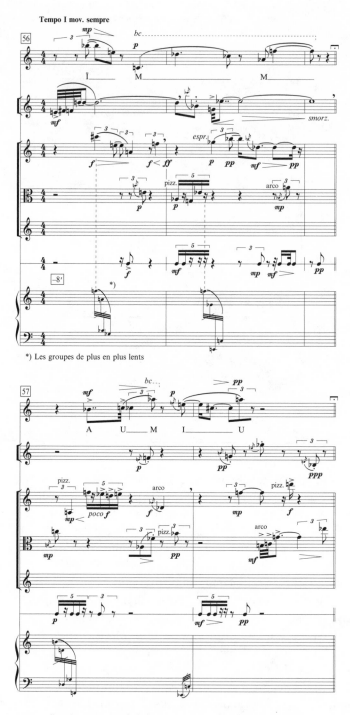

Example 3.16a. Volkonsky, *Laments of Shchaza*, movement IV, rehearsal 56–57.

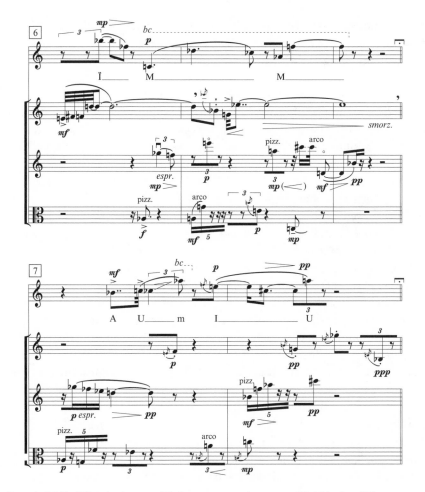

Example 3.16b. Volkonsky, *Laments of Shchaza*, movement I, measures 15–19 (rr. 6 and 7).

The intricate and dense flow of sonic information subsumes rather than reinforces its texts of lamentation and farewell.

If *Suite of Mirrors* was about mirrors and reflections, then *Laments of Shchaza* was about rotations. This shows a compelling adjustment to Volkonsky's serial thought. The most fundamentally serial work of his (in an orthodox sense) was *Musica Stricta,* after which he continued to work with different, equally intricate, approaches to the technique, stimulated by exotic texts. In both of the following vocal pieces basic serial practices served as a springboard for Volkonsky's own stylistic imagination and intuition. In both he continued

to construct very detailed compositions that were received by Soviet authorities and listeners as abstract, even as he expanded his repertoire of devices, first with mirrors and then with rotations.

Unlike his earlier compositions, Volkonsky's *Laments of Shchaza* had a large, albeit delayed, impact. Volkonsky reportedly finished the work in 1962, but owing to his troubles with the Soviet arts authorities and his gradual retreat from composition between 1962 and 1965, it remained unperformed. Volkonsky found himself in especially difficult circumstances following the attacks on artists and composers after the Manezh exhibition in late 1962 and early 1963 during which he was so frequently targeted (recall Muradeli's remarks on *Suite of Mirrors* cited earlier). After being singled out in the meeting with Il'ichev on 26 December 1962, Volkonsky escaped to Riga to work on the music for a film titled "3 + 2," a comedy directed by Genrikh Oganisyan.[135] His retreat only provoked further criticism, for in late March, at a plenary meeting of the Union of Composers (USSR) directorate, Shchedrin declared: "It has become almost trite to mention Volkonsky's name at every plenary session. By now it is obvious that his position of social indifference is deliberate. He has deliberately estranged himself from the Union of Composers and isolated himself from public opinion, from friendly criticism, even from the public function of his music. I believe that Volkonsky's position is tragic and without future for a musician, and if he is a true artist, he must understand it eventually."[136] The focus on Volkonsky grew so intense at this time that according to his friend, Alexander Baltin, Volkonsky was summoned by Pyotr Savintsev (b. 1921), a Secretary of the Union of Composers ("Khrennikov's right-hand man," as Baltin said). Savintsev asked Volkonsky, "Look, Khrushchev wants to see you. What will you say to him?" Volkonsky responded: "Well, what will I say to him? If he forces me to write the type of music that he likes, and I put it on in concerts, it will still be like casting pearls before swine."[137] Savintsev became understandably frightened, and the meeting between Khrushchev and Volkonsky apparently never took place. Volkonsky did not mention this incident to Pekarsky, but he did recall that Karen Khachaturyan had phoned him in Riga to notify him of the meeting with Khrushchev on 7 March 1963, and that he himself had called Khrennikov to announce his intended absence. Volkonsky then sought refuge in Georgia and was hidden by an acquaintance there for several months.[138]

135. Pekarsky gives an incorrect date for this meeting (17 December), for the remarks Volkonsky recalls occurred at the 26 December meeting. NVV: 138 and 140–41; and Afiani, ed., *Ideologicheskiye komissii TsK KPSS. 1958–1964: Dokumentï*, 375; and Il'ichev, "Silï tvorcheskoy molodyozhi—na sluzhbu velikim idealam," 2.

136. Quoted in Schwarz, *Music and Musical Life in Soviet Russia*, 420.

137. Baltin, interview.

138. NVV: 140–41 and 177; and Baltin, interview.

By chance, *Laments of Shchaza* was first performed in Leningrad two years later, sometime in the spring of 1965.[139] At the time its premiere was not covered by the Soviet press, instead receiving what Boris Schwarz called the standard "burial by silence."[140] This was a notable change: no longer could Volkonsky be reached through "harsh" public criticism. The premiere of *Laments of Shchaza* took place in Leningrad, no doubt a result of the machinations of Irina Semyonova, the director of the Small Glinka Hall of the Leningrad Philharmonic (it was deemed impossible to perform the work in Moscow).[141] Davïdova was again entrusted with the soprano part, Blazhkov conducted, and Volkonsky played the harpsichord. Few eyewitness accounts of the event exist, except those of the American music critic Paul Moor (b. 1924) and of Davïdova. Moor called the composition "sensitive [and] expressive," noting Webern's influence, as well as Volkonsky's "assimilation of other post-Webernist influences into a rich and moving style of his own."[142] Like Denisov's *Sun of the Incas* (1964), composed after *Laments of Shchaza,* but performed before it, Davïdova said that *Laments of Shchaza* was a huge success with the audience, yet because of Volkonsky's "innovations with regard to form" she thought that *Sun of the Incas* was more successful with listeners.[143] These, of course, are memories extending back thirty-five years, but a comparison of the two pieces suggests that they are plausible.

The American composer Richard Swift criticized *Laments of Shchaza* in 1972 as "dull and inert, without adequate ongoing musical pitch and rhythmic activity" (he had heard a performance of the work by the BBC Symphony with Boulez conducting).[144] After hearing a 28 August 1967 London performance— again by Boulez and the BBC Symphony—the British music critic Ronald Crichton observed that "though it made a decent impression, [*Laments of Shchaza*] was perhaps more notable as a portent than as an achievement."[145] Despite the hints in Crichton's remarks of the usual condescension that greeted the European and American performances of works by the "young composers," both of these comments are telling. Crichton responded to the scope of the work, certainly the most ambitious of Volkonsky's compositions to date, but also to the relative muteness of the score: it promised much, but failed to overwhelm. This is the same quality that Swift identified, a quality of inertia that is both the work's strength and its weakness. Static effects were clearly a

139. The exact date of its premiere is unclear. Schwarz is the source for dating it in the spring, and the date of Paul Moor's review (July 1965) puts the performance sometime in the first half of the year. See Schwarz, *Music and Musical Life in Soviet Russia,* 443; and Moor, "In Russia, Music for May Day," 120–21.

140. Schwarz, ibid.

141. Davïdova, interview, 14 September 1999.

142. Moor, "In Russia, Music for May Day," 121.

143. Davïdova, interview, 14 September 1999.

144. Swift, review, 321.

145. Crichton, "London Music: The Proms," 919–20.

crucial, ongoing component of Volkonsky's developing aesthetic (influenced by both Webern and, perhaps overly so, by Boulez's *Le Marteau sans maître*): they played an increasingly prominent role in *Musica Stricta, Suite of Mirrors,* and *Laments of Shchaza.* These static moments allowed Volkonsky to concentrate on new combinations and juxtapositions of timbres and colors, and, especially in the latter two works, to feature the diverse vocal abilities of his favorite soprano. In *Suite of Mirrors,* as in *Le Marteau sans maître,* the most static moments—movements VII, "Eyes," and IX, "Berceuse for a Sleeping Mirror"—are set off by the more dynamic movements that precede and surround them. In *Laments of Shchaza* the static moments dominate the texture, and as a result of the narrative arc of the composition, ultimately end the work. Furthermore, the colors in *Laments of Shchaza* are handled less adeptly than those in *Suite of Mirrors;* it lacks the satisfying conclusion to the *Suite* provided by the constant woodblock pulse and guitar and vocal flourishes, the weighted atmosphere of silence, in "Berceuse for a Sleeping Mirror" (Denisov would mine this moment for both the end of his *Sun of the Incas* as well as the sixth movement of his own *Laments*). The movements in *Laments of Shchaza* are also longer and fewer in number, allowing for less variety of color and texture from movement to movement. This is why, though the second movement and the opening of the fourth movement of *Laments of Shchaza* are far from "dull and inert," it is no surprise that Swift was left with that impression. This might also explain the difficulties that Davïdova claimed Soviet audiences had with Volkonsky's "innovations with regard to form." By 1965 novelty alone was no longer enough even for them.

Despite these reported difficulties, the impact of *Laments of Shchaza* on its first Soviet audience was great, the long term effect on Soviet listeners and composers greater still. As we shall see in the next chapter, there can be no doubt that both *Laments of Shchaza*—in addition to its Boulez model—and *Suite of Mirrors* were foremost in Denisov's mind when he composed his *Sun of the Incas.* The nature of Denisov's texts, the use of aleatory devices, and the overall coloristic emphasis of both scores all point to such a modeling. Later pieces such as Denisov's *Laments* from 1966, or compositions by Schnittke (e.g., *Three Songs of Marina Tsvetayeva,* 1965) and Gubaidulina (especially her *Rubaiyat* and *Night in Memphis* from 1968) are also clearly indebted to both Volkonsky's and Denisov's pieces.

Also important, despite lukewarm reviews, was the temporary international impact *Laments of Shchaza* made in both London, thanks to Boulez, and also in New York, where Joel Spiegelman, who had met Volkonsky while a foreign exchange student in Moscow, arranged several performances. Unfortunately for Volkonsky, his work never found the kind of European resonance that Denisov's *Sun of the Incas* would achieve during the summer and fall of 1965 in Darmstadt and Paris. Thus when Volkonsky's performances were curtailed

in the Soviet Union, he lacked the alternative foreign outlets that Denisov enjoyed when his own performances at home were blocked.

ANXIOUS INFLUENCES

The official silence that greeted the first audition of *Laments of Shchaza* gives some indication of the increasingly hostile atmosphere that began to surround Volkonsky following the premiere of *Suite of Mirrors*. Such hostility inevitably took its toll on him. In a 1974 interview with the Parisian newspaper *Russkaya mïsl'* he was quoted as saying: "From the beginning no one even understood what [*Musica Stricta*] was all about. They continued to perform my works for a few more years. But from 1962 on I was definitively banned."[146] Regarding this oft-quoted last statement, Kholopov cautions: "The last words must not be understood absolutely literally, but generally the situation was precisely that."[147] There is some question as to what form this "ban" took and how wide-ranging it was. If it existed the ban could not have been definitive, owing to the 1965 performance of *Laments of Shchaza* and the 1970 Soviet publication of *Suite of Mirrors* (albeit in an edition of only 630 copies).[148] Furthermore, there was at least one Volkonsky performance later in the decade. Leonid Hrabovsky told me that he saw the manuscript of *Suite of Mirrors* before it was performed in Leningrad on 9 January 1967 under the direction of Blazhkov, with Davï-dova and Volkonsky as participants.[149] Apparently this concert took place due to the contemporaneous Soviet tour of Pierre Boulez with the BBC Symphony Orchestra, the Volkonsky concert serving as a musical Potyomkin village, falsely proclaiming the openness of Soviet musical life to the foreign visitors

146. Volkonskiy, "Andrey Volkonskiy," 8. Cited in Kholopov, "Initsiator," 10. Volkonskiy also told me that he was "banned" at this time (see chapter 5). Volkonskiy, interview, 21 October 1999.

147. Kholopov, "Initsiator," 10.

148. On the publication of *Suite of Mirrors*, see Baltin, interview; Pekarskiy, interview; and Baltin in NVV: 121–22. Baltin, who was employed by the "Muzïka" publishing house at the time, says that he was responsible for the publication of *Suite of Mirrors*. According to Baltin, he slipped Volkonsky onto the publication list, and Somov, the person responsible for checking the list, did not notice it at all, since he was paying more attention to their intended publication of the collected works of Robert Schumann: "What is this? One Schumann, two Schumann, three Schumann, four Schumann!?" As Baltin told me, "It was very easy to trick them"; yet he described a "scandal" surrounding the decision in the version he told Pekarsky. Pekarskiy credited Alexander Rabinovich for the publication of *Suite of Mirrors*, saying that he was fired for doing so. Baltin did not mention Rabinovich, but his name does appear as editor on the published version of *Suite of Mirrors*. It is very possible that both men, Baltin and Rabinovich, played a role in getting the work in print. To further cloud the issue, Schnittke gave credit for the publication of *Suite of Mirrors* to Eduard Khagagortyan, but this was not confirmed by either Baltin or Pekarskiy, and lacks the first-hand credibility of Baltin's account. See GNAS: 22–23 (see also chapter 5).

149. Hrabovsky, e-mail to author, 5 January 2000. The exact date for the concert is taken from Kučera, *Nové proudy v sovětské hudbě*, 22 and photo insert no. 28, between pp. 80 and 81.

(Boulez missed the concert—he was in Leningrad only from 13–15 January). Unfortunately no other details of this chance concert remain, although a photograph of the beaming musicians on stage following the performance is reproduced in Kučera's 1967 *New Trends in Soviet Music*.[150] Whether by official order or common understanding, however, the end result was the same: by the late 1960s, despite very rare exceptions, Volkonsky's music ceased to be performed. He eventually sacrificed his compositional career for the activities of his early music group "Madrigal," an ensemble that would become the leading performer in the Soviet Union of "early music" (or "music before Bach," as it was called); it will be discussed in more detail in chapter 5. He later said that "I gave myself up to this only because I was not free to be the composer I wanted to be. It was second best."[151] While Volkonsky did continue to compose, most notably his *Concerto itinérant* to texts of Omar Khayyam, his works from the late 1960s were few.[152]

By the time that Volkonsky turned his back on new music in favor of the very old, most of his colleagues were well on their way to "catching up" with the West and were beginning to experiment with the very newest techniques, or what they felt were the very newest techniques: aleatory devices and the noise experiments akin to gestures familiar from the Polish avant-garde that were known in Russia as *sonorika*. Although Volkonsky was the only composer writing serial music in the late 1950s, others quickly followed his lead, including Pärt, Schnittke, and Denisov. Almost more important than Volkonsky's actual compositions, however, were the concert subculture and the audience for new music cultivated by the first performances of *Musica Stricta, Suite of Mirrors,* and *Laments of Shchaza*. It was commonly understood that such works should not be performed, but sometimes "flukes" ("sluchainosti") occurred, as the composer Viktor Yekimovsky put it in my interview with him.[153] *Musica Stricta, Suite of Mirrors,* and *Laments of Shchaza* were the first flukes and hence the most significant.

The reactions to the earliest performances of these works testify to the great curiosity with which new music was greeted at such rare concerts within the Soviet Union. Not all listeners reacted so favorably at first, however. Nikolai Karetnikov recalled an anecdote involving the renowned pianist and pedagogue Heinrich Neuhaus (1888–1964), teacher of Richter among other Soviet pianists, and his first encounter with Webern's music. In the summer of 1963 or 1964 (Neuhaus died in October 1964), Karetnikov had left Moscow for the nearby Koktebel' home of his friend, the art historian and philosopher

150. Kučera, *Nové proudy v sovětské hudbě,* photo insert no. 28, between pp. 80 and 81. The same photograph is reproduced in NVV: 123.

151. Kamm, "Composer Tells of Artistic Battle in Soviet."

152. For more on this composition see chapter 6.

153. Yekimovskiy, interview.

Alexander Gabrichevsky (1891–1968), with whom Neuhaus was staying. Karetnikov had brought with him a supply of reel-to-reel tapes with performances of Bach, Mahler, Stravinsky, Brahms, and Schubert, as well as Webern. Every evening the three men would gather together, and Karetnikov would play selected pieces for his friends. On the first evening of his visit the three listened to Schubert and Mahler and then Webern's String Quartet and *Five Movements* for string quartet. Neuhaus reacted with hostility: "No matter what [you two] have said, your Webern is still absolute sh—!"[154] Karetnikov was shocked, and was even more so the next evening when Neuhaus wanted to hear Webern again: "All the same I want to hear your Webern again even though he is sh—; I would like to understand something of why you like him so much. It's even begun to get to me somehow."[155] His reaction was the same the second time. This continued, by Karetnikov's account, every evening for the entire summer, with Neuhaus "becoming visibly upset with his own 'Webern-incomprehension' ['Vebernoneponimaniye']." He later heard a performance of the same Webern pieces in Moscow under the direction of the Italian-born conductor Antonio Janigro (1918–89) and "completely fell in love with that music."[156] He would talk of nothing else at the time.

Neuhaus's response to Webern was typical of both Soviet audiences and Soviet composers during the Thaw. His curiosity for this music was strong, and although his initial reaction was one of disgust, he felt compelled to try again and again to understand the music. Is it any coincidence that both Volkonsky's and Denisov's initial reactions to Schoenberg and Webern were similar? Volkonsky told me that as a conservatory student he "still didn't know Schoenberg or Berg, though I had heard their names…and I think that I'd heard *Pierrot Lunaire* once, but I didn't like it at the time."[157] When Denisov first heard Webern's String Trio, Op. 20 (thanks to his roommate Frémy), he reportedly "criticized his music as artificial and bad…[but] as he immersed [himself] more and more in Webern's musical world, he grew captivated by it."[158] Even Karetnikov himself later recalled that when he first heard Webern's music, "I laughed for a long time—it seemed to me a monstrous absurdity.…It took me a whole year in order to learn to accept it."[159] Like Neuhaus, all of these younger musicians initially reacted with distaste to the music of Schoenberg and Webern, but gradually "grew captivated by it." Volkonsky, Denisov,

154. Karetnikov, "Genrikh Neygauz i 'Novaya venskaya shkola,'" in *Gotovnost' k bïtiyu,* 58.

155. Ibid.

156. Ibid., 59.

157. Volkonskiy, interview, 21 October 1999.

158. Kholopov and Tsenova, *Edison Denisov,* 21.

159. Karetnikov and Golubeva, "Osvobozhdeniye ot dvoyemïsliya," 16. Silvestrov had a similar reaction to Webern. See Sil'vestrov and Frumkis, "Sokhranyat' dostoinstvo…," 12; and Sil'vestrov, "Vïyti iz zamknutogo prostranstva…," 100.

Karetnikov, and Neuhaus all felt the need to understand what they had initially disliked. In part this would be the reaction of most curious performers or composers. But years of socialist realist dogma seemed further to undermine their confidence in their own aesthetic judgments. This, coupled with the Union of Composers' extreme reactions to this music and the cachet it held in the West at the time, pressed them to figure it out. So it was with the original audiences, for whom curiosity was a primary motivation.

Political considerations also played a strong role, albeit in a negative sense, with musical (and textual) abstraction acting as a refuge and reaction to the predominant forced "content" of socialist realism. The unofficial music from the 1960s was undeniably political, insofar as all music was politicized in the Soviet Union. Rather than espousing conventional dogma by following sanctioned forms and styles, Volkonsky's example reveals the extent to which unofficial music initially retreated. Only after 1968, as we shall see, did the unofficial composers comment directly (if rarely) on specific political incidents.

4

From Young to Unofficial: Denisov's *Sun of the Incas*

When I first arrived in Moscow fresh from Siberia, I was a naive and foolish young man. Although I never wrote a cantata about Stalin, like most of my generation I very much idealized our politicians.

—Edison Denisov to Elizabeth Wilson (1988)

By the early 1960s, Volkonsky was no longer the only young Soviet composer provoking official rebuke. Early compositions by Arvo Pärt and Nikolai Karetnikov received almost as much critical attention as had Volkonsky's. At the Third All-Union Composers' Congress held on 26–31 March 1962, the elder statesmen of Soviet music used Pärt's recent *Obituary* (*Nekrolog*) (1960) as a pretense to condemn the serial techniques that were then beginning to find numerous adherents among Soviet composers, both young and not-so-young (*Obituary* had received a 1961 Moscow performance by the Large Symphony Orchestra of All-Union Radio, conducted by Roman Matsov [1917–2001]).[1] As Kabalevsky opined: "Certain young composers show an interest in twelve-tone music. Well, what about it? I am firmly convinced that if a composer has talent he will either ignore such music completely or, having tried his hand at it, discard it as have talented composers all over the world."[2] Khrennikov chastised Pärt's *Obituary* explicitly: "It bears the characteristics of the productions of foreign 'avant-gardists': an ultra-expressionistic, purely naturalistic depiction

1. According to Krebs, Silvestrov and Volkonsky were also mentioned in this speech. See Krebs, *Soviet Composers and the Development of Soviet Music,* 457 n. 12 (diss.) and 338–39 n. 1 (book). On *Obituary,* see Yudina, "A. Pyart," 252.

2. Schwarz, *Music and Musical Life in Soviet Russia,* 345.

of a state of fear, terror, despair, and dejection."[3] The composition was dedicated to the "memory of the victims of fascism" (reportedly not by Pärt), but according to the official critics this dedication did not justify its style, or rather, its style was found ill-suited to such a serious subject.[4] Similar denunciations were made in contemporary internal documents from the Union of Composers, where serialism—and by extension Pärt's composition and the Estonian Union of Composers who failed to curtail him—was predictably condemned as a "bourgeois style … ideologically foreign to Soviet music."[5]

Obituary was a raucous, disjointed composition, influenced by Shostakovich and other socialist realist symphonic showpieces.[6] The most effective moment comes at its end, with a ghostly coda for winds, gradually dying away to a single bass clarinet with echoing timpani. The serial elements in *Obituary* are rather superficial components in a predominantly atonal framework; despite the vehemence of Pärt's Soviet critics, he did not extensively deploy serial techniques in the composition. And when he did so, he echoed certain moments of *Musica Stricta,* for like Volkonsky's first serial foray, Pärt also used multiple rows simultaneously, each unrelated to the others, each appearing only in its prime form without retrogrades or inversions.[7]

Nikolai Karetnikov's "twelve-tonish" ballet *Vanina Vanini* (1959–60), based on the Stendhal novella, itself received notable performances in 1962, this time at one of Soviet Russia's most prestigious venues, Moscow's Bolshoi Theater. Although the piece is not serial at all, and is in fact strongly rooted in tonality—despite Karetnikov's later claim that in the score he "already confidently applied serial dodecaphony ['seriynaya dodekafoniya']"—its musical language proved difficult for the Bolshoi performers at the time.[8] Karetnikov

3. Schwarz, *Music and Musical Life in Soviet Russia,* 346. These criticisms of Pärt were recalled later in 1962 during the fallout from the Manezh exhibition. See Afiani, ed., *Ideologicheskiye komissii TsK KPSS, 1958–1964: Dokumentï,* 316.

4. Hillier, *Arvo Pärt,* 36.

5. RGALI, f. 2329, op. 3, yed. khr. 1186. "Spravka o tvorcheskoy deyatel'nosti Soyuza Kompozitorov SSSR 5 Fev. 1962." This is from a draft document dated 5 February 1962 and possibly never completed; only this draft is extant, with paragraphs handwritten and pasted in or folded over and its last two pages (of eleven) scrawled out in blue ink. The author is never named, but it is dated and signed with an illegible signature.

6. There are many stylistic similarities between *Obituary* and Shostakovich's Fourth Symphony, although the latter was premiered only after *Obituary* was completed (on 30 December 1961 in Moscow). Nevertheless, the influence of the Fourth Symphony cannot be completely ruled out as Shostakovich's two-hand piano reduction had been published in 1946. Fay, *Shostakovich: A Life,* 96, 225, and 307 n. 45. Another more general influence might have been Lutosławski's *Funeral Music* (*Muzyka żalobna,* 1958).

7. See Schmelz, "Shostakovich's 'Twelve-Tone' Compositions," 326–28. For a late Soviet appraisal of the piece, see Soomere, "Simfonizm Arvo Pyarta," 166–70.

8. See Karetnikov and Golubeva, "Osvobozhdeniye ot dvoyemïsliya," 16 (here Karetnikov states that the rehearsals started in 1961); and Selitskiy, *Nikolai Karetnikov: Vïbor sud'bï,* 94–95, 113, and 121–22.

later wrote that the Bolshoi musicians "didn't understand the music and didn't accept it. They angrily turned their heads every time that a phrase continued in an instrument other than the one that started it. Gradually both they and I became aware that they simply wouldn't be able to play the piece." The musicians began to sabotage the preparations, conspiring to go on "strike" by playing only pianissimo. Karetnikov discovered this only after nine days of rehearsals, having furiously doubled all the parts each evening following the day's practice. The combative preparations had meanwhile been attracting the negative attention of higher-ups from the Union of Composers. It was only Karetnikov's appeal to Shostakovich for help, and Shostakovich's subsequent intervention at the dress rehearsal that saved the work and guaranteed its performance. After Shostakovich spoke, "the matter was decided."[9]

The audience at the premiere proved more amenable to Karetnikov's music than the professionals had been; no doubt the accompanying ballet choreography helped ameliorate, or at least justify, the difficulties of the score. "When the first performance had finished, thunderous applause and shouts of 'Bravo' were audible from the auditorium," Karetnikov recollected, and he remembered being called out for numerous bows.[10] Soviet critics, on the other hand, seemed more interested in the choreography than the music, which they almost uniformly found cold, dry and unmelodic.[11] *Vanina Vanini* received only eight performances at the time and had to wait until 1973 before a piano score was published.[12] Karetnikov's subsequent, more exactingly serial scores lay unheard and unpublished; in some cases performance and publication came after nearly two decades or longer (e.g., his 1960 Lento Variations for piano, Op. 11, first published in 1978 by Peters).[13]

Such a fate was typical. Unlike Pärt's *Obituary* or Karetnikov's *Vanina Vanini*, the majority of compositions by young Soviet composers from the first half of the 1960s lay unperformed. There were some notable exceptions, however, the most significant of which was Edison Denisov's vocal cycle *Sun of the Incas*. In fact, although Volkonsky dominated the 1950s, by most accounts Denisov already had assumed the leading role among young Soviet composers by the beginning of the next decade. Volkonsky's absence from Schnittke's later recollection of his early influences is both striking and significant: "All of us [Karamanov, Karetnikov, etc.] began to play new music, by and large, at Denisov's instigation."[14] The reasons for Denisov's newfound influence were

9. Karetnikov, "Lekarstvo ot tshcheslaviya," 42–44; in English as Karetnikov, "Two Novellas: 1. A Cure for Vanity," 44–47. The present translation is mine.

10. Ibid.

11. Selitskiy, *Nikolai Karetnikov: Vïbor sud'bï*, 120–21.

12. Ibid., 121; and Karetnikov and Golubeva, "Osvobozhdeniye ot dvoyemïsliya," 16. Anton Karetnikov generously provided me an unreleased recording of the ballet's premiere.

13. Karetnikov, *Klavierstücke, Op. 11, 23, 25.*

14. GNAS: 18–19.

his "direct contact[s] with foreign music," including the foreign composers who began to gather with the "young composers" at his home, chief among them Nono. As Schnittke also indicated, "He was the first to show us the road to Western publishers."[15]

The key difference between Volkonsky and Denisov, then, was a shift from isolated domestic performances to wider foreign exposure. Of course, domestic performances continued, with Denisov's *Sun of the Incas* signaling a general increase in the number of unofficial concerts. After its 1964 Leningrad performances the unofficial musical world began to take shape in its most extensive form. The more frequent performances that he and the other "young composers" began to obtain, along with Denisov's increasingly public role both at home and abroad, also instigated more frequent attacks in the Soviet press. Soon the musical products of this generation ceased to be youthful indiscretions, but instead became intolerable provocations; their creators moved from young to unofficial. Stylistically, *Sun of the Incas* also indicated the continued relevance of abstraction based on serial techniques in at least some circles, even as other "young composers" began moving in more mimetic directions.

DENISOV'S CONVERSION

Although we began the discussion of Volkonsky's *Musica Stricta, Suite of Mirrors,* and *Laments of Shchaza* with biography, we begin our discussion of *Sun of the Incas* with theory, for of all the "young composers," Denisov responded most fervently to both the theory and practice of serial techniques and continued to compose with them well into the 1970s. Initially he was not alone: all of the other "young composers," from Pärt and Karetnikov to Schnittke and Gubaidulina felt duty-bound to experiment with serialism. During the early 1960s most of the "young composers" produced compositions ranging across the serial spectrum from "twelve-tonish" to forms of total serialism. Examples of the former include Slonimsky's Sonata for Solo Violin (1960) and Sonata for Piano (1962–63); Karamanov's piano works *Prologue, Idea and Epilogue* (*Prolog, mïsl' i epilog;* 1962–63), five preludes and twelve concert fugues (1964, published as fifteen concert fugues in 1984); Hodzyats'ky's *Ruptures of Flatness* (*Rozlyvy ploshchyn* in Ukrainian, or *Razrïvï ploskostey* in Russian; 1963); Silvestrov's *Triad* (*Triada,* 1962); and Roman Ledenyov's Prelude from his Six Pieces, Op. 16 (1965–66), and movement 5 of his *Ten Sketches* (*Desyat' eskizov,* 1967).[16]

15. Ibid., 22.
16. For a more detailed examination of these compositions, see Schmelz, "Listening, Memory, and the Thaw," esp. pp. 128–47 and 186–91.

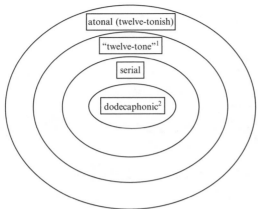

[1] "Non-serial dodecaphony": uses multiple twelve-tone rows that do not determine every note in the composition.

[2] Uses a single row of twelve pitches that governs the entire piece.

Figure 4.1. Soviet serial bull's-eye diagram.

The first movement of Karamanov's *Prologue, Idea and Epilogue* is representative. Kholopov cites this as an example of "non-serial dodecaphony" (or "twelve-tone"—as opposed to "dodecaphonic"—music), freely using multiple twelve-tone rows that do not determine every note in the composition. (Kholopov sees the "freedom of structure" demonstrated by this approach as "one of the distinctive features of Russian music."[17]) This terminology reflects the specifically Russian understanding of the dodecaphonic/serial hierarchy that can also be conceived of as the "Soviet serial bull's-eye" (fig. 4.1).[18]

Regardless of any underlying harmonic framework, as a whole Karamanov's movement is primarily motivically driven. The first system of the movement introduces the intervals and motives that will dominate the piece: the augmented octaves, minor seconds, and minor ninths of the opening F/F♯, D♯/E, and B/C dyads (and the G♯/G♮/A triad), the major/minor thirds (B♭/D♭/D), and the stacked tritone and fifth (a chord also favored by the Schoenberg circle, as well as Bartók): C♯-G-D (at the end of the right hand in the first system of ex. 4.1).

In the three parts of his *Triad,* by contrast, Silvestrov apparently worked inward through the rings of the "serial bull's-eye," beginning with atonality in the second part, "Serenade," and moving on in the outer two parts in a process

17. Kholopov, "Autsaider sovetskoy muzïki: Alemdar Karamanov," 122.

18. See Schmelz, "Shostakovich's 'Twelve-Tone' Compositions," 324–26. For the relationship between this dodecaphonic/serial hierarchy and tonality, and especially Kholopov's theorizing of the "chromatic tonal system" or "full chromatic modal system" and its role in the full range of "twelve-step" systems, see Schmelz, "After Prokofiev," 509–11 and 515.

Example 4.1. Karamanov, *Prologue, Idea and Epilogue*, movement I, opening bars.

of gradual clarification and mastery of serial principles, finally reaching twelve-tone serialism in the final part, "Music of Silvery Tones" ("Muzïka serebristïkh tonov") (the first part is called "Signs" or "Znaki").

Other works from the early 1960s were more consistently serial, like Karet-nikov's Lento Variations for piano, his very Schoenbergian String Quartet from 1963, and his Violin Sonata (1961), which uses only the untransposed prime, retrograde, inversion, and retrograde inversion forms of its series.[19] The same holds for many of Schnittke's early compositions, especially the initial movement of his First Violin Sonata, which uses only the P_0 and R_0 forms of the row (its later movements, however, include several references to tonality).[20] As we have already seen, Pärt too wrote twelve-tone works that quickly departed from the norms of the Schoenbergian method, as did Gubaidulina in her first serial com-position, her beat-poet, bongo-influenced Five Etudes from 1965 (see also chap-ter 6). Many of these works were overtly indebted to Volkonsky, like Schnittke's *Improvisation and Fugue* (1965), and especially its fugue. Such modeling was hardly exceptional, for the majority of early "twelve-tonish" Soviet piano com-positions (and not only the piano compositions) from the period betray at least aural familiarity with Volkonsky's scores, and especially *Musica Stricta*.

As we shall see, most of these composers soon moved away from serial experimentation. Denisov, however, was more convinced of the necessity of the cause. Despite the fact that he initially displayed incomprehension when Frémy showed him Webern's Op. 20, he soon began to assiduously write serial music. Denisov's colleague Aleksey Nikolayev provides a valuable perspec-tive on Denisov's serial beginnings. In the early 1960s Nikolayev and Denisov were both teaching in the same wing of the Moscow Conservatory. Once, after finishing his classes (he was teaching orchestration and score-reading at the time) Denisov came to Nikolayev's room and said, "You know I've decided that I am no longer going to write tonal music."[21] Nikolayev was taken aback by this declaration and responded: "Edison, how can you decide just like that?" Denisov answered: "[Tonal music] doesn't have any future; it's already finished." To which Nikolayev responded: "But Edison, how can you say to yourself that 'starting on Monday I will be a completely different person.' If it comes naturally, then God bless. That makes sense. But to say like that, that before yesterday you were a blonde and tomorrow you.... That's impossible."[22] Nikolayev's recollection underscores the rapidity and the force with which

19. Different authors provide different dates for these compositions. I am using Selitsky's dates, as he had the most interaction with the Karetnikov family and Karetnikov's personal archive. As a com-parison see McBurney, "Karetnikov, Nikolay Nikolayevich."

20. See Kholopova and Chigaryova, *Al'fred Shnitke: Ocherk zhizni i tvorchestva*, 27–28.

21. Nikolayev stated that he thought this conversation took place in 1962 or 1963, but these dates might be inaccurate.

22. Nikolayev, interview.

Denisov turned to serialism, having already adopted the Boulezian avant-garde rhetoric about the necessity and inevitability of his change. As Denisov began using serial techniques he did not immediately abandon his earlier idiom, yet by 1964 he had moved almost exclusively (at least in his "serious" compositions) to serialism of a particularly systematic sort, befitting his determined transformation in Nikolayev's account. Many of the approaches evident in his first serial works became distinctive features of Denisov's serial style in the mid-to-late 1960s.

Denisov had come to composition by an indirect path. Born in Tomsk, Siberia, in 1929, he began his career as a mathematician, perhaps intending to live up to the promise of his given name, which was taken from that of the American inventor by his radio physicist father.[23] (His surname itself, although not as illustrious as Volkonsky's, was also familiar from Tolstoy, for Denisov is a secondary character in *War and Peace*.) Near the end of his mathematical education, he decided that he wanted to become a composer and with the aid of Shostakovich applied to the Moscow Conservatory.[24] After being refused admission once, he was accepted on his second try and began his formal compositional study with Shebalin. While at the conservatory, Denisov took a very active role in student life, leading the NSO in several notable concerts, as we have seen. At this point he was already beginning to attract attention and to play a prominent role in his generation's musical life.[25]

The unofficial Denisov only gradually emerged in the 1960s; during his student years he was still viewed as a malleable, impressionable youth, a true "young composer." As the epigraph to this chapter indicates, he himself later admitted his own naiveté at the time. Pieces like his early symphony and his vocal cycle, "Nocturnes," received positive reviews in *Sovetskaya muzïka* and the journal *Sovetskiy muzïkant,* and several of his articles were published in the former periodical, among them his "Yet Again on the Education of the Young" (cited in chapter 3).[26] In the late 1950s this reception began to shift as critics took him to task for his modernist tendencies, his aping of Shostakovich and Bartók (in, e.g., his Seven Bagatelles from 1960), and the difficulties and "dryness" ("sukhost'") of his musical language. In fact, in the May 1960 issue of *Sovetskaya muzïka,* his Sonata for Two Violins was labeled "an alien piece, of no use to listeners."[27]

23. Denisov and Pantiyelev, "Ne lyublyu formal'noye iskusstvo...," 20. Denisov remembered that his "mother cried for a whole week because she wanted to name me Igor." See Denisov and Armengaud, *Entretiens avec Denisov,* 29.

24. Numerous sources exist for their correspondence; see the bibliography.

25. See PED: 27.

26. V. P. Bobrovskiy, *Sovetskiy muzïkant,* 22 May 1953, 2 (cited in Kholopov and Tsenova, *Edison Denisov,* 19); and Denisov, "Yeshcho o vospitanii molodyozhi," 28.

27. The quotations in this and the preceding sentence are cited in Kholopov and Tsenova, *Edison Denisov,* 19–20.

He naturally paid little heed to this criticism, and began writing serial compositions starting with his *Music for Eleven Winds and Timpani* (*Muzïka dlya odinnadtsati dukhovïkh i litavr*) and the *Piano Variations,* both from 1961.[28] The former was a three movement work for large ensemble that was his first thorough-going attempt at using twelve-tone techniques, an aspiration that extended even to its instrumentation (twelve instruments). It still exhibited Denisov's early fascination with Bartók, whose influence can be heard in the additive rhythms and repeated motivic cells in the work, but it also shows Denisov testing a variety of serial applications.[29]

Music for Eleven Winds and Timpani begins with straightforward, repeated iterations of the P_0 form, but quickly moves to more idiosyncratic structures (and although the row is combinatorial, he never uses it combinatorially). Moments like the rhythmically driven transition from measures 8–11 depart almost entirely from the row, instead using motives drawn from it to complete the total chromatic on every beat (or nearly every beat) (ex. 4.2).

This transitional section also contains several moments in which a rotation pattern saturates the texture in the woodwinds, including both measures 6–7 and measures 12–13, while the brass punctuate the beginning and end of each measure with the first and last tetrachords of the row, respectively. A similar "rotation" of the pitch order occurs in measures 16–23, where the straightforward statements of various row forms now begin on the fifth pitch of the prime and inverted forms of the row (or the ninth pitch in the retrograde forms) (ex. 4.3).

This "rotation" can be traced back both to the opening melody in the trumpet, which begins on the fifth pitch of P_0 as a result of the same tetrachordal subdivision seen in the brass in measures 6–7 and measures 12–13 of example 4.2 (in both of these entrances, the flute also begins on the fifth pitch of P_0). Denisov thus experiments with several devices ranging from multiple, successive twelve-tone chords ("twelve-tone" writing) to rotations and segmentations of a single twelve-tone row (and its permutations), possibly influenced by Krenek's *Lamentations of Jeremiah*, Thilman, Jelinek, Volkonsky's *Laments of Shchaza,* or all of these.

Like a large number of Denisov's subsequent pieces, *Music for Eleven Winds and Timpani* did not receive a public performance until after a considerable delay, heard for the first time on 15 November 1965 in Leningrad, conducted

28. Kholopov and Tsenova discuss this period and these works in *Edison Denisov,* 54–56.

29. In his later interviews with Shul'gin, Denisov admitted the overt modeling on Bartók that occurred in the work, particularly in the first movement. He also heard the third movement as derivative of Shostakovich. PED: 137–39. This was not the first time Bartók weighed heavily on Denisov's early style, for after his 1960 Bagatelles the Hungarian composer's influence continued in his Symphony for Two String Orchestras and Percussion from 1962, while Denisov's 1961 Second String Quartet is dedicated to Bartók and is based on a theme from his Fifth Quartet.

Example 4.2. Denisov, *Music for Eleven Winds and Timpani,* measures 4–13.
Credit: Copyright © 1961 C. F. Peters. Used by permission of C. F. Peters Corporation.

by Gennadiy Rozhdestvensky (b. 1931), to whom the piece was subsequently dedicated.[30] Its contemporary, Denisov's *Piano Variations,* was also heard for the first time in 1965, but not in the Soviet Union. Like most of Denisov's later works, particularly those from the 1960s and 1970s, it was premiered abroad, in Copenhagen by Torben Peterson on 28 March 1965.

30. According to Rozhdestvensky's performance diary from the 1960s and 1970s, published as an appendix to his 1989 book *Preambuli, Music for Eleven Winds and Timpani* was premiered in Leningrad at the Small Hall of the Philharmonic by an "ensemble of soloists." The other works on the program were Ibert's Concerto for Cello and Ensemble, with Anatoliy Nikitin as soloist (the first performance in the USSR), and Berg's Chamber Concerto for Piano, Violin and 13 Winds, with Anatoliy Ugorsky and Viktor Liberman as soloists (also a USSR premiere). Rozhdestvenskiy, *Preambuli,* 265.

Example 4.2. *Continued*

As in the *Music for Eleven Winds and Timpani,* the serialism in the *Piano Variations* also ranges from free to strict, with the straightforward opening row forms giving way to freer approaches, aided by the variations structure. Although Webern's Op. 27 Variations are usually mentioned as a serial composition familiar to most of the young Soviets (thanks to Glenn Gould), there are few overt similarities between Denisov's composition and Webern's. As was true for so many pieces by these composers, the sound of Webern rather than a literal imitation of his score seems to have inspired Denisov. As a result, Denisov's own personal approach to serialism becomes even more apparent. One of Denisov's later stylistic tics, the almost obsessive repetition of pitches from the row, is evident throughout, especially in the first and third variations (exx. 4.4 and 4.5).

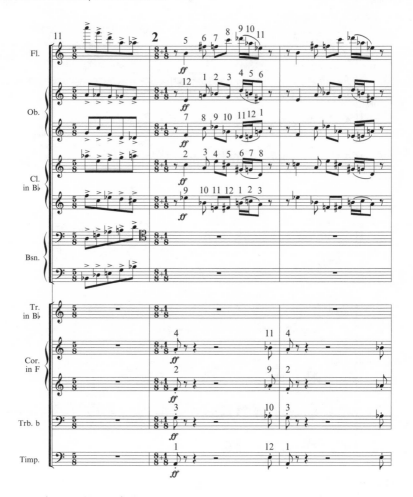

Example 4.2. *Continued*

The third variation in particular is indicative of things to come, as Denisov builds on the motivic fragmentation of the *Music for Eleven Winds and Timpani*. Here he states five-note segments of the row (P_0 and I_0, then R_0 and RI_0) and their own retrogrades (i.e., the reverse of R_0, which is also the last five pitches of P_0, followed by the reverse of P_0, or the last five pitches of R_0), treating all four row segments as if they were independent series. Denisov flirts with but does not immediately sound the central dyad of each row, withholding each missing segment (F-B and E♭-A, respectively—not coincidentally tritones) until measure 5 of the variation, a process that is repeated in the variation's second half (ex. 4.5).

The serial techniques displayed in this piece are basic ones that might have been gleaned by any diligent reader of Krenek's, Jelinek's, Eimert's, or Thilman's

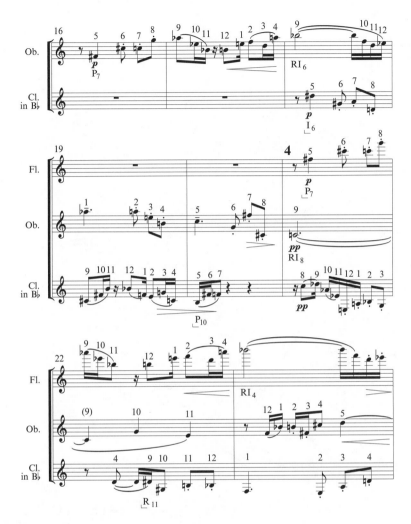

Example 4.3. Denisov, *Music for Eleven Winds and Timpani*, measures 16–23.
Credit: Copyright © 1961 C. F. Peters. Used by permission of C. F. Peters Corporation.

twelve-tone texts. While experimental for Denisov, and far more intricate than Pärt's or Karetnikov's serial writing, this type of serial composition was old hat for European or American composers in 1961. Stravinsky's *In Memoriam Dylan Thomas* had used five-note series, and Stravinsky had also divided series into separately-functioning hexachords in *Agon* (1957). As usual, it was the mere fact that the *Piano Variations* was serial in any respect that mattered the most politically. Denisov ran into trouble politically because of his continued pursuance of ever-increasing levels of abstract serial rigor.

By the time of his Violin Sonata (1963), Denisov had grown more adept at serial procedures and also more ambitious. The work is much more substantial

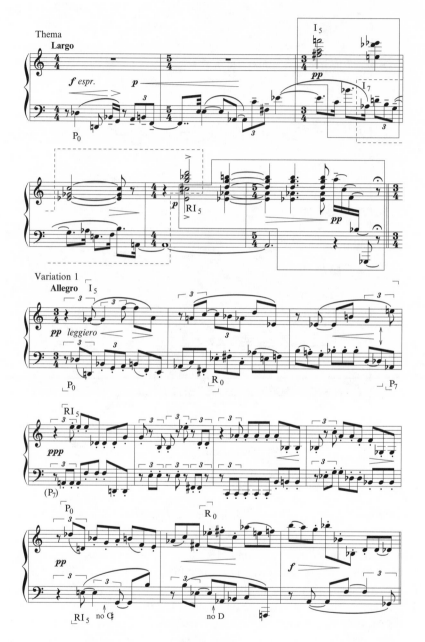

Example 4.4. Denisov, *Piano Variations*, theme and variation 1.
Credit: Copyright © by Deutscher Verlag für Musik, Leipzig.

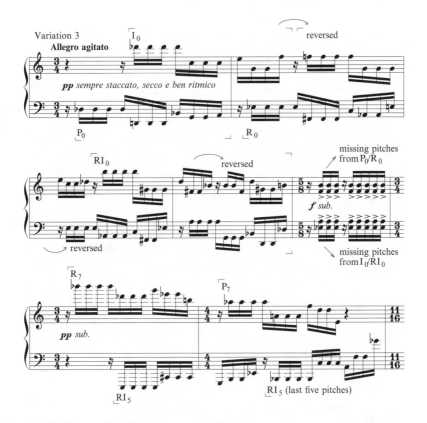

Example 4.5. Denisov, *Piano Variations*, variation 3.
Credit: Copyright © by Deutscher Verlag für Musik, Leipzig.

than the preceding compositions, but at the same time it continues to maintain a toehold in tradition. Not only is the work still indebted to Bartók, and in fact bears some resemblance to the finale of his First Violin Sonata, but it also has tonal hallmarks: the row features thirds and fourths, and the first movement contains numerous diatonic sonorities, including the piano's repeated C major triads in measure 24 (again, Denisov uses a nearly combinatorial row, but does not exploit this attribute in the composition). In terms of its serial manipulations, the Violin Sonata is more straightforward; it lacks the rotations or row subdivisions in the *Music for Eleven Winds and Timpani* or the *Piano Variations*. Instead Denisov concentrates on alternating loose statements of the row with clearer, more linear statements, much as Volkonsky had done in several movements of *Musica Stricta*.

The opposition is audible in the first measures of Denisov's sonata where a succession of amorphous row statements—an obscured P_0, then several rapidly repeated violin statements of I_0 over a pounded E in the piano—give

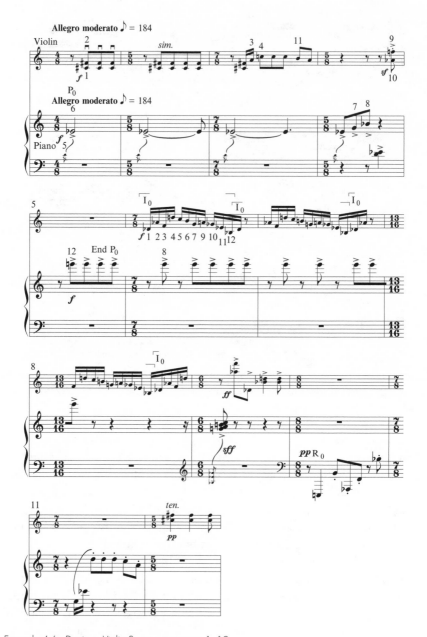

Example 4.6. Denisov, Violin Sonata, measures 1–12.

way in measure 10 to clear statements of first the retrograde form (R_0), and then the P_9 form (and again note Denisov's favorite pitch repetitions) (ex. 4.6). This is followed in measure 15 by linear statements of P_6 and P_9 that begin clearly but then intermingle (not shown in the example). Similar alterations or combinations of "free" and "strict" twelve-tone styles occur over the course of the movement, with the freer sections reserved for climatic moments, like the beginning, the middle (esp. mm. 60–66), and the ending, which revisits the piece's murky opening.[31] By the time of the Violin Sonata's composition Denisov had grown confident with serial techniques and could adeptly manipulate them in the service of increasingly large-scale forms. In his next work, *Sun of the Incas*, Denisov turned away from abstract forms and attempted to use serial devices to more evocative, poetic effect.

DENISOV AS SERIAL THEORIST

Thanks to his early serial compositions, Denisov had quickly become one of the most well-versed of the "young composers" at employing the new techniques. In the process he had also become one of the more theoretically savvy of the "young composers" regarding serialism and began to speak and publish on the topic. We do not know what Volkonsky thought of serialism to the extent that we know Denisov's views on the subject. Denisov was the most prolific Soviet writer on the topic, the one who had obviously contemplated and studied serialism the most thoroughly and the most sympathetically. One of the important early documents of his serial thinking was also roughly contemporaneous with *Sun of the Incas*. In January 1963 he wrote a theoretical paper called "Dodecaphony and the Problems of Contemporary Compositional Technique" that reveals much about his personal attitude toward serialism during the 1960s (it was not published until 1969).

In many ways, Denisov's first published treatise on the twelve-tone method is rather conservative and anodyne, especially to Western readers.[32] Yet it

31. For another analysis of the entire first movement, see Kholopov, "Ob obshchikh logicheskikh printsipakh sovremennoy garmonii," 263–68.

32. Denisov, "Dodekafoniya i problemï sovremennoy kompozitorskoy tekhniki," 478–525. It first appeared in the 1969 issue (vol. 6) of the irregularly published yearbook, *Music and the Present* (*Muzïka i sovremennost'*) (see Schwarz, *Music and Musical Life in Soviet Russia*, 561–62, for more on this yearbook and its editors Tat'yana Lebedeva and, after vol. 7, Dmitriy Frishman). According to the editors, the revised version included few new additions, primarily adding a newer composition by Babadzhanyan, and references to recent articles by Mazel' and Boulez. It is also helpful to compare it with a 1965 Denisov lecture with which it overlaps considerably: "For Objectivity and Justice in the Evaluation of Contemporary Music" ("Za ob'yektivnost' i spravedlivost' v otsenke sovremennoy muzïki"; published in Tsenova, ed., *Svet-dobro-vechnost'*, 22–33).

deserves pride of place as the first and only article of its kind in the Soviet Union to argue for twelve-tone music as well as to provide a description of its history and basic techniques illustrated with examples drawn from a wide range of European modernist compositions, both from the early twentieth century as well as the postwar period. In its breadth and in the depth of knowledge that it demonstrated regarding modern compositional practice and theory it stood apart from contemporaneous articles by Lev Mazel' or Mikhaíl Tarakanov, a musicologist sympathetic to the avant-garde.[33] In fact, it would be the only large-scale treatment of its topic in the entire Soviet period, aside from those aspects of serial writing that were discussed in rare articles or some books, like Yuriy Kholopov's later *Essays on Contemporary Harmony,* a few of his articles from the 1970s, or his monograph (written with his sister Valentina Kholopova) on Webern from the early 1980s.[34]

As he presents a rather typical genealogy for serial techniques in the article, Denisov argues repeatedly for the "naturalness" of the process, in so doing countering the repeated official accusations that serialism was an "unnatural" ("neyestestvennïy") method of composition. Much as Gould had done in his lecture at the Moscow Conservatory in May 1957, Denisov begins his narrative with the dissolution of tonality at the end of the nineteenth century and the beginning of the twentieth in compositions like Liszt's *Faust Symphony,* Mahler's *Kindertotenlieder,* and Berg's Chamber Concerto. He then moves on to atonal music, and then to serial music, which of course developed logically and inevitably from atonality: "Dodecaphony was never 'thought up' by anyone, or even 'imposed' upon art; all of its rules gradually came together in the creative practice of composers from the most various countries, and it was the fate of Arnold Schoenberg [to take] only the most difficult and responsible step: the realization of those rules and the first attempt at their consistent application in his work."[35] Having triumphantly arrived at his goal, Denisov then outlined the principles that Schoenberg was "fated" to discover, among them the basic properties of the series (including a discussion of the term "series" itself), illustrated with numerous examples from Berg, Webern, Nono (*Il canto sospeso*) and Lutosławski (*Funeral Music*), among others. These examples reveal which composers Denisov then had access to and which were

33. Before 1969 few articles had been published in the Soviet Union that directly addressed serial techniques. Notable exceptions included sections of Shneyerson's *On Music Living and Dead,* Thilman's and Rubin's articles on twelve-tone and serial composition (see chapter 2), as well as *Sovetskaya muzïka* articles by Lev Mazel' and Mikhaíl Tarakanov: Mazel', "O putyakh razvitiya yazïka sovremennoy muzïki"; and Tarakanov, "Novïye obrazï, novïye sredstva."

34. Only in 1996 did a monograph on serial music appear in Russia: Kurbatskaya, *Seriynaya muzïka.* See also Kholopov, *Ocherki sovremennoy garmonii;* Kholopov, "Ob obshchikh logicheskikh printsipakh sovremennoy garmonii"; and Kholopova and Kholopov, *Anton Vebern.*

35. Denisov, "Dodekafoniya i problemï sovremennoy kompozitorskoy tekhnii," 490.

acceptable for publication in official journals at the time. (Of course, almost anything was potentially publishable if the accompanying text was duly critical and "objective," as Denisov's editors emphasized in their cautious introduction to his text.)

Yet unlike Shneyerson's *On Music Living and Dead*, with its disposable texts and essential examples, Denisov's text is at least as important as the accompanying illustrations. Particularly important is Denisov's discussion of the rules for composing twelve-tone music, including the various treatments of the series, among them its forms and transpositions (prime, inversion, etc.) as well as the question of octave doublings.[36] One of the other official criticisms that he is explicitly countering in his thorough discussion, represented by a quotation from Shneyerson's book, is the idea that twelve-tone music is modish, something that anyone can do, especially those without talent.[37] As he attempted to live up to his editors' emphasis of his article's "serious and calm tone" and its evenhanded manner, Denisov also took pains to discuss the negative situations that confront composers as they employ serial techniques and especially total serialism, especially the resulting problems with perceptibility that frequently arise.[38]

Although important historically as a marker of 1960s Soviet knowledge of and opinions regarding serial music, Denisov's article also reveals his own personal approach to serialism and his own influences. For example, he notes that in serial compositions, the original series can be divided into "segments" that may be used "independently," but will "in all their autonomy always retain the connection with their great-grandmother [the original series]."[39] Such an approach was already witnessed in Denisov's *Piano Variations*, and would also reappear in *Sun of the Incas*. Similarly, the style of the excerpts that Denisov cites at the end of his article from Toshirō Mayuzumi's sparse, pointillistic, coloristic pieces for prepared piano and string quartet was echoed in *Sun of the Incas*.

Some of Denisov's most revealing comments come in the footnotes to the article, particularly those on Schoenberg's *A Survivor from Warsaw* and Benjamin Britten.[40] Representative is this on Webern: "The music of A. Webern is profound and unusual, and its unusualness lies not in its use of unaccustomed means (we adjust very quickly to the novelties of Webern's language, most likely because of the strength of their naturalness), but in the richness and brightness of the musical world being opened up before us."[41] These comments

36. Ibid., 494–97.
37. Ibid., 480. The Shneyerson quotation is from *O muzïke zhivoy i myortvoy*, Second Ed., 27.
38. Ibid., 478–79 and 505.
39. Ibid., 493.
40. Ibid., 493–94 n. 2 and 504 n.
41. Ibid., 499 n.

show Denisov's assumptions and prejudices better than anything else: the per-
ceived need to "adjust" to Webern's musical language, the use of "naturalness"
as a critical criterion (both for and against serial music), and those aspects of
Webern's music that Denisov valued the most: its color and expressivity. These
comments may strike contemporary readers as banal, but they were informed
and candid appraisals in the Soviet Union at the time. Denisov was one of the
few composers in a position to be making such judgments.

SERIALISM BETWEEN CHILDISHNESS AND THE ABYSS

The piece that Denisov began working on a year after he first delivered "Dode-
caphony and the Problems of Contemporary Compositional Techniques " was
Sun of the Incas, a song cycle (sometimes called a cantata) for soprano, three
speakers (live or recorded on tape), and eleven instruments, based on texts
by the Chilean poet and Nobel Prize–winner Gabriela Mistral (1889–1957).
Before it became widely known in Europe, it received an extremely successful
premiere in Leningrad. Davïdova, the singer of the premiere, remembers that
the first performance of *Sun of the Incas* "came about very easily." "After the
performance of *Suite of Mirrors* in 1961," She recalled: "All the composers threw
themselves at me (all the 'Left' [i.e., unofficial] composers) and asked me to sing
their pieces.... I already don't remember, either Rozhdestvensky... or Denisov
called me and said that *Sun of the Incas* would be premiered in Petersburg [she
meant Leningrad] in the Glinka Small Hall [of the Leningrad Philharmonic].
In the first half I sang a concert aria by Mozart.... And *Sun of the Incas* was
performed in the second half."[42] Denisov attributed the first performance to
Rozhdestvensky's initiative, and recounted the encounter that led to the pre-
miere. Sometime in early to mid-1964 the two ran into one another "by chance"
in front of the Moscow Conservatory. Rozhdestvensky asked Denisov if he was
composing anything, and Denisov showed him the score to *Sun of the Incas.*
Denisov remembered that "[Rozhdestvensky] paged through it very quickly,
[then asked]: 'When will you finish?' I said: 'Well look, I don't know, but most
likely soon.' 'Okay, go ahead and finish and I'll play it at my concert in Lenin-
grad.' And it was one of only a few of my compositions that were performed
literally two-three months after they were finished."[43] Thus, owing to the machi-
nations of several interested parties, including Rozhdestvensky and no doubt
the director of the Small Hall of the Leningrad Philharmonic, Semyonova, *Sun
of the Incas* was premiered in Leningrad and not in Moscow.

42. Davïdova, interview, 14 September 1999.
43. PED: 31.

As both Rozhdestvensky and Davïdova remembered it years later, the premiere on 30 November 1964 was very well received (there is a recording of this performance, but aside from the occasional cough, no audience response is audible).[44] Davïdova called it a huge success, and found Denisov's work to be a "more accessible piece" than Volkonsky's more difficult *Laments of Shchaza* (again, premiered a year later in 1965).[45] Rozhdestvensky reminisced about the premiere in a 1989 interview with the theorist Valeriya Tsenova: "I don't remember [that concert] very well, but what remains is a feeling of the significance of the piece, but at that time [the feeling] was stronger than it is now. It was all being done for the first time and was always connected with a sufficiently serious risk for both the composer and the performers. In so far as it was forbidden [to perform such music], it meant that you had already violated a defined relationship within society."[46] He also commented on the great success of the premiere, noting that "the public always received that [piece] extremely enthusiastically." And Rozhdestvensky acknowledged that its success was due to more than the fact that it was a "forbidden fruit," that people went to hear it only "because it was forbidden": "it seems to me that even if to some extent that were true...the very value of the music remains evident, objective and lasting."[47]

As might be expected, Denisov remembered the concert in more detail: on the first half of the program were pieces by Mozart (the concert aria that Davïdova recalled, K. 61c, "A Berenice...Sol nascente," according to Rozhdestvensky's notebook) and Silvestre Revueltas (his "Octet," most likely the 1933 *Ocho x radio* [*Ocho por radio*]; "Gennadiy always loves to present anything exotic"), followed on the second half by *Sun of the Incas* and finally Stravinsky's *Ragtime*. (Denisov neglected to mention that the concert began with Bohuslav Martinů's *Round Dances* [*Khorovodï*, or *Les rondes;* 1930], or that the Mozart, Martinů, and Revueltas pieces were all being performed for the first time in the USSR.[48]) Denisov also described the concert's reception:

The first concert went, so to say, normally...fine—no one asked for extra tickets, as they say. Then, to my own surprise (most of all) and that of Rozhdestvensky, *Sun of the Incas* had the biggest success of the entire concert.

44. This date is taken from the List of Performances ("Perechen") from Denisov's personal file ("lichnoye delo") at the Moscow Union of Composers. These lists were semiannual accounts of a composer's performances and publications. It is supported by Rozhdestvensky's performance notebook (see Rozhdestvenskiy, *Preambulï*, 263). A recording of the premiere appears on Denisov, *Le Pleurs*. A photo featuring the performers and well-wishers after the performance is reproduced in Talochkin and Alpatova, eds., *"Drugoye iskusstvo,"* I:135.

45. Davïdova, interview, 14 September 1999.

46. Rozhdestvenskiy and Tsenova, "Grazhdanin mira," 152.

47. Ibid., 153.

48. See PED: 31–32; and Rozhdestvenskiy, *Preambulï*, 263.

In the Small Hall of the Leningrad Philharmonic something was created that I would not have believed for anything had I not been at the concert. The public literally shouted when they called me out onto the stage. And as a result, at the next concert Gena [Rozhdestvensky] presented my work at the very end, after Stravinsky's.... He literally said to me the following: "Edik! After your piece it is impossible to play Stravinsky's *Rag-time*. It won't go over well with the audience."[49]

Davïdova added to the accounts of the overwhelming response at the premiere. After *Sun of the Incas* was performed, she said, the audience "shouted hurrah, shouted, and applauded."[50]

The reaction at the second concert was even greater, as Denisov told it: "I was already struck by the fact...that there was a huge crowd on the street in front of the hall. And literally everyone was asking for extra tickets. And after the concert Seryozha [Sergey] Slonimsky...counted on his fingers the number of times they called me out—and said, 'Never in my life have I seen such a thing, Edik: They called you out 11 times!'"[51] In another account, Denisov also indicated that "militia were standing outside the hall and for three blocks people were asking for tickets for a composition by a composer completely unknown to anyone in Leningrad."[52] Despite the fact that all of these descriptions come from many years after the premiere of *Sun of the Incas,* and despite the fact that memories of seminal events are naturally colored and embellished in the retelling, it is not difficult to believe that the audience responded with such vigor to the music in Denisov's cycle. Audiences in the Soviet Union had literally never heard anything like it. *Suite of Mirrors* comes close to the piece in terms of its sound, but it had been performed once almost three years earlier, and in Moscow at that. On its surface, the music of *Sun of the Incas* was captivating to its initial listeners. It also engaged with topics and techniques that were of common interest to many of the "young composers" and that we have already witnessed in Volkonsky's early compositions: abstraction, exotic texts, unusual instrumental colors, and a wide array of compositional techniques, ranging from hints of total serialism to free atonality, from aleatory devices to *sonorika.*

What stands out about *Sun of the Incas* is not only the specifics of its serial language but also its texts, which provide a good entry point into a discussion

49. PED: 32.

50. Davïdova, interview, 14 September 1999.

51. PED: 32. The number of curtain calls the piece received varied with the telling. In Kholopov and Tsenova's monograph, Denisov reported that they called him out fifteen times. Kholopov and Tsenova, *Edison Denisov,* 23.

52. Kholopov and Tsenova, *Edison Denisov,* 23.

of the intricacies of the work and introduce the strain between mimesis and abstraction that colored its composition and reception. In his own analysis of the composition, Denisov highlighted the opposition between ordered and unordered material in *Sun of the Incas,* between strict twelve-tone material and looser, even aleatory, constructions. On a formal scale there is also an opposition between vocal and instrumental movements: the odd movements (I-III-V) are rapid-fire instrumental pieces (five has a text, but it is unsung) and the even movements (II-IV-VI) are longer, more static meditations for voice. Predictably, it was the disjunction between texts and music perceived by critics in the even-numbered movements that would receive the bulk of the charges directed at the composition.

The texts might seem a strange choice, by an author—Mistral—unfamiliar to most Soviets. Like the circumstances of *Sun of the Incas'* "chance" performance, Denisov also came across Mistral's works by chance in a used bookstore in Moscow's Arbat district (which Bittner has appropriately dubbed "Moscow's Left Bank").[53] The poems that Denisov used in the cycle were taken from several of Mistral's early books—"El Dios triste" ("Pechal'nïy Bog," "The Sad God") from Mistral's first collection *Desolacion* (1922), from the section called *Vida,* and "Cima" ("Krasnïy vecher," "Red Evening") from the section *Naturaleza* of the same collection. "Song about a Tiny Finger" ("Pesnya o pal'chike") was originally titled "La Manca" ("The Crippled One") and was taken from Mistral's second collection *Ternura* (1924) from the section *Jugarretas.* The source of "Curse" ("Proklyatoye slovo") is the opening and closing sections of a text Mistral wrote about the cold war called "The Accursed Word" ("La Palabra Maldita"). This essay was a call for peace that was originally published in 1951, and was later frequently reprinted in Chile by the Communist Party.[54] Oddly enough, nowhere in any of these poems does the title of the song cycle appear. Instead it is taken from a different poem of Mistral's, "Dos Himnos," from the section called "America" in Mistral's book *Tala* from 1938. The title is from the first line of the first of these two hymns, "Sun of the Tropics" ("Sol del Trópico"), which begins "Sun of the Incas, sun of the Mayas, ripe sun of

53. According to Denisov, the translation was by Lev Eydlin, although the Universal Edition scores indicate the Russian translation was by Ovadiy Savich (Owadij Sawitsch). PED: 35 (Denisov tells basically the same story on p. 147); and Denisov, *Die Sonne der Inkas.* See also Bittner, "Exploring Reform: De-Stalinization in Moscow's Arbat District, 1953–1968," 25 and 29 (also Bittner, *The Many Lives of Khrushchev's Thaw,* 3).

54. As a result of its adoption by the communists in Chile, many anthologies of Mistral's work exclude this essay; it is not surprising that the edition that Denisov purchased in the Soviet Union included it. I am indebted to Mistral scholars Elizabeth Horan and Marjorie Agosin for their assistance in locating the source of this text and particularly to Horan for her background information about its place in Mistral's output. Reprinted in Mistral, *Escritos Politicos,* 159–61. The other books can be found anthologized in Mistral, *Desolación-Ternura-Tala-Lagar,* 15 ("El Dios triste"), 46–47 ("Cima"), and 82 ("La Manca").

America" ("Sol de los Incas, sol de los Mayas, maduro sol americano").[55] Denisov picked the phrase because, in his own words, it "seemed to me that those words best of all immediately approached the contents of the entire cycle."[56]

Even with these somewhat ambiguous clues from its creator, the texts that Denisov selected for the cycle only loosely cohere. The disjunction between the title and the poems that make up the cycle itself raises eyebrows; in no poem do the Incas appear, although the sun, and specifically the setting sun, appears in at least the first two poems, "The Sorrowful God" and "Red Evening." Each poem treats a different subject, but there are certain images in common, particularly in the first two texted movements (II and IV). For example, the setting sun of these movements joins together images of melancholy: the "noise of the falling of leaves…in the autumnal alley" of "The Sorrowful God" finds its companion in the "valley already full of shadows, of silence" in "Red Evening." And in the former the "autumnal god" who is "without fervor, without singing" leads the narrator to prayer while in the latter the narrator "timidly begin[s] singing a sorrowful song." The text of silent prayer is succeeded by the text of sorrowful incantation. In fact, of all four texts in the cycle it is "The Sorrowful God" and "Red Evening" that have the most in common. In the formal scheme of the cycle as a whole, they are connected, while the more absurd and sui generis "Song about a Tiny Finger" is set on its own at the end of the cycle. The instrumental song, "Curse," is set even further apart from the other three texts, and not only because it is the sole unsung text.

In his conversations with Shul'gin, Denisov was much more concerned with discussing the various timbral and orchestrational effects in *Sun of the Incas* than its serial construction. He particularly emphasized the colors of the individual instruments involved and the shifting instrumentation from movement to movement. The piece begins with the winds and percussion, turns to the two pianos, percussion, and voice in the second movement, returns to the winds and strings in III, and then contracts to flute, violin, cello and voice in IV, concentrating on a languid, extended duet for soprano and flute, before returning to the full ensemble (minus voice) for V. The final movement employs various percussion instruments, voice, and the two pianos. As this progression suggests, a large part of the instrumental drama in *Sun of the Incas* is created by the opposition between the larger forces in the instrumental movements and the more intimate settings of the vocal movements. Furthermore, Denisov made a large point of saving his most novel timbres until the final movements. In fact, Denisov traced the basic idea of the entire piece to the increasing

55. Mistral, *Desolación-Ternura-Tala-Lagar*, 138.

56. See PED: 35. Here Denisov also emphatically denied any influence on the name by the title of Boulez's piece *Le Soleil des eaux* (*Sun of the Incas* was later dedicated to Boulez).

"bell-likeness" ("kolokol'nost'") of the timbres, culminating in the bell strokes that end the composition.[57]

Denisov pointed to the basic opposition in the piece between what he called "two tendencies: the movement to definiteness, and...to indefiniteness."[58] Most of the material is "definite," here taken to mean serial. But there are also moments of aleatory writing in the piece, most prominently in the fourth movement. The serial techniques in *Sun of the Incas* vary from movement to movement as Denisov later described them to French pianist Jean-Pierre Armengaud.[59] Despite his disingenuous claim in this interview that "there is not a single measure of dodecaphony" in the work, the piece is strictly patterned and is consistently, if not exclusively, serial (at moments Denisov does abandon or only loosely adheres to the serial structure—as in the fifth movement). At the same time, other than the third movement, much of the piece was not as completely structured as Schnittke's and Pärt's contemporaneous experiments in total serialism, such as Schnittke's *Music for Chamber Orchestra* and *Music for Piano and Chamber Orchestra* (both from 1964, see chapter 6). But, of course, the Leningrad audiences had never heard those compositions.

In the first two movements, the serial techniques are rather free, with many repetitions and alterations in the order of pitches. These repetitions and alterations are particularly evident in the vocal line and provide the characteristic melodic contours of this piece, including the repeated oscillations between pitches followed by flourishes of smaller note values, as in measures 8–10 in the second movement (ex. 4.7). One interval series does govern the entire work, but as Denisov mentioned to Armengaud, in the third and fourth movements he concentrated on hexachordal segments of the original series (similar to his practice in several of the *Piano Variations*). In the short, staccato outbursts of the instrumental third movement he used the first six notes of the series, while in the more leisurely vocal fourth movement he used the second half. The fourth movement, clearly reminiscent of the third movement of Boulez's *Le Marteau sans maître,* "L'artisant furieux," adds another free element, literally, as the violin at letter A, the cello at J, and the flute at K perform aleatory segments not strictly governed by the row, while the other voices continue to play row segments.

There are some attempts at serializing multiple elements of the texture in movement three. In this movement there is a dynamic series unnoticed by previous analysts—*p mf pp mp f ppp*—which appears with its retrograde—*ppp f mp pp mf p*—, as well as its complementation—*mp f ppp p pp mf*—and its corresponding (slightly altered) retrograde—*pp mf p ppp f mp.* These are used

57. PED: 151.
58. Ibid., 152.
59. Denisov and Armengaud, *Entretiens avec Denisov,* 121.

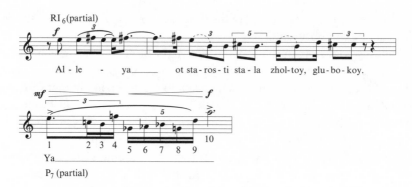

Example 4.7. Denisov, *Sun of the Incas,* movement II, measures 8–10 (voice only).

throughout the movement with some deviations, as in the final chord where the dynamics are arranged from loudest to softest, reading down the score.[60] There is also a loose timbral series dictated by groupings of six instruments that governs the entrance and pairing of voices.[61] Denisov was obviously interested in controlling as many components of this movement as possible. Only rhythm escaped his permutations, although individual rhythmic patterns are repeated quasi-canonically from instrument to instrument throughout the movement. The final third of the fifth movement is constructed with similar attention to rhythm and dynamics, but with a more deliberately programmatic end in mind.

Denisov viewed the final two movements, "Curse" and "Song about a Tiny Finger," as the "instrumental culmination" and the "epilogue and…quintessence" of the cycle, respectively.[62] As the summation of the instrumental and vocal movements of the piece, these final two movements are also representative of the wide variety of techniques at play in the entire cycle and crucial to

60. Denisov acknowledged a dynamic series in the movement, but did not go into specifics; Kholopov focused only on the final chord; and Kholopov and Tsenova examine only the timbres. PED: 153; Kholopov, "Dvenadtsatitonovost' u kontsa veka," 80; and Kholopov and Tsenova, *Edison Denisov,* 131–32.

61. PED: 153. Kholopov and Tsenova cite the opening "six-lined timbral retrograde" in the first two measures that applies only to the entrance of the instruments (horn-clarinet-violin-trumpet-oboe-cello), not pitch, as both halves of this timbral retrograde are governed by two separate hexachords that are not retrogrades: the first hexachord of P_0 and the second of RI_8. This order of entrances is repeated in mm. 13–15 and again in mm. 15–18. Pairs of instruments from the same family enter in m. 9 (strings, brass, then winds); later a new sequence is presented first forward, then in retrograde (as in the opening measures) in the final six measures of the piece—first horn, then cello-violin-clarinet-trumpet-oboe. This is then reversed as trumpet-oboe (maintained from the previous series), violin-clarinet, and, finally, cello-horn to end the piece. Kholopov and Tsenova, *Edison Denisov,* 131–32. See also Kholopov, "Dvenadtsatitonovost' u kontsa veka," 80.

62. PED: 149–50.

an interpretation of the work as a whole. Movement five, the unsung "Curse," is at once the most political and the most straightforward text, and also the movement least evocative of the Incas. It is also the loudest and densest movement of the piece. Because its text is not sung but instead "set" instrumentally, it acts as a pivot between the texted and untexted movements in the work, and also, in a sense, between mimesis and abstraction. Like the composition as a whole, it blurs the boundary between the two modes. In Denisov's words: "It concentrates in itself everything that preceded it in the instrumental movements up to that point" ("and even something of the vocal movements," he later added).[63] Denisov commented further on the contents of the final two movements and their connection with the preceding:

> If you take the fourth movement—"Red Evening"—there are very important lines about the evening sun, with its bloody light spilling over the mountains—and that is not just a metaphor, that is also about the curse hanging over our world. Take those words "Is it not from my blood that the heights grow crimson?" What is that about? On whose conscience does our blood lie? What should we do in order that it is never [spilled] and that no one spills it on those mountains, on the entire earth? Who will save it? And the answer is the fifth movement, and the sixth movement, it is the same: only striving for general peace, only love for our children.[64]

This was Denisov speaking later in his life. As with a majority of Denisov's own comments, his interpretation of the piece sounds heartfelt. However, he engages with only one layer of this complex movement.

Denisov speaks in generalities about the meaning of the texts and music in the piece, and specifically the fifth movement, but more politically minded analysts like Kholopov and Tsenova have made explicit the correspondences between the fifth movement and the text of the preceding sung movement only alluded to by Denisov. They suggest that the blood in "Red Evening" has a political implication to it, specifically related to the immediate past and present and "not at all [to] the ancient Incas." They contend that these lines "unexpectedly open the unhealed wounds of the twentieth century.... And the abyss opens wide in the fifth movement."[65] The abyss does indeed open in the fifth movement, for if "Red Evening" carries implicit political overtones, "Curse" is explicit in its calls for peace and its grim description of the "odor of blood" rising from the "dead lying everywhere on the land of ill-fated Europe." In fact, the noticeable difference in the tone of this text is because it is taken

63. Ibid., 149 and 154.
64. Ibid., 154.
65. Kholopov and Tsenova, *Edison Denisov*, 130.

from a very political speech.[66] The effaced date, which could very easily be supplied—1945 springs immediately to mind (although it is 1914 in Mistral's original text)—and the concrete location—"ill-fated Europe"—would bring this text closer to home for a reader in the post-World War II Soviet Union.[67] (But remember that the listeners at the premiere were unaware of this text.) Beyond its blatant appeals for peace, Denisov is of little help in deciphering "Curse." Instead, when discussing this particular movement and its text, Denisov declared that "it is quite...political" before resorting to platitudes: "It is very important: the battle for peace....It is always necessary to make it so that people talk with one another, and don't spill blood, don't fight. Naturally, I didn't formally write that because party representatives called us to do that, but because to me every form of evil, and all the more any aggression or war, has really always been deeply antithetical to me."[68]

The fifth movement's music mimetically reflects the "massacre" of the first line of Mistral's text. The movement nearly abandons the row "so that practically nothing from the series remains."[69] This is what Kholopov and Tsenova call the "catastrophe" of the row in the fifth movement, which they claim "leads not to a simple further renewal of its expression, but to a radical change in the musical order."[70] As if to underscore this "catastrophe," Denisov also applied the dynamics so that "there would not be any kind of metrical coincidence," so that the dynamics would cancel each other out and present a disorganized facade to the musical surface.[71] The entire fifth movement, and most evidently the final third (from m. 19 on), also draws upon textures and constructions first seen in the third movement, particularly the imitative waves and repeated thirty-two-note bursts. Here there are several entrances, each completing the total chromatic before beginning again, starting with the brass then fanning out to the winds, strings, and pianos. By the end, the instruments are playing the same rhythm, while the pianos hammer out a motive—D-E-D-B\flat-(D), found in one row form (R_8), but here with a separate significance, especially as its final pitch D, is the author's musical "signature." This final pitch is, according to Denisov, the "main point" ("glavnaya tochka"), and the ending of this movement is certainly one of the most striking moments in the cycle.[72]

66. For some reason, the Spanish original to this poem was not included in the 1971 Universal Edition score, although it includes the Spanish originals for the other three texted movements (and the Russian and German translations of "Curse").

67. It is unknown whether the date was excluded from the translation that Denisov used, or whether he himself omitted the date, striving for a more general effect by leaving it open to interpretation.

68. PED: 154.

69. Ibid., 153.

70. Kholopov and Tsenova, *Edison Denisov*, 131.

71. PED: 153.

72. Ibid. See also Kholopov and Tsenova, *Edison Denisov*, 133.

Despite the weight that Denisov gave to "Curse," it is the final movement of the work, "Song about a Tiny Finger" (the title is his own), that he prized the most, calling it the "center of the work" and the "most important movement."[73] Denisov was striving for the character of a child's song here.[74] Remarking on the simplicity of this movement and its contrast with the apocalyptic tone of the fifth movement, Kholopov and Tsenova discuss the opposition between these two movements as the embodiment of the cycle's central theme: "Its simplicity is deceiving because it is impossible to erase from consciousness the horrible picture of the fifth movement. The idea of *Sun of the Incas* culminates in this dichotomy."[75] In fact, after the *fortississimo* climax to "Curse," the bare opening of "Song about a Tiny Finger," with only voice and wood blocks, comes as a shock.

The text to this movement is a narrative about a girl who has her finger bitten off by an oyster, which is caught by a fisherman and brought to Gibraltar to market, pursued all the while by the girl (box 4.1). The narrator of the song is at once the little girl and an omniscient third-person reporter of events. The girl calls for a ship with a captain with a drummer, who will go to the city of Marseille where an organ-grinder sings the song about the girl's finger. After she states that "I need my finger," the girl and her finger become entangled in a succession of images that she calls forth—captain, ship, drum, drummer, Marseille, organ-grinder—that circularly return to a distanced retelling of the girl's plight intoned by three reciters: "On the distant sea, far from land, they found the girl's tiny finger." But there is no resolution to this absurd yet pitiful quest. After all, the finger is taken to Gibraltar and in the course of the song never returns to the girl, its rightful owner, preventing the drama, such as it is, from coming to a satisfactory conclusion.

The row technique in this movement is quite free, with numerous repetitions (as in mm. 1–4), somehow fitting the absurdity of the text, with its loops and shifts of voice, the non sequiturs and disjunctions, all aspects of what Denisov call its "childishness."[76] The vocal writing here is particularly simple, emphasizing repeated figures that only haltingly move forward, coupled with extreme registral leaps, as in measure 11. These are typical of the vocal writing throughout the piece, but here they are distilled and pared down (ex. 4.8).

Formally, the sixth movement can be divided into five sections, verse (mm. 1–16)—refrain (mm. 17–22)—verse (mm. 23–54)—refrain (mm. 55–61)—coda (m. 62–end). In actuality the first verse/refrain and the second

73. Denisov and Armengaud, *Entretiens avec Denisov,* 121. See also PED: 150.

74. PED: 153.

75. Kholopov and Tsenova, *Edison Denisov,* 133.

76. Denisov reported that in the sixth movement "the series is divided into small cells which are repeated. Although the vocal writing is based on the twelve tones, the ensemble gives the impression of nearly tonal, or in any case, modal writing." Denisov and Armengaud, *Entretiens avec Denisov,* 151.

Box 4.1. Text to "Song about a Tiny Finger" (Gabriela Mistral, "La Manca" ["The Crippled One"], 1924)

Ustritsa pal'chik moy otkusila,	An oyster bit off my finger,
tut zhe ustalost' yeyo podkosila,	Then and there, it [the oyster] was cut down by fatigue,
i na pesok upala ona.	And it fell to the sand.
I podkhvatila yeyo volna.	And was picked up by a wave.
A... Vilovil v more yeyo kitoboy	Ahh... A whaler caught it in the sea
i v Gibraltar privyoz s soboy.	And brought it to Gibraltar.
I ribaki poyut v gibraltare:	And the fishermen sing in Gibraltar:
"Kto poteryal, ishchi na bazare."	"Whoever lost [it], search in the bazaar."
Daite korab' mne,	Give me a ship,
pal'chik mne nuzhen:	I need my finger:
na korable dolzhen bit' kapitan;	On the ship must be a captain;
u kapitana obed i uzhin,	The captain must have dinner and supper,
mnogo matrosov i baraban.	Many sailors and a drum.
V gorod Marsel' poydyot barabanshchik:	The drummer will go to the city of Marseille:
ploshchadi, bashni i korabli.	Squares, towers and ships.
Pesnyu o pal'tse poyot tam sharmanshchik:	An organ grinder there sings a song about a finger:
"V more dalyokom, vdali ot zemli	"On the distant sea, far from land
Devochkin pal'chik v more nashli."	They found the girl's tiny finger."

Translated from the Spanish original by Lev Eydlin or Ovadiy Savich (after Mistral). Translation from Russian is my own.

verse/refrain pairings are very similar, giving the movement the character of a strophic song, which is reinforced by the three speakers who appear only in the refrains. This moment was recorded on tape for the premiere by Denisov's friend Anatoliy Agamirov, and Denisov wanted that moment to be "like a voice from another sphere" (judging from the haunting and otherwordly sound at this moment on the recording of the premiere, his wishes were answered).[77] The writing for the first refrain is fairly strict, but as the second refrain moves into the coda, the twelve-tone writing is gradually loosened, becoming freer until the section starting in measure 62B, when

77. PED: 151; and Agamirov in Talochkin and Alpatova, eds., "Drugoye iskusstvo," I:308–9.

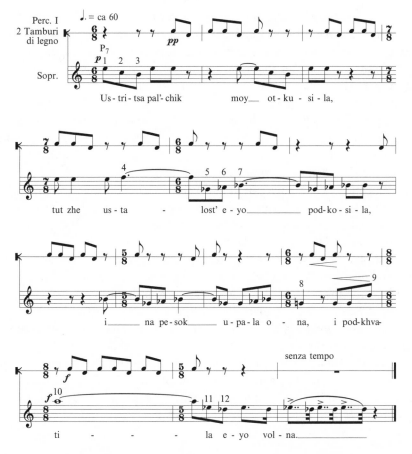

Example 4.8. Denisov, *Sun of the Incas*, movement VI, measures 1–13 (ensemble omitted in m. 13).
Credit: Copyright © 1971 by Universal Edition (London) Ltd., London/UE 13597.

P_0 enters, the culmination of both the piece and the movement, and ending with vague suggestions of P_7 (and its final pitch C♯).[78] The coda presents new timbral colors: vibraphone, marimba, tam-tams, and bells, with the first piano oscillating in its highest register and the second plucking strings within the instrument.

To underscore the message of the final movement, toward the end of its coda a quotation from the Orthodox psalm "O Gladsome Light" ("Svete tikhiy") also appears, like "a ray that illuminates everything and then gradually disappears,"

78. The row form P_7 receives special prominence throughout the movement, occurring at the beginning of each verse and refrain and ending the piece. The I_7 and RI_7 forms are also emphasized.

according to Denisov.[79] The movement, and the cycle as a whole, was perhaps overly dense and overdetermined in its messages and musical techniques. The texts, the novel instrumental devices, and the difficult musical language of *Sun of the Incas* were a lot for the audience to take in after one hearing. Although Denisov held specific mimetic intentions, most listeners were instead caught up in the unusual vocal and instrumental effects as well as the overall mood of the work and its fleeting ethereal and impressionistic moments. Like *Suite of Mirrors* and *Laments of Shchaza,* in the sheer exoticism of its sound—its abstract sonic surface—*Sun of the Incas* was antithetical to almost every other Soviet piece written at the time; this more than any specific political agenda made it enticing to its Soviet auditors. Denisov's composition succeeded with its listeners not only because of its exoticism and abstraction, but also because it combined the best qualities of Volkonsky's earlier vocal cycles, and almost exceeded both, but especially *Laments of Shchaza.* Schnittke later observed the resemblance between the two works, concluding that "Volkonsky's work was composed earlier, but this does not mean that *Sun of the Incas* is inferior."[80] Quite the contrary, for Denisov's sense of dramatic shape was more honed in *Sun of the Incas* than Volkonsky's was in *Laments of Shchaza.* The static moments in *Sun of the Incas* are surrounded by propulsive instrumental movements that carry the work forward; the most striking example of this is the succession and opposition of the final two movements. In the end, Denisov wrote more convincingly and more memorably for voice in his cantata than Volkonsky, even if he did not always create the striking colors of, especially, *Suite of Mirrors.*

THE MAN WHO WAS FORBIDDEN TO EAT CHOCOLATE

Both Rozhdestvensky and Davïdova recall an extremely favorable, even ecstatic, audience response at the Leningrad premiere of *Sun of the Incas.* The piece "had an unexpectedly quick impact," as Denisov later said. "True, it was unofficial, because the critics did not write a single word about it."[81] The immediate response from the officials within the Union of Composers was more mixed. It is true that there were no reviews immediately following the premiere, but Denisov recalled wider repercussions: "I also just remembered that the scandals as a result of *Sun of the Incas* were horrible. They removed the director of the Philharmonic [the concert hall] after the concert, and also

79. PED: 151. In 1988 Denisov also set this liturgical text for unaccompanied chorus.
80. Translation from SR: 14; original in BAS: 140.
81. PED: 141.

spoke offensively of Gena [Rozhdestvensky]. Only with him that was like water off a duck's back. On the contrary, he even walked around fiercely proud after all of that."[82]

If Denisov himself did not initially suffer any personal fallout from *Sun of the Incas,* he would soon begin paying penalties for his compositions and his actions on behalf of contemporary music. It is also important to remember that *Sun of the Incas* was not immediately silenced as was often the case for difficult, "left" works such as *Laments of Shchaza.* Instead it was prominently reviewed at a Fall 1965 meeting of the Secretariat of the Union of Composers (USSR), a summary of which was printed in the January 1966 number of *Sovetskaya muzïka* and titled "When the Secretariat Gathers...."[83] At this particular meeting, Shostakovich, Shchedrin, Mazel', Andrey Eshpai, Ledenyov, Vladimir Feré, Khrennikov, and Nikolai Sidel'nikov discussed new works by several younger composers including Nodar Kalistratovich Gabuniya (b. 1933), Nodar Levanovich Mamisashvili (b. 1930), and Giya Kancheli (b. 1935), as well as Denisov, the sole Russian among the other Georgian composers. According to the account in *Sovetskaya muzïka* the Secretariat's discussion of Denisov's piece was preceded by "behind-the-scenes 'storms,'" or controversies. They also acknowledged "conversations about the undervalued work of Denisov" and questions regarding "the fact that his music was seldom promoted" that had been raised in the past and aimed at both the Secretariat and at "the editors of specialist papers and journals," among them *Sovetskaya muzïka.*[84] The article was thus ostensibly a means for making amends and meeting these criticisms head-on.

Despite claims from the time and later by Denisov and others that his work was "seldom promoted," some evidence suggests that *Sun of the Incas* was in fact recommended for performance by the Union of Composers. In archival materials dating from 1965 and titled: "New Works by Soviet Composers Recommended for Promotion in the 1965–66 Season" ("Spiski proizvedeniy rekomenduyemïkh dlya propagandï v sezone 1965–1966 god") two pieces by Denisov are listed under the heading "Symphonic Works" ("Simfonicheskiye proizvedeniya"): his earlier Symphony for Two String Orchestras and Percussion (1962) and "*Sun of the Incas* (Cantata for Voice

82. Ibid., 32. That the director of the Leningrad Philharmonic was dismissed after this is doubtful, and Denisov himself seemed a bit uncertain about this in the conversation with Shul'gin. Neither Rozhdestvensky nor Davïdova mentioned these specific repercussions, although Rozhdestvensky did mention the danger of performing the piece. In any case, of all the contemporary eyewitnesses only Denisov said that Semyonova was fired, while most of the others (like Pekarsky) said that she never was. Pekarskiy, interview.

83. Unsigned article, "Kogda sobirayetsya sekretariat," 29–32.

84. Ibid., 30.

and Eleven Instruments)."[85] Although this list does not carry a more exact date, and might in fact have been compiled as early as 1964, the date on some of the other materials with which it is filed makes it likely that it dates from early 1965, and thus from before the discussion of the work that took place at the Union of Composers. At the very least, it demonstrates that the workings of the official machinery of the Union of Composers did not always run smoothly, or that the left hand did not always know what the right hand was doing in the Soviet arts bureaucracy. The situation was more complicated than a monolithic view of the system would suggest.

Like most "creative discussions" at the Union of Composers, the comments about *Sun of the Incas* published in *Sovetskaya muzïka* in 1966 leaned heavily toward clichés and catch phrases. Shostakovich was circumspect about the composition, criticizing the text setting, but calling for future performances. Other critics focused on not only the text-setting but also on the "exoticisms" in the piece, as they honed in on the work's perceived imbalance between mimesis and abstraction. For example, Vladimir Feré (1902–71), a composer and former student of Myaskovsky, considered that "here was too much of the exotic" and "the text doesn't come through, the content of the poems is not revealed." Theorist Lev Mazel' called the work "Neoimpressionistic" ("Neoimpressionizm"), and "stated in passing that he took the exotic in *Sun of the Incas* to be a display of a national idiom that Denisov was trying to recreate."[86] Trying, but not succeeding, was Mazel's message. The exotic was permissible if presented as national coloring, but otherwise was detrimental.

Shchedrin, on the other hand, took a much harsher stance, perhaps feeling challenged by the work of his colleague. The two composers were only a year apart at the Moscow Conservatory, and Denisov would have been in Shchedrin's cohort had he been accepted the first year that he applied (see table 2.1). Shchedrin declared to me in an interview that he recalled this discussion and at the time actually did dislike *Sun of the Incas*. He continues to call it the work of an untalented composer, just as he did when he first heard the composition.[87] As a junior member of this official review body Shchedrin must have also felt the need to maintain a more conservative stance, demonstrating to the officials that he could be counted on to toe the party line, however hazy it might have been at this time, and however much his own compositions were breaking away from the conventions of socialist realism.

85. RGALI, f. 2077, op. 1, yed. khr. 2381, l. 1. These lists, as noted in chapter 5, were distributed to the various concert organizations within the Soviet Union for domestic performances. The list that contains *Sun of the Incas* also includes Karayev's Third Symphony, Pärt's First Symphony (here just *Simfoniya*), Salmanov's Third Symphony, and Ustvolskaya's Concerto for Piano and Orchestra.

86. Both Feré and Mazel' in "Kogda sobirayetsya sekretariat," 31.

87. Shchedrin, interview.

In the 1965 discussion Shchedrin complained of the overly cerebral nature of *Sun of the Incas:* "One mustn't let erudition substitute for creativity; one mustn't put erudition alone in place of creativity." Shchedrin also took a few digs at Denisov, pointing out that he had already imitated Shostakovich, Stravinsky's works from around the time of *Histoire du soldat,* and had now moved on to imitations of Nono, Boulez, Penderecki, and Lutosławski. Shchedrin then departed from the formulaic commentary typical in such discussions and launched into what sounded like a Russian *anekdot,* that is to say, a joke:

A short while ago fate brought me together with the director of the candy factory "Bolshevik." He told me that when a new worker took a job with him, he applied one unconditional rule—do not pay attention to the fact that he ate chocolate! If that rule was strictly carried out he [the new worker] would eat chocolate for only three days. If someone reprimanded him, he would eat chocolate for three weeks. If he continued to be observed and forbidden, he would eat chocolate for as long as he continued to work at the factory.

After this long setup, Shchedrin finally reached his punch-line and triumphantly declared that Denisov was the "man who was forbidden to eat chocolate." It was too late; the damage had already been done. The earlier criticisms (both public and private) of Denisov had set him firmly on the serial path. Furthermore, according to Shchedrin, it was only the other Soviet composers' ignorance of contemporary European and American music that allowed them to hear Denisov's work as innovative and new. And, in conclusion, Shchedrin (as summarized by the anonymous *Sovetskaya muzïka* editors) damningly "called into doubt the existence in Denisov of any genuine creative talent."[88] Later speakers on the panel, like Andrey Eshpai, concurred. Unfortunately, there was probably some degree of truth to these criticisms, particularly the idea that it was only lack of familiarity that made Soviet composers find Denisov's work to be innovative. But even so, Shchedrin failed to do it justice. Of Denisov's compositions from the 1960s, *Sun of the Incas* is one of the few that maintains its interest after repeated hearings.

Among the other participants in the session some were in favor of the piece (Roman Ledenyov) while others were more lukewarm (Andrey Eshpai). Khrennikov acknowledged that the work was "beautiful from a coloristic point of view," but also took issue with Denisov's abstract text setting: "Under the vocal line of his cantata you may place any text, any verses, any content." Khrennikov also admitted that, although "avant-garde" musicians often "[deny] melody

88. All of Shchedrin's statements in this paragraph and the preceding are from "Kogda sobirayetsya sekretariat," 31.

and harmony, [and attempt] to compensate for them with noisy shocking effects...no one will dispute that in some of these works there is coloristic beauty, pleasing to the ears."[89]

The jury was still out on Denisov's work. Although there were criticisms of the text setting, it was not strongly condemned, and yet despite some approving remarks about the attractive, pleasant sound, the "beautiful colors," of the piece, neither was the overall reception overwhelmingly positive. The decision made before the 1965 season to promote the work was evidently placed in limbo following the "storms" surrounding the Secretariat session. This did not mean that Denisov was put completely off limits, however, as later, equally serial pieces of his did receive subsequent Soviet performances. The next was to be his *Italian Songs,* which were premiered in Leningrad the very same year that the discussion was published (1966).

DENISOV'S ABSTRACT MYSTICISM

The *Italian Songs* after Alexander Blok (*Ital'yanskiye pesni*) (1964) were composed just after *Sun of the Incas* but are more representative of Denisov's compositions from the second half of the decade. This cycle also provides clues as to the motivations for Denisov's attraction to serial techniques. It showed Denisov becoming much stricter in his serial writing as he continued to move to total serialism, particularly in the fourth (and final) movement, "Uspeniye" (The Virgin Mary's "Assumption").[90] In this movement separate series govern pitch, dynamics, the duration of pitches, and the distance between pitch entrances. However, the movement does not use the work's entire twelve-note series, instead concentrating on subsets, in this case groupings of six similar to the practice already observed in the third and fourth movements of *Sun of the Incas* and the third of the *Piano Variations.*[91] This factor of six also determines the other parameters:

Pitch (first entrance, mm. 1–3): (P_0) A♭-D-E♭-G-A-B♭
Distance between statements (from the beginning of one pitch to the next in eighth notes): 4, 3, 5, 2, 1, 6

89. All of Khrennikov's statements in this paragraph are from "Kogda sobirayetsya sekretariat," 32.

90. Blok's poem was meant to depict the fresco of the same name in the *Life of the Virgin* series by Fra Filippo Lippi (1406–69) in the Spoleto Cathedral. PED: 157.

91. As Kholopov and Tsenova add, in actuality there are really only groups of four because of the overlap between successive statements of the series, e.g., between the last two pitches (A-B♭) of the first P_0 segment and the RI₃ segment that follows in mm. 2–3. Kholopov and Tsenova, *Edison Denisov,* 135.

Duration of each pitch (in sixteenth notes): 25, 5, 9, 21, 9, 17
Dynamics: *f, pp, pppp, mf, ppp, mp*[92]

Liberties are taken with each of the parameters, especially the dynamic series. For example, the second time through the dynamic series, measures 3–6, the series is rearranged and expanded by one: *pp, f, p, pppp, mf, ppp, mp.* The third iteration (mm. 6–9) is a slightly altered retrograde of both preceding series: *pp mp ppp mf ppp p f* (ex. 4.9). (A portion of the duration series is also treated as a retrograde in mm. 10–12: 21–9–5–25.)

As these alterations indicate, Denisov no sooner set his components in motion then he began tinkering with them. At the beginning of the movement there are six statements of six pitches (P_0, RI_3, I_0, R_9, P_6, and RI_9) then beginning in measure 12 there are four statements of four (I_3, I_5, P_7, and R_6). And in the midst of the four statements of four, the dynamic, duration, and rhythmic series lose their hold. Kholopov and Tsenova aptly characterize the process that occurs after the opening of the movement, remarking that the rhythmic and dynamic series "split up, intermix, and a free combination of elements arises."[93] At this point (mm. 14–15), the rhythmic values condense to eighth notes, and then lengthen again, but in general remain smaller than the initial values of the series. In measure 18 Denisov returns to six-note segments of the series and sticks to them for the rest of the movement, although the typical Denisov stutters and repetitions later enter into the fray. In the service of larger expressive goals, Denisov thus allowed the rigid opening structure to become more malleable.

Similarly, at the end of the movement (beginning in m. 72), the entire serial structure dissipates, and only clusters in the lowest register of the piano remain, together with the sound of the flute's clicking keys, tapping on the violin's body with fingers and the tip of the bow, and tapping on the horn, all slowly fading into silence. This is reminiscent of the ending of *Sun of the Incas,* but here instead of the "distant sea" the retreat into unstructured sound is meant to evoke the poem's three deceased kings standing over the fog-filled valley observing the Virgin Mary. Denisov even thought this a type of "musical theater," and later observed that "in all my works from the 1960s the most calculated movement turned out to be very important dramatically."[94] But the tension between mimesis and abstraction heard in *Sun of the Incas* persisted; Denisov's intentions were often contradicted by his compositional results. (Despite the concluding mimetic touch, the most mimetic moment

92. These are adapted from the chart in ibid., 84.
93. Ibid., 135.
94. PED: 159–60 and 161.

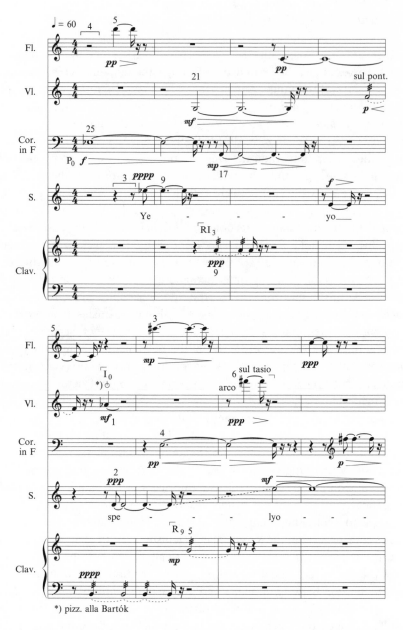

Example 4.9. Denisov, Italian Songs, movement IV, measures 1–16 (the numbers in mm. 1–3 indicate the duration series, the numbers in mm. 5–7 indicate the order of the pitch series in I₀).
Credit: Copyright © 1971 by Editio Musica Budapest.

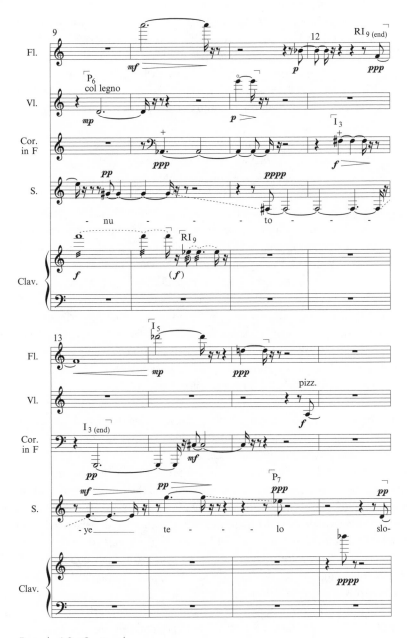

Example 4.9. *Continued*

in the *Italian Songs* remains its second movement "Florence" ["Florentsiya"], which opens with, and periodically returns to, an agitated waltz—more like later Schnittke than Denisov—between its more abstractly static moments.)

When asked by Shul'gin whether "calculations such [as those in 'Assumption'] speed up the creative process," Denisov's lengthy response provides a possible window into the reasons for his application of ever stricter serial techniques, reasons deeper than the stimulus of any particular text:

> No, it is just the opposite: the more you calculate, the slower you write.
> I remember, for example, that when I put before myself the very difficult problems connected with the work on those microstructures and their various combinations [in "Assumption"] it was unbelievably difficult work. And sometimes the following would happen: you sit six-eight hours over a few notes and the longer you sit, the longer you need internal concentration and will in order to hear internally what you are doing with the calculations, and of course in order to check everything. And you have practically no strength left, but at some moment, suddenly and unexpectedly, you begin to feel everything literally like your very self. That is, all the notes—they are already you yourself, your personality, your spirit, your soul. The following would also happen: you sit with some kind of listlessness and write absolutely distractedly; or the opposite: you sit full of passion and no kind of exertion, and only with the feeling that your ears are immersing you in some kinds of, as it seems to you, unknown spheres or worlds. So not all calculations are alike.[95]

The mystical, trancelike experiences that Denisov described are telling. He set up elaborate computations and then lost himself in them, experiencing a kind of involuntary transcendence, a type of freedom of its own, "full of passion and no kind of exertion," moving into "unknown spheres." Francisco Infante used his geometric abstractions to control the infinity surrounding and threatening to engulf him, while Denisov used his serial abstractions to escape into infinity. Composers like Karetnikov no doubt also experienced a similar structured freedom, not far removed from religious ecstasy. And, as we will see in chapter 6, in Karetnikov's case serial music was later coupled explicitly with devout religious convictions. (A similar equation inspired Denisov's use of a rigorous serial framework in "Assumption" to depict a religious transformation.) For both composers, Denisov and Karetnikov, serialism really was a type of glass bead game, a refuge from the very real oppressions of mid-1960s Soviet society into "unknown worlds" of numbers and calculations. The appeal of serial music to such minds must have been irresistible.

95. PED: 162–63.

The premiere of the *Italian Songs* in Leningrad on 10 May 1966 under the direction of Blazhkov and with Davïdova as the soprano soloist does not have the same prominence as *Sun of the Incas* does in contemporary documents or in the memory of the participants.[96] By all accounts it was successful, at least as far as Davïdova remembers, but in her memory all of these performances were equally successful. For her, all of them went off with "great success" ("bol'shoy uspekh"). But details are not as easy to come by for this premiere as they were for the previous concerts that have been discussed (*Musica Stricta, Suite of Mirrors, Sun of the Incas,* and *Laments of Shchaza*).[97] The freshness had begun to fade. Other serial pieces had already been performed by this time. Although the performance of a piece by Denisov was certainly a rarity, by mid-decade the world of unofficial music had expanded and audiences had heard more music like this. As the core audience that attended such concerts was relatively homogeneous, a very "intimate circle" ("tesnïy krug"), as Pekarsky put it to me, they had already tasted, and been somewhat acclimated to, the "forbidden fruit."[98] The novelties were still there to be sure, but not enough to generate eleven (or fifteen) curtain calls, as *Sun of the Incas* had done. In short, the premiere of the *Italian Songs* in 1966 was not the landmark that *Sun of the Incas* had been in 1964 or Volkonsky's *Laments of Shchaza* had been in 1965. If anything was remarkable about the performance of this work, it was the fact that Denisov was still receiving performances in the USSR as late at 1965 and 1966.

DENISOV AGONISTES, I

Despite such rare domestic performances, Denisov began to turn his attention more and more toward Europe even as he continued to compose serial pieces like the *Italian Songs, Laments* (written in 1966, but not premiered until 1968 in Brussels), and String Trio (1969). Almost more significant than the Leningrad premiere of *Sun of the Incas* were the European performances that it received at Darmstadt and in Paris under Bruno Maderna's direction in the summer and fall of 1965, respectively (the 21 July performance at Darmstadt omitted the final movement).[99] It also received several performances in the

96. Davïdova's recollections of this concert were very vague. She did not remember any specific details, including the other works (if any) on the program. Davïdova, interview, 22 November 2000.

97. Davïdova, interviews, 14 September 1999 and 22 November 2000.

98. Pekarskiy, interview.

99. It was premiered on 24 November 1965 in Paris, and at Darmstadt in a performance on 21 July 1965 with soprano Gertie Charlent and flautist Severino Gazzelloni. The other works on the Darmstadt program included Boguslaw Schäffer, *Permutationen* (1956); Mauricio Kagel, Four Movements for *Sonant,* version for Spanish and electric guitars (1960); Ramon Zupko, *Reflexions* (1964); and Bernd Alois Zimmermann, *Monologue* (1960–64). Kholopov and Tsenova, *Edison Denisov,* 23; Borio and Danuser, eds., *Im Zenit der Moderne,* III:631.

late 1960s in the United States, including those at the State University of New York at Buffalo (at a festival of Russian music held on 27–29 January 1967), Sarah Lawrence College, and Indiana University (at the Symposium on Soviet Avant-Garde Music on 20–21 February 1967), in addition to a "rough and ready" performance in the United Kingdom at the 1967 Brighton Festival.[100] Also of importance was the publication of *Sun of the Incas* by Universal Edition in Hungary and London in both performance and study scores. This was the only appearance in print of *Sun of the Incas:* a work that the Muzïka publishing house in the Soviet Union had accepted, but had never published, despite the fact that Denisov had corrected three sets of proofs.[101] It was this 1971 publication that was dedicated to Boulez, whom Denisov had first met on 6 January 1967 when he was touring Russia with the BBC orchestra.[102] It was also this publication that led to further performances of *Sun of the Incas* throughout Europe and America.

In a later interview, Denisov devoted his attention almost exclusively to the foreign performances of *Sun of the Incas.* "The work that opened the doors of the whole world for me was *Sun of the Incas,*" he said.[103] The composition did indeed open doors for him to Europe and America, but it also began to solidify his status, and that of his generation, as unofficial within the Soviet Union. He summarized the situation as follows: "I was banned not only in Moscow, but also in Berlin, Warsaw, and Sofia....In the USSR there was an attempt to publish it but it never got beyond proofreading—[it was] forbidden. They play *Sun of the Incas* everywhere....And at the same time, when Gennadiy Rozhdestvensky wanted to record *Sun of the Incas,* they forbade him. In our country they forbid everything that departs from the limits of the official standard."[104] This was Denisov speaking near the end of his life in 1989, and these reminiscences are colored by the bitterness of a composer praised abroad but virtually ignored or reviled by officials at home for most of his career, a situation that began with *Sun of the Incas* and only worsened over the next decades. He later expressed a similar frustration as he questioned why the banning of performances and publication of *Sun of the Incas* continued: "Why

100. For details of the Indiana University symposium, see Brody and Oncley, "Current Chronicle," 87–92. The other works performed in Bloomington included V. Zagortsev, *Dimensions* (1965), Silvestrov's *Projections* (1965), Hrabovsky's *From Japanese Haiku* (1964), Schnittke's *Music for Piano and Chamber Orchestra* (the U.S. premiere), and Herschkowitz's Four German Songs (1963). The Buffalo performance of "New Soviet Chamber Music" took place on 28 January and featured Volkonsky's *Musica Stricta*, Hrabovsky's Trio (1964), Silvestrov's *Projections*, Herschkowitz's Four German Songs, and *Sun of the Incas*. My thanks to John Bewley for his assistance in obtaining the program for the Buffalo festival. On the Brighton performance, see Bradshaw, "The Music of Edison Denisov," 2.

101. See PED: 34; and Denisov, *Die Sonne der Inkas*.

102. This is according to Boulez's records of the tour at the Paul Sacher Foundation.

103. Denisov and Pantiyelev, "Ne lyublyu formal'noye iskusstvo," 20.

104. Ibid., 19.

[this happened]—I am unable to understand. I have the impression that for some reason I turned out to be enemy number one for our bureaucrats. But I don't know why. I always occupied myself only with my own business. And in general all of that dirty trouble around me—all of that never interested me. It was all repulsive."[105] Denisov only wanted to be left alone to compose, but Soviet officials would not permit this.

It was Denisov's misfortune that he never fully comprehended the Soviet cultural situation. For, of course, no matter how much Denisov tried to retreat from politics and "all of that dirty trouble around me" into his abstract and refined sound worlds, no music in the Soviet Union was allowed to be just music. It was all of that "dirty trouble" that made Denisov and his colleagues in Moscow, Leningrad, Kiev, and Tallinn famous within the USSR. Although the novel effects of *Sun of the Incas* enraptured the many Soviet listeners who had never heard anything like it, the controversies surrounding *Sun of the Incas* did still more to stimulate the growth of the unofficial musical culture in Moscow and Leningrad. In fact, the number of unofficial concerts at which the music of Denisov and his generation was heard only increased after 1965, as indicated by the personal records of individual performers that I saw in Moscow.

The controversial success of *Sun of the Incas* together with Denisov's growing stature in Europe and his growing list of European contacts made him the leading member of the "young composers," both at home and abroad. How surprising this seemed to some may be gleaned from the following statement that Schnittke later made to Shul'gin: "I remember, really,...that [in the conservatory] Denisov wrote so uninterestingly, that no one would have been able to imagine that after five or six years *he* would become the leader of the Russian avant-garde."[106] Schnittke continued: "The most talented...at that time I would say were Karamanov, Ovchinnikov, Sidel'nikov and Ledenyov. Their judgments were unusually important for all of us."[107]

After the premiere of *Sun of the Incas* all of that changed. While some like Silvestrov felt "very grateful to Denisov as the first..., tireless propagandist of several of our composers...in the West," many resented Denisov for the fact that *he,* who had been the most academic and apparently untalented of them all, the one who had been refused admittance to the conservatory on his first attempt—he had become the "leader of the Russian avant-garde."[108] Like Shchedrin, many were of the opinion that Denisov had become a European darling by using an unnatural method that was the last refuge of the talentless. Schnittke, however, claimed to suffer the most from Denisov's ascendancy. He

105. PED: 34–35.
106. GNAS: 16.
107. Ibid.
108. Sil'vestrov and Frumkis, "Sokhranyat' dostoinstvo," 15–16.

later recalled that "several unpleasant consequences [also arose] from [his] contacts with Denisov," because he felt overshadowed by Denisov and his reputation.[109] Schnittke's gradual rejection of serialism was therefore also an attempt to distinguish himself from Denisov, and he later claimed that "all the compositions that I myself consider to be my most important ones were written after my departure from Denisov's influence."[110]

DENISOV AGONISTES, II

One final twist in Denisov's saga must be addressed, for despite his claims to innocence in later interviews, at the end of the 1960s Denisov instigated more direct repercussions from the regime. While Volkonsky voluntarily switched to a more sanctioned path, Denisov actively stuck to his avant-garde pursuits. The fact that after *Sun of the Incas* and the *Italian Songs* he continued to write primarily abstract compositions strictly serial in nature, such as his *Laments* or his *Five Stories after Herr Keuner* (*Fünf Geschichten nach Herr Keuner*) (written in 1966 and premiered in 1968, in Berlin), did little to help his case in the eyes of the Soviet authorities.[111] But it was as a result of his vocal support of serialism and other newer Soviet compositional trends abroad that he suffered severe setbacks and reprisals near the end of the 1960s. Such a response on the part of Soviet officialdom was to be expected, given the campaign against Boris Pasternak following the foreign publication of *Doctor Zhivago* and his subsequent receipt of the Nobel Prize for Literature in 1958. The response to Denisov's foreign press was also preceded by earlier articles against the "young composers" like Israel Nestyev's 1963 "From the Position of the Cold War," which expressed fears that the compositions by the young Soviets were becoming propaganda tools in the West, or, as Nestyev put it, "sensational material, adroitly used in the anti-communist 'Cold War.'"[112]

In 1966 Denisov had an article published in the Italian Communist Party's newspaper *Rinascita* in the supplement *Il contemporaneo* titled "The New Techniques Are Not a Fad." (Remember that Denisov's "Dodecaphony and the Problems of Contemporary Compositional Technique," discussed earlier in this chapter, was not published until 1969.) In the *Il contemporaneo* article, Denisov wrote a series of statements that would come back to haunt him at

109. GNAS: 22.

110. Ibid. Schnittke wrote an article about Denisov, published in Polish as "Edison Denisov," 109–24. An excerpt in Russian is included in BAS: 112–13. The Russian original is published in its entirety in Shnitke, *Stat'i o muzïke*, 105–23. For more on the rivalry between the two composers see the survey of their relationship by Denisov's wife: Grigor'yeva, "Al'fred Shnitke i Edison Denisov."

111. Kholopov and Tsenova, *Edison Denisov*, 75–79.

112. Nest'yev, "S pozitsiy 'kholodnoy voynï,'" 129.

the end of the decade (including his earlier-cited paean to *Suite of Mirrors*). Several are worth quoting at length, beginning with this summary of his generation's stylistic proclivities:

> Characteristic of the vast majority of young composers in the Soviet Union (or by at least their most gifted representatives) is the tendency to amplify the expressive limits of the musical means employed, and not limit themselves artificially only to the tonal system, which preserves in itself ample possibilities, but which to all appearances appears exhausted. The majority of young composers are now widely engaged with either methods of serial composition or diverse types of aleatory techniques; and in a few cases we may find works in which the predominating logic is that of its sonic material [e.g., *sonorika*].[113]

Denisov evoked the classic "death of tonality" narrative, the same narrative he repeated in the 1969 article. By this account, Soviet composers, as much as composers of any other nationality, needed to turn to other systems and techniques because tonality had been "exhausted."

Denisov continued by explaining that the experimentation with new techniques was intended by the Soviets as "an excellent guarantee against the fundamental danger that was threatening our music in the years after the war, namely the danger of academicism ['akademizatsii']."[114] Denisov wanted to avoid academicism, but of course academicism to him meant, borrowing the critic Harold Schonberg's phrase, the "Kabalevsky-Khrennikov school of composition."[115] Yet for many Europeans and Americans—think of the contemporary composers of American minimal music—by this time, the mid-1960s, serial techniques were nothing if not academic. This is the trap in which Denisov fell: more than any other Soviet composer from his generation, he is today noted as an "academic" composer, an assessment that the obviously still-smarting Schnittke agreed with in his 1970s conversations with Shul'gin.[116] Denisov's unenviable position was further encapsulated by Schonberg's contemporary assessment: "Andrei Volkonsky and Edison Denisov stem from the Boulez-Berio axis, and their competent music illustrates a modern kind of academism."[117] It did not matter that Denisov was fighting against Soviet academicism, for to Western ears his was but a more exotic form of their own home-grown brand. But not just to Western ears, for as the Russian critic

113. Denisov, "Le tecniche nuove non sono una moda," 12; and "Novaya tekhnika—eto ne moda," 34 (*Svet-dobro-vechnost'*). I am indebted to the late John Thow and to Michael Long for assisting me with these Italian translations.

114. Ibid.

115. Schonberg, "The World of Music," 189.

116. GNAS: 22.

117. Schonberg, "The World of Music," 182.

Tatyana Cherednichenko has astutely written, Denisov "imperceptibly became an academic.... [In his] countless instrumental concertos from the end of the 1970s and in the 1980s...the 'Sun' was increasingly replaced by an artificial light source, and the 'Incas' diminished in size, losing their exotic brightness and increasingly resembling something poetically felt, but dressed in the uniforms of functionaries in a perfectly running production engineering office ['ideal'no rabotayushchego tekhnologicheskogo byuro']."[118] In the Italian article, Denisov also addressed a different reason for his turn to serialism, as he answered the hypothetical query, why do "the majority of young Soviet composers of the recent past prefer to use serial, dodecaphonic and aleatory techniques in their works?" He explained this preference as an attempt to escape from the "artificial limitations of the confines of socialist art," one of the chief confines of which was tonality. Denisov also emphasized yet again the fact that serialism was not merely a passing fancy: "The Soviet composers of the young generation did not turn to modern techniques in order to follow a fad, but because the limits of the tonal system grew too narrow for the elaboration of the new ideas imposed on us continuously by reality itself."[119] For the first time Denisov linked the compositional styles of the young Soviet composers to the reality surrounding them, the changing reality of the Thaw. The connection is similar to that made by author Hans Magnus Enzenberger in relation to postwar German literature: new times demand new means of expression.[120] For his part, however, the "new ideas" imposed upon Denisov by "reality" were only negatively reflected in his continued sterile—or, read more positively, "mystical"—application of serialism. Moreover, any mimetic intentions behind works like *Sun of the Incas* or the *Italian Songs* were (perhaps unfairly) ignored by Soviet listeners and Soviet arts managers, both fixated on the abstract surface of the music, which the listeners continued to hear as gripping and the arts managers as repellent.

The response to Denisov's article conclusively indicated that the "young composers" had become unofficial. As a result of the *Rinascita/Il contemporaneo* article in July 1967 Denisov received a letter from Sveshnikov, rector of the Moscow Conservatory, that informed him that he was to be relieved of his teaching responsibilities beginning in September 1967 because of a "lack of students in the orchestration department in the upcoming academic year (1967–68)."[121] This action had its origins at the highest levels of power, as is

118. Cherednichenko, *Muzïkal'nïy zapas,* 64.

119. Denisov, "Le tecniche nuove non sono una moda"; and "Novaya tekhnika—eto ne moda," 35 (*Svet-dobro-vechnost'*).

120. McMillan, *Khrushchev and the Arts,* 66. Similar debates about the relationship between new times and new music were common in Soviet music in the early 1960s. See Schmelz, "After Prokofiev," 507–15.

121. Kholopov and Tsenova, *Edison Denisov,* 27.

indicated by an excerpt from the minutes of a session of the Secretariat of the Union of Composers (USSR) from 8 February 1967 titled "On the Violation of Ethical and Civil Norms of Behavior by Several Members of the Union of Composers" ("O narushenii eticheskikh i grazhdanskikh norm povedeniya nekotorïmi chlenami soyuza kompozitorov") and signed by Khrennikov. The minutes read as follows: "The Secretariat considers that the article published by composer E. Denisov in the Italian bourgeois press includes principally untrue statements about the path of development of Soviet music, [and] is a violation of the ethical and civil rules of behavior necessary for every member of the Union."[122] As a result, the union must have approved the decision to expel him from his teaching post, although the minutes do not explicitly mention this action.

The key phrase in these minutes, however, is "Italian bourgeois press," for Khrennikov and the other members of the Secretariat were unaware that *Rinascita/Il contemporaneo* was in fact an organ of the Italian Communist Party. This revelation caused the leadership of the Moscow branch of the Union, and specifically its Chair Vano Muradeli, to treat the situation more lightly. Muradeli realized the mistake that his colleagues in the central Union had made and according to Kholopov and Tsenova did not want "to cast a shadow on the international connections of the Union of Composers."[123] For this reason, Denisov was not expelled from the Union, although that presumably had been the goal of the original statement signed by Khrennikov. Kholopov and Tsenova also claim that the more immediate result of the discussions at the Unions were "bans on the performance and publication of Denisov's music."[124] Again, these "bans" remain undocumented, but it is true that no composition by Denisov was premiered in the Soviet Union between 1966 (*Italian Songs*) and 1968 (*Ode for Clarinet, Piano, and Percussion* on 22 January; and *Three Pieces for Cello and Piano* on 11 May, with Natalya Gutman as soloist). And the *Ode* was permissible only because Denisov strategically (and retroactively) dedicated it to Che Guevara.[125]

The results of Denisov's expulsion from his post were short-lived. It quickly became evident that the Italian press in question was not bourgeois at all, in fact quite the opposite. Denisov received a formal apology and was reinstated (albeit after the school year had already begun); the "head of the department... called the entire affair a 'misunderstanding.'"[126] Yet this "misunderstanding" was a

122. This document remains in Denisov's personal file at the Moscow Union of Composers. It is also cited in full by Kholopov and Tsenova, *Edison Denisov,* 26; and in Talochkin and Alpatova, eds., *"Drugoye iskusstvo,"* I:315–16.

123. Kholopov and Tsenova, *Edison Denisov,* 26 n. 28.

124. Ibid., 26.

125. Berman, interview, 23 March 2001.

126. Kholopov and Tsenova, *Edison Denisov,* 28.

signal of the difficult situation that Denisov was in with the Union of Composers. They were keeping their eyes on him.[127] Further problems followed, and as we shall see in chapter 7 the Italian affair was to come up again in 1970 when an interview Denisov gave to a German newspaper caused renewed controversy. Denisov was now the most outspoken and the most openly criticized of the "young composers," and the new official attitude to him marked a shift in attitude to them all. As the following chapter will demonstrate, the concert life of the mid-1960s responded to this shift. Increasingly unwelcome at the major official concert spaces, the unofficial composers were forced to seek alternatives.

127. At the same time Denisov was still permitted to attend the Warsaw Autumn Festivals in September 1968 and September 1969, and in November 1968 the rector of the Moscow Conservatory, Sveshnikov, recommended that he be allowed to travel to Italy the following month. This information is from a character reference dated 23 November 1968 found in Denisov's personal file at the Moscow Union of Composers.

5

Unofficial Venues, Performers, and Audiences

By 1965, still just the beginning of the Brezhnev period, life was simultaneously (if not paradoxically) more promising and increasingly bleak. The most poignant reflection of the darkness and depression facing many of the unofficial composers in the years surrounding Khrushchev's dismissal from office in October 1964 was Nikolai Karetnikov's Fourth Symphony. Karetnikov explained the piece in a 1992 film that documented a later recording session of the composition. In interviews included in the documentary, Karetnikov, between long drags on his cigarette, states flatly that the "Thaw ended in 1962."[1] After that everything became worse: "Again very hard times set in. Following this year, they banned performances of my works.[2] After the Bolshoi Theater's production of my ballet *Vanina Vanini* I remained simply without work, and my hopes ended. . . . And I had a sensation of horrifying gloom into which I was plunged, despite the fact that at that time I was already a religious man." The Fourth Symphony is a reflection of that dark period, and although at first reluctant to discuss any narrative underpinning the work, Karetnikov later revealed a program involving a personality and its plunge into the depths, especially in the work's penultimate movement: "The fourth movement is not only a funeral march (although that is there)—it is everything, it is the end, when you begin to understand that absolutely everything has been lost." In the early 1990s, he admitted that he would no longer be able to write such a gloomy, hopeless work: "And I suppose, now, when that side of life [religion and the sin of despair] has been explained, I would not write a work as horrific as the Fourth Symphony."

1. "Professiya—Kompozitor." Anton Karetnikov kindly provided me with a transcript of Nikolai Karetnikov's comments from this film. All of the quotations here by Karetnikov are taken from this film.

2. Like Volkonsky's contention that he was banned, it is unknown what form this ban took and if it was written or just an unspoken understanding among concert organizers.

The serial Fourth Symphony (1963) is an unrelenting, brutal composition. The work sounds unlike any of the other pieces discussed up to this point. It eschews the pointillism of Webern or Boulez for the large-scale symphonic rhetoric of Mahler or Shostakovich. Unfortunately it remained unperformed at the time. Not only would it have been difficult to find a Soviet orchestra capable of tackling the piece's complexities, but the gloomy second movement andante, the unrelenting fate motive of the fourth movement, and the passacaglia-like bass line of the final fifth movement all contribute to a tone of desolation and pessimism that unconditionally violate the cheery optimism demanded of socialist realist musical compositions.

Karetnikov's Fourth Symphony is perhaps the first piece in which a composer from this generation used serial methods, even liberally, to express some facet, however indirectly, of the moral and social atmosphere of the time in which he lived.[3] Although not an act of direct protest, it instead acts as a key bellwether of the difficulties that increasingly faced Soviet citizens, and especially creative artists, during the mid-1960s. Karetnikov's Fourth Symphony reflects the sentiments of those who believed, like Karetnikov and Volkonsky, that by 1965 the Thaw had ended. Either it had been cut off in late 1962 as a result of Khrushchev's Manezh visit and his rants there about abstractionism as well as his subsequent attacks against dodecaphony, or it had ended in October 1964, with Khrushchev's own ouster.

At the same time, because life in the USSR was complex and contradictory, even as life became more difficult in some areas, the positive effects of the Thaw continued to be felt in others. Nowhere was this more apparent than in the world of unofficial music. After all, it was becoming easier, especially in Moscow, to hear "new" music by composers from Schoenberg to Denisov because of the development of several institutions that ranged across a wide spectrum of *vnye* milieus. At mid-decade several important clubs, like Grigoriy Frid's Moscow Youth Musical Club, were created in Leningrad and Moscow to promote new music, while scientific institutes like Moscow's Kurchatov Institute also began to advocate and present "avant-garde" music. Moscow's Scriabin Museum became the unlikely, yet strangely appropriate, center for an electronic music studio that briefly attracted a number of the unofficial composers. And in 1964 Volkonsky formed his early music group Madrigal. Thanks to its tours and performances, older music began to be more widely heard for the first time throughout the Soviet Union. These were early precedents for the institutions and venues that Yurchak describes as *vnye*, or "'suspended' simultaneously inside and outside of [the Soviet

3. For an analysis of Karetnikov's composition, see Schmelz, "Listening, Memory, and the Thaw," 131–35.

system]": literary clubs, archeology circles, and even the legendary Leningrad Café Saigon.[4]

At such institutions, a degree of what Russians term "obshcheniye," or discussion and communication, emerged. Yurchak interprets *obshcheniye* as more than interaction, for it "is both a process and a sociality that emerges in that process, and both an exchange of ideas and information as well as a space of affect and togetherness." Yurchak correctly emphasizes this combination of social space, intense social interaction, and accompanying social identification, as an important component of "late socialism," a means by which different groups learned to separate themselves from others, dividing society into "us" and "them," or "svoy" (or "nashi") and "nenashi" as Yurchak terms them, employing the Russian equivalents.[5] This differentiation was already happening at the very beginning of the musical Thaw in the NSO and SNO gatherings in the Moscow and Leningrad conservatories, but also at Gould's 1957 concerts, when the word "Krenek" became the "password for an entirely new comprehension of life" (recalling Viklyuk's description of the event).

As we shall see later, the literal discussions that ensued at venues like Frid's club initially differed not only in degree, but also in kind from those at the venues Yurchak describes, where escapism or disinterestedness in Soviet life predominated. Yurchak writes that "for members of these [*vnye*] milieus critical debates about Soviet political and social issues were considered 'uninteresting.'"[6] But at unofficial music venues, aesthetic issues represented broader political and social concerns. At Frid's club discussions of Beethoven's contentious relationships with his patrons were understood as allusions to the difficult relationships the audience frequently had with Soviet power and its various representatives.[7] At the unofficial concerts or clubs, listeners could directly challenge and question the aesthetic norms of socialist realism even as they attempted to force a redefinition of the doctrine, thereby suggesting or implying reform in other areas of Soviet life.

The young people who comprised a large portion of the Soviet audience for new music, literature, and art were often willing to contradict received authority and to defend abstract art and artists. In March of 1963 a frustrated student at Moscow State University, G. Shchegol'kova, wrote to the Central Committee of the Communist Party of the Soviet Union protesting the recent attacks on artists that were spurred on by the Manezh exhibition: "I now find myself utterly confused. Everything in which I believed, for the sake of which I lived, is collapsing.... The atmosphere being created today is an atmosphere of orders

4. Yurchak, *Everything Was Forever, until It Was No More*, 127 and 134–48.
5. Ibid., 148–49 and 103.
6. Ibid., 145.
7. Frid, interview.

and decrees ['administrirovaniya'], force, unfounded accusations, humiliation, demagogy, and the declamation of the most lofty words, which an honest person utters only at the most difficult moment."[8] Although Shchegol'kova's letter might have been exceptional, it does not rise to the level of "dissent," but rather works within the terms of the existing discourse ("everything in which I believed"). More accurately, her letter reflects a shifting discourse, from one of discussion and debate to one of "order" and "force."[9] Similar shifts were widespread over the course of the 1960s, and as a result disillusionment and dissatisfaction similar to that expressed by Shchegol'kova understandably arose. Like her (and unlike many of the unofficial composers), many listeners at unofficial concerts not only escaped or withdrew, but also actively defended their aesthetic, and not just aesthetic, beliefs. The degree of optimism and idealism in the early stages of the Thaw, particularly among the Soviet youth, again must be emphasized in contradistinction to the later surface malaise, the paradox of simultaneous immutability and porousness that Yurchak describes during the 1970s and 1980s in the Soviet Union. The porousness predominated in the mid-1960s thanks to the flourishing of unofficial musical venues, at least for a small, select group of "insiders," usually avid young listeners.

Performers, in contrast, often found themselves in more direct confrontation with authorities. Their attempts to perform new music seemed to be perpetually blocked by concert hall managers or other administrators and bureaucrats, and as a result an antagonistic relationship developed between the two sides. Both often resorted to subterfuge or deception to achieve their desired results—either an unannounced performance of Cage, or a complete cancellation of that performance. Of course, this is resistance of a very specific kind: opposition to specific aesthetic demands within the system, without necessarily agitating for the demise of the system itself. Alexander Glezer, one of the individuals behind the 1974 Bulldozer exhibition (of which there will be more to say in chapter 8), applauded a suggestion made in the 10 March 1975 issue of *Evening Moscow* (*Vechernyaya Moskva*) by Yuriy Nekhoroshev, editor-in-chief of the magazine *Tvorchestvo* (*Creation*). In Glezer's own paraphrase, Nekhoroshev wrote that "occasionally it is necessary to display such [modernist] paintings before a wide audience so that they can see with their own eyes that the emperor has no clothes." Glezer embraced this notion: "A long-awaited idea! The artists had been dreaming of nothing else. They had been seeking exactly that for twenty years. Curse and criticize—only allow a discussion with the audience."[10] This is what performers and composers also

8. Cited in Pïzhikov, *Khrushchovskaya "ottepel'*," 287.

9. Recall the discussions among students connected to the 1956 Picasso exhibit (see n. 46 in chapter 1), although many of these were silenced by force. See Reid, "Toward a New (Socialist) Realism," 222.

10. Glezer, ed., *Iskusstvo pod bul'dozerom*, 37–38.

wanted: to be allowed to perform any music they wanted, where and when they wanted. Venues such as Frid's club gave them this opportunity before audiences eager to discuss the merits of the music and the broader cultural situation alike. By performing and listening to new music at these venues, the performers and listeners were also able to flaunt the perceived freedom that allowed them this seeming luxury.

One other important distinction lies in the specifics of musical composition and performance, issues that Yurchak understandably avoids. In unofficial musical venues the particularities of the music that was performed, as well as who performed it and how it was performed, dictated the types of social bonds that were formed, what limits were being breached, and what aesthetic, social, and possibly political, ideals were being challenged. We do not need to return to outmoded binaries to acknowledge that, although not resistant in a strict sense, at certain moments and in select venues, different musical works, composers, and performers that departed from the norm still promised alternatives, promised difference, or hinted at or suggested opposition. These effects varied over time. Despite Davïdova's claim that every one of her concerts was a "huge success," we have already seen a shift in reception occur over the period marked by the premieres of *Musica Stricta* and *Suite of Mirrors* in 1961 and 1962, the premieres of *Sun of the Incas* and *Laments of Shchaza* in 1964 and 1965, and the *Italian Songs* in 1966.

There were fewer concerts in the mid to late 1960s that were as newsworthy as these premieres had been. Specific concerts necessarily diminish in importance after 1965. Therefore, this chapter will present several representative case studies of the groups or individuals involved in the dissemination of new, unofficial music within the Soviet Union as well as their venues and audiences, including a survey of Frid's club and a history of Volkonsky's Madrigal. A brief, preliminary portrait of life within the Union of Composers and the government oversight of unofficial music in the second half of the 1960s will provide the official framework and foil for the various unofficial, *vnye* venues and organizations that constitute this chapter's main subject matter.

OFFICIAL POWER AND THE ARTS

By the early 1960s, all of the "young composers" (including Volkonsky) had become members of the Union of Composers. This allowed them to be paid for their work, whether performed or unperformed, and it also allowed them access to "closed" (professionals only) performances at the various Houses of Composers in the Soviet republics. Like the Union of Writers and the Union of Cinematographers, the Union of Composers fell under the jurisdiction of the Ministry of Culture, which was headed by Yekaterina Furtseva from 1960

to just before her death in 1974. Since 1932, when the various unions were created from the ashes of the old independent arts organizations like the Russian Association of Proletarian Musicians (RAPM) and the Association of Contemporary Music (ASM), and especially after 1948, the Union of Composers had dominated the affairs of Soviet musicians.[11] The Union had its own ruling Secretariat, headed, since the First All-Union Composers' Conference of 1948, by Tikhon Khrennikov.

Besides the national organization, large cities such as Moscow, Leningrad, and Kiev all had their own local branches of the Union of Soviet Composers. In addition to these local units there was also a union for each of the republics, thus there was a Union of Composers for the Russian Soviet Federal Socialist Republic (RSFSR), as well as for Estonia, Ukraine, etc. This meant that in Moscow there were three composers' unions (Moscow, Russian, and Soviet) all housed in the same location, the House of Composers ("Dom kompozitorov"), where the Moscow and Russian Unions remain to this day.[12] As well as housing and travel privileges (paid for in part by Muzfond, the financial arm of the union), every composer who was a member of the Union of Composers was entitled to performances of his or her works at the House of Composers.[13] Publication was another matter. It was controlled by *glavlit,* the Main Administration for Affairs of Literature and Publishing Houses (i.e., the censorship), and overseen by one of the publishing houses that at various times were responsible for music.[14] All of this was overseen by the Ministry of Culture of the USSR (there was also a Ministry of Culture for each republic, e.g., the Ministry of Culture RSFSR).

Even if a composer's works were unacceptable to the Secretariat of the Union of Composers, and therefore could not be performed at other official venues in Moscow (e.g., the Large Hall or Small Hall of the Moscow Conservatory, or the Philharmonic, i.e., the concert hall), they could still be performed at the Moscow House of Composers. The compositions of Schnittke, Gubaidulina, and Denisov were performed with some frequency at the Union of Composers during the 1960s, but they were often refused publication rights.[15] As a result of this fluidity of categories at the time, it is difficult if not overly

11. For a history of the union up to Stalin's death, see Tomoff, *Creative Union.*

12. For a contemporary Russian-American's depiction of the House of Composers as it was in 1960, see Schwarz, *Music and Musical Life in Soviet Russia,* 398–403.

13. Ibid., 473. Also Tomoff, *Creative Union,* 57.

14. See Schwarz, *Music and Musical Life in Soviet Russia,* 409–13.

15. This is the reason that European publishers such as Hans Sikorski Verlag, Universal Edition, and C. F. Peters now own the European publication rights to the works of the three composers. The Union of Composers did not want many of them and the composers were also trying to get around the liabilities of Soviet copyright law. Kurtz discusses Sikorski's first contacts and negotiations with Gubaidulina. Kurtz, *Sofia Gubaidulina,* 88–89.

simplistic to identify any composer from the period as being simply "banned" ("zapreshchon").

In a post-Soviet interview Khrennikov declared: "The avant-garde complains that its works were forbidden, but nothing at all was forbidden. Bans were not a factor for composers.... When our avant-garde complained, it was because it was a small clique. They didn't find support from broader musical circles, nor from our great composers. No-one censored them, they were simply performed less than other composers."[16] Khrennikov's evaluation of the situation in his polemically titled memoirs—*As it was...(Tak eto bïlo...)*—further reflects the official version of events:

> [The Union of Composers] never had a campaign against the avantgardists like the artists did. And when the Ministry of Culture asked me how our affairs stood, I answered that we had a normal creative situation with naturally varying creative opinions and artistic tastes, that we decided all questions independently and did not require decrees of any kind.... In any case, no one was ever expelled from our union because of a passion for modern [i.e., avant-garde] music. And only...two composers, Andrey Volkonsky and Arvo Pärt, ever left the union and emigrated abroad, both of their own volition.[17]

The historian Kiril Tomoff's research on the Union of Composers during the Stalin period supports some of Khrennikov's contentions. As a "juridically distinct" professional organization, Tomoff argues, the Union's "agency" often allowed it to police its own ranks. But the organization was not as autonomous as this suggests, for the internal policing often obviated the need for any decrees. Without specific directives, the union both anticipated and responded to general actions and declarations by the Central Committee, the Ministry of Culture, or other government officials and agencies.[18]

Cherednichenko emphasizes the positive role that Khrennikov played, acknowledging him as an unwitting "father of the Soviet avant-garde school ['avanshkola']." Like Shchedrin, she underscores the apartments that many of the unofficial composers received: "[Khrennikov] both banned performances and obtained apartments for the composers: he did everything so that the avant-garde could form and survive."[19] But this is only partially true, for composers like Volkonsky were effectively precluded from performance or publication. This latter condition explains why so many composers took refuge in the film world and earned a living not by publishing their "academic" music,

16. Khrennikov, "My Conscience Is Clear," 255.
17. Khrennikov and Rubtsova, *Tak eto bïlo*, 181.
18. Tomoff, *Creative Union*, 3, 36, 58, 99, and elsewhere.
19. Cherednichenko, *Muzïkal'nïy zapas*, 53.

but by writing music for feature films, shorts, or animated films (in addition to incidental music for theatrical productions). Volkonsky, Schnittke, Karetnikov, Karamanov, Hrabovsky, Gubaidulina, and Denisov are only some of the composers who took this route. We should be wary of discounting the real difficulties that these composers faced when they were unable to earn money from their "serious" creative activity. Cherednichenko criticizes the "sentimental pathos" with which writers in the 1990s emphasized that Gubaidulina was "thin from hunger" during the Soviet period, but Gubaidulina plausibly describes her own financial situation during the time as "horrible" ("uzhasnoye material'noye polozheniye").[20]

Like the Union of Composers itself, individuals in charge of performing venues often policed the repertoire of their artists without specific directives from above. In his 1970 open letter in support of Solzhenitsyn, Mstislav Rostropovich wrote: "In 1948 there were LISTS of banned compositions. Now they prefer ORAL BANS, citing that there 'is an opinion,' that it is not recommended" [emphasis in original].[21] Explicit, written orders prohibiting the performance of specific works usually came directly from the Ministry of Culture (or higher in the government) and were saved for prominent musicians, composers, or venues, for the revival of Shostakovich's *Lady Macbeth* as *Katerina Izmailova* in 1963, or Rostropovich's 1970 letter, or the Bolshoi Theater's plan to stage Bartók's *Miraculous Mandarin* in 1961.[22] The repertoire of Soviet artists touring abroad was also carefully scrutinized.[23] Although many of the unofficial composers (including Volkonsky, Karetnikov, and Denisov) claim that they were banned, and many of the performers with whom I spoke asserted that lists of prohibited composers existed, any written decrees banning performances of works by any of the unofficial composers have apparently not survived and are not to be found in archival materials from the Union of Composers of the USSR, the Ministry of Culture, or the personal files of these composers at the Moscow and Russian Unions of Composers.[24] What does survive, at least in the materials in the collection of the Union of Composers at RGALI, is an

20. Cherednichenko, *Muzïkal'nïy zapas*, 41; and Gubaidulina and Tsïbul'skaya, "Oni nenavideli menya do togo, kak slïshali moyu muzïku…," 40.

21. Grum-Grzhimailo, *Rostropovich i yego sovremenniki*, 116–18. For further testimony about this see Schmelz, "Listening, Memory, and the Thaw," 333–36. Rostropovich's letter appears in English in Wilson, *Rostropovich*, 354–57 (the present translation is mine).

22. See Bogdanova, *Muzïka i vlast'*, 364–71, 360–64 and 40–73, and 262–63, respectively.

23. Ibid., 29–30.

24. In my interview with Volkonsky he stated unequivocally that at some point in the early 1960s (after either 1962 or 1963, he was unsure) he had seen the written order ("tsirkulyar") from Minister of Culture Furtseva "that [said] not to play me." As previously mentioned, the later performance of his *Laments of Shchaza* in 1965 belies the totality of such an order. Yet for a composer as outspoken against the regime as Volkonsky, it is no wonder that such a concrete action might have been deemed necessary. Volkonskiy, interview, 21 October 1999; Volkonsky's personal file no longer seems to be

innocuous series of lists of recently composed pieces "Recommended for Performance" or "Recommended for Promotion" from the early to mid-1960s no doubt meant for circulation among Moscow's concert halls.[25] The lists are at best only indirect proof of any bans that might have existed. They are, after all, lists of recommended pieces, not lists of pieces prohibited from performance, although the prohibited can certainly be inferred from the permissible. Each is usually arranged by genre (choral music, chamber music, symphonic music) and includes conservative composers—Khrennikov, Kabalevsky, Karayev—or conservative works by the unofficial composers, for example Pärt's cantatas *Our Garden* and *Stride the World* and Schnittke's *Songs of War and Peace.*[26] Notable are the rare exceptions. Nowhere do the names Volkonsky or Karetnikov appear, perhaps indirectly confirming an unwritten understanding (or an as yet undiscovered formal ban). At first Denisov is absent as well—although, as we have seen, *Sun of the Incas* was surprisingly recommended for performance in the 1965–66 season, as was Pärt's First Symphony.[27] In addition to these exceptions, the lists state the obvious, supporting claims that any specific bans

held at the Union of Composers in Moscow, although Oksana Drozdova cites it in her 1994 Moscow Conservatory dissertation on the composer. In Denisov's records at the Union of Composers there are documents indicating specific actions taken against him for his foreign publications at the end of the 1960s (see chapter 4). These actions did not explicitly include bans on performances of his music, and no specific bans are listed in the record ("protokol") in his personal file at the Russian Union of Composers. Both Pekarsky and Grindenko told me that "black lists" of banned composers existed. See Schmelz, "Listening, Memory, and the Thaw," 334–35.

25. Lists of this sort survive for the years 1962, 1963, 1964–65, and 1965–66. The lists receive a different title for each year, e.g., "List of Works by Soviet Composers Recommended to the Philharmonic, 1962" ("Spisok proizvedeniy sovetskikh kompozitorov rekomendovannïkh filarmoniyam 1962 g."), or "List of New Compositions by Soviet Composers Recommended for Promotion in the 1965–66 Season" ("Spisok novïkh proizvedeniy sovetskikh kompozitorov, rekomenduyemïkh dlya propagandï v sezone, 1965–66 g."), or "List of Works by Soviet Composers Recommended for Promotion Abroad [1963]" ("Spisok proizvedeniy sovetskikh kompozitorov, rekomenduyemïkh dlya propagandï za rubezhom"). See RGALI, f. 2077, op. 1, yed. khr. 2025 (1962); f. 2329, op. 3, yed. khr. 1986 (1963); f. 2077, op. 1, yed. khr. 2195 (1963); f. 2077, yed. khr. 2381 (1964–65); and f. 2077, op. 1, yed. khr. 2381 (1965–66). There are also lists in the files of the Union of Composers USSR that recommend certain pieces for recording or broadcasting, as in a list from 1963 titled "List of Works by Soviet Composers Included in the Plan of Subjects for Recording on Gramophone for 1963" ("Spisok proizvedeniy sovetskikh kompozitorov vklyuchennïkh v tematicheskiy plan zapisey dlya gramplastinki na 1963 god") (RGALI, f. 2077, op. 1, yed. khr. 2153). Two other lists of this sort, both from 1963, can be found in RGALI, f. 2077, op. 1, yed. khr. 2152, ll. 19 and 28: "List of Works by Soviet Composers Recommended for Gramophone" ("Spisok proizvedeniy sovetskikh kompozitorov rekomenduyemïkh dlya gramzapisi") and "List of Works Recommended for Recording in the Collection of Musical Broadcasting" ("Spisok proizvedeniy rekomenduyemïkh dlya zapisi v fond muzïkal'nogo veshchaniya"). A similar list from 1965, "Works by Soviet Composers to Be Recorded on Gramophone in 1965" ("Proizvedeniya sovetskikh kompozitorov v plane zapisey na gramplastinki na 1965 g."), is in RGALI, f. 2077, op. 1, yed. khr. 2381.

26. RGALI, f. 2077, op. 1, yed. khr. 2381; and RGALI, f. 2077, op. 1, yed. khr. 2025, l. 1: "List of Works of Soviet Composers Recommended to the Philharmonic, 1962." This includes both of Pärt's cantatas as well as Schnittke's composition.

27. RGALI, f. 2077, op. 1, yed. khr. 2381.

were only oral or tacitly understood. Shchedrin reported that he never saw any of these lists (and specifically the ones recommending works for perfor- mance and promotion) when he was Chairman of the Union of Composers RSFSR, a position he assumed in November 1973 (admittedly well after the period under discussion).[28] More representative of official oversight of music and composers are the monthly reports ("otchotï") that were sent by each of the republics to the central Union of Composers and that included day by day accounts of the musical events in that republic. They reveal how liberal Estonia was and how reactionary Ukraine was. In general the silence in the Ukrainian reports regarding new music—like the silence greeting the 1965 premiere of Volkonsky's *Laments of Shchaza*—is the most telling.

Another compelling list similar to the monthly reports appears in the RGALI materials. Titled "List of Works by the Young Composers of Moscow from the Last Two Years" ("Spisok proizvedeniy molodïkh kompozitorov Moskvï za posledniye dva goda"), it is found in a folder of documents from 1963 and is, apparently, the only list of its kind from the period.[29] It includes most of the young Moscow composers: Volkonsky, Karetnikov, Karamanov, Gubaidulina, Schnittke, and Shchedrin, although Denisov's name is curiously missing. An inventory of works along with commentary is given for each composer. Volkonsky is credited for writing *Suite of Mirrors* but the comment "Has not shown anything for a long time" ("Davno ne pokazïvalsya") is appended next to his name. The same is true of Karetnikov, who was "writing a ballet." Gubaidulina is "writing an opera 'the Magic Violin'" ("pishet operu 'Volshebnaya skripka'"; not extant in her list of works), and Schnittke is credited with having composed a Concerto for Piano and Orchestra, Concerto for Violin and Orchestra, and is "working on an opera," possibly his unfinished opera *The Eleventh Command- ment (Odinnadtsataya zapoved')* (1962).[30] The most interesting entry however is Karamanov, whose name is underlined and next to whose name appears: "Symphony—questionable composition" ("Simfoniya; spornoye sochineniye"). The Union of Composers was explicitly keeping track of what the young Soviets were up to, and was already sensing trouble from some.

In a broader sense, without needing explicit instructions most officials in charge of performance groups or venues realized that certain "modern"

28. Shchedrin, interview.

29. RGALI, f. 2077, op. 1, yed. khr. 2152, l. 25.

30. See Ivashkin, *Alfred Schnittke*, 75, 85–86. In the chronology in *A Schnittke Reader,* the section from p. 75 of Ivashkin's biography is repeated where he writes that in 1962, "[Schnittke] is...blacklisted by the Composers' Union and remains so until the mid-1980s." Yet as the RGALI documents indicate, Schnittke cannot be said to have been "blacklisted." Or, if so, the "blacklist" (whatever that specifically means) was frequently ignored. SR: xx. Schnittke discussed the *Eleventh Commandment* in a brief 1967 contribution to *Sovetskaya muzïka.* See Shnitke, untitled article in the section "Nad chem vï rabo- tayete?" 151–52.

works were not to be performed. Gubaidulina recalled a specific incident from the 1960s when the director of the Philharmonic (the concert bureau), Kuznetsov, was approached by an ensemble from the state orchestra led by Pyotr Meshchaninov (Gubaidulina's third husband, d. 2006) who wanted to play compositions by Gubaidulina. Kuznetsov "eliminated all our works from the list. He justified this by saying that we represented an incorrect ideological position and told the leader of the ensemble quite clearly that he had better show some maturity and had to understand that such works could not be performed under any circumstances."[31] Certain pieces by Denisov were also prevented from individual performances. According to him, the cellist Natalya Gutman was informed by Moskontsert that "she could not perform the works of Stravinsky, Denisov, and Schnittke, as it was prohibited to perform their music."[32] Most likely this was the result of an independent decision by individuals at Moskontsert, guided by their understanding of "an opinion" that such works were not recommended for performance (borrowing Rostropovich's language). The violinist Tatyana Grindenko's concerts were also blocked by the militia on several occasions, yet it is unclear on whose behest they acted:

> They very frequently closed us down. For example in Moscow there was a House of Work and Technology opposite the Pushkin Museum. They allowed us to perform in that building.... Two hours before the concert the militia arrived,... tore down the posters, and demanded that we write that the concert was canceled due to the illness of the performers. We refused to write that. The whole story [ended] with the public demanding [us], and there was a demonstration, after which they summoned me (since the concert was arranged under my name because of the academic necessity of playing something classical there).[33]

Most decisions were made on a case-by-case basis, and, as Grindenko's memory suggests, often at the last minute. After Shchedrin helped successfully smooth over the controversy surrounding the premiere of his First Symphony, Schnittke realized:

> that no kind of total conspiracy against me existed in secret circles.... There were also people, who if they wanted something done, then it was wonderfully carried out. For example, the representative of the main editor of "Sovetskiy

31. Gubaidulina, "An Interview with Dorothea Redepenning," 449. In a more recent interview she declared that in the Ministry of Culture RSFSR "there was a black list that included my name." See Gubaidulina and Tsïbul'skaya, "Oni nenavideli menya do togo, kak slïshali moyu muzïku...," 40.

32. Kholopov and Tsenova, *Edison Denisov*, 30.

33. Grindenko, interview.

Kompozitor," [Eduard] Khagagortyan [1930–83], published a large number of significantly "left" compositions by Slonimsky, *Suite of Mirrors* by Volkonsky, Denisov, [my] Second Violin Concerto and Second Violin Sonata, and something of Sofia Gubaidulina. And because that was possible, it indicates that no one ever gave any kinds of central directives about this matter.[34]

Schnittke's own experience showed that with official allies, works could be performed or even published. There were always exceptions to the rules, whether written or unwritten.

Another important factor, emphasized to me by more than one informant, was the role that personal rivalry, professional jealousy, and what Tomoff calls "informal networks" played in the politics of the Union of Composers.[35] Toward the end of my conversation with Vladimir Martïnov, a composer from the generation after the "young composers," he entreated me: "Don't forget that the repressions of the musicians weren't ideological."[36] They were more like a rivalry, he said, in that the other composers, the traditional, party-toeing ones, were jealous of their more talented, usually younger, colleagues. Or as Denisov later said (somewhat defensively and egotistically), "The mafia in the Composers' Union...held power for forty years. They often supported mediocre artists in order to get more support, more power, and they fought against composers who had a different way of thinking because the latter group had the talent. I don't believe that there was any political reason for banning performances, recordings or publications of our music, or for preventing us from traveling very often. It had...nothing to do with politics, but rather with rivalry."[37] In many cases, it was the more talented colleagues, Schnittke, Denisov, Volkonsky, et al., who were bucking the system. The "mediocre" composers were perfectly content to continue writing socialist realist showpieces. Such an institutionalized support of mediocrity was one of the reasons why it is particularly apt to refer to the 1970s as an era of Stagnation that permeated more than just the Soviet economy. Martïnov's and Denisov's categorical claims that repressions of musicians were not ideological may be overstated, but it is undoubtedly true that motives were never ideologically pure. The compounded, sometimes

34. GNAS: 22–23 (a typographical error here identifying Khagagortyan as "Khachagortyan" has been corrected in the 2004 edition, 23). Khagagortyan was a Khachaturyan pupil who assumed his post ("zamestitel' glavnogo redaktora") at *Sovetskiy kompozitor* in 1973 (*Suite of Mirrors* and Schnittke's Second Violin Concerto were both published in 1970, and Schnittke's Second Violin Sonata appeared in 1976).

35. Tomoff, *Creative Union*, 268–99.

36. Martïnov, interview. This was echoed by the artist Oscar Rabin, who recalled that "certain elements within the KGB might not have objected to the Bulldozer and Izmailovsky exhibitions, but the artists' union was always opposed to us." Baigell and Baigell, eds., *Soviet Dissident Artists*, 97.

37. Denisov, "Music Must Bring Light," 191.

contradictory, levels of ideology and personal rivalry meant that the actual behavior of the Union of Composers was apt to be fickle and underhanded.

Several of the offenses against Denisov cited by Kholopov and Tsenova in the "Chronicle of Prohibitions" in their 1993 monograph on the composer demonstrate this capriciousness. In 1967 two Bulgarian musicians were looking for Volkonsky and Denisov, and asked Khrennikov how they might be found. According to Denisov, Khrennikov responded that Denisov was in Poland and Volkonsky was out of town. In actuality, both men were in Moscow, Denisov in that very building.[38] Another example of this type of behavior also involved Denisov. As Gubaidulina reported in an interview with the Italian musicologist Enzo Restagno, when Pierre Boulez was in Moscow with the BBC Symphony Orchestra in January 1967, he invited Denisov to meet with him, "but only a restricted group of people could attend that meeting—limited to only those composers close to the leadership of the Union." When Denisov "attempted to enter the hall [where it was being held], they wouldn't let him in. Then Boulez came up and began to literally drag Denisov into the premises. However, the guards threw him out.... [In the end] Boulez won, as Denisov was allowed to attend the meeting."[39] Like Boulez, other foreign guests found themselves in similar situations. During his 1962 visit to Kiev, Nicolas Slonimsky was told that Blazhkov was away, only to receive a telephone call from the young conductor, still in Kiev eagerly anticipating their planned meeting.[40] Vladimir Martïnov also recalled that on one occasion when Nono visited in the early 1960s (either 1963 or 1964) the officials told him that everyone he wanted to meet was sick.[41] This sort of subterfuge was more common, and no doubt more psychologically frustrating, than direct prohibitions. Yekimovsky notes that "practically with every performance the most unexpected problems could arise—a sudden sickness of the musicians, or the halls turned out to be occupied by some kind of pre-jubilee celebrations, or during the rehearsals they began to spray for cockroaches, etc. Musical politicos were always able to place a stick in the wheels."[42]

These bans, "understandings," prohibitions, and underhanded actions explain why many unofficial compositions were only heard for the first time in the West long after they were written. And yet several seminal works already discussed, such as Volkonsky's *Musica Stricta, Suite of Mirrors,* and *Laments of Shchaza,* and Denisov's *Sun of the Incas* did manage to slip through

38. Kholopov and Tsenova, *Edison Denisov,* 29–30.

39. SG: 30; see also n. 142 in chapter 2. Boulez and Denisov met again at Denisov's apartment on 11 January 1967; Yudina also attended. See Yudina, "O sovremennoy muzïke (zapiska P'yeru Bulezu)," 242–43.

40. Slonimsky, *Perfect Pitch,* 217.

41. Martïnov, interview. See also Kholopova, *Kompozitor Al'fred Shnitke,* 67.

42. Yekimovskiy, *Avtomonografiya,* 117.

the cracks and have come to embody this music today. Remember Viktor Yekimovsky's "fluke events," first mentioned in chapter 3: "Fluke events happened here.... Sometimes they suddenly performed a type of piece which they shouldn't have been allowed to perform.... Suddenly they published Volkonsky."[43] Rostropovich explained how Schnittke's First Symphony was allowed its Gorky premiere: "You see, with a little luck, one can sometimes slip through the mousetrap. But never in Moscow! And never in Leningrad!"[44]

Performers understandably often resorted to subterfuge. Lyubimov noted that he would frequently list one concert program and then change it at the very last minute by announcing the new program from the stage, or perform a "normal" program and then play more "avant-garde" pieces as encores. Grindenko did the same in the 1970s: "I would write that it would be an evening of violin music, while really everything there would be different. But I wrote on the advertisement that in the concert would be so and so and so and so. And when the public saw the names of the performers...then everyone knew that there would be something special there. And everyone came; on that day the hall would fill up until they simply had to turn people away, and we played— our [rock] group [Bumerang]—because of such deception."[45] Yekimovsky summarized the psychological boost such chances afforded musicians: "We lived in constant battle with the ideological serpents that whole time, and even the rare, small victory...gave us the strength for further work and further existence."[46]

PRIVATE AND CLOSED CONCERTS: APARTMENTS AND INSTITUTES

Moscow

A large factor in successfully outwitting the "ideological serpents" depended on finding alternate performance spaces. Fortunately, if a composer could not be performed at the larger venues in Moscow, Leningrad, or Kiev, there were other possibilities. There was always a back door, a way of getting around the official regulations or exploiting official rules for personal purposes, of discovering the *vnye* space suspended to various degrees within, or sometimes occasionally without, the official. In Moscow in particular the situation was much looser and more liberal than in Leningrad or Kiev. Only

43. Yekimovskiy, interview.

44. Samuel, *Mstislav Rostropovich and Galina Vishnevskaya: Russia, Music, and Liberty*, 107.

45. Lyubimov, interview; Grindenko, interview. For more on *Bumerang*, see Schmelz, "From Scriabin to Pink Floyd."

46. Yekimovskiy, *Avtomonografiya*, 117.

in Estonia and the other Baltic States, however, was the atmosphere toward the arts virtually open.[47] Of course these generalizations, although for the most part tenable, must be taken with a word of caution, for as Mark Pekarsky explained: "If it was possible [to perform something] in Moscow, in Petersburg it was impossible, and sometimes vice versa. It was a nightmare to understand where and what you could perform—it was very complicated. It would seem that the Baltic states were free, in opposition. Nothing of the sort. The leaders, wanting to gain favor with Moscow and be good, they banned on their own initiative."[48]

The rarest and yet most discussed of the unofficial venues in Moscow were the "home exhibits" ("domashnïye vïstavki") that took place in artists' apartments for small groups of close friends or associates. These usually only applied to painting, but if musicians did not perform at such exhibits they often attended and organized them.[49] According to one source, Volkonsky held exhibits from 1959 to 1962 of paintings by Anatoliy Zverev, Lev Kropivnitsky, Vladimir Yakovlev, Oleg Prokofiev, and Yevgeniy Kropivnitsky.[50] Volkonsky emphasized to Pekarsky that he had held only one exhibit, featuring the works of Yevgeniy Kropivnitsky, but seemed to be splitting hairs, given that he had the work of the other artists from the Lianozovo school—including Dmitriy Plavinsky, Rabin, Dmitriy Krasnopevtsev, Oleg Prokofiev, and Yakovlev—permanently on display in his apartment and, by all accounts, frequently invited people to view them (Aygi remembered the date for the "first" Kropivnitsky exhibit as 1958).[51] Volkonsky told Drozdova that his "underground exhibits" ("podpol'nïye vïstavski") were attended by various people from the "intelligentsia," and not necessarily musicians, although he noted that several prominent musicians did visit, among them Neuhaus, Yudina, and Richter (from whom he borrowed the idea of holding such exhibits in the first place).[52] Pekarsky also noted that foreigners were frequently among the attendees.[53] The number of people who came to these gatherings—whether called "exhibits" or not—varied, sometimes ten to fifteen, while at other times only three or four.[54] Aygi said that exhibits of Yakovlev and others followed Kropivnitsky's: "It was

47. See preface to Misiunas and Taagepera, *The Baltic States.*

48. Pekarskiy, interview.

49. Aygi, interview. See also Scammell, "Art as Politics and Politics as Art," 52. Scammell records that pianist Sviatoslav Richter held an exhibit of the painter Dmitriy Krasnopevtsev's paintings in his home but does not specify the date.

50. Talochkin and Alpatova, eds., "*Drugoye iskusstvo*," 57.

51. NVV: 39; and Aygi, interview. Scammell also writes as if this was the only exhibit ever held at Volkonsky's home. See Scammell, "Art as Politics and Politics as Art," 52.

52. Drozdova, "Andrey Volkonskiy" (diss.), 34; and NVV: 39 and 139.

53. NVV: 139.

54. Aygi, interview; and Pekarskiy, interview.

already important. It became like a gallery [with] poetry and prose."[55] Such gatherings continued up until Volkonsky's emigration. Volkonsky's home also became the destination for musicians and their friends after concerts, especially those of Madrigal: "They always took place up to his final departure. Only the appearance changed a bit. But they always took place, because, as a rule, everyone from that narrow circle immediately commemorated any concert. [After] any concert of Madrigal,...everyone went [to Volkonsky's],...as a rule. It was always expansive in mood, very extraordinarily cheerful, extraordinarily bubbling with life, witty, and so forth.... They appeared from various cities and from various countries also. People [there] were always extraordinarily interesting, witty, and the drinking got really heavy."[56] Pekarsky told me that he and his friends would often meet at Volkonsky's to listen to music on LP or tape. It was, as he said, "a very tight circle, a defined circle."[57] The exhibits and gatherings at Volkonsky's apartment are a perfect example of events that took place more literally *vnye* official power structures, where friends could congregate and engage in *obshcheniye,* temporarily escaping from the pervasive politics normally surrounding them (although officials were doubtless aware of many such gatherings). At other venues the sense of withdrawal and "suspension" became more politicized.

Major performances at the Moscow Conservatory (particularly the Large Hall) or the Chaikovsky Concert Hall were out of the question, but unofficial composers could be performed in smaller venues, or in musical or artistic clubs. Many of these musical clubs were affiliated with other non-musical official institutions. Lyubimov provided an important description of the politics behind these venues:

When Volkonsky was alone, and Denisov was only beginning, then it was truly a difficult time. Later, somehow, they [the officials] understood that it was impossible to settle with that [new music], that it was going forward and it was impossible to ban everything. Therefore they didn't ban it, they limited it: only in some institutes or in some kinds of proportions. For example, it was impossible to perform an entire concert of Schoenberg, but two or three things were possible. Thus such large concerts, like for example, a festival of one composer, weren't in the system of the Ministry of Culture, that is in...the Philharmonic, concert halls, etc. [But] an artistic academy or polytechnical institute had nothing to do with the Ministry of Culture.[58]

55. Aygi, interview.
56. Ibid.
57. Pekarskiy, interview. For impressions of these more intimate gatherings, see also NVV: 127 and 130.
58. Lyubimov, interview.

In Moscow there were clubs at the Physics Institute of the Academy of Sciences ("Fizicheskiy institut akademii nauk," or FIAN), the House of Culture of the Kurchatov Institute of Atomic Energy ("Dom kul'turï instituta atomnoy energii im. Kurchatova"),[59] and the House of Folk Art ("Dom narodnogo tvorchestva").[60] The medical students also had their own club. The electronic music studio founded at the Scriabin Museum in Moscow was another institution that hosted its own series of weekly concerts, beginning in the late 1960s and continuing until the studio was shut down in the mid 1970s.[61] According to most contemporaries, information regarding concerts was typically spread by word of mouth, and most of these venues held very few people (usually under one hundred, if not under fifty). As Savenko remembered, in the late 1960s Schnittke's Second Violin Sonata was played to an audience of only fifty people at the House of Folk Art, a packed house for that particular hall.[62] Many of these concerts were not publicly advertised and did not have official programs, although as we shall see there were some exceptions.

The art historian John Bowlt acknowledged a similar phenomenon regarding the abstract artists of the period, who became attached to various institutes in Moscow and Leningrad. Scientific specialists "began to consider abstract art in the light of such concepts as aerodynamics or algebra, [which] rendered the art more palatable and 'relevant.'"[63] Other than any merely avocational attraction to these paintings, however, some of these institutes held exhibits of abstract art and also lent studio space to the artists.[64] Why these exhibitions and concerts were allowed to continue is especially easy to see in the case of the Kurchatov Institute of Atomic Energy in Moscow. This institute had both its own concert series as well as its own series of art exhibitions, and due to the high status of atomic energy in the midst of the cold war, they were allowed to exist with almost no impediments.[65] (The saxophonist Aleksey Kozlov even remembers a summer 1973 rock festival at the Kurchatov Institute.)[66] It has been claimed that one needed a security clearance to attend these concerts, but reports vary. Lyubimov said that the entrance to the Kurchatov

59. See Pekarskiy, "Kryostnïy otets," 185.
60. Literary and poetry readings were also frequently held in such institutes. Patricia Blake describes a poetry reading by Yevtushenko, Okudzhava, and Voznesensky at the Moscow Polytechnic Museum in August 1962. See the introduction to Blake and Hayward, eds., *Half-way to the Moon: New Writing from Russia*, 19–28.
61. See Schmelz, "From Scriabin to Pink Floyd."
62. Savenko, interview.
63. Bowlt, "'Discrete Displacement': Abstract and Kinetic Art in the Dodge Collection," 296.
64. Ibid.
65. Igor Kurchatov had wide leeway in assisting his colleagues and staff. See Josephson, "Atomic-Powered Communism," 313.
66. He called it the "Kurchatov House of Culture" ("DK im. Kurchatova"). Kozlov, *Kazyol na sakse*, 265–66.

Institute was open while at FIAN it was closed, but "it was possible to arrange to bring several people from the Conservatory."[67] Advertisements, most likely for employees, do survive from some of these concerts, one of which is reproduced in the collection *Other Art*.[68] It is a handwritten poster for the "Club" at the Kurchatov Institute for a concert dated 28 October at 17:15 (reportedly in 1963) reading: "Our Guests Will Be: Young Composers Roman Ledenyov, Edisson [*sic*] Denisov, Al'fred Shnipke [*sic*], Alimber Koranov [*sic*]. On the Program: Contemporary Chamber Music, Romances. Admission Is Free." As the typographical errors in Denisov's, Schnittke's, and poor Karamanov's names suggest, the club was an amateurish affair, and these "young composers" were not yet well known. As Lyubimov noted earlier, such clubs survived largely because they operated outside the system of the Ministry of Culture or the local concert organizations (the Moscow Philharmonic, Leningrad Philharmonic, etc.). But because they operated outside the system, the performers at the institutes in Moscow mainly appeared without pay: "They [the listeners] came for the pleasure of hearing, we came for the pleasure of playing."[69]

Poet Aygi was more negative about the clubs. He told me that he saw through the facade of the concerts at the Kurchatov Institute. His reported comments to the officials there reflected the negative aspects of the "suspended," withdrawn arrangement:

> When the Kurchatov Institute invited me [to read my poetry], I said:... "You
> know, I'm not going to come, because I think that with your exhibits
> and evenings you are only making it appear that art...exists. That is
> disinformation, [and] not true: it does not exist. If you were for art, you would
> try to get your writings published, write a newspaper, make demands....But
> you pretend, because you are protected from the real situation....I'm not going
> to come." And I never went. They were offended, saying: "It's too bad, too
> bad."[70]

He added that he "stopped reading in 1961 thanks to [his friend, the poet Stanislav] Krasovitsky." Because of Krasovitsky's example, Aygi said, "I understood that we were only pretending that it existed. In circumstances where [your work] is printed and well-known, it is always easier to read. But when it is read [aloud] and not a single line is published.... Among a close circle [of

67. Lyubimov, interview. Pekarsky's account of the Kurchatov Institute matched Lyubimov's generalizations about FIAN: "It was, after all, a closed institute of atomic energy. But it was possible to come, [if you] put your name on an advance list." Pekarskiy, interview.

68. See Talochkin and Alpatova, eds., "*Drugoye iskusstvo*," I:121 (again, the dates in this book are not always reliable; the same date is in the second edition, p. 106); and Pekarskiy, interview.

69. Lyubimov, interview.

70. Aygi, interview.

friends], for yourself, okay, but when people come, 10 or 15, and the author declaims [his poems] as if everything is all right... nothing is all right."[71] Music, of course, differed in that composers could not readily perform their compositions for one another in private residences as easily as poets could recite their poetry. And composers never had the moral qualms that Aygi expressed. If they did, the rare opportunities for hearing their music or hearing other new compositions—amplified by the enthusiastic responses they received—even in the closed world of the scientific institutes, outweighed any doubts they might have felt about the restricted terrain their music was inhabiting.

Leningrad and Kiev

The situations in Leningrad and Kiev were not as open as in Moscow during the post-Stalin years, a factor that affected all the arts to an equal degree. Because of the dictatorial manner of the local political boss, Leningrad Party Secretary Vasiliy Tolstikov, even the limited freedoms encountered in Moscow were denied to Leningrad artists.[72] For example, touring exhibitions of newer art from abroad (including Calder, de Kooning, Pollock, Rauschenberg, and Rothko) became more frequent in Moscow during the Thaw, but they rarely made it to Leningrad.[73] And if the situation in Leningrad was poor, it was even worse in Kiev.

In Ukrainian literature the concerns of artists in the Thaw years were similar to those faced by their compatriots in Moscow or Leningrad, but with a more nationalist slant. In the words of the historian Orest Subtelny, the new generation of writers "demanded the end of the Party's meddling in art and literature, the right to experiment with various styles, and the recognition of the central role of the Ukrainian language in the education and cultural activity of the republic."[74] Ukrainian composers wanted a similar freedom to experiment, but faced even more entrenched obstacles than their literary counterparts. As Hrabovsky reports: "The Composers' Union in Kiev was until 1968 a most reactionary organization."[75] Most of the "young composers" in Kiev were not allowed to join the Union. Only Hrabovsky, who came to Soviet attention as a result of his prize for his *Four Ukrainian Songs* at the 1962 Young Composers' Competition in Moscow, was allowed to join. Silvestrov and Hodzyats'ky were

71. Ibid.

72. Frumkin, interview, 30 November 1999. Tolstikov was removed from office in 1970, but "the reason for his dismissal was not politics but his sexual escapades on a yacht in the Gulf of Finland." He became the Soviet ambassador to Beijing. See Service, *A History of Twentieth-Century Russia*, 392.

73. Khidekel, "Traditionalist Rebels: Nonconformist Art in Leningrad," 129.

74. Subtelny, *Ukraine: A History*, 507.

75. Hrabovsky, e-mail to author, 14 December 1999.

only able to become members of the Union in the late 1960s, but, as we shall see in chapter 7, in the early 1970s both were expelled for a number of years as part of a crackdown on the Ukrainian intelligentsia.[76] This is not to deny that some things were better in Kiev. Following the twisted logic of the Soviet bureaucracy, it was actually easier to mail scores to the West from Kiev than it was from Leningrad, where post offices were reportedly instructed to refuse all international shipments of manuscript scores.[77]

The "backwardness" of Leningrad similarly had a positive side. It seems that such potentially dangerous concerts as those of works by Volkonsky and Denisov discussed in the first half of this book could be relegated to Leningrad, thereby avoiding the negative publicity that might attend such a performance in Moscow. Although Blazhkov played a large role, Davïdova attributed the concerts of contemporary music in Leningrad to the industry of Irina Nikolayevna Semyonova, the director of the Small Glinka Hall there.[78] According to Davïdova, the leadership in charge of concerts at the time were located in the Large Hall of the Leningrad Conservatory. It was these "bosses" ("nachal'stvo") who decided whether to allow or prohibit certain works from performance. Semyonova "was a very smart woman, and she somehow succeeded in concealing, in making it appear that this composition [i.e., an 'avant-garde' work] would in no way threaten anything."[79] As was often the case, when individuals tried hard enough, the rules, unwritten or otherwise, could be broken or circumvented.

OPEN CONCERTS: CLUBS

Leningrad

Despite variations in the number of closed venues where unofficial music could be heard in Moscow, Leningrad, and Kiev, there were several organizations in each city that managed to straddle the gap between official and unofficial and occasionally performed "modern" pieces of music. These occasional performances showed how fluid the situation was and how contingent each category could be, proving the usefulness and necessity in the Soviet context of concepts like Yurchak's *vnye*. In Leningrad, concerts and

76. Ibid.

77. Hrabovsky, e-mail to author, 4 January 2000.

78. Davïdova (14 September 1999), Lyubimov, Pekarsky, Frumkin, and Tishchenko, interviews.

79. Davïdova, interview, 14 September 1999. Frumkin (echoing Denisov in the previous chapter) said that "She was, I think, removed from her office," but Tishchenko said that she was not. Tishchenko, interview; and Frumkin, interview, 23 December 1999.

lecture-performances occurred at both the House of Composers and at such provocative locations as the House of Culture of the Baking Industry ("Dom kul'turï pechevoy promïshlennosti").[80] Vladimir Frumkin tells of two organizations that he was involved with, one modeled upon Grigoriy Frid's Moscow Youth Musical Club called the Young People's Club of Contemporary Music ("Molodyozhnïy klub sovremennoy muzïki") that emphasized "academic," classical music. The other, more politically dangerous one, the Club of Amateur Song ("Klub samodeyatel'noy pesni"), focused on the works of the "guitar-poets" or "bards" (also known as "avtorskaya pesnya," "author's song," or "samodeyatel'naya pesnya," "amateur" or "homemade song"). These guitar poets were one of the major Soviet social movements in the late 1960s, and included such well-known musicians as Bulat Okudzhava and Vladimir Vysotsky.[81] Both clubs originated in the late 1960s, around 1966, but it was the bard club that was only quasi-official.

It is telling that this bard club was considered more dangerous than the classical organization. There were several reasons for this. One was the programming for the classical concerts, which were tamer than Frid was able to arrange in Moscow. The second factor was that the bards attracted a larger, more youthful audience. In Leningrad, at least, the musical club did not attract the youth to the same extent that Frid's group was able to do. Nonetheless, there were moments of tension at the Leningrad Young People's Club of Contemporary Music. Frumkin related one incident when the well-known conductor Yuriy Temirkanov gave a presentation comparing contemporary opera productions "In the West and Here" ("Na zapade i u nas"). Not only did the presentation show obvious biases toward the Western productions, but in discussing the "dictatorial" style of conducting that had become infamous in the West through the examples of Karajan and Toscanini, Temirkanov made the bold statement that such conductors were musical dictators on par with "Hitler or Stalin." Because KGB agents were possibly in the audience that night (as they were on several other occasions—supposedly two seats at every concert were reserved for them), the head of the Union of Composers "became green" and "almost had a heart attack." The next morning he paid a visit to Frumkin along with a group of "bosses" from the Union of Composers, who referred to Temirkanov's comparison as an "ideological diversion, sabotage." Temirkanov was beyond criticism, but Frumkin had to defend himself, which

80. Frumkin, interview, 30 November 1999. According to Frumkin, the House of Culture of the Baking Industry also had its own jazz club and a cafe called Café Orient ("Kafe vostok") where guitar poets from Leningrad could be heard.

81. For more on this genre both past and present, see Daughtry, "The Intonation of Intimacy," esp. 47–58 on the various labels applied to it (54 discusses the Clubs of Amateur Songs).

he did successfully by referring to Khrushchev's "Secret Speech" and its condemnation of Stalin's crimes. The club was allowed to continue.[82]

Kiev

Kiev's concert life was much more restricted than that in Moscow or Leningrad. The only viable venue for concerts was the Philharmonic concert hall, where orchestral and chamber music concerts, including those of the Ukrainian Symphony Orchestra, were performed.[83] Musical clubs, whether at open or closed venues, were unknown in Kiev. When Hrabovsky approached Academician Hlushkov, a leading researcher on cybernetics, in Kiev in 1965 or 1966 "and proposed to join forces for developing applications of cybernetics in art. [Hlushkov] was scared to death—and literally fled from me."[84] Later attempts at forming musical clubs in Kiev were more successful, but short-lived. In 1970 a club titled "The Sun Clarinets" (after a poem by the Ukrainian Symbolist poet Pavlo Tychyna) was formed under the auspices of the centenary of Lenin's birth. The club survived for just under a year; when a campaign against the Ukrainian intelligentsia began in January of 1971, the "club was closed—forever."[85]

In 1960s Kiev, Igor Blazhkov was the strongest proponent of contemporary music, both Western and Ukrainian. Until 1963 he was the assistant conductor of the Philharmonic Orchestra, under the direction of Natan Rakhlin (1905/06–79). Under Blazhkov's direction Kiev was able to hear Gershwin's *Rhapsody in Blue* in 1959 for the first time since 1930, along with works by Karol Szymanowski on the occasion of the latter's eightieth birthday in 1962. Blazhkov was removed from his post in either late 1962 or early 1963 (or possibly both, with the 1962 dismissal a temporary prelude to the final firing in 1963). In a 13 November 1962 letter from Kiev, Nicolas Slonimsky wrote that Blazhkov was "kicked out of his conductor's post" for an article he wrote with his wife for a Polish music periodical on contemporary Ukrainian music in which he "condemn[ed] in very strong terms virtually the whole setup in the [Kiev] conservatory and extoll[ed] the music of a young dodecaphonic beatnik."[86] Hrabovsky remembers Blazhkov's ultimate dismissal occurring after a planned performance of the composer's *Symphonic Frescoes* (1961) in early

82. The information in this and the preceding paragraph are from my interviews with Frumkin on 30 November and 23 December 1999.

83. Hrabovsky, interview, 24 October 1999.

84. Hrabovsky, e-mail to author, 14 December 1999.

85. Ibid.

86. Slonimsky, *Perfect Pitch*, 262 (see also n. 36 in chapter 2).

1963 was canceled when a Party member in the brass section of the orchestra informed the Central Committee of the Ukrainian Communist Party that "an ideological diversion is being prepared."[87] In either case, in 1963 Blazhkov moved to Leningrad and served there as Yevgeniy Mravinsky's assistant until 1968.[88] As we have seen, from his position in Leningrad Blazhkov was able to arrange several important premieres of unofficial music. He also continued to maintain connections with the composers in Kiev, even arranging a trip for them to Leningrad and a personal meeting with Boulez when he was on tour there with the BBC Symphony Orchestra in 1967.[89]

Moscow

In Moscow, the most notable open organization was the composer Grigoriy Samuilovich Frid's Moscow Youth Musical Club ("Moskovskiy molodyozhnïy muzïkal'nïy klub"), founded in 1965. The Scriabin Museum Studio was a special case that fell somewhere between open and closed. On paper it was a center for "scientific research" established in 1966 that belonged to the Melodiya record company. But in reality, for many years it actually fell "outside"—*vnye*—official jurisdiction due to the laxity of the officials ostensibly responsible for its oversight. Because of this exceptional position the concerts of new music held there featuring the first Soviet synthesizer, the ANS (named after Scriabin's initials), "drew everyone who was dissatisfied, who sought something new, wanted to become familiar with something, they came there," in composer Eduard Artem'yev's words.[90] Frid's club was scrutinized more carefully by officials. It was a very public version of the clubs that gathered at the Kurchatov Institute and FIAN. Unlike those clubs, however, the Moscow Youth Musical Club was open to all. As a result, most survivors of the period agree that Frid's club was not only one of the few places to hear new music in Moscow during the 1960s, but was by far the most popular, with a full house most evenings.[91]

Frid organized his club in 1965 and held the first meeting on 21 October of that year at the House of Composers in Moscow, where all subsequent

87. Hrabovsky, e-mail to author, 14 December 1999. Hrabovsky claimed that he was also removed from his conservatory post after this event, which he recalled occurring in March 1963, but his dismissal was effected by a letter dated 11 February 1963. See RGALI, f. 2077, op. 1, yed. khr. 2174, l. 25 (see also n. 36 in chapter 2).

88. Tishchenko, interview.

89. Like Restagno and Gubaidulina (see n. 142 in chapter 2), Hrabovsky also misremembered the date of this visit as 1964. Hrabovsky, e-mail to author, 14 December 1999 (compare with SG: 30).

90. Artem'yev, interview. See also Schmelz, "From Scriabin to Pink Floyd."

91. Davïdova, interview, 14 September 1999; Artem'yev, interview; and Yekimovskiy, interview. See also Kurtz, *Sofia Gubaidulina*, 75–76.

meetings would also be held on Thursdays from October through April or May. Each session of the club was devoted to a specific topic, and the order of events included performances, recordings, and open debates: "Everything took the form of an argument, both in the hall and on stage."[92] During the first five years of its existence the topics ranged from the safe and banal: "Soviet Mass Songs" (1965–66 season), "The Problems of Soviet Opera" (1965–66), "To the 50th Anniversary of the October Revolution: Vocal and Piano Music of Soviet Composers" (1967–68), and "Composer Tikhon Khrennikov" (1967–68); to the more risky: "Anton Webern" (1966–67), "Contemporary Music from Abroad" (1967–68), and "Problems of Electronic Music" (1968–69).[93] Other evenings were devoted to broader subjects: "On Jazz, Light Music and Good Taste" (1966–67), "Problems of Abstract Form and Art" (1968–69), or "On Scientific and Artistic Creation" (1969–70). According to Frid there were more evenings about Shostakovich than about anyone else.[94]

Frid's concerts attracted a wide-ranging group of musicians, students, scientists ("psychologists, biologists, and linguists" he said), and intellectuals, and usually the hall was overcrowded, with audience members sitting on the stage and in the aisles (the hall at the House of Composers held—and still holds—approximately 500 when filled to capacity).[95] Lidiya Davïdova said that it was the "one place where you could hear the music of Webern, Schoenberg, Denisov, and Volkonsky.... And there at Frid's club it could only be heard because afterwards any person could speak his mind"—that is, potentially criticize it. She also reported that: "The most varied people [attended]. They sold subscriptions to the club and any person could buy them and come. And thus there were a great deal of people who didn't have any kind of relationship with music and spoke all sorts of... nonsense.... I remember there was an evening dedicated to Webern, and Volkonsky was there, and he said about the discussion, 'How can a person who doesn't know Chinese be able to speak Chinese?'" As she said: "Thank God, there were a lot of musicologists there who put in their place those who spoke poorly."[96] As Frid admitted, "There were many who simply said that they didn't understand either the music... not only

92. Frid also noted that he was helped in organizing the club by musicologist Grigoriy Golovinsky and that Vladimir Zak also worked with the club for five years. Frid, interview.

93. Frid, Muzïka—obshcheniye—sud'bï, 231.

94. Frid, interview.

95. Most of this information was drawn from an interview with Grigoriy Frid at his apartment in Moscow on 21 September 1999, as well as an examination of his collection of photographs taken over the course of the club's existence. These photographs, a majority of which are dated, provide a good insight into the dynamics of the club, frequently showing members of the club in heated argument. Some of them have been reproduced in Frid's book about the Moscow Youth Musical Club, Muzïka—obshcheniye—sud'bï.

96. Davïdova, interview, 14 September 1999.

Schoenberg, we also had the music of Xenakis, the music of Boulez.... [There were people] who simply didn't accept it."[97]

The club attracted such a wide variety of people because of Frid's own wide-ranging interests: "I believed and believe that everything is related to music—mathematics, and politics, and biology—all of that is connected with music, or music is connected with all of the sciences.... And therefore I attracted to that club very famous scientists, and very great musicians, and those evenings took the form of a free conversation, a free discussion." According to Frid, the audience members packed the hall because "at that time the people in the hall...had a stimulus and desire because they were highly spiritual people, they were from the intelligentsia, they were young people who always wanted to display an interest in new ideas." The notable musicians who attended included Shostakovich, Khachaturyan, Kara Karayev, Yudina, Gidon Kremer, Vladimir Spivakov, Gutman, and Oleg Kagan.[98] Other figures who attended included Scriabin's youngest daughter Marina, Lev Termen (inventor of the Theremin electronic instrument), and Alexander Men' (1935–90, a priest who went on to become one of the leading figures in the Russian Orthodox Church and a confessor of artistic luminaries like Solzhenitsyn and Nadezhda Mandelstam[99]).

The Moscow Youth Musical Club occupied a unique role in the musical life of the capital. Frid tried to explain the appeal of his club and its positive reception by officialdom: "The club was popular, because although we didn't occupy ourselves with politics, the entire tendency of the club was a bit—I don't know how to put it in English, dissident or nonconformist—most likely dissident. Therefore from the side of power, the club did not have support and the club was considered to be against the Party." To call it "dissident" seems an exaggeration—it was officially sanctioned, after all—but there certainly were moments of direct questioning or exchange, as well as moments in which politics was a not-so-veiled subtext.[100] These moments were more common, and more public, than in the *vnye* milieus that Yurchak discusses. Frid said: "It appeared that we were busy with music—for example there was an evening devoted to Beethoven, but at the Beethoven evening I read Beethoven's letter to Prince Lichnowsky where he said: 'There were and will be thousands of princes but only one Beethoven.' And we discussed the fact that the personality of the artist stands infinitely higher than the personalities of those in

97. Frid, interview. Unless otherwise indicated, all of the quotations from Frid and any details in the following paragraphs are taken from this interview.

98. For Yudina's brief 1968 account of her participation, see Yudina, "G. S. Frid," 250. See also Yudina, *Luchi bozhestvennoy lyubvi*, 529.

99. For more on the importance of Alexander Men', see Remnick, *Lenin's Tomb*, 357–65.

100. For a notable exchange concerning dodecaphony, see Schmelz, "Shostakovich's 'Twelve-Tone' Compositions," 344–45.

power.... We spoke of Prince Lichnowsky, but our students understood that the discussion was about our princes who sat on [high]." Although the club could perform contemporary music, they had to be more circumspect about it. Frid said that he could play Stockhausen, but only "unofficially," meaning that he could not advertise an entire evening devoted to Stockhausen. The same applied to Schoenberg: "The Central Committee board of directors for cultural matters followed everything that was done, and if I advertised on a poster that there would be an evening of Schoenberg they would immediately summon me: 'And why Schoenberg, huh?' And one time they even completely canceled an evening, banned it. It was that very evening when we wanted to give *Jesus Christ Superstar*, because it was rock music. Then we did it anyway, but [they banned] one evening." Of course, by the time of those performances in the mid-1970s on an evening devoted to representations of the Passion in music that included both Bach's Passions and Andrew Lloyd Webber's *Jesus Christ Superstar* (1971), the new youth culture of rock music was considered more dangerous than either Schoenberg or religion.

When asked why his club was allowed to continue despite its sometimes controversial subjects, Frid provided a number of reasons. First, he said that so many people attended the sessions that it would have created a public scandal if the club had been disbanded. Furthermore, "It was also considered work with the young. And although Party circles were against 'Bourgeois dialogues,' there was a certain [rule] that it was necessary to work with the young." He added: "And besides that, [the officials] also understood that with all those kids, to close the club?! When our club held..., together with the stage, 500 people, and for so many years...and that it was well-known in Moscow. That was also bad." Besides these factors, Frid also said that Khrennikov was in favor of the club, which went a long way toward securing the approval of both the Union of Composers and the Ministry of Culture. Finally, Frid acknowledged that he was a member of the Communist Party, and had been since the German invasion of the Soviet Union at the beginning of World War II. No doubt all of these reasons, but especially Frid's political connections and the generally safe fare offered by the club, assured its continued existence, and also belied his claims that it was "dissident." Frid offered another plausible explanation: "It was all very difficult. When you ask, you ask a lot—'Why didn't they close the Club? How did you succeed?' To tell the truth, I myself don't know. It seems to me that what played a role here was that it was music. If it had been a club of poetry, or a club of literature, they would have shut it down a long time ago." Perhaps the fact that the club featured music in the age of the "Word" made a difference, but this does not diminish the impact of the club, the aesthetic and political debates that it fostered, and its often oppositional—although not dissident or even necessarily directly resistant—stance.

At the House of Composers in Moscow, Frid's club had another official counterpart in a club for chamber music organized by Mark Mil'man (1910–?). Mil'man's club featured more "classical" music, but performers sometimes managed to perform more outlandish works there, as Lyubimov did at a concert on 20 January 1969 featuring works by Estonian composer Kuldar Sink (1942–95), Morton Feldman, Pierre Schaeffer, Terry Riley, and Swiss composer Pierre Mariétan (b. 1935).[101] For his encore, Lyubimov made a rather odd selection: "I played [Cage's *4'33"*] as an encore. After Feldman and Sink, there was a mixed program: Bach mixed with new music. Then we sat down and played Cage." Lyubimov remembers Mil'man standing in the wings and whispering: "Play something, only don't be silent." Then, Lyubimov continued, "At first, the listeners sat, and later began to applaud, but I don't know, I didn't ask anyone" if there was a scandal. "The public was mainly musical—varied— it was an open concert." According to Pekarsky, another participant at the club that evening, the resulting "scandal was wild."[102] The very nature of the piece selected by its deliberately provocative performer signaled opposition, revealing the often antagonistic quality of these more "suspended" concerts, both on stage and in the hall.

PERFORMERS

As we have seen, an important factor in successfully performing "modern" pieces in open and closed venues alike was the leverage in programming accorded popular performers. Charismatic and strong-willed musicians such as the conductors Blazhkov and Rozhdestvensky, the violinist Kremer, the cellist Gutman, and the pianist Lyubimov, could sneak dangerous works onto their programs in a way that composers could not, as Lyubimov had done with Cage's *4'33"* at Mil'man's club. This explains why so many Soviet pieces that were written in the 1960s are for small chamber ensembles, often for one or two performers. The importance of the performer no doubt also explains the sheer number of pieces by Schnittke that highlight soloists, in particular his series of virtuosic concerti grossi. In the end, Schnittke's gambit paid off, for one of the first works by him to be performed in the Large Hall of the Moscow Conservatory was his Concerto Grosso No. 1 with Kremer and Grindenko as the soloists in November 1977 (with Schnittke on

101. Lyubimov, interview. In his performance notebook, Lyubimov listed the following pieces for this concert: Sink—*Kompozitsiya*, Feldman—Piece for Four Pianos; Schaeffer—*Montaggio*, Cage— *4'33"*; Riley—*Keyboard Studies No. 2*; and Mariétan—*Circulaire*. According to Lyubimov, all but the Sink were Soviet premieres.

102. Pekarskiy, interview.

harpsichord).[103] As Savenko remarked: "The reason that piece was performed was not Schnittke, it was Kremer."[104] Concerts featuring Gutman and Kagan at the end of the 1960s also demonstrate this. Kagan performed Schnittke's serial First Violin Sonata on 3 March 1968 in the Small Hall of the Moscow Conservatory in a program featuring otherwise innocuous works by Beethoven, Bach, and Paganini, while Gutman, on 25 October 1969 also in the Small Hall, performed Denisov's Three Pieces for Cello and Piano along with sonatas by Bach, Debussy, and Shostakovich.[105] The Borodin Quartet was also able to use its clout to secure numerous performances, and even a recording (albeit unreleased), of Schnittke's First String Quartet at the end of the 1960s.[106]

In conversation with the music critic Claude Samuel, Rostropovich placed performers on the same level as composers: "For instance, David Oistrakh's position was surely not inferior to that of Shostakovich." Nor, for that matter, was Rostropovich's own position. Rostropovich explained the situation: "Why is this? Because performers have the resources of their repertoire. They aren't punished, but they are intimidated with orders to drop Shostakovich here, Schnittke there. That doesn't deprive the performer of his means of earning a living. He can always replace Shostakovich with Bach and Schnittke with Chaikovsky, and life goes on. This privileged situation of performers explains why today the level of our school of performing is ultimately far superior to that of our school of composition."[107] There is no denying that in the 1960s because of their influence and visibility Rostropovich and Oistrakh were already far removed from the world of unofficial music that we are describing.

103. This was a concert in preparation for their upcoming European tour with the Lithuanian Chamber Orchestra. The work's premiere was in Leningrad. See Kremer, *Zwischen Welten*, 239. An earlier work of Schnittke's, the Second Violin Sonata, was performed in the Large Hall of the Conservatory by Kagan, along with Mendelssohn's Op. 4 and the Brahms Third Sonata, on 4 May 1976. The program is held in the archive at the Moscow Conservatory.

104. Savenko, interview. Kremer acknowledges that in the late 1960s and early 1970s even he had difficulties performing Schnittke, specifically the Second Violin Sonata and the Second Violin Concerto. See Kremer, *Zwischen Welten*, 225–27.

105. Moscow Conservatory archive of programs. This "burying" of potentially problematic works also applied to modern foreign pieces. For example, on a concert on 17 November 1967, Gutman played Webern's Op. 11 pieces for cello and piano on a program featuring compositions by Chopin (Op. 65 sonata), Britten (Op. 72), and Prokofiev (Adagio from the ballet *Cinderella*). By 1967, these Webern pieces were certainly not as problematic as they would have been a decade earlier.

106. The Borodin Quartet violinist Rostislav Dubinsky's memoirs and the cellist Valentin Berlinsky's memory diverge on this matter. Berlinsky's performance diary—which even Dubinsky admired for its thoroughness—and the Melodiya recording of the quartet indicate that Dubinsky's statements regarding the difficulties the quartet had in arranging performances of Schnittke's work are greatly exaggerated. Berlinskiy, interview; and Dubinsky, *Stormy Applause*, 221–29. See also Schmelz, "Listening, Memory, and the Thaw," 391–96. Schnittke's Quartet was recorded by the Borodin Quartet in 1967. This has been issued on CD as Borodin Quartet, *Russian Chamber Music: Schnittke, Shebalin, Stravinsky.*

107. Samuel, *Mstislav Rostropovich and Galina Vishnevskaya: Russia, Music, and Liberty*, 114.

Despite Rostropovich's political actions in the early 1970s, and despite the fact that Rostropovich later became a champion of Schnittke, only rarely was he directly involved in Soviet performances of Schnittke's music, or of any other unofficial music in the 1960s. That came after his exile from the USSR in 1974. In the 1960s, other than Mariya Yudina, support for the unofficial composers came from performers younger and less visible than Rostropovich or Oistrakh. Kagan could perform Schnittke's Violin Sonata and Gutman could perform Denisov's cello pieces in the Small Hall of the Moscow Conservatory, but Rostropovich had to be content with Shostakovich or Bach at the Philharmonic.

In the mid-to-late 1960s, the circle of young performers in Moscow included Davïdova, Lyubimov, and Pekarsky, all of whom, as we have seen, played important roles in the premieres of contemporary works. They were close friends with Denisov, Schnittke, Gubaidulina and Volkonsky, and often received dedications from them. In Kiev, aside from Blazhkov (who, of course, also promoted new music when he relocated to Leningrad), there were few proponents of new music. They included the pianist Vsevolod Rukhman, as well as the violinist Armen Mardzhanyan and Anton Sharoyev, the former second violinist with the Chaikovsky Quartet in Moscow and the founder and chief conductor of the Kiev Chamber Orchestra.[108] These were the rare performers in either city who were adventurous enough to attempt unfamiliar repertoire, both home-grown and imported, and not only for fear of reprisals. The wariness was also musical, for as Boris Berman told me, the Bartók Sonata for two pianos and percussion, to name one piece, "was very infrequently played because by that time the difficulty was already musical... because of the tempo and change of direction in the rhythms.... Too few performers felt comfortable with this music because it was unfamiliar and hard to make sense of."[109]

All of the performers from the younger generation I spoke with said that they could more or less perform whatever they wanted. Lyubimov told me: "All in all, situations were always found when it was possible to play any composition. As a rule you did it once or twice. In my concerts across the country I could play some kinds of pieces many times, but not often large pieces for ensembles."[110] Grindenko added: "You know, we always deceived them.... When we weren't able to deceive them it always ended up... [with questioning by officials and banning of repertoire], but when we succeeded in deceiving, we succeeded in deceiving a lot, very often."[111] Pekarsky also was

108. Hrabovsky, e-mail to author, 14 December 1999.
109. Berman, interview.
110. Lyubimov, interview.
111. Grindenko, interview.

confident of his ability to play what he wanted and escape the repercussions: "They didn't arrest [people] any more; the Stalin period had already passed. I always played what I wanted—[including] the music of Schnittke, Denisov, and Gubaidulina. They almost never banned [me], because I wasn't anyone's person. I almost never served the government. And it was impossible to punish me."[112] Other than these resourceful young performers, one group stood apart at the time because of the influence they exercised in performing music that carried an unofficial cachet, occasionally new but predominantly old: Volkonsky's early music ensemble Madrigal.

Madrigal

The history of the performing collective that Volkonsky founded in 1964 and directed for six years, known for most of its over forty years of existence as Madrigal, has yet to be written, and can only be briefly sketched here.[113] This ensemble played a crucial role in the musical and artistic life of Moscow and the Soviet Union as a whole, and continues to perform concerts in Russia today under the directorship of Lidiya Davïdova. During the 1960s, it had an interesting alliance with the unofficial musical scene, as it managed to live a doubled existence, officially sanctioned yet still maintaining an unofficial reputation.

The beginnings of Madrigal were rocky. At first the Ministry of Culture refused to support the plans to found an early music ensemble when Volkonsky approached them with that request in 1964, after being inspired by hearing the 1964 Russian tour of the New York Pro Musica ensemble under the direction of Noah Greenberg.[114] Because of an earlier incident involving Volkonsky's intransigence, when he went to Shchepalin, an official in the musical section of the Ministry of Culture, with a request to form an ensemble for early music, Shchepalin greeted him with less than open arms. Shchepalin told Volkonsky that the Ministry of Culture was not interested in an early music ensemble. Shocked that such an innocent request was being denied him, Volkonsky immediately grasped for a more viable alternative. He proposed that he really did not want to form an ensemble of early music: "I want to form an ensemble

112. Pekarskiy, interview.

113. Drozdova provides a good overview of its foundation in her important, yet difficult to obtain dissertation, drawing from interviews with Volkonsky, Pekarsky, and Berman. See Drozdova, "Andrey Volkonskiy" (diss.), 42–44. I have supplemented her account with my own interviews, as well as the information in NVV: 153–68.

114. The initial refusal of Volkonsky's request by the Ministry of Culture had a significant prehistory, see Schmelz, "Listening, Memory, and the Thaw," 397–99. On Greenberg's tour, see Schwarz, *Music and Musical Life in Soviet Russia*, 420; and also Greenberg, "A Soft Sound in the U.S.S.R.," 41–43, 102.

of singers that will specialize in performing Soviet operas and will take them around the *kolkhozes*." Shchepalin responded: "Ah, then that's a different story. At the right moment I see that you have become more prudent. If you continue in such a spirit, then we will be able to come to an understanding."[115] With those words he approved the formation of Volkonsky's ensemble, known at first simply as "Vocal Ensemble" or "Vocal-instrumental Ensemble" ("Vokal'nïy ansambl'" or "Vokal'no-instrumental'nïy ansambl'"—a term also often used in the 1960s to designate official Soviet rock-and-roll bands).

Volkonsky was incredibly pleased when he formed this group. Aygi recalled his ecstatic reaction, reflecting the concerns that had been plaguing him for the recent past: "Now I will be so busy that no one will be able to misuse my time. I may no longer see people. I can refuse. I can say 'I am busy, I am truly busy.'"[116] The group's first concert took place on 16 April 1965 in Moscow.[117] In the beginning, the "Vocal Ensemble" included the singers Davïdova, the Ecuadorian Beatriz Parra (b. 1940, now Vice-Minister of Culture in Ecuador), Alexander Tumanov, and the Lisitsian sisters, Ruzanna and Karina, along with their brother Ruben. In 1966 other members joined, including the percussionist Pekarsky. It was at this time (1966) that the group also became known as "Madrigal." Volkonsky mocked the bureaucrats' incomprehension of the name: "'And what's this "Madrigal,"' the arts officials asked, 'Is that a type of monkey?'"[118]

At first it was very difficult for Volkonsky to find music from the fifteenth and sixteenth centuries. He did it surreptitiously, ferreting out scores buried in the libraries in Moscow and Leningrad: he found Palestrina's music at the Leningrad Conservatory and found Purcell's complete works at the Moscow Union of Composers.[119] He also received scores from his contacts abroad.[120] Through these efforts, Volkonsky eventually accumulated a sizeable collection of early music, enough to provide a wide variety of programs, with a repertoire that ranged from Machaut and Binchois to "just before Bach," including Schütz as well as sixteenth and seventeenth century Italian music (Peri, Caccini, Monteverdi and their successors, but not Vivaldi), and "a lot of Elizabethan English music."[121] Berman described the scope and structure of Madrigal's performances: "There were basically several programs, or, even better to say, several half-programs, which constantly were rejuvenated and mixed and matched.

115. Volkonsky's statement and Shchepalin's response are both from Drozdova, "Andrey Volkonskiy" (diss.), 44. See also NVV: 153–54 and 50.

116. Aygi, interview.

117. Kučera, *Nové proudy v sovětské hudbě*, 21.

118. Drozdova, "Andrey Volkonskiy" (diss.), 44.

119. Ibid., 154. For more on Volkonsky's attitude toward "authenticity" and early music performance, see NVV: 157–68.

120. Aygi, interview; and NVV: 155–56.

121. Berman, interview, 4 February 2007.

So, for instance, there would be a Russian half and an Italian half, or an English half and a Spanish half."[122]

To complicate matters, often members of Madrigal would perform a different repertoire with other musicians. Berman said, "Members of Madrigal would perform let's say in concerts of Bach cantatas, and it was not a concert of Madrigal—it was not billed as a concert of Madrigal, but I remember several concerts in which I would play continuo (harpsichord) and Markiz, who was a member of Madrigal a little bit later, he was the conductor, and the singers were all singers from Madrigal. With an orchestra—a pick-up orchestra." These concerts nonetheless were associated with Madrigal. Members of Madrigal also formed the "Ensemble of the XX Century," and often toured under that name playing twentieth-century music, frequently with Madrigal itself, thereby "cutting travel expenses."[123]

Because of its wide and unfamiliar repertoire, like all of the concerts of unofficial music examined thus far Madrigal's concerts were usually greeted excitedly by audiences, filled largely with young people.[124] After all, most Soviets had never heard this music in any form. The same curiosity that led listeners to concerts of serial music also drew them to concerts of early music. Under the auspices of the Ministry of Culture, the group toured around the Soviet Union, to cities like Leningrad, Novgorod, Pskov, Omsk, Baku, and Yerevan, and received wide press in periodicals throughout the country.[125] Their often theatrical performances, that on at least one New Year's Eve concert (31 December 1970) included the use of a starter's pistol, consistently enraptured audiences throughout the 1960s and into the 1970s.[126] Berman recalled, "They had a kind of fancy dresses, gowns for the women which were loosely historical, they were not really historical but they looked 'old.' And the men were in tails." He also remembered a Spanish carol, a "number which proved to be very effective and [that] they kept doing mainly as an encore": "It was sung starting behind the stage and then sung in a procession across the stage in a kind of darkened hall, with each singer carrying a candle."[127]

Madrigal did encounter some difficulties, usually connected with sacred music, especially Russian. Berman recalled, "The authorities got used to all kinds of Requiems, Sanctuses and all that performed [by Madrigal], but now it was the Russian church service in the language that would be understood,

122. Berman, interview, 4 February 2007. A list of Madrigal recordings, giving a sense of their specific repertoire, is available in Bennett, *Melodiya: A Soviet Russian L. P. Discography*.

123. Berman, interview, 4 February 2007.

124. Ibid.

125. Drozdova provides an exhaustive list in her dissertation's bibliography. Drozdova, "Andrey Volkonskiy" (diss.), 195–200.

126. NVV: 61 and 173–74.

127. Berman, interview, 4 February 2007.

albeit vaguely [by audiences]."[128] Thus, Berman told me, "Concerts [of Russian church music] were also...often banned. Once when it was permitted, there was a special lecture, a kind of very well-known and trusted musicologist—maybe someone like Keldïsh—who came to say that it was basically, of course, only nominally religious music."[129] According to Kholopov, an official told Volkonsky that he could not perform religious texts, to which Volkonsky replied, "But what about the ikons on display in Soviet Museums?" The official's response was suggestive: "Yes, but they are passive, performing religious texts is active."[130] Baltin remembered another instance when Volkonsky had the group vocalize Russian religious pieces whose texts had proven objectionable.[131] Because of such official opposition, Berman recalled that Madrigal's Russian church music program was "one of [their] greatest hits."[132]

Drozdova's evaluation of the significance of Madrigal is worth considering: "When Volkonsky shook the library dust off musical pieces that had remained unheard up to that time, he did something comparable to the work of the avantgardists, and the public could hear movement forward from the rebirth of the old."[133] But this generally fitting interpretation needs some qualification. It is true that the same curiosity drove concertgoers to attend performances by both Madrigal and the unofficial composers, but Madrigal's concerts were rarely, if ever, prohibited. Instead they were actively supported by the Ministry of Culture in their tours. All the same, there was an air of freedom and openness surrounding these concerts similar to that surrounding the concerts of works by the unofficial composers. Aygi said that more than half of Madrigal's audience came just to be part of what they perceived as a demonstration of freedom.[134] As a result, Madrigal was not the last early music ensemble in the Soviet Union. In 1976 in Estonia, Andres Mustonen founded the Hortus Musicus ensemble, an ensemble with which Pärt frequently interacted and that he declared created "an atmosphere [that] had the effect of a midwife for my new music."[135] Nor was Volkonsky's Madrigal the first in the Eastern Bloc, for in 1963 a Madrigal choir had been founded in Romania.[136]

128. Ibid.

129. Berman, interview, 23 March 2001.

130. Kholopov, interview, 27 September 2000. This anecdote is repeated in a slightly different version in NVV: 156. In their "Chronicle of Cultural Life" in the 1970s, Uvarova and Rogov list 1970 as a year in which "Madrigal was banned from performing Russian Church music." Uvarova and Rogov, "Semidesyatïye: Khronika kul'turnoy zhizni," 37.

131. Baltin, interview.

132. Berman, interview, 4 February 2007.

133. Drozdova, "Andrey Volkonskiy" (diss.), 45–46.

134. Aygi, interview.

135. Hillier, Arvo Pärt, 77–78. A photo of the ensemble in period garb is in the "Pictorial Record of Estonian Music" in Olt, Estonian Music. The date given for their founding here is 1972.

136. Pieslak, "Romania's Madrigal Choir and the Politics of Prestige."

As many composers at the time were doing in the West, Volkonsky wanted to combine these two trends, past and present, in his Madrigal concerts. And naturally he hoped to perform his own music, as well as music by other contemporary composers, but the performers in Madrigal were too afraid to do so and resisted this side of Volkonsky's personality. Pekarsky said that Madrigal performed "only early music. Andrey wanted to play contemporary music. He wanted to compose. He was promised [performances], but no one carried out the promise. Everyone was afraid of contemporary music, and even more of Volkonsky... [who was] in general an ideological figure."[137] However, on at least one occasion, as Davïdova and Berman remembered, Madrigal recorded music that Schnittke had written for a cartoon, Khrzhanovsky's *In the World of Fables* (*V mire basen*, 1973).[138]

Much as the Evenings on the Roof concerts in Los Angeles or the Group for Contemporary Music in New York combined very old and very new music, Volkonsky managed to unite the two movements. When personal tensions began to arise between the leadership of Madrigal (i.e., Volkonsky) and its performers in 1967, Volkonsky reportedly turned his attention to his own solo performances and recordings, some of which were even released by Melodiya.[139] Berman, more or less Volkonsky's successor at the helm of Madrigal, provided the most detailed explanation of the end of Volkonsky's tenure with the group, a time when "he got fed up, he got bored, and he wanted to get out." Although he was an "ideological figure," according to Berman Volkonsky was also an asset to the group: "The singers [in Madrigal] were very much afraid that the moment that Volkonsky left, the group would just be banned. Because he was a name..., he was at that time the only harpsichordist; he was a name, and without him the group would lose a lot of appeal." Therefore, Volkonsky continued his association with the group but only appeared in select concerts in Moscow or Leningrad, while Berman directed the ensemble on their tours.[140] Berman remained the group's de facto leader until Spring 1973 (when Volkonsky emigrated), at which time he resigned in anticipation of his own emigration from the USSR, which occurred in November 1973.

Like Volkonsky himself, Madrigal had a *vnye* status that took advantage of the blurred lines dividing official and unofficial in this period. By the end of the 1960s, Volkonsky was a "name," a figure with a certain influence and prestige

137. Pekarskiy, interview.

138. Davïdova, interview, 14 September 1999; Berman, interview, 4 February 2007; Alexander Ivashkin, e-mails to author, 28 January 2008; and BAS: 297.

139. See Bennett, *Melodiya: A Soviet Russian L. P. Discography*. At least one CD has been issued containing Volkonsky recordings from this period (if only as accompanist): Shafran, *Bach: Three Sonatas for Cello and Harpsichord*.

140. Berman, interview, 23 March 2001.

of his own. Nonetheless, the increasing tension that began to develop between Volkonsky and the Soviet arts establishment in the mid-1960s only grew after he vacated Madrigal's directorship in the late-1960s. While Madrigal continued to thrive, Volkonsky did not.

AUDIENCES

After surveying the venues, organizations, and performers responsible for performing unofficial music during the 1960s, one vital aspect of Soviet concert life during the period remains, namely that of the audiences for this music. The question of who attended unofficial concerts is a vexing one for the historian. As these concerts and these venues lacked tickets or printed programs, and had minimal advertising, attendance records are scant, as is reliable information as to when concerts took place, or what pieces were performed. There are no equivalents in music for the comment books that sometimes accompanied exhibitions such as those at the Manezh that the art historian Susan Reid has used to glean information about Soviet audience reactions to abstract art in the 1960s, or those that Susan Costanzo has used (along with letters and post-performance questionnaires) to detail responses to amateur theater-studio performances in the 1970s and 1980s.[141]

The closest source of such information is described in a letter Nicolas Slonimsky wrote from Moscow on 28 November 1962 in which he provided entries from a "book of suggestions for new publications" he found at an unnamed Moscow music store. The comments he transcribed are tantalizing, if selective. One writer begs: "Can't you publish some Schoenberg? This continued discrimination against this great composer is absurd. After all, his music was published in the Soviet Union in the 1920s. Can't you at least follow your predecessors—not, of course, the immediate predecessors of the period 1938–1953." A second asks: "Please publish some Schoenberg, Berg, Webern, Stravinsky, instead of these alleged opuses by Dmitriy Kabalevsky. I am not leaving my address. What's the use? You won't publish anything worthwhile anyway."[142] Apparently, some shoppers felt emboldened to ask for the newest in musical fashion. Without knowing further details about this comment book (including the other comments it held), these anonymous remarks provide only the briefest glimpses of unofficial listeners (or possibly musicians).

141. Reid, "In the Name of the People: The Manège Affair Revisited," 673–716; and Costanzo, "Reclaiming the Stage: Amateur Theater-Studio Audiences in the Late Soviet Era," 398–424. See also Dobson, "Contesting the Paradigms of De-Stalinization: Readers' Responses to *One Day in the Life of Ivan Denisovich*."

142. Slonimsky, *Perfect Pitch*, 264–65.

As we have seen, however, information does exist for the most famous concerts of the decade by Volkonsky and Denisov. And, thankfully, performers including Lyubimov, Rozhdestvensky, and the Borodin Quartet cellist Valentin Berlinsky have kept detailed notebooks or diaries of their performance activities during the decade.[143] Unfortunately, in describing the rest of the unofficial musical scene, one can do little more than generalize on the basis of information gathered from the recollections of the performers and composers who performed in or attended these concerts. Not even the notebooks of Lyubimov, Rozhdestvensky, and Berlinsky contain any details about who attended or why. The exception of course is an institution such as Frid's Moscow Youth Musical Club, which remains much better documented, as several books now attest.[144]

Who, then, attended these concerts? When asked this question, Yekimovsky repeatedly emphasized: "Muzïkanti"—that is, musicians—those who had a professional interest in hearing new compositions. Aside from that, other venues necessarily drew their own specific constituencies. For example, the Kurchatov Institute and the electronic music studio at the Scriabin Museum obviously drew many scientists, although some informants report that in general scientists were frequent auditors of new music at all venues.[145] In the end, we may say that the concerts generally attracted young, educated professionals, many with a vested, specialist's interest in the music that was being performed. According to Lyubimov the scientists—"especially physicists" he said—were attracted to new music because "avant-garde music also gave them a very great impulse emotionally. That is, they felt that the music gave them creative energy.... That exactly the freedom of that music gave them such impulses that generally reminded them of the freedom of their research." When I asked "And freedom in life as well?" He responded, "Yes, Yes, of course, of course. It was such a demonstration of internal freedom."[146] We may surmise that other listeners, and not only at the scientific institutes, felt something similar. Volkonsky remembered the "hunger for the new" that drove Soviet audiences, and commented in a 1974 interview that the "enthusiasm of the public is perhaps also a form of protest against censorship, against oppression."[147] He also noted that "dissidents attended my concerts

143. Lyubimov's and Berlinsky's diaries remain in their personal possession. For Rozhdestvensky's performance notebooks from 1950 until 1987 see Rozhdestvenskiy, *Preambulï*, 247–94. These latter notebooks seem to be complete. That is, potentially problematic figures like Karetnikov, Denisov, and Schnittke are included and not excised as might have been the case even a few years before this publication.

144. See, e.g., Frid, *Muzïka—obshcheniye—sud'bï*.

145. Yekimovskiy, Frid, Artem'yev, and Martïnov, interviews; and Frumkin, interviews, 30 November and 23 December 1999.

146. Lyubimov, interview.

147. Volkonskiy, "Sprechen ohne gehört zu werden," 21.

in order to receive a kind of support."[148] By the 1990s, however, Volkonsky had also become embittered about his remembered Soviet auditors, complaining in another interview with Pekarsky that "they began to listen to my music from sensationalism, because it was scandalous. When I first began to perform, I even joked: 'My concerts are attended by everyone who dislikes Soviet power.' Just from interest in my personality and not because of the music. Those bearded guys ['borodachi'] in sweaters. It was very unpleasant to me."[149]

When I asked if many people were in the audience at the concerts when he performed Schnittke's *Serenade* at the Central House of Workers of Art (TsDRI—"Tsentral'nïy dom rabotnikov iskusstv"), the Kurchatov Institute, or the Lebedev Institute, Pekarsky responded:

> There were always a lot of people, because in general it was an "underground" ["andergraund"] of sorts. A sort of underground art ["podpol'noye iskusstvo"]. And the public there was always absolutely excellent. Not at open concerts. But at those [closed] concerts the public came to gulp a bit of fresh air, of such freedom, if only musical ["glotnut' nemnozhko svezhego vozdukha, takoy svobodï, khotya bï muzïkal'noy"]. Somewhere in a magazine, *Muzïkal'naya zhizn'* perhaps, there was some kind of article about me. It stated both too strongly and with such pathos that at my concerts people received a gulp of freedom ["glotok svobodï"]. That was stated too strongly. It was correct, [but] it had nothing to do with me. At my concerts I simply played the music that I wanted to play. That's all. It was a sort of musical protest against that vileness ["merzost'"] that took place all around.[150]

Gubaidulina used a similar expression in describing her audiences at the time: "In the 1960s society needed purity. And they came to performances of our music not out of curiosity, not from the desire to become familiar with it because it was banned, but from the craving to gulp pure air ['iz zhazhdï glotnut' chistogo vozdukha']."[151] So we return to one of our central paradoxes: the music performed was closed off, but audiences still heard in it "freedom," as well as both "purity" and "freshness." This paradox became especially acute when the featured works were abstract—figuratively closed off. Yet, as we will see in the next chapter, in Schnittke's *Serenade* freedom was already becoming more explicit and more literal, reflecting the gradual ascendancy of mimesis for many of the unofficial composers.

148. NVV: 142.

149. Pekarskiy, "Umnïye rasgovorï s umnïm chelovekom," 118–19.

150. Pekarskiy, interview. The concert of Schnittke's *Serenade* at TsDRI apparently took place in 1970 alongside Denisov's *D-S-C-H* (1969). See Uvarova and Rogov, "Semidesyatïye: Khronika kul'turnoy zhizni," 37.

151. Gubaidulina and Tsïbul'skaya, "Oni nenavideli menya do togo, kak slïshali moyu muzïku...," 40.

6

From Abstraction to Mimesis, from Control to Freedom: Pärt, Schnittke, Silvestrov, and Gubaidulina

Over the course of the Thaw artistic and social freedoms waxed and waned, often seemingly at random. Although the overall trend of the period was one of gradual liberalization, the reception of Volkonsky's *Suite of Mirrors* already suggested that after the 1962 Manezh exhibit the early promise of the Khrushchev years gave way to new, more severe repressions against artists. When Khrushchev was deposed in 1964, encroachments on the freedoms of every citizen of the Soviet Union soon followed, for despite its lenient beginning the Brezhnev leadership quickly showed its intolerance. The trial and conviction of writers Andrey Sinyavsky (whose pseudonym was Abram Tertz) and Yuliy Daniel' (pseudonym Nikolai Arzhak) in Moscow in February 1965 (they had been arrested in September 1964), sent up a red flag to Soviet intellectuals and especially to artists, whether writers, painters, or composers.[1]

The unofficial music world of the mid-1960s could not last forever. Soviet society was changing, and the musical interests of both audiences and the unofficial composers were changing as well. Initially most of the unofficial composers experimented heavily with serialism, yet by the middle of the decade several of them, and most notably Arvo Pärt, Alfred Schnittke, and Valentin Silvestrov, had become dissatisfied with what they perceived as the confines of the technique and the abstract style that it seemed to necessitate. For all three of these composers, the crucial year was 1964—the limit point of their abstract serial engagement. From 1964 until the early 1970s, these composers experimented with a variety of other techniques and devices, gradually

1. For a good introduction to the events surrounding and following their arrests, see Rubenstein, *Soviet Dissidents*, 31–62.

incorporating into their personal styles a number of musical languages from increasingly blatant uses of tonality—including citations of particular tonal works from the past—to aleatory methods or other ways of introducing performative spontaneity into their music, even as they continued to apply serial techniques to varying degrees. Even if her language was never as abstract as the others, Sofia Gubaidulina made similar negotiations between serialism, spontaneity, communication, and tradition in her works from the end of the decade.

The implications of these shifts are wide-ranging. Although their proximate causes differed, the unofficial Soviet composers were not the only musicians grappling with stylistic change in the mid-1960s. By the end of the 1950s, many composers in Europe and America, spurred on by John Cage's coin-tossing compositions, had begun to move from serialism to other forms of chance or aleatory elements. In his 1957 essay "Alea," Pierre Boulez grudgingly admitted the introduction of chance elements into musical compositions, writing, "Wouldn't the composer's ultimate ruse be to *absorb* this chance? Why not tame these potentialities and force them to render an account, to account for themselves?" In other words, the composer must, in Boulez's memorable closing formulation, "fix the infinite"; the opportunities for performative "initiative" should be treated as strictly as the other parameters of serial music, as Boulez himself did in his Third Piano Sonata (1955–57). Boulez feared that a composer's relinquishing of "constant choice"—a synonym for "control"—would lead to what he derided as the flagrant excesses, the "artificial paradise," of the music of John Cage, his erstwhile friend and correspondent.[2]

Denisov also worried about the abuse of aleatory's freedoms. In a 1966 paper entitled "Stable and Mobile Elements of Musical Form and Their Interaction," which Denisov had presented at a conference held in Leningrad that year dedicated to the "Theory of Forms and Genres," he addressed several of his concerns with "mobile form" (his synonym for aleatory devices).[3] He also hinted at the larger connotations these methods carried in the Soviet context. This article, like Denisov's 1969 tract on serialism, traced the history of mobile form, leaping from Beethoven to Berg to Boulez to his own *Sun of the Incas*. The emphasis on openness here might be strange for a composer previously distinguished by his obsession with serialism, but Denisov's real attitude

2. Boulez, "Alea," 45–50.

3. Denisov, "Stabil'nïye i mobil'nïye elementï muzïkal'noy formï i ikh vzaimodeystviye." A revised version of this paper was published five years later in a 1971 collection of essays called: *Theoretical Problems of Musical Forms and Genres* (*Teoreticheskiye problemï muzïkal'nïkh form i zhanrov*). It appeared again with additional revisions in a 1986 collection of Denisov's theoretical writings called *Modern Music and Problems of the Evolution of Compositional Technique* (*Sovremennaya muzïka i problemï evolyutsii kompozitorskoy tekhniki*).

toward aleatory music comes through in his scorn for Cage, whose techniques he deemed responsible for "opening a wide path to chaos and the absurd."[4]

Like Boulez, Denisov's derision extended far beyond Cage (and his young American followers) to a distrust of all compositional devices that lacked the proper rationalized controls. Denisov acknowledged that the "introduction of mobile principles in music gives us a great deal of freedom in operating with the musical material and allows us to obtain new sonic effects." Nonetheless, he argued, the "ideas of mobility may give us good results only when…the composer controls all that is occurring in those processes and orients them in the necessary direction for the expression of his ideas, [so that] the destructive tendencies hidden in mobility do not destroy the constructiveness necessary for the existence of any form of art."[5] As Boulez had suggested in "Alea," that freedom is best that is rigorously controlled.

Aside from his article's historiographical and classificatory schemes (which are most useful as evidence of his wide familiarity with the contemporary music of the European avant-garde), Denisov's concluding remarks suggest a rationale for many of the unofficial composers' adoption of aleatory techniques (and also tonal quotations, although he does not mention this). Denisov acknowledges that "ideas of mobility have found a wide dissemination not only in music," noting that "they have inspired a number of writers, poets, sculptors, artists, and film-makers." The reason for this attraction, Denisov proposes, is the "desire to introduce the reader (viewer, listener) into the very center of the creative process, making him something of a type of participant in the event, strengthening his active involvement."[6] Positioning the listener at the center of aleatory musical processes is an idea clearly at odds not only with Boulez, but also with Denisov's own aloof stance toward the audience, a stance that only strengthened as he grew older.[7] Putting the listener at the center of aleatory creation also owed a strange debt to (and put a new slant on) socialist realism's ideal of *narodnost'*, or composing music of wide accessibility.

4. Denisov, "Stabil'nïye i mobil'nïye elementï muzïkal'noy formï i ikh vzaimodeystviye," 132 (1986) and 125 (1971).

5. Ibid., 133 (1971). See also Denisov's analysis of his composition *Ode for Clarinet, Piano, and Percussion*, and especially his comments on the "limitations" on the three performers during the improvisatory section of the work, and the final triumph of the "constructive" tendencies in the work over the "destructive" aleatory moments. Denisov, "Kratkaya avtorskaya annotatsiya" and "Avtorskiy analiz" for " 'Oda' dlya klarneta, fortepiano i udarnïkh," 121 and 132.

6. This section is taken from p. 132 of the original 1971 publication of ibid. A few phrases were slightly altered in the 1986 version where it appears on pp. 135–36.

7. For example, when asked by Shul'gin, "When you compose do you think about a concrete listener?" Denisov responded, "I never think about anyone. No! I write music because I cannot not write it. And in that moment I think only about sound, color, notes. For me it is a type of monologue without a listener. But later, when the music begins to sound from the stage, he [the listener] is absolutely necessary." PED: 114. See also his statement to Pantiyelev, "An orientation toward the public is always

Read skeptically, one might interpret Denisov's foregrounding of the audience's role in mobile form in his essay as a bald attempt to placate Soviet authorities who might otherwise look suspiciously on a text that quoted liberally, albeit with feigned "objectivity," from numerous nefarious Western avant-garde composers (it might also be an attempt to excuse his recent experiment in aleatory techniques, the 1965 *Crescendo and Diminuendo for Harpsichord and Twelve Strings*).[8] Skepticism might win out had Denisov not returned to and amplified his earlier, audience-centered stance in the later 1986 revision of the "mobile form" article. On the final page of the 1986 version, Denisov referred to the French writer Michel Butor (b. 1926) and his *Recherches sur la technique du roman* of 1964, quoting a passage in which Butor explained that "the idea of mobility of a much higher order may also be possible, which would also be exactly and fully defined, in which the reader becomes responsible for what is occurring in the microcosmos of the work, a mirror of our human condition, which is mainly inexplicable, undoubtedly, as it is in life,—with every step, with every choice [the reader] selects and presents the meaning, illuminating it with his freedom. Sometime, undoubtedly, we will arrive at that point."[9] This utopian pronouncement is unlike any other statement made or cited by Denisov. Naturally he ignored his own theoretical advice; aleatory moments figure rarely in his works from the time. But the freedom for the reader/listener that Denisov advocated provides a compelling motivation for many of the other unofficial composers' mid-decade aleatory compositions.

The shift from serialism to aleatory (however grudgingly accepted) marked by these two articles by Boulez and Denisov has traditionally been viewed by music historians as one of the crucial stylistic boundaries between the musical 1950s and 1960s, even if the exact ramifications or extent of the change still remain unclear. Aside from their broader stylistic significance, Boulez's and Denisov's discussions of compositional control and performed freedom resonate strongly with contemporaneous cold war political and aesthetic debates regarding the meanings of the artistic products paid for, promoted by,

suspicious to me....Such an orientation is very dangerous for an artist." Denisov and Pantiyelev, "Ne lyublyu formal'noye iskusstvo...," 16.

8. The prefatory remarks to the collection of essays from which the 1971 version of the paper is drawn highlight its "objective" treatment of the subject. See preface of Rappoport, ed., *Teoreticheskiye problemï muzïkal'nïkh form i zhanrov*, 5. The later perestroika-era publication of the essay also includes more examples, possibly intended for the earlier version but refused by the publisher (see later). Bernstein performed *Crescendo and Diminuendo* with the New York Philharmonic in 1967 and included it on the orchestra's LP *Bernstein Conducts Music of Our Time, vol. 2*, alongside works by Lukas Foss and Gunther Schuller.

9. The date of Butor's book allows for the possibility that Denisov had meant to include this quotation in the 1971 version. Butor was well known in musical circles in the 1960s for his writings on music and for his texts to compositions such as Henry Pousseur's *Votre Faust* (1960–67). Denisov, "Stabil'nïye i mobil'nïye elementï muzïkal'noy formï i ikh vzaimodeystviye," 136 (1986).

or otherwise seen as representative of the Soviet Union and the United States.[10] We have already had occasion to examine this issue in our discussion of the abstract phase of unofficial Soviet music, but the question of freedom becomes more acute when actual freedom or openness is inserted into a composition, when chance or aleatory is introduced and serialism's strictures are either loosened or abandoned. Therefore, leaving aside questions of direct government funding or intervention, there are provocative political implications to the rhetoric surrounding later debates pitting the strict controls of serialism against the open freedoms of aleatory or chance elements. "Alea" and "Stable and Mobile Elements of Musical Form and Their Interaction" threaten to dissolve the neat opposition between the serial freedom of the West and the tonal control of the Soviet sphere. Boulez's and Denisov's discussions thus force a further questioning of the political meanings of serialism and particularly the move away from serialism, both in the USSR and in the West.

As we have already seen, the opposition between American and European serial freedom and Soviet tonal control was complicated by serialism's prominent emergence in the Soviet Union—in the guise of Volkonsky's *Musica Stricta*—at almost the same moment as "Alea" first reached print. Because serialism carried different connotations—a contradictory combination of freedom and control, liberation and retreat—for audiences and composers in the USSR when it first appeared there, it is understandable that the Soviet abandonment of serialism had different motivations and meanings. Although similar applications of aleatory devices were happening in Europe and America, the unofficial Soviets did not employ them in the same manner or for the same reasons.

Returning again to Berger's characterization of the 1950s and 1960s discussed in this book's introduction, we may view the adoption of aleatory devices in the USSR as part of a general and gradual shift toward mimesis. For, whether or not Boulez's Third Sonata or other similar Western works can be dubbed mimetic, the shift from abstraction to mimesis does occur in the late 1960s compositions by Pärt, Schnittke, Silvestrov, and Gubaidulina. By the mid-1960s, these four composers had grown dissatisfied with what they considered to be the abstractions and constraints of serialism. They all began turning in their own fashions to something that felt freer: both to actual freedom in the music, that is, aleatory elements, and often to various invocations of tonality. Ultimately, the new styles they developed were compatible with the dramatic demands of socialist realism, and this music was increasingly embraced by Soviet critics who responded to its familiar "dramatic contents" despite its often disjointed, free forms. Yet the content of their musical dramas differed widely from Soviet expectations, and their music was still embraced

10. See, e.g., Shreffler, "Ideologies of Serialism," 217–45.

by audiences seeking something "new," particularly when heard against the backdrop of Brezhnev's renewed campaign against writers and political dissidents in the late 1960s. "Mimetic" matches the style of these works, but it is also appropriate to call them "dramatic" after the Russian word "dramaturgiya," or "dramaturgy," recurrently used by critics in their responses to these compositions. In an article on Scriabin, Viktor Bobrovsky offers an imprecise although representative capsule definition: "A definite order in the alternation and development of types of expressiveness in a composition."[11] He further attempts to elucidate the term: "A process organized—on the basis of the dialectical triad or another principle—of contrasting and developing types of expressiveness and psychological states embodied in music."[12]

Aleatory devices—by the end of the decade frequently, but not always, in conjunction with recollections of the tonal past—allowed these composers to construct more detailed—more "definite" and "expressive"—narratives than had been possible with serial techniques. Although their listeners did not "become responsible for what is occurring in the microcosmos of the work" to the extent that Butor and Denisov desired, Schnittke, Pärt, Silvestrov, and Gubaidulina used aleatory devices as prominent "types of expressiveness" in dramatic mixtures of a broad number of techniques and styles in order to communicate something more precise to their audiences. They established the symbolic nature of the aural, to borrow from the art historian Yevgeni Barabanov, who has described the movement of the "alternative" Soviet visual arts during the 1960s as a "shift...from acts of pure affect and bursts of protest (fueled by Abstract Expressionism, action painting, and Expressionism) to the establishment of the symbolic nature of the visual: the plastic representation of spiritual, religious, or aesthetic categories."[13]

For all of these composers, no single concerts or compositions stand out as they did for Volkonsky or Denisov. Instead, we will need to examine the totality of their outputs from the mid to late 1960s. This chapter will thus trace the development of aleatory techniques, tonal citations, and mimetic representation in the music of Pärt, Schnittke, Silvestrov, and Gubaidulina. At the same time, we will have cause to examine briefly a related set of conversions that took place among many of the unofficial composers, those of an explicitly religious nature. As in the visual arts (recall the Madonna in Rabin's *Ferris Wheel in the Evening,* fig. 1.2), religion was one of the new "categories" most frequently represented symbolically in the unofficial music of the late 1960s. Some of the religious conversions, like Pärt's, began with mimetic stylistic explorations, but eventually led to the adoption of entirely new, simplified styles. Others like

11. V. Bobrovskiy, "O dramaturgii Skryabinskikh sochineniy," *Sovetskaya muzïka,* 1 (1972): 114–15.
12. Ibid., 115.
13. Barabanov, "Art in the Delta of Alternative Culture," 18.

Karamanov abandoned serialism on converting and returned to more familiar tonal idioms. Still other religious shifts, like Karetnikov's, had nothing to do with technique; in his case religion and serialism comfortably coexisted. These "true" conversions will thus form a subcurrent throughout this chapter, reflecting another type of freedom beginning to be felt in the late 1960s USSR.

THE LIMITS OF SERIALISM I

Pärt to 1964 and After

Pärt's "conversion" to mimesis began early. As *Obituary* demonstrated, Pärt's interest in serial techniques was connected to a dramatic sensibility from the very start. Although this did not mitigate the negative official responses to *Obituary* (and in fact by and large fueled the criticisms it received for its "ultra-expressionistic," "naturalistic" mood), such a dramatic tendency helped his subsequent compositions gain acceptance. For one, his 1963 *Perpetuum Mobile*, Op. 10, in which Pärt applied the strict serialization of both pitch and rhythm, was received positively by Soviet critics who read dramatic intent behind its obsessive sounds. In fact, the official reception given all Pärt's 1960s compositions reveals the shifts and ambiguities in socialist realist doctrine as much as it does his own shifting aesthetic priorities.

In principle the brief *Perpetuum Mobile* (dedicated as we have seen to Nono) was both more complex and more transparent than any of the compositions that have been discussed up to now; it was a bald attempt at total serialism governed by one pitch row and a series of rhythmic rows.[14] Each section of the piece states one of the four basic permutations of the pitch row, as each note is introduced by a new instrument. The rhythm for each instrument is governed by the rhythmic row for that particular section of the piece, and the rhythmic rows are constructed so that there is an increase in rhythmic activity that builds to the climax of the piece, followed by a gradual subsidence.

Almost more important than these technical procedures is the way that the construction of *Perpetuum Mobile*, as in the overaggressive *Obituary*, is subsumed by the work's brief, dramatic course. A listener is aware of the gradual increase in dynamics, volume, and tension, but is not necessarily aware of the calculations governing its progress. The monthly report ("otchot") for December 1963 that the Estonian Union of Composers sent to Moscow reported that: "In concert the public received the piece very well—it was repeated as an encore. As an experiment, the work fulfilled its goal and purpose."[15]

14. See Hillier, *Arvo Pärt*, 40 for a table of these rows.
15. RGALI, f. 2077, op. 1, yed. khr. 2275, ll. 5–6 (17 December 1963).

In most performances the work was applauded. It is easy to hear why it was well received by audiences; the transparent dramaturgy of the piece successfully overshadowed its painstaking serial construction.

In his review of the performance of *Perpetuum Mobile* at the 1965 Warsaw Autumn Festival, Viktor Tsukkerman noted that it reminded him of Ravel's *Bolero*.[16] His review ignored the work's serial basis, although Tsukkerman commented that the "harmony is rather sharp but not excessively so."[17] Marina Nestyeva and Yuriy Fortunatov also published a review of Estonian music in *Sovetskaya muzïka* in 1966 in which they discussed *Perpetuum Mobile* and also ignored the fact that the work was serial. (They instead referred to it as using a "chromatic row" ["khromaticheskiy ryad"], another synonym, perhaps, for "twelve-toneness.") Their stream-of-consciousness description of the work is worth sampling: "*Perpetuum* causes a great impact on listeners. At first you conceive only some noisy process. But as the work unfolds a multitude of associations emerge. It seems as if during those four minutes a busy port is stirring to life in the morning, as if you are meeting two satellites in space, as if at night a supersonic airplane flies over the city, as if.... And when the work ends, after the involuntary feeling of amazement, you are suddenly sorry that the sonic mass has dissipated, vanished."[18] Throughout their review of Pärt's music, Nestyeva and Fortunatov stress Pärt's ability to counteract his interest in experimentation with his musicality, his "captivating lyricism."[19] When they declare that "Pärt the artist turns out to be stronger than Pärt the architect," they are not far from the mark.[20] Pärt's mimetic sense was always stronger than his constructivist bent. This might explain the relative leniency with which official reviewers treated his music: despite serial underpinnings that normally drew rebukes, works like *Perpetuum Mobile* are actually quite listener-friendly.

Pärt's First Symphony, a work contemporaneous with *Perpetuum Mobile* (it was started before but finished after) and dedicated to his composition teacher Heino Eller, shares its row with the shorter orchestral piece (albeit inverted and transposed), and also relies on a similar propulsive dramatic sensibility, particularly in its second movement, "Prelude and Fugue." The most striking moments in the work include the climax of this second movement, a section of piling row forms that quickly exhaust the total chromatic, resulting in a section more notable for its sonoristic qualities (or *sonorika*) and its "twelve-tonish"

16. Tsukkerman, " 'Varshavskaya Osen' ' 1965 goda," 99.

17. Ibid.

18. Nest'yeva and Fortunatov, "Molodyozh' ishchet, somnevayetsya, nakhodit," 20. A later commentator noted that *Perpetuum Mobile* might be used as a soundtrack to accompany a "scientific film about the cosmos aimed at a wide audience." Soomere, "Simfonizm Arvo Pyarta," 177.

19. Nest'yeva and Fortunatov, "Molodyozh' ishchet, somnevayetsya, nakhodit," 21–22.

20. Ibid, 21.

sound than the niceties of the underlying serial construction.[21] Also notable are the jazzy, syncopated opening measures of the symphony's first movement, "Canons," with their hocketing brass and driving hi-hat interjections.

Pärt's First Symphony stands apart from the other pieces of the time by virtue of its strong forward propulsion, especially in the second movement's "fugue." The piece never really loses its momentum, yet is also based on an extensive serial foundation. Hillier is correct to note that "the strongest features of [Pärt's] earlier works are those larger dramatic gestures in which musical time is frozen and a particular idea is allowed to attain its own organic shape, owing nothing particularly to the serial process itself."[22] The dramatic approach that would pattern nearly all of Pärt's subsequent pieces is already audible in embryo in the First Symphony. In its dramatic shape and inventiveness the First Symphony eclipsed anything that Pärt had written up to that point in his career. Even if the whole fails to cohere satisfactorily—much of it is still brash and somewhat crude—many of the individual moments, Hillier's "larger dramatic gestures," still sparkle. It also showed a technical finesse absent from the clunky "twelve-tone" *Obituary* or the pedantically serial *Perpetuum Mobile*. Put in the terms of Soviet music criticism, Pärt might be said to have matched form and content in the First Symphony. And, as had been the case with *Perpetuum Mobile,* it was the "content" that dominated initial discussions of the piece.

When the Estonian Union of Composers met on 18 February 1964 to hear and discuss the First Symphony, they called it, rather generically, an "emotional and bright piece, with good dramaturgy, written with talent." They acknowledged its technical basis without naming those techniques ("Pärt used contemporary techniques of musical expression well"), managing, as only a sympathetic Soviet account could, to argue that serial techniques were used "in service of the contents of the work." Although typically jargon-ridden, the remainder of the comments from this discussion are useful for the particular jargon they employ, as they repeatedly emphasize the symphony's "profound ideological content" ("ideynost'") and "musical dramaturgy."[23] Apparently there were few problems. Pärt's First Symphony was even recommended for

21. See Schmelz, "Shostakovich's 'Twelve-Tone' Compositions," 329–30.

22. Hillier, *Arvo Pärt,* 46. Here Hillier also correctly identifies Pärt's preoccupation with canon and counterpoint as important features of his later music prefigured in these earlier compositions.

23. RGALI, f. 2077, op. 1, yed. khr. 2275, l. 18. The most prominent review of the First Symphony occurred over four years after its composition in an important article by Tarakanov from the June 1968 *Sovetskaya muzïka,* called "The New Life of an Old Form" ("Novaya zhizn' staroy formï"), one of the few in the Soviet Union to include a serial schema and discuss the specifics of serial techniques. Its discussion of Schnittke's Second Violin Concerto was also significant, as will be seen later. Tarakanov, "Novaya zhizn' staroy formï," 54–62. For a later Soviet period overview of the symphony, see Soomere, "Simfonizm Arvo Pyarta," 178–82.

performance in Moscow in April 1964 and appeared on a later Union of Composers (USSR) "List of Pieces Recommended for Promotion" during the 1965–66 season.[24] It was also performed in Kiev in January 1965 by Neeme Järvi and the State Symphony Orchestra of Ukraine, and recorded for Melodiya by Järvi and the Estonian Radio Orchestra in 1966.[25] Pärt's symphony was not as harshly received as his *Obituary* had been, indicating more than a gradual shifting in official taste. The symphony's more familiar "dramaturgy" (based on a more familiar genre) and its nonspecific "profound ideological content" probably spared it much criticism. After all, one of the central offenses of *Obituary* had been its use of serial techniques to memorialize the victims of fascism.[26]

Pärt's nationality also might have worked in his favor. In addition to the generally liberal atmosphere within Estonia, Estonian works could always be viewed through a nationalistic lens by outside critics. This allowed critics to forgive as national tics those aspects of the music that might have caused problems if submitted by an ethnic Russian. As Nestyeva and Fortunatov wrote in their review of *Perpetuum Mobile:* "In such moments [of lyricism], if you listen sensitively and attentively, you also distinguish national peculiarities, testifying to a system of intonation that determines the whole sonic structure."[27] The authors seem to suggest that traces of Pärt's national heritage linger even in works like *Perpetuum Mobile* that are not explicitly "national" in form, thereby saving him from falling into the trap of "constructivism" (a synonym for "formalism"). Yet the question of nationality, like all Soviet musical criteria, was invoked opportunistically and could be used just as easily to damn as to praise. The failure to find national colors or "intonations" could be used to disparage, but when desirable it was always possible to locate them.

The greatest indication of Pärt's increasing dissatisfaction with serialism as a structuring principle is evident in his 1964 compositions, which included *Solfeggio, Quintettino, Collage on the Theme BACH,* and *Musica Sillabica.* Over the course of 1964, these works show Pärt actively probing the boundaries of (and

24. RGALI, f. 2077, op. l, yed. khr. 2275, l. 66 (p. 6 of the April 1964 report): "Rekomendovat' dlya ispolneniya v Moskve na kontsertakh sleduyushchiye proizvedeniya." Also RGALI, f. 2077, op. 1, yed. khr. 2381: "Spisok novïkh proizvedeniy sovetskikh kompozitorov, rekomenduyemïkh dlya propagandï v sezone, 1965–1966 god." See chapter 5 for a further discussion of these lists.

25. Hrabovsky, e-mail to author, 10 March 2000. The 1966 recording (Melodiya D 018049/50; S 01325/6; D 018049-25076) also included *Perpetuum Mobile, Collage on the Theme BACH, Pro et Contra* (Thomas Velmet, soloist), and *Musica Sillabica* (Eri Klas and the Tallinn Chamber Orchestra). See Bennett, *Melodiya: A Soviet Russian L. P. Discography,* 444–45.

26. A rebuke of *Obituary* for these reasons is contained in RGALI, f. 2329, op. 3, yed. khr. 1186: "Spravka o tvorcheskoy deyatel'nosti Soyuza Kompozitorov SSSR 5 Fev. 1962"; see also chapter 4.

27. Nest'yeva and Fortunatov, "Molodyozh' ishchet, somnevayetsya, nakhodit'," 22. The concept of the "intonation" is taken from Boris Asafyev. See Brown, "The Soviet Russian Concepts of 'Intonazia' and 'Musical Imagery,' " 557–67.

the alternatives to) serial techniques.[28] The reception of the 1964 pieces revealed the growing bemusement and frustration with which the Estonian Union of Composers greeted each of Pärt's successively more outlandish works. When the Union met to discuss each of his new compositions, several adjectives stood out in their remarks, among them "humorous" (*Quintettino*), "experimental" (*Solfeggio*), "film music" (*Musica Sillabica*), and "lacking content" (*Solfeggio*, again).[29] These official descriptions of Pärt's 1964 works are equally descriptive of his later 1960s compositions. His next composition, however, was received far more critically.

The final point in Pärt's most experimental year was reached in a rather whimsical yet deadpan piece for solo piano called *Diagrammid*, his first extensive attempt at combining and exploiting the disparities between serial and aleatory writing (although there were already hints of aleatory in the First Symphony). *Diagrammid* was first performed at the House of Composers in Tallinn on 15 June 1965. The full account that was passed on to Moscow is telling:

> [The assembled listeners] noted that such music has its place already, though only because it presents the performer with the problem of improvisation. In that sense such a repertoire holds great meaning. At the very same time *they noted that in the music they heard there was neither harmony nor melody.* It was a musical experiment, a joke. *The piece gratified the ears, it is true, but was it art—that is another question!* It is possible and necessary to experiment, but the piece heard [by us] was not a high point in the work of Arvo Pärt [emphasis in original].[30]

The score of *Diagrammid* is visually arresting, as the first movement consists of a series of ever enlarging circles containing notes linked by lines. As Hillier notes, the color of the first Estonian publication of the score was in red, black, and white, and the circles in the first movement were shaded according to "the order in which they appear in the color spectrum" (fig. 6.1).[31] *Diagrammid*'s first movement is based on an increasing quantity of pitches within each circle, a sequence that begins on each successive staff with the next in a series of odd numbers from 1 to 7. Thus, the first six circles contain 1, 2, 3, 4, 5, and 6 pitches, respectively, the next contain 3, 4, 5, 6, 7, and 8, respectively and so forth, until the final, largest circle contains all 12 pitches. The final line of the piece is a series of hammered clusters, alternating in register, dynamics, and tempo. Underlying this sequence is a pointillistic, linear statement of successive basic forms of the

28. Hillier provides a good, brief survey of these pieces in his monograph on the composer: Hillier, *Arvo Pärt*, 46–52. Soomere discusses *Collage on the Theme BACH* and *Musica Sillabica* in "Simfonizm Arvo Pyarta,"183–87. See also Schmelz, "Listening, Memory, and the Thaw," 241–43.

29. RGALI, f. 2077, op. 1, yed. khr. 2275, ll. 21–22 (January 1964); and f. 2077, op. 1, yed. khr. 2275, l. 130 (November 1964).

30. RGALI, f. 2077, op. 1, yed. khr. 2380, l. 58 (June 1965).

31. Hillier, *Arvo Pärt*, 47.

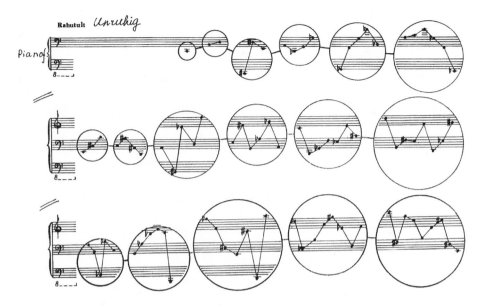

Figure 6.1. Pärt, *Diagrammid*, movement I, p. 1.

initial row, all at the original transposition level save one (R_2). The movement ends with two repeated Cs separated by four octaves, followed by the aforementioned clusters.[32] The second, even more pointillistic, movement uses the same rows, but this time states only five versions: I_0-P_0-RI_0-R_2-I_0 (fig. 6.2). In neither movement are rhythm, dynamics, or tempo (other than the *unruhig* and *ruhig* at the head of each) indicated, giving the performer great freedom in the manner of presenting the fixed pitch content.

Only in the most limited and literal of senses is this serial or twelve-tone music. This is music that exhibits "twelve-toneness" at its most basic. *Diagrammid* is a piece where aleatory and twelve-tone techniques commingle to create a parody of twelve-tone music that was heard by the Estonian listeners as being without harmony or melody. In fact, the only aspect of the piece that reached them was that it was "a musical experiment, a joke," as it and most of Pärt's 1964 works in many ways seemed to be. *Diagrammid* would later become a staple of Lyubimov in Moscow in the late 1960s and early 1970s; it is unknown what later audiences thought of the piece. (It was even recorded for Melodiya by Mart Lillye in 1971.[33]) With its mix of twelve-tone writing and aleatory

32. There are two misprints in the score, one in the second circle of the third stave on p. 1 (F should be A in the treble clef) and the other in the final circle (the F# in the highest treble clef should be a Bb). Pärt, *Diagrammid*, Op. 11.

33. Melodiya D 029569/70. See Bennett, *Melodiya: A Soviet Russian L. P. Discography*, 445. A 4 October 1969 studio recording of Lyubimov performing *Diagrammid* was recently released on CD: Lubimov, *Fractured Surfaces: Soviet Avant-Garde 1957–1970* (this recording apparently was first released in 1976 on Melodiya C10-06869/70; it does not appear in Bennett's discography).

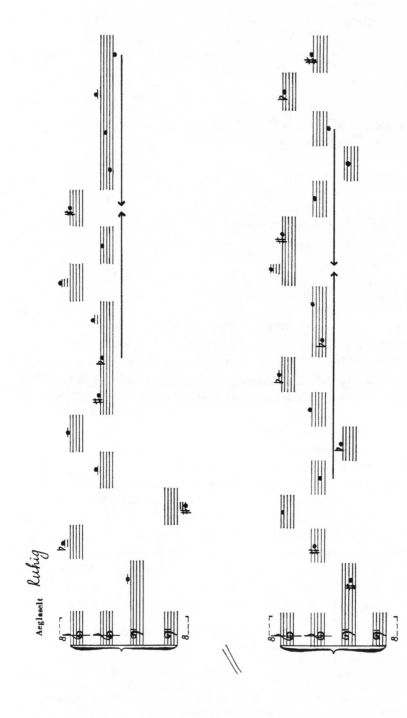

Figure 6.2. Pärt, *Diagrammid*, movement II, p. 1.

graphic notation this short piano piece served as a signal of greater shifts to come. It was in many ways a study for Pärt's next large-scale pieces, the Second Symphony and *Pro et Contra* for cello and orchestra, which began the trend of assembling mimetic collages out of competing musical styles (the collisions between *sonorika* and tonality in his *Collage on the Theme BACH* also pointed in this direction).

Pärt's Second Symphony was heard and discussed by the Estonian Union of Composers on 28 March 1967. The verdict was positive: "Among compositions with such a new musical language, Pärt's symphony is without doubt one of the brightest and most emotional."[34] The Estonians also indicated that they wanted to hear the work performed in concert. The composition made a splash with the Estonian Union, despite the fact that its second and third movements sounded more pointillistic, chiseled, and darker in tone than the First Symphony. Most significantly, the Estonian Union seemed to be further sanctioning Pärt's "new musical language" because it led to a "bright, emotional piece," the exact terms used to approve of the First Symphony. The Estonian composers were responding here to the piece's dramaturgy, as they had to that of the First Symphony and *Perpetuum Mobile*. As in those compositions, it was the emotional, signifying aspect of the Second Symphony that ultimately justified its "new musical language."[35]

Aside from the improvised percussion near the very start that in several recordings includes children's squeaky toys and whistles, the opening of the Second Symphony does not aurally grab attention in the same way that the First Symphony does. Yet from its very first pages, the score indicated a decisive shift for Pärt in the direction of aleatory devices despite his continued use of serial elements: to the opening melange of sound are added longer linear statements of first 3, then 6, then 8, then finally, at rehearsal 10, all twelve pitches of a tone row.[36] Several moments in the first two movements also include the serialization of rhythm.

The first two movements of the Second Symphony are fraternal twins; they both trace a path of mounting strain aided by a gradual accumulation of twelve-tone rows and aleatory elements. In both movements the twelve-tone rows lose their meaning in the general dramatic build-ups and the overall

34. RGALI, f. 2077, op. 1, yed. khr. 2605, l. 26 (28 March 1967).

35. See also Soomere, "Simfonizm Arvo Pyarta," 187–91.

36. The first complete twelve-tone row at r. 10 is labeled RI_0 by Hillier, because he designates the incomplete row in the clarinet at r. 4 as P_0 (see p. 53 of his monograph). There is no satisfactory solution to this labeling, as the fragmentary rows become clear only retrospectively, but for the sake of clarity I call the first three-note horn entrance in mm. 12–15 a fragmentary iteration of P_0 (the full row would be: D-Db-Eb-C-Bb-A-B-Ab-F#-F-G-E; Hillier labels this R_{10}). According to my interpretation, the second row entrance at r. 4 is R_2 (Hillier's is P_0), the third row entrance at r. 7 is RI_2 (Hillier's is I_8), and the first full row statement at r. 10 is I_{11} (Hillier's is RI_5).

cacophonous *sonorika* climaxes. Although the serialism here was obviously thought-out and creatively employed, it is buried and perhaps ultimately irrelevant to understanding the heard piece, as the reaction of the Estonian Union of Composers suggests.[37] Instead this disjuncture underscored the continuing clash between Pärt's means and ends, his craft and its reception.

The third movement follows a slightly different path, and provides the real key to an interpretation of the Second Symphony. It is driven inexorably and almost comically forward at the start by the implacable octave E♭ timpani strokes that gradually decrease by one on each entrance, from 12 strokes at the beginning of the movement to one at 1 before rehearsal 32. But rehearsal 32 is not the climax toward which the piece is headed, for the real climax occurs at rehearsal 36, where the unremitting *sonorika* of the preceding movements (and the immediately preceding section) gives way to a "familiar" melody: Chaikovsky's "Sweet Daydream" ("Sladkaya gryoza"), No. 21 from the 1878 album of children's piano pieces, Op. 39. The composition is unsettled and ultimately unsatisfying, because in its own stylistic tug of war, the B major of Chaikovsky is obviously not a stable solution. In the aftermath of all the preceding noise the final B major cadence fails to satisfy; it ultimately is only the memory of what a tonal cadence should sound like. It is not tonal but a stylization of tonality.

Hillier is right to call the Second Symphony Pärt's "most disturbing work." He also perceptively discusses its "cinematic quality": "an equivalent approach to material and structure: the cut and dissolve technique, the sense of movement and shifting perspective sometimes at the viewer's expense, the juxtaposition of contrasting, seemingly unrelated images."[38] What Hillier calls the cinematic quality is a response to what I am calling the mimetic tendency of these compositions, the "juxtaposing of contrasting images" that has precedents in traditional symphonic and socialist realistic rhetoric but is taken a step further.

Pärt's other 1966 composition, *Pro et Contra* for cello and ensemble, continued this tearing up of genres and styles and further demonstrated the struggle that Pärt was feeling with regard to his own aesthetic direction. The first of the composition's three movements opens with two gestures in opposition, the first a D major chord, the second a *sonorika* chord—aleatory blocks in the winds, brass, vibraphone and marimba, with the mallet instruments both cycling through the same twelve-tone row while the strings hold a cluster. These were the two forces newly at battle in Pärt's creative consciousness—tonality contra aleatory and serialism, tradition versus the avant-garde. Serialism and aleatory had been merged into a single style for Pärt, yet for him they would be not the

37. For a more detailed analysis of these movements, see Schmelz, "Listening, Memory, and the Thaw," 465–69.

38. Hillier, *Arvo Pärt,* 55.

Pro but the *Contra*. It is unclear how audiences responded to the work at its 1967 Tallinn premiere, but in both Tallinn and Moscow the Soviet authorities were not immediately hostile to the piece and even recommended it for performance (it, too, was recorded and released by Melodiya in 1966).[39] Greater changes lay ahead in Pärt's output.

For Pärt the turning point was his 1968 *Credo* for chorus, orchestra and piano solo. Successfully premiered by Neeme Järvi—it was reportedly encored by its first audience—its title and its text provoked a "scandal...that reached absurd proportions."[40] (Before writing *Credo*, Pärt continued his experimentation with one final work, for he had a commission to complete for a piece dedicated to, of all things, the fiftieth anniversary of the October Revolution, a commission that he fulfilled with a work titled "Op. 17" that consisted of "a five-pointed star composed of fragments of the 'International' with sonoristic episodes," and that the officials in charge of the commission called "more than dubious."[41]) *Credo* broke from all of Pärt's previous compositions, mainly because it set a very personal religious text. Pärt explains the change that occurred with this composition:

> Until '66 or '67, my chief concern was to study as much Western music as possible. I had assimilated serial and aleatory techniques and I believed that I had found a rational formula with which to compose good music; but I later realized that nothing had been changed by this approach—everything remained the same. Good music cannot be created by good intentions. The composer must listen to his inner voice; either he has it, or he hasn't. I sought a synthesis of styles, juxtaposing different elements that would yet allow each element to retain its individuality.[42]

In *Credo*, Pärt set in motion just such a "juxtaposition of different elements" in a stylistic drama more blatant than those encountered in the Second

39. Melodiya D 018049–25076; see Bennett, *Melodiya: A Soviet Russian L. P. Discography*, 444. The work was premiered in 1967 by the Estonian Radio Symphony Orchestra with Velmet as the soloist and Neeme Järvi conducting (I am indebted to David Pinkerton for providing me with this information). Nearly all of Pärt's works from the 1960s were discussed by the Estonian Union of Composers. Although no record of such a discussion exists for *Pro et Contra*, the Melodiya recording was heard on 28 December 1967 and was recommended for performance and publication by the Estonian Union, as archival copies of their monthly reports to Moscow indicate. See RGALI, f. 2077, op. 1, yed. khr. 2605, l. 75 and l. 85; and f. 2077, op. 1, yed. khr. 2951, l. 9. Rostropovich had asked Pärt to write the work, but only performed it himself in Tallinn on 16 February 1968. See Wilson, *Rostropovich*, 282–83. A later positive appraisal is in Soomere, "Simfonizm Arvo Pyarta," 191–94.

40. Hillier, *Arvo Pärt*, 58.

41. RGALI, f. 2077, op. 1, yed. khr. 2724, ll. 6–8. Hillier provides incorrect details for this composition, including the wrong date. See Hillier, *Arvo Pärt*, 118–19.

42. Polin, "Interviews with Soviet Composers," 10.

Symphony or *Pro et Contra*. Beginning with a declaration of faith—"I believe in Jesus Christ" ("Ego Credo in Jesum Christum"), an alteration of the standard liturgical Credo's espoused belief in one God—Pärt then presents an unadulterated quotation of the C Major prelude from Bach's *Well-Tempered Clavier*, transposed up an octave into a music-box register. Nothing about the work is subtle, not least its symbolism. Pärt then contrasts this opening with passages of "twelve-tonish" music and crashing Polish-school dissonances, building up to a climax from which only the Bach theme emerges at rehearsal 43, unscathed and triumphant despite fading traces of the "twelve-tonish" music. The piece ends on a radiant C major chord, slowly unfolded in the piano and strings.[43]

In *Credo* Pärt was very obviously, perhaps too obviously, laying out a sort of morality play. The religious text that he added to this ongoing musical drama was the final straw and, according to Hillier, resulted in a ban on this and his other works as well.[44] Yet *Credo* hardly represented a viable, sustainable style. It was instead a clearing of Pärt's musical slate and a statement of new allegiances. His next compositions, including the Third Symphony, would actually lay the groundwork for his new style, founded on medieval church music. This new style was not fully developed until 1976, when Pärt's initial "tintinnabuli" compositions were completed (including *Calix, Modus, Trivium, Für Alina, Kui Bach oleks mesilasi pidanud* [*Wenn Bach Bienen gezüchtet hätte*], *Pari Intervallo,* and *In Spe* [later reissued as *An den Wassern zu Babel sassen wir und weinten*, Psalm 137]—all from 1976[45]), followed by *Tabula Rasa* (1977). This final, self-consciously "blank slate" ended Pärt's long period of conversion. As we shall see later, like Karamanov's conversion, Pärt's involved a shift to a simpler musical style and a retreat into the provinces. Gubaidulina told a later interviewer: "At a certain moment Pärt felt that there was a split between his technique and the spirit of the time, and then he ceased composing music, went into the countryside and intently withdrew into himself, into his ideas, into his hearing. After some time, he composed *Tabula Rasa*, a work from which began a new period in his creative life."[46] Thus *Credo* marked the first, decisive step in Pärt's long process of musical and spiritual redefinition,

43. A good overview of this piece and the twelve-tone row that underlies it (based on the circle of fifths—C-G-D-A-E, etc.) can be found in Hillier, *Arvo Pärt*, 59–63. See also Quinn, "Out with the Old and in with the New: Arvo Pärt's *Credo*," 16–20.

44. Hillier, *Arvo Pärt*, 58. I saw no written evidence of such a ban in the communications between the Estonian Union of Composers and the central Moscow Union that are currently held at RGALI in Moscow. For a critical Soviet appraisal, see Soomere, "Simfonizm Arvo Pyarta," 194–200.

45. Hillier, *Arvo Pärt*, 98.

46. SG: 31. See also Hillier, *Arvo Pärt*, 65–66.

a process of redefinition irrevocably connected with an emerging and increasingly refined mimetic sensibility, and tied to a gradual abandonment of serial structures.

THE LIMITS OF SERIALISM II

Schnittke, 1964 and After

Schnittke, who was born in 1934 to a Jewish father and a German mother in the German-speaking settlement of Engels on the Volga river, claims to have become acquainted with serial techniques both before and during his years at the Moscow Conservatory, beginning his most serious study around 1954 and 1955. He apparently began investigating serialism while still in preparatory school ("uchilishche"), in part due to the influence of Thomas Mann's *Doktor Faustus*.[47] Schnittke remembered working with the technique while he sat on the train during his lengthy commute to and from school, and he claimed an initial reaction to serialism vastly different from that of Karetnikov, Volkonsky, or Denisov. He recalled that "at first dodecaphony seemed to me an extraordinarily easy method of composition." After "several years at the conservatory," he continued to feel the same way, "however, there I already began to understand the main thing: that the seeming ease was something you felt only when sketching (and not even always then), while the basic difficulty—composing a dynamic form—remained as problem number one."[48] Schnittke expanded on the reasons for his initial attraction to serialism, underscoring the appeal of its novelty: "It simply seemed then that everything had died, and that [serialism] was still alive; there was the sensation of a new, unexplored musical intonational world. And there was the very tempting idea, that here it is as if, so to speak, both the felt and the reasoned ideally interact."[49] Although his initial serial studies reportedly date from the early 1950s, Schnittke's first works employing the techniques only appeared after 1963, perhaps because of the difficulty of form that Schnittke perceived in the system.

Like many of the "young composers," Schnittke's attitude to serialism underwent several changes during the early stages of his compositional career. Schnittke himself later admitted to Kholopova that his works fell into three periods that he described as "black," "gray," and "white," referring respectively to those works that he did not acknowledge, those that he acknowledged with

47. Kholopova, *Kompozitor Al'fred Shnitke*, 31.
48. GNAS: 16.
49. Shnitke, Makeyeva, and Tsïpin, "Real'nost' kotoruyu zhdal vsyu zhizn'...," 18.

reluctance, and those that he thought of as his true, mature works. From what he told Kholopova, the "black" works included the First Violin Sonata (1963) as well as a series of strict serial works from the period 1963–65, including the *Music for Chamber Orchestra,* the *Music for Piano and Chamber Orchestra,* and the piano pieces *Improvisation and Fugue* and *Variations on a Chord* (only the First Violin Concerto from 1957—revised in 1962—was spared).[50] These "black" works are among the most intricate and the most abstract of the unofficial composers' serial compositions, comparable only to Denisov's.

This comparison is especially apt, for the "black" works were all written while Schnittke was still close to Denisov and still under his influence. The "black" compositions are among his earliest, least performed, and most intricately conceived compositions, compositions very much at odds with those later works for which Schnittke is best known by audiences today. Two works in particular provide a glimpse of Schnittke as strictest serialist: *Music for Chamber Orchestra* and *Music for Piano and Chamber Orchestra,* both written in 1964. By the time he completed the second of these Schnittke was already having intimations of a style based on something other than a row.

The best example of Schnittke's total serial technique is the four-movement *Music for Chamber Orchestra* written for an ensemble of thirteen performers (five strings, four winds, harpsichord, piano, and two percussionists). In this work, Schnittke applied a process of rotations by which he permuted series that dictate rhythm, pitch, and in some movements, the number of pitches in each instrument's entrance, as well as the overall form.[51] What follows will be the most complicated musical discussion in this book (second only perhaps to the examination of Volkonsky's rotations in *Laments of Shchaza*), for it marks the moment of greatest serial detail among any compositions by the unofficial composers. Yet as is the case with many serial compositions, once the basic procedure is grasped, the logic of the work's layout is actually quite elegant.

The constructive principles behind the work are most apparent in the final, culminating movement, when the entire ensemble is heard together for

50. The three periods were "Chornïy, serïy, i belïy" ("Black, Gray, and White"). See Kholopova, *Kompozitor Al'fred Shnitke,* 49. In a 1988 interview with Yuliya Makeyeva, Schnittke more or less concurred with Makeyeva's slightly different tripartite division of his output: early 1960s, 1960s to the first half of the 1970s, and everything after the mid-1970s. See Shnitke, Makeyeva, and Tsïpin, "Real'nost', kotoruyu zhdal vsyu zhizn'...," 17. Schnittke's own handwritten resume from the mid-1970s reflects this division, insofar as it eliminates all of the "black" works mentioned earlier, save the First Violin Sonata. The resume is reproduced on the back cover of BAS.

51. Savenko claims that in this work he "directly used the techniques of *Structures* by P. Boulez," basing this on Schnittke's comments to Shul'gin. The connection between the two works is only general, however, as they do not share either pitch or duration series. Nor are Schnittke's pitch and duration series connected in the same manner as Boulez's. GNAS: 38; Savenko, "Interpretatsiya idey avangarda v poslevoyennoy sovetskoy muzïke," 35; and Ligeti, "Pierre Boulez: Decision and Automatism in Structure Ia," 37–41.

the first time (each of the preceding three movements focuses on a different subset of the group: strings in I, winds in II, and keyboards and percussion in III). Like the other movements many of its series are derived from the series that initially appeared in the first movement. In the fourth movement the number of pitches in each subsection, the durations of the pitches, and the pitches themselves are all serialized. For example, all of the instruments entering in each section play the same number of notes, and this sequence of numbers is serialized according to the following series (itself derived from the duration series in the first movement, series A, by selecting every eighth pitch from that series, beginning with '1'—note that in the derived series the second thirteen in the series is replaced by the missing twelve; see ex. 6.1a):

Series B: Number of pitches in each entrance in movement IV:
1 (m. 1)–2 (1–6 after r. 2)–5 (rr. 3–4)–3 (rr. 4–5)–11 (rr. 5–6)–4 (rr. 6–7)–10 (rr. 7–8)–9 (rr. 8–9)–6 (rr. 9–10)–8 (rr. 10–11)–12 (rr. 11–12)–7 (rr. 12–13)–13 (r. 13–end)

Schnittke indicates this overall form by marking the score with bold vertical lines at the beginning of each new micro-section, that is, each new entrance. We will concentrate on the final entrance, from rehearsal 13 to the end.

Series A: Violin duration series from movement I (in sixteenth notes):

13	11	8	2	10	7	3	6	1	4	13[12]	5	9

position:

1	2	3	4	5	6	7	8	9	10	11	12	13

Series B: Number of pitches in each entrance in movement IV:

1	2	5	3	11	4	10	9	6	8	12	7	13

position in rhythmic series from I:

9	4	12	7	2	10	5	13	8	3	11	6	1

+8	+8	+8	+8	+8	+8	+8	+8	+8	+8	+8	+8

(i.e., reading every eighth number in the movement I series)

Example 6.1a. Schnittke, *Music for Chamber Orchestra*, rotations and derivation of rhythmic series.

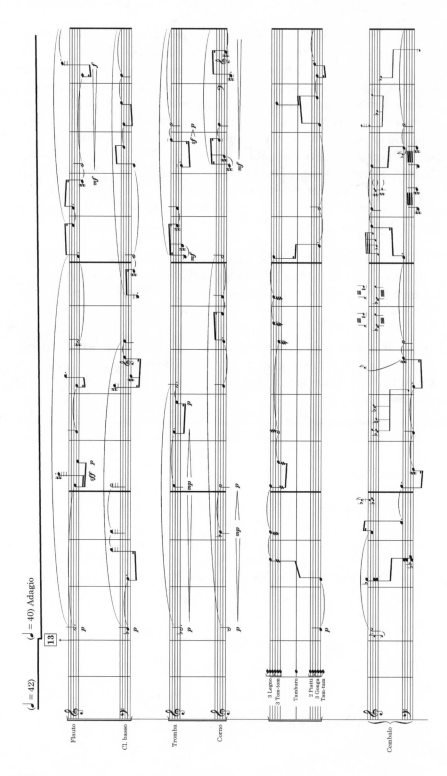

236

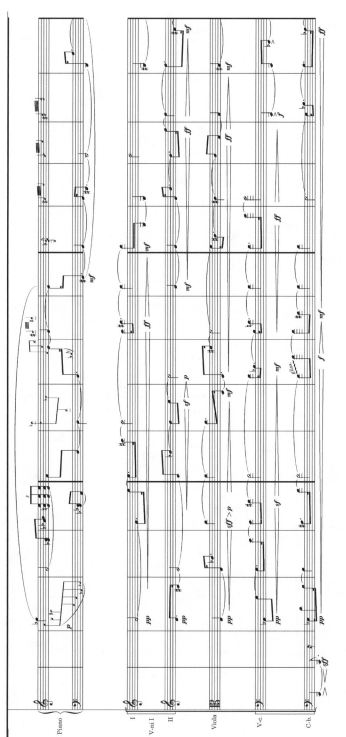

Example 6.1b. Schnitke, *Music for Chamber Orchestra*, movement IV, rehearsal 13–end.

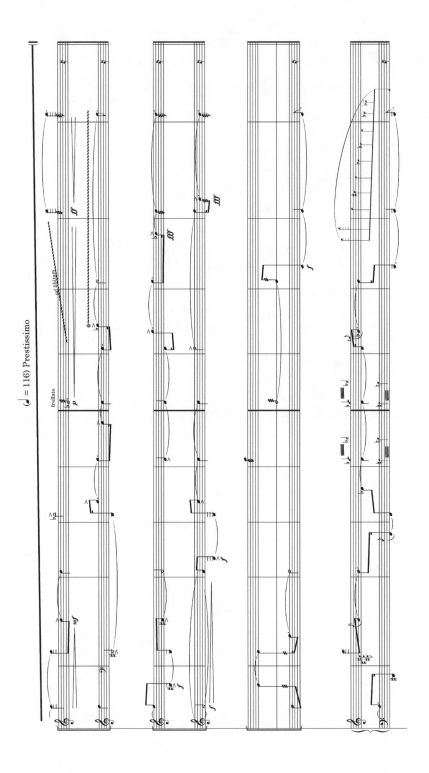

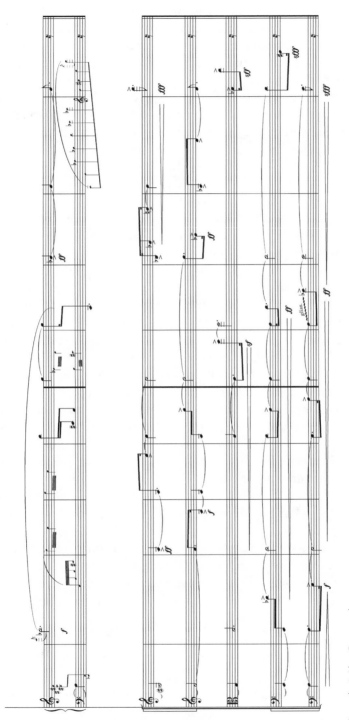

Example 6.1b. Continued

239

The pitches in the final movement are controlled by a series that is the retrograde of the series heard in movement II (itself a new series containing only twelve pitches not derived from the series in movement I). With each succeeding entrance the specified number of pitches from the series is "revealed," but with different rhythmic values and at different transposition levels (no overall pattern appears to govern the transposition levels). The complete series of thirteen pitches in movement IV is not heard (as the series determining the entrances indicates) until the final measures of the movement (the extra pitch in the series in this movement comes from a repetition of the initial pitch at the end) (ex. 6.1b):

First violin P_0[52]: F-E-C\sharp-D\sharp-G-D-G\sharp-A-C-B\flat-G\flat-B-F.
Second violin P_9; Viola P_{11}; Cello P_3; Bass P_{10}; Flute P_4; Bass Clarinet P_5;
Trumpet P_8; Horn P_6; Harpsichord P_7; Piano P_1; only P_2 is missing (presumably assigned to the unpitched percussion).

The rhythm in the fourth movement—the duration of each pitch in each entrance—is also governed by a series, seen in the first violin's last entrance as (in sixteenth notes) (Series C): 11–4–10–9–6–8–12–7–13–1–2–5–3; and in the second violin's as 3–11–4–10–9–6–8–12–7–13–1–2–5 (ex. 6.1b). As these two examples indicate, these series are the same as that governing the number of pitches in each section of the movement (series B), but rotated so that with each entrance, each instrument begins at a different position in the series (a similar type of rotation within a single series had occurred in the first movement's series for pitch and rhythm) (ex. 6.1a). Furthermore, every entrance includes a different permutation of this derived rhythmic series. For example, in the third entrance (five notes, rr. 3–4), the durations in the first violin are (again in sixteenth notes) 12–6–10–11–5 and in the second violin are 8–9–4–3–2. In other words, each selects every other position (reading backward) from the first violin's final duration series (series C) (or every eleventh position, reading forward).[53]

In the *Music for Chamber Orchestra*, Schnittke attempted to control every parameter of the music. And although the resulting composition is exhaustively detailed, his actual serial technique is not unusually complex or orthodox. He preferred creating variety through rotations of various types, rather

52. Although the slow revelation of the row in this composition makes any designation of P_0 somewhat arbitrary, the pitches from this transposition level are those first heard at the beginning of the movement in the Bass Clarinet.

53. As would be expected, these series can also be derived from the series governing the number of pitches in each section (series B), reading forward every eleven. They are, therefore, also ultimately derived from the violin duration series from movement I (series A), reading forward every tenth (or backward every three positions), and remembering to replace the second thirteen in that series with twelve.

than using the traditional row permutations (inversion, retrograde, retrograde inversion). In this way, he was indebted to both *Musica Stricta* and especially *Laments of Shchaza* (and possibly Denisov's *Music for Eleven Winds and Timpani*). Schnittke's composition was one of his most abstract, least successful pieces and has received almost no performances or commercially available recordings other than the radio recording made at a 1967 Leipzig performance.[54] "I lost interest in that composition" Schnittke bluntly stated to Shul'gin,[55] and he described the piece in 1972 to the East German musicologist Hannelore Gerlach as "serial crochet work, entirely dead music" ("eine serielle Häkelei, ganz tote Musik").[56] The work undeniably lacks all of the characteristics that would set Schnittke's mature music apart and give it his own individual stylistic stamp. From this point, Schnittke would gradually relax his serial grip, although he would not completely abandon it until well into the 1970s.

The other work that Schnittke composed in 1964, the *Music for Piano and Chamber Orchestra* is also consistently serial, but is not as overdetermined as the *Music for Chamber Orchestra*. This work does have features that predict his later style, as is particularly the case with the final (third) movement in which the prime musical interest and forward propulsion is provided by a driving ostinato in the bass and cello, akin to a walking bass line in a jazz improvisation but here based on successive statements of a twelve-tone row. Against this ostinato, the other instruments play fragments of the row. This is apparent in measures 13–17, where the cello and bass unfold RI_6, RI_0, and R_6 forms of the row, and where one pitch from each piano dyad is a row pitch (the exceptions are the first dyad in m. 14 and the second dyad in m. 17; ex. 6.2).

Schnittke also indicated his interest in the "consistency" of the second movement of this composition, in which he applied a "tree" form, in which row forms "branch" off from one another, expanding and interconnecting, "in some places thicker, in others more sparse," as Schnittke later described. A prime example is the section at the top of page 26 of the score, where P_{10} and RI_4 begin simultaneously and in turn spin out I_6, R_8, and so on (ex. 6.3).

Music for Piano and Chamber Orchestra was performed at the Warsaw Autumn Festival on 28 September 1965 by pianist Alexandra Utrecht with Witold Krzemieński conducting, and was also given in Leningrad "twice in a row" ("dva raza podryad") by the pianist Tal'roza, with Rozhdestvensky

54. GNAS: 39. The performance history of this work is unknown; it is unclear whether this recording has survived.

55. Ibid.

56. Alfred Schnittke, letter of 18 December 1972 to Hannelore Gerlach, cited in Gerlach, *Zum Musikschaffen in der Sowjetunion (1960–1975)*, 113 n. 24. See also Gerlach, *Fünfzig sowjetische Komponisten der Gegenwart*, 363.

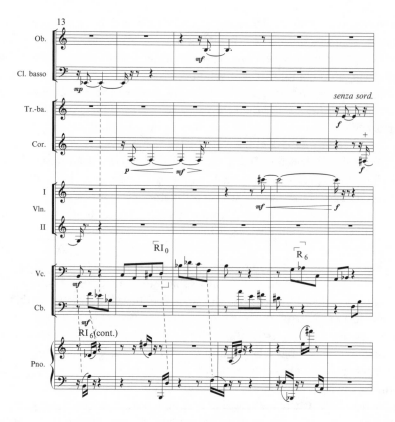

Example 6.2. Schnittke, *Music for Piano and Chamber Orchestra*, movement III, measures 13–18. Credit: Copyright © 1965 by Universal Edition A.G., Vienna/UE 14864.

conducting.[57] Schnittke said that the latter performance was "very successful" ("ochen' udachnïy"), a comment echoed by Denisov in an official discussion of the piece held on 8 December 1965: "A portion of the audience left, but those who stayed demanded an encore and called out the composer several times. It was a great success." The other responses at the discussion were more tepid. As Genrikh Litinsky (1901–85) declared, "Alfred Schnittke's path of development as a composer does not lie in this direction ['ne na etoy magistrali']."[58] Despite this negative official reception, Schnittke remembered that in performance the "piece came off dynamically and was received [by audiences] fairly

57. See Kaczynski and Zborski, *Warszawska Jesien/Warsaw Autumn*, 286–87; and GNAS: 39–40 (the quotation in the preceding paragraph is on 39).

58. GNAS: 40 ("very successful" in the preceding sentence); and Kholopova, *Kompozitor Al'fred Shnitke*, 82–83 (Denisov in the preceding sentence; Litinsky in the present).

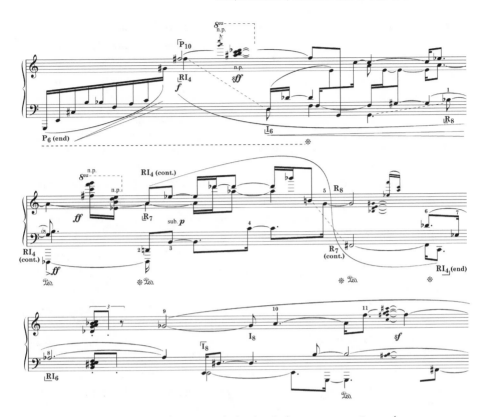

Example 6.3. Schnittke, *Music for Piano and Chamber Orchestra*, movement II, top of p. 26 of score (numbers indicate pitches belonging to R₈).
Credit: Copyright © 1965 by Universal Edition A.G., Vienna/UE 14864.

well," a sentiment echoed by Indiana University graduate students James Brody and Lawrence Oncley who found it the "most imposing work" on the program at the Symposium on Soviet Avant-Garde Music held at Indiana University in February 1967 (the program also featured Denisov's *Sun of the Incas*).[59] The relative success of Schnittke's composition is surprising, for the piece is the densest, and apart from the last movement, the most austere to issue from the unofficial composers during the 1960s. It is larger in scope than any of his previous pieces, save his conservatory cantata *Nagasaki*. Although certainly not as rigidly structured as the *Music for Chamber Orchestra*, the detail of the work is nevertheless minute; apart from parts in the third movement and other isolated sections, nearly every note can be traced back to the row. The first movement in particular achieves an unremitting sameness from its constant and exclusive iterations of the P_0 form of the row, creating a repetitiveness

59. GNAS: 39–40; and Brody and Oncley, "Current Chronicle," 91.

that no doubt would have been a challenge even to those audiences accustomed to and interested in hearing new music. Of course, its novelty and rarity more than compensated for this, as Denisov's comments attest. Schnittke later regarded this piece, like the *Music for Chamber Orchestra*, unenthusiastically: "I've grown cooler toward it because it is too dried out by dogmatic serial techniques." What did stick in his mind was the "tree" form of the second movement, which tellingly seemed to him "very promising in its particular dramatic tendencies."[60] He would use a similar approach in the third movement of his First Symphony.

Schnittke summarized his skepticism toward serialism following his work on the two orchestral compositions from 1964: "It seemed to me that there was something not quite satisfactory with those techniques: the pretensions of the people who create it reached such an extreme that you might think that it was a technique that in and of itself guaranteed quality. That is, if everything was in agreement with its rules, very exactly calculated, then the quality would be perfect, and if something did not turn out very well it meant that it was the result of an inexact calculation, but never in any way an insufficiency of the technique itself."[61] These comments ironically matched familiar official Soviet pronouncements about serialism, to the effect that it was the refuge of dilettantes and those who could not compose traditional music—composers, in other words, who retreated to serialism because it "guaranteed" success. These were the same criticisms, after all, that Denisov fought so hard to counteract in his "Dodecaphony and the Problems of Contemporary Compositional Technique," and his other theoretical writings.

Schnittke elaborated on the reasons for his rejection of serialism, focusing on his thoughts when composing the work in which he began to break away from "the technique," the *Three Poems of Marina Tsvetayeva* (1965), again emphasizing the fact that he felt "a bit uncomfortable" after composing the "two strictly calculated serial compositions." He later declared:

> It seemed to me that I was writing a sort of new, complicated form of hackwork. Of course, if you start the composition from only calculations then it is possible to substitute them for that real creative work that is connected with vagaries, with torments, with the incomprehension of how to proceed further, and with finding true solutions ["istinnïye resheniya"]. It is possible to [do] that work by dint of the computational and superficial functions of reason. That is, you may sit for ten or twelve hours a day at a desk, painstakingly adjusting the transpositions of the series, one after the other, calculating the

60. GNAS: 40.
61. Ibid.

texture, timbres and everything else and be pleased with that, supposing that this is composing music. But in my opinion that is an absolute deviation from the main responsibility that rests upon a composer and which consists in the fact that he himself must find everything he writes.[62]

Like many Soviet composers, particularly those in positions of leadership, Schnittke held true to the tenets of musical Romanticism and the stereotype of the suffering, struggling creative genius. Schnittke felt like a true composer only if he could be like Beethoven in his garret, cursing, stomping, and pulling out his hair, rather than sitting peacefully behind a desk counting tone rows. Schnittke was as skeptical as some of the others, and notably Pärt and Gubaidulina, but his rationale was a bit different. Most important, his attitude was completely at odds with that of Denisov, who was indeed content to sit and calculate his rows, finding in this solitary industry a transcendence of its own.

Schnittke continued to experiment with serial techniques in his 1965 compositions for piano, *Improvisation and Fugue* and *Variations on a Chord*, but his discontent and his search for a harder, more "real" path were to set the eclectic and unsettled tone for the rest of his compositions from 1965 until 1972. These seven years of creative soul-searching eventually led to his development of polystylism. Schnittke elaborated on what he was striving for during the period from 1965 to 1968: "At that time I attempted to find some kind of new language that would be free and independent from the stamp of traditional tonal music, but would not be so very strictly calculated like dodecaphony."[63] As a way out of his dilemma he composed his *Dialogue* for cello and seven performers (*Dialog dlya violoncheli i semi instrumentalistov*), written for piano in 1965 and orchestrated for chamber ensemble with cello soloist in 1967, an ensemble and title clearly influenced by Pärt's *Pro et Contra*, to which score Schnittke may have had access at the time.[64] Schnittke's *Dialogue* meshed aleatory devices with very loose, "twelve-tonish" elements in an attempt to inject freedom—novelty and spontaneity—into what he perceived as dogmaticism. *Dialogue* would be the first of a series of works including the Second Violin Concerto and the First String Quartet in which Schnittke explored satisfactory substitutes for "pure" serial music by using both serial and aleatory devices to construct more overtly dramatic compositions. The title of *Dialogue*, like Pärt's

62. Ibid., 40–41; see also Shnitke, Makeyeva, and Tsïpin, "Real'nost', kotoruyu zhdal vsyu zhizn'…," 17.
63. GNAS: 43.
64. Ibid. Kholopova told me that in the early 1960s all the composers knew about Pärt and had seen his scores, even if most of them remained unperformed. His name was so well known among the composers in Moscow, in fact, that Schnittke was shocked to learn that Kholopova was unfamiliar with Pärt. Kholopova, interview.

Pro et Contra, alone marked a shift in signification toward mimesis. No longer were Schnittke's pieces neutrally named "Music for" He commented in a later interview that "[*Dialogue's*] very title...was, of course, not accidental: there precisely a dialogue takes place, a musical conversation, an exchange of ideas."[65]

Schnittke's Second Violin Concerto, in which both aleatory techniques and serialism closely interact in the service of a distinct dramatic end, namely the telling of the Biblical Passion, is an ideal example of the transitional work that led to his polystylistic compositions. According to Hakobian, "the idea of 'instrumental theater' with a peculiar plot symbolizing the existence of a lonely human in the alien world," began with his *Dialogue* and the Second Violin Concerto.[66] But the general "dialogue" of the cello concerto found increased specificity in the Second Violin Concerto's narration of Christ's crucifixion and resurrection, which as Schnittke explained to Shul'gin, he followed unerringly.

Both aleatory and twelve-tone techniques are integral to this Biblical narrative, each connected with precise aspects and precise moments of the unfolding drama. The instrumentation is also crucial, as each instrumental group plays a different role: the solo violin is Christ, the strings are the twelve disciples, the solo bass is Judas (also the "anti-soloist"), and the percussion and woodwinds play together with the bass and represent a type of "destructive force against the soloist," as Schnittke put it.[67] In the explicit narrative that Schnittke maps out, serial sections containing both rhythmic and pitch series represent the twelve disciples mastering the religious "dogma" (rr. 17–19), the Last Supper (rr. 21–26), the "mourning and burial" preceding the resurrection (rr. 46–48), as well as the resurrection itself (r. 61).[68] Schnittke also uses aleatory blocks, usually to represent chaos or opposition and hostility to the soloist (i.e., Christ; as at r. 31 after the bass's [Judas's] first extended solo).

In the Second Violin Concerto individual compositional techniques had become stylized and assumed symbolic meanings for Schnittke, much as they had for Pärt. These meanings are rather obvious, if somewhat unexpected: serial music signified dogma, Christ's teachings to the twelve disciples, while aleatory techniques symbolized chaos, the opposition of the hostile secular world to the spiritual law. This stylization would become increasingly important—and not only for Schnittke. Like others of his generation such as Gubaidulina, who saw it as an already "classical" style, Schnittke also began to view

65. Shnitke, Makeyeva and Tsïpin, "Real'nost', kotoruyu zhdal vsyu zhizn' ...," 23.
66. Hakobian, *Music of the Soviet Age, 1917–1987,* 274.
67. GNAS: 47.
68. Ibid.; and Schmelz, "Listening, Memory, and the Thaw," 484–87.

serialism as a particular idiom that could be used in conjunction or opposition to others.

The violinist Mark Lubotsky, the concerto's dedicatee, remembers how he became familiar with the secret program to Schnittke's composition: "'What could it all mean?' I wondered. At first Alfred refused to comment, although he dropped a hint, relying on my acuity."[69] Initially Lubotsky guessed that the work was influenced by the "Gospel Cycle" of poems from Pasternak's *Doctor Zhivago,* but later Schnittke "gave [him] a fully concrete description of everything that takes place in the Second Violin Concerto, analyzing it literally bar by bar" (no doubt similar to the account published in Schnittke's conversations with Shul'gin).[70] It would seem, then, that at the time of its premiere Lubotsky was aware of the general subject of the concerto but not its specifics. The same was true of other members of Schnittke's circle, to whom he hinted at the work's subtext, yet did not reveal the whole story (only with the publication of his conversations with Shul'gin did the details become widely known).[71] The audience, of course, also remained unaware. Yet the positive reception of the concerto in prominent official articles is at least as telling as any audience testimony (premiered in Finland in July 1966, it was first performed in Leningrad on 20 February 1968, but was not heard in Moscow until 1973).[72] And as Valentina Kholopova notes, the Second Violin Concerto did become a staple of Soviet music and pedagogy.[73] It was discussed in a number of theoretical and musicological works, of which Tarakanov's article "New Life for an Old Form" from the June 1968 *Sovetskaya muzïka* was but the first.[74]

This article, which also examined Pärt's First ("Polyphonic") Symphony and Tishchenko's Third Symphony, was significant for its open discussion of serial methods, including such intricacies as combinatoriality. Tarakanov ably conveyed the drama inherent in Schnittke's concerto, even though he was mainly concerned with discussing the form. He recognized that there were two subgroups among the orchestral instruments, the "supporters" ("storonniki") of the violin and its "opponents" ("protivniki"), among which the bass, the

69. Lubotsky, "Schnittke as Remembered by Mark Lubotsky (1998)," 251.

70. Ibid. Lubotsky also noted that in an early stage of planning for the concerto, Schnittke considered the idea of including a choir.

71. Kholopova, *Kompozitor Al'fred Shnitke,* 86. In his memoirs, Kremer writes as if by the early 1970s he was aware of at least the work's general connection to the Passion. See Kremer, *Zwischen Welten,* 227.

72. The Finnish premiere was by the orchestra of Radio Helsinki, conducted by Friedrich Cerha (an Austrian composer and conductor most famous for completing the orchestration in the third act of Berg's *Lulu*), and with Lubotsky performing the violin part. Lubotsky also was soloist in the Leningrad premiere; Rozhdestvensky conducted. (From Schnittke's personal file at the Moscow Union of Composers.) The 1973 Moscow premiere was conducted by Yuriy Nikolayevsky.

73. Kholopova and Chigaryova, *Al'fred Shnitke,* 47.

74. Tarakanov, "Novaya zhizn' staroy formï," 60.

"antisoloist" ("antisoloist") played a uniquely "evil" part. Tarakanov was also aware of the role that aleatory devices played in the composition, namely, their use as a "specific dramatic device" in the ongoing conflict. The most important aspect of the article for the present argument was Tarakanov's discussion of the concerto's form, for in its single movement he recognized aspects of "traditional sonata allegro, since it is not difficult to discern exposition material, its development, recapitulatory repeat and, finally, its culmination—coda." This structure is overlaid by the dramatic elements in the piece: "The opposition of the two spheres of imagery... underlined by the 'personifications' of the timbral groups."[75] The traditional elements of sonata form are amplified by the dramatic and mimetic qualities of the concerto genre, further emphasized in Schnittke's case by several additional instrumental "characters" illustrated by contrasting serialism with aleatory devices (Bobrovsky described just such an "ordered" combination of "types of expressiveness" in his definitions of dramaturgy cited earlier.)

The clarity of this form and its dramatic nature were evident to a critic familiar with the score, even when the specifics of the religious drama to which it actually referred were hidden. The form would no doubt have been less obvious to audiences, although the "personification" of the soloist and the bass would surely have registered. As spun by Tarakanov, a sympathetic reviewer versed in the buzzwords of contemporary socialist realist music criticism, the "traditional" elements of the Second Concerto allowed it to be discussed in *Sovetskaya muzïka* as a successful work by a composer who "relies on the last word in musical techniques, [yet still must] decide many classical artistic problems."[76] Although the Second Concerto was a difficult, at times disjointed piece, its successful mimetic dramaturgy demonstrated that, ironically enough, Schnittke was moving closer to Soviet stylistic expectations (despite the covert program), even as he was wrestling with his own stylistic development.

Most of Schnittke's subsequent pieces from the 1970s and after had a larger dramatic narrative behind them, even if they were not tied as directly to a specific story as the Second Violin Concerto had been. It was no accident that Schnittke's first "dramatic" works were concertos (and that many of his most successful later compositions were concertos as well). The drama implicit in the concerto form attracted Schnittke, and this new-found sense of drama extended from his concertos to other orchestral and chamber works as well.[77]

75. All of the quotations in this paragraph are from ibid., 61

76. Ibid., 62.

77. Shnitke, Makeyeva, and Tsïpin, "Real'nost', kotoruyu zhdal vsyu zhizn'...," 23. Berger contends that "mimetic music is the music of the performer," but does not specifically mention the concerto. Berger, *A Theory of Art*, 132–33.

The First String Quartet that followed the Second Concerto expressed a more general plot. Schnittke described "mounting destruction" as the "idea" of the First Quartet, illustrated musically by the gradual dissolution and ultimate abandonment of the work's opening serial structure.[78] (Despite lacking the aleatory devices of Schnittke's preceding compositions, the quartet does contain a somewhat freer—meter-less, yet still measured and fully notated—section at the beginning of its third part, "Cadenza," specifically rr. 36–50.) Rostislav Dubinsky, the leader of the Borodin Quartet, although unreliable in his account of the piece's genesis and his own role in its composition and first performances,[79] offers a compelling interpretation of the work: "The climax of the quartet, called 'Disintegration,' was a complete contrast. After the scrupulous exactness and organization of all the music, everything suddenly fell apart. The analogy with Soviet society clearly suggested itself. The whole composition ended with a return to the initial series of twelve tones, like the results of the search" (the published score does not contain the word "disintegration").[80] It is unlikely that Soviet audiences gave the First Quartet such an oppositional interpretation, but an official review from 1972 by Sergey Razoryonov described its thematic processes as "including contrasts that allow us to speak of dramaturgy on a large scale. And therefore the complicated constructive thinking of the author of the composition is not coldly abstract; that impassioned, convinced narrative in its own way reflected the contradictions and conflicting situations of contemporary reality."[81] Although the vocabulary here is typical of many official reviews from the period (and different from Dubinsky's specific reading), the author does acknowledge an "impassioned narrative" behind the quartet, founded, as he noted earlier, "on the effect of an uninterrupted development, the expression of dynamic growth."[82] Owing to Schnittke's own penchant for very specific narratives in at least one of his preceding compositions, it is not impossible that he had in mind a scenario similar to the one suggested by Dubinsky (and hinted at by the reviewer's "conflicting situations of contemporary reality"). Audiences had plenty of opportunities to hear and interpret this composition themselves, thanks to the Borodin Quartet. In their hands, Schnittke achieved his widest audience yet. But it was not only their political clout that enabled them to perform this composition. Schnittke's turn in the quartet from "cold abstraction" to a mimetic narrative made it more palatable for Soviet critics, as well.

78. GNAS: 48.

79. For a more detailed account of this see Schmelz, "Listening, Memory, and the Thaw," 391–96.

80. Dubinsky, *Stormy Applause: Making Music in a Worker's State*, 222; and Shnitke, *Streichquartett*.

81. Razoryonov, "Ob odnom muzïkal'nom vechere," 34.

82. Ibid., 32.

Schnittke did not immediately abandon serialism as a tool for assembling detailed narratives, for his most thoroughgoing use of serial techniques after *Music for Piano and Chamber Orchestra,* namely *Pianissimo* (1968), tells a very specific story. In this work serialism came to represent something more negative than it had in the Second Violin Concerto. Here, Schnittke engaged in rhythmic and pitch serialization in an exercise analogous to Pärt's *Perpetuum Mobile,* although the result came out sounding more like Ligeti's *Atmosphères,* despite Schnittke's professed unfamiliarity with Ligeti's score at the time.[83] In *Pianissimo,* he used three series, one each for rhythm and pitch, and one for the overall length of each individual instrument's row statements (the rhythmic series is applied in proportion to this overarching series).[84] As in the Pärt piece, the basic idea is quickly audible: a very gradual crescendo to a fortissimo climax followed by a short diminuendo. Also like *Perpetuum Mobile,* the serial techniques in *Pianissimo* are secondary to the overall shape of the work, although they are not indispensable, instead playing a key role in the narrative it describes. As Schnittke unexpectedly told Shul'gin, the work was inspired by Kafka's chilling short story "In the Penal Colony."[85] Schnittke explained to Shul'gin that he did not directly follow the story when composing the work, but he did identify the serial framework here as the inscription chiseled in the body of the criminal in Kafka's story, the law that he had violated. The serial process of the piece, then, is the movement of the needles across the body of the condemned, while the slowly increasing volume and the high, "celestial" timbres reveal the gradually dawning enlightenment on his face. This grim subtext is hardly apparent to a casual listener, and yet it speaks volumes about Schnittke's compositional attitude at the time. It suggests how trapped he felt by the unfolding processes of "dogmatic" serialism, even as he sought new motivations for employing it.[86]

In 1968 Schnittke took a different tack with his Second Violin Sonata, as he made a shift that tried to embrace everything. Before the Second Sonata, however, Schnittke composed an important transitional piece, the short *Serenade for Five Musicians* (*Serenada dlya pyati muzïkantov*), a bridge between aleatory

83. See GNAS: 26 (and chapter 2). Schnittke also observed that his techniques in *Pianissimo* were based on Boulez's *Structures*. See ibid., 54.

84. For an explanation of the derivation and operation of these rows, see Kholopova and Chigaryova, *Al'fred Shnitke,* 317–19.

85. GNAS: 53.

86. Ibid. It seems unlikely that Schnittke was unaware of the connections between Kafka's penal colony and the Soviet Gulag, especially in light of the prominent arrests and trials of dissident writers and activists—e.g., Brodsky, Sinyavsky, and Daniel'—during the latter half of the 1960s. Taruskin has suggested an oppositional stance to the very title of Schnittke's composition, because "Soviet composers were expected to make affirmative public statements, fortissimo." Taruskin, *Oxford History of Western Music,* V:467.

and polystylism that still contained serial moments.[87] In many ways it is a fitting parallel to Pärt's 1964 *Diagrammid*, although the tension between aleatory and serialism in Schnittke's work is arguably more strained. In the first movement of the *Serenade*, the tubular bells periodically interrupt the cacophony of the other instruments and play an unfolding twelve-tone series; the magic moment, of course, is when twelve is reached and the movement can safely end (a reverse of the timpani strokes in the third movement of Pärt's Second Symphony) (ex. 6.4). The row still provided a necessary crutch for Schnittke, as it helped to structure, or, *pace* Boulez, "fix" his freedom. Or as he later told Shul'gin in reference to his First Symphony, "if when composing there are no restrictions, then you need any kind, even the most absurd."[88]

At the same time, the work was intended by Schnittke to be "dancelike" and "entertaining" and was described as having "no pretensions towards being anything serious."[89] This was surely an understatement, for the *Serenade* was a serious attempt at confronting the conflicts Schnittke was then feeling between high and low art, between structured and unstructured music, and between abstraction and mimesis. It was also one of the first pieces he wrote that drew specifically on his experience with film music, as it included excerpts from his film scores alongside material from Chaikovsky's First Piano Concerto and Violin Concerto (among other works) in its collage of styles and quotations.[90] Berman, the pianist at the premiere, noted that the "idea was these things are appearing for a very short time and appear simultaneously, so the audience doesn't really have time to figure out what they hear, just something definitely, painfully familiar." He added that the audience would not have recognized the quotations from Schnittke's film music, and "we would not have recognized, of course, had we not been told. It was more of a private joke for himself."[91]

Schnittke himself acknowledged the disparity between sound and structure in the *Serenade*: "[It] was easy to listen to. There was practically no singling

87. The *Serenade* was written at the clarinetist Lev Mikhailov's behest (and prominently features his instrument) and was dedicated to Mikhailov's ensemble: the violinist Alexander Mel'nikov, the bassist Rustem Gabdullin (bassist of the Moscow Chamber Orchestra), the pianist Berman, and the percussionist Pekarsky (who also served as the "stage director" of the piece). (Pekarsky noted that Shul'gin had neglected to mention his name as a performer of the piece in his book on Schnittke [Pekarskiy, interview; see GNAS: 49 for the comment about the percussionist's role].) These instrumentalists premiered the work at a festival of contemporary music in Vilnius and Kaunas, Lithuania. According to Pekarsky they also played it at various closed venues throughout Moscow like the Kurchatov Institute or the Central House of Workers on Pushechnaya Street, because "you couldn't play it in open concerts" (Pekarsky, interview). Berman did not remember exactly where it had been performed, but thought they had played it in the Small Hall of the Moscow Conservatory (Berman, interview, 23 March 2001).

88. GNAS: 66.

89. Ibid., 49.

90. Ibid., 49–50.

91. Berman, interview, 23 March 2001.

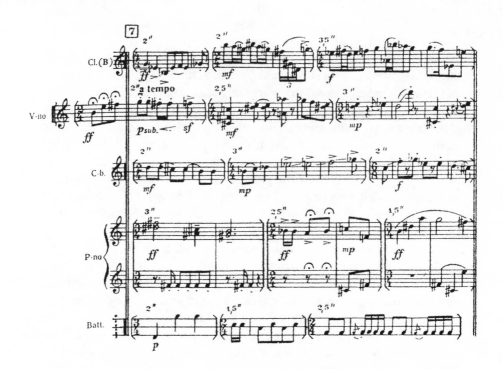

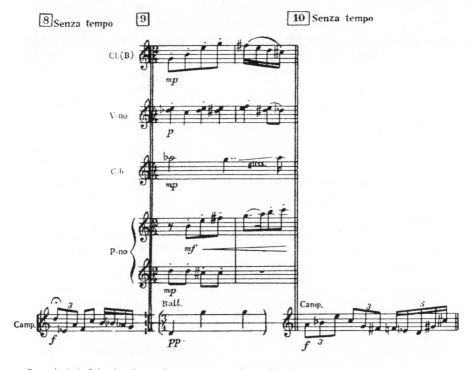

Example 6.4. Schnittke, *Serenade*, movement 1, rehearsal 7–10.

out of any melodies by ear—what is heard is only a melodic 'kasha' of some sort of excerpts of generally banal content. That image of banality is also the first impression that arises and that was thought of before composing the *Serenade*."[92] The "kasha" of melodies was what Berman and the other performers had found so novel about the *Serenade*. They were no doubt unconcerned with the composition's structural details. The contradiction between serial structures—no matter how contrived—and chaotic, "banal" musical surfaces that we have already identified in the *Serenade*'s first movement is one of the central attributes of Schnittke's works from the late 1960s and early 1970s, up to and including the First Symphony. As Schnittke expanded his stylistic vocabulary and wrote more accessible, mimetic music, he felt all the more strongly a need to provide a rigorous rationalization of his structures. The more mimetic the content became, the more determined the form needed to remain. This variance was more palpable in some works than others. His Violin Sonata No. 2 (*Quasi Una Sonata*), his most important piece from the late 1960s, confronted head-on the stylistic impasse in which Schnittke found himself.

In his own descriptions of the Second Violin Sonata, Schnittke discussed the destruction he was sensing in the world around him at the time. He viewed the present as a time of musical disorganization, an "opposite point" to the period of "increasing organization" in which Beethoven lived when sonata form was "just beginning to crystallize." Schnittke saw his contemporary moment as one in "which destructiveness has reached the limit where forms may be realized only approximately (I have in mind their classical examples), when the very idea of form stands under suspicion as a kind of dishonest convention, when a composition may be alive only in the condition that its form be doubtful, when there is some kind of risk in the form of a piece—if there is no risk then the piece is not alive." This pervasive suspicion explains Schnittke's attitude to sonata form in the piece—"when it requires a discovery every second along with an improvised formulation of the new." It also explains the name *Quasi Una Sonata*, for as Schnittke stated, "here everything...is relative—there is almost no material."[93]

This conditionality and risk had already been reflected in Schnittke's earlier compositions, like the First String Quartet, with its underlying "idea of mounting destructiveness."[94] The *Quasi Una Sonata*, however, addressed this idea more directly, as the title alone already indicated. A contingent work, a work of frustration akin to those that Pärt wrote in 1964, the sonata actively searches, pushes at the limits, and is full of risk and doubt. In this it reflected not only the musical situation but also the upheavals and mounting repressions of

92. GNAS: 50.
93. All of the quotations in this paragraph are from ibid., 50–51.
94. Ibid., 48.

contemporary Soviet society and politics. At times it is violent, yet there is something ultimately ineffectual about this not-quite-sonata, where the searching and the risk is overwhelmed by profound misgiving. Unlike Pärt's *Credo* nothing is actually resolved (even if only temporarily) by this composition.

As Schnittke told Shul'gin, the work is loosely modeled on sonata form, although it also resembles a deformed—and condensed—three movement sonata (Allegro—Andante—Allegro).[95] Schnittke cryptically described its beginning in terms of sonata form, but a sonata form whose first subject lacks any "themes not only in the traditional sense, but also serial, in that there is no series, but there is a certain image, some kind of goings-on, the stage is set for a first subject—something seemingly active, but only that."[96] The sonata continues with an extended slow middle section and a long allegro conclusion that includes at first a rapid fire theme and later a fuguelike section on the theme B-A-C-H (B♭-A-C-B♮). Its main aural impression is that of a series of loosely connected episodes and gestures: the hammering piano chords— minor, diminished-seventh, or simply clusters—and the furious, yet somehow empty because directionless, virtuosic violin passages. As Pärt had done in his Second Symphony, *Pro et Contra*, and *Credo*, here Schnittke widened the drama of the two avant-garde styles—serialism and aleatory—to include a third "contestant"—tonality.

The most notable moments come in the final allegro sections when the B-A-C-H motive rises to prominence and is intercut with quotations (both real and fabricated) from a variety of composers that Schnittke later identified: Schumann, Liszt/Franck ("not Liszt, not Franck, but only imitations of them"), Beethoven (the Finale of the Third Symphony and theme of the Op. 35 piano variations, originally used in his ballet *The Creatures of Prometheus*), sections of quasi-folk melodies, and Brahms (including his musical signature B♭, A, B♮, E♭—B-r-A-m-H-Es [or S]).[97] These quotations introduce the motoric finale and the repeated hammered G-minor chords in the piano. The rhetoric of this ending is so overstated as to border on the absurd, like the comic sketch about the pianist who is unable to conclude his piece, stuck instead in a seemingly endless series of stereotypical cadential patterns. The only distinct message is embodied not so much in the form as in the B-A-C-H motive and the G-minor chords.

Although both Pärt and Schnittke turned to Bach in their 1968 compositions, they used him in very different ways. In Schnittke's Sonata, the B-A-C-H motive slowly overwhelms the texture; it does not seem to represent the clear salvation that the *Well-Tempered Clavier* did for Pärt in his *Credo*. For Pärt,

95. An outline of the composition's form appears in Kholopova and Chigaryova, *Al'fred Shnitke*, 317.
96. GNAS: 51.
97. Ibid., 51–52.

Bach was a musical savior on par with the religious savior, Christ, elevated in *Credo*'s first choral declamation. The *Quasi Una Sonata* gives the sense that for Schnittke, by contrast, Bach was a default. Nothing else worked: neither serial techniques, nor atonality, nor graphic notation. Bach was merely the nearest and most solid flotsam one could grasp on to.

At the time of its composition, Schnittke had not yet formally described the idea of polystylism that he presented in his paper "Polystylistic Tendencies in Modern Music" at the Seventh International Music Congress held in Moscow by UNESCO's International Music Council on 8 October 1971.[98] In the *Quasi Una Sonata* Schnittke was cast adrift in a violent storm of loose ideas, ideas that must have taken on a mimetic cast for audiences. The striking juxtapositions, two instrumental actors, the aleatory sections and recurring motives—including the G minor at the start and the B-A-C-H motive—are inherently dramatic, but with a meaning more difficult to discern than in his mid-decade works (on any level).

On a fundamental creative level, the sonata was rooted in drama. The *Quasi Una Sonata,* and especially its B-A-C-H motive, were drawn from Schnittke's score to the cartoon *Glass Harmonica* (*Steklyannaya garmonika*). When he was writing the sonata, however, Schnittke was thinking in terms of the theater, introducing pauses throughout the sonata based on a version of *Macbeth* he knew of (but never saw) at Moscow's Mikhoels Theater in which "during the increase of the general tension to an unbearable condition everything suddenly froze, completely stationary, after which it again collapsed and then went further."[99] More than an essay on the destruction of sonata form, the *Quasi Una Sonata* became an essay on the fundamental destruction and impossibility of musical communication. No longer was a dialogue possible. The sonata is more theatrical than any of Schnittke's other pieces from the 1960s, and its theatricality is a musical equivalent of the theater of the absurd. As we shall see, the cartoon that it borrowed from conveyed a different message, more along the lines of Pärt's *Credo*, preaching the saving grace of Bach against the corrupt chaos of aleatory, *sonorika*, and serialism.

The Second Violin Sonata was premiered in Kazan in the Tatar Autonomous Soviet Socialist Republic on 24 February 1969 with Mark Lubotsky on violin and Lyubov Yedlina on piano (the program also included violin sonatas by Mozart and Debussy).[100] Later it was performed by other leading Soviet violinists, including Kremer and Kagan, both of whom were to play it

98. A short summary of this paper first appeared in Shneyerson, ed., *Muzïkal'nïye kul'turï narodov: Traditsii i sovremennost'*, 289–91. The original text appeared as Shnitke, "Polistilisticheskiye tendentsii v sovremennoy muzïke" (see this entry in the bibliography for its full publication history).

99. GNAS: 52.

100. Ibid.; and Tarakanov, "Tri stilya ispolneniya," 81–84.

in the Large Hall of the Moscow Conservatory. The reaction of the listeners at such concerts is unknown, but the *Quasi Una Sonata* was surprisingly well received by the official press, among them Marina Nestyeva: "The Second Violin Sonata by A. Schnittke is in our opinion a significant step on the evolutionary path of the artistic consciousness of the composer. In that sense the work continues the line already noticeable in works like his Second Violin Concerto."[101] Other critics remarked on the "new qualities of the personality of the composer" that the work "revealed," and commented on the "turning point" that the Second Violin Concerto and the Second Violin Sonata marked in Schnittke's development away from the works of the middle 1960s in which he "even lost for a time ... the lapidary and emotional brightness of his early work."[102]

Responding favorably to the more accessible dramaturgy of both the Second Violin Concerto and the Second Violin Sonata, little did these critics realize that the first was about Christ and the second about noncommunication and complete collapse. And it was the dramaturgy to which they reacted, even in the rather challenging Second Sonata, noting that "in the juxtaposition of basic elements one feels visually the dramaturgical idea of shock and torpor." The same critic who wrote this, the composer Yuriy Butsko (b. 1938), also acknowledged the "amazing almost theatrical visibility of the behavior of the two instrument-actors."[103] Butsko even heard the two instruments as "literally two sportsmen staking out a field of battle" and spoke of the various sections of the sonata form that he heard in the movement as various parts of the ongoing match—to him the section before the ending fugue was the "final round" ("posledniy raund").[104] He also resorted to the language of film to analyze the piece, speaking of its "various visual lines"—or points of view ("razniye zritel'niye ryadi").[105] Butsko's closing lines are indicative of the enthusiastic reception that greeted Schnittke's new path, noting that B-A-C-H is the victor of the composition, the "third, invisibly following the battle" between the two instrumentalists. He then closed: "The return of A. Schnittke to authentic dramaturgy—even of an old cathartic type—may only be welcomed. It allows us to expect from the composer still more vivid compositions, in particular for

101. Nest'yeva, "Pis'mo iz redaktsii," 17. See also Tarakanov, "Tri stilya ispolneniya," 83–84.

102. Butsko and Litinskiy, "Vstrechi s kamernoy muzïkoy," 10.

103. Ibid., 10–11. Kholopova also comments on the sonata's "almost instrumental theater." Kholopova and Chigaryova, *Al'fred Shnitke,* 59. Dmitriy Smirnov, responding to this passage in Kholopova and Chigaryova, insists that "the 'program' of this music is purely musical." Smirnov, "Marginalia quasi una Fantasia," 4.

104. Butsko and Litinskiy, "Vstrechi s kamernoy muzïkoy," 10–11. Kholopova also notes that the "final phrase of the violin is a special type of 'Acoustic Dialogue.'" Kholopova and Chigaryova, *Al'fred Shnitke,* 59 n. 10 (Schnittke's own discussion of the ending is also quoted here).

105. Butsko and Litinskiy, "Vstrechi s kamernoy muzïkoy," 11.

orchestra."[106] Butsko wrote as if he was aware of Schnittke's impending First Symphony, but little could he have expected the profound stylistic turn that composition would betoken.

For Soviet critics, the Second Violin Concerto and the even more extreme Second Violin Sonata marked a return in Schnittke's compositions to a dramaturgical model that they could easily adapt to their own criteria and critical language. Yet while the Second Violin Concerto saw a rapprochement between Schnittke's language and critics' expectations (ignoring for a moment the hidden, implicitly anti-Soviet plot of that piece), the Second Violin Sonata showed Schnittke pushing away from that dramaturgy toward something different, while still composing a piece that could be read in the traditional Soviet manner. The First Symphony would push the boundaries of this dramaturgic model still further, to the bursting point.

Savenko proposes a compelling reading of the shift in Schnittke's style marked by the Second Violin Sonata. She sees this shift as a movement from a "closed, monologic, unfolding" to a "dialogic outburst," a "collision of worlds."[107] The move from monologic to dialogic, from the monologue of the Second Violin Concerto and the First String Quartet to the dialogue of the Second Violin Sonata, is one of not only style but also attitude (prefigured, appropriately, by Schnittke's earlier *Dialogue*). Savenko's terminology pointedly echoes Bakhtin's categories for Dostoevsky's fiction, and to pursue the admittedly loose parallels one step further, Schnittke's dialogic style had yet to incorporate a "polyphony" of voices. But his decisive change to a dialogic style eventually allowed Schnittke to write the First Symphony, the Anti-Symphony that encompassed every voice imaginable.

META-MUSIC: VALENTIN SILVESTROV

Like many of the composers in Kiev inspired by the Polish avant-garde (including Hrabovsky), by the mid-1960s Silvestrov had also begun moving toward a more mimetic style predicated on extensive use of aleatory devices together with serial and tonal elements.[108] One of the first works in which an opposition between serialism and aleatory techniques appears was his intended conservatory graduation piece, his Symphony No. 1 (1963). In Silvestrov's account, this symphony was based on a "dialogue of various sound systems," and specifically "three systems: atonality, dodecaphony, and polytonality, which determine the structure of the corresponding three movements: Sonata, Concerto, and

106. Ibid.

107. Savenko, "Portret khudozhnika v zrelosti," 37.

108. For an examination of representative works by Hrabovsky, see Schmelz, "Listening, Memory, and the Thaw," 435–38.

Fugue." Silvestrov attempted to give lie to official Soviet declarations about dodecaphony's suitability only for depicting "evil images" by making the central movement a "melodious, tender pastoral," while the "most dissonant movement was the polytonal fugue." The official conservatory examination committee naturally refused to accept the work, and Silvestrov was forced to compose a substitute, his *Classical Overture* (*Klassicheskaya uvertyura*) (1964).[109]

Silvestrov continued the "dialogue" begun in the First Symphony in his *Misteriya* for Flute and Percussion (1964), in which clear twelve-tone statements in the flute (supported by the percussion) eventually dissolve into entirely graphic, aleatory notation. Serialism of any sort is absent from both his Symphony No. 2 (1965), as well as his graphic score *Projections* for Harpsichord, Vibraphone, and Chimes (1965). Both are entirely aleatory, and both far surpass Pärt's *Diagrammid* in the range of their notation: squiggles, squares, dotted lines, blobs, and points (ex. 6.5). These graphic, aleatory elements persisted in Silvestrov's works even though he also occasionally composed exclusively "twelve-tonish" pieces like his *Elegy* (*Elegiya*) for piano from 1967, which received numerous performances in the Soviet Union during the late 1960s and early 1970s thanks to the efforts of its dedicatee, Lyubimov.[110]

More frequently Silvestrov pursued a dramatic combination of quasi-serial or serial elements and aleatory devices, or as he interpreted them " 'cultural' (precisely notated) and 'mysterious' (improvisational) structures."[111] (He called his works from the 1960s "spontaneous outpourings akin to medieval mysteries."[112]) These oppositions appear in his Symphony No. 3, "Eschatophoniya" ("Eskhatofoniya") from 1966, which, like *Misteriya,* juxtaposed serial and aleatory elements, including a wide array of wavy and dotted lines, and other approximations of melodies similar to that seen in *Misteriya,* Symphony No. 2, and *Projections.*[113] Silvestrov's *Monodia* for piano and symphony orchestra

109. All of the information in this paragraph about the First Symphony is taken from Frumkis, "K istorii odnoy (ne)lyubvi," 87. Silvestrov revised the work in 1974. Nest'yeva, "Tvorchestvo Valentina Sil'vestrova," 120.

110. I am indebted to Aleksey Lyubimov for providing me with his copy of Silvestrov's score for *Elegiya.* In his performance notebook Lyubimov noted all of his performances of *Elegiya,* including the Warsaw, Poland premiere on 28 September 1968 and the Moscow premiere at the Gnesin Institute on 10 October 1968 (on a program with Schoenberg's Op. 19, Hodzyats'ky's *Ruptures of Flatness,* and Volkonsky's *Musica Stricta*).

111. Baley, "Sil'vestrov, Valentyn Vasil'yovych"; and Savenko, "Rukotvornïy kosmos Valentina Sil'vestrova," 74.

112. Frumkis, "Life-Music—The Postludes of Valentin Silvestrov," 5. This, like most of the statements by Silvestrov in Frumkis's notes, is taken from Sil'vestrov and Frumkis, "Sokhranyat' dostoinstvo...," 13.

113. *Eschatophoniya* won the Koussevitsky Prize in 1967 and was performed on 6 September 1968 in Darmstadt with Bruno Maderna conducting. Virko Baley, "The Kiev Avant-Garde," 11. Silvestrov told me the work was premiered in Italy, likely a memory slip. It was also reportedly performed in the United States, although again Silvestrov did not remember where it had been performed, and I have been unable to confirm any U.S. performances. Sil'vestrov, interview.

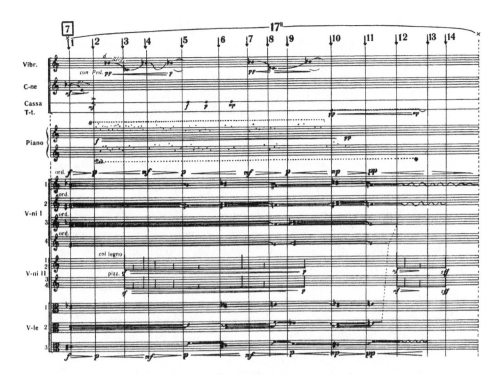

Example 6.5. Silvestrov, Symphony No. 2, rehearsal 7 (p. 10).

from 1965; *Hymn* for five instrumental ensembles from 1967; *Poem* from 1968; *Drama* for violin, cello, and piano from 1970–71; and *Meditation* for cello and chamber ensemble from 1972, built on this dramatic tendency. He later called these works from the late 1960s and early 1970s his "exit from the avant-garde ghetto."[114] (The *Hymn* for five instrumental groups was first performed in Rotterdam on 15 September 1970, while *Drama* received important performances by Lyubimov and Grindenko in Moscow.[115])

Both *Drama* and *Meditation* include matches to theatrical effect. In *Meditation*, at rehearsal 14 the flute player is instructed to turn off the lights to the concert hall, and in the succeeding section (until r. 15, when the lights are turned on again), selected players are to periodically "strike a match and blow it out immediately."[116] Schwarz quoted Seppo Heikinheimo, an Estonian eyewitness to a performance of *Drama* at the November 1978 Tallinn Festival of Early and Contemporary Music: "Violent outbursts…are followed by a simple

114. Frumkis, "K istorii odnoy (ne)lyubvi," 87.
115. Baley, "The Kiev Avant-Garde," 12; Grindenko, interview.
116. Sil'vestrov, *Meditation for Violoncello and Chamber Orchestra,* 87–96.

stroke.... When the pianist has finished playing furioso on the keys and has wedged the loud pedal down with his hands and feet, the violinist strikes a match and then immediately blows it out."[117] *Drama's* suggestive title became a not-so-subtle theatricality in performance. In Silvestrov's *Meditation* and *Drama,* the nascent mimetic sensibility in the music of many of the unofficial composers spilled over into drama actually enacted on the stage.

Like Pärt's *Credo* and Schnittke's *Quasi Una Sonata,* Silvestrov's compositions from this time, but mainly *Drama,* marked, in his words, his personal "transition" or "shift" ("perekhod"). *Drama* was the first work he wrote after ceasing composition for a year (1969) because of a creative "crisis" during which he "felt... a need for silence."[118] Amidst its mixture of aleatory gestures and twelve-tonish sections, *Drama* includes generally step-wise diatonic melodies at points in all three movements, and concludes with a haunting section of these melodic fragments that are trilled and echoed across the trio, as each player slowly rises and leaves the stage. It finishes, however, with noise: the tinkling of a glass vibrating atop the strings of the piano, kept in motion by the violinist, who from the wings of the now-emptied stage tugs a previously affixed string.[119] *Meditation's* resolution was more conventional: the harpsichord's concluding G-major triad provided a more definite—although not entirely convincing—end to the stylistic crisis. Silvestrov aimed for something more profoundly conclusive, or rather inclusive in this work. He said, "Not only the conflict [between various styles] is important for me, but also the identity [i.e., the oneness] of all the systems and styles appearing in a composition." This is why he described the work as "meditation—leading to identity ['privedeniye k tozhdestvu']."[120]

In the mid-1970s, much as George Rochberg had done with his String Quartet No. 3 (1972), Silvestrov began writing entire pieces that consciously imitated or revived earlier styles, chiefly those of nineteenth-century Romanticism: Schubert in his 1974 String Quartet No. 1, and Romantic pianism in general in his 1977 *Kitsch Music* for piano. In 1973 Silvestrov, like Schnittke, wrote a piece "in the old style": *Music in the Old Style* (*Muzïka v starinnom stile,* for piano); his was dedicated to the recent émigré, Volkonsky.[121] In the 1970s Silvestrov also began

117. Schwarz, *Music and Musical Life in Soviet Russia,* 627. This moment occurs on p. 44 of the score, the final page of the first movement, titled Sonata for Violin and Piano. I am indebted to Virko Baley for generously providing me a copy of this and several other Silvestrov scores.

118. Sil'vestrov and Frumkis, "Sokhranyat' dostoinstvo...," 13 and 14.

119. McBurney's description of the progression of *Drama's* movements is not entirely accurate. See McBurney, "Soviet Music after the Death of Stalin," 134. A recording has recently been released: Silvestrov, *Drama: World Premiere Recording.*

120. Sil'vestrov and Frumkis, "Sokhranyat' dostoinstvo...," 13.

121. The dedication to Volkonsky is visible in the first example from the composition reprinted in Savenko, "Rukotvornïy kosmos Valentina Sil'vestrova," 76 and 88.

concentrating increasingly on vocal music, most notably the extended cycle for baritone and piano, *Silent Songs* (*Tikhiye pesni,* 1974–84) (one of these, "La Belle Dame Sans Merci" after the Keats ballad, was dedicated to Volkonsky; songs in the cycle were also dedicated to Schnittke, Lyubimov, Gubaidulina, and Blazhkov, among others). Over the course of the 1970s as his style gradually became more mimetic, the attitude within Kiev toward Silvestrov warmed. In fact, in a 1979 essay Vsevolod Zaderatsky criticized his 1960s compositions but praised the more recent String Quartet. The reviewer lauded his transformation: Silvestrov had "arrived at his own type of neoclassicism." The quartet was "a work of the most subtle and highest levels of feelings, and of a grand ethical sense."[122]

Silvestrov later said that the "most important lesson of the avant-garde was: to be free of all preconceived ideas, particularly those of the avant-garde."[123] He has called his works from the 1970s his "weak style," in which he used an "untimely ['neaktual'nïy'] or banal language."[124] Silvestrov has also said that what he does "might be termed poetry in music" or a "metaphorical style" (or an "allegorical style") or "meta-musik."[125] As these labels suggest, in Silvestrov's case the entire period from the early 1960s to the mid-1970s was based on an increasing mimesis, from a stylistic opposition between aleatory and serialism, to a dramatic style actually enacted on the stage, followed by an "allegorical" modeling rooted in previous, fundamentally tonal, styles. The culmination of this development was his Fifth Symphony (1980–82), the "Post-Symphony" in which Silvestrov—no doubt influenced by Schnittke's own First Symphony (the "Anti-Symphony")—focused on the idea of the "postlude," on "something not so much beginning, as responding to something already uttered."[126]

THE INCORRECT PATH

Like Pärt and Silvestrov, Gubaidulina's music was almost immediately representational. One reason for this was that, because she followed her "own incorrect path," as Shostakovich had reportedly urged her to do, she came later to

122. Zaderatskiy, "O nekotorïkh novïkh stilevïkh tendentsiyakh v kompozitorskom tvorchestve 60–70-kh godov." For another approving survey of Sil'vestrov's music from the late 1960s onward, beginning with *Drama* and *Meditation,* see Nest'yeva, "Tvorchestvo Valentina Sil'vestrova," 79–121.

123. Frumkis, "An Avant-Garde Romantic: On the Music of Valentin Silvestrov," p. 2 of the English text; originally in Sil'vestrov and Frumkis, "Sokhranyat' dostoinstvo...," 12.

124. Sil'vestrov and Frumkis, "Sokhranyat' dostoinstvo...," 14.

125. See Frumkis, "An Avant-Garde Romantic: On the Music of Valentin Silvestrov," p. 1 of the English text; Sil'vestrov and Frumkis, "Sokhranyat' dostoinstvo...," 14; and Baley, "Sil'vestrov, Valentyn Vasil'yovych."

126. Sil'vestrov and Frumkis, "Sokhranyat' dostoinstvo...," 16. For a useful discussion of this symphony, see Savenko, "Rukotvornïy kosmos Valentina Sil'vestrova," 80–83. For more on Sil'vestrov's "post" style, especially in relation to Shostakovich's posthumous reception, see Schmelz, "What Was 'Shostakovich,' and What Came Next?" 329–33.

serialism than most of the other "young composers."[127] In her own words, as a composer she was a "very late, autumnal fruit."[128] Her first work using the method, the Five Etudes for Harp, Double Bass and Percussion (premiered in 1965), resembled the other serial experiments from the early 1960s by Silvestrov, Karamanov, and others. Yet in this composition, the row is the source of the fixed pitch material, but not the primary organizing principle. Glimpses of the row provide context, but the colors are the main emphasis, a concern central to Gubaidulina's output throughout her career. For example, the final bars of the first movement linger on the oscillating final pair of row pitches in the harp (R_{10}/RI_{10}), E and D\sharp, with the marimba's brief chromatic interjection and the bass pizzicatos and glissandi providing brief, pianissimo counterpoint (ex. 6.6).

Aleatory sections and moments that temporarily abandon the row show Gubaidulina treating serialism as only one of several viable techniques. And the twelve-tone bass ostinato in the final movement demonstrates that, like Schnittke in the final movement of his *Music for Piano and Chamber Orchestra*, Gubaidulina was also picking up trends from other genres, this time jazz. When audiences heard this piece—and it was heard several times in the mid-1960s in Moscow, first at the Union of Composers on 30 March 1966, where the comments were quite positive, and again on 21 April 1966 at Frid's Moscow Youth Musical Club—they were no doubt especially taken by the unusual instrumentation: the double bass, harp, and the vast array of percussion instruments on stage.[129]

If her later statements about her stylistic development are to be trusted (and like all autobiographical statements they should probably be viewed with some skepticism), for Gubaidulina, more than for Pärt, Schnittke and the others, serialism was already an historical technique that, like sixteenth- or eighteenth-century counterpoint, needed to be studied as a composer developed her own personal compositional style. Gubaidulina remarked in a later interview: "We entered into the realm of [serial] music later than our

127. SG: 16. Other retellings of the same event can be found in Wilson, *Shostakovich: A Life Remembered*, 347; and in Gubaidulina and Lukomsky, "My Desire Is Always to Rebel, to Swim against the Stream!" 15–16 (Kurtz quotes the version in Wilson; see his *Sofia Gubaidulina*, 44–46).

128. SG: 39.

129. Kurtz, *Sofia Gubaidulina*, 72–75. The initial performances featured Boris Artem'yev on bass, Vera Savina on harp, and Valentin Snegiryov on percussion (he was a last minute substitute for Pekarsky, who as reported in Kurtz was still a student and unable to obtain the necessary percussion instruments). Gubaidulina had written the composition with Pekarsky's help. Pekarskiy, interview. See also Schmelz, "Listening, Memory, and the Thaw," 229. The Five Etudes were also heard on 13 March 1967 at a concert at the House of Composers in Moscow, alongside works by Viktor Suslin, Frid, Boris Klyuzner, and others. According to Kurtz, Gubaidulina's former teacher Peyko played a role in arranging this performance (p. 74).

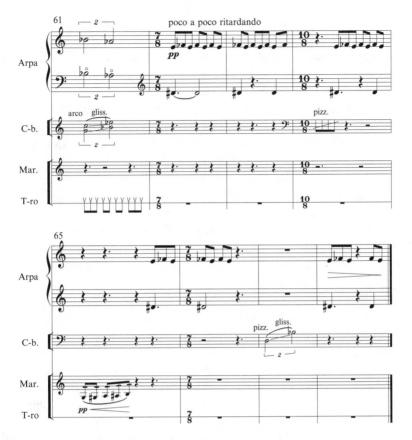

Example 6.6. Gubaidulina, *Five Etudes*, movement I, measures 61–end.
Credit: Copyright © 1972, 1991 by G. Schirmer, Inc. and MUSIKVERLAG HANS SIKORSKI
GMBH & CO. KG, Hamburg. International copyright secured. All rights reserved. Used by
permission.

contemporaries in the West.... That thinking seemed to me for example some-
how readymade, already settled into place, accomplished, and even, in a way,
over. And therefore it needed to be put behind us.... It was something that
inspired enthusiasm, but not the ground where I wanted to live. I could still
look forward to searching and searching for my own true ground. A long jour-
ney stood before me."[130] As Gubaidulina "searched and searched" for her "own
true ground" during the late 1960s, her works were all mimetic to varying
degrees. They ranged from the evocative, yet jarring, juxtapositions of *Night
in Memphis* to the dramatic declamations of *Rubaiyat*. By the time of her First

130. SG: 20 and 40.

String Quartet, she was actively attempting to reflect the world around her in her music.

Kholopova calls *Night in Memphis* the "lyrical center" of Gubaidulina's works of the 1960s.[131] It was Gubaidulina's longest and most commanding work to date. Written for female soloist (contralto) and men's choir (to be taped in advance) with large symphony orchestra, this cantata drew on exotic, mystical Egyptian texts (translated into Russian by Anna Akhmatova and Vera Potapova).[132] It also had an extremely detailed serial construction modeled on both *Laments of Shchaza* and *Sun of the Incas*. As Kholopova pointed out in her 1974 survey of the piece, much of the work is based on a single twelve-tone series that also influenced aspects of the form, as many sections of the work's seven movements are divided into what she calls twelve-section ("12-stupennaya") forms. In the final movement the form is underlain by an end-lessly repeating and varied (through pitch rotation) twelve-tone pizzicato bass line that represents, according to Kholopova, the forward march toward eternity.[133] Thus, for Gubaidulina, as for Schnittke in his Second Violin Concerto, and for Denisov more generally, serialism represented order, and specifically the perfect, limitless order of the beyond. The methodical, unrelenting bass-line is thereby a counterweight to both the more bombastically unpredictable taped (and aleatory) choral outbursts and the subdued vocal sections that pre-ceded it. Because of its orderliness, the twelve-tone process that Gubaidulina employed in the final movement thus matched the third, heavenly voice of the text that was speaking for the first time here to impose order and stability.

When *Night in Memphis* was first shown to the Ministry of Culture RSFSR, one of the bureaucrats, Ushkarev, objected to the Egyptian texts and not the musical setting. Gubaidulina remembered him saying, "Write the very same music, but on texts glorifying the party and the government."[134] The work remained unperformed within the Soviet Union until 1989, thereby making it difficult to trace its influence on Gubaidulina's career or the world of unofficial music performance.[135] Most likely the members of Gubaidulina's circle saw the

131. SG: 165. I am indebted to Valentina Kholopova for allowing me to copy her personal scores to both *Night in Memphis* and *Rubaiyat*.

132. Katsnel'son, ed., *Lirika drevnego Egipta*.

133. Kholopova, "Dramaturgiya i muzïkal'nïye formï v kantate S. Gubaidulinoy 'Noch' v Mem-fise,'" 124–28.

134. Gubaidulina and Tsïbul'skaya, "Oni nenavideli menya do togo, kak slïshali moyu muzïku...," 40.

135. The work was first performed in Zagreb on 13 May 1971 by the Zagreb Radio Symphony Orchestra with Eva Novšak-Houška as the soloist, and Igor Gjadrov conducting. The program also included Lutosławski's *Jeux Venetiens* and compositions of Hans Werner Henze and Aribert Reimann (b. 1936). It had been recorded on 1–4 December 1970 for broadcast on Prague Radio. Kurtz, *Sofia Gubaidulina*, 91–92 and 276. Kholopova says that the work's 1989 Soviet premiere at Moscow's Festival Alternativa was "unsuccessful" ("neudachno"), but that a 1990 performance at a festival of Gubaidulina's music in Sverdlovsk was truly successful ("po-nastoyashchemu uspeshno"). SG: 165. A recording of the

score in manuscript while others became familiar with it only in the pages of *Music and the Present* in 1974. The argument that Kholopova made in this volume of the yearbook regarding the cantata's "heartfelt singing feminine lyricism" and its national intonations is indicative of the reception that Gubaidulina was generally accorded then and continues to be accorded today both in Russia and abroad. She told Gerard McBurney that "nobody took much notice of me. They could always dismiss what I did as simply female eccentricity. It was much harder for the men."[136] In a 1974 interview Volkonsky praised Gubaidulina as one of the "most interesting" Soviet composers: "Although in general I don't believe in female composers, she is the exception that proves the rule."[137] Her eccentricities could be (and still are) doubly explained away by her gender and her nationality.

After *Night in Memphis,* Gubaidulina never so thoroughly applied serial techniques. In fact, it was the timbral and aleatory aspects of her earlier *Five Etudes* that seemed to be the most compelling to her, for it is those aspects that became most representative in her style of the 1970s, beginning with her next pieces, including *Rubaiyat,* her First String Quartet, and *Concordanza.* Therefore, the real legacy of *Night in Memphis* is not its soon-abandoned serial writing. Rather its importance stems from its emphasis on novel colors and textures and its more spiritual content expressed by a dynamic framework featuring lingering meditative "scenes" for the voice separated by the crashing uproars of the choral/percussion interludes. In this sense, the socialist realist buzzwords Kholopova employed in her 1974 essay, including her discussion of new "intonations" and the work's "fundamental dramatic idea," are not far from the mark.[138]

Kholopova correctly notes that *Rubaiyat,* composed the year after *Night in Memphis,* opposes the earlier work in almost every way. Where *Night in Memphis* was rationalized, *Rubaiyat* is spontaneous. From the very first sparse pages, almost exclusively graphic and aleatory, it is apparent that something new is happening in *Rubaiyat.* Furthermore, in performance, the vocal writing of *Rubaiyat*—the prominent role of the baritone/bass soloist who declaims and shouts and cackles amidst the cacophony—is a direct shift away from the

Alternativa performance was released most recently on *Gubaidulina: Orchestral Works and Chamber Music* (it had been released earlier by Col Legno in a boxed set with the other performances at the festival: *Festival Alternativa: Moscau 9–23 October 1989*).

136. McBurney, "Encountering Gubaydulina," 121. The quotation in the preceding sentence is from Kholopova, "Dramaturgiya i muzïkal'nïye formï v kantate S. Gubaidulinoy 'Noch'' v Memfise,'" 130 (see also 109).

137. Volkonskiy, "Andrey Volkonskiy," 8. See also Gubaidulina and Yuzefoaich, "Ob uchitelyakh, kollegakh i o samoy sebe," 9.

138. Kholopova, "Dramaturgiya i muzïkal'nïye formï v kantate S. Gubaidulinoy 'Noch'' v Memfise,'" 109 and 130.

more traditional lyricism of *Night in Memphis*.[139] It is more in the nature of an accompanied declaimed text, almost a monodrama.

Like many in her generation, by the early 1970s Gubaidulina had come to an impasse. As her musical vocabulary expanded to focus on other elements, Gubaidulina still felt the need for control over such diverse material, a control that serial structures had provided in *Night in Memphis*. In the instrumental chamber works that followed, the issue of structure was foregrounded, as she searched for the ideal way to order her musical "content." She later expressed her anxiety that the "exceptionally rich and expressive, very complicated and even, I would say, aggressive" techniques, styles, and devices with which she was working, including serial techniques, as well as "elements of folklore near and far, instruments ancient and modern, sounds concrete and synthesized, microtones, [and] noises of every type, recorded on tape and electronically transformed...threatens to escape from our control." The "sonoristic material" (i.e., *sonorika*) that resulted was, in her words, "complex and fluid to such an extent that it does not permit the creation of a pitch system corresponding to its structure." Because of this she was in despair, for "without a pitch system it is impossible to achieve unity, a single palette of sound colors. And that is authentic beauty."[140] Like Boulez and Denisov, and to a lesser extent Schnittke, Gubaidulina wanted to guarantee order for her musical language. Yet one of her first major compositions of the 1970s, the First String Quartet (1971), was not about unity but disintegration, as, appropriately, were many of her works from the decade of "stagnation."

At this time, Gubaidulina had also started working at the electronic music studio at the Scriabin Museum in Moscow.[141] Her experience there influenced and expanded her interests in color and in overarching "pitch systems" that would achieve unity, as serialism had for a time. Among those working at the studio, Gubaidulina especially noted Meshchaninov, who like many other twentieth-century composers before him saw the twelve pitches of the tempered scale as too restrictive (he was also the first performer of the piano part to *Rubaiyat*). As an alternative, Meshchaninov wanted to subdivide the octave with the help of electronics. Yet as Gubaidulina aptly commented, in waiting for the development of electronic devices that would realize the composer's intentions: "The resolution of the problem is carried over into the distant future. We, however, live now and are not in the condition to wait: we should already write music today. And I decided to find a solution beyond

139. *Rubaiyat* was premiered in Moscow on 24 December 1976 by the Soloists of the Moscow State Symphony Orchestra with Sergey Yakovenko as soloist and Rozhdestvensky conducting. Kurtz, *Sofia Gubaidulina*, 126–28 and 276.

140. SG: 45.

141. See Schmelz, "From Scriabin to Pink Floyd."

the boundaries of pitch, discover for the formation of the thing some kind of other aspect of musical language."[142] As she sought structures other than pitch to unify her works, Gubaidulina began emphasizing sonic elements that had already been heard in her previous works like *Night in Memphis* and *Rubaiyat*. But she also emphasized the mimetic aspects of her musical language. As she told Restagno, her First String Quartet, like many of her works from the period, was "one of my attempts to find an answer [beyond pitch]." According to her, "At the basis of the First Quartet is the idea of disintegration, falling-apart." She also acknowledged that it was "somewhat pessimistic, a metaphor of the impossibility of being together, the impossibility of understanding those near [to you], a metaphor of the total deafness of people (life itself in those years was so dark, so sad and hopeless ...)."[143]

Throughout the episodic quartet, a shifting array of sound images is heard. Perhaps the most significant is the moment of total disintegration that Gubaidulina is speaking of at the ending where the players have gradually shifted to the opposite corners of the stage and are each freely playing various figures from the early pages, including pizzicato and glissandi: "every participant concentrates only on his personal part and already does not entirely hear the others. Full isolation right up to the point of insanity."[144] There cannot be a better musical expression of the claustrophobia felt by many during the Brezhnev years.[145] In this sense, Gubaidulina's First Quartet parallels Pärt's *Credo*, Schnittke's *Quasi Una Sonata* (and also his First Symphony), and Silvestrov's *Drama* and *Meditation,* as musical and social documents of the boundary between Thaw and Stagnation, of the artistic crises many unofficial composers were suffering as they attempted to balance control and freedom, form and content, and abstraction and mimesis.

Gubaidulina later told Kholopova that she was unable to maintain such a negative tone in her compositions: "From 1975–1976 I began intensively searching for integration, attempting to find for the instruments some kind of 'common point of view,' for it was already impossible for the soul to survive

142. SG: 51. See also Gubaidulina and Lukomsky, "My Desire Is Always to Rebel, to Swim against the Stream!" 11.

143. SG: 51.

144. Ibid., 52. The quartet borrows from the theatricality evident in Western avant-garde works like Kagel's string quartets (the first two of which both date from 1965–67), which she might have known, as Schnittke mentions Kagel and theatricality in his 1971 "Polystylistic Tendencies in Modern Music." Sergey Slonimsky's 1968 *Antiphons* for string quartet is a clear model from closer to home.

145. The scream added by at least one performer, the bassoonist Harri Ahmas, at r. 8 in the fourth movement of Gubaidulina's Concerto for Bassoon and Low Strings (1975) is also suggestive, but it is not notated in the score, which reads "quasi 'clamore.'" There is no scream in the 1978 recording by the work's first performer, Valeriy Popov; he just flutter-tongues at this moment. See Gubaidulina, *Bassoon Concerto/Concordanza/Detto II*; and Gubaidulina, *Rubaiyat/Detto II/Misterioso/Concerto for Bassoon and Low Strings*.

in an overly negative world. And in the 1980s I succeeded in arriving at consonance and lucidity."[146] This description can also be read in a religious sense, as a searching for salvation, a search likely stimulated by Gubaidulina's own Orthodox faith (encouraged by Yudina, she had been baptized in the Orthodox Church on 25 March 1970).[147] The eventual "arrival at consonance and lucidity" in her compositions coincided with her overt turn to religious subjects: *Introitus* (1978), *In Croce* (1979), *Offertorium* (1980), *Seven Last Words* (1982). It also coincided with her frequent use of a very literal mimesis in the "instrumental symbolism" of works like the *Seven Last Words*, where, in Gubaidulina's words, "the cello itself becomes the cross, a place of crucifixion" as well as the "crucified deity."[148] At the same time Gubaidulina began adopting new means for structuring her music through the use of the Fibonacci sequence or other numerical processes, attempting to construct what she called the "Rhythm of the Form."[149] Gubadiulina, like Denisov and Karetnikov, sought refuge in order. In both Gubaidulina's and Karetnikov's cases, this refuge was religious in nature.

Religion, then, played a vital role in the ongoing stylistic development of many of these composers. In both Pärt's and Schnittke's cases, a more mimetic musical language, driven by both aleatory and tonal elements, was connected with more pronounced religious subjects in compositions like *Credo* and the Second Violin Concerto. Over the course of the 1970s, as his music grew increasingly tonal, increasingly austere, and increasingly antiquated, Pärt turned almost exclusively to religious topics. Schnittke's explicit turn to religion came later; he was baptized into the Catholic Church only in 1982 (in Vienna).[150] But Pärt and Schnittke were not the earliest.

One of the first "young composers" to explicitly convert, both musically and spiritually, was Karamanov, who in 1965 left Moscow for the Crimea after being baptized into the Russian Orthodox faith in the capital. At the same time as he

146. SG: 132. This is from an interview between Kholopova and Gubaidulina on 18 January 1990.

147. Kurtz, *Sofia Gubaidulina*, 86–87.

148. Gubaidulina and Lukomsky, "My Desire Is Always to Rebel, to Swim against the Stream!" 20–21.

149. See, e.g., Zenowa, *Zahlenmystik in der Musik von Sofia Gubaidulina*. Gubaidulina also discusses this in her interview with Redepenning: Gubaidulina, "An Interview with Dorothea Redepenning," 452. See also Gubaidulina and Lukomsky, "'Hearing the Subconscious': Interview with Sofia Gubaidulina," 27–31; Gubaidulina and Lukomsky, "My Desire Is Always to Rebel, to Swim against the Stream!" 10; and Gubaidulina and Bugrova, "'Dano' i 'zadano,'" 2–3.

150. There is a discrepancy regarding the date of Schnittke's conversion. Ivashkin and Ivan Moody place it in 1982, as does Kholopova in a 1999 article (noting also that it occurred when Schnittke was forty-eight years old; he was born in 1934). In Kholopova's more recent biography of the composer, however, the date is now 1983 (and Schnittke was forty-nine when it happened). See Ivashkin, *Alfred Schnittke*, 160; SR: xxiii; Moody, "Alfred Schnittke"; Kholopova and Biryukov, "Shnitke: Prodolzheniye ispovedi"; and Kholopova, *Kompozitor Al'fred Shnitke*, 156.

physically retreated for the provinces, Karamanov's musical language moved away from the "twelve-toneness" he had explored in his early 1960s piano compositions. Instead, as works like his monumental *It Is Finished* (named after Christ's last words on the cross in the Book of John) demonstrate, he turned to a late-nineteenth-century, Scriabinesque tonal idiom.[151] Karetnikov, another early religious adherent, was an exception. His spiritual conversion was not accompanied by any stylistic shift. Karetnikov became increasingly religious in the wake of the "unpleasantries" that had begun after the production of *Vanina Vanini*. He later cited his 1965 meeting with Father Alexander Men' as a significant important turning point in his life, a moment that saved him from the "despair" that had increasingly taken hold of him.[152] At the same time, Karetnikov's musical language in his compositions from the late 1960s like the Concerto for Wind Instruments (1965) or the Chamber Symphony, Op. 21 (1968) continued to be firmly grounded in serial techniques; none of his music from the late 1960s treated religious subjects. His turn to openly religious themes came later, with works like his opera, the *Mystery of the Apostle Paul* (*Misteriya apostola Pavla*), composed between 1972 and 1987.

DENISOV AND VOLKONSKY

Despite some suggestive titles, Denisov's works from the late 1960s and early 1970s—*Laments* (1966) (a topic in the next chapter), *Ode* (1968), *Romantic Music* (1968), String Trio (1969), and Piano Trio (1971)—lean toward the abstract. (*Ode* is the most mimetic of the group, but its dedication to Che Guevara came only after its composition as a pragmatic measure to ensure performance.)[153] The argument could be made that Denisov's style became more mimetic in the 1970s and 1980s, and certainly the large number of dramatic vocal works from this period, including *La Vie en rouge* (1973) to texts of Boris Vian, the opera *L'Écume des jours* (1977–81, also based on Vian), and his important Requiem from 1980 would suggest a move in that direction. The texts in these compositions are also more straightforward and are treated more pictorially by Denisov than in his earlier vocal pieces. Despite the frequent absurdities of *La Vie en rouge*, Denisov is more concerned to imitate their subject matter scrupulously, from the march of the "brave soldier" in "Le prisonnier" to the dance undergirding parts (but not all) of the "Dance of the Atomic

151. Schmelz, "Listening, Memory, and the Thaw," 505–16.

152. Karetnikov, "Otets Aleksandr," in *Gotovnost' k bïtiyu*, 142; also Schmelz, "Listening, Memory, and the Thaw," 516–17. For more on religion in the USSR at the time, see Corley, *Religion in the Soviet Union: An Archival Reader*.

153. Berman, interview, 23 March 2001.

Bomb" ("La java des bombes atomiques"). Denisov also began incorporating moments of popular music, as he does briefly in the final movement of the Sonata for Alto Saxophone (1970) and more explicitly in the third movement of the Piano Concerto (1974). References to tonality, and specifically a quotation from Schubert's "Morgengruss" also appeared in his Violin Concerto (1977) (mm. 152–63).[154]

Nonetheless, Denisov's orchestral composition *Peinture* from 1970, one of his most compelling compositions, is perhaps more emblematic of his music from the decade. This work, dedicated to his friend, the painter Boris Birger, follows a recognizable trajectory of prolonged growth and slow decay using a rhetoric of colors and gestures heavily influenced by Schoenberg's *Five Pieces* for Orchestra, Op. 16, and Debussy's *Nuages* from his *Nocturnes*. Its language, however, is not as fraught, stylized, or fundamentally familiar as the pieces by Pärt, Schnittke, Silvestrov, and Gubaidulina that we have been surveying. Although the title hints at a program, Birger was an artist whose paintings stood between abstraction and mimesis, blurring figures, nudes, or landscapes into colors, shades, and shadows. Similarly, Denisov evokes without specifying; he represents hesitatingly.[155]

With *Peinture*, Denisov also began composing more orchestral works. If the 1960s was a decade of chamber music for Denisov, the 1970s would be a decade of orchestral and vocal music. Despite the exceptions mentioned earlier, Denisov's later instrumental compositions are consistently abstract, including the concerti from the 1970s and the countless chamber pieces from the 1980s (recall Cherednichenko's description of them as "functionaries in a perfectly running production engineering office").[156] In short, Denisov never went through an extended stylistic crisis as Pärt, Schnittke, and Silvestrov (and to a lesser extent Gubaidulina) all did. His shift toward mimesis was more gradual and was not as exclusive as the stylistic shifts of the others. It was also supported by a slow movement away from strict serialism, although the more abstract of Denisov's compositions continued to maintain a strong linear chromatic or jaggedly pointillistic fingerprint inspired by his early serial essays. (In 1989 Denisov was still emphasizing the necessity for "every composer...to work for several years with twelve-tone and serial techniques...without knowledge of [which] is it very difficult to achieve real professionalism.")[157] The response of the Soviet authorities to his 1970s works is undocumented; most of them were heard only abroad, and often a considerable time after their completion. In fact, of all his compositions from the 1970s, only two minor

154. See Bradshaw, "The Music of Edison Denisov," 6–8.
155. See Glade and Proffer, eds., *Boris Birger: A Catalogue.*
156. Cherednichenko, *Muzïkal'nïy zapas,* 64. See also chapter 4.
157. See Denisov and Pantiyelev, "Ne lyublyu formal'noye iskusstvo...," 12.

works—the Sonata for Clarinet Solo (1972), and the Sonata for Flute and Guitar (1977)—were performed in the Soviet Union during that decade. Only in the early 1980s, and especially after 1982, were Denisov's works premiered and heard with any regularity in the USSR.

Volkonsky's mimetic engagement progressed somewhat differently. Volkonsky had experimented briefly with aleatory composition in his *Jeu à Trois* ("Mobile" for Flute, Violin, and Harpsichord) (*Igra vtroyom*) (1962), a set of individual fragments to be played in any order, as many times as desired, divided into any number of movements (starting always with the same initial fragment), not unlike Stockhausen's *Klavierstück XI* (1956).[158] Volkonsky did not write dramatic compositions like Pärt or Schnittke until after he emigrated, but the overall small number of his compositions from the late 1960s and early 1970s makes tracing his stylistic development difficult.[159]

His *Concerto itinérant* (*Stranstvuyushchiy kontsert,* 1963/4–67) for voice and orchestra to texts of Khayyam remains, in his words, his most "formally ambitious" composition; it is also his "freest." Volkonsky still has misgivings about his "somewhat mechanistic" ("neskol'ko mekhanistichno") treatment of its form, doubts reinforced by Silvestrov's comment to him that the "labor is apparent" ("rabota vidna") in the piece.[160] At nearly double the length of either *Suite of Mirrors* or *Laments of Shchaza,* it retains the exotic, abstract cast of those earlier vocal cycles as it juxtaposes aleatory devices of various types with "twelve-tonish" writing. The *Concerto itinérant* is overly long, and its length caused Volkonsky to falter in his pacing. Nonetheless, it contains several striking moments, like the extensive aleatory section that begins at no. 237 and culminates at nos. 251–67 (25:16–28:00 on the only recording) in the voice and the three soloists (flute, violin, and percussion), unlike anything else he ever composed (aside perhaps from *Jeu à trois,* which was clearly a model). In many ways the *Concerto itinérant* is an implicit rejection of his earlier serial techniques, even if it perpetuates the abstract style they allowed him to cultivate. We have already seen that nearly a decade later Volkonsky provided a more direct critique of his earlier serial infatuation in *Immobile* for Piano and Orchestra from 1977–78. The section from his discarded *Music for Twelve*

158. Volkonskiy, *Jeu à Trois: Mobile pour Flûte, Violon et Clavecin.* I am indebted to Benjamin Walton for helping me obtain a copy of this score.

159. Two of these compositions remain unpublished: *Les mailles du temps* (*Uzelki vremeni*) (1969) and *Mugam* for tar and piano (1974) (this last is from Drozdova, "Andrey Volkonskiy" [diss.], 206–8; Kholopov, "Initsiator: O zhizni i muzïke Andreya Volkonskogo," 20; and NVV: 204–5; but is absent from Lemaire, "Volkonsky, Andrey Mikhaylovich").

160. Quotations in this and the preceding sentence from NVV: 124–25. There is some discrepancy over the dates for this composition. The published score reads "Terminé en 1967" (Volkonskiy, *Concerto Itinerant*). Drozdova does not provide a date, while Kholopov has 1964–67, Pekarsky has 1964–68, and Lemaire gives 1963–67. See Drozdova, "Andrey Volkonskiy" (diss.); Kholopov, "Initsiator"; NVV: 124; and Lemaire, "Volkonsky, Andrey Mikhaylovich."

Instruments that he inserted in the more restrained framework of *Immobile* was a clear signal of his new more mimetic allegiances, a drama akin to those we saw in the music by Pärt, Schnittke, and Silvestrov from the late 1960s.[161] Unfortunately, neither of these later Volkonsky compositions was performed in the USSR until long after their completion: the *Concerto itinérant* was first heard there only in October 1989—as Concerto for Soprano, Flute, Violin, Percussion Ensemble, and String Orchestra—at the Festival Alternativa in Moscow (from which its only recording is taken).[162] In 1974 Volkonsky fittingly summarized his generation's recent stylistic sea change: "Composers today are becoming bored from cerebralism, as previously boredom occurred from sentimentality."[163]

THE END OF THE MUSICAL COLD WAR

The attitude of most of the unofficial composers toward serialism and aleatory, fixed and free elements, at the end of the 1960s is best summarized by the cartoon that preceded and shared music with Schnittke's *Quasi Una Sonata,* Andrey Khrzhanovsky's *Glass Harmonica* (1968), the first cartoon scored by the composer.[164] The film is a thinly veiled depiction of the repression of the arts and, in turn, society under a totalitarian state, implicitly the USSR (as the opening titles have it the official target of the film is "modern bourgeois society").

When a foreigner arrives and plays his magical instrument—a glass harmonica that more closely resembles a cross between an electric guitar and a portative organ (à la Landini), the society awakens.[165] But when the mysterious leader—a bowler-hatted menace straight from Magritte—gets wind of the changes being wrought by the instrument, he immediately smashes it and personally conveys the interloper to jail (a prison with resemblances to both Moscow's Lyubyanka Prison and the Kremlin). An interlude follows depicting

161. See NVV: 206; and chapter 3.

162. This recording was included in *Festival Alternativa: Moscau, 9–23 October 1989.* Volkonsky stated that the leader of this performance, Timur Mïnbayev (b. 1943), was the most successful conductor of the piece because of his "sense of space": "He is a Kazakh and understands what a desert is." See NVV: 126. Blazhkov reportedly had planned to premiere it during the 1965–66 Leningrad Philharmonic season. Moor, "In Russia, Music for May Day," 121.

163. Volkonskiy, "Andrey Volkonskiy," 8.

164. Khrzhanovskiy, *Glass Harmonica.*

165. When he scored the film, Schnittke had never heard a glass harmonica, and he later "regretted his ignorance," although the novel string and keyboard sonorities he used (organ, xylophone, etc.), often enhanced electronically with extra reverberation, proved much more effective in the animated context than an authentic glass harmonica. Kholopova, *Kompozitor Al'fred Shnitke,* 100.

the greed of the society, culminating in a scene in which a variety of frightening misshapen beasts canter around an enlarged gold coin (the Golden Calf, as it were). Presumably the director thought (erroneously) that by making the oppressive environment a capitalistic one the censors would condone the cartoon. (Unfortunately, the cartoon is fatally scarred by its prominent anti-Semitism, embodied by the central gold-hoarding hunchbacked creature—an Alberich-type and also a *stukach,* or informer, who sells out the musical hero of the film.) In the end a young boy recreates the magical instrument, and when that too is smashed, a rose that had appeared in conjunction with the instrument in previous scenes suffices both to spread beauty throughout the populace, represented by invocations of classical works of art, and to drive the oppressor away.

As obvious and banal as this allegory appears, *Glass Harmonica* effectively conveys the repression and the saving power of music during the Thaw. But what really counts is the musical opposition that drives the cartoon. As in Pärt's *Pro et Contra* and *Credo,* it equates aleatory and serialism alike with any dissonant or unpleasant percussive sound or electronic effect, any or all of which are meant to represent the evils of modernity in the West (really the evils looming at home in the USSR). Difficult, "modern" music represents the greed of the populace and their enslaved orgiastic rapture in the face of the upraised golden coin. The clarity of J. S. Bach—indicated by the B-A-C-H motive—on the other hand signifies tonality and, by extension, the saving grace of tradition, the restoration of time and the past (a restoration of time symbolized by the rebuilding of the land's central timepiece at the cartoon's end). Bach also, perhaps, ultimately promises freedom.

According to Berger, the "canonization of Mahler in the 1960s"—another recovery of time and the past—was an "emblem" of the "gradual erosion" of the "musical Cold War," for "in composition, where it [the gradual erosion] was clearly noticeable already in the early 1960s, this tendency manifests itself in such diverse phenomena as the reappearance of poetic imagery as integral to instrumental composition in the work of Ligeti and Penderecki, the dramatic terms in which instrumental form is reconceived by Carter and Lutosławski, the new interest in quotation and collage in the work of Berio, above all in the international reappearance of interest in tonality as a viable compositional option...."[166] But this did not demonstrate a clear victory for mimesis, for Berger views these events as evidence of the "rapprochement and accommodation between the abstract and mimetic ideas, a refertilization of abstraction with mimesis."[167] These tendencies, and just such a "refertilization," were also

166. Berger, *A Theory of Art,* 150–51.

167. Ibid. For another thoughtful reading of the turn to collage and mimesis (specifically in the works of Rochberg) in relation to the cold war, see Fosler-Lussier, *Music Divided,* 157–64.

observable in the Soviet Union, where for a brief time from the late 1950s to the mid-1960s, abstraction had triumphed. By the end of the 1960s, as we have seen, many of the unofficial composers had experienced a crisis of representation and had started adopting more mimetic approaches to musical composition, approaches accompanied by a more literal interpretation of musical freedom. Perhaps it is no surprise that the works they wrote in their mimetic phase are those that have best stood the test of time (as brief as it has been). Of course, their turn to mimesis was driven by concerns at variance with those on the other side of the Iron Curtain. The continued modernist striving for novelty was replaced instead by an interest in addressing matters of broader importance (existential, social, and spiritual) in a less confining, often familiar, language—it was a renewed interest in meaningfulness and intelligibility inculcated (in part) by years of socialist realist tutelage. As a result, when composers like Schnittke, Pärt, Silvestrov, and Gubaidulina wrote works that were more accessible—because more mimetic—they were applauded by official critics. They were not derided with the charges of epigonism that greeted similar works in Europe and America (after all, it had been their earlier abstract works that were so labeled).[168] At the same time, after these composers had mastered the techniques of serialism and aleatory, the need to catch up that had fueled their stylistic experimentation in the early 1960s began to give way, and the sanctified aura of novelty that first surrounded those once-new devices began to wane. What remained were concerns of communication and style that were increasingly separate from technique.

168. See Fosler-Lussier, *Music Divided*, 161–62.

7

Denisov's *Laments*, Volkonsky's *Rejoinder*

In that August of Sixty-Hate they had all been in the Crimea when they heard the
news; they had been just about to open their mouths to start a furious howl, but
instead they suddenly shut up. They didn't understand what was really happening,
which was why they didn't protest, but only opened their mouths for vodka or to put
the mouthpieces of their instruments between their teeth. They did nothing but play
and drink, play and drink, play and drink, until they were nearly aging from their
terrible music, from vodka, and from keeping silent.

—Vasiliy Aksyonov, *The Burn* (1980)

The musical ramifications of Khrushchev's Thaw continued to be felt into the
early 1970s, yet the Thaw's early optimism was already waning by the late 1960s
when Brezhnev had solidified his hold on power. After 1968, idealism began
turning into the "immutability" that Yurchak sees as a defining characteristic
of "late socialism."[1] For many, the end of this idealism was driven home forc-
ibly by the Soviet invasion of Czechoslovakia in August 1968, when the idea of
"socialism with a human face" was literally crushed. The year 1968 served as
a pivot from hope to resignation, from the promise of change to the seeming
unchangeability of the status quo.

The musical repercussions of 1968 were widespread and were felt well
before the August invasion. In Leningrad, the transplanted Ukrainian, Igor
Blazhkov, was removed from his assistant conducting post with the Leningrad

1. Yurchak, *Everything Was Forever, until It Was No More*, 283 and 47–50. See also Schmelz, "From
Scriabin to Pink Floyd"; and Schmelz, "What Was 'Shostakovich,' and What Came Next?" 302–3 and
332–33.

Philharmonic on 1 July 1968, ostensibly for "Inadequacies of the Repertoire," meaning his performances of pieces by Schoenberg, Webern, Ives, Varèse, Volkonsky, Silvestrov, and Denisov.[2] Shostakovich tried to help him find employment again, but his letters of recommendation to Vasiliy Kukharsky (deputy minister of culture of the USSR), G. P. Alexandrov (deputy minister of culture of the RSFSR), and I. G. Boldïrev (chief editor of the repertory-editorial board for music of the Ministry of Culture of the RSFSR) proved ineffectual.[3] Shostakovich reportedly told Blazhkov that after the recent action in Czechoslovakia, which had occurred shortly after his dismissal: "I would have liked to intervene, but *they* don't listen to me now" [emphasis in original].[4]

Other Ukrainian musicians fared no better. "In order to avoid participation in...mandatory meetings and not to act against [his] convictions," Hrabovsky had resigned from the Kiev Conservatory in 1968, "when all had to 'support and OK the policy of Party and Government' in the case of Czechoslovakia."[5] Silvestrov's comments about contemporary music (both Soviet and European) in an open and considered (and hence extremely valuable) interview published in the bellwether liberal journal *Youth* (*Yunost'*) in September 1967 had already proved controversial.[6] Subsequently, at a Plenum of Young Composers in Kiev in 1970, Grigoriy Romanovich Shirma (1892–1978), a functionary from Belorussia in attendance at the plenum who was conductor of the Belorussian Ensemble of Song and Dance and also a member of the Belorussian Central Committee, accused both Silvestrov and Hodzyats'ky of being sympathetic to West Germany and America and of being a "tail" ("khvost"), or follower, of those countries. Shirma claimed that their music was "bourgeois" and was merely a vehicle for protest against political events in Czechoslovakia. According to Silvestrov: "Because of that Blazhkov was also in trouble for conducting and we were thrown out [of the Ukrainian Union of Composers]."[7] The official explanation was that they were expelled for "disturbing the social order."[8]

2. Blazhkov, ed., "Pis'ma Shostakovicha I. I. Blazhkovu," 499. An October *Sovetskaya muzïka* article reported the news of the accusations that led to his dismissal: Kukharskiy, "V interesakh millionov," 2–10.

3. Blazhkov, ed., "Pis'ma Shostakovicha I. I. Blazhkovu," 499–500; and Shostakovich, *Dmitriy Shostakovich v pis'makh i dokumentakh,* 409 (letter to Kukharsky from 9 June 1969).

4. Blazhkov, ed., "Pis'ma Shostakovicha I. I. Blazhkovu," 500.

5. Hrabovsky, e-mail to author, 14 December 1999.

6. This interview was condemned publicly (although Silvestrov's name was deliberately left unstated) by Khrennikov on 16 December 1968 at the All-Union Congress of Soviet Composers. See Khrennikov's remarks in "Sovetskaya muzïka—tovarishch, pomoshchnik stroiteley novogo mira: chetvyortïy s'yezd soyuza kompozitorov SSSR," 8; Sil'vestrov, "Vïyti iz zamknutogo prostranstva...," 100–1; and Schwarz, *Music and Musical Life in Soviet Russia,* 487.

7. All of the preceding is taken from Sil'vestrov, interview.

8. Frumkis, "K istorii odnoy (ne)lyubvi," 87.

Silvestrov and Hodzyats'ky fruitlessly wrote letters to Shostakovich, Khacha-turyan, Rostropovich, and Kara Karayev requesting assistance; Shostakovich was the only one who responded and he told them to approach Khrennikov instead.[9] Silvestrov believed that Khrennikov finally intervened with the head of the Ukrainian Union of Composers, Andrey Shtoharenko (1902–92), because both composers were eventually readmitted into the Union two years later (in 1973), after being expelled for a total of three years. In 1976 the First Plenum of the new Kiev branch of the Ukrainian Union of Composers took place, at which, as Schwarz reported, "[t]he return to active participation of Leonid Grabovsky [Hrabovsky], Valentin Silvestrov, and Vitali Godziatsky [Hodzyats'ky] was noted with satisfaction."[10]

It was not only unofficial conductors or composers who suffered during this period, for Shchedrin also became a target after he refused to sign a letter in support of the 1968 invasion.[11] As he told me: "At the time I didn't sign the let-ter about the introduction of troops into Czechoslovakia in 1968—that already was a drastic action. And 'Voice of America' broadcast every hour that three people (of the intelligentsia) refused to sign that letter—two writers: Konstan-tin Simonov [1915–79] and [Alexander] Tvardovsky [1910–71],[12] and one composer: Shchedrin. And they stopped greeting my wife [Bolshoi prima bal-lerina Maya Plisetskaya] out of fear."[13] As a result, Shchedrin's 1968 composi-tion *Poetoriya* received heavy criticism in an extended "discussion" published in the November 1969 issue of *Sovetskaya muzïka*.[14] Rather than rework *Poeto-riya*, as some had suggested in this discussion (foremost among them *Sovet-skaya muzïka* deputy editor Yuriy Korev [b. 1928]), Shchedrin curried favor by writing an entirely new, more orthodox work: *Lenin in the Heart of the People* (*Lenin v serdtse narodnom*): "And so what? I wrote a new composition. I wrote *Lenin in the Heart of the People* because I didn't sign the letter, because not so much even for me, but for my wife they cut off the oxygen. After all, she had to work. Shostakovich wrote *Song of the Forests*."[15] Shchedrin's composed act of contrition was duly accepted by the authorities and even given a prominent, positive review in *Sovetskaya muzïka* in 1970. That same year it also received the State Prize of the USSR, along with his first opera *Not Love Alone* (*Ne*

9. A copy of Shostakovich's response to Silvestrov (dated 19 June 1972) is reproduced in Frumkis, "K istorii odnoy (ne)lyubvi," 88.

10. Schwarz, *Music and Musical Life in Soviet Russia*, 592.

11. Shchedrin, interview.

12. Alexander Tvardovsky was the editor of *Novïy mir* during the important period 1958–70. He helped to publish works by major Soviet authors like Solzhenitsyn, Sinyavsky, Pasternak, Akhmatova, Mandelstam, Babel, and others.

13. Shchedrin, interview.

14. "Obsuzhdayem 'Poetoriyu' R. Shchedrina," 18–32.

15. Shchedrin, interview.

tol'ko lyubov') (1961, revised in 1971).[16] Shchedrin himself went on to replace Shostakovich as Chairman of the Union of Composers RSFSR in 1973, both as a result of Shostakovich's urging ("It was difficult to refuse Shostakovich") but also to protect both himself, and especially his wife from further problems.[17] As Plisetskaya wrote in her autobiography: "I needed Shchedrin's honorary post in the Union of Composers as a warning to people to wipe their feet on me less frequently, step on my soul less often."[18]

The broader ramifications of 1968 on unofficial music are raised by a concert that took place in 1970 featuring two compositions, one of which was Denisov's *Laments* (*Plachi*, 1966), the other a work called *Rejoinder* (*Replika*, 1970). *Rejoinder* in particular encapsulates many of the shifts that 1968 signaled even as it illuminates the ambiguous possibilities for resistance, or at least opposition, at a pivotal moment in unofficial Soviet music. By looking more closely at both *Laments* and *Rejoinder* we can thus pinpoint the most important artistic and social changes that were occurring around 1970, near the end of the Thaw and the beginnings of Yurchak's "late socialism." These two works help refine our understanding of the development of the "paradox" of the 1970s simultaneous "immutability" and "displacement" that Yurchak so provocatively proposes.

Rejoinder is a work usually attributed to Andrey Volkonsky, but in many respects of both composition and performance it was a group effort; in fact, *Rejoinder* was one of the first "happenings" ("khéppening") in the Soviet Union. Because no recording of *Rejoinder* survives, and because of its open-ended, improvisational nature, we will never be able to know what this work sounded like in performance. Nor, more importantly, will we ever be able to recreate it with any real accuracy. *Rejoinder* then is already resistant on a historiographic level; we are unable to pin it down, left only with the surviving fragments of its score and the traces it has left in its participants' memories.

The October 1970 issue of *Sovetskaya muzika* contained an anonymous article titled "Rejoinder: Regarding an Interview " ("Replika: Po povodu odnogo interv'yu"). The "Rejoinder" responded to an interview that Denisov had given to the West German journal *Musica* in December 1968, but which had appeared in print only in the summer of 1970 under the rubric "It Is Valid to Search for a New Beauty: Interview with a Young Soviet Composer."[19] The

16. Danilevich, "Lenin v serdtse narodnom," 2–5; and Kholopova, *Put' po tsentru: Kompozitor Rodion Shchedrin*, 74.

17. Shchedrin, interview. He served in this post until 1990. See Vlasova and Daragan, eds., *Soyuz kompozitorov Rossii: 40 let*, esp. 5–10.

18. Note her careful use of the word "honorary" here. Plisetskaya, *I, Maya Plisetskaya*, 330.

19. Denisov, "Es gilt, neue Schönheit zu suchen," 391–92. See also the commentary to "Replika" in *Svet-dobro-vechnost'*, 40. All subsequent citations are to the Russian original of this interview: Denisov, " 'Nuzhno iskat' novuyu krasotu.' "

author of the October 1970 Soviet "Rejoinder" (an anonymous "journalist," of course) reminded readers of Denisov's previous adventure in foreign publication, namely his 1966 Italian article "The New Techniques Are Not a Fad," which we may recall "was subjected at the time to criticism in the Moscow Union of Composers."[20] According to the *Sovetskaya muzïka* reviewer, this past criticism was justified by the statements that Denisov had made in the earlier article, among them his memorably heretical comparison of the influence of Volkonsky's *Suite of Mirrors* on his generation to that of Shostakovich's Fifth Symphony in the 1930s (see chapters 3 and 4).

As it had been in the earlier Italian publication, Denisov's characterizations of the group of "Soviet avant-garde" composers was prominently called into question. In the West German interview Denisov had been asked a general opening question about the "Soviet avant-garde" to which he had given a considered response, acknowledging the "arbitrariness" of what he called the "grouping of musicians into a school or tendency called the 'avant-garde.'" He also somewhat condescendingly observed that "very often that which passes itself off as avant-garde does not correspond with that designation." Denisov then reversed course and defined the "Soviet avant-garde," saying, "The composers that are usually called the 'Soviet avant-garde' are comparatively young, in age roughly 33 to 40 years.... All of them are united by only one [thing]: they do not consider tonality to be the single possible form for organizing pitch."[21] The *Sovetskaya muzïka* reviewer saved his most heated denunciation for this response: "What kind of definition of the mythical Soviet 'avant-garde' is this, which has nothing specific to it?... To whose benefit is the attempt of E. Denisov to oppose the entire mass of Soviet musicians to a certain group of 'young people between 33 and 40,' endowed with the exceptional license to create 'new music'? We can ask a broader question: to whose benefit is the juggling of slogans like 'Soviet avant-gardism,' [or] 'Soviet avantgardists'? I believe that it is unnecessary to answer these questions here."[22] Unfortunately, the anonymous author did have a point. The so-called Soviet avant-garde had become more fragmented by the late 1960s, as demonstrated by the variety of their stylistic pursuits as they abandoned their common serial interests from the first half of the decade. That much had become clear by 1968, the date of the interview, and had become especially evident by 1970, the date of the *Sovetskaya muzïka* "Rejoinder." By 1970, the "Soviet avant-garde" had indeed become, in many senses, "mythical." The reviewer had unintentionally touched on a key factor in the development of this generation.

20. "Replika," 44.
21. Denisov, "'Nuzhno iskat' novuyu krasotu,'" 38.
22. "Replika," 45.

In the very next paragraph, the journalist chided Denisov for "avoid[ing] any ideological or social categories in his judgments," thereby "creating the appearance that in general the 'avant-garde' is merely the search for various elements of compositional technique (only technique!), merely various formal devices (only devices!)." This would not do:

> No, the works of the avantgardists are not the sum of devices and not a technical phenomenon. They are a phenomenon of public life. It is also necessary to judge them in this capacity, for, as with any such phenomenon, they carry in their individual forms a definite ideological content, in the end neither separable from the social environment that gives rise to it, nor from the personality of the creator who expresses it. And even if a certain creator specially stipulates that he uses the "theory of probability, science of multiplicity and so forth, with the goal of the conscious construction and ordering of the material,"[23] art will not become mathematics, indifferent to the social interests of those whom it serves; art maintains as its object the representation both of its specific forms and of its socio-cognitive functions. Otherwise, why should it exist?[24]

The reviewer stressed several crucial aspects of the phenomenon of the unofficial composers that we have been discussing. The emphasis on music as an expression of public life was common in Soviet music criticism, but rarely was it stated so forcibly in reviews concerning these composers. Of course, while the "Rejoinder" hit close to home regarding Denisov's concentration on new music and specifically on the serialism he had referred to as "very fruitful" in the interview, it pointedly failed to acknowledge the real social role that this music, and particularly the concert subculture that it had cultivated, had assumed by 1970.[25] Furthermore, the reviewer ignored the mimetic tendencies that Soviet critics had been responding to so favorably in the recent works by many of the other unofficial composers. The reviewer saw a negative withdrawal in Denisov's compositions, which was true enough, but ignored the corresponding positive social role much of this music increasingly played for Soviet audiences.

After suggesting that perhaps Denisov had been misquoted, in which case he "should protest in print against such crudely tendentious distortions," the later parts of the review cautiously hoped for Denisov's "retreat from avant-garde aesthetics," a move "hinted" at by the recent *Laments*. Yet, according

23. This quotation is taken from that point in the original interview in which Denisov is discussing the music of Xenakis. Denisov, "'Nuzhno iskat' novuyu krasotu,'" 39.

24. "Replika," 45.

25. Denisov, "'Nuzhno iskat' novuyu krasotu,'" 39.

to Soviet critical fashion, at the end of the "Rejoinder," the reviewer thrust a more loaded suggestion at the composer/critic: "And in terms of whether or not Denisov ought to appear in the future in the foreign press with articles and interviews, then that, of course, should be decided by him alone."[26] The article had the character, then, of an ultimatum, even as it acknowledged the fact that the Europeans were taking a great and understandable interest in Denisov because of their common concern for serialism (even if they still held a "disdainful and ironic" opinion of his music). In the end, the fact that the Western European press was so intrigued by Denisov meant that he had an even greater obligation to express a "sense of the worthiness of a Soviet musician."[27] At certain points in Soviet history such comments would have been grim harbingers. In 1970, they still carried enough weight to be taken seriously.

The October article could not have come at a more inopportune time for the so-called Ensemble of the XX Century, a subgroup of Madrigal that in early November was on tour in Tbilisi, Georgia, with a program that included Denisov's 1966 vocal chamber composition *Laments*. Because the article prominently discussed *Laments* in a context generally critical of its composer, "a telegram from Soyuzkontsert yanked *Laments* from performance."[28] This was the case even though the article was not specifically critical of that composition, and had in fact complimented *Laments* as a sign of improvement for Denisov.

Denisov's *Laments* was typical of his compositions from the late 1960s. The work was based on traditional Russian lamentations, but stylistically was an idiosyncratic blend of Boulez's *Le Marteau sans maître*, Volkonsky's *Laments of Shchaza,* and Denisov's own *Sun of the Incas*. Denisov culled his texts from a collection published in 1960 called *Lamentations* (*Prichitaniya*), which immediately struck him ("as it had been with Gabriela Mistral" in *Sun of the Incas,* he said) and from which he combined sections in a "montage," "in order to maintain the entirety of the whole ceremony of the burial, the entirety of that ritual, taking place in ancient Russia, in its villages."[29] He divided the composition into six sections representing the burial ritual: (1) "Lament of the Viewing" ("Plach—voprosheniye"), (2) "Lament of Singing" ("Plach—opoveshchaniye"), (3) "Lament during the Carrying In of the Coffin" ("Plach pri vnose groba"), (4) "Lament during the Carrying Out of the Coffin" ("Plach pri vïnose groba"), (5) "Lament along the Road to the Cemetery" ("Plach po doroge na kladbishche"), and (6) "Lament during the Lowering of the Coffin into the Grave" ("Plach pri opuskanii groba v mogilu").

26. "Replika," 46
27. Ibid.
28. Kholopov and Tsenova, *Edison Denisov,* 29; and Pekarskiy, "Kryostnïy otets," 187.
29. PED: 167.

Many Russian commentators as well as Denisov himself have mentioned the influence of Stravinsky's *Les Noces* (*Svadebka/The Wedding*) on *Laments*. Denisov said, "I, of course, then felt the influence of Stravinsky and especially his *Les Noces*. . . . I don't know, for some reason the following words continually spun around inside me: it's *Les Noces* the other way round."[30] As *Les Noces* is to traditional Russian wedding rituals, so the comparison goes, *Laments* is to traditional Russian burial practice. Although it bears some resemblance to *Les Noces,* no listener to *Laments* would mistake another obvious model: Volkonsky's *Laments of Shchaza,* which it closely emulated in both subject matter, its musical devices (serialism), and its overall style. At several key points, Denisov also made several allusions to Volkonsky's score.

The unmistakably avant-garde sound of *Laments* led to the initial difficulties that the composition encountered with Soviet critics. For while the texts were folk-derived, the vocal and instrumental writing clearly was not. The instrumentation of *Laments* was itself unusual (and here the comparisons with *Les Noces* have some merit): soprano, piano and three percussionists playing a variety of instruments from timpani to bells and claves. But the instrumentation also resembles *Sun of the Incas,* which itself shifted from movement to movement and emphasized "bell-likeness."[31] In fact, the instrumentation (voice and percussion), vocal delivery (repeated notes, wide leaps) and "modal" sound of the opening movement to *Laments* act like a direct continuation of the "Song about a Tiny Finger" from *Sun of the Incas,* as do the soprano and claves in the final, sixth movement of *Laments.* (These moments are also clearly derived from the final movement, "Berceuse for a Sleeping Mirror," from Volkonsky's *Suite of Mirrors.*)

The final movement of Denisov's *Laments,* "Lament during the Lowering of the Coffin into the Grave," is the logical conclusion and climax of the funeral ritual traced by the cycle and also its most striking moment. It also demonstrates Denisov's continued fascination with serializing multiple parameters of his texture, here pitch and rhythm (1, 2, 7, 11, 10, 3, 8, 4, 5, 6, 9, 12—in terms of a single eighth note within a triplet or a single sixteenth note within a quintuplet; ex. 7.1).[32] This is the most straightforward of the movements, a movement

30. PED: 171. See also Kholopov and Tsenova, *Edison Denisov,* 135; and Kholopova, "Tipï novatorstva," 184.

31. Denisov discussed the role of the bells in *Laments* in PED: 168 and 169–70.

32. PED: 170 (see also n. 38 on p. 170). Kholopov and Tsenova describe this in *Edison Denisov,* 136; Kholopova does so in "Tipï novatorstva," 187–88. Kholopova has also noted a shifting "scale of dynamics" (Kholopova's term) that, despite Denisov's claim, is not serialized. See Kholopova, "Tipï novatorstva," 187. She additionally refers to a "group of timbrally articulated sounds" ("gruppa tembro-artikulyatsionnïkh zvuchaniy"), by which she apparently means the simultaneity of certain pitches in the voice and claves that occur primarily on the "odd" quintuplet beats. See her example on p. 188 and commentary on p. 187.

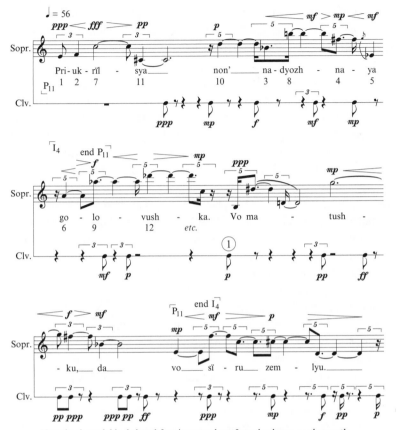

Now the dependable, beloved face is covered up. Into the damp, mother earth.

Example 7.1. Denisov, *Laments*, movement VI, opening (numbers indicate the rhythmic series based upon numbers of eighth notes; P and I indicate forms of the pitch series). Credit: Copyright © 1972 by Universal Edition A.G., Vienna/UE 14138.

in which the rows unfold in a manner reminiscent of "Assumption" from the *Italian Songs* but with only an occasional alteration of pitches and few other changes.[33] According to Denisov, the point of such strict calculations here was paradoxically to achieve an effect of improvisation: "But you will agree,... all of that makes an impression more than anything of a free, improvised monologue in the soprano part, which is accompanied by the improvising commentary of the percussionist."[34]

33. The only interruptions to the rhythmic series are the occasional interjections of Denisov's favorite quintuplets. Kholopova identifies these in a table on p. 188 of "Tipï novatorstva."

34. PED: 170–71.

As a climax, this sixth movement is exceedingly subdued, the most static moment of an extremely static score. It returns to the thin texture—soprano and vibraphone—of the third movement and continues the hypnotic monotony of the fifth movement. Yet the ending of the final movement is also unexpectedly effective, especially when the rest of the ensemble (the other two percussionists and pianist) enter softly, accompanying the soprano vocalise (on "A," "O," and "M"). This moment is *Lament's* clearest homage to Volkonsky aside from the opening vocal entrance and the hummed "M" of the voice at one before rehearsal 4 in the first movement, both of which mimic the wordless vocables that pervade the first movement and return to complete the final movement of *Laments of Shchaza*.

Denisov's *Laments,* however, was not as novel as either *Laments of Shchaza* or, in particular, *Sun of the Incas*. Despite the variety of instruments and techniques at play in the ensemble, the score, like *Laments of Shchaza,* has an unremitting sameness about it that Soviet critics immediately pounced upon. Part of this monotony was perhaps intentional, reflecting the unrelenting, numbing grief of the texts. This explains, in part, the effectiveness (and relief) of the understated final movement, or as Kholopov and Tsenova impressionistically describe it, the "mysterious, unreal silence of the coda, full of enigmatic rustlings."[35] The remainder might have proven tiresome for an audience, and would have been redeemed only by the charisma and talent of the original performers. As a recording from the time indicates, Davïdova's vocal virtuosity on such a demanding score, although not without rough edges and missed pitches, would alone have ensured rapt attention.[36]

Like many Soviet compositions that later suffered political denunciations (Shostakovich's *Lady Macbeth of the Mtsensk District* for one), *Laments* did not have a difficult beginning. The work, naturally, was first heard abroad—in Brussels on 17 December 1968 (with Basia Retchitska as the soloist)—but it also went on to receive several Soviet performances.[37] It was the most prominent of Denisov's compositions from the end of the decade. According to Lyubimov's notebook of performances, after its Soviet premiere on 27 October 1969 in Tartu, Estonia by the Ensemble of the XX Century (on a program including Schoenberg's Op. 14 songs, Ives's "Three-Page Sonata," and Cage's *Amores*), it received an unusual number of additional performances. The next day (October 28), it was performed in Tallinn alongside the same pieces, though Ligeti's *Volumina* (in a Soviet premiere, according to Lyubimov's annotation) was substituted for the Ives Sonata. *Laments* was then heard at the House of Composers in Moscow on 26 November and was recorded on

35. Kholopov and Tsenova, *Edison Denisov,* 137.

36. *Edison Denisov: Les Pleurs; Lidia Davydova, soprano.*

37. Kholopov and Tsenova, *Edison Denisov,* 220.

9 December 1969 and 15 January 1970 by an ensemble consisting of Davïdova, Lyubimov, Pekarsky, Snegiryov, Mikhaíl Arshinov, and Rozhdestvensky (the same recording referred to earlier).

In the August 1970 issue of *Sovetskaya muzïka, Laments* received prominent reviews by Butsko and Litinsky alongside Schnittke's Violin Sonata No. 2 (*Quasi Una Sonata*). Now Denisov was receiving the frequent official critical coverage that Volkonsky had been given in the 1950s and early 1960s. This factor alone was indicative of Denisov's new role. As the tacit ringleader of the unofficial composers, he could not be given the silent treatment, but needed to be prodded and cajoled by the Soviet press in the hopes of favorably molding both his future compositions and those of his colleagues.

In their separate discussions of the *Laments,* both Butsko and Litinsky expressed ambivalence about the work, responding to its uneasy tension between abstraction and mimesis. They praised it as a new direction in Denisov's output because it was based upon folk texts and tried to model itself, indirectly at least, on traditional Russian "drawn-out singing" ("protyazhnaya pesennost'"). Despite this laudable folk basis, Litinsky found the entire work to be founded on a "false idea" and as a result to have a "lack of contrast, and because of that seem long-winded."[38] He criticized the "immoderate use of the 'uneven recitative,'" and Denisov's "supermarket of sounds" that "noticeably standardizes all of the instrumentation."[39] Butsko's review implicitly preferred Schnittke's Violin Sonata No. 2 to Denisov's *Laments,* as he breathlessly praised the compelling dramaturgy of the former and bemoaned the "loss of the dramaturgy of great breath" ("dramaturgiya bol'shogo dïkhaniya") that resulted from the serialism of the latter.[40] Litinsky also discussed the work's performance and particularly praised Davïdova's singing (as Butsko also had done). He wrote that after the concert at Frid's Moscow Youth Musical Club (the 26 November 1969 performance), "the complete and in its own way vivid impression could hardly have left anyone indifferent,"[41] from which he concluded, like Butsko, that the work should be heard before a broader public.

An unidentified[42] *Sovetskaya muzïka* writer also weighed in at the end of the August 1970 "Tribune: Encounters with Chamber Music," and was much more negative than either Butsko or Litinsky in her evaluation of *Laments.* True to form, this commentator's critical perspective put Denisov in a bind. Although others, like Pärt and Gubaidulina, were praised for using folklore no matter how abstractly, Denisov's elaborate folk structure was for naught. As the

38. Butsko and Litinskiy, "Vstrechi s kamernoy muzïkoy," 13 and 14.
39. Ibid.
40. Ibid., 12.
41. Ibid., 14.
42. Marina Nest'yeva was mentioned in the preface as the head of the department responsible for writing this article-commentary, but the authorship of the article itself remains uncertain.

anonymous critic noted after a long discussion of the attributes of traditional Russian lamentations, Denisov's *Laments* was a step in the right direction, but he was not to be praised for his turn to folklore, for he had done it incorrectly: "The intonational language of *Laments* is not free from a certain abstraction, as if dismissing the meaning that is being depicted.... This very dismissal prevents the composer from unfolding a convincing dramaturgy that would unite the cycle into a kind of integral act ['deystvo']."[43] The critic also took him to task for "only seeing the exotic side" to the traditional Russian forms that he was borrowing.[44] The double standard to which he was subjected by all the authors, but particularly the final, unnamed reviewer, at once praised and damned for using folklore, left Denisov in an unfair and unenviable position.

As tempting as it may be in retrospect to read a deeper meaning into the coincidence of a composition based on lamentations achieving frequent performance in the years following the Soviet invasion of Czechoslovakia, no reception evidence exists to confirm that contemporary audiences made such a connection. Although the reviews in the *Sovetskaya muzïka* "Tribune" were critical, Denisov did not suffer any consequences from the performances of *Laments*. Nor did the official musical organizations prevent any of these concerts, for when the Ensemble of the XX Century began its tour of the southern republics in late 1970 its programs that included *Laments* must surely have been vetted by the proper authorities in the Union of Composers and Soyuz-kontsert (if not the Ministry of Culture).

Denisov's next and possibly most outlandish work, the 1969 electronic composition *Singing of the Birds* (*Peniye ptits*) for synthesized tape and piano performed by Lyubimov several times in 1970, got off scot-free as well.[45] Despite the "scandal" that Lyubimov claimed resulted from his initial costumed performance of the piece in April 1970, and the fact that the officials at the concert "appealed to the Central Committee," there were no specific reprisals against either performer or composer.[46] When neither Denisov nor Lyubimov were rebuked for these aggressive performances that almost begged for criticism, Denisov seemed to be in the clear. Until, that is, the anonymous "Replika" appeared in the October 1970 *Sovetskaya muzïka*.

In response to "Replika" and the removal of *Laments* from their concerts, Volkonsky and his colleagues in the Ensemble of the XX Century composed a substitute for Denisov's *Laments*, a "rejoinder" to the "rejoinder" as it were: a

43. Unsigned article, "Pis'mo iz redaktsii," 16.

44. Ibid., 17.

45. See Schmelz, "From Scriabin to Pink Floyd."

46. Katunyan, "'Peniye ptits' E. Denisova: Kompozitsiya—grafika—ispolneniye," 397; Denisov and Tsenova, "O 'Penii ptits': Interv'yu," in *Svet-dobro-vechnost'*, 61–62; and Denisov, *"Peniye ptits": Partitura, fonogramma, materiali, interv'yu*, 74.

performance piece, titled appropriately *Rejoinder* (*Replika*). This piece combined graphic notation, improvisation, theatrical effects, and political commentary. It would be the first, and only, overt criticism of musical officialdom by the unofficial composers, and surprisingly *Rejoinder* was actually performed publicly twice in short succession immediately following its composition.

Pekarsky gives a more polished and humorous account of the composition of this piece in a 1999 reminiscence. Pekarsky describes a meeting of musicians Davïdova, Lyubimov, Berman, Arshinov, and Volkonsky in Volkonsky's Tbilisi hotel room after their first concert (which may or may not have included *Laments*, Pekarsky was unsure).[47] Pekarsky remembers that:

> [After the concert, in the hotel room] all of us... continued to act friendly after a bottle of "Mukuzani" (and perhaps, not only "Mukuzani"...and perhaps, and not only one...). And then someone there—I don't recall who—passed around the "Rejoinder" from "Sovmuz" [*Sovetskaya muzïka*]. Everyone then became extraordinarily excited, and sent for yet another bottle (and, perhaps...). "Edik is such a good guy that to simply say something bad about him is impossible, and just look at this!"—cried the prince [Andrey Volkonsky], and the lenses of his glasses steamed up from indignation. Aleksey Borisovich Lyubimov...with [his] glittering and gleaming head of hair, rolling in his larynx his luxurious "r-r-r," fiercely shook what were customarily called fists. I will give the text of the Honored Artist of Russia Lidiya Anatol'yevna Davïdova in an adapted translation: "How could they (...!) be so bold as to (...!) offend (...!) our beloved Edik [Edison], they are such (...!...!...!)!" Boris Berman rabidly rolled his eyes; Mikhaíl Arshinov was busy with what he should have been busy: filling and emptying glasses; and I, foreseeing that it would fall upon me to sometime describe this historic meeting,—I attentively gazed upon all of that and remembered.[48]

Pekarsky continues his description of *Rejoinder*'s composition: "Thus, having heard the 'Rejoinder' [the article], the assembled company discussed and decided exactly tomorrow to avenge poor wronged Edik, since there was a concert tomorrow at the Tbilisi House of Friendship (I don't remember in whose name, I don't remember with whom). They decided further to entrust Comrade Prince Andrey Mikhaílovich to write the musical piece by morning

47. Pekarsky mentions that this gathering took place after a concert, but Lyubimov had no record of an Ensemble of the XX Century performance in Tbilisi before the concert featuring *Replika*. It might also have been a Madrigal performance, as the two groups sometimes toured together (see chapter 5). Pekarskiy, interview (see also NVV: 175); Lyubimov, interview; and Berman, interview, 4 February 2007.

48. Pekarskiy, "Kryostnïy otets," 187. Berman said that this account was "more or less" accurate. Berman, interview, 4 February 2007.

and to name it as ingenuously as the original: 'Rejoinder.'" The company met the next day in the hotel room to rehearse the composition. Pekarsky describes the actual performance: "Several details remain in my memory: Lidiya Davïdova smiling with her trademarked smile 'to no one in particular,' very quietly purring: 'Journalist.... Journalist,' while I typed on a typewriter, typed until the moment when the pianist Lekso [Alexander] Toradze [b. 1952] said something to me in Georgian from the audience ['You are wanted at the telephone'[49]]. I answered: 'Yes, Yes, of course,' stood up, and left the stage."[50] Although usually attributed to Volkonsky, as Pekarsky himself does in the above account,[51] Pekarsky told me that the piece was actually a group collaboration: "The material was worked on together... after the concert in Tbilisi. I said: 'Why don't I read in English with a Russian accent?'... I then typed on a typewriter, and Lidiya Davïdova repeated after me. No, rather, I [repeated] after her: She said: 'Journalist.... Journalist.'"[52] Volkonsky emphasized that "it was in the fullest sense a collective work, which I like so much." (He also remembered that the portion in English—mentioned by Pekarsky—was from an advertisement for tourists.[53]) Berman gave Volkonsky primary credit: "We were actually very happy because for Volkonsky this was a period of considerable hiatus in his composing and we were very glad that he produced something."[54]

Rejoinder survives in a score in the collection of Aleksey Lyubimov. It is on eight sheets of paper, the first page of which reads: "A. Volkonskiy 'Replika' 4 NOVEMBER 1970 (4.XI.1970)."[55] The pages include some of the individual parts (marked "Pekarskiy," "Berman," "Piano" [in Latin letters], presumably Lyubimov, and "Lida" [in Cyrillic]—fig. 7.1 is Pekarsky's part). There are also what appear to be a full score and an annotated sketch of the entire piece (fig. 7.2—sketch—and fig. 7.3—full score). The directions to the full score, the sketch page, and all the parts reflect the occasional nature of the composition, for they consist of a series of directions and diagrams that anyone other than the original performers would be hard pressed to decipher. By now, even the original performers do not recall the niceties of interpreting *Rejoinder*, as I discovered when I went over the piece with Lyubimov.

The schematic sketch for the piece includes brief instructions in a mixture of Cyrillic and Latin characters, including: "Separate sounds. Lida [and] Pek

49. Volkonsky remembered this detail. NVV: 175–76.

50. Pekarskiy, "Kryostnïy otets," 188. Pekarsky's account can also be found, slightly revised, in NVV: 175.

51. See also Kholopov, "Initsiator: o zhizni i muzïke Andreya Volkonskogo," 20.

52. Pekarskiy, interview.

53. NVV: 176.

54. Berman, interview, 4 February 2007.

55. I am indebted to both Yuriy Kholopov and Aleksey Lyubimov for permitting me to view and copy this score.

Figure 7.1. *Replika*, Pekarsky's part.

silent" ("Otdel'nïye zvuki. Lida Pek tacet"), moving to "Chopin, Jazz," then a block of "Waltz," a "Climax," and a "Cadenza" (fig. 7.2). The more legible full score (fig. 7.3) includes the names of all the performers (the "percussionist" was Arshinov): "Lida, Pek, Lyub, Perc, Ber." In the first performance Volkonsky conducted—"or at least made it look like I was conducting"—and in the Moscow performance Volkonsky played the bell "in order to mark the form of the Happening"; the latter role is indicated by a large direction at the bottom of

Figure 7.2. *Replika*, sketch of the entire composition.

Figure 7.3. *Replika*, full score.

the sketch sheet.[56] The full score is divided into six sections, with graphic nota-tion indicating the activities that were described on the sketch sheet's rough outline for the piece. The same central sections and directions mentioned in the sketch page also appear in the full score, including "Chopin" played by Lyubimov in section II, and "Jazz" in the percussion. The climaxes, and the sections that Pekarsky most clearly remembered, occur in sections III, V, and VI. In section III the score is marked "Duet" and in Davïdova's part reads "article" ("stat'ya") then "sing [Denisov's] *Laments*"—in other words, parts of *Laments* were included in *Replika*—then "Duet with Pekarsky." (Next to her name on the sketch page it also indicates "read passages" and "quotations from Denisov.") As the full score indicates, in section V everyone is to engage in a "gradual transition to 'sch'" ("postepennïy perekhod na Sch. [*sic*]")—that is, everyone moves about the stage saying "Sh." Then at the beginning of section VI Pekarsky ("Pek") "repeats" and Davïdova ("Lida") sings "journalist" (this is the section that Pekarsky most vividly recalled). Unfortunately, no record-ing of the piece exists; only the score can help us reimagine the sound of this bizarre "composition."

It is hard to know what the audience thought of a piece of performance art that included sections of Denisov's *Laments* as well as a mock recitation of the text from an anonymous *Sovetskaya muzïka* "Rejoinder" that no doubt few attendees had actually read. Most listeners were probably still reeling from a long program that also included works by Berg, Schoenberg, Stravinsky, Ives, and Cage (See box 7.1).

It is even more astounding that the same piece received an encore perfor-mance in Moscow a month later (on 14 December 1970) on a program that added Denisov's *Singing of the Birds* and works by Webern and Stockhausen in place of Cage's *Water Music* and the Berg and Schoenberg pieces (the Stravin-sky selections also changed).[57] In neither case were the performers punished, although Denisov was reportedly displeased with the "happening" and the additional attention it gave to his situation.[58]

The original reception of *Laments* had not been overwhelmingly supportive, but Denisov had been censured not for his music, but for his foreign interview. He was not, however, left completely untouched by the subsequent "Rejoin-der" affair. On 26 July 1971 the Secretariat of the Union of Composers of the USSR passed a resolution that, in Tsenova and Kholopov's words: "Banned the transmission of music or literary material abroad without the knowledge and approval of the Secretariat."[59] The resolution concluded with these lines

56. NVV: 176.
57. All of this repertoire information is from Lyubimov's performance notebook.
58. NVV: 176.
59. Kholopov and Tsenova, *Edison Denisov,* 29.

Box 7.1. Programs for concerts including *Replika*

4/11–70: Tbilisi (GODIKS) (M-XX)

Berg—Three songs ("From the early songs"/*Iz rannïkh pesen*)

Schoenberg—Six Little Piano Pieces, op. 19

Stravinsky—Three Pieces for Piano Four Hands

 Three songs: *Podblyudnaya* [from the Four Russian Songs of 1919]; and *Gusi, lebedï* and *Tilim-bom* [both from *Trois histoires pour enfants* of 1917]

Ives—"Three-Page Sonata"

Cage—*Water Music*

 Amores

Volkonsky—*Rejoinder* (*Replika*)

14/12–70: Moscow (NIÉOS) (M-XX)

Stravinsky—Six songs

Webern—Five songs, op. 4

Ives—"Three-Page Sonata"

Stockhausen—*Klavierstück IX*

Denisov—*Singing of the Birds* (*Peniye ptits*)

Cage—*Amores*

Volkonsky—*Rejoinder*

Program given at Tbilisi, 4 November 1970, and Moscow, 14 December 1970. Transcribed from Aleksey Lyubimov's performance notebook.

(quoted from the original): "Those violating this resolution in the future are warned that strict disciplinary measures will be taken right up to expulsion from the Union of Composers of the USSR."[60] In Denisov's case things never got that far, but the resolution marked the hardening attitude of the union toward Denisov and his fellow composers.

In the end, it is difficult to discuss a composition like *Rejoinder* in terms of either resistance or of being *vnye*. Rather, it stands somewhere uncomfortably in the middle, containing aspects of resistance, opposition, and protestation, but of a rather meager sort, with limited, local effects, if any. Wanting to call it resistant at all may betray, as Yurchak avers, a nostalgia for the assumed clear-cut binaries of the past. Furthermore, perhaps any resistance that did not appear as a straightforward agitation for the demise of the regime was only qualified at best and hence not worthy of the term. Yet our examination of *Rejoinder* profits from an approach similar to Viola's "categories of resistance," which address both motivation and context while acknowledging that

60. Ibid.

"any understanding of resistance is relative and the factors of analysis highly subjective."[61]

According to such an approach, the stated intent of *Rejoinder's* authors/performers was clearly oppositional, meant to defend Denisov from the unjust attacks of officialdom. Berman told me, "Andrey kind of as an expression of our communal protest wrote this piece."[62] *Rejoinder* was clearly more "resistant" than the subtle acts Yurchak describes from the 1970s and 1980s performed by average, believing Soviet citizens, like reading during official meetings or organizing rock concerts for official communist gatherings. *Rejoinder* also was more actively antagonistic to the state than Volkonsky's earlier works like *Musica Stricta* that did not confront but rather withdrew, and were at best a type of passive resistance, an avoidance signaled by silence and a retreat into abstraction. Yet, in the end *Rejoinder* is an ambiguous example of resistance. After all, its effect was not far removed from the cloistered world of *Musica Stricta,* its intended opposition contained, buried in its two isolated performances, its obscure style, and its obscure references.

We have already noted other venues from the 1960s that allowed for more active confrontation with the dictates of socialist realism. Such was the case with Frid's Moscow Youth Musical Club, where anyone in the audience could enter into a discussion about the merits of a composition or an aesthetic viewpoint. This type of more direct questioning and debating was possible during the mid-1960s, before the hardening of the 1970s and 1980s that Yurchak describes had set in.[63] In the mid-1960s, performances of "new" music, whether by Western or Soviet composers were still events. By the early 1970s, the music seemed less fresh, and audiences had become more jaded, turning their ears instead toward rock and roll and other Western popular music. The moment of unofficial art music was relatively brief, and *Rejoinder* came near its end. In its singularity, then, *Rejoinder* represents one of the last times when such explicit musical opposition may have seemed, or in fact have been, possible.

61. Viola, "Popular Resistance in the Stalinist 1930s," 75. See also chapter 1.
62. Berman, interview, 4 February 2007.
63. Yurchak, *Everything Was Forever, until It Was No More,* 135–41.

8

Conclusion: The Farewell Symphony

According to the art critic Lyudmila Bekhtereva, in the late 1960s the Soviet artistic " 'underground' lost its youthful immediacy and characteristic youthful energy." Furthermore, she declared, "at the beginning of the 1970s the 'underground,' like the 'carnival' (employing Bakhtin's terminology), had exhausted itself."[1] For Bekhtereva, writing in the early 1980s, the second half of the 1960s seemed the "zenith" of unofficial art. In many respects, these generalizations apply to unofficial music as well, for as we have seen, during the late 1960s and early 1970s the once seemingly unified group of "young composers" began pursuing remarkably distinct stylistic avenues (despite their many shared aesthetic concerns). The youthful energy that drove both them and their audiences also began to wane, though by no means to the point of "exhaustion." At the same time, a new, younger generation of composers drew increasing attention. A member of this generation, Viktor Yekimovsky, provides a compelling description of the shift in generations and the resulting changes in Soviet musical life, focusing on the composition that he thought marked the divide: "Starting in the mid-70s our avant-garde music began to be widely performed here. The boundary was not between the 1960s and 1970s, but in the middle of the 1970s. Because after Schnittke's First Symphony was performed here for the first time in 1974, they began to present that music more. They criticized it just as they had before, but still played it more often. And before that time, everything was difficult."[2] As the unofficial composers achieved greater prominence and stability, even respectability, both at home and abroad, the generation of composers born in the 1940s and after, the Russian "baby boomers" as it were, began to draw more attention. Composers of Yekimovsky's age, for example, Dmitriy Smirnov, Elena Firsova

1. Bekhtereva, *Variantï otrazheniy: Ofitsial'naya zhizn' neofitsial'nogo iskusstva*, 5.
2. Yekimovskiy, interview.

(b. 1950), Martïnov, and Artem'yev (slightly older but still associated with this generation), were devoted to contemporary European and American art music—and especially John Cage—but as we have seen many of them also had a deep interest in popular music, and especially American jazz of the 1950s and 1960s, the contemporary progressive rock movement, and recent jazz-rock fusion experiments.[3]

A concert planned by Yekimovsky, Alexander Ivashkin (b. 1948), Vyacheslav Rozhnovsky (b. 1947), Berman, and Lyubimov for April 1969 at Moscow's Gnesin Institute illustrates the influences and aspirations of the younger generation. As it was originally envisioned, the concert, a festival really, was to have included four concerts of chamber compositions by Schoenberg, Berio, Pousseur, Kazimierz Serocki, Denisov, Volkonsky, Gubaidulina, and Pärt, in addition to "creative meetings" with Silvestrov, Tigran Mansuryan, Hrabovsky, and Kuldar Sink.[4] There was also to have been an electronic music concert at the Scriabin Museum and theoretical papers read by Schnittke on Stockhausen and by Ivashkin and Yekimovsky on Messiaen.[5] Needless to say, this ambitious program was severely curtailed by the institute's Organizing Committee (Orgkomitet), which reduced it to a single concert. The officials realized that banning it outright would have created a greater ruckus than allowing it to go forward with a smaller selection of music accompanied by appropriate public criticism, like an aural *On Music Living and Dead*.[6]

The fact that the concert was allowed to proceed at all indicates that the world of art-music was not monolithically repressive in the late 1960s. Such

3. For more conservative musicians, such as Dmitriy Paperno, the growing interest in popular music signaled a gradual loss of quality in concert life at the end of the 1960s. See Paperno, *Notes of a Moscow Pianist*, 130 and 142. See also Schmelz, "From Scriabin to Pink Floyd."

4. Yekimovskiy, *Avtomonografiya*, 36–37. Yekimovsky says that he, Ivashkin, and Rozhnovsky planned this. Dmitriy Smirnov writes that it was planned by Ivashkin, Lyubimov, and Berman. See Firsova and Smirnov, "Fragments about Denisov; Part I: 1965–1986," under the "April 1969, Moscow" entry.

5. Yekimovskiy wrote the first Russian study on Messiaen. Yekimovskiy, *Oliv'ye Messian: Khudozhnik i vremya* (1971); later reworked in 1979 (although published almost a decade later) as *Oliv'ye Messian, zhizn' i tvorchestvo*.

6. Yekimovskiy, *Avtomonografiya*, 37. Smirnov's diary entry from April 1969 lists some of the pieces that he heard at this concert (according to him there was only one concert and not the two that Yekimovsky described), including works by Mansuryan (piano sonata), Vladimir Zagortsev (*Ritmï* [*Rhythms*]), Sink (Composition for Two Pianos), Silvestrov, Yekimovsky (Composition No. 2), Schnittke (*Serenade*), Denisov (Three Pieces for Cello, Three Pieces for Piano Four Hands), Berg (Four Pieces for Clarinet), Webern, and Schoenberg (Violin Phantasy and "Ode to Napoleon"). This is taken from Firsova and Smirnov, "Fragments about Denisov; Part I: 1965–1986," under the "April 1969, Moscow" entry. Thanks to Lyubimov's performance notebook, we know exactly when that concert occurred and what was performed on it (or at least what he performed). According to this source, there was only one concert at which Lyubimov participated at the Gnesin Institute, this on 20 April 1969. Lyubimov's list corresponds closely to Smirnov's: Denisov's Three Pieces for Piano Four Hands; Silvestrov's *Elegiya;* Sink's "Two Compositions"; Mansuryan's Sonata; Schoenberg's Six Pieces, Op. 19, and Phantasy, Op. 47; and Webern's Four Pieces, Op. 7.

a concert would have been unimaginable a decade earlier. Although the post-Czechoslovakia Soviet Union was socially and artistically restrictive, in other respects it was becoming easier to perform "avant-garde" music by both Soviet and foreign composers. Lyubimov's notebook entries for the late 1960s and early 1970s show the freedom with which determined performers were able to premiere formerly prohibited pieces like Cage's *4'33"*, *Atlas eclipticalis, Fontana Mix,* and Riley's *In C* (the last three on 28 June 1969 at the House of Folk Art), or Stockhausen's *Kreuzspiel* (14 October 1969 in Moscow at the Ippolitov-Ivanov Musical Preparatory School, and 29 October 1970 in Tallinn) and *Klavierstück IX* (premiered on 10 April 1969 at the House of Composers in Moscow and then repeated on 22 April 1969 in Moscow at the Kurchatov Institute, and also on 23 April 1969 at MIFI, the Moscow Historical Philological Institute).[7] Of course, the situation for unofficial music was still complicated: fluke bans still occurred and difficulties still arose.

Generational change and the gradual relaxation of restrictions were only two of the markers of the musical Thaw's end. Volkonsky's emigration from the Soviet Union in 1973, and, as Yekimovsky noted, the premiere of Schnittke's First Symphony in 1974 were more definitive signals that the period had come to a close. With Volkonsky's exit, unofficial music lost one of its most outspoken and visible personalities. Schnittke's First Symphony, by contrast, revealed how much distance had passed musically and socially since the composition and premiere of Volkonsky's early serial works over a decade before. With Schnittke's polystylistic magnum opus, unofficial music "caught up" with the West, even as it presaged a new stage of musical development and aesthetic thinking in the Soviet Union.

THE "BIRD FROM BEYOND THE SEAS" RETURNS HOME

Volkonsky had first thought about leaving the USSR after the Soviet invasion of Czechoslovakia,[8] but, according to Drozdova, what finally spurred his departure was the fact that the director of the Moscow Philharmonic concert bureau had decided to pay Volkonsky only 20 rubles per concert (roughly $27.00 at the time, or about $95.00 in today's dollars when adjusted for inflation[9]). As Drozdova retells it, the director believed that "playing on the harpischord,

7. For a brief account of a Lyubimov "Evening of Cage" from the late 1970s, see Cherednichenko, *Muzïkal'nïy zapas,* 309–10.

8. NVV: 217.

9. See *USSR Facts and Figures Annual,* vol. 1 (1977); and U.S. Department of Labor, Bureau of Labor Statistics (http://data.bls.gov/cgi-bin/cpicalc.pl). Many thanks to Charles Lyons for his assistance in locating these sources.

organ, and piano, and leading Madrigal was not performing music but moonlighting," or in other words, was opportunistic and not worthy of more pay.[10] Duly offended and already frustrated by his inability to find performances for his own compositions, Volkonsky began to think more seriously about leaving the country. He told a reporter in 1973: "If they had let me compose and occasionally go abroad to perform, who knows whether I would have wanted to leave. But I am not a Schubert, who never heard any of his symphonies. And I am not a hermit or ascetic, to compose all my life without ever hearing myself. My music is experimental, and they did not allow me to experiment. Art, after all, is a form of magic. It needs a public."[11] Aygi told me:

> [Volkonsky] always said that he wanted to leave. But in the beginning of the 1970s, around 1971, he very actively began to talk to me about it. I gave him the following idea, that several people should first write to Brezhnev, and…put in the letter, that "we only want to leave because we are not in agreement with our politics and culture, and here we may not live," and nothing else besides that. And that it should become well-known and the noise would be terrible, and maybe they would even let us go. He really grappled with that, very willingly. He said that he would notify [them in writing].[12]

According to the 1973 *New York Times* article that informed American readers of Volkonsky's "artistic battle" in the USSR, Volkonsky requested the right to emigrate in December 1972. Volkonsky said, "The next day I was expelled from the Union of Composers. All my concerts were canceled. The record company was instructed not to issue the records I had just made. The program of the Taganka Theater was reprinted to remove my name as the composer of the incidental music for their production of 'Tartuffe,' although the music is still played."[13] When they learned of his desire to leave, the Union of Composers RSFSR threw Volkonsky out of both the organization and of Muzfond, cutting him off from the payroll and thereby all but preventing him from existing in the Soviet Union.[14] Volkonsky heard nothing from the passport bureau for five months, during which time he was also forced to retire permanently as leader of Madrigal. Because he had no source of income, he was forced to sell most of his books and scores.[15] Aygi remembered this bleak time: "Then he began to leave,

10. Drozdova, "Andrey Volkonskiy" (diss.), 47.
11. Kamm, "Composer Tells of Artistic Battle in Soviet."
12. Aygi, interview.
13. Kamm, "Composer Tells of Artistic Battle in Soviet."
14. Drozdova quotes the transcript of the Union of Composers meeting on 7 December 1972 at which these decisions were made. Drozdova, "Andrey Volkonskiy" (diss.), 48.
15. Kamm, "Composer Tells of Artistic Battle in Soviet."

beginning in 1972....In 1972 and 1973 he became very indifferent to external affairs, completely, as if he began to stop living. He drank a lot, let his affairs fall apart....He adored and loved Madrigal a great deal, but he left them because someone [made] a declaration, and he could not stay there. They threw him out of something [some organization], someone [else] also threw him out. He was only waiting for an answer."[16] A response to his request eventually arrived: "I finally got [a Soviet exit visa] this month, when despair was not far away," he told the *New York Times* correspondent. That same month, May 1973, Volkonsky left the Soviet Union for Israel, giving up his remaining records, books, scores, and photographs—the majority of his personal possessions.[17] According to Schwarz he made a marriage of convenience with a Jewish woman in order to receive the necessary exit visa and promptly divorced her after his emigration (he took a train from Moscow to Vienna and stayed in Europe, never reaching Israel).[18] Of course, he could not return to the Europe of his childhood; as Aygi said, "There it was a different matter. The world turned out to be completely different, an entirely different Europe. It was unbelievably difficult for him."[19]

Volkonsky's departure dealt a heavy blow to his close friends. Aygi especially recalled it with sadness. He told me: "For me that was the end....I wrote for a long time about him and about the fact that everything had ended. With Andrey everything ended."[20] Aygi was to write a later poem on the departure called "To a Friend: On Jasmine Somewhere" (1979) that reflected his sorrow. For Aygi, it meant the end of his circle of artists in Moscow, which as he told me had "already fallen apart. Someone had already left, someone had died.... At the very beginning of the 1960s everything was,... perhaps, healthy,... [but] at the beginning of the 1970s everything became more real, so to speak."[21] A highly personal reflection on the departure of his friend, the poem began

16. Aygi, interview.

17. Ibid. Volkonsky gave many of his belongings to both Aygi and Baltin, among other friends, who slowly returned it to him on their rare trips to Europe. Kurtz puts his departure in May of 1973 (and is corroborated by Kamm). Kurtz, *Sofia Gubaidulina*, 102; and Kamm, "Composer Tells of Artistic Battle in Soviet." Pekarsky give the incorrect date of November 1971 for his departure. NVV: 196.

18. Schwarz, *Music and Musical Life in Soviet Russia*, 542; and NVV: 196.

19. Aygi, interview. For more on Volkonsky's experience after emigrating, see NVV: 192–201. After moving to Europe, Volkonsky went to several avant-garde festivals and, hating the music he heard there, began to write "retro-music," as Kholopov called it (Kholopov, interview, 8 November 2000). Volkonsky's new style is evident in his 1985 composition *The 148th Psalm* for three voices, organ, and trombones, heard on Volkonskiy, *Musica Stricta, Suite of Mirrors, et al.* By contrast, Volkonsky's 1989 composition *Was noch lebt* (on the same CD) is an austere vocal composition whose Webernesque style is similar to *Suite of Mirrors* and *Laments of Shchaza*. Ledenyov thought Volkonsky's departure a "very great mistake," believing that he would have composed more if he had remained in the USSR. See Ledenyov, "Mne vsegda khotelos' idti ot emotsiy," 21.

20. Aygi, interview. For a recollection of their first meetings (and their trip to Dagestan after Volkonsky's divorce from his second wife), see NVV: 215–16.

21. Aygi, interview.

in the world of his and Volkonsky's journey to Dagestan and ended with the prophetic scattering of Russia's artistic ashes in the direction of the oblivion that Aygi then thought lay in wait for the so-called Russia:

(budto	(As if
o t s u t s t v i ye	*absence*
veyan'yem	lengthens into a
dlitsya:	trend:
gde?—v umolkan'i takoy zhe "Rossii"	where?—in the silencing of the very "Russia"
davno raspilyayemoy	long ago scattered
nami i vami:	by us and you:
ot'yezdami-dushami!):	by departing souls!):
Dolgo: kak dolgoye-dolgo:	Long: like a long-long:
("gde-to"—ideyeyu pepla pustogo:	("somewhere"—to the idea of ashes of emptiness:
"vokrug"):	"around"):
rovnoye—v vozdukh-pozharishche.	evenly—into the air at the scene of a fire.[22]

In 1972 Gubaidulina set five of Aygi's poems for soprano and piano.[23] This cycle, called *Roses* (*Rozi*) was written before Volkonsky emigrated, but at a time when it must have seemed imminent (as Aygi reported, in 1972 he "began to leave"). The second of the five texts is a poem from 1962 written by Aygi for Volkonsky and titled "Bird from Beyond the Seas."[24] It reflects the period of the Dagestan journey, the "white-simple-and-mountains" of the later poem. How fitting that Gubaidulina's setting is a perfect example of "twelve-toneness," as its first measures indicate with their chromatic, motivic, quasi-twelve-tone pointillistic texture. The driving motive is that first heard in the piano and then in the voice: a chromatic tetrachord whose order varies, as does the interval content, as suggested by the expansion of one of the minor seconds to a major second in the first piano statement (in ex. 8.1, compare the beginning of the work with the first vocal entrance: G♯-A-B-C vs. C-C♯-D-E♭). Such a style

22. Aygi, "To a Friend: On Jasmine Somewhere" ("Drugu—o gde-to-zhazminakh") in *Mir etikh glaz-2: Aygi i yego khudozhestvennoye okruzheniye*, 97. The translation is my own.
23. Aygi's version of the genesis of this composition can be found in Kurtz, *Sofia Gubaidulina*, 98–100.
24. The five poems are "Dream: Path in the Field" ("Son: Doroga v pole"); "Bird from Beyond the Seas: To Andrey Volkonskiy" ("Zamorskaya ptitsa: Andreyu Volkonskomu"); "Roses in the Mountains" ("Rozï v gorakh"); "Field: At the Height of Winter—to René Char" ("Pole: V razgare zimï—Rene Sharu"); and "And: The Roses Wither" ("I: Ottsvetayut rozï"). The text for "Bird from Beyond the Seas" (1962) is reprinted in Talochkin and Alpatova, eds., *"Drugoye iskusstvo"*, I:274; as well as in NVV: 105. An English translation (with the Russian original) is in Aygi, *Selected Poems*, 48–49.

was, after all, the legacy of the technique and sound that Volkonsky was the first to employ in *Musica Stricta* and that eventually inspired the rest of the "young composers" (the central motive also resembles the opening English horn motive in *Laments of Shchaza,* see ex. 3.13a).

It is appropriate that Kholopova comments on the "Webernesque" aspects of Aygi's poetry, especially its long pauses, much like the characteristic pauses

Example 8.1. Gubaidulina, *Roses,* movement II, opening.

between measures in Volkonsky's compositions.[25] Aygi himself freely admits the impact that Webern's music (first played for him by Volkonsky) had on his writing with its "pauses and silence," pauses ultimately reflected in Gubaidulina's setting.[26] Thus *Roses* was influenced by Volkonsky's legacy in both its text and its music. It was also performed on 1 March 1973 by Davïdova and Gubaidulina at Frid's Moscow Youth Musical Club, an institution itself a legacy of the Thaw. At this concert a tape of Gubaidulina's *Night in Memphis* was played, and she dedicated the work to Volkonsky.[27]

Gubaidulina was one of the composers who stepped in to replace Volkonsky as Aygi's supporters (two decades later she would write two more works based on his poetry, *And: The Feast Is in Full Progress* for cello and orchestra, and *Now Always Snow* [*Teper' vsegda snega*] for chamber chorus and chamber ensemble, both from 1993). He told me that he also became friends with Silvestrov in the early to mid 1960s,[28] and as Aygi was to write: "Valentin Silvestrov...in many respects filled that emptiness that I began to feel after Andrey's departure. He is immensely gifted. He supported me in all of those desolate years. The awareness of the fact that he was working, creating new works, also helped me not fall into despair. Valentin Silvestrov and Sonya Gubaidulina are those personalities without whom it would have been difficult to hold on. Their creative energy helps me up to the present."[29] These comments point to the importance of the interactions between artists, writers, and composers at the time and the intimate artistic world they all inhabited, where the connections were tight between Moscow, Kiev, Tallinn, and Leningrad. They also suggest the deeply emotional reactions that audience members had to this music both in the 1960s and into the 1970s, the moral support that listeners felt knowing that these composers were "working, creating new works" even if they were only rarely heard. Indeed, it was their rarity that gave these works much of their aura.

POLYSTYLISM IN WORD AND DEED

All of the stylistic currents that were coming to the forefront at the beginning of the 1970s, including rock and jazz, were reflected in Schnittke's 1971 paper "Polystylistic Tendencies in Modern Music." In this essay, originally a

25. SG: 173.

26. Aygi, interview.

27. Kurtz, *Sofia Gubaidulina*, 102 and 277; and Aygi, interview.

28. Aygi, interview. Silvestrov wrote a song cycle *Forest Music* (*Lesnaya muzïka*) for soprano, horn, and piano (1977–78) to texts by Aygi. He also dedicated one of the *Silent Songs*, "Winter Journey," based on a Pushkin text, to Aygi.

29. *Mir etikh glaz-2: Aygi i yego khudozhestvennoye okruzheniye: Al'bom-katalog*, 96.

lecture, he discussed both the types of polystylism (whether through quotation or allusion), its historical development, and the factors that led composers to embrace it: the "crisis of neo-academicism of the 1950s with the purist tendencies in serialism, aleatory writing, and *sonoristika*."[30] He also noted the problems that polystylism could create, including the blurring of the boundary between quotation and plagiarism, whether it effaced the identity of the author using the quotations or allusions ("is the individual and national personality of the author maintained?"), and whether the use of polystylistic elements "lowered the absolute, association-less value of a work" (i.e., its abstract worth). Schnittke also advocated polystylism because it led to "the widening of the circle of expressive means, integrating 'low' and 'high' styles, 'banal' and 'refined', . . . a wider musical world and a general democratization of styles."

Schnittke cited Berio's *Sinfonia* ("In Memory of Martin Luther King," as he called it) as his prime example, and his description of that work summarizes his own goals for composing polystylistic music: "[Berio's *Sinfonia* is an] apocalyptic reminder of our responsibility for the fate of the world . . . expressed through a collage of quotations, that is of musical documents of various epochs—as in a documentary film ['dokumental'naya kinopublitsistika']."[31] Schnittke also spoke generally of the benefits of polystylism: "New opportunities arise for the musical-dramatic fulfillment of 'eternal' problems—'war and peace,' 'life and death,' and so on," before citing Zimmermann's opera *Die Soldaten* and Slonimsky's cantata *A Voice from the Chorus* as other examples of the successful use of polystylistic devices.[32] Despite the fact that the "crisis of academicism" in the 1950s that Schnittke spoke of actually occurred in the Soviet Union a decade later, and was something that he began grappling with in 1964, this article and the formation of the idea of polystylism represented the moment when the Soviet and European avant-gardes came together, when the Soviet unofficial composers finally "caught up" with the West. Yet the "eternal problems" that were facing Schnittke behind the Iron Curtain were very different from those

30. Schnittke's thinking in this article is still very much beholden to modernist myths of the "development of the organized unity of form" ("vozrastaniye organicheskogo edinstva formï"): "Organum—fauxbourdon—motet—imitative polyphony—temperament—functional harmony—tonal unity and tonal plans—the sonata-symphonic cycle—leitmotivic techniques—thematic factors—dodecaphony—serialism, etc. etc." See Shnitke, "Polistilisticheskiye tendentsii v sovremennoy muzïke," 329–30 (1990) (this section does not appear in the 1988 revised article).

31. In the 1988 revision this last phrase was altered to read: "—reminiscent of the documentary cinema of the 1970s" ("—eto zastavlyayet vspomnit' o kinopublitsistike 70-kh godov"). See Shnitke, "Polistilisticheskiye tendentsii sovremennoy muzïki," 24 (1988). In the SR version this reads: "—reminding one of cinema advertising in the 1970s" (p. 90), although Schnittke must be thinking of Romm's documentaries here, as in the remainder of the essay, and as its original wording suggests (see later).

32. All of the excerpts in this paragraph are taken from Shnitke, "Polistilisticheskiye tendentsii v sovremennoy muzïke," 329–30 (1990).

facing Berio in the West.[33] (In fact, a pluralistic approach similar to the concept of "polystylism" ["polistilistika"] had been advocated by the Russian composer Vladimir Shcherbachov in the 1920s.[34])

The work that put polystylism into practice was Schnittke's own First Symphony, Yekimovsky's "boundary" between the 1960s and 1970s, and a convenient, yet not entirely arbitrary, end point for the musical Thaw. Composed over the period from 1969 to 1972, this monumental work and its final funereal movement act as a summary of the Thaw in music and also acknowledge the beginning of the period of Stagnation. With this composition, Schnittke received a much wider resonance, thanks in no small part to the circumstances of its 1974 premiere in the closed city of Gorky, the city best known to Westerners as the place of internal exile for Academic Andrey Sakharov from 1980 through 1986.

Schnittke was able to obtain a performance, even in Gorky, only with the help of several officials, including Khrennikov and fellow composer Shchedrin.[35] Schnittke asked Shchedrin, then Chair of the Union of Composers of the Russian Republic (RSFSR), to write a letter on his behalf to the Gorky Philharmonic advocating the performance of the symphony. When I spoke to Shchedrin in Moscow in December 2000, he related that: "They had their own Party organization there, their own director, who was frightened....I was very friendly with the main conductor of the Philharmonic in Gorky—Izraíl' Borisovich Gusman [b. 1917]. And he also called me and said, 'help us, because they're going to fire everyone....'" Shchedrin complied with Schnittke's and Gusman's requests: "I wrote that it was a remarkable composition, and that it would be very interesting to perform it, and so on and so forth." Shchedrin continued: "I may only say what Schnittke did not know. This is the first time I'm telling anyone about this. When that scandal occurred,...the Central Committee of the [Communist] Party sent a courier to Gorky in order to bring the original of my letter to Moscow. I learned about it later. That is, they didn't believe it and demanded the original be presented to Moscow. Not simply [mailed], but [brought] by courier."[36] Apparently the Central Committee

33. For a useful consideration of the similarities between East and West, Schnittke and Rochberg around this time, see Fosler-Lussier, *Music Divided: Bartók's Legacy in Cold War Culture,* 164.

34. See Haas, *Leningrad's Modernists: Studies in Composition and Musical Thought, 1917–1932,* 90, 174, 180, and 197. Another possible Soviet influence on Schnittke (other than Pärt) was Boris Chaikovsky's Symphony No. 2 (1967), which included quotations from Mozart, Beethoven, Bach, and Schumann (Shostakovich's 1971 Fifteenth Symphony also includes prominent quotations from Rossini and Wagner, but it was not premiered until January 1972). See Fanning, "Shostakovich and His Pupils," 297.

35. Schwarz writes that "Khrennikov was in favor of giving it a chance to be heard and discussed." Schwarz, *Music and Musical Life in Soviet Russia,* 559.

36. Shchedrin, interview. Schnittke discusses Shchedrin's involvement in securing the premiere in BAS: 92–93.

was satisfied with Shchedrin's imprimatur and the go ahead was given for the performance, which took place on 9 February 1974.[37] Many made the journey from Moscow to Gorky to hear it. Cherednichenko remembers that "nearly an entire train full of Moscow's musicologists, composers, and other sympathizers left from the Kazan train station" to attend the premiere.[38]

The listeners in Gorky were greeted by a work in many ways more easily described than most from the Thaw, relying as it did on quick stylistic shifts, oppositions, and familiar quotations. The symphony was an extreme product of the musical dramaturgy of Schnittke's Second Violin Concerto, Violin Sonata No. 2 (*Quasi Una Sonata*), and *Serenade,* plus his *Suite in the Old Style* for violin and piano (1972) and his music for the unrealized ballet *Labyrinths* (*Labirinti,* 1971). Superimposed on this was the type of open theatricality that composers such as Kagel and others were then exploring in Europe, and that Silvestrov and Gubaidulina had already used in their own contemporaneous compositions. As Kholopova has written: "The symphony opened discussion with the listeners, a two-way contact of actor and viewer thanks to elements of theatricality and improvisation."[39] Yet at times the symphony was also strictly controlled by means similar to those in Schnittke's 1964 serial compositions as well as the more recent Double Concerto for Oboe, Harp, and String Orchestra (1971), *Canon in Memory of Igor Stravinsky* (1971), and *Pianissimo.*[40]

In 1969 Schnittke began writing the symphony for a variety of reasons. One of them originated in his experience in film music, namely the disparity it caused him to feel between his "serious" and "light" compositions. For many years (starting in 1962), Schnittke had been supporting himself by writing music for films.[41] Although Schnittke also taught at the Moscow Conservatory from 1961 through 1972 (orchestration, score reading, counterpoint, and composition), he owed his survival to the money he earned from film: "That work practically fed me. Fed me in the direct sense of the word....Besides my work in film I had no opportunity at all to earn money....I existed exclusively on what my work in film gave me."[42] We have already seen how

37. Schnittke later said that "up to the last minute it was not clear whether the concert would take place" ("Bis zum letzten Moment war es nicht klar, ob das Konzert stattfinden konnte"). Shnitke and Porwoll, "Verschieden Einflüsse und Richtungen," 26.

38. Cherednichenko, *Muzïkal'nïy zapas,* 55. See also Kholopova, *Kompozitor Al'fred Shnitke,* 107.

39. Kholopova and Chigaryova, *Al'fred Shnitke,* 87.

40. For a discussion of the Double Concerto, see Schmelz, "Listening, Memory, and the Thaw," 560–63.

41. Ivashkin, *Alfred Schnittke,* 104–18; and Kholopova, *Kompozitor Al'fred Shnitke,* 131–43 (primarily on his film music from the 1970s). See also Egorova, *Soviet Film Music: An Historical Survey,* 252–54 and passim. Aygi told me that in the late 1960s Schnittke was better known through his film music than through his concert music. Aygi, interview.

42. Shnitke, Makeyeva, and Tsïpin, "Real'nost', kotoruyu zhdal vsyu zhizn'...," 26.

Schnittke's film (and cartoon) music informed his compositions from the *Serenade* and *Quasi Una Sonata* onward, but his works from the late 1960s and early 1970s were often drawn directly from his film scores, including *Voices of Nature for Ten Female Voices* (*Golosa prirodï*, 1972), taken from the same score that inspired his First Symphony, and the *Suite in the Old Style*, taken from the scores to two films by the director Elem Klimov, *Adventures of a Dentist* (*Pokhozhdenii zubnogo vracha*, 1965) and *Sport, Sport, Sport* (*Sport, Sport, Sport*, 1970).[43]

Schnittke's film music gave him ample excuses to experiment with unusual timbres, techniques and juxtapositions of sound, in addition to a wider variety of styles. These experiments also caused him to rethink his approach to his "serious" compositions. As he later said, as a result of his work in film he began wanting to bring the "mud" into his serious work by crafting a "mixture" of "high" and "low" musics:

> There is not any type of musical material which would not serve to become
> [part of the mixture], and the trouble with contemporary music and the
> avant-garde was that in their formal searches—very pure and exact—they lose
> the "mud," and, after all, the "mud" is also a necessary condition of life....
> I have worked for many years in film and do Lord knows what, and then I write
> pure, serial compositions—now that order did not suit me—in that arises a
> definite lie—both in one and the other. All the same I can't drive out from my
> life the fact of working in film and performing rather low musical tasks. I can't
> for practical considerations. And I always felt that all of that should somehow
> combine in one composition.[44]

The First Symphony was the culmination of all of Schnittke's compositions—both high and low—up to that time (and in many ways those of the other "young composers" as well), just as it would go on to influence all of his compositions (and those of his fellows) afterwards. He later said, "Everything that I did later, after the First Symphony, was in a definite sense an offshoot from it, a continuation of its ideas and tendencies."[45] In fact, the new mixture he achieved was so successful that Schnittke later declared, "I succeeded for some time in continuing my work in film without becoming internally a slave to the director."[46]

Film inspired the First Symphony in a more direct sense as well, for Schnittke began writing the composition in 1969 while working on the

43. GNAS: 60–61.
44. Ibid., 67. See also Gerlach, *Fünfzig sowjetische Komponisten der Gegenwart*, 363–64.
45. Shnitke, Makeyeva, and Tsïpin, "Real'nost', kotoruyu zhdal vsyu zhizn'...," 22–23.
46. Ibid., 27.

music for director Mikhaíl Romm's film *The World Today* (*Mir segodnya;* this was the working title; its final title was *And I Still Believe...* [*I vsyo-taki ya veryu...*], 1971–75). In his unfinished film (later completed by his students Klimov, Marlen Khutsiev, and German Lavrov), Romm (1901–71) depicted contemporary social, political, and environmental problems, ranging from the Vietnam War and the Chinese Cultural Revolution, to pollution, the Left student movement in Europe and America, and drug addiction. Very little of Schnittke's music for the film ended up in the First Symphony (or vice versa; the two works share more general common features), but it caused him to become interested in the larger implications of his mixture of musical styles.[47] He also consciously attempted to respond to broader social and political concerns, concerns that he had touched on in the polystylism essay. In the program note that Schnittke provided at the premiere, he described watching "thousands of meters of documentary material" as he composed the score to *The World Today*. He declared that "if the tragic and beautiful chronicle of our time [in Romm's film] had not been imprinted in my consciousness, I would never have written [the symphony]."[48] These comments begin to explain why Schnittke later said that in the symphony he "began to concentrate more on not how to say, but on what to say."[49] What Schnittke might have been saying was informed not only by Romm's broad, personal survey of the "World Today," but also by the pivotal time, the "today," in which the symphony itself was composed and first performed. Schnittke told an interviewer in 1988: "It may be said—with a certain grain of salt, to be sure—that the First Symphony represents a response to a great deal, a response to the time in which it was written."[50] And it was written and first heard amidst the increasingly grim period of the early 1970s in the Soviet Union.

The other, more personal, inspiration for the First Symphony came from Schnittke's experience at the funeral of a friend's father in Moscow, where he heard the musical intermingling and conflict between several simultaneously sounding funeral marches emanating from different parts of the cemetery. This Ivesian cacophony was recreated at the opening to the final, fourth movement of the Symphony. This moment revealed that the time lag still had an

47. I am indebted to the British Film Institute and the School of Slavonic and East European Studies (SSEES) at University College London for allowing me to view their copies of the Romm film (and many thanks to Philip Bullock for helping to arrange my viewing at SSEES).

48. This "annotation to the score" as it was called, was printed in the *Sovetskaya muzïka* discussion of the symphony, "Obsuzhdayem Simfoniyu A. Shnitke," 13. The "annotation" does not appear in the manuscript copy of the score, and was most likely similar to a program note. See also Kholopova and Chigaryova, *Al'fred Shnitke,* 75.

49. Shnitke, Makeyeva, Tsïpin, "Real'nost', kotoruyu zhdal vsyu zhizn'...," 17.

50. Ibid., 23.

impact on the no-longer-young unofficial composers, for Schnittke later apologized: "That was thought up by me before I heard the compositions of Ives (I became familiar with them later, from 1970 to 1971, when I was sent an album with his works) and, ignoring the definite similarity, all of that arose independently of Ives."[51]

The resulting composition, one of the most mimetic from the Thaw, included numerous quotations, including Beethoven's Fifth Symphony, ragtime, free jazz, Soviet funeral music, the "The Death of Åse" from Grieg's *Peer Gynt*, Johann Strauss's waltz "Tales from the Vienna Woods," Gregorian chant (fourteen versions of the Sanctus), a twelve-tone form of the Dies Irae, Chaikovsky's Piano Concerto No. 1, and Haydn's "Farewell" Symphony (No. 45), in addition to self-quotations like the second movement's faux-baroque melody, taken from the second movement "Ballet" of Schnittke's *Suite in the Old Style* (remember that this itself was lifted from his scores to *Adventures of a Dentist* and *Sport, Sport, Sport*).[52] There were also aleatory sections and strictly calculated serial sections that were added to the collage of styles and quotations. All the "mud" of low art came together with high art in the dramatic mixture that Schnittke desired: from the theatrical opening with the gradual entrance of the improvising musicians and the prominent quotation of the transition between the third and fourth movements of Beethoven's Fifth Symphony (at what might be called the retransition of Schnittke's own first movement), to improvisation (both a cadenza for the entire ensemble and a "cadenza per solo") that interrupts the second movement (which itself contains a structure reminiscent of the intermingling, interrupted quotations in movement III of Berio's *Sinfonia*); from the strictly controlled serial third movement to the fourth movement's funereal collage and the quotation of Haydn's "Farewell" Symphony at the very end (Rozhdestvensky had paired the Haydn symphony with Schnittke's for the Gorky concert).[53] Valentina Kholopova regarded Schnittke's symphony and Romm's film as sharing a common worldview, both "capturing a tremendous chronicle of the contrasts of contemporary life."[54] Foremost among the "contrasts of contemporary life,"

51. GNAS: 63.

52. Ibid., 66.

53. "Gennadi Rozhdestvensky on Schnittke (1989)," 237. In Gorky, the improvisational moments featured the Melodiya jazz ensemble and especially trumpeter Vladimir Chizhik and saxophonist Georgiy Garanyan. See Shnitke, "On Gennadi Rozhdestvensky," 76. Schnittke analyzed the third movement of Berio's *Sinfonia* in his aptly titled essay, "The Third Movement of Berio's *Sinfonia*," 216–24. He rather implausibly downplayed the influence of Berio's work on his First Symphony. Schnittke might have heard *Sinfonia* for the first time in 1969, only after conceiving of his composition's form and polystylism (as he claimed), but undeniable similarities exist between the two compositions, suggesting some degree of influence nonetheless. See GNAS: 26.

54. Kholopova and Chigaryova, *Al'fred Shnitke*, 75.

that Schnittke captured in his First Symphony were the multiple musical influences of the Thaw. Schnittke's symphony became a musical documentary of the 1960s and 1970s, a compendium of the many tendencies, both foreign and domestic, that confronted the "young composers" as they had tried to catch up with Western modernism while still fighting to discover their own compositional voices.[55]

Despite Schnittke's later claims that serial techniques "guarantee...purity, but also sterility," amidst the clashing styles in the First Symphony, movements and sections were strictly serialized, as is the case with the entire third movement.[56] Like the earlier Double Concerto for Oboe, Harp, and String Orchestra (dedicated to Heinz Holliger), the third movement (like much of the symphony) was controlled by the Eratosthenes Row, the sequence of prime numbers (1, 2, 3, 5, 7, 11, 13, 17, 19 and so on) that Schnittke had been introduced to by the Romanian composer and former Khachaturyan pupil Anatol Vieru (1926–98), who had written a chamber piece called "The Riddle of Eratosthenes" (1969; *Sita lui Eratostene,* published in French as *Crible d'Eratosthene;* Schnittke translated the title as "Eratosthenes' Sieve" ["Eratosfenovoye resheto"]).[57] Schnittke's reliance in this movement on the Eratosthenes Row is significant because the greatest impression of the First Symphony is one of barely contained chaos, the freely cacophonic episodes standing out as emblematic of the whole. Yet we may recall that Schnittke claimed that before starting to compose the First Symphony he needed a structure, "even the most absurd."[58] Schnittke favored the Eratosthenes Row because it was a "third type of technique" that allowed him to generate sonorities that were "neither dodecaphonic, nor tonal."[59] Nonetheless, it did not completely replace serialism as a foundation for Schnittke's ideal of structured yet dramatic forms.

55. Despite his other statements to the contrary (especially those he made to Shul'gin), Schnittke later stated that the symphony had no "program," but acknowledged that because of the many quotations "it has a documentary feeling." Polin, "Interviews with Soviet Composers," 12.

56. GNAS: 67.

57. Ibid., 63–64. Vieru's use of the series in this score is very different from Schnittke's in any of his works. Vieru's composition is almost entirely graphic/aleatory, although it also uses quotations from Beethoven, Mozart, Sarasate, the Romanian composer Adrian Rațiu (b. 1928), and the composer himself, as well as spoken dialogue taken from Eugène Ionesco's play "The Chairs." All of the actions in Vieru's score are assigned a number from the Eratosthenes series, and each measure of the score is subdivided into its constituent prime numbers, thereby determining which actions (and how many of each) occur in that measure (e.g., m. 102 = 2 · 3 · 17, meaning that one instrument each perform actions 2, 3, and 17 in that measure; while m. 54 = 2 · 3³, meaning that one instrument performs action 2, while three perform action 3). Vieru, *Crible d'Eratosthene.*

58. GNAS: 66.

59. Ibid., 64.

Schnittke described the third movement as the most significant of the "strictly controlled serial episodes" in the symphony. He used the main series of the composition here, but also "calculated the rhythm, and the entrances, and everything that it was possible to calculate." Furthermore, Schnittke said, "There are…vertical and intonational or intervallic lines of some sort which were derived entirely from…the Eratosthenes row."[60] A brief glance at the first page of this movement reveals the specifics of Schnittke's "calculations."

The row for the piece is slowly unveiled according to the growing number of pitches at each entrance. The first violin entrances reveal one, two, and then three pitches, as each successive violin enters (ex. 8.2). The next entrances (r. 3) in the second violins reveals five pitches, followed by seven pitches in the first violins (r. 4). The number of pitches in each group of entrances thus follows the Eratosthenes Row, repeatedly cycling through the row until the given number has been reached. During the initial entrances there are also interjections on the snare drum, celesta, timpani, harpsichord, and piano distracting from the ongoing process. The number of instruments gradually expands with each successive group of entrances, eventually reaching the cellos and basses, as the dynamics also grow louder (although not according to strict calculation). The rhythmic values, by contrast, diminish. This process is prefigured by the gradually decreasing rhythmic values from voice to voice within each group of entrances but also within each voice upon each entrance, as in the initial second violin entrance where the durations for each part decrease by roughly one-quarter: whole note, dotted half, two-thirds, dotted quarter. For at least the first few entrances, the transposition level of each instrument (using either P or I, the only two row forms) is also determined by the sequence of pitches within P or I. That is, each new subgroup of entrances begins on the next pitch of P_0 (C-E♭-D-B-A♭-G-F-F♯-B♭-A-D♭-E): starting on C at the beginning, E♭ at rehearsal 1, D at rehearsal 2, B at rehearsal 3, and so on, using this pitch as the initial pitch of the row that each subgroup unfolds (e.g., P_3 at r. 1, P_2 at r. 2, P_{11} at r. 3). Furthermore, each instrument within each group of entrances often begins with the next pitch in the preceding instrument's series (e.g., after r. 2, the fifth violin enters on F, the second pitch in the row unfolding in the seventh violin that had begun on D—P_2). This process of growth—inspired in part by the "tree" structure in the *Music for Piano and Chamber Orchestra*—continues until the climax of the movement, beginning after rehearsal 10 in the basses, and reaching its peak on pages 110–13 of the autograph score with the final entrances in the first violins. At the climax, all of the voices gradually start voicing the repeating pitches of a radiant A major triad. The sheer sonic excess of this tonal gesture overloads the "strictly controlled" structure before crashing to C minor. The whole process then reverses itself.

60. GNAS: 63.

For Schnittke, the ongoing sense of narrative within the symphony was most important. Schnittke told Shul'gin that the fourth movement "represented its absolute center," and that the "preceding movements arise only to prepare it": "[The first three movements] are three conditions, three separate sensations—let's say, drama, genre, and lyrical sufferings ['pere-zhivaniya']—they are separated, cut off from one another—and in the finale there is an attempt to present all of them in parallel, like a single condition."[61] According to this loose narrative, Schnittke used serialism in the symphony to represent "lyrical sufferings." The third movement is thus not far removed from the symbolic structuring of *Pianissimo,* in which serialism was equated with brutal punishment. It again emphasized Schnittke's ambivalence to serial techniques. Schnittke wanted dramatic forms, but also wanted control over these forms. Serialism continued to appeal to the unofficial composers, even as they sought to break free from its aesthetic strictures. It provided a useful point of contrast to, and a useful constraint on, the mimesis that increasingly occupied their musical thinking.

Following the Gorky premiere, Schnittke's First Symphony could not be performed again; the difficulties of its first performance alone showed how troublesome it would have been to arrange additional performances closer to Moscow. The work did create enough of a stir to warrant two open discussions at the Union of Composers in late February 1974 (with Schnittke present) in addition to an extended treatment in *Sovetskaya muzïka* in the October 1974 issue based on another discussion that Schnittke did not attend.[62] The reactions at the open discussions at the Union of Composers ranged from those of A. Buzovkin who thought the symphony too negative, to those of the composer Boris Klyuzner (1909–75) who applauded that it "truly hears and sees what is happening in world," to those of Gubaidulina who enthused that it "stands among the most significant musical compositions that have ever existed."[63] The *Sovetskaya muzïka* article,

61. Ibid., 68. For an unsupported reading of the third movement based upon Bulgakov's novel *Master and Margarita,* see Adamenko, *Neo-Mythologism in Music,* 259–61.

62. Kholopova cites the "Stenograms of the Committee for Symphonic and Chamber Music of the Moscow Organization of the Union of Composers RSFSR" ("Stenogrammï komissii simfonicheskoy i kamernoy muzïki Moskovskoy organizatsii soyuza kompozitorov RSFSR") from 27 February 1974, but writes that there were "two entire discussions" (Kholopova, *Kompozitor Al'fred Shnitke,* 108 and 242). The symphony was also reviewed in the Polish periodical *Musical Movement* and was accompanied by photographs taken at the premiere, including the horn section marching on to the stage, a lone trumpeter playing, and Rozhdestvensky conducting. Pietrow, "Happening w Gorkim: Symfonia Alfreda Sznitke," 12–13.

63. Someone at these discussions also proposed that Schnittke receive a state prize for the work, but, of course, nothing came of this. Kholopova, *Kompozitor Al'fred Shnitke,* 108–9.

Example 8.2. Schnittke, Symphony No. 1, movement III, rehearsal 1–5 (interjections by snare drum, celesta, timpani, harpsichord, and piano before rr. 1, 2, 3, 4, and 5, respectively, are omitted).

titled "We Discuss the Symphony of A. Schnittke" ("Obsuzhdayem Sim-foniyu A. Shnitke"), included a similar diversity of opinions, accompanied by the typical concluding summation and official judgment by Korev. Alongside its own reviews, *Sovetskaya muzïka* reprinted reviews published shortly after the premiere in the local Gorky press. These more immediate responses hint at the excitement in the concert hall that evening. As V. Blinova wrote in the *Gorky Worker* (*Gor'kovskiy rabochiy*) on 19 February 1974 (that is, ten days after the premiere): "The public took in the entire evening, and Schnittke's symphony above all, in various ways. Some applauded

Example 8.2. *Continued*

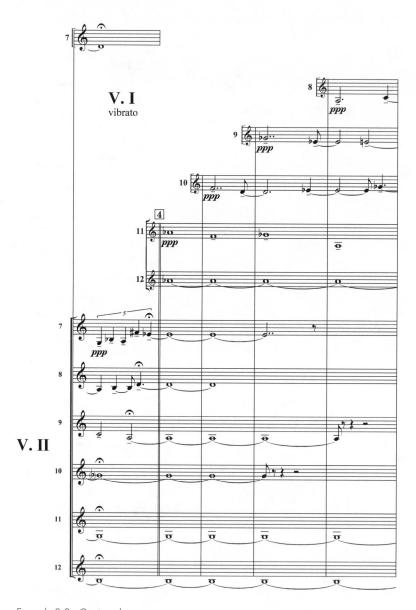

Example 8.2. *Continued*

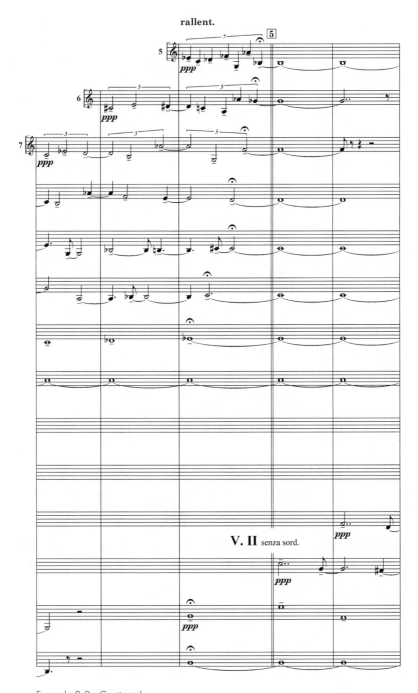

Example 8.2. *Continued*

passionately, in ecstasy from the originality; others were openly outraged; still others were not ecstatic, but watched everything with curiosity and patience and then seriously asked themselves and others: What was all of that for? And do people really need that music?"[64] In an aside, Manashir Yakubov (b. 1936) wrote that the "accessibility of the music was evident already at the premiere in Gorky, where it was enthusiastically received by the listeners, who had filled to capacity the Kremlin Concert Hall."[65]

The sheer excitement of the premiere is still palpable in the musicologist Inna Barsova's contribution to the *Sovetskaya muzïka* discussion: "The symphony of Alfred Schnittke is one of the most unusual compositions that I have ever had an opportunity to hear. Its effect did not disappear the evening of the premiere. It continues to this moment: I want to hear the symphony again and again if only on recording; you continue to persistently think about it."[66] Barsova is proof of how the first-hand impressions of the concert were transmitted, and how those in Moscow unable to attend the premiere heard about it from friends like Barsova or Savenko.[67] Barsova wrote: "When I attempted to 'retell' Schnittke's symphony for my friends in Moscow and explain to them how its very strong effect had been evoked, it turned out to be an effective though purely external narration, intriguing some to the very limit and calling forth the opposition of others."[68] Barsova's friends were shocked at what they heard and immediately asked her about the sheer logistics of the performance: "Why did [the musicians] walk [about the stage]?" and "Did so many [musicians] really immediately [improvise]? And didn't all of that prevent hearing the music?"[69]

These were the elements of the symphony that all the critics fixated on: its theatricality, the moments of improvisation, the use of collage and quotation, and the relationship of the symphony to "tradition," both Soviet and Western. Some, like Barsova and Yakubov, put it strongly in the symphonic tradition of precursors like Mahler and Ives (a similar use of space and the "music of the street" ["muzïka ulitsï"]) and also compared it with the (provocatively phrased) "genre utopias" ("zhanrovïye utopii") composed

64. V. Blinova, "Iz stat'i 'Koeffitsiyent poleznogo deystviya...bïl li on?'" from *Gor'kovskiy rabochiy*, 19 February 1974, reprinted in "Obsuzhdayem Simfoniyu A. Shnitke," 13.

65. Yakubov in "Obsuzhdayem Simfoniyu A. Shnitke," 20. Yakubov also noted on p. 21 that the improvised music was more "bright and compact" in rehearsal than in performance.

66. Barsova (b. 1927) in "Obsuzhdayem Simfoniyu A. Shnitke," 14.

67. Savenko wrote an article on the concert titled "The Outstanding Event of the Season" ("Yarkoye sobïtiye sezona"), which appeared in the *Leninskaya smena* (a local Gorky newspaper) on 28 February 1974. Portions are reprinted in "Obsuzhdayem Simfoniyu A. Shnitke," 13–14.

68. Barsova in "Obsuzhdayem Simfoniyu A. Shnitke," 14.

69. Ibid.

by these two as well as by Berlioz, Scriabin, and Beethoven.[70] Others, like Rozhdestvensky, downplayed the innovations of the symphony, focusing instead on its wider emotional compass.[71] These authors, of course, all had political goals in mind: trying to save Schnittke from being condemned as an "avant-gardist." By comparing him favorably to the general Soviet tradition or specifically to composers like Shostakovich, as the composer Boris Getselev (b. 1940) did in his discussion of large-scale form and dramaturgy in the composition, they might secure a chance for Schnittke's symphony to be heard again.[72]

In the characteristically overinflated preamble to his main remarks, Korev (then editor-in-chief of *Sovetskaya muzïka*) belittles this tendency: "They like the work and, *voilà*, already Schnittke's symphony appears in the ranks of the central traditions of Soviet symphonism, *voilà*, it already opens up new paths in the development of our art."[73] Korev, the central voice of authority in the discussion, had of course missed the premiere, although he reportedly had heard a tape of the performance (according to Schwarz, he "was a long-standing admirer of Schnittke's creative talent").[74] As was standard in such discussions, despite his reservations Korev admitted that he still regarded the works of Schnittke "with deep respect and faith," and also acknowledged that the symphony was at least "conceived in the tradition of the Soviet symphonic school."[75] Yet for Korev, it lacked an overall "grand idealogical-aesthetic conception," or an overall sense of a "whole."[76] He took issue with the fact that Schnittke made reference to a "chronicle" in his program note, declaring that it was exactly this quality of a loose sequence of events that limited the composition.[77] Korev also criticized the theatrical elements in the work, which he thought unmotivated, sniffing that "external forms of theatricality in and of themselves today do not shock or please anyone."[78] Ironically, Korev, like Getselev, found the serial third movement to be one of the highlights of the composition, with its "unusually expressive, profound music, among the best pages

70. Both phrases are Barsova's. Ibid., 16.

71. "G. Rozhdestvenskiy: Iz interv'yu vzyatogo nashim korrespondentom," in ibid., 14. Rozhdestvensky expressed a similar assessment in an interview with Ivashkin: "I found it a shocking experience, although I could sense the roots and threads linking its music with the past." See "Gennadi Rozhdestvensky on Schnittke (1989)," 237.

72. Note especially Getselev's comparison of Schnittke's and Shostakovich's epilogues in "Obsuzhdayem Simfoniyu A. Shnitke," 17.

73. Korev in "Obsuzhdayem Simfoniyu A. Shnitke," 22.

74. Schwarz, *Music and Musical Life in Soviet Russia*, 559.

75. Korev in "Obsuzhdayem Simfoniyu A. Shnitke," 22.

76. Ibid., 24.

77. Ibid.

78. Ibid., 25.

in all of Schnittke's work."[79] That the serial episode could come as a moment of relief for conservative critics after the other excesses of the score spoke volumes about the changing musical landscape, both the increasing official tolerance for serialism, but also the limits of mimetic music. For many listeners, Korev first and foremost, in the remainder of his First Symphony Schnittke had passed the boundaries of acceptable dramaturgy and circled back around to a new form of abstraction, an effect similar to the ultimately bewildering *Replika*. The conclusion proffered Korev's, and officialdom's, charged words of advice to the composer: this symphony's time had not yet come, and his "best composition remains his very old cantata *Songs of War and Peace*."[80] Korev thus delivered the conservative and critical verdict that had been expected of him, and the symphony was not performed again in Russia until the period of perestroika and *glasnost'* (although it was performed in Tallinn under the direction of Eri Klas in 1975).[81]

For the public, however, the damage had been done. The work circulated widely on bootleg tapes among musicians throughout the Soviet Union.[82] As the American musicologist Laurel Fay wrote years later: "One of my earliest encounters with Alfred's music took place with a group of student composers and musicologists at the Leningrad Conservatory in the mid-1970s. Crouched reverently around a prehistoric tape recorder, we strained our ears to disentangle the music from the white noise of an umpteenth-generation dub of his iconoclastic *First Symphony*, which had been premiered in Gorky in 1974. Never have I felt the 'relevance' of the experience of new music so palpably."[83] This unofficial *magnitizdat* dissemination established Schnittke's preeminence among the musical elite of the country. Schnittke's concerts had always drawn listeners, but thanks to the First Symphony's prominent press and wide distribution, he reached a new level of popularity and influence in the USSR. In a 1989 interview, Viktor Suslin even went so far as to call it the "*Gulag Archipelago* in music."[84]

79. Ibid. For Yakubov this moment was one of the "miscalculations" in the score that was too "drawn out" despite its "wonderful music for strings." Yakubov in ibid., 21. In his later (1979) discussion of the symphony, Aranovsky calls the third movement a "meditation" (Aranovskiy, *Simfonicheskiye iskaniya*, 165 and 169).

80. Korev in "Obsuzhdayem Simfoniyu A. Shnitke," 26.

81. Schwarz somewhat oddly viewed the "tone of the entire presentation" in *Sovetskaya muzïka* as "friendly and encouraging." Schwarz, *Music and Musical Life in Soviet Russia*, 559–560. There is a Rozhdestvensky Melodiya recording from 1987 (Shnitke, *Symphony No. 1*). The Tallinn performance is discussed in Kholopova, *Kompozitor Al'fred Shnitke*, 110.

82. Kholopova writes that one of her students, Igor Gershberg, was expelled for playing a tape of Schnittke's symphony to a group of students at the Moscow Conservatory, only to be reinstated later. See Kholopova, *Kompozitor Al'fred Shnitke*, 109.

83. Fay, "Remembering Alfred Schnittke."

84. McBurney, "Soviet Music after the Death of Stalin," 133. For a consideration of Schnittke's growing fame and its causes and effects from the late 1970s into the 1980s, see Kholopova, *Kompozitor Al'fred Shnitke*, 148–55.

Ivashkin writes that Schnittke's First Symphony "was the work which indicated for the first time that he was an heir of Shostakovich. Since then, all premieres of Schnittke's work in Russia have attracted a large and varied audience."[85] Ivashkin's first assertion is one that has been repeated so often in the popular press to require comment here.[86] No doubt evaluations like Getselev's that explicitly compared Schnittke and Shostakovich did much to cultivate this (both Getselev and Ivashkin gave great emphasis to the similarities between the codas and epilogues of the two composers).[87] The later very perceptive discussion of Schnittke's symphony in Mark Aranovsky's 1979 history of the genre in the USSR over the period 1960–75 also took this tack, comparing Schnittke's dramaturgy to Shostakovich's: "[In the First Symphony] Schnittke becomes a follower of the tradition of Shostakovich, for whom music was always a representation of one or another level of culture...," both high and low.[88] The similarity of tone and mood in many works by the two composers consolidated this claim, as did the quotations in Shostakovich's own Fifteenth Symphony (completed in 1971, premiered in January 1972). Of course, in a broader sense Schnittke's entire generation were heirs to Shostakovich, or more specifically, the "tradition of Shostakovich."[89] Yet Schnittke was certainly closer stylistically to Shostakovich than any of the others, as would become more apparent in his succeeding works, beginning most poignantly with his Piano Quintet (1972–76), dedicated to the memory of his mother.[90] More significantly, Ivashkin's statement underscores the fact that the premiere of Schnittke's First Symphony had a wider effect than any of the concerts of his generation since the success of *Laments of Shchaza* nearly a decade earlier in 1965. Schnittke's concerts had been noteworthy for some time, but after the premiere of the First Symphony it is easy to see how he achieved a new level of popularity. From this point,

85. Ivashkin, *Alfred Schnittke*, 123.

86. See Ivan Moody in the *New Grove Dictionary of Music and Musicians:* "[Polystylism] proved... to be an efficient generator of that kind of alienation, expressed through irony, which Schnittke inherited from Shostakovich, whose natural successor he has often been considered to be" (Moody, "Alfred Schnittke"); Paul Griffiths, writing in *The Times* in 1987: "Each new work by Alfred Schnittke establishes him more firmly as Shostakovich's heir" (Griffiths, "A Debut," in *The Substance of Things Heard: Writings about Music*, 1); and Alex Ross: "Schnittke... was Shostakovich's heir apparent," in Ross, *The Rest Is Noise*, 529. See also Schmelz, "What Was 'Shostakovich,' and What Came Next?" 319–28.

87. See Ivashkin, "Shostakovich and Schnittke: The Erosion of Symphonic Syntax"; and Getselev in "Obsuzhdayem Simfoniyu A. Shnitke," 17.

88. Aranovskiy, *Simfonicheskiye iskaniya*, 161. This echoes Schnittke's own statement to Shul'gin that he used an "emotional thought characteristic of the tradition called 'Shostakovich.'" GNAS: 27–28.

89. For more on this see McBurney, "Soviet Music after the Death of Stalin," 120–37; and Schmelz, "What Was 'Shostakovich,' and What Came Next?"

90. Like Shostakovich (e.g., in his late string quartets), many of Schnittke's most memorable compositions were dedicated to the memory of friends who had passed away. Another example is the hauntingly brutal Second String Quartet (1980), dedicated to the memory of the cinematographer Larisa Shepitko.

Schnittke suffered fewer repercussions from the regime than the more outspoken Denisov or even Gubaidulina.[91]

In the West (and specifically in Great Britain and America), critics and historians also wrangled over the meaning and significance of the First Symphony and Schnittke's music in general, but by the mid-1990s a common consensus had emerged.[92] Rare is the musicologist, such as Taruskin, who has actually objected to using the term "postmodern" to describe Schnittke's music.[93] Far more representative are those such as Jonathan Kramer, who comfortably lumped Schnittke's First Symphony in with the usual litany of "postmodern" compositions that "simultaneously embrace and repudiate history," including works by Zygmunt Krauze, John Adams, Henryk Górecki, Rochberg, Steve Reich, John Corigliano, Bernard Rands, and Berio.[94] Whether or not they call him a postmodernist, many musicologists and critics also see Schnittke's work as an embodiment of the contemporary condition of art music in Europe and America as well as in Russia. In an essay from 1992, the possible height of Schnittke reception in the West (when America at least was still morbidly curious about the tortured artistic products of its former cold war adversary), critic Alex Ross wrote in the *New Republic* that: "Schnittke represents not only a moment in the history of Russia, but also a moment in the history of music. He will not vanish when his times are up. The multiplicity of styles, of schools, of genres; the weight of an impressive past; the brilliance and energy of present-day 'popular' modes outside the classical tradition; the possibilities of a future in which parochial barriers will crumble away—all this is acutely observed in Schnittke's music."[95] And the musicologist Glenn Watkins declared in 1994:

91. Kholopova notes some difficulties that arose for Schnittke during the 1970s: he resigned from his post at the Moscow Conservatory in 1972, and further general troubles arose after he alone refused to vote for Khrennikov's reelection to the post of chairman during the Union of Composers Congress in 1975. Kholopova, *Kompozitor Al'fred Shnitke*, 120–21.

92. I am not discussing the German-language reception of Schnittke. See Wolfgang Gratzer, "'Postmoderne' überall?: Aktuelle (In-)Fragestellungen im Blick auf sowjetische Musik nach 1945," 63–87; and also Tillman, "Postmodernism and Art Music in the German Debate," 75–92.

93. Taruskin, "After Everything," 99.

94. Kramer, "The Nature and Origins of Musical Postmodernism," 13–14. Lemaire also openly discusses "Schnittke's postmodern symphonies" ("Les symphonies postmodernes d'Alfred Schnittke"). Lemaire, *Le destin russe et la musique*, 449. See also Rothstein, "A Russian at Play amid the Wreckage of a Lost Past," C15; and Wright, "Peinture: Some Thoughts on Denisov," 243. It is reassuring that several other commentators are generally reluctant to directly label Schnittke "postmodern." Leading twentieth-century survey authors such as Morgan and Griffiths take varying approaches, from Griffiths's more considered, albeit brief appraisal that avoids the term altogether, to Morgan's placing of Schnittke alongside Henze and Cage as composers who used "quotational procedures" after 1970. See Griffiths, *Modern Music and After: Directions since 1945*, 252–54; and Morgan, *Twentieth-Century Music*, 415–16. In her article on "Postmodernism" for the *New Grove Dictionary of Music and Musicians*, Jann Pasler also links Schnittke (and Berio) with a type of postmodernism favoring quotation and collage, but only mentions Schnittke's Third Quartet as an example (Pasler, "Postmodernism").

95. Ross, "The Connoisseur of Chaos," 30.

"Alfred Schnittke, whose music first became widely known outside the Soviet Union in the late 1970s and 1980s, showed a particular disposition to play the collage game throughout this period—not via his native Russian repertoires but through an obsessive exploration of Western European traditions, both high and low. In this it is possible to view him as an agent provocateur in the dissolution of the Iron Curtain mentality."[96] Although Schnittke's music might have begun circulating beyond the Soviet Union's (and the Eastern Bloc's) borders at the end of the 1970s, it took nearly twenty years and the end of the cold war for Western listeners to critically engage with his music. At this time Schnittke provided Western critics and historians an additional, striking confirmation of what they perceived as a general aesthetic condition. In an abundance of diplomatic good-will, critics sought to ensure Schnittke's historical position by calling attention to his cosmopolitan, which is to say Western, attributes (even if it meant the risk of ghettoizing Russian composers, as Watkins does, by assuming that Schnittke should be exploiting his "native Russian repertoires" while he simultaneously ignores the obvious Russian sources at play in Schnittke's music). By the end of the 1970s, early astute and sympathetic commentators in the Soviet Union like Aranovsky were also able to assert that "Schnittke's symphony recreates a many-sided sound portrait of contemporary civilization."[97] Aranovsky pit Berio's *Sinfonia* against Schnittke's First Symphony and found the former lacking, because Berio's *Sinfonia* did not "pretend to a conception... of such a wide scale" as Schnittke's symphony, which was a "condensed drama of a conception global in scale" (of course, Aranovsky felt it necessary to add that the Soviet symphony had always addressed such global issues).[98]

After the fall of the Soviet Union, Russian scholars became increasingly concerned with definitions of postmodernism.[99] As one might expect given the topic, there are numerous competing interpretations of the phenomenon, many, like Mikhaíl Epstein's, initially rooted in the uncertainties of the "transitional" Russian 1990s. Most writers agree, however, that something new began to happen in Soviet art already in the 1970s.[100] During this decade, the modernism of the avant-garde of the 1960s gave way, at least in the visual arts, to

96. Watkins, *Pyramids at the Louvre*, 410.

97. Aranovskiy, *Simfonicheskiye iskaniya*, 161.

98. Ibid., 165. Kholopova also compares Schnittke's First Symphony to Berio's work, and argues multiple times for the important role of the former—and especially its composer—in "saving all of musical culture at the end of the 20th century." Kholopova, *Kompozitor Al'fred Shnitke*, 92–94 (on Berio) and 8, 128, and 153 (on Schnittke's role in developing a new "universal" musical language).

99. See, e.g., Epstein, Genis, and Vladiv-Glover, *Russian Postmodernism*.

100. See Epstein, "The Origins and Meaning of Russian Postmodernism," 210; Epstein, "Conclusion: On the Place of Postmodernism in Postmodernity," 467 (see also Epstein's introduction to the same volume); Groys, "The Other Gaze: Russian Unofficial Art's View of the Soviet World," 56; and Groys, *The Total Art of Stalinism*, 75–112.

"conceptualism."[101] But something new also began to happen in Soviet music, whether or not one wants to call it postmodern: abstraction ceded way to— or "productively interacted" with—mimesis, and mimesis took increasingly different forms in each composer's maturing style, often including wholesale resuscitations of earlier tonal models. These musical shifts are best represented by Schnittke's First Symphony, for as critics like Aranovsky noted, it success- fully mirrored the sound world of the contemporary Soviet Union, progres- sively permeated by Western music of all styles and genres, and ever more frustrated by the lack of clear direction they collectively signaled.[102]

Schnittke's First Symphony dealt directly with the stylistic mess of late 1960s and early 1970s Soviet culture. Even his mimetic works from the late 1960s had not been so avowedly (and comprehensively) representational. This is why Ivashkin is wrong to assert that: "Only after that [the collapse of the Soviet Union and Schnittke's move to Hamburg] did his compositions start to be appreciated in the West as a very important part of twentieth-century music, without any local and idiosyncratic Soviet flavour."[103] That the Soviet mess had grown close to that of the West is important, but such outward simi- larities should not blur the dramatic political, social, and cultural differences that continued to persist. After all, Schnittke's First Symphony represented the moment the musical Thaw moved onto a new stage, from Thaw to Stagnation, or from the Thaw to Yurchak's "late socialism."

THE END OF THE SOVIET SIXTIES

As Aygi's description of the period after 1974 as the "desolate years" or the "deaf years" suggests, the era of Stagnation touched all of Soviet society. In 1974, the year of Schnittke's First Symphony and the year after Volkonsky's depar- ture, several events took place that demonstrate a widespread cultural shift. It began with the forced exile of Solzhenitsyn (February 14) and continued with the May departure, purportedly for two years of touring, of Rostropovich and his wife Galina Vishnevskaya (their Soviet citizenship was revoked in 1978). As if to drive home the point, the representatives of the artistic Thaw were literally and symbolically crushed in what became known as the "Bulldozer Exhibition" held near Belyayevo in southwest Moscow on 15 September 1974

101. See Groys, "The Other Gaze: Russian Unofficial Art's View of the Soviet World," 57–58.

102. For Savenko, on the other hand, polystylism pointed in a clear, if essentialized and nation- alistic, direction: it "returned Soviet composers to the bosom of the national spiritual tradition, connected with the discussion of existential problems." Savenko, "Poslevoyenniy muzïkal'niy avan- gard," 424.

103. Ivashkin, *Alfred Schnittke*, 124.

(organized by Rabin and Nemukhin).[104] At this event bulldozers moved in to break up an outdoor exhibition of unofficial visual art. At the end of the 1980s Aksyonov described the subsequent officially sanctioned exhibit in Izmailovo Park on 29 September, permitted as a "concession" for the shocking brutality at the first: "It was a fine Indian summer day, and a crowd several thousand strong, representing Moscow's unofficial art colony, gathered to have a look at what was new in art and to show their solidarity with the daring artists. It was an unforgettable day and one never to be repeated (at least half of the artists, weary of senseless persecution, have since moved abroad, and probably a third of the art lovers have followed), but at least it gave us an inkling of what the 'real' sixties had been like." Aksyonov, like many historians, declares that "in August 1968...two years early, the sixties came to an abrupt end in the Soviet Union...[when] Soviet troops...invaded Czechoslovakia," but he also suggests that the Izmailovo exhibit of late 1974 was the last gasp of the Soviet sixties, the simultaneous summary and recollection of an era that in some senses had never been, of a promise that remained unfulfilled.[105] Music had no event as violently dramatic as the Bulldozer Exhibition to mark the end of its Thaw, but as with the Manezh exhibit in 1962, the assault on the visual arts in 1974 and the subsequent immigration of many of the leading figures of unofficial art (preceded by the immigration of the leading figure of unofficial music) indicated a change in the official response to all the arts. (For many musicians Shostakovich's death in 1975 also marked a decisive turning point.)

The rest of the 1970s unfortunately merited the retrospective label of Stagnation assigned the decade during perestroika. Although American reception of contemporaneous Soviet events should usually be viewed with skepticism, Harold Schonberg's article in the *New York Times* of 29 September 1974 touched on the general surface malaise of Soviet artistic life during the years of "immutability" under Brezhnev. Titled "Is Anyone Writing Serious Music in Russia Today?" the article was provocatively illustrated with photos of both a youthful Denisov ("Avant-gardist Denisov 'seems to have disappeared'") and a fiery Shostakovich with a clenched, raised fist ("Shostakovich is the only Soviet who 'gets any play'").[106] Schonberg began by noting the Bulldozer Exhibition and went on to write: "Things seem to be as bad as ever....Painters still cannot paint the way they want to; musicians cannot compose according to their

104. This was also known as the "First Fall Open-Air Show of Paintings" and the follow-up exhibition at Izmailovo (Izmailovskiy) Park in Moscow was known as the "Second Fall Open-Air Show of Paintings" (also called by at least one critic the "Soviet Woodstock"; see Barabanov, "Art in the Delta of Alternative Culture," 24). See, among others, Glezer, ed., *Iskusstvo pod bul'dozerom,* esp. 9–45; the chronicle of artistic events in Talochkin and Alpatova, eds., *"Drugoye iskusstvo";* Baigell and Baigell, eds., *Soviet Dissident Artists,* 5 and 96–97; and White, ed., *Forbidden Art,* 114, 313, 300, and 303.

105. Aksyonov, *In Search of Melancholy Baby,* 197–98 ("It was a fine..."); 196 ("in August 1968...").

106. Schonberg, "Is Anyone Writing Serious Music in Russia Today?"

own dictates.... Many talented young people who would like to compose turn instead to performance.... The result is artistic sterility. Soviet culture means virtually nothing to the world today.... How long can the Soviet ideologists sit on their creators and intellectuals? What are they afraid of?"[107] There are, of course, many oversimplifications here typical of American commentators. Aaron Copland made a similar diagnosis in the revised edition of his *The New Music,* where he wrote, "Where are the adventurous [Soviet] youngsters who can hold their own with their counterparts in Western Europe or Japan or America?... If they do exist, they are not being exported."[108] It is understandable why Schonberg and Copland could see only the bleak surface of Soviet society from their vantage point. Yet during the 1970s the unofficial composers continued to compose and continued to receive performances. The opportunities to hear newer music also increased dramatically after 1970, as Yekimovsky recalled and as Lyubimov's notebook of his "avant-garde" music concerts records (he stopped keeping track after 1976, perhaps an indication of how routine such performances had become by then). Composers were writing "serious music" in Russia, but their music was not being presented in New York for critics such as Schonberg or in the main concert halls of Moscow for Soviet officials. They continued to be heard primarily in smaller, out-of-the-way venues in order to circumvent those officials who still attempted to limit or prevent their performances. At the same time, the most prominent of the unofficial composers, Denisov, Gubaidulina, Schnittke, Pärt, and Silvestrov, all became better known and generally received fewer direct attacks from the government than had been the case in the 1950s and 1960s.

There were two exceptions. The first was directed at Schnittke as a result of his contribution to the theater director Yuriy Lyubimov's production of Chaikovsky's *Queen of Spades* planned for the Paris Opera in 1978, to be conducted by Rozhdestvensky, and loosely modeled upon Meyerhold's 1935 Leningrad production of the opera. Schnittke had been called on to compose new music to fit Lyubimov's/Meyerhold's reconception of the opera, including a revised text and reshuffled scenes more closely matching the original Pushkin story. The chief outrage on the part of Soviet officials came from the idea that Schnittke, et al., were "[destroying] the great heritage of Russian culture," by tampering with Chaikovsky's original.[109] The letter containing this statement

107. Ibid., as quoted in Boris Schwarz, *Music and Musical Life in Soviet Russia,* 560–61.

108. Copland, *The New Music,* 84–85; cited in Schwarz, *Music and Musical Life in Soviet Russia,* 534. During his 1960 tour of the USSR, Copland was finally able to hear compositions by some "adventurous youngsters," including Pärt, Schnittke, and Volkonsky. See Pollock, *Aaron Copland,* 464. Copland wrote about the tour himself in his "Composers in Russia."

109. Hakobian, *Music of the Soviet Age,* 280–81. See also Kholopova, *Kompozitor Al'fred Shnitke,* 143–49; BAS: 197–201; and Shnitke, "On Staging Tchaikovsky's *The Queen of Spades* (1977)," 53–55.

was published in *Pravda* on 11 March 1978, and as a result the production was quickly halted (it was staged as envisioned by Lyubimov with Schnittke's new music in Karlsruhe only in 1990).[110]

A second exception was the so-called Khrennikov Seven ("Khrennikov-skaya semyorka"). Proclaimed in 1979 by Khrennikov in an address at the VI Congress of the Union of Composers USSR, this list included the following names: Elena Firsova, Dmitriy Smirnov, Alexander Knaifel' (b. 1943), Suslin, Vyacheslav Artyomov (b. 1940), Gubaidulina, and Denisov.[111] Schnittke's name was conspicuously absent, although he told Schwarz at the time that his "relations with Khrennikov are strained."[112] The real brunt was borne by Denisov and his pupils (Firsova, Smirnov, Suslin). (Of all the unofficial composers, Denisov had arguably the greatest impact on the next generation as a pedagogue, both in Moscow and later in Paris.)[113] In fact, Yekimovsky wrote that "according to Dima [Dmitriy] Smirnov, after that, neither radio, nor television, nor the Philharmonic, nor the publishers, nor the ministries bought one of [Denisov's] compositions."[114] The Khrennikov Seven list shows that even into the 1980s troubles persisted for some of the unofficial composers (of both generations) but not for others. The vagaries of Soviet life continued, despite the appearance of increasing "immutability."

CONCLUSION

Hakobian claims that the Soviet "musical avant-garde" ended on 15 April 1982 at a concert in the Large Hall of the Moscow Conservatory featuring Denisov's *Peinture*, Gubaidulina's *Offertorium*, and Schnittke's incidental music from a production of Gogol's *Inspector General* (at Moscow's Taganka Theater), together with a March for Symphony Orchestra composed by all three of the composers.[115] As Hakobian writes, "Thus, three years before the first timid steps of *Perestroika*, any discrimination on ideological ground had virtually disappeared from the sphere of serious music in the USSR."[116] This concert

110. The letter to *Pravda* appears in BAS: 197–98. See also Bogdanova, *Muzïka i vlast'*, 89–103, 431.

111. Kholopov and Tsenova, *Edison Denisov*, 35; Vlasova and Daragan, *Soyuz kompozitorov Rossii: 40 let*, 131–32, quoting from "Velikaya missiya sovetskoy muzïki," 14.

112. Schwarz, *Music and Musical Life in Soviet Russia*, 631 (Schwarz discusses the list on pp. 623–26).

113. Smirnov and Firsova remain vocal proponents of Denisov's music. See in particular Smirnov's appreciation of "Denisov the Teacher": Smirnov, "Denisov—uchitel'," 206–9.

114. Yekimovskiy, *Avtomonografiya*, 117.

115. For more on the program, see Rozhdestvenskiy, *Preambuli*, 128–36.

116. Akopyan [Hakobian], "The Beginning and End of the Soviet Musical Avant-Garde: 1956–1982," 78. I am indebted to Professor Hakobian for allowing me to see a typescript of this essay before its publication.

was undeniably a milestone for Schnittke, Gubaidulina, and Denisov within the Soviet Union, marking their acceptance by officials, and uniting them in the public's mind as the "Moskovskaya troitsa."[117] Hakobian's interpretation has some merit, but by focusing only on official ideology he overlooks earlier changes in musical style and audience response, the fact that the compositional interests and popular reception of the three composers were markedly different during the 1970s and 1980s than during the 1960s.

The 1960s were a time of gradual technical and stylistic development for the unofficial composers to which Soviet officials responded by gradually and begrudgingly accepting their previously taboo techniques. Audiences went willingly along for the ride, drawn as much by the novelty of the sounds and texts they were hearing as by the air of illegality surrounding the music and its composers. They were also drawn by the camaraderie of the "suspended" venues in which the music was performed, where, buoyed by the promises of the Thaw, they could often openly question many of the once-sanctified verities of official Soviet life.

Even as officials began responding more positively to their music, the composers became dissatisfied with the abstraction engendered by their newfound compositional techniques, and primarily serialism. Their mimetic styles of the late 1960s were an attempt to combine the new techniques, including serialism, but particularly aleatory devices, with a more familiar musical rhetoric, the rhetoric of the eighteenth and nineteenth century classics as well as the rhetoric encouraged by socialist realism. Mimetic compositions from the late 1960s, such as Pärt's *Pro et Contra* or Schnittke's Violin Sonata No. 2 (*Quasi Una Sonata*), literally enacted the stylistic confusion of the unofficial composers, as they attempted to negotiate between serialism, aleatory, and the familiar gestures of tonality. Schnittke's polystylism was an extreme extension of this dramatic approach. Its often striking juxtapositions of dissimilar styles reflected not only the stylistic muddle of his own work in film and art music, but also the muddle of his generation, and of Soviet society writ large.

The 1970s were a pivotal moment musically, when the mature styles of Schnittke, Denisov, Gubaidulina, Silvestrov, and Pärt were formed and began to be displayed (Volkonsky, of course, developed differently because of his emigration). These composers created some of their most memorable music during this decade; stylistic development continued despite the apparently static nature of society.[118] The music and social changes of the 1960s continued

117. Fay rightly points to the "localized" significance of this concert: the main works on this program had already been premiered in Western Europe. See Fay, review of Levon Hakobian, *Music of the Soviet Age, 1917–1987*, 166. See also Cherednichenko, *Muzïkal'nïy zapas*, 52.

118. See Schmelz, "What Was 'Shostakovich,' and What Came Next?" 332–33; and Mazo, "The Present and the Unpredictable Past," 372.

into the 1970s but in many respects the idealism was lost. Clubs persisted, but now younger listeners were more interested in rock and roll than in "serious" art music. No longer were composers driven to explore all of the techniques that had been denied them. In a broad sense, anything and everything became possible. With Schnittke's First Symphony, the era of late socialism began, and Yurchak's "immutability" set in. Now audiences recognized that certain things could be heard in limited amounts in selected venues, but that drastic aesthetic, social, and political changes would be impossible. The promise and the idealism first fostered under Khrushchev were no more, replaced instead by the perceived immutability of the existing state of affairs.

EPILOGUE: REFLECTIONS ON MEMORY AND NOSTALGIA

In those days [the Thaw]... it was not a matter of being original or innovatory. Official stagnation repulsed them to such a point that painters were enthusiastic about all manifestations of a living art, whatever it may be.

—Oscar Rabin (1981)

[Former East Germans] don't have to be ashamed [and can] look back at their memories in a positive or nostalgic way, because even in a dictatorship, positive things in personal life happen.... You have your first kiss. You have your father and mother. You don't have to hide your memories because you were unlucky enough to experience things under the wrong circumstances.

—Wolfgang Becker to Duane Dudek (2004)

The years of the underground composers were a time of genuine hunger for something original or fresh. They were not always pure and wonderful. They were good enough. They don't need to be idealized.

—Vladimir Feltsman to Joseph Horowitz (2003)

In the 2003 film *Goodbye, Lenin!* (directed by Wolfgang Becker), a young East German named Alex enlists the support of his family and friends in a bizarre enterprise. The year is 1989. Just before the collapse of the government, Alex's mother, a devout communist, lapses into a coma after seeing him participating in a protest march. When she regains consciousness several months later, following the fall of the East German government, Alex wants to protect her health and spare her the shock were she to discover the upheavals that had occurred while she was unconscious; thus he engineers an elaborate charade to perpetuate the communist regime even as it unravels before all of their eyes. As might be expected, Alex's scheme necessitates some creative lying. One

of the more extreme moments occurs when his confused mother encounters West Germans moving into their apartment complex. In response, Alex and a friend construct a fake newscast that shows refugees from the economically failing West granted asylum (and a stipend) in East Germany by the benevolent Erich Honecker.

By the end of the film, as his collaborators grow tired of the game, Alex realizes that it was he who was nostalgic for the past, he who wanted to prolong the comfortable fiction of life in the German Democratic Republic. He states: "Somehow, my scheme had taken on a life of its own. The GDR I created for [my mother] increasingly became the one I might have wished for." We realize that Alex's mother and the GDR are connected for him. By fabricating an ideal GDR for her, he is creating both an ideal mother and an ideal "motherland" for himself. When his mother dies just three days after unification, Alex recognizes that he was only protecting himself. Alex patches together a utopian GDR from the fragments of his memory, trying to retain its essence even as it and his mother both slip irrevocably away. He says at the film's close, "The country my mother left behind was a country she believed in, a country we kept alive until her last breath, a country that never existed in that form, a country that, in my memory, I will always associate with my mother." Nostalgia and utopia intertwine; the utopian future traditionally predicted by the communist propaganda machine has now become an idealized past.[1]

The sentiments of a film like *Goodbye, Lenin!* still strike Western, and especially American, viewers as unusual, simultaneously humorous, quaint, and misguided. In fact, critics like David Denby took a typically American perspective on the film, writing that the "point of the fable . . . is that Communism in Germany was always an ersatz reality—that for forty years Party leaders were creating a large-scale version of the fiction that Alex creates in his mother's bedroom."[2] This is undeniably one aspect of the film's message, but it does not account for the film's success in Germany; it misses out on the nostalgia that is the primary emotion of the film. Denby continues, "Yet the movie is

1. The success of the film in Germany is attributable not only to the "Ostalgia" for life in the GDR (after the German for "East"), but also to nostalgia for the heady events of late 1989. See Wassener, "Let's Do the Timewarp Again," 10. See also Berdahl, " '(N)Ostalgie' for the Present: Memory, Longing, and East German Things," 192–211; and Bach, "The Taste Remains: Consumption, (N)ostalgia, and the Production of East Germany," 545–56.

2. Denby, "Women and the System: 'Goodbye, Lenin!' and 'Osama,'" 92. A useful counterexample is the National Public Radio report by Emily Harris on the film that includes the reactions of former East Germans. Harris, "New German Film 'Goodbye, Lenin!' bringing nostalgic feelings to former East Germans." For more on opinions East and West during the immediate post-1989 period, see von Plato, "The Consensus against the Victors, 1945 and 1990," 73–79.

sweetly enjoyable as a sardonic elegy for a dream that went bust. It lets both the system and its recumbent heroine down easily, with a wistful sigh of regret rather than a blast of scorn." Denby clearly longs for that blast of scorn. But the value of a film like *Goodbye, Lenin!* is its ability to put a human face—if only fictional—to the increasingly distant communist past, not to scornfully blast the communist regime yet again for creating only an "ersatz reality." The point is that Alex misses and longs for that "ersatz" reality. He is nostalgic for his past. (The "blast of scorn" was delivered in 2006 with Florian Henckel von Donnersmarck's fictionalized account of the East German *Stasi* in his *The Lives of Others,* an undeniably gripping film that nonetheless more closely matches American—or rather non-German—preconceptions, as Timothy Garton Ash has commented.[3])

Denby's reading of Alex's machinations on behalf of his mother and his motherland is similar to the astonishment that greeted the Russian government's decision in late 2000 to keep the old Alexandrov hymn from the Soviet regime, changing only the words.[4] As one British journalist wrote, was this "a mere blip on the road to a democratic future, or the latest step by the old guard to return to the bad old days?"[5] Although in many ways a blatant example of Putin's efforts at tightening and centralizing his political control, the return of the old Soviet anthem also responded to and reflected deeper societal and cultural yearnings within Russia, yearnings similar to Alex's fabrication of his idealized version of the GDR. These yearnings were taken even further by the director Alexander Sokurov's beguiling yet disturbing *Russian Ark* (*Russkiy kovcheg,* 2002), in which nostalgia was evinced not for the Soviet past but for nineteenth-century Imperial Russia.[6]

There have been many attempts over the past decade and a half to examine the musical effects of the change from communism to postcommunism across Eastern Europe and Russia, particularly the impact the political, economic, and social changes had on folk, traditional, or other popular musics.[7] Anthropologists especially have been interested in the impact that this "transition" has had on those writing ethnographic studies of the region, leading many to question whether the idea of "transition" was not itself a myth, a teleological narrative imposed on the former communists by Westerners desiring and indeed expecting that they move from communism to a Western brand of

3. Garton Ash, "The Stasi on Our Minds."

4. For an analysis, see Daughtry, "Russia's New Anthem and the Negotiation of National Identity," 42–67.

5. Warren, "Putin Revives Soviet National Anthem," 19.

6. For a historical critique of the film, see Kachurin and Zitser, "After the Deluge: *Russian Ark* and the Abuses of History," 17–22.

7. See, e.g., Slobin, ed., *Retuning Culture: Musical Changes in Central and Eastern Europe.*

market capitalism.[8] Anthropologists have also considered the broader symptoms of what the anthropologist Marko Živković has called the "post-socialist syndrome," one of which is nostalgia.[9] This is a matter that oral historians of the Soviet period have also encountered as they have interviewed, for example, survivors of the Gulag, some of whom have surprisingly positive recollections of their incarceration.[10]

While I conducted interviews with numerous post-Soviets over the course of my research for this book, it became clear that I was learning about not only the past, but also the present, the period from 1999 to 2001, a moment when "transition" did indeed seem like a myth, and nostalgia for the securities of the past was growing ever more acute. I was faced with a dilemma familiar to both oral historians and ethnomusicologists, struggling to sort out the implications of their informants' conflicting narratives about the past. In my case, although I was focused more on past than present, I also needed to consider the contemporary causes and implications of the stories they were telling me. In *Goodbye, Lenin!* the fantasy elements of the East Germany Alex presented for his mother tell us as much as the truthful elements. The same holds for my informants' memories about the Soviet past.

When interviewing Davïdova, as a last, almost idle question, I asked her, "So what are your general impressions of the period?" (meaning the 1960s). She replied: "I remember that period with pleasure, because I really liked singing those compositions, having contact with such remarkable musicians as Rozhdestvensky, Lyubimov, Volkonsky.... It helps any musician to have contact with such remarkable musicians.... Thus there are simply remarkable memories.... Everything was very interesting. It was a wonderful time."[11] It quickly became clear that Davïdova was not alone; many of the figures with whom I spoke—among them several composers from her generation—missed the 1960s for similar reasons. Even Volkonsky laments the passing of the Soviet Empire because of the corresponding loss of the "exchange of cultural values" cultivated between its constituent republics (he is undoubtedly

8. See Verdery, *What Was Socialism, and What Comes Next?* 15–16 (she prefers "transformation" to "transition"); Berdahl, Bunzl, and Lampland, eds., *Altering States: Ethnographies of Transition in Eastern Europe and the Former Soviet Union;* and De Soto and Nora Dudwick, eds., *Fieldwork Dilemmas: Anthropologists in Postsocialist States.*

9. Živković skirts the issue of nostalgia, preferring to focus on the admittedly more pressing issue of nationalism in post-Yugoslavia Serbia. Živković, "Telling Stories about Serbia: Native and Other Dilemmas on the Edge of Chaos," 54–55. See also in the same collection Herzfeld, "Afterword: Intimations from an Uncertain Place," 220. Another important examination of postsocialist (and especially post-Soviet) nostalgia is Boym, *The Future of Nostalgia;* as is Nadkarni and Shevchenko, "The Politics of Nostalgia: A Case for Comparative Analysis of Postsocialist Practices," 487–520.

10. A good survey of the main issues involved in this seeming paradox is Sherbakova, "The Gulag in Memory," 521–30.

11. Davïdova, interview, 14 September 1999.

thinking of "exchanges" similar to that behind *Laments of Shchaza*). Now he is willing to overlook his memories of the "composition department" at the Moscow Conservatory ("a complicated and contentious issue"), but fondly recalls the "tremendous Russian tradition" of musical performance fostered during the Soviet period, singling out Neuhaus in particular.[12] (Volkonsky now sees "Empire as, above all, an opportunity for communication" ["Imperiya—eto, prezhde vsego, vozmozhnost' kommunikatsii"].[13]) Such nostalgia is not a recent occurrence for Volkonsky. Inspired in part by Gorbachev's reforms, during an August 1988 reunion with Madrigal in Darmstadt he declared his (unrealized) intention to return to the USSR ("I want to help Russia") and his desire to teach harpsichord at the Moscow Conservatory.[14]

Tishchenko also spoke glowingly of the "many remarkable, outstanding performing musicians" like Rozhdestvensky active during the 1960s.[15] For Tishchenko, as for Davïdova and Volkonsky, speaking of the 1960s conjured youthful memories, and despite the occasions when his works were prevented performance, or his friends like Joseph Brodsky were arrested, he remembered the 1960s fondly. Tishchenko told me that this was the time that he knew people like Brodsky, Shostakovich, and Akhmatova. He said of these figures: "And I consider myself to have been defended by these people who took upon themselves all of those blows [from officialdom]. And I was defended both externally and internally, prepared for anything....These people gave me the ability to consider myself free." Like the others, Tishchenko remembers the period fondly not just because of the wonderful music that he heard for the first time, but also because of the individuals he knew. He continued, "I remember that in one of my letters to Shostakovich I wrote that I could be free even in a torture chamber. True, I was never taken to a torture chamber, but if I had been, then what those individuals cultivated in me would have helped to protect me." Although the danger of Tishchenko being tortured in the 1960s was fairly low, the stakes were still such that Shostakovich, Akhmatova, and Brodsky could rise above the fray and serve as cultural touchstones for their audiences, providing sustenance spiritually, culturally, and also, in the case of Shostakovich, materially. In the Yeltsin 1990s and the early years of Putin's rule, the only irreproachable models were the iconic figures from the past, growing increasingly mythical with each passing year.

Paradoxically, Tishchenko's statement and those of the other composers from his generation betray a sense of loss for both their strong defenders and for the offenses that necessitated defense in the first place. This is the same paradox that

12. NVV: 142 and 179–80.
13. Ibid., 180.
14. Ibid., 74.
15. Tishchenko, interview.

Ivashkin described in 1992, immediately after the collapse of the Soviet Union: "Russian art does not flourish under conditions of total freedom; it is (and was) usually more productive in an atmosphere of social and political contradictions."[16] A similar yearning for the oppositional politics of the period lies at the heart of the popular embrace in the West of *Testimony*'s "dissident" Shostakovich, even as the Russian nostalgia for Shostakovich as good Soviet official reveals the complex and prominent role he actually played in Soviet cultural life. As one of my informants poignantly told me in late 2000: "I wouldn't have any problems if he was still alive." A more richly textured account of the Soviet period is possible by listening to the often unexpected attitudes of its participants.

When I attempted to contact Pärt for an interview, his spokesman informed me that "The period of the Soviet Union is a completely closed chapter for him and he is not prepared to evoke this era again," betraying the clearest sense of non or even anti-nostalgia that I encountered, a refusal to even acknowledge let alone discuss his memories.[17] Of all my actual interviewees, Shchedrin had the least nostalgia for the Soviet past. But his aversion for the past was predicated largely on his disdain for those who trade in on nostalgia, particularly the Western nostalgia for the cold war and the preconceptions to which it has given rise. Shchedrin continuously adjured me not to believe figures such as Lyubimov whom he called a "storyteller" ("skazochnik"). "Don't believe storytellers," he said ("Ne ver'te skazochnikam"). In Shchedrin's telling Lyubimov perpetuated the idea that he was persecuted in the 1960s in order to fuel his concert career in the present. As Shchedrin said:

And now it is very easy to say, "I wanted to write a masterpiece [in the Soviet period], but I couldn't, they gagged me, I wanted to express myself." Write it, play it now. Where is it? It's that simple. But today that time has already ended. Already the political credit that people wanted to receive has come to an end. Show any conductor, "Look, I wrote this in 1958," and he says, "A masterpiece! I'll play it tomorrow!" That's all a myth. And people in the West believe in it. Music is one of those things.... Thankfully the time of the new lies is ending. There was once one lie, and today another new lie that they have created. In my opinion, these people are sufficiently talentless. Whether you like it or not, for music you need to have a sense of hearing, talent, memory, imagination, intuition, and inspiration. The political is a small factor.[18]

16. Ivashkin, "The Paradox of Russian Non-Liberty," 546.

17. Arvo Pärt (by way of Eric Marinitsch), e-mail to author, 19 March 2001.

18. Shchedrin, interview. Shchedrin made similar comments in a response to David Fanning's labeling him the "Soviet Union's first 'licensed modernist.' " See Shchedrin, "Musical Compromise? [letter to the editor]," 8; and Fanning, "Professional Compromise," 23. See also Shchedrin and Vlasova, "Iskusstvo—eto tsarstvo intuitsii," 3–4; and Khrennikov, "My Conscience Is Clear."

"Dissident music" became a big selling point in the immediate post-Soviet period, and as a result unofficial music, often called "avant-garde music," was made to seem more glamorous and dangerous than many of my informants said that it actually was.[19] As Shchedrin said, music is unfortunately uniquely capable of being simplistically manipulated, or as Alex Ross, writing about Shostakovich, recently lamented in the *New Yorker*, "For some reason...music is treated as a childish realm in which fables serve as well as facts."[20]

Shchedrin's defense of his actions in the 1960s is analogous to the attitude expressed in some obituaries both in Russia and abroad for recently deceased former head of the Soviet Union of Composers, Tikhon Khrennikov (1913–2007)—praised for what he was able to do despite the constraints under which he operated.[21] In such cases, the "antinostalgia" of our interlocutors or their sanguinity about the past—"They did the best they could," or "It could have been worse," or "Others were worse than I"—collides with our overeagerness to redress perceived historical wrongs.[22] Our yearning for the good guy/bad guy, black-and-white divisions of the past—think of the rhetoric surrounding the June 2004 funeral ceremonies for former U.S. president Ronald Reagan, the man who "won" the cold war—confronts the simultaneous desire to forget the indelicate episodes from the past and to remember only the "wonderful" moments.

Shchedrin is in a difficult position. In the past decade he has become a widely played, widely commissioned genial composer of crowd-pleasing music, but he was sufficiently implicated in officialdom so that he is unable to trade in on the "new lies," while the unofficial composers cash in on the mystique generated by their supposed opposition to the Soviet state. Therefore, Shchedrin argues for objective "musical" criteria, an unattainable level playing field that will eliminate the "political credit" of figures such as Schnittke or Lyubimov. This is similar to the musicologist at the Glinka Museum in Moscow who angrily told me in 1998: "During the Soviet period we were forced to talk about music and politics. Now when we no longer need to, all you want to do is talk about music and politics!" It is also similar to the position of many unofficial visual artists who celebrated the variety and diversity of their

19. For a considered critique of "musical protest" and the commercial "branding" of Soviet "avant-gardists" in the West, see Cherednichenko, *Muzïkal'nïy zapas*, 40–44.

20. Ross, "Unauthorized: The Final Betrayal of Dmitri Shostakovich," 164.

21. See, e.g., Khrennikov's obituary in *The Economist*: "Having made himself comfortable within the regime, he extended these comforts to others....The Western press called him a lackey and dictator when he died, but Russians, who knew him, did not." "Tikhon Khrennikov," 77. For previous Russian examples of this approach, see the special issue of *Muzïkal'naya akademiya* 2 (2003) devoted to Khrennikov on the occasion of his ninetieth birthday. For an example of the complexities surrounding any judgment of Khrennikov's role in the Soviet Union, see Heikinheimo, Khrennikov, and Parsons, "Tikhon Khrennikov in Interview," 18–20.

22. See Sherbakova, "The Gulag in Memory."

colleagues' creations until they were forced to compete with one another on the open market after *glasnost'* took hold.[23]

At the same time Shchedrin, like Davïdova and Tishchenko, was also nostalgic for concert life during the 1960s, for the "Brahms Concerto as performed by Oistrakh, or Brahms's Second as performed by Gilels." Shchedrin continued, "That was also an event; in that sense we were all fortunate people. Ah, what ballet there was. Ah, what opera!"[24] During the Thaw the musical floodgates burst open, inundating Soviet musical society with high-quality music (both known and unknown) from abroad. Even average listeners with whom I spoke remembered the Thaw eagerly. They, however, were recalling the concerts of the New York, Philadelphia, or Boston Philharmonics (all 1959[25]), Glenn Gould ("No one knew who this Gould was..."); the Robert Shaw Chorale (19 November 1962—performing Schoenberg and Ives, among others); Isaac Stern (1956 and 1960[26]); Greenberg's New York Pro Musica (Autumn 1964[27]); or the touring soloists from La Scala (1964)—"A wonder" ("chudo")—as one of my informants breathlessly remembered.[28] As this last listener also said, during this period they "increasingly began to hear live the names they had only heard in recordings."[29]

In comparison to the financial hardships and sagging attendance of the Russian concert environment of the late 1990s, it is no wonder that many of my informants—listeners, performers, and composers alike—were nostalgic for the Soviet period, and specifically the Thaw. Gubaidulina told an interviewer in 1994 that "[economic pressure] is even more terrible than ideological [pressure]."[30] During the Thaw, their performances meant something and attracted far larger audiences. Grindenko told me: "When they banned us [in the 1970s], the whole musical scene was much more active than it is now, when everything is possible, when everyone can do everything.... Apparently the forbidden fruit is sweet, or something, I don't know. But in any case, the public was much bigger at such concerts [then]."[31] The music produced by the

23. See Eimermacher, "From Unity to Diversity: Sociocultural Aspects of the Moscow Art Scene, 1945–1988," 122.

24. Shchedrin, interview.

25. Pekarsky recalled unsuccessfully waiting in line with his father for tickets to the Boston Symphony on their visit: "I didn't go to a single concert. I stood for three nights with my father, an invalid from the war.... Stood for three nights, and there weren't tickets for us. I was offended and couldn't even listen to it on the radio." Pekarskiy, interview.

26. See Stern with Potok, *Isaac Stern: My First 79 Years*, 115–31 and 150–53.

27. See Greenberg, "A Soft Sound in the U.S.S.R."

28. Prus, interview (hers is the "chudo" comment); and Tambiyeva, interview (hers is the Gould comment; "Nikto ne znal, kto takoy Gul'd"). I am also indebted to Karma Mikhaĭlovna Slezkina for allowing me to borrow and photocopy her personal collection of concert programs from the period.

29. Prus, interview.

30. Gubaidulina and Yuzefoaich, "Ob uchitelyakh, kollegakh i o samoy sebe," 9.

31. Grindenko, interview.

unofficial composers during the Thaw attracted such eager listeners because, like the unofficial paintings described by Rabin, it was a "living art," an anti-dote to the artistic homogeneity of the 1950s and 1960s.[32] Because it was "alive" and youthful and allowed listeners to escape, withdraw, or imagine alternatives to the increasingly immutable reality around them, unofficial music played an important social role during the Thaw. It suggested important meanings and values, paradoxical, contradictory, and changing as they were. Boris Groys has summarized the significance of the unofficial visual arts in the post-Soviet era: "In this post-Soviet time, as the majority of Russians try either to forget that unhappy century altogether or to glorify the Soviet past without actually remembering it, the unofficial art of the Soviet era functions, paradoxically, as the only cultural space where the private memories from the Soviet era are still kept."[33] The same can be said of the unofficial music of the 1960s, a testament to the ambiguities, the shared dreams, and the eventual disillusionment of a generation.

32. The Rabin quotation here appears in Lindey, *Art in the Cold War*, 153.
33. Groys, "The Other Gaze: Russian Unofficial Art's View of the Soviet World," 88.

APPENDIX A: BIRTHDATES FOR PRINCIPAL INTERVIEWEES

The list below excludes those provided in table 2.1.

Artem'yev, Eduard (b. 1937)
Aygi, Gennadiy (1934–2006)
Baltin, Alexander (b. 1931)
Berlinsky, Valentin (b. 1925)
Berman, Boris (b. 1948)
Davïdova, Lidiya (b. 1932)
Frid, Grigoriy (b. 1915)
Frumkin, Vladimir (b. 1929)
Grindenko, Tatyana (b. 1946)
Kholopov, Yuriy (1932–2003)
Kholopova, Valentina (b. 1935)
Ledenyov, Roman (b. 1930)
Lyubimov, Aleksey (b. 1944)
Martïnov, Vladimir (b. 1946)
Marutayev, Mikhaíl (b. 1926)
Nikolayev, Aleksey (b. 1931)
Pekarsky, Mark (b. 1940)
Yekimovsky, Viktor (b. 1947)

APPENDIX B: TRANSCRIPT OF GLENN GOULD'S COMMENTS AT HIS MOSCOW LECTURE-RECITAL

The below has been transcribed, with permission, from *Glenn Gould in Russia, 1957*. The lecture took place on 12 May 1957.

[Gould plays Berg, Sonata, Op. 1]

As you can see, with Alban Berg the possibilities of writing with a key signature are just about exhausted. Within a year Alban Berg and his teacher Arnold Schoenberg were writing music absolutely without relation to any one tonality. The earliest works of Schoenberg and Berg without tonality were also to a certain extent without form. They were much too fluid without any real control over the material. Within a decade, within ten years, Schoenberg had begun to formulate, to work on a principle, whereby all the melodic units could be combined into what he called a "supertheme." To combine all the thematic ideas of the music into one complex of themes which would be used again and again in every conceivable position and variation of itself.

Now it's a long way from the Alban Berg sonata to the music that I'm going to play next. This is music by another pupil of Schoenberg—Anton von Webern. Webern as a composer was much less interested than was Berg in great masses of color, much less interested in the effect of an instrumental sound. His very first work for orchestra already shows this, and it is a passacaglia for orchestra, a passacaglia for orchestra, in which the theme is already a typical Webern motive [Gould plays the theme of the passacaglia]. Passacaglia for orchestra [He continues playing]. Now Webern develops this principle of using a very short group of motives, often the same one. The work which I want to play for you was written in 1936, thirty years after this piece. It is his only work for piano, a set of variations in three, very brief movements. It also shows something that is typically Webern: there is throughout this piece no crescendo, no diminuendo, everything is entirely in terms of absolute piano-forte. I would also like to apologize because I haven't practiced it for two years [excited audience response].

[Gould plays Webern, Piano Variations, Op. 27]

Now finally from this school I would like to play a piece which in some way sums up a little bit of the attributes of both these men. It is a composition by the Czechoslovakian

composer Ernst Krenek [audience disturbance]. I would like to play the first and last movements of his Third Piano Sonata [continued disruption in audience]. This I think is music which has the... [The translator shouts out "Krenek, Krenek!"; Gould also repeats the name].

This I think is music which has both the melodic agility of Webern and also the tremendous harmonic strength of Berg. In my opinion it's one of the best piano compositions of the century. The first and last movements of the sonata.

[Gould plays Krenek, Piano Sonata, No. 3, Op. 62, No. 4, movements I and IV]

Thank you very much; I only hope I haven't bored you with too much of this music, but it is very dear to me, and I really wanted to play it for you. ["No!" ("Nyet!") a woman audibly yells over the enthusiastic audience applause that follows the translation.]

I think the highest compliment that I can pay it is to say that the principles which one finds here are not new, but are at least 500 years old. They are principles which reached their heights with the Flemish school, with Josquin des Prez and many other people in the mid and late 15th century. So finally I would like to play for you some music which is very much of the end of something also: some music by Johann Sebastian Bach from the *Art of the Fugue* [*sic*], three fugues.

[Gould plays Bach, in *Die Kunst der Fuge*, BWV 1080, Contrapuncti 1, 4, 2 and as an encore: Bach, *Goldberg Variations*, BWV 988, Variations Nos. 3, 18, 9, 24, 10, 30]

APPENDIX C: PRONUNCIATION GUIDE

Russian names and words have a single strong accented syllable, and even native speakers occasionally have difficulty placing the accent for an unfamiliar name. Accordingly, I have provided accents for some of the names that recur most frequently throughout the book, in addition to my own approximate pronunciation tips for the most troublesome.

Art'yémev
Aygí (Eye-*gee*, with a hard "g")
Báltin
Bérman
Blazhkóv
Davïdova (accent on ï)
Edíson Denísov (Eh-*dee*-son Dyen-*ee*-suhv, accent on both "i"s)
Frúmkin
Gubaidúlina (Goo-by-*du*-lee-nuh)
Hrabóvsky
Karamánov
Karétnikov
Lyubímov
Martïnov (accent on ï)
Marutáyev
Pekársky
Rozhdéstvensky
Shchedrín (Shheh-dr*een*)
Silvéstrov
Slonímsky
Tíshchenko
Volkónsky
Yekimóvsky
Yúdina

BIBLIOGRAPHY

Whenever possible in the bibliography that follows, I have indicated translations in more common European languages (usually English, German, or French) of the Russian sources cited in my text.

INTERVIEWS, E-MAIL, AND OTHER CORRESPONDENCE

Unless otherwise noted, all of the interviews cited here were conducted in Russian and were recorded on audiotape with the interviewee's permission, then transcribed and translated. All translations are those of the author, although the invaluable assistance of Richard Taruskin in editing and amending these translations is gratefully acknowledged. All e-mail correspondence was in English, as were the interviews with Vladimir Frumkin and Boris Berman.

Artem'yev, Eduard. Interview by author, tape recording, Moscow, 23 September 1999.

Aygi, Gennadiy. Interview by author, tape recording, Moscow, 27 January 2001.

Baltin, Aleksandr. Interview by author, tape recording, Moscow, 2 October 2000.

Berlinskiy [Berlinsky], Valentin. Interview by author, tape recording, Moscow, 15 February 2001.

Berman, Boris. Telephone interview by author, tape recording, 23 March 2001 and 4 February 2007 (in English).

Brown, Malcolm H. Conversation with author, Bard College, Annandale-on-Hudson, NY, 15 August 2004.

Davïdova, Lidiya. Interview by author, tape recording, Moscow, 14 September 1999.

———. Interview by author, tape recording, Moscow, 22 November 2000.

Frid, Grigoriy. Interview by author, tape recording, Moscow, 21 September 1999.

Frumkin, Vladimir. Telephone interview by author, tape recording, 30 November 1999 (in Russian and English).

———. Interview by author, tape recording, Washington, DC, 23 December 1999 (in Russian and English).

Grindenko, Tat'yana. Interview by author, tape recording, Moscow, 12 January 2001.

Hrabovsky [Grabovskiy], Leonid. Telephone interview by author, tape recording, 24 October 1999.

Hrabovsky [Grabovskiy], Leonid. E-mails to author, 13 December 1999, 14 December 1999, 4 January 2000, 5 January 2000, 13 January 2000, and 10 March 2000.

Ivashkin, Alexander. E-mails to author, 28 January 2008.

Kholopov, Yuriy. Interviews by author, Moscow, September 1999 and 27 September, 25 October, 1 November, 8 November, and 15 November 2000.

Kholopova, Valentina. Interview by author, Moscow, 15 November 2000.

Kuznetsov, Anatoliy. Telephone interview by author, 19 October 2000.

———. Interview by author, tape recording, Moscow, 30 January 2001.

———. Telephone interview by author, tape recording, 15 September 2004.

Ledenyov, Roman. Interview by author, tape recording, Moscow, 18 October 2000.

Lyubimov [Lubimov], Aleksey. Interview by author, tape recording, Moscow, 12 November 2000.

Markiz, Lev. Telephone interview by author, tape recording, 13 September 2004.

Martïnov, Vladimir. Interview by author, tape recording, Moscow, 16 September 1999.

Marutayev, Mikhaíl. Interview by author, tape recording, Moscow, 31 October 2000.

Nikolayev, Aleksey. Interview by author, tape recording, Moscow, 22 November 2000.

Pärt, Arvo (by way of Eric Marinitsch). E-mail to author, 19 March 2001.

Pekarskiy [Pekarsky], Mark. Interview by author, tape recording, Moscow, 30 September 2000.

Prus, Inna. Interview by author, Moscow, 5 February 2001.

Radziwon, Ewa (Warsaw Autumn Festival). E-mail to author, 19 April 2006

Savenko, Svetlana. Interview by author, 7 September 1999.

Schaller, Erika (Archivio Luigi Nono, Venice). E-mail to author, 31 July 2002.

Shchedrin, Rodion. Interview by author, tape recording, Moscow, 8 December 2000.

Sil'vestrov [Silvestrov], Valentin. Telephone interview by author, 13 November 2000.

Slonimskiy [Slonimsky], Sergey. Interview by author, tape recording, Moscow, 6 December 2000.

Tambiyeva, Irina Nikitishna. Telephone interview by author, 1 February 2001.

Tishchenko, Boris. Interview by author, tape recording, Moscow, 1 December 2000.

Volkonskiy [Volkonsky], Andrey. Telephone interview by author, tape recording, 21 October 1999.

———. Telephone interviews by author, 30 July and 23 and 27 September 2004.

Yekimovskiy [Yekimovsky], Viktor. Interview by author, tape recording, Moscow, 28 September 1999.

Unsigned Articles, Reviews, Program Booklets, and Official Documents

"Declaration of the Central Committee of the Communist Party of the Soviet Union Amending and Canceling the Resolution of 10 February 1948 and Restoring the Dignity and Integrity of Soviet Composers Attacked in That Resolution." In *Music since*

1900, edited by Laura Kuhn and Nicolas Slonimsky, 952–53. Sixth Edition. New York: Schirmer Reference, 2001.

"Focus!: Breaking the Chains: The Soviet Avant-Garde, 1966–1991." Juilliard School Festival program booklet, 21–28 January 2005.

"Glavnoye prizvaniye sovetskogo iskusstva." *Sovetskaya muzïka* 2 (1963): 6–9.

"Herschkowitz Encountered: Memoirs by Victor Suslin, Gerard McBurney and David Drew." *Tempo*, no. 173 (June 1990): 39–43.

"Kogda sobirayetsya sekretariat...." *Sovetskaya muzïka* 1 (1966): 29–32.

Liner notes to Gerard Frémy, *John Cage: Sonatas and Interludes for Prepared Piano*. Etcetera Records, KTC 2001 (1983).

"Obsuzhdayem 'Poetoriyu' R. Shchedrina." *Sovetskaya muzïka* 11 (1969): 18–32.

"Obsuzhdayem Simfoniyu A. Shnitke." *Sovetskaya muzïka* 10 (1974): 12–26.

"Otmechaya 100-letiye so dnya rozhdeniya B. N. Lyatoshinskogo: Svidetel'stvuyut ucheniki." *Muzïkal'naya akademiya* 1 (1996): 23–28.

"Pis'mo iz redaktsii." *Sovetskaya muzïka* 8 (1970): 15–18.

Slushatel' [a listener]. "Na kontserte M. Yudinoy." *Sovetskaya muzïka* 7 (1961): 89–90.

"Sovetskaya muzïka—stroiteley: Chetvyortïy s'ezd soyuza kompozitorov SSSR." *Sovetskaya muzïka* 2 (1969): 2–18.

"Soviet Music Policy, 1948" and "Discussion at a General Assembly of Soviet Composers, Moscow, 17–26 February 1948." In *Music since 1900*, edited by Laura Kuhn and Nicolas Slonimsky, 942–52. Sixth Edition. New York: Schirmer Reference, 2001.

"Tikhon Khrennikov." *The Economist*, 1 September 2007, 77.

"Velikaya missiya sovetskoy muzïki." *Sovetskaya muzïka* 1 (1980): 2–29.

Zhurnalist' [a journalist]. "Replika: Po povodu odnogo interv'yu." *Sovetskaya muzïka* 10 (1970): 44–46. Reprinted in *Svet-dobro-vechnost': Pamyati Edisona Denisova, stat'i, vospominaniya, materiali*, edited by Valeriya Tsenova, 40–44. Moscow: Moskovskaya gosudarstvennaya konservatoriya im. P. I. Chaikovskogo, 1999.

Books and Articles

Abukov, K. I., A. M. Vagidov, and S. M. Khaibullayev, eds. *Antologiya Dagestanskoy poezii*, Vol. II: *Poetï dorevolyutsionnogo Dagestana*. Makhachkala, USSR: Dagestanskoye knizhnoye izdatel'stvo, 1980.

Adamenko, Victoria. *Neo-Mythologism in Music: From Scriabin and Schoenberg to Schnittke and Crumb*. Hillsdale, NY: Pendragon, 2007.

Adlington, Robert, ed. *Sound Commitments: Avant-Garde Music and the Sixties*. Oxford: Oxford University Press, forthcoming.

Adorno, Theodor W. "The Aging of the New Music." In *Essays on Music*, edited by Richard Leppert, 181–202. Berkeley: University of California Press, 2002.

Afiani, V. Yu., ed. *Ideologicheskiye komissii TsK KPSS, 1958–1964: Dokumentï*. Moscow: Rosspen, 1998.

Akopyan [Hakobian], Levon. "The Beginning and End of the Soviet Musical Avant-Garde: 1956–1982." In *Duchowość Europy Środkowej i Wschodniej w muzyce końca XX wieku,* edited by Krzysztof Droba, Teresa Malecka and Krzysztof Szwajgier, 73–79. Kraków: Akademia Muzyczna, 2004.

———. *Music of the Soviet Age, 1917–1987.* Stockholm: Melos Music Literature, 1998.

———. "A Perspective on Soviet Musical Culture during the Lifetime of Shostakovich." In *A Shostakovich Casebook,* edited by Malcolm Hamrick Brown, 216–29. Bloomington: Indiana University Press, 2004.

Aksyonov, Vassily. *The Burn: A Novel in Three Books (Late Sixties—Early Seventies).* Translated by Michael Glenny. New York: Aventura, Vintage Library of Contemporary World Literature, 1985.

———. *In Search of Melancholy Baby.* Translated by Michael Henry Heim and Antonina W. Bouis. New York: Random House, 1987.

Aksyuk, Sergey. "Razvorachivaisya v marshe, muzïka!" *Sovetskaya kul'tura,* 4 November 1961, 3.

Anninskiy, Lev. "Shestidesyatniki, semidesyatniki, vos'midesyatniki . . . : K dialektike pokolenii v russkoy kul'ture." *Literaturnoye obozreniye* 4 (1991): 10–14.

Aranovskiy, Mark, ed. *Russkaya muzïka i XX vek: Russkoye muzïkal'noye iskusstvo v istorii khudozhestvennoy kul'turï XX veka.* Moscow: Gosudarstvennïy institut iskusstvoznaniya Ministerstva kul'turï Rossiyskoy Federatsii, 1997.

———. *Simfonicheskiye iskaniya: Problema zhanra simfonii v sovetskoy muzïke 1960–1975 godov.* Leningrad: Sovetskiy kompozitor, 1979.

Ashby, Arved. "Schoenberg, Boulez, and Twelve-Tone Composition as 'Ideal Type.'" *Journal of the American Musicological Society* 54 (2001): 585–625.

Aygi, Gennadiy. "Drugu—o gde-to-zhazminakh." In *Mir etikh glaz-2: Aygi i yego khudozhestvennoye okruzheniye: Al'bom-katalog,* an exhibit at the Chuvashki gosudarstvennïy khudozhestvennïy muzey, Cheboksarï, Chuvash Republic, Russia, 11 November–14 December 1997. Also in Pekarskiy, Mark. *Nazad k Volkonskomu vperyod,* 194–95. Moscow: Kompozitor, 2005.

———. *Selected Poems, 1954–94.* Edited and translated by Peter France. Evanston, IL: Northwestern University Press, 1997.

———, and Victoria Adamenko. "Sud'ba Andreya Volkonskogo." *Rossiyskaya muzïkal'naya gazeta* 6 (1989): 10–11.

Babbitt, Milton. "Who Cares If You Listen?" *High Fidelity* 8, no. 2 (1958): 38–40. Reprinted in *Contemporary Composers on Contemporary Music,* edited by Elliott Schwartz and Barney Childs, 243–50. New York: Holt, Rinehart, and Winston, 1967.

Bach, Jonathan. "The Taste Remains: Consumption, (N)ostalgia, and the Production of East Germany." *Public Culture* 14, no. 3 (Fall 2002): 545–56.

Baigell, Renee, and Matthew Baigell, eds. *Soviet Dissident Artists: Interviews after Perestroika.* New Brunswick, NJ: Rutgers University Press, 1995.

Baley, Virko. "The Kiev Avant-Garde: A Retrospective in Midstream." *Numus-West* 6 (1974): 8–20.

———. "Sil'vestrov, Valentyn Vasil'yovych." In *The New Grove Dictionary of Music and Musicians,* edited by S. Sadie and J. Tyrrell, 23:395–96. Second Edition. London: Macmillan, 2001.

Barabanov, Yevgeni. "Art in the Delta of Alternative Culture." In *Forbidden Art: The Postwar Russian Avant-Garde,* edited by Garrett White, 7–47. Los Angeles: Curatorial Assistance, 1998.

Barker, Adele Marie, ed. *Consuming Russia: Popular Culture, Sex, and Society since Gorbachev.* Durham, NC: Duke University Press, 1999.

———. "The Culture Factory: Theorizing the Popular in the Old and New Russia." In *Consuming Russia: Popular Culture, Sex, and Society since Gorbachev,* edited by Adele Marie Barker, 12–45. Durham, NC: Duke University Press, 1999.

Barsova, Inna, G. Golovinskiy, and M. Roytershteyn. "Kompozitorskaya molodyozh' Moskovskoy konservatorii." *Sovetskaya muzïka* 5 (1952): 26–31.

Bazzana, Kevin. *Wondrous Strange: The Life and Art of Glenn Gould.* Oxford: Oxford University Press, 2004.

Beal, Amy C. *New Music, New Allies: American Experimental Music in West Germany from the Zero Hour to Reunification.* Berkeley: University of California Press, 2006.

Beckles Willson, Rachel. *Ligeti, Kurtág, and Hungarian Music during the Cold War.* Cambridge: Cambridge University Press, 2007.

Bek, Mikuláš, Geoffrey Chew, and Petr Macek, eds. *Socialist Realism and Music.* Musicological Colloquium at the Brno International Music Festival 36 (2001). Prague: KLP, 2004.

Bekhtereva, Lyudmila. *Variantï otrazheniy: Ofitsial'naya zhizn' neofitsial'nogo iskusstva.* Elancourt, France: A-Ya, 1981.

Bennett, John R. *Melodiya: A Soviet Russian L. P. Discography.* Westport, CT: Greenwood, 1981.

Berdahl, Daphne. "'(N)Ostalgie' for the Present: Memory, Longing, and East German Things." *Ethnos* 64, no. 2 (1999): 192–211.

———, Matti Bunzl, and Martha Lampland, eds. *Altering States: Ethnographies of Transition in Eastern Europe and the Former Soviet Union.* Ann Arbor: University of Michigan Press, 2000.

Berg, Michael, Albrecht von Massow, and Nina Noeske, eds. *Zwischen Macht und Freiheit: Neue Musik in der DDR.* Cologne, Germany: Böhlau, 2004.

Berger, Karol. *A Theory of Art.* New York: Oxford University Press, 2000.

———, and Anthony Newcomb, eds. *Music and the Aesthetics of Modernity.* Isham Library Papers 6, Harvard Publications in Music 12. Cambridge, MA: Harvard University Press, 2005.

Beyer, Anders. *The Voice of Music: Conversations with Composers of Our Time,* edited and translated by Jean Christensen and Anders Beyer. Aldershot, UK: Ashgate, 2000.

Bittner, Stephen V. "Exploring Reform: De-Stalinization in Moscow's Arbat District, 1953–1968." Ph.D. dissertation, University of Chicago, 2000.

———. *The Many Lives of Khrushchev's Thaw: Experience and Memory in Moscow's Arbat.* Ithaca, NY: Cornell University Press, 2008.

Blake, Patricia, and Max Hayward, eds. *Half-way to the Moon: New Writing from Russia.* London: Weidenfeld and Nicolson, 1964.

Blakesley, Rosalind P., and Susan E. Reid, eds. *Russian Art and the West: A Century of Dialogue in Painting, Architecture, and the Decorative Arts.* DeKalb: Northern Illinois University Press, 2007.

Blazhkov, Igor. "Pis'ma Shostakovicha I. I. Blazhkovu." In *Shostakovich: Mezhdu mgnoveniyem i vechnost'yu: Dokumenti, materiali, stat'i,* edited by L. G. Kovnatskaya, 490–508. St. Petersburg: Kompozitor, 2000.

Bogdanova, Alla. *Muzïka i vlast' (poststalinskiy period).* Moscow: Naslediye, 1995.

Boretz, Benjamin, and Edward T. Cone, eds. *Perspectives on Contemporary Music Theory.* New York: W. W. Norton, 1972.

Borio, Gianmario, and Hermann Danuser, eds. *Im Zenit der Moderne: Die Internationalen Ferienkurse für Neue Musik Darmstadt 1946–1966,* 4 vols. Freiburg im Breisgau, Germany: Rombach, 1997.

Boulez, Pierre. "Alea." *La Nouvelle revue française* 59 (November 1957): 839–57. Reprinted in Boretz, Benjamin, and Edward T. Cone, eds., *Perspectives on Contemporary Music Theory,* 45–50. New York: W. W. Norton, 1972 [all citations are to this version].

Bowlt, John E. "'Discrete Displacement': Abstract and Kinetic Art in the Dodge Collection." In *Nonconformist Art: The Soviet Experience, 1956–1986,* edited by Alla Rosenfeld and Norton T. Dodge, 294–302. New York: Thames and Hudson, 1995.

———. "The Soviet Nonconformists and the Legacy of the Russian Avant-Garde." In *Forbidden Art: The Postwar Russian Avant-Garde,* edited by Garrett White, 49–80. Los Angeles: Curatorial Assistance, 1998.

Boym, Svetlana. *The Future of Nostalgia.* New York: Basic Books, 2001.

Bradshaw, Susan. "Arvo Paart." *Contact* 26 (1983): 25–28.

———. "The Music of Edison Denisov." *Tempo,* no. 151 (December 1984): 2–9.

Bretanitskaya, Alla, ed. *Pyotr Suvchinskiy i yego vremya.* Moscow: Kompozitor, 1999.

Brody, James, and Lawrence Oncley. "Current Chronicle." *Musical Quarterly* 54 (1968): 87–92.

Brody, Martin. "'Music for the Masses': Milton Babbitt's Cold War Music Theory." *Musical Quarterly* 77 (1993): 161–92.

Brown, Malcolm Hamrick, ed. *Russian and Soviet Music: Essays for Boris Schwarz.* Ann Arbor, MI: UMI Research, 1984.

———, ed. *A Shostakovich Casebook.* Bloomington: Indiana University Press, 2004.

———. "The Soviet Russian Concepts of 'Intonazia' and 'Musical Imagery.'" *The Musical Quarterly* 60 (1974): 557–67.

Burlatsky, Fedor. *Khrushchev and the First Russian Spring.* Translated by Daphne Skillen. London: Weidenfeld and Nicolson, 1991.

Burns, Robert. *The Canongate Burns: The Complete Poems and Songs of Robert Burns.* Edited by Andrew Noble and Patrick Scott Hogg. Canongate Classics 104. Edinburgh: Canongate, 2001.

Butsko, Yuriy, and Genrikh Litinskiy. "Vstrechi s kamernoy muzïkoy." *Sovetskaya muzïka* 8 (1970): 10–15.

Bylander, Cynthia. "The Warsaw Autumn International Festival of Contemporary Music 1956–1961: Its Goals, Structures, Programs, and People." Ph.D. dissertation, Ohio State University, 1989.

Carroll, Mark. *Music and Ideology in Cold War Europe.* Cambridge: Cambridge University Press, 2004.

Chase, Gilbert. *America's Music: From the Pilgrims to the Present.* New York: McGraw-Hill, First Edition, 1955; Revised Second Edition, 1966.

Cherednichenko, Tat'yana. *Muzïkal'nïy zapas: 70-ye. Problemï. Portretï. Sluchai.* Moscow: Novoye literaturnoye obozreniye, 2002.

Clark, Katerina. *The Soviet Novel: History as Ritual.* Third Edition. Bloomington: Indiana University Press, 2000.

Codrescu, Andrei. *The Disappearance of the Outside: A Manifesto for Escape.* St. Paul, MN: Ruminator Books, 2001.

Condee, Nancy. "Cultural Codes of the Thaw." In *Nikita Khrushchev,* edited by William Taubman, Sergei Khrushchev, and Abbott Gleason, 160–76. New Haven, CT: Yale University Press, 2000.

Copland, Aaron. "Composers in Russia." *Boston Symphony Orchestra Bulletin* (1961–62): 100–8.

———. *The New Music.* Second Edition. New York: W. W. Norton, 1968.

Corley, Felix. *Religion in the Soviet Union: An Archival Reader.* New York: New York University Press, 1996.

Costanzo, Susan. "Reclaiming the Stage: Amateur Theater-Studio Audiences in the Late Soviet Era." *Slavic Review* 57, no. 2 (Summer 1998): 398–424.

Craft, Robert. *Stravinsky: Chronicle of a Friendship.* First Edition. New York: A. A. Knopf, 1972.

———. "Stravinsky's Return: A Russian Diary." *Encounter* 117 (June 1963): 33–48.

Crichton, Ronald. "London Music: The Proms." *The Musical Times* 108, no. 1496 (October 1967): 919–20.

Dahlhaus, Carl. "Progress and the Avant-Garde." In *Schoenberg and the New Music,* 14–22. Cambridge: Cambridge University Press, 1987.

Danilevich, L. "Lenin v serdtse narodnom." *Sovetskaya muzïka* 8 (1970): 2–5.

Danko, Larisa Georgievna. "Slonimsky, Sergey Mikhaylovich." In *The New Grove Dictionary of Music and Musicians,* edited by S. Sadie and J. Tyrrell, 23:511–12. Second Edition. London: Macmillan, 2001.

Danuser, Hermann, Hannelore Gerlach, and Jürgen Köchel, eds. *Sowjetische Musik im Licht der Perestroika: Interpretationen, Quellentexte, Komponistenmonographien.* Laaber, Germany: Laaber, 1990.

Daughtry, J. Martin. "The Intonation of Intimacy: Ethics, Emotion, Metaphor, and Dialogue among Contemporary Russian Bards." Ph.D. dissertation, University of California, Los Angeles, 2006.

———. "Russia's New Anthem and the Negotiation of National Identity." *Ethnomusicology* 47, no. 1 (Winter 2003): 42–67.

David-Fox, Michael. "Whither Resistance?" In *The Resistance Debate in Russian and Soviet History*, edited by Michael David-Fox, Peter Holquist, and Marshall Poe, 230–36. Kritika Historical Studies 1. Bloomington, IN: Slavica, 2003.

———, Peter Holquist, and Marshall Poe, eds. *The Resistance Debate in Russian and Soviet History*. Kritika Historical Studies 1. Bloomington, IN: Slavica, 2003.

DeLapp, Jennifer. "Copland in the Fifties: Music and Ideology in the McCarthy Era." Ph.D. dissertation, University of Michigan, 1997.

Deleuze, Gilles, and Félix Guattari. *A Thousand Plateaus: Capitalism and Schizophrenia*. Translation and foreword by Brian Massumi. Minneapolis: University of Minnesota Press, 1987.

Denby, David. "Women and the System: 'Goodbye, Lenin!' and 'Osama.'" *The New Yorker*, 8 March 2004, 92–93.

Denisov, Edison. "Dodekafoniya i problemï sovremennoy kompozitorskoy tekhniki." *Muzïka i sovremennost'* 6 (1969): 478–525.

———. "Es gilt, neue Schönheit zu suchen: Interview mit einem jungen sowjetischen Komponisten." *Musica* 24 (July–August 1970): 391–92. Published in Russian as "'Nuzhno iskat' novuyu krasotu': Interv'yu s molodïm sovetskim kompozitorom." In *Svet-dobro-vechnost': Pamyati Edisona Denisova, stat'i, vospominaniya, materialï*, edited by Valeriya Tsenova, 38–40. Moscow: Moskovskaya gosudarstvennaya konservatoriya im. P. I. Chaikovskogo, 1999.

———. "Le tecniche nuove non sono una moda." *Il contemporaneo/Rinascita* (August 1966): 12. Original Russian version published as "Novaya tekhnika—Eto ne moda." In *Svet-dobro-vechnost': Pamyati Edisona Denisova, stat'i, vospominaniya, materialï*, edited by Valeriya Tsenova, 33–38. Moscow: Moskovskaya gosudarstvennaya konservatoriya im. P. I. Chaikovskogo, 1999. Also published in an abbreviated form in *"Drugoye iskusstvo": Moskva 1956–76, k khronike khudozhestvennoy zhizni*, edited by Leonid Talochkin and Irina Alpatova, I:313–15. Moscow: Moskovskaya kollektsiya, 1991.

———. "Music Must Bring Light: Interview with Anders Beyer." In Anders Beyer, *The Voice of Music: Conversations with Composers of Our Time*, edited and translated by Jean Christensen and Anders Beyer, 191–98. Aldershot, UK: Ashgate, 2000.

———. "'Nuzhno iskat' novuyu krasotu': Interv'yu s molodïm sovetskim kompozitorom." [*See* Denisov, "Es gilt, neue Schönheit zu suchen: Interview mit einem jungen sowjetischen Komponisten."]

———. "'Oda' dlya klarneta, fortepiano i udarnïkh": "Kratkaya avtorskaya annotatsiya" and "Avtorskiy analiz." In *Muzïka Edisona Denisova: Materialï nauchnoy konferentsii, posvyashchonnoy 65-letiyu kompozitora*, edited by Valeriya Tsenova, 121–32. Moscow: Moskovskaya gosudarstvennaya konservatoriya im. P. I. Chaikovskogo, 1995.

———. *"Peniye ptits": Partitura, fonogramma, materialï, interv'yu*. Edited by Margarita Katunyan. Moscow: Kompozitor, 2006.

———. "Shebalin-uchitel'." In *Pamyati V. Ya. Shebalina: Vospominaniya, materialï*, edited by A. M. Shebalina. Moscow: Sovetskiy kompozitor, 1984.

———. *Sovremennaya muzïka i problemï evolyutsii kompozitorskoy tekhniki*. Moscow: Sovetskiy kompozitor, 1986.

————. "Stabil'nïye i mobil'nïye elementï muzïkal'noy formï i ikh vzaimodeystviye." In *Teoreticheskiye problemï muzïkal'nïkh form i zhanrov,* edited by L. Rappoport, 95–133. Moscow: Muzïka, 1971. Reprinted with revisions in Denisov, Edison. *Sovremennaya muzïka i problemï evolyutsii kompozitorskoy tekhniki,* 112–36. Moscow: Sovetskiy kompozitor, 1986.

————. "Vstrechi s Shostakovichem." *Muzïkal'naya akademiya* 3 (1994): 90–92.

————. "Yeshcho o vospitanii molodyozhi." *Sovetskaya muzïka* 7 (1956): 28–32.

————. "Za ob'yektivnost' i spravedlivost' v otsenke sovremennoy muzïki." In *Svet-dobro-vechnost': Pamyati Edisona Denisova, stat'i, vospominaniya, materialï,* edited by Valeriya Tsenova, 22–33. Moscow: Moskovskaya gosudarstvennaya konservatoriya im. P. I. Chaikovskogo, 1999.

————, and Jean-Pierre Armengaud. *Entretiens avec Denisov: Un compositeur sous le régime soviétique.* Paris: Plume, 1993. Portions of this were translated into Russian as Denisov, Edison. "Esli tï nastoyashchiy artist, tï vsegda nezavisim...." *Muzïkal'naya akademiya* 3 (1994): 72–76. Also published in Russian as "'Muzïka ostalas' zhiva v Rossii...'. Besedï E. Denisova s Zh.-P. Armango." In *Muzïka Edisona Denisova: Materialï nauchnoy konferentsii, posvyashchonnoy 65-letiyu kompozitora,* edited by Valeriya Tsenova, 112–20. Moscow: Moskovskaya gosudarstvennaya konservatoriya im. P. I. Chaikovskogo, 1995.

————, and Aleksey Nikolayev. "Tonchaishiy muzïkant, zamechatel'nïy pedagog (o V. Ya. Shebaline)." *Sovetskaya muzïka* 6 (1962): 56–58.

————, and G. Pantiyelev. "Ne lyublyu formal'noye iskusstvo." *Sovetskaya muzïka* 12 (1989): 12–20.

————, and Dmitriy Shul'gin. *Priznaniye Edisona Denisova: Po materialam besed.* Moscow: Kompozitor, 1998. Second Corrected Edition: Moscow: Kompozitor, 2004.

————, and Valeriya Tsenova. "O 'Penii ptits': interv'yu." In *Svet-dobro-vechnost': Pamyati Edisona Denisova, stat'i, vospominaniya, materialï,* edited by Valeriya Tsenova, 59–67. Moscow: Moskovskaya gosudarstvennaya konservatoriya im. P. I. Chaikovskogo, 1999.

Dennis, Nigel. "Lorca in the Looking-Glass: On Mirrors and Self-Contemplation." In *"Cuando yo me muera...": Essays in Memory of Federico García Lorca,* edited by C. Brian Morris, 41–55. Lanham, MD: University Press of America, 1988.

De Soto, Hermine G., and Nora Dudwick, eds. *Fieldwork Dilemmas: Anthropologists in Postsocialist States.* Madison: University of Wisconsin Press, 2000.

Dobson, Miriam. "Contesting the Paradigms of De-Stalinization: Readers' Responses to *One Day in the Life of Ivan Denisovich.*" *Slavic Review* 64, no. 3 (2005): 580–600.

Droba, Krzysztof, Teresa Malecka, and Krzysztof Szwajgier, eds. *Duchowość Europy Środkowej i Wschodniej w muzyce końca XX wieku.* Kraków: Akademia Muzyczna, 2004.

Drozdova, Oksana. "Andrey Volkonskiy." "Kandidat" dissertation (the Russian Ph.D. equivalent), Moskovskaya gosudarstvennaya konservatoriya im. P. I. Chaikovskogo, 1996.

————. "Andrey Volkonskiy—Chelovek, kompozitor, ispolnitel'." In *Sator Tenet Opera Rotas: Yuriy Nikolayevich Kholopov i yego nauchnaya shkola (k 70-letiyu so dnya rozhdeniya),* edited by Valeriya Tsenova, 290–98. Moscow: Moskovskaya gosudarstvennaya konservatoriya im. P. I. Chaikovskogo, 2003.

Druzhinin, Fyodor. *Vospominaniya: Stranitsï zhizni i tvorchestva.* Edited by Ye. S. Shervin-skaya. Moscow: Greko-Latinskiy kabinet Yu. A. Shichalina, 2001.

Dubinsky, Rostislav. *Stormy Applause: Making Music in a Worker's State.* New York: Hill and Wang, 1989.

Dudek, Duane. "German Reunification: 'Goodbye, Lenin!' Personalizes Transition of East, West Germanies." *The Times Union* (Albany, NY), 22 April 2004, P39.

Durnev, M. "Eto ne muzïka." *L'vovskaya pravda,* 25 February 1962.

Eggeling, Vol'fram. *Politika i kul'tura pri Khrushchove i Brezhneve, 1953–1970 gg.* Moscow: Airo-XX, 1999.

Egorova, Tatiana. *Soviet Film Music: An Historical Survey.* Translated by Tatiana A. Ganf and Natalia A. Egunova. Amsterdam: Harwood Academic, 1997.

Ehrenburg, Ilya. *The Thaw.* Chicago: Henry Regnery, 1955.

Eimermacher, Karl. "From Unity to Diversity: Sociocultural Aspects of the Moscow Art Scene, 1945–1988." In *Forbidden Art: The Postwar Russian Avant-Garde,* edited by Garrett White, 83–127. Los Angeles: Curatorial Assistance, 1998.

Eimert, Herbert. *Grundlagen der musikalischen Reihentechnik.* Vienna: Universal Edition, 1964.

———. *Lehrbuch der Zwölftontechnik.* Wiesbaden, Germany: Breitkopf and Härtel, 1950.

Epstein, Mikhail. *After the Future: The Paradoxes of Postmodernism and Contemporary Russian Culture.* Translated with an introduction by Anesa Miller-Pogacar. Amherst: University of Massachusetts Press, 1995.

———, Alexander Genis, and Slobodanka Vladiv-Glover. *Russian Postmodernism: New Perspectives on Post-Soviet Culture.* New York: Berghahn Books, 1999.

Erjavec, Aleš, ed. *Postmodernism and the Postsocialist Condition: Politicized Art under Late Socialism.* Berkeley: University of California Press, 2003.

Eydel'man, Natan. "Vremya, sulivsheye stol'ko nadezhd." In *"Drugoye iskusstvo": Moskva 1956–76, k khronike khudozhestvennoy zhizni,* edited by Leonid Talochkin and Irina Alpatova, I:7–12. Moscow: Moskovskaya kollektsiya, 1991.

Fanning, David. "Professional Compromise." *Gramophone* 75, no. 892 (September 1997): 23.

———. "Shostakovich and His Pupils." In *Shostakovich and His World,* edited by Laurel E. Fay, 275–302. Princeton, NJ: Princeton University Press, 2004.

———, ed. *Shostakovich Studies.* Cambridge: Cambridge University Press, 1995.

Fay, Laurel. "Remembering Alfred Schnittke." September 1998, Schirmer News. http://www.schirmer.com/news/sep98/schnittke.html. Accessed 7 May 2002; inoperative link.

———. Review of *Music and Musical Life in Soviet Russia: Enlarged Edition, 1917–1981* by Boris Schwarz. *Slavic Review* 42 (1984): 359.

———. Review of *Music of the Soviet Age, 1917–1987* by Levon Hakobian. *Notes,* 2nd Ser., 56, no. 1 (September 1999): 165–66.

———. *Shostakovich: A Life.* Oxford: Oxford University Press, 2000.

———, ed. *Shostakovich and His World.* Princeton, NJ: Princeton University Press, 2004.

Figes, Orlando. *The Whisperers: Private Life in Stalin's Russia.* New York: Henry Holt, 2007.

Firsova, Elena, and Dmitri Smirnov. "Fragments about Denisov." http://homepage.ntlworld. com/dmitrismirnov/denfrag1.html. Accessed 30 January 2008.

Fitzpatrick, Sheila. "Introduction." In *Stalinism: New Directions,* edited by Sheila Fitzpatrick, 1–14. New York: Routledge, 2000.

————, ed. *Stalinism: New Directions.* New York: Routledge, 2000.

Fosler-Lussier, Danielle. *Music Divided: Bartók's Legacy in Cold War Culture.* Berkeley: University of California Press, 2007.

Frid, Grigoriy. *Muzïka—obshcheniye—sud'bï: O Moskovskom molodyozhnom muzïkal'nom klube.* Moscow: Sovetskiy kompozitor, 1987.

Friedrich, Otto. *Glenn Gould: A Life and Variations.* New York: Random House, 1989.

Frumkis, Tatjana. "An Avant-Garde Romantic: On the Music of Valentin Silvestrov." Liner notes to Valentin Sil'vestrov [Silvestrov], *Leggiero, pesante,* ECM New Series CD, 1776 (289 461898-2) (2002).

————. "K istorii odnoy (ne)lyubvi." *Muzïkal'naya akademiya* 3 (2006): 85–91. This essay originally appeared in German as "Silwestrow und Schostakowitsch: Zur Geschichte einer (Nicht)Liebe" (translated by Sigrid Neef). In *Schostakowitsch und die Folgen: Russische Musik zwischen Anpassung und Protest/Shostakovich and the Consequences: Russian Music between Adaptation and Protest,* edited by Ernst Kuhn, Jascha Nemtsov, and Andreas Wehrmeyer, 211–28. Berlin: Ernst Kuhn, 2003.

————. "Life-Music—The Postludes of Valentin Silvestrov." Liner notes to Valentin Sil'vestrov [Silvestrov], *Symphony no. 5/Postludium,* Sony CD, SK 66 825 (1996).

Gakkel', L. Ye. "Iz pyatidesyatïkh godov." In *Leningradskaya konservatoriya v vospominaniyakh,* edited by Georgiy Tigranov and E. S. Barutcheva. Second Expanded Edition, 2:101–5. Leningrad: Muzïka, 1987.

Gamzatov, G. G., and U. B. Dalgat, eds. *Traditsionnïy fol'klor narodov Dagestana.* Moscow: Nauka, 1991.

García Lorca, Federico. *Collected Poems.* Edited and with an introduction and notes by Christopher Maurer. Translated by Christopher Maurer, Francisco Aragon, Catherine Brown, et al. New York: Farrar, Straus and Giroux, 1991.

Garton Ash, Timothy. "The Stasi on Our Minds." *The New York Review of Books* 54, no. 9 (31 May 2007): 4–8.

Gerlach, Hannelore. *Fünfzig sowjetische Komponisten der Gegenwart: Fakten und Reflexionen* (Leipzig: Peters, 1984).

————. *Zum Musikschaffen in der Sowjetunion (1960–1975).* Berlin: Kulturbund der DDR, 1977.

Gershkovich [Herschkowitz], Filipp. "Tonal'nïye istoki Shonbergovoy dodekafonii." *Trudï po znakovïm sistemam* 6 (1973): 344–79. Published in German as "Die Tonalen Quellen des Schönbergschen Zwölftonsystems." In *Philip Herschkowitz über Musik,* edited by Lena Herschkowitz and Klaus Linder, IV:67–84. Vienna: Mechitaristen Druckerei, 1997. An English-language summary of this essay, along with lengthy excerpts, appears in Slonimsky, Nicolas. "Schoenberg in the Soviet Mirror." *Journal of the Arnold Schoenberg Institute* II, no. 2 (February 1978): 138–42.

Gessen, Masha. *Dead Again: The Russian Intelligentsia after Communism.* London: Verso, 1997.

Glad, John, ed. *Conversations in Exile: Russian Writers Abroad.* Durham, NC: Duke University Press, 1993.

Glade, Shirley, and Ellendea Proffer, eds. *Boris Birger: A Catalogue.* Ann Arbor, MI: Ardis, 1975.

Glezer, Aleksandr, ed. *Iskusstvo pod bul'dozerom (sinyaya kniga).* London: Overseas Publications Interchange, 1977.

Gojowy, Detlef. *Neue sowjetische Musik der 20er Jahre.* Laaber, Germany: Laaber, 1980.

———. "Nikolai Andreevič Roslavec, ein früher Zwölftonkomponist." *Die Musikforschung* 22 (1969): 22–38.

Golomshtok, Igor. "Unofficial Art in the Soviet Union." In Igor Golomshtok and Alexander Glezer, *Soviet Art in Exile,* edited by Michael Scammell, 81–106. New York: Random House, 1977.

———, and Alexander Glezer. *Soviet Art in Exile.* Edited by Michael Scammell. New York: Random House, 1977 (published in London by Secker and Warburg as *Unofficial Art from the Soviet Union*).

Gol'tsman, A. M., ed. *Problemï traditsiy i novatorstva v sovremennoy muzïke.* Moscow: Sovetskiy kompozitor, 1982.

Gratzer, Wolfgang. "'Postmoderne' überall? Aktuelle (In-)Fragestellungen im Blick auf sowjetische Musik nach 1945." In *Wiederaneignung und Neubestimmung der Fall "Postmoderne" in der Musik,* edited by Otto Kolleritsch, 63–87. Vienna, Austria: Universal Edition, 1993.

Greenberg, Noah. "A Soft Sound in the U.S.S.R." *High Fidelity/Musical America* 15, no. 5 (May 1965): 41–43, 102.

Griffiths, Paul. *Modern Music and After: Directions since 1945.* Oxford: Oxford University Press, 1995.

———. *The Substance of Things Heard: Writings about Music.* Rochester, NY: University of Rochester Press, 2005.

Grigor'yeva, G. "Al'fred Shnitke i Edison Denisov." *Shnitke posvyashchayetsya...* 4 (2004): 121–26.

Groys, Boris. "The Other Gaze: Russian Unofficial Art's View of the Soviet World." In *Postmodernism and the Postsocialist Condition: Politicized Art under Late Socialism,* edited by Aleš Erjavec, 55–89. Berkeley: University of California Press, 2003.

———. *The Total Art of Stalinism: Avant-Garde, Aesthetic Dictatorship, and Beyond.* Translated by Charles Rougle. Princeton, NJ: Princeton University Press, 1992.

Grum-Grzhimailo, Tamara. *Rostropovich i yego sovremenniki. V legendakh, bïlyakh i dialogakh.* Moscow: Agar, 1997.

Gubaidulina, Sofiya [Sofia]. "An Interview with Dorothea Redepenning." In *Contemporary Composers on Contemporary Music,* edited by Elliot Schwartz and Barney Childs, 448–54. Expanded Edition. New York: Da Capo, 1998.

———, and O. Bugrova. "'Dano' i 'zadano.'" *Muzïkal'naya akademiya* 3 (1994): 1–10.

———, and Vera Lukomsky. "'Hearing the Subconscious': Interview with Sofia Gubaidulina." *Tempo,* no. 209 (July 1999): 27–31.

———, and Vera Lukomsky. "My Desire Is Always to Rebel, to Swim against the Stream!" *Perspectives of New Music* 36 (1998): 5–41.

———, and Alla Tsïbul'skaya. "Oni nenavideli menya do togo, kak slïshali moyu muzïku...." *Muzïkal'naya akademiya* 1 (2004): 39–41.

———, and V. Yuzefoaich [Yusefovich]. "Ob uchitelyakh, kollegakh i o samoy sebe." *Muzïkal'naya akademiya* 3 (1994): 8–9.

Guerrero, Jeannie Ma. "Serial Intervention in Nono's *Il canto sospeso*." *Music Theory Online* 12, no. 1 (2006).

Haas, David. *Leningrad's Modernists: Studies in Composition and Musical Thought, 1917–1932.* New York: Peter Lang, 1998.

Hakobian, Levon. [*See* Akopyan, Levon.]

Harris, Emily. "New German Film 'Goodbye, Lenin!' Bringing Nostalgic Feelings to Former East Germans." *National Public Radio: Weekend Edition Sunday,* 20 April 2003. Transcript on LexisNexis. Accessed 10 March 2005.

Haskell, Harry, ed. *The Attentive Listener: Three Centuries of Music Criticism.* Princeton, NJ: Princeton University Press, 1996.

Heikinheimo, Seppo, Tikhon Khrennikov, and Jeremy Parsons. "Tikhon Khrennikov in Interview." *Tempo,* no. 173 (June 1990): 18–20.

Herschkowitz, Filipp [Philip]. [*See* Gershkovich, Filipp.]

Herschkowitz, Lena, and Klaus Linder, eds. *Philip Herschkowitz über Musik.* Vol. 4. Vienna: Mechitaristen Druckerei, 1997.

Hillier, Paul. *Arvo Pärt.* Oxford: Oxford University Press, 1997.

Horowitz, Joseph. "Where Composers Still Held Sway, from Underground." *New York Times,* 19 January 2003, section 2, 39.

Hrabovsky [Grabovskiy], Leonid. "O moyom uchitele." *Sovetskaya muzïka* 2 (1969): 47–51.

Il'ichev, Leonid. "Silï tvorcheskoy molodyozhi—na sluzhbu velikim idealam. Rech' Sekretarya TsK KPSS L. F. Il'icheva." *Literaturnaya gazeta* 34, no. 5 (10 January 1963): 1–3.

Infante, Frantsisko [Francisco]. "Kak ya stal khudozhnikom." In *Monografiya,* 8–9. Moscow: Gosudarstvennïy tsentr sovremennogo iskusstva, 1999.

Ivashkin, Alexander. *Alfred Schnittke.* London: Phaidon, 1996.

———. "The Paradox of Russian Non-Liberty." *The Musical Quarterly* 76 (1992): 543–56. Reprinted in abbreviated form in *The Attentive Listener: Three Centuries of Music Criticism,* edited by Harry Haskell, 378–83. Princeton, NJ: Princeton University Press, 1996.

———. "Shostakovich and Schnittke: The Erosion of Symphonic Syntax." In *Shostakovich Studies,* edited by David Fanning, 254–70. Cambridge: Cambridge University Press, 1995.

Jelinek, Hanns. *Anleitung zur Zwölftonkomposition, nebst allerlei Paralipomena. Appendix zu Zwölftonwerk, op. 15.* 2 vols. Vienna: Universal Edition, 1952–58.

Johnson, Priscilla. [*See* McMillan, Priscilla Johnson.]

Josephson, Paul R. "Atomic-Powered Communism: Nuclear Culture in the Postwar USSR." *Slavic Review* 55, no. 2 (Summer 1996): 297–324.

Kabalevskiy, Dmitriy. "Kompozitor—prezhde vsego grazhdanin." *Sovetskaya muzïka* 2 (1959): 13–20.

Kabalevskiy, Dmitriy. "Tvorchestvo molodïkh." *Sovetskaya muzïka* 12 (1958): 3–15.

———. "Tvorchestvo molodïkh kompozitorov Moskvï." *Sovetskaya muzïka* 1 (1957): 3–17.

Kachurin, Pamela, and Ernest A. Zitser. "After the Deluge: *Russian Ark* and the Abuses of History." *NewsNet: News of the American Association for the Advancement of Slavic Studies* 43, no. 4 (2003): 17–22.

Kaczynski, Tadeusz, and Andrzej Zborski. *Warszawska Jesien/Warsaw Autumn.* Kraków: Polskie Wydawn. Muzyczne, 1983.

Kamm, Henry. "Composer Tells of Artistic Battle in Soviet [On Andrey Volkonsky]." *New York Times,* 5 June 1973, 14.

Karamanov, Alemdar. "Muzïka—provodnik zvuchashchego mira." *Sovetskaya muzïka* 8 (1985): 29–33.

Karetnikov, Nikolai. *Gotovnost' k bïtiyu.* Moscow: Kompozitor, 1994.

———. "Two Novellas": "1. A Cure for Vanity" and "2. The Visit of a Distinguished Modernist." *Tempo,* no. 173 (June 1990): 44–47.

———, and Anna Golubeva. "Osvobozhdeniye ot dvoyemïsliya." *Ogonyok* 1 (1990): 15–17.

Kats, Boris. *O muzïke Borisa Tishchenko: Opït kriticheskogo issledovaniya.* Leningrad: Sovetskiy kompozitor, 1986.

Katsnel'son, I., ed. *Lirika drevnego Egipta.* Translated by Anna Akhmatova and Vera Potapova. Moscow: Khudozhestvennaya literatura, 1965.

Katunyan, Margarita. "'Peniye ptits' E. Denisov: Kompozitsiya—grafika—ispolneniye." In *Svet-dobro-vechnost': Pamyati Edisona Denisova, stat'i, vospominaniya, materialï,* edited by Valeriya Tsenova, 382–98. Moscow: Moskovskaya gosudarstvennaya konservatoriya im. P. I. Chaikovskogo, 1999.

Keldïsh, Yuriy. *100 let Moskovskoy konservatorii: Kratkiy istoricheskiy ocherk.* Moscow: Muzïka, 1966.

———. "Pesnya, kotoraya ne prozvuchala." *Sovetskaya muzïka* 11 (1958): 126–29.

Kelly, Catriona, and David Shepherd, eds. *Russian Cultural Studies: An Introduction.* Oxford: Oxford University Press, 1998.

Kennedy, Janet. "Realism, Surrealism, and Photorealism: The Reinvention of Soviet Art of the 1970s and 1980s." In *Nonconformist Art: The Soviet Experience, 1956–1986,* edited by Alla Rosenfeld and Norton T. Dodge, 273–93. New York: Thames and Hudson, 1995.

Kennicott, Philip. "The Strong, Silent Type [On Alfred Schnittke]." *Pulse!* (August 1991): 64.

Khachaturyan, Aram. "O tvorcheskoy smelosti i vdokhnovenii." *Sovetskaya muzïka* 11 (1953): 7–13.

Khidekel, Regina. "Traditionalist Rebels: Nonconformist Art in Leningrad." In *Forbidden Art: The Postwar Russian Avant-Garde,* edited by Garrett White, 129–47. Los Angeles: Curatorial Assistance, 1998.

Kholopov, Yuriy [Yuri]. "Autsaider sovetskoy muzïki: Alemdar Karamanov." In *Muzïka iz bïvshego SSSR,* edited by Valeriya Tsenova, 2 vols., I:120–38. Moscow: Kompozitor, 1994. Published in English as "Alemdar Karamanov: An Outsider in Soviet Music." In *Underground Music from the Former USSR,* edited by Valeria Tsenova, translated by

Romela Kohanovskaya, 110–27. Amsterdam: Harwood Academic, 1997. Also published in English as "Alemdar Karamanov: An Outsider in Soviet Music." In *"Ex oriente…—II": Nine Composers from the Former USSR,* edited by Valeria Tsenova, translated by Romela Kohanovskaya, 59–82. Studia slavica musicologica 30. Berlin: Ernst Kuhn, 2003.

———. "Dvenadtsatitonovost' u kontsa veka: Muzïka Edisona Denisova." In *Muzïka Edisona Denisova: Materialï nauchnoy konferentsii, posvyashchonnoy 65-letiyu kompozitora,* edited by Valeriya Tsenova, 76–94. Moscow: Moskovskaya gosudarstvennaya konservatoriya im. P. I. Chaikovskogo, 1995.

———. "Initsiator: O zhizni i muzïke Andreya Volkonskogo." In *Muzïka iz bïvshego SSSR,* edited by Valeriya Tsenova, 2 vols., I:5–23. Moscow: Kompozitor, 1994. Published in English as "Andrei Volkonsky the Initiator: A Profile of His Life and Work." In *Underground Music from the Former USSR,* edited by Valeria Tsenova, translated by Romela Kohanovskaya, 1–20. Amsterdam: Harwood Academic, 1997. Also published in English as "Andrei Volkonsky the Initiator: A Profile of His Life and Work." In *"Ex oriente…—II": Nine Composers from the Former USSR,* edited by Valeria Tsenova, translated by Romela Kohanovskaya, 1–27. Studia slavica musicologica 30. Berlin: Ernst Kuhn, 2003.

———. "Ob obshchikh logicheskikh printsipakh sovremennoy garmonii." *Muzïka i sovremennost'* 8 (1974): 229–77.

———. *Ocherki sovremennoy garmonii: Issledovaniye.* Moscow: Muzïka, 1974.

———. "Tekhniki kompozitsii Nikolaya Roslavtsa i Nikolaya Obukhova v ikh otnoshenii k razvitiyu dvenadtsatitonovoy muzïki." In *Muzïka XX veka: Moskovskiy forum; materialï mezhdunarodnïkh nauchnïkh konferentsiy,* edited by Valeriya Tsenova, A. S. Sokolov, and Vladimir Tarnopol'skiy, 75–93. Moscow: Moskovskaya gosudarstvennaya konservatoriya im. P. I. Chaikovskogo, 1999.

———. "V poiskakh utrachennoy sushchnosti muzïki: Filipp Gershkovich." In *Muzïka iz bïvshego SSSR,* edited by Valeriya Tsenova, 2 vols., I:24–40. Moscow: Kompozitor, 1994. Published in English as "Philip Gershkovich's Search for the Lost Essence of Music." In *Underground Music from the Former USSR,* edited by Valeria Tsenova, translated by Romela Kohanovskaya, 21–35. Amsterdam: Harwood Academic, 1997. Also published in English as "Philip Gershkovich's Search for the Lost Essence of Music." In *"Ex oriente…—III": Eight Composers from the Former USSR,* edited by Valeria Tsenova, translated by Romela Kohanovskaya, 1–22. Studia slavica musicologica 31. Berlin: Ernst Kuhn, 2003.

———, and Valeriya [Valeria] Tsenova. *Edison Denisov.* Moscow: Kompozitor, 1993. There have been two English translations of this book, first as *Edison Denisov.* Translated by Romela Kohanovskaya. Chur, Switzerland: Harwood Academic, 1995. The second time it appeared in the same translation, but included several new chapters not found in the Russian original (primarily translations of other writings by Kholopov and Tsenova on Denisov, including material on his posthumously published diaries): *Edison Denisov: The Russian Voice in European New Music.* Translated by Romela Kohanovskaya. Studia slavica musicologica 28. Berlin: Ernst Kuhn, 2002.

Kholopova, Valentina. "Dramaturgiya i muzïkal'nïye formï v kantate S. Gubaidulinoy 'Noch' v Memfise.'" *Muzïka i sovremennost'* 8 (1974): 109–30.

Kholopova, Valentina. "Impul'sï novatorstva i kul'turnïy sintez v tvorchestve Sergeya Slonimskogo." In *Muzïka iz bïvshego SSSR*, edited by Valeriya Tsenova, 2 vols., I:41–55. Moscow: Kompozitor, 1994. Published in English as "Sergei Slonimsky: The Impetus to Innovation and Cultural Synthesis." In *Underground Music from the Former USSR*, edited by Valeria Tsenova, translated by Romela Kohanovskaya, 36–50. Amsterdam: Harwood Academic, 1997. Also published in English as "Sergei Slonimsky: The Impetus to Innovation and Cultural Synthesis." In *"Ex oriente...—II": Nine Composers from the Former USSR*, edited by Valeria Tsenova, translated by Romela Kohanovskaya, 29–58. Studia slavica musicologica 30. Berlin: Ernst Kuhn, 2003.

———. *Kompozitor Al'fred Shnitke*. Chelyabinsk, Russia: Arkaim, 2003.

———. *Put' po tsentru: Kompozitor Rodion Shchedrin*. Moscow: Kompozitor, 2000. Published in German as Cholopowa, Valentina. *Der Weg im Zentrum: Annäherungen an den Komponisten Rodion Shchedrin*. Translated by Gabriele Leupold. Mainz, Germany: Schott, 2000.

———. "Tipï novatorstva v muzïkal'nom yazïke russkikh sovetskikh kompozitorov srednego pokoleniya." In *Problemï traditsiy i novatorstva v sovremennoy muzïke*, edited by A. M. Gol'tsman, 158–204. Moscow: Sovetskiy kompozitor, 1982.

———, and Sergey Biryukov. "Shnitke: Prodolzheniye ispovedi." *Trud*, 3 August 1999.

———, and Yevgeniya Chigaryova. *Al'fred Shnitke: Ocherk zhizni i tvorchestva*. Moscow: Sovetskiy kompozitor, 1990.

———, and Yuriy Kholopov. *Anton Vebern: Zhizn' i tvorchestvo*. Moscow: Sovetskiy kompozitor, 1984.

———, and Enzo Restan'o [Restagno]. *Sofiya Gubaidulina*. Moscow: Kompozitor, 1996. This is a retranslation from the Italian of Restagno, Enzo. *Gubajdulina*. Turin, Italy: E. D. T., 1991. A new updated edition has recently been published but has not been consulted: Moscow: Kompozitor, 2008.

Khrennikov, Tikhon. "My Conscience Is Clear: Interview with Anders Beyer." In Anders Beyer, *The Voice of Music: Conversations with Composers of Our Time*, edited and translated by Jean Christensen and Anders Beyer, 253–60. Aldershot, UK: Ashgate, 2000.

———, and V. Rubtsova. *Tak eto bïlo: Tikhon Khrennikov o vremeni i o sebe*. Moscow: Muzïka, 1994.

Khrushchev, Nikita. "Declaration Made by Nikita Khrushchev on 8 March 1963 Stating His Views on Music in Soviet Society." In *Music since 1900*, edited by Laura Kuhn and Nicolas Slonimsky, 953–54. Sixth Edition. New York: Schirmer Reference, 2001.

———. *The Great Mission of Literature and Art*. Moscow: Progress, 1964.

Koblyakov, Lev. "P. Boulez, 'Le Marteau sans maître,' Analysis of Pitch Structure." *Zeitschrift für Musiktheorie* VII (1977): 24–39.

Kohoutek, Ctirad. *Novodobé skladebné teorie západoevropské hudby*. Prague: Státni hudebni vydavatelstvi, 1962. Revised in 1965 as *Novodobé skladebné směry v hudbě*.

Kolleritsch, Otto, ed. *Wiederaneignung und Neubestimmung der Fall "Postmoderne" in der Musik*. Vienna: Universal Edition, 1993.

Komaromi, Ann. "The Unofficial Field of Late Soviet Culture." *Slavic Review* 66, no. 4 (Winter 2007): 605–29.

Korev, Yuriy. "Vecher al'tovïkh sonat." *Sovetskaya muzïka* 8 (1959): 137–38.

Kovnatskaya, L. G., ed. *Shostakovich: Mezhdu mgnoveniyem i vechnost'yu: Dokumentï, materialï, stat'i.* St. Petersburg: Kompozitor, 2000.

Kozlov, Aleksey. *Kazyol na sakse: I tak vsyu zhizn'.* Moscow: Vagrius, 1998.

Kramer, Jonathan D. "The Nature and Origins of Musical Postmodernism." In *Postmodern Music/Postmodern Thought,* edited by Judy Lochhead and Joseph Auner, 13–27. New York: Routledge, 2002.

Krebs, Stanley Dale. "Soviet Composers and the Development of Soviet Music." Ph.D. dissertation, University of Washington, 1963. Published as *Soviet Composers and the Development of Soviet Music.* New York: W. W. Norton, 1970.

Kremer, Gidon. *Zwischen Welten.* Munich, Germany: Piper, 2003.

Krenek, Ernst. "Extents and Limits of Serial Techniques." In *Problems of Modern Music: The Princeton Seminar in Advanced Musical Studies,* edited by Paul Henry Lang, 72–94. New York: W. W. Norton, 1960.

———. *Studies in Counterpoint Based on the Twelve-Tone Technique.* New York: G. Schirmer, 1940. Published in German as *Zwölfton-Kontrapunkt-Studien.* Translated by Heinz Klaus Metzger. Mainz, Germany: B. Schotts Sohne, 1952.

Kučera, Václav. *Nové proudy v sovětské hudbě: Eseje a stránky z deníku.* Prague: Panton, 1967.

Kuhn, Ernst, Jascha Nemtsov, and Andreas Wehrmeyer, eds. *Schostakowitsch und die Folgen: Russische Musik zwischen Anpassung und Protest/Shostakovich and the Consequences: Russian Music between Adaptation and Protest.* Berlin: Ernst Kuhn, 2003.

Kukharskiy, Vasiliy. "Preds'yezdovskiye zametki." *Sovetskaya muzïka* 5 (1956): 50–51.

———. "V interesakh millionov." *Sovetskaya muzïka* 10 (1968): 2–10.

Kurbatskaya, Svetlana. *Seriynaya muzïka: Voprosï istorii, teorii, estetiki.* Moscow: Sfera, 1996.

Kurtz, Michael. *Sofia Gubaidulina: Eine Biographie.* Stuttgart, Germany: Freies Geistesleben and Urachhaus, 2001. Published in English as *Sofia Gubaidulina: A Biography.* Translated by Christoph K. Lohmann. Edited by Malcolm Hamrick Brown. Bloomington: Indiana University Press, 2007. All references are to the English edition of this book.

Kuznetsov, Anatoliy, ed. *Mariya Veniaminovna Yudina: Stat'i, vospominaniya, materialï.* Moscow: Sovetskiy kompozitor, 1978.

Lang, Paul Henry, ed. *Problems of Modern Music: The Princeton Seminar in Advanced Musical Studies.* New York: W. W. Norton, 1960.

Ledenyov, Roman, and Margarita Katunyan. "Mne vsegda khotelos' idti ot emotsiy." *Muzïkal'naya akademiya* 1 (2006): 18–25.

Lemaire, Frans C. *La musique du XXe siècle en Russie et dans les anciennes Républiques soviétiques.* Paris: Fayard, 1994.

———. *Le destin russe et la musique: Un siècle d'histoire de la Révolution à nos jours.* Paris: Fayard, 2005.

———. "Volkonsky, Andrey Mikhaylovich." In *The New Grove Dictionary of Music and Musicians,* edited by S. Sadie and J. Tyrrell, 26:883–84. Second Edition. London: Macmillan, 2001.

Lerner, Leonid, ed. *Artur Fonvizin: Ya pishu nebo: Stat'i, pis'ma, stenogrammï, fotografii, risunki, illyustratsii, kartinï.* Moscow: Elita-Dizain, 2002.

Ligeti, György. "Metamorphoses of Musical Form." *Die Reihe* vii (1965): 5–19. Originally published in German in *Die Reihe* vii (1960): 5–17.

———. "Pierre Boulez: Decision and Automatism in Structure Ia." *Die Reihe* iv (1960): 36–62. Originally published in German in *Die Reihe* iv (1958): 38–63.

Linder, Klaus. "Herschkowitz, Philip." In *The New Grove Dictionary of Music and Musicians,* edited by S. Sadie and J. Tyrrell, 11:444–45. Second Edition. London: Macmillan, 2001.

Lindey, Christine. *Art in the Cold War: From Vladivostok to Kalamazoo, 1945–1962.* London: Herbert, 1990.

Lochhead, Judy, and Joseph Auner, eds. *Postmodern Music/Postmodern Thought.* New York: Routledge, 2002.

Lourie, Richard. *Russia Speaks: An Oral History from the Revolution to the Present.* New York: Edward Burlingame Books, 1991.

Lubotsky, Mark. "Schnittke as Remembered by Mark Lubotsky (1998)." In *A Schnittke Reader,* edited by Alexander Ivashkin, translated by John Goodliffe, 248–56. Bloomington: Indiana University Press, 2002.

Mazel', Lev. "O putyakh razvitiya yazïka sovremennoy muzïki: Dodekafoniya i pozdneyshiye avangardistskiye techeniya." *Sovetskaya muzïka* 8 (1965): 6–20.

Mazo, Margarita. "The Present and the Unpredictable Past: Music and Musical Life of St. Petersburg and Moscow Since the 1960s." *International Journal of Musicology* 5 (1996): 371–400.

McBurney, Gerard. "Encountering Gubaydulina." *The Musical Times* 129, no. 1741 (March 1988): 120–23, 125.

———. "Karetnikov, Nikolay Nikolayevich." In *The New Grove Dictionary of Music and Musicians,* edited by S. Sadie and J. Tyrrell, 13:375–76. Second Edition. London: Macmillan, 2001.

———. Review of recordings of Denisov, Gubaidulina, Karetnikov, and Silvestrov. *Tempo,* no. 182 (September 1992): 50–54.

———. "Soviet Music after the Death of Stalin: The Legacy of Shostakovich." In *Russian Cultural Studies: An Introduction,* edited by Catriona Kelly and David Shepherd, 120–37. Oxford: Oxford University Press, 1998.

McCarthy, Jamie. "An Interview with Arvo Pärt." *Musical Times* 130 (March 1989): 130–33.

McMillan, Priscilla Johnson. *Khrushchev and the Arts: The Politics of Soviet Culture, 1962–1964.* Cambridge, MA: MIT Press, 1964.

McPhee, John. *The Ransom of Russian Art.* New York: Farrar, Straus and Giroux, 1994.

Misiunas, Romuald, and Rein Taagepera. *The Baltic States: Years of Dependence, 1940–1990.* Revised and Expanded Edition. Berkeley: University of California Press, 1993.

Mistral, Gabriela. *Desolación-Ternura-Tala-Lagar.* Mexico City: Editorial Porrúa, 1981.

———. *Escritos Politicos.* Edited by Jaime Quezada. Santiago, Chile: Fondo de Cultura Economica Chile, 1994.

Molchanov, Kirill. "Tvorchestvo molodïkh." *Sovetskaya muzïka* 7 (1953): 7–10.

Moody, Ivan. "Alfred Schnittke." In *The New Grove Dictionary of Music and Musicians,* edited by S. Sadie and J. Tyrrell, 22:564–68. Second Edition. London: Macmillan, 2001.

Moor, Paul. "In Russia, Music for May Day." *High Fidelity/Musical America* 15, no. 7 (July 1965): 120–21.

———. "Notes from Our Correspondents: Moscow." *High Fidelity/Musical America* 15, no. 4 (1965): 22–23.

Morgan, Robert. *Twentieth-Century Music.* New York: W. W. Norton, 1991.

Morris, C. Brian, ed. *"Cuando yo me muera...": Essays in Memory of Federico García Lorca.* Lanham, MD: University Press of America, 1988.

Morrison, Simon, ed. *Sergey Prokofiev and His World.* Princeton, NJ: Princeton University Press, 2008.

Muradeli, Vano. "Za narodnost' muzïki." *Pravda,* 17 December 1962, 3.

Nadkarni, Maya, and Olga Shevchenko. "The Politics of Nostalgia: A Case for Comparative Analysis of Postsocialist Practices." *Ab-Imperio* 2 (2004): 487–520.

Nest'yev, Izrail' [Israel]. "S pozitsiy 'kholodnoy voynï.'" *Sovetskaya muzïka* 10 (1963): 125–30.

———. "Vechera Igorya Stravinskogo." *Sovetskaya muzïka* 12 (1962): 92–95.

Nest'yeva, Marina. "Tvorchestvo Valentina Sil'vestrova." *Kompozitorï soyuznïkh respublik* 4 (1983): 79–121.

———, and Yuriy Fortunatov. "Molodyozh' ishchet, somnevayetsya, nakhodit." *Sovetskaya muzïka* 3 (1966): 17–25.

Nono, Luidzhi [Luigi]. "Naiti svoyu zvezdu." *Sovetskaya muzïka* 2 (1989): 109–14.

Olt, Harry. *Estonian Music.* Tallinn, Estonia: Perioodika, 1980.

Paperno, Dmitry. *Notes of a Moscow Pianist.* Portland, OR: Amadeus, 1998.

Pasler, Jann. "Postmodernism." In *The New Grove Dictionary of Music and Musicians,* edited by S. Sadie and J. Tyrrell, 20:213–16. Second Edition. London: Macmillan, 2001.

Pekarskiy [Pekarsky], Mark. "Kryostnïy otets." In *Svet-dobro-vechnost': Pamyati Edisona Denisova, stat'i, vospominaniya, materialï,* edited by Valeriya Tsenova, 184–205. Moscow: Moskovskaya gosudarstvennaya konservatoriya im. P. I. Chaikovskogo, 1999.

———. *Nazad k Volkonskomu vperyod.* Moscow: Kompozitor, 2005.

———. "Pokloneniye piligrima Pekarskogo gore Sent-Viktuar." *Muzïkal'naya zhizn',* no. 8 (2002): 36–39, 47.

———. "Pravdivaya istoriya, rasskazannaya Markom Pekarskim o tom, kak on poznako-milsya s Luidzhi Nono, kak tot namerilsya yego odarit', kak Pekarskiy skrïvalsya, no yego izlovili i odarili,—i vsyo eto s razglagol'stvovaniyami o muzïke, o yede (i izhe s ney), o kompozitorakh, o pogode i, konechno, o sebe." *Muzïkal'naya akademiya* 1 (1996): 60–65.

———. "Umnïye rasgovorï s umnïm chelovekom." *Muzïkal'naya akademiya* 1 (2002): 107–22. This is the second of a four-part series that began in 4 (2001), and continued in 3 and 4 (2002).

Perks, Robert, and Alistair Thomson. *The Oral History Reader.* Second Edition. London: Routledge, 2006.

Perle, George. *Serial Composition and Atonality: An Introduction to the Music of Schoenberg, Berg, and Webern.* Berkeley: University of California Press, First Edition, 1962; Second Edition, 1968.

Pieslak, Sabina Păuta. "Romania's Madrigal Choir and the Politics of Prestige." *Journal of Musicological Research* 26, no. 2–3 (April 2007): 215–40.

Pietrow, Arkadij. "Happening w Gorkim: Symfonia Alfreda Sznitke." *Ruch muzyczny* 18, no. 8 (1974): 12–13.

Pilkington, Hilary. "'The Future Is Ours': Youth Culture in Russia, 1953 to the Present." In *Russian Cultural Studies: An Introduction,* edited by Catriona Kelly and David Shepherd, 368–86. Oxford: Oxford University Press, 1998.

———. *Russia's Youth and Its Culture: A Nation's Constructors and Constructed.* London: Routledge, 1994.

Pïzhikov, Aleksandr. *Khrushchovskaya "ottepel'."* Moscow: Olma-Press, 2002.

Plato, Alexander von. "The Consensus against the Victors, 1945 and 1990." *Oral History Review* 21, no. 2 (Winter 1993): 73–9.

Plisetskaya, Maya. *I, Maya Plisetskaya.* Translated by Antonina W. Bouis. New Haven, CT: Yale University Press, 2001.

Polin, Claire. "Interviews with Soviet Composers." *Tempo,* no. 151 (December 1984): 10–16.

Pollack, Howard. *Aaron Copland: The Life and Work of an Uncommon Man.* New York: Henry Holt, 1999.

Prokofiev, Sergei. *Soviet Diary 1927 and Other Writings.* Edited and translated by Oleg Prokofiev. Boston: Northeastern University Press, 1992.

Quinn, Peter. "Out with the Old and in with the New: Arvo Pärt's *Credo.*" *Tempo,* no. 211 (January 2000): 16–20.

Rappoport, L. *Teoreticheskiye problemï muzïkal'nïkh form i zhanrov.* Moscow: Muzïka, 1971.

Razoryonov, Sergey. "Ob odnom muzïkal'nom vechere." *Sovetskaya muzïka* 5 (1972): 32–35.

Reid, Susan E. "In the Name of the People: The Manège Affair Revisited." *Kritika: Explorations in Russian and Eurasian History* 6, no. 4 (Fall 2005): 673–716.

———. "Toward a New (Socialist) Realism: The Re-engagement with Western Modernism in the Khrushchev Thaw." In *Russian Art and the West: A Century of Dialogue in Painting, Architecture, and the Decorative Arts,* edited by Rosalind P. Blakesley and Susan E. Reid, 217–39. DeKalb: Northern Illinois University Press, 2007.

Remnick, David. *Lenin's Tomb: The Last Days of the Soviet Empire.* New York: Vintage, 1994.

Roberts, Peter Deane. *Modernism in Russian Piano Music: Skriabin, Prokofiev, and Their Russian Contemporaries.* 2 vols. Bloomington: Indiana University Press, 1993.

Rogov, K. "O proyekte 'Rossiya/Russia'—1970-ye godï." In *Semidesyatïye kak predmet istorii Russkoy kul'turï,* edited by K. Rogov, 7–11. Rossiya/Russia 1 (9). Moscow: O. G. I., 1998.

————, ed. *Semidesyatïye kak predmet istorii Russkoy kul'turï.* Rossiya/Russia 1 (9). Moscow: O. G. I., 1998.

Rosenfeld, Alla, and Norton T. Dodge, eds. *Nonconformist Art: The Soviet Experience, 1956–1986.* New York: Thames and Hudson, 1995.

Rosenstiel, Léonie. *Nadia Boulanger: A Life in Music.* New York: W. W. Norton, 1982.

Ross, Alex. "The Connoisseur of Chaos." *The New Republic,* 26 September 1992, 30–34.

————. *The Rest Is Noise: Listening to the Twentieth Century.* New York: Farrar, Straus and Giroux, 2007.

————. "Unauthorized: The Final Betrayal of Dmitri Shostakovich." *The New Yorker,* 6 September 2004, 164–66.

Rothstein, Edward. "A Russian at Play amid the Wreckage of a Lost Past." *New York Times,* 8 February 1994, C15.

Rozhdestvenskiy, Gennadiy. "Gennadi Rozhdestvensky on Schnittke (1989)." In *A Schnittke Reader,* edited by Alexander Ivashkin, translated by John Goodliffe, 236–39. Bloomington: Indiana University Press, 2002. This interview was published in Russian in Shnitke, Al'fred, and Aleksandr Ivashkin. *Besedï s Al'fredom Shnitke,* 248–51. Moscow: RIK "Kul'tura," 1994.

————. *Preambulï.* Moscow: Sovetskiy kompozitor, 1989.

————, and Valeriya Tsenova. "Grazhdanin mira." In *Svet-dobro-vechnost': Pamyati Edisona Denisova, stat'i, vospominaniya, materialï,* edited by Valeriya Tsenova, 151–57. Moscow: Moskovskaya gosudarstvennaya konservatoriya im. P. I. Chaikovskogo, 1999.

Rubenstein, Joshua. *Soviet Dissidents: Their Struggle for Human Rights.* Second Revised Edition. Boston: Beacon, 1985.

Rubin, Marcel' [Marcel]. "O muzïkal'nom i nemuzïkal'nom." *Sovetskaya muzïka* 3 (1961): 182–84.

————. "Vebern i yego posledovateli." *Sovetskaya muzïka* 4 (April 1959): 177–84. A slightly revised version of this appeared in East Germany as "Webern und die Folgen," *Musik und Gesellschaft* 10 (1960): 463–69.

————. "Yest' li budushcheye u atonal'noy muzïke?" *Sovetskaya muzïka* 8 (1956): 142–46.

Rïtsareva, Marina. *Kompozitor Sergey Slonimskiy.* Leningrad: Sovetskiy kompozitor, 1991.

Sabinina, Marina. "Fortepiannïy kvintet Andreya Volkonskogo." *Sovetskaya muzïka* 6 (1956): 20–24.

Sachs, Joel. "Note on the Soviet Avant-Garde." In *Russian and Soviet Music: Essays for Boris Schwarz,* edited by Malcolm Hamrick Brown, 287–307. Ann Arbor, MI: UMI Research, 1984.

Salisbury, Harrison E., ed. *The Soviet Union: The Fifty Years.* New York: Harcourt, Brace and World, 1967.

Samuel, Claude. *Mstislav Rostropovich and Galina Vishnevskaya: Russia, Music, and Liberty.* Translated by E. Thomas Glasow. Portland, OR: Amadeus, 1995.

Sandu-Dediu, Valentina. "Dodecaphonic Composition in 1950s and 1960s Europe: The Ideological Issue of Rightist or Leftist Orientation." *Journal of Musicological Research* 26, no. 2 (2007): 177–92.

Savenko, Svetlana. "Interpretatsiya idey avangarda v poslevoyennoy sovetskoy muzïke." In *Muzïka XX veka: Moskovskiy forum: Materialï mezhdunarodnïkh nauchnïkh konferentsiy*, edited by Valeriya Tsenova, A. S. Sokolov, and Vladimir Tarnopol'skiy, 33–38. Moscow: Moskovskaya gosudarstvennaya konservatoriya im. P. I. Chaikovskogo, 1999.

———. "Portret khudozhnika v zrelosti." *Sovetskaya muzïka* 9 (1981): 35–46.

———. "Poslevoyennïy muzïkal'nïy avangard." In *Russkaya muzïka i XX vek: Russkoye muzïkal'noye iskusstvo v istorii khudozhestvennoy kul'turï XX veka*, edited by M. Aranovskiy, 407–32. Moscow: Gosudarstvennïy institut iskusstvoznaniya Ministerstva kul'turï Rossiyskoy Federatsii, 1997.

———. "Rukotvornïy kosmos Valentina Sil'vestrova." In *Muzïka iz bïvshego SSSR*, edited by Valeriya Tsenova, 2 vols., I:72–89. Moscow: Kompozitor, 1994. Published in English as "Valentin Silvestrov's Lyrical Universe." In *Underground Music from the Former USSR*, edited by Valeria Tsenova, translated by Romela Kohanovskaya, 66–83. Amsterdam: Harwood Academic, 1997. Also published in English as "Valentin Silvestrov's Lyrical Universe." In *"Ex oriente...—II": Nine Composers from the Former USSR*, edited by Valeria Tsenova, translated by Romela Kohanovskaya, 83–108. Studia slavica musicologica 30. Berlin: Ernst Kuhn, 2003.

Savitskiy, Stanislav. *Andegraund: Istoriya i mifï Leningradskoy neofitsial'noy literaturï.* Moscow: Kafedra slavistiki universiteta Khel'sinki, 2002.

Scammell, Michael. "Art as Politics and Politics as Art." In *Nonconformist Art: The Soviet Experience, 1956-1986*, edited by Alla Rosenfeld and Norton T. Dodge, 49–63. New York: Thames and Hudson, 1995.

Schaeffer, Pierre. *A la recherche d'une musique concrète.* Paris: Éditions du Seuil, 1952.

———. *Traité des objets musicaux, essai interdisciplines.* Paris: Éditions du Seuil, 1966.

Schmelz, Peter J. "After Prokofiev." In *Sergey Prokofiev and His World*, edited by Simon Morrison, 493–529. Princeton, NJ: Princeton University Press, 2008.

———. "Andrey Volkonsky and the Beginnings of Unofficial Music in the Soviet Union." *Journal of the American Musicological Society* 58 (2005): 139–207.

———. "From Scriabin to Pink Floyd: The ANS Synthesizer and the Politics of Soviet Music between Thaw and Stagnation." In *Sound Commitments: Avant-Garde Music and the Sixties*, edited by Robert Adlington. Oxford: Oxford University Press, forthcoming.

———. "Listening, Memory, and the Thaw: Unofficial Music and Society in the Soviet Union, 1956-1974." Ph.D. dissertation, University of California, Berkeley, 2002.

———. "Schnittke and the Bomb." Paper presented at the 2007 Annual Meeting of the American Musicological Society, Québec City.

———. "Shostakovich's 'Twelve-Tone' Compositions and the Politics and Practice of Soviet Serialism." In *Shostakovich and His World*, edited by Laurel E. Fay, 303–54. Princeton, NJ: Princeton University Press, 2004.

———. "What Was 'Shostakovich,' and What Came Next?" *Journal of Musicology* 24, no. 3 (Summer 2007): 297–338.

Schonberg, Harold C. "An Evaluation of Richter." *New York Times*, 8 January 1961. Reprinted in the liner notes for *Richter Rediscovered: Carnegie Hall Recital, December 26, 1960*, RCA CD, 09026–63844–2 (2001).

———. "Is Anyone Writing Serious Music in Russia Today?" *New York Times*, 29 September 1974, D19.

———. "The World of Music." In *The Soviet Union: The Fifty Years*, edited by Harrison E. Salisbury, 175–98. New York: Harcourt, Brace and World, 1967.

Schwarz, Boris. "Arnold Schoenberg in Soviet Russia." *Perspectives of New Music* 4, no. 1 (Fall–Winter 1965): 86–94.

———. *Music and Musical Life in Soviet Russia: Enlarged Edition, 1917–1981*. Bloomington: Indiana University Press, 1983.

Schwartz, Elliot, and Barney Childs, eds. *Contemporary Composers on Contemporary Music.* Expanded Edition. New York: Da Capo, 1998.

Scott, James C. *Domination and the Arts of Resistance: Hidden Transcripts.* New Haven, CT: Yale University Press, 1990.

Selitskiy, Aleksandr. *Nikolai Karetnikov: Vïbor sud'bï, issledovaniye.* Rostov-on-Don: Kniga, 1997.

Service, Robert. *A History of Twentieth-Century Russia.* Cambridge, MA: Harvard University Press, 1998.

Shchedrin, Rodion. "Musical Compromise? [letter to the editor]." *Gramophone* 75, no. 894 (November 1997): 8.

———. "Tvorit' dlya naroda vo imya kommunizma." *Sovetskaya muzïka* 6 (1963): 9–24.

———, and Yekaterina Vlasova. "Iskusstvo—eto tsarstvo intuitsii, pomnozhennoy na vïsokiy professionalizm tvortsa." *Muzïkal'naya akademiya* 4 (2002): 1–9.

Shebalina, A. M., ed. *Pamyati V. Ya. Shebalina: Vospominaniya, materialï.* Moscow: Sovetskiy kompozitor, 1984.

Sherbakova, Irina. "The Gulag in Memory." In *The Oral History Reader,* edited by Robert Perks and Alistair Thomson, 521–30. Second Edition. London: Routledge, 2006.

Shneyerson, Grigoriy, ed. *D. D. Shostakovich: Stat'i i materialï.* Moscow: Sovetskiy kompozitor, 1976.

———, ed. *Muzïkal'nïye kul'turï narodov: Traditsii i sovremennost'.* Moscow: Sovetskiy kompozitor, 1973.

———. *O muzïke, zhivoy i myortvoy.* Moscow: Sovetskiy kompozitor, 1960 and 1964.

———. "O nekotorïkh yavleniyakh zarubezhnoy muzïki." *Sovetskaya muzïka* 9 (1956): 120–25.

———. "Serializm i aleatorika—'tozhdestvo protivopolozhnostey.'" *Sovetskaya muzïka* 1 (1971): 106–17. Reprinted in *Stat'i o sovremennoy zarubezhnoy muzïke, ocherki, vospominaniya*, 28–63. Moscow: Sovetskiy kompozitor, 1974.

———. *Stat'i o sovremennoy zarubezhnoy muzïke, ocherki, vospominaniya.* Moscow: Sovetskiy kompozitor, 1974.

Shnitke, Al'fred [Alfred Schnittke]. Untitled article in the section "Nad chem vï rabotayete?" *Sovetskaya muzïka* 2 (1967): 151–52.

————. "Between Hope and Despair: Interview with Anders Beyer." In Anders Beyer, *The Voice of Music: Conversations with Composers of Our Time,* edited and translated by Jean Christensen and Anders Beyer, 239–42. Aldershot, UK: Ashgate, 2000.

————. "Edison Denisov." *Res facta* 6 (1972): 109–24. An excerpt in Russian is included in Shnitke, Al'fred, and Aleksandr Ivashkin. *Besedï s Al'fredom Shnitke,* 112–13. Moscow: RIK "Kul'tura," 1994. It appears in full in Shnitke, Al'fred. *Stat'i o muzïke.* Edited by Aleksandr Ivashkin, 105–23. Moscow: Kompozitor, 2004.

————. "In Memory of Filip Moiseevich Gershkovich." In *A Schnittke Reader,* edited by Alexander Ivashkin, translated by John Goodliffe, 70–71. Bloomington: Indiana University Press, 2002. This obituary was published in Russian in Shnitke, Al'fred, and Aleksandr Ivashkin. *Besedï s Al'fredom Shnitke,* 215–16. Moscow: RIK "Kul'tura," 1994. Also in Shnitke, Al'fred. *Stat'i o muzïke.* Edited by Aleksandr Ivashkin, 183–84. Moscow: Kompozitor, 2004.

————. "Krugi vliyaniya." In *D. D. Shostakovich: Stat'i i materialï,* edited by Grigoriy Shneyerson, 225. Moscow: Sovetskiy kompozitor, 1976. Also in Shnitke, Al'fred, and Aleksandr Ivashkin. *Besedï s Al'fredom Shnitke,* 89–90. Moscow: RIK "Kul'tura," 1994; and in Shnitke, Al'fred. *Stat'i o muzïke.* Edited by Aleksandr Ivashkin, 163–64. Moscow: Kompozitor, 2004. Published in English as "On Shostakovich: Circles of Influence." In *A Schnittke Reader,* edited by Alexander Ivashkin, translated by John Goodliffe, 59–60. Bloomington: Indiana University Press, 2002.

————. "On Gennadi Rozhdestvensky." In *A Schnittke Reader,* edited by Alexander Ivashkin, translated by John Goodliffe, 75–78. Bloomington: Indiana University Press, 2002. In Russian as Shnitke, Al'fred. "O ser'yoznom i neser'yoznom." In *Stat'i o muzïke,* edited by Aleksandr Ivashkin, 196–200. Moscow: Kompozitor, 2004. Also in Shnitke, Al'fred, and Aleksandr Ivashkin. *Besedï s Al'fredom Shnitke,* 224–28. Moscow: RIK "Kul'tura," 1994.

————. "On Prokofiev (1990)." In *A Schnittke Reader,* edited by Alexander Ivashkin, translated by John Goodliffe, 61–66. Bloomington: Indiana University Press, 2002. Published in Russian in Shnitke, Al'fred, and Aleksandr Ivashkin. *Besedï s Al'fredom Shnitke,* 210–15. Moscow: RIK "Kul'tura," 1994. Also in Shnitke, Al'fred. *Stat'i o muzïke.* Edited by Aleksandr Ivashkin, 188–94. Moscow: Kompozitor, 2004.

————. "On Staging Tchaikovsky's *The Queen of Spades* (1977)." In *A Schnittke Reader,* edited by Alexander Ivashkin, translated by John Goodliffe, 53–55. Bloomington: Indiana University Press, 2002. Published in Russian in Shnitke, Al'fred, and Aleksandr Ivashkin. *Besedï s Al'fredom Shnitke,* 202–4. Moscow: RIK "Kul'tura," 1994. Also in Shnitke, Al'fred. *Stat'i o muzïke,* edited by Aleksandr Ivashkin, 165–68. Moscow: Kompozitor, 2004.

————. "Polistilisticheskiye tendentsii v sovremennoy muzïke." In Kholopova, Valentina, and Yevgeniya Chigaryova. *Al'fred Shnitke: Ocherk zhizni i tvorchestva,* 327–31. Moscow: Sovetskiy kompozitor, 1990. According to Kholopova and Chigaryova, this is the text that was originally delivered by Schnittke in October 1971. A short conspectus and critique (with only brief quotations from Schnittke's text, and without a title) appeared

shortly after it was initially presented in Shneyerson, Grigoriy, ed. *Muzïkal'nïye kul'turï narodov: Traditsii i sovremennost'*, 289–91. Moscow: Sovetskiy kompozitor, 1973. A later, somewhat revised version with a slightly different title from that in Kholopova and Chigaryova—"Polistilisticheskiye tendentsii sovremennoy muzïki"—was published in *Muzïka v SSSR* (April–June 1988): 22–24. This last (1988) version subsequently appeared in Shnitke, Al'fred, and Aleksandr Ivashkin. *Besedï s Al'fredom Shnitke*, 143–46. Moscow: RIK "Kul'tura," 1994; and also in Shnitke, Al'fred. *Stat'i o muzïke.* Edited by Aleksandr Ivashkin, 97–101. Moscow: Kompozitor, 2004. It has been published in English as "Polystylistic Tendencies in Modern Music." In *A Schnittke Reader*, edited by Alexander Ivashkin, translated by John Goodliffe, 87–90. Bloomington: Indiana University Press, 2002. The 1988 version also appeared in German as "Polystilistische Tendenzen in der modernen Musik." *MusikTexte* 30 (July–August 1989): 29–30.

———. "Razvivat' nauku o garmonii." *Sovetskaya muzïka* 10 (1961): 44–45.

———. *A Schnittke Reader.* Edited by Alexander Ivashkin. Translated by John Goodliffe. Bloomington: Indiana University Press, 2002.

———. *Stat'i o muzïke.* Edited by Aleksandr Ivashkin. Moscow: Kompozitor, 2004.

———. "The Third Movement of Berio's *Sinfonia:* Stylistic Counterpoint, Thematic and Formal Unity in Context of Polystylistics, Broadening the Concept of Thematicism (1970s)." In *A Schnittke Reader,* edited by Alexander Ivashkin, translated by John Goodliffe, 216–24. Bloomington: Indiana University Press, 2002. In Russian as Shnitke, Al'fred. "Tret'ya chast' Simfonii L. Berio. Stilisticheskiy kontrapunkt. Tematicheskoye i formal'noye edinstvo v usloviyakh polistilistiki. Rasshireniye ponyatiya tematizma." In *Stat'i o muzïke.* Edited by Aleksandr Ivashkin, 88–91. Moscow: Kompozitor, 2004.

———, and Aleksandr Ivashkin. *Besedï s Al'fredom Shnitke.* Moscow: RIK "Kul'tura," 1994. Most recent edition: Moscow: Klassika-XXI, 2005; all citations are from the 1994 edition but have been verified with the 2005 edition.

———, Yuliya Makeyeva, and Gennadiy Tsïpin. "Real'nost' kotoruyu zhdal vsyu zhizn'…." *Sovetskaya muzïka* 10 (1988): 17–28.

———, and Tatjana Porwoll. "Verschieden Einflüsse und Richtungen: Alfred Schnittke im Gespräch." *MusikTexte* 30 (July/August 1989): 25–30.

———, and Dmitriy Shul'gin. *Godï neizvestnosti Al'freda Shnitke: Besedï s kompozitorom.* Moscow: Delovaya liga, 1993. Second Corrected Edition: Moscow: Kompozitor, 2004; all citations are from the 1993 edition but have been verified with the 2004 edition.

Shostakovich, Dmitriy. *Dmitriy Shostakovich v pis'makh i dokumentakh.* Edited by Irina Bobïkina. Moscow: RIF "Antikva," 2000.

———. "Shostakovich: Letters to His Mother, 1923–1927." Selected by Dmitrii Frederiks and Rosa Sadykhova, in *Shostakovich and His World,* edited by Laurel E. Fay, 1–26. Princeton, NJ: Princeton University Press, 2004.

———, and Edison Denisov. "Dimitri Schostakowitsch: Briefe an Edison Denissow." Translated and with commentary by Detlef Gojowy. *Musik des Ostens* 10 (1986): 181–206.

Shreffler, Anne C. "Ideologies of Serialism: Stravinsky's *Threni* and the Congress for Cultural Freedom." In *Music and the Aesthetics of Modernity,* edited by Karol Berger and

Anthony Newcomb, 217–45. Isham Library Papers 6, Harvard Publications in Music 12. Cambridge, MA: Harvard University Press, 2005.

Silverberg, Laura. "The East German *Sonderweg* to Modern Music, 1956–1971." Ph.D. dissertation, University of Pennsylvania, 2007.

Sil'vestrov [Silvestrov], Valentin. "Vïyti iz zamknutogo prostranstva...." *Yunost'* 9 (1967): 100–1.

————, and Tat'yana Frumkis. "Sokhranyat' dostoinstvo...." *Sovetskaya muzïka* 4 (1990): 11–17. Portions translated into German as Silwestrow, Walentin. "In Gespräch mit Tatjana Frumkis." In *Sowjetische Musik im Licht der Perestroika: Interpretationen, Quellentexte, Komponistenmonographien,* edited by Hermann Danuser, Hannelore Gerlach, and Jürgen Köchel, 288–93. Laaber, Germany: Laaber, 1990.

Sjeklocha, Paul, and Igor Mead. *Unofficial Art in the Soviet Union.* Berkeley: University of California Press, 1967.

Slobin, Mark, ed. *Retuning Culture: Musical Changes in Central and Eastern Europe.* Durham, NC: Duke University Press, 1996.

Slonimskiy [Slonimsky], Sergey. *Burleski, elegii, difirambï v prezrennoy proze.* St. Petersburg: Kompozitor, 2000.

————. "Iz vospominaniy." In *Leningradskaya konservatoriya v vospominaniyakh,* edited by Georgiy Tigranov and E. S. Barutcheva, 1:204–207. Second Expanded Edition. Leningrad: Muzïka, 1987.

————. "Varshavskaya osen'—69." *Sovetskaya muzïka* 1 (1970): 125–27.

————. "Zapretit' zapretï!" In *Georgiy Sviridov v vospominaniyakh sovremennikov,* edited by A. B. Vol'fov, 90–106. Moscow: Molodaya gvardiya, 2006.

Slonimsky, Nicolas. *Perfect Pitch: An Autobiography.* Edited by Electra Slonimsky Yourke. Second Expanded Edition. New York: Schirmer, 2002.

————. "Schoenberg in the Soviet Mirror." *Journal of the Arnold Schoenberg Institute* II, no. 2 (February 1978): 138–42.

————, and Laura Kuhn, eds. *Music since 1900.* Sixth Edition. New York: Schirmer Reference, 2001.

Smirnov, Dmitriy. "Denisov—uchitel'." In *Svet-dobro-vechnost': Pamyati Edisona Denisova, stat'i, vospominaniya, materialï,* edited by Valeriya Tsenova, 206–09. Moscow: Moskovskaya gosudarstvennaya konservatoriya im. P. I. Chaikovskogo, 1999.

————. *A Geometer of Sound Crystals: A Book on Herschkowitz.* Studia slavica musicologica 34. Berlin: Ernst Kuhn, 2003.

————. "Geometr zvukovïkh kristallov." *Sovetskaya muzïka* 3 and 4 (1990): 74–81 (3) and 84–93 (4).

————. "Marginalia quasi una Fantasia: On the Second Violin Sonata by Alfred Schnittke." *Tempo,* no. 220 (April 2002): 2–10.

————. "A Visitor from an Unknown Planet: Music in the Eyes of Filipp Herschkowitz." *Tempo,* no. 173 (June 1990): 34–38.

Sokol'skiy [Grinberg], Mattias. "Tormozï sovetskoy muzïki." *Sovetskaya muzïka* 5 (1956): 57–64.

Soomere, U. "Simfonizm Arvo Pyarta." *Kompozitorï soyuznïkh respublik* 2 (1977): 161–221.

Stern, Isaac, with Chaim Potok. *Isaac Stern: My First 79 Years.* New York: Da Capo, 1999.

Stockhausen, Karlheinz. *Texte, i: Zur elektronischen und instrumentalen Musik,* edited by Dieter Schnebel. Cologne, Germany: DuMont, 1963.

Stravinsky, Igor, and Robert Craft. *Dialogues and a Diary.* Garden City, NY: Doubleday, 1963.

Subtelny, Orest. *Ukraine: A History.* Third Edition. Toronto: University of Toronto Press, 2000.

Swift, Richard. Review of *In Praise of Shahn, a Canticle for Orchestra* by William Schuman; *Les plaintes de Chtchaza* (1962) by André Volkonsky; and *Musique pour Ars nova, pour 13 instrumentistes avec un groupe aléatoire pour chaque morceau* by Darius Milhaud. *Notes,* 2nd Ser., 29, no. 2 (December 1972): 320–22.

Talochkin, Leonid, and Irina Alpatova, eds. *"Drugoye iskusstvo": Moskva 1956–76, k khronike khudozhestvennoy zhizni.* 2 vols. Moscow: Moskovskaya kollektsiya, 1991. Second Revised Edition (condensed into a single volume): Alpatova, Irina, ed. *"Drugoye iskusstvo": Moskva 1956–1988.* Moscow: Galart/Gosudarstvennïy tsentr sovremennogo iskusstva, 2005. All citations are to the first edition.

Tarakanov, Mikhaíl. "Novaya zhizn' staroy formï." *Sovetskaya muzïka* 6 (1968): 54–62.

———. "Novïye obrazï, novïye sredstva." *Sovetskaya muzika* 1 and 2 (1966): 9–16 (1) and 5–12 (2).

———. "Tri stilya ispolneniya." *Sovetskaya muzïka* 3 (1970): 81–84.

Taruskin, Richard. "The 2000 Cramb Lecture." *DSCH Journal* 14 (January 2001): 25–43.

———. "After Everything." In *Defining Russia Musically,* 99–104. Princeton, NJ: Princeton University Press, 1997.

———. *Defining Russia Musically: Historical and Hermeneutical Essays.* Princeton, NJ: Princeton University Press, 1997.

———. "'Entoiling the Falconet.'" In *Defining Russia Musically,* 152–85. Princeton, NJ: Princeton University Press, 1997.

———. "A Myth of the Twentieth Century: *The Rite of Spring,* the Tradition of the New, and 'The Music Itself.'" *Modernism/Modernity* 2, no. 1 (1995): 1–26. Also in *Defining Russia Musically,* 360–88. Princeton, NJ: Princeton University Press, 1997.

———. "Nationalism." In *The New Grove Dictionary of Music and Musicians,* edited by S. Sadie and J. Tyrrell, 17:689–706. Second Edition. London: Macmillan, 2001.

———. "The Opera and the Dictator: The Peculiar Martyrdom of Dmitri Shostakovich." *The New Republic,* 20 March 1989, 34–40.

———. *The Oxford History of Western Music.* 6 vols. Oxford: Oxford University Press, 2005.

———. Review of Peter D. Roberts, *Modernism in Russian Piano Music: Skriabin, Prokofiev, and Their Russian Contemporaries.* In *Slavic Review* 53, no. 3 (Fall 1994): 865–66.

———. *Stravinsky and the Russian Traditions: A Biography of the Works through Mavra.* Berkeley: University of California Press, 1996.

Taubman, William. *Khrushchev: The Man and His Era.* New York: W. W. Norton, 2003.

Taubman, William, Sergei Khrushchev, and Abbott Gleason, eds. *Nikita Khrushchev*. New Haven, CT: Yale University Press, 2000.

Tertz, Abram [Andrey Sinyavskiy]. *The Trial Begins and On Socialist Realism*. Berkeley: University of California Press, 1982.

Thomas, Adrian. *Polish Music since Szymanowski*. Cambridge: Cambridge University Press, 2005.

Tigranov, Georgiy, and E. S. Barutcheva, eds. *Leningradskaya konservatoriya v vospominaniyakh*. 2 vols. Second Expanded Edition. Leningrad: Muzïka, 1987.

Tillman, Joakim. "Postmodernism and Art Music in the German Debate." In *Postmodern Music/Postmodern Thought*, edited by Judy Lochhead and Joseph Auner, 75–92. New York: Routledge, 2002.

Til'man, Iogannes Paul' [Thilman, Johannes Paul]. "O dodekafonnom metode kompozitsii." *Sovetskaya muzïka* 11 (1958): 119–126. Originally published in full in German as "Die kompozitionsweise mit zwölf Tönen." *Musik und Gesellschaft* 6, nos. 7 and 8 (July and August 1956): 7–11 (no. 7) and 8–12 (no. 8).

Tishchenko, B. I. [Boris]. "Moya konservatoriya." In *Leningradskaya konservatoriya v vospominaniyakh*, edited by Georgiy Tigranov and E. S. Barutcheva, 1:234–42. Second Expanded Edition. Leningrad: Muzïka, 1987.

Tomoff, Kiril. *Creative Union: The Professional Organization of Soviet Composers, 1939–1953*. Ithaca, NY: Cornell University Press, 2006.

Trambitskiy, Viktor. "Znacheniye zamïsla." *Sovetskaya muzïka* 2 (1959): 21–26.

Tsenova, Valeriya [Valeria], ed. *Muzïka Edisona Denisova: Materialï nauchnoy konferentsii, posvyashchonnoy 65-letiyu kompozitora*. Moscow: Moskovskaya gosudarstvennaya konservatoriya im. P. I. Chaikovskogo, 1995.

———, ed. *Muzïka iz bïvshego SSSR*. Vol. I. Moscow: Kompozitor, 1994. Published in English as *Underground Music from the Former U.S.S.R*. Translated by Romela Kohanovskaya. Amsterdam: Harwood Academic, 1997. Portions have also been translated into English as *"Ex oriente…—II": Nine Composers from the Former USSR*. Translated by Romela Kohanovskaya. Studia slavica musicologica 30. Berlin: Ernst Kuhn, 2003. Other portions have appeared in English as *"Ex oriente…—III": Eight Composers from the Former USSR*. Translated by Romela Kohanovskaya. Studia slavica musicologica 31. Berlin: Ernst Kuhn, 2003.

———, ed. *Sator Tenet Opera Rotas: Yuriy Nikolayevich Kholopov i yego nauchnaya shkola (k 70-letiyu so dnya rozhdeniya)*. Moscow: Moskovskaya gosudarstvennaya konservatoriya im. P. I. Chaikovskogo, 2003.

———, ed. *Svet-dobro-vechnost': Pamyati Edisona Denisova: Stat'i, vospominaniya, materialï*. Moscow: Moskovskaya gosudarstvennaya konservatoriya im. P. I. Chaikovskogo, 1999.

——— [Valeria Zenowa]. *Zahlenmystik in der Musik von Sofia Gubaidulina*. Translated by Hans-Joachim Grimm and Ernst Kuhn. Berlin: E. Kuhn; Hamburg: H. Sikorski, 2001. Originally published in Russian as *Chislovaya taina muzïki Sofii Gubaidulinoy*. Moscow: Moskovskaya gosudarstvennaya konservatoriya im. P. I. Chaikovskogo, 2000.

————, A. S. Sokolov, and Vladimir Tarnopol'skiy, eds. *Muzïka XX veka: Moskovskiy forum: Materialï mezhdunarodnïkh nauchnïkh konferentsiy*. Moscow: Moskovskaya gosudarstvennaya konservatoriya im. P. I. Chaikovskogo, 1999.

Tsukkerman, Viktor. "'Varshavskaya Osen'' 1965 goda." *Sovetskaya muzïka* 1 (1966): 97–107.

Uvarova, I. P., and K. Rogov. "Semidesyatïye: Khronika kul'turnoy zhizni." In *Semidesyatïye kak predmet istorii Russkoy kul'turï,* edited by K. Rogov, 29–76. Rossiya/Russia 1 (9). Moscow: O. G. I., 1998.

Vail', Pyotr, and Aleksandr Genis. *60-ye: Mir sovetskogo cheloveka*. Second Corrected Edition. Moscow: Novoye literaturnoye obozreniye, 1998.

Verdery, Katherine. *What Was Socialism, and What Comes Next?* Princeton, NJ: Princeton University Press, 1996.

Viola, Lynne. "Popular Resistance in the Stalinist 1930s: Soliloquy of a Devil's Advocate." In *The Resistance Debate in Russian and Soviet History,* edited by Michael David-Fox, Peter Holquist, and Marshall Poe, 69–102. Kritika Historical Studies 1. Bloomington, IN: Slavica, 2003. This essay previously appeared in Viola, Lynne, ed. *Contending with Stalinism: Soviet Power and Popular Resistance in the 1930s,* 17–42. Ithaca, NY: Cornell University Press, 2002.

Vlasova, Yekaterina, and D. Daragan, eds. *Soyuz kompozitorov Rossii: 40 let*. Moscow: Kompozitor, 2000.

Vol'fov, A. B., ed. *Georgiy Sviridov v vospominaniyakh sovremennikov*. Moscow: Molodaya gvardiya, 2006.

Volkonskiy [Volkonsky], Andrey. "Andrey Volkonskiy [Interview by Andrey Lishke]." *Russkaya mïsl'* (Paris), 27 June 1974, 8.

————. "Optimisticheskaya tragediya." *Sovetskaya muzïka* 3 (1954): 25–28.

————. "Sprechen, ohne gehört zu werden: Der Komponist Andrej Wolkonski begründet seine Emigration aus der Sowjetunion." *Frankfurter Allgemeine Zeitung,* 5 October 1974, 21.

Volkov, Solomon. *Shostakovich and Stalin: The Extraordinary Relationship between the Great Composer and the Brutal Dictator*. Translated by Antonina W. Bouis. New York: Alfred A. Knopf, 2004.

Walters, D. Gareth. *Canciones and the Early Poetry of Lorca: A Study in Critical Methodology and Poetic Maturity*. Cardiff: University of Wales Press, 2002.

Warren, Marcus. "Putin Revives Soviet National Anthem." *Daily Telegraph,* 9 December 2000, 19.

Wassener, Bettina. "Let's Do the Timewarp Again." *Financial Times,* 2 April 2003, Arts, 10.

Watkins, Glenn. *Pyramids at the Louvre: Music, Culture, and Collage from Stravinsky to the Postmodernists*. Cambridge, MA: Belknap Press of Harvard University Press, 1994.

Werth, Alexander. *Musical Uproar in Moscow*. London: Turnstile, 1949.

————. *Russia under Khrushchev*. New York: Hill and Wang, 1962, 1961.

White, Garrett, ed. *Forbidden Art: The Postwar Russian Avant-Garde*. Los Angeles: Curatorial Assistance, 1998.

Wilson, A. N. *Tolstoy*. New York: W. W. Norton, 1988.

Wilson, Elizabeth. *Rostropovich: The Musical Life of the Great Cellist, Teacher, and Legend*. Chicago: Ivan R. Dee, 2008.

———. *Shostakovich: A Life Remembered*. Second Edition. Princeton, NJ: Princeton University Press, 2006.

Wright, David. "Peinture: Some Thoughts on Denisov." *The Musical Times* 132, no. 1779 (May 1991): 242–43.

Yekimovskiy [Yekimovsky], Viktor. *Avtomonografiya*. Moscow: Kompozitor, 1997.

———. *Oliv'ye Messian: Khudozhnik i vremya*. Moscow: GMPI im. Gnesinïkh, 1971. This was revised in 1979, but published almost a decade later, as *Oliv'ye Messian, zhizn' i tvorchestvo*. Moscow: Sovetskiy kompozitor, 1987.

Yudina, Mariya. "A. M. Volkonskiy." In *Vï spasyotes' cherez muzïku: Literaturnoye naslediye*, edited by A. M. Kuznetsov, 251–52. Moscow: Klassika-XXI, 2005.

———. "A. Pyart." In *Vï spasyotes' cherez muzïku: Literaturnoye naslediye*, edited by A. M. Kuznetsov, 252. Moscow: Klassika-XXI, 2005.

———. "G. S. Frid." In *Vï spasyotes' cherez muzïku: Literaturnoye naslediye*, edited by A. M. Kuznetsov, 250. Moscow: Klassika-XXI, 2005.

———. *Mariya Yudina: Luchi bozhestvennoy lyubvi: Literaturnoye naslediye*, edited by Anatoliy Kuznetsov. Moscow: Universitetskaya kniga, 1999.

———. "Ob istorii vozniknoveniya russkogo teksta (perevoda) 'Zhizni Marii' Rainera Marii Ril'ke." In *Mariya Yudina: Luchi bozhestvennoy lyubvi*, edited by Anatoliy Kuznetsov, 166–76. Moscow: Universitetskaya kniga, 1999.

———. "O sovremennoy muzïke (zapiska P'yeru Bulezu)." In *Vï spasyotes' cherez muzïku: Literaturnoye naslediye*, edited by A. M. Kuznetsov, 242–43. Moscow: Klassika-XXI, 2005.

———. *Vï spasyotes' cherez muzïku: Literaturnoye naslediye*. Edited by A. M. Kuznetsov. Moscow: Klassika-XXI, 2005.

Yurchak, Alexei. *Everything Was Forever, until It Was No More: The Last Soviet Generation*. Princeton, NJ: Princeton University Press, 2006.

Zaderatskiy, Vsevolod. "O nekotorïkh novïkh stilevïkh tendentsiyakh v kompozitorskom tvorchestve 60–70-kh godov." In *Muzïkal'naya kul'tura Ukraínskoy SSR*. Moscow: Muzïka, 1979.

Zagyanskaya, Galina. *Artur Vladimirovich Fonvizin*. Moscow: Sovetskiy khudozhnik, 1970.

Zhirov, L. "Udacha molodogo kompozitora." *Sovetskaya muzïka* 2 (February 1959): 125.

Živković, Marko. "Telling Stories about Serbia: Native and Other Dilemmas on the Edge of Chaos." In *Fieldwork Dilemmas: Anthropologists in Postsocialist States*, edited by Hermine G. De Soto and Nora Dudwick, 54–5. Madison: University of Wisconsin Press, 2000.

SCORES

Denisov, Edison. *Die Sonne der Inkas*. London: Universal Edition, 1971; Budapest: Universal Edition/Editio Musica, 1971.

Gershkovich [Herschkowitz], Filipp. *Kaprichchio dlya dvukh fortep'iano*. Moscow: Sovet-skiy kompozitor, 1957.

Karetnikov, Nikolai. *Klavierstücke, op. 11, 23, 25*. Leipzig, Germany: Peters, 1978.

Krenek, Ernst. *Lamentatio Jeremiae Prophetae: Secundum Breviarium Sacrosanctae Ecclesiae Romanae, op. 93*. New York: Independent Music, 1942; Kassel, Germany: Bärenreiter, 1957.

Marutayev, Mikhaíl. *Skertso dlya simfonicheskogo orkestra, soch. 4*. Moscow: Sovetskiy kompozitor, 1962.

Pärt, Arvo. *Diagrammid, Op. 11*. Hamburg, Germany: Hans Sikorski, n.d.

Shnitke, Al'fred [Alfred Schnittke]. *Streichquartett (1966)*. Vienna, Austria: Universal Edition, 1969.

Sil'vestrov [Silvestrov], Valentin. *Meditation for Violoncello and Chamber Orchestra*. Hamburg, Germany: Hans Sikorski, 1981.

Vieru, Anatol. *Crible d'Eratosthene*. Paris: Salabert, 1970.

Volkonskiy [Volkonsky], Andrey. *Concerto itinérant*. Paris: Salabert, 1976.

———. *Immobile*. Paris: Salabert, 1978.

———. *Jeu à Trois: Mobile pour Flûte, Violon et Clavecin*. Paris: Salabert, 1976.

———. *Les plaintes de Chtchaza*. London: Universal Edition, 1970.

———. *Musica Stricta*. Frankfurt, Germany: M. P. Belaieff, 1997.

———. *Sérenade pour un insecte*. Frankfurt, Germany: M. P. Belaieff, 1990.

———. *Syuita zerkal*. Moscow: Sovetskiy kompozitor, 1970.

Discography and Videography

Bernstein, Leonard. *Bernstein Conducts Music of Our Time, vol. 2*. Columbia Records LP, ML6452/MS7052 (1967). Also available on CD as Sony Classical, SMK 61845 (1999).

———. *Leonard Bernstein in Russia: The New York Philharmonic Orchestra: Beethoven, Brahms, Ravel, 1959*. Jimmy Ltd. CD, OM 03-131 (1997).

Borodin Quartet. *Russian Chamber Music: Schnittke, Shebalin, Stravinsky*. Melodiya CD, 10 00958 (2005).

Edison Denisov: Les Pleurs; Lidia Davydova, Soprano. Solyd Records CD, SLR 0332 (2003).

Festival Alternativa: Moscau 9–23 October 1989. Col Legno CD, AU 31840-31845 (1992).

Gould, Glenn. *Glenn Gould in Russia, 1957*. Manufactured under license of Melodiya, released by Jimmy Classic CD, OM 03-101/102 (1996). The original Melodiya LP was released in 1984 as M10 45963 009.

———. *Glenn Gould: The Russian Journey*. CBC/Kultur DVD, D2820 (2002).

Gubaidulina, Sofiya [Sofia]. *Bassoon Concerto/Concordanza/Detto II*. BIS CD, CD-636 (1993).

———. *Gubaidulina: Orchestral Works and Chamber Music*. Col Legno CD, WWE 1CD 20507 (2000).

———. *Rubaiyat/Detto II/Misterioso/Concerto for Bassoon and Low Strings*. Musica non Grata, Melodiya/BMG CD, 74321 49957 2 (1997).

Khrzhanovskiy, Andrey [Andrei Khrjanovsky]. *Glass Harmonica.* On the DVD *Masters of Russian Animation, vol. 1.* Image Entertainment (1997/2000).

Lyubimov [Lubimov], Aleksey. *Elegies for Piano.* ECM CD, New Series 1771 (2002).

———. *Fractured Surfaces: Soviet Avant-Garde 1957–1970.* Solyd Records CD, SLR 0333 (2003).

Pärt, Arvo. *Pro and Contra.* Virgin Classics CD, 7243 5 45630 2 7 (2004).

Professiya—Kompozitor [On Nikolai Karetnikov]. Film. Director: Vadim Zobin, Russia (1992).

Shafran, Daniel. *Bach: Three Sonatas for Cello and Harpsichord.* Daniel Shafran, vol. 4. DOREMI CD, DHR-7853 (2005).

Shnitke, Al'fred [Alfred Schnittke]. *Symphony No. 1.* Rozhdestvensky, cond. Melodiya CD, SUCD 10-00062 (1987).

Sil'vestrov [Silvestrov], Valentin. *Drama: World Premiere Recording.* Koch International CD, KIC-CD-7740 (2007).

Stravinsky in Moscow 1962. Melodiya/BMG CD, 74321 22330 2 (1996).

Volkonskiy [Volkonsky], Andrey. *Mirror Suite, et al.* Solyd Records CD, SLR 0331 (2003). Also available on Thorofon (Bella Musica) Records: André Volkonsky. *Suite de los espejos, et al.* Bella Musica/Thorofon CD, CTH 2502 (2004).

———. *Musica Stricta, Suite of Mirrors, et al.* Wergo CD, 286 601–2 (1996).

INDEX